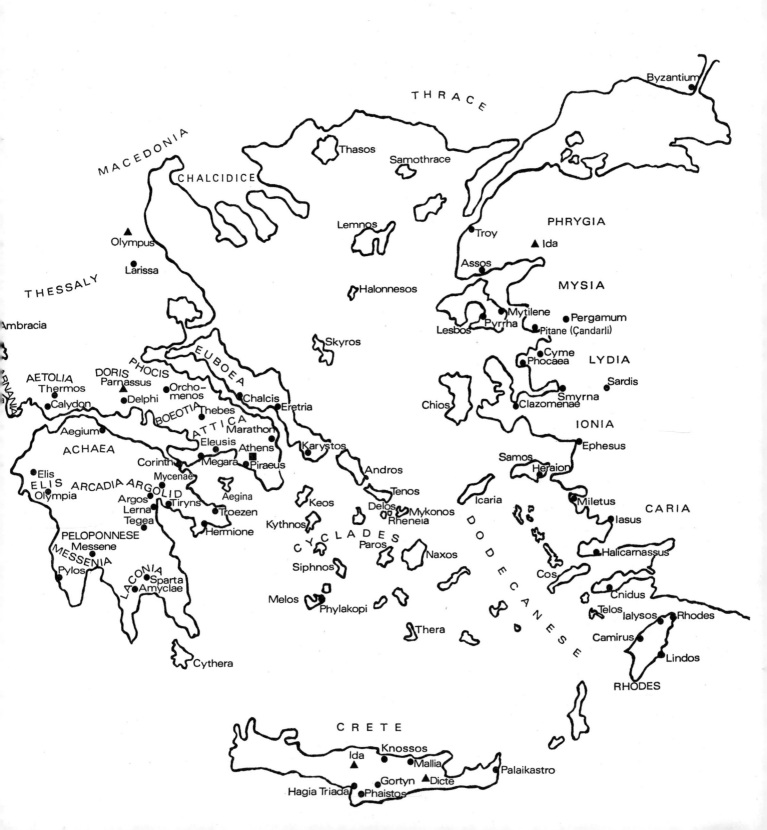

THRACE

MACEDONIA

CHALCIDICE

Thasos

Samothrace

Byzantium

PHRYGIA

Lemnos

Troy

▲ Ida

MYSIA

▲ Olympus

Larissa

THESSALY

Assos

Halonnesos

Pergamum

Ambracia

Mytilene

Lesbos Pyrrha

Pitane (Çandarli)

Skyros

Cyme

LYDIA

Phocaea

AETOLIA DORIS PHOCIS EUBOEA

Thermos Parnassus ▲

Orcho-

Chios

Sardis

Calydon ▲ Delphi menos

Clazomenae Smyrna

BOEOTIA Thebes Chalcis

Eretria

IONIA

Aegium ATTICA Marathon

ACHAEA Eleusis Karystos

Samos

Ephesus

Corinth Athens

Heraion

Elis Mycenae Megara Piraeus

Andros

Miletus

Olympia ARCADIA ARGOLID Tiryns

Tenos

Icaria

CARIA

ELIS

Argos

Aegina

Keos Delos

Iasus

Lerna

Troezen

Kythnos Rheneia Mykonos

Tegea

Hermione

Halicarnassus

PELOPONNESE

CYCLADES Paros

Naxos

Messene

Siphnos

Cos

MESSENIA

LACONIA

DODECANESE

Cnidus

Pylos

Sparta

Melos

Telos Ialysos

Amyclae

Phylakopi

Rhodes

Thera

Camirus

Cythera

Lindos

RHODES

CRETE

Ida ▲ Knossos

Mallia

Gortyn ▲ Dicte

Palaikastro

Hagia Triada Phaistos

Greek Geometric Art

Bernhard Schweitzer

Greek Geometric Art

Phaidon

Edited by Ulrich Hausmann
in co-operation with Jochen Briegleb

Translated by Peter and Cornelia Usborne

Phaidon Press Limited, 5 Cromwell Place, London SW7

Published in the United States by Phaidon Publishers, Inc.
and distributed by Praeger Publishers, Inc.,
111 Fourth Avenue, New York, N.Y. 10003

Originally published as *Die geometrische Kunst Griechenlands*
© 1969 by Verlag M. DuMont Schauberg, Cologne

Translation © 1971 by Phaidon Press Limited

ISBN 0 7148 1411 3
Library of Congress Catalog Card Number: 71–111066

Printed in Germany by Boss-Druck, Kleve

Contents

Introduction

A whole epoch lies between the Geometric period and the brilliant earlier civilization which gradually declined during the Mycenaean period until it was overtaken, during the eleventh and tenth centuries B.C., by changes so catastrophic that the memory of it was virtually eradicated, or at best consigned to the twilight of legend and saga. Not even the epics of Homer were able to revive the remnants of that great age, traces of which were still to be found at the time in Crete, Cyprus and Syria. The highly civilized court life already cultivated by the Ionian and Aeolian Greek tribes before the middle of the second millennium B.C. was based on the foreign Minoan culture from Crete.[1] Once Crete declined, the whole culture to which it had given rise was also doomed to disappear. The two or three centuries between its destruction and the beginnings of a new culture on the Greek mainland early in the first millennium B.C. was long enough for a great civilization to disappear into total oblivion.

The difference between the great cultures of pre-Greek Crete and Greek Mycenae can be seen in the Mycenaeans' religion, sagas, architecture, fortifications and better weapons, their rough-hewn tombstones of the shaft graves, and the monumental relief over the Lion Gate, rather than in their art. For in art the early Greek settlers in the Aegean and on its western and eastern shores learnt to use the highly developed idioms of the Minoans. Their precious gold and silver work, their ivory carvings, faience pottery and architectural ornamentation, their cut stones and their gold rings which have flat oval bezels engraved with reversed images in place of semi-precious stones —all these were products of Cretan Minoan art, which had been spread deep into the Mycenaean mainland by Minoan craftsmen and instructors. No doubt eager Mycenaean apprentices were quick to copy, and the dominant influence was always the Minoan art of the second millennium, based on Crete.

During Late Helladic periods I and II, even vase painting was no exception to this rule, and it is not until Late Helladic III that we find a new direction in art.[2] By this time, a unified style of decoration had spread across the whole of the Mycenaean world, in the Aegean, on the mainland, and in Anatolia down as far as Cyprus. In all these places local workshops were set up, and there appeared the first traces of a tendency to make the decoration geometrical. The exuberant plant, tree and flower motifs disappeared, and images of bulls and other animals, and of people in action began to appear in the modest vase paintings of the period. These also showed scenes of hunting, sallies by armed troops, and fighting around Mycenaean citadels. The world had changed, and moved a long way from Minoan Crete. But artists continued to use the formal idioms of the Minoan culture, which had survived even its Mycenaean conquerors. The octopus, the final echo of a splendid image from Minoan metalwork and vase paintings, continued to be one of the most frequent decorative motifs in Mycenaean art. And in the tenth century, almost two hundred years after the destruction of the Mycenaean citadels, the octopus reappeared, albeit completely stylized, geometrical and misunderstood, as the most repeated ornamental motif in Protogeometric vase painting on the Greek mainland and on the islands.[3] But by this time, the thread with the past had been broken, and a whole age had disappeared into oblivion.

The split between Minoan-Mycenaean art and Greek Geometric art, which coincides with the transition from the Late Bronze Age to the Early Iron Age, implies a slow decline of the Minoan and Mycenaean civilizations between the end of the twelfth century and the beginning of the tenth. This decline, which followed the destruction of the material and political foundations of these civilizations, and the arrival of new Greek tribes, set the seal on the total

disappearance of this great second-millennium culture. The best explanation of the vanishing of Minoan-Mycenaean art is probably the fact that the seed of highly developed Cretan culture had been sown on the still underdeveloped and infertile ground of the Mycenaean world.

Minoan and Mycenaean culture

The relationship between the Minoan population and the Mycenaean-Helladic settlers in the Aegean, on the islands, and on the mainland, probably alternated continuously between friendship and feud, harmony and discord. The island of Crete had an ancient and sophisticated culture, the first to break away from Egypt and the Near East. The immigrant Greek tribes were eager, energetic people, keen to learn, who took over a great deal of the Minoan culture, particularly in art and architecture. But they had their own system of government, and their own gods and heroes. They still lived in an heroic age, as is illustrated on the gold discs and inlaid daggers found in the Mycenaean shaft graves, at a time when in Crete the later palaces displayed their greatest splendour, and the Minoan world was reaching the peak of its power and material prosperity. But towards the end of the fifteenth century, the Minoan palaces were largely destroyed, although it is not known whether this was the result of an earthquake or an invasion. Soon afterwards, or perhaps a good deal later, an archive on clay tablets written in the Greek language but in Minoan script, Linear B, was created. The tablets survived the fire which finally destroyed the palace of Knossos in the fourteenth century. This destruction was a blow from which the Minoan power never recovered. It was succeeded in the Aegean by the Mycenaean Greek tribes, the Ionians, Achaeans and Aeolians. Now the splendid courts of Mycenae, Tiryns, Athens, Iolkos, Pylos and Melos began to flourish. From Minoan art, they copied the large-scale plans of their palaces (although not the ingenious multi-storied construction), the sophistications of advanced civilization (from armouries and workshops to bathrooms) and many techniques of building and architectural decoration. But the core of a Mycenaean building was a non-Minoan feature and one which had been developed, over the course of a thousand years, outside the Aegean. Even in Pylos, where the terrain would have allowed it, there is no central courtyard, as found in the Minoan palaces. Instead, there is the so-called *megaron*, a large, high hall with a broad antechamber and an open porch with two columns between the antae. In the middle of the main hall, there was an *eschara* or circular hearth, which served as an altar, and was set between four columns supporting the roof. The porch always faced south. In the Mycenaean period, a small courtyard was built onto the *megaron*. In Tiryns this was surrounded on three sides by a colonnade. The *megaron* style has been found spread across a large area, from central and southeastern Europe, to Troy II and Asia Minor. It is not possible to say whether the direction of this spread was from southeast to northwest or from a central point outwards in both directions. At all events, the new core of the palace, the *megaron* hall with its annexed courtyard, was not Minoan, and it replaced the great central court, the one monumental feature of Minoan architecture. To the south of the eastern Cretan town of Gournia with its ruined palace, which had the usual internal courtyard, a carefully constructed mansion in the *megaron* style, similar to the mansion in the town of Phylakopi on Melos, (dated from the small finds as Late Helladic III),[4] was built right on the edge of the ruined town. Mycenaean architecture on the mainland, the islands and Crete was as Greek as the Linear B tablets in the ruins of the palace of Knossos. During the early part of the Greek historical period, after Mycenaean culture, too, had disappeared, the Late Helladic palace and mansion, with the *eschara* in the middle, developed into the temple with antae in a *megaron* plan, with an altar in the main room and columns supporting the roof. So the Mycenaean ruler's palace became a religious building.

With the collapse of the Minoan power and culture, the Mycenaean Greeks achieved undisputed supremacy in the Aegean, and reached the peak of their material prosperity. This lasted for nearly two centuries. They expanded into the islands, making Rhodes an important base of operations. Trading links were established as far afield as Troy and the

Aeolid, Byblos, Ras Shamra and Minet el-Beida in Syria, and even Sicily. Trade channels already opened up by the Minoans were often taken over. It was a prosperous and generally peaceful world, which has been called the 'Age of Court Culture'. But during the thirteenth century, its appearance underwent a change. The palaces were surrounded with strong fortifications. Gates were protected by parallel walls, bastions by casemates, the route to the well and the sallyports by massive outworks. At a slightly lower level, but almost as large, a special stronghold was built for the peasants and all their possessions. So the palaces became fortified citadels, in Mycenae, Tiryns, Athens, Thebes, and Gla in Boeotia. The Greeks of a later period assumed these massive fortifications belonged to some mythical age, and they could only understand them as creations of the 'Cyclopes'. The huge effort which must have gone into turning the Mycenaean palaces into fortified citadels makes it clear that they were seriously threatened at the time. Feuds between the Argives and Eteokles, the ruler of Thebes, and the second campaign of the Epigoni against Thebes, may have led to the destruction of the palace of Thebes in the early thirteenth century.[5] But the building of massive citadels on the western edge of the Aegean in the following century suggests that they were threatened by a danger greater than mere feuds between Mycenaean princes. In the event, Greek tribes from the northwest drove down in two powerful waves towards the Peloponnese and the Aegean. Greek tradition called this movement the 'Dorian Invasion', or 'The return of the Herakleidai'. The first wave came in the second half of the thirteenth century and occupied the western regions of the Peloponnese, but did not succeed in getting a foothold in the Mycenaean kingdoms or the fortified citadels on the eastern coast. The 'Minyan' places around the palace of Pylos in Messenia also escaped. It was not until the second wave, which was much better prepared, and also came in the second half of the century, that catastrophe really fell. This time, the Dorians smashed the fortifications in the Argolid and in Laconia. They occupied the islands of Kythera, Melos, Thera, Crete, Cos and Rhodes. With the exception of a small region called Doris, in central Greece, the Dorians conquered and occupied all the key positions

of the early Greeks. The Greeks from the northwest settled firmly in Aetolia, Phokis and Lokris. Only the Athenians and Arcadians stayed where they were. These wars meant not only bitter fighting and destruction, but the seizure by invaders (albeit of related stock) of what they regarded as a promised land. These Dorians must have advanced with the irresistible force of an avalanche as they spread across the country and changed the map of Greece. The Mycenaean Greeks, based on the Argolid and Laconia, were predominantly of Ionian stock, as can be seen from the relics of their religion.[6] A mythical tale related how the survivors of these Ionians and the Minyans from Pylos, with the help of Athens, founded a new Ionia on the west coast of Asia Minor. The Aeolians later settled further to the north on the same coast, and a whole series of Ionian towns sprang up on the northern edge of the Aegean. The native Ionian inhabitants were able to stay, however, in the Cyclades. In Cyprus, Ionian-Mycenaean settlements had been founded on the west and north coast before the catastrophe (Old Paphos, Soloi, the 'Mycenaean' palace of Vouni, Salamis), and in Enkomi highly productive workshops were established, producing Mycenaean gold jewellery, ivory reliefs and bronze utensils, which continued to exist and function after the Mycenaean world had been obliterated. The important fact, however, is that after their second invasion the Dorians conquered virtually the whole of the Ionian-Mycenaean world, from the Peloponnese to Rhodes, with the exception of Miletus in Asia Minor, Athens, and Aeolian Iolkos. The civilization built up over many centuries by the Mycenaeans, with the help of the Minoans, was destroyed. Although they spoke the same language, the Dorians came as invaders and conquerors, culturally half a millennium behind the people whom they vanquished. It was a catastrophic, unprecedented disaster—a plunge into an abyss. A new beginning could take shape only very slowly.

The dark age

This decline into a nearly unhistoric state was followed by the 'dark age', from the eleventh century until well into the ninth. The transition from a bronze

culture to an iron culture was accompanied by what F. Matz has emphasized as a 'Caesura between the Ages', rather than by a new flowering of civilization. It was a period which produced no significant architecture, no wall painting, sculpture, precious utensils or jewellery, either of ivory, wood or gold. There seems to be only one narrow path leading from the vanquished Minoan civilization to the slow beginnings of a new culture, and the landscape through which that path leads looks like a new prehistory. Painted pottery forms this slender connection. For a long time, the painting was in a poor and confused sub-Mycenaean style. But in the tenth century a highly disciplined style developed, based on a few strongly geometrized Late Mycenaean decorative motifs. This was the so-called Protogeometric style. The limited range of shapes of vessel in this style, in contrast with the endless variety of the Mycenaean period, reflects the extent of the collapse of the earlier civilization. The new style is evident even in the form of the vases. The amphorae with shoulder or neck handles, the hydriai, jugs, kraters, kantharoi and bowls were the foundations for the principal shapes not only of Geometric but of all later Archaic Greek pottery. The vessel began to be treated as something sculptural rather than merely as an object with volume as it was in the Minoan-Mycenaean period. A new beginning is unmistakable, not only in the shape of the vases, but also in the choice of a few Late Mycenaean motifs. Even these were adapted into a new style, seen in the transition from the infinite spiral to finite concentric circles. The Protogeometric vase style seems to have originated in Athens, the Argolid and Corinth, but while in these regions it was superseded as early as the ninth century by the Geometric style, it survived much longer in outlying areas and in the colonies. Protogeometric was particularly plentiful in Crete, where it dates even further back. In Ionian Asia Minor, particularly in Miletus, in Rhodes (at that time Dorian), in Marmariani in the Aeolid, and in the Cyclades, so much Protogeometric pottery has been found that it is reasonable to regard the style as an undercurrent to Geometric art until well into the eighth century. It was used primarily on ritual vessels for burials, and it had a late revival towards the end of the Geometric period with a special pattern of circles and small concentric circles.

It was not until more than three centuries after the collapse of the Mycenaean world that the Greek Aegean re-entered the still rather feeble light of history. A massive population migration was set in train amongst the Ionians, Achaeans and Aeolians when the powerful Dorians broke through and conquered the southern part of the Balkan peninsula and the islands of the Mycenaean-Ionian world. The displaced tribes had to find new land on the islands, in the east, in Thessaly and in northern Anatolia, and having found it, then had to fortify and cultivate it. How long must it have been before the hunger of the conquerors was satisfied, and firm boundaries could be agreed? How long must it have taken until the Ionians and the Dorians, both of the same Greek stock and speakers of the same Greek language, could bring themselves to remember that they both shared the name of Hellenes, in spite of their feuds, which undoubtedly took place? How long was it before the different cultural and intellectual gifts of the native Ionians and the recent Dorian invaders gradually achieved a compromise and merged? How long did it take for the Ionian and Dorian Hellenes to learn to combine their complementary strengths eventually as, respectively, the race of daring seafarers and the great land power? The beginnings of this development can be seen in the flowering of the Protogeometric style of vase of the tenth century, and its completion in the founding of the Olympic Games in 776 B.C. in the decades of the Ripe Geometric period.

These questions need to be asked in order to comprehend the depth of the abyss into which the dark ages had sunk. War and destruction had ushered in a new age. The lush, delicate plant motifs and the wonders of the sea featured in Minoan vase paintings disappeared soon after the final destruction of the Cretan palaces (before 1300 B.C.). Mycenaean vase painting gradually froze into standardized images, or became simply pointless. Large kraters from the final decades of the Mycenaean period, decorated with figure painting crudely derivative of wall paintings, have been found in Cyprus, in a few places in Asia Minor, and rather less frequently in mainland Greece. We also find around this time, on the main-

land, birds, goats, millipedes, grotesque human figures and chariot wheels arranged haphazardly on jugs without any sense of ornament or decoration.[7] Sub-Mycenaean vase painting degenerated into undisciplined geometrical decoration of a pseudo-prehistoric kind. The cultural barrenness which followed the wars and the collapse of Mycenaean civilization is not easy to grasp. It was an age which produced no significant architecture, no sculpture or large-scale painting, and no work in precious materials such as gold or ivory. It was not until 1000 B.C. that something new began to stir. In the ninth century bronze tripod-cauldrons begin to appear,[8] although we cannot be sure when they were first produced as prizes in the games—probably not until the second half of the century. In the same century, we find bronze fibulae decorated with engravings of ships.[9] From the second quarter of the eighth century onwards gold reliefs[10] begin to appear in Attic graves, and later, around the middle of the century, gold fibulae with decorative engraving and ivory statuettes of an Oriental-type goddess, but carved by an Attic hand and pure Greek (Pls. 146–148). From the eighth century onwards, art becomes increasingly and noticeably richer.

So almost four centuries passed before the effects of the collapse produced by the Dorian invasion from the northwest were finally overcome. In the meantime, the world changed so radically that we can barely trace the connection between the Mycenaean civilization and the Geometric period. We have already indicated that it was painted pottery which formed the slender link between the centuries. Protogeometric was an important improvement after the depths to which art had sunk, and Geometric art finally introduced a completely new artistic horizon. It was only in certain remote districts in previously Minoan Crete, and in Cyprus, Syria and Palestine, that small-scale artforms from the second millennium lived on for some time. In the grotto of Phaneromeni, for instance, Minoan bronze styles have been found as late as the Geometric period;[11] in particular, bronze tripods, produced in Cyprus and Crete, seem to have been fairly widespread up to the eighth century.[12] It is significant that, to date, no locally produced bronze statuettes of warriors have been found in the Mycenaean areas, in contrast to Crete. Two small

cast-lead statuettes from Laconia, of a woman and a boy (Pls. 113, 114) must have been part of a procession.[13] Nevertheless, we often find warrior figures imported into the Mycenaean areas from Hittite-Syrian sources. The obvious absence of small-scale Mycenaean bronze sculpture, and the corresponding lack of bronze workshops in Mycenaean territories, indicate that there was no bronze casting of the small-scale pieces in the period after the catastrophe. It is not until towards the end of the ninth century, and perhaps not until the eighth century, that locally produced bronze figures, including ring handles on tripod-cauldrons, harnesses and warriors, begin to appear. But there seems to be no connection between the second millennium and later centuries. Early works are extremely primitive, and vary from area to area. Many of these early efforts are reminiscent of the sub-Minoan, doll-like statuettes, without proper bases, from Phaneromeni in Crete. Where new sculptural structures take shape, they have no affinities with Minoan-Mycenaean art, but reveal a genuinely Greek indigenous style. And because there were now more individual, different regional powers, we find a far larger number of different patterns of development than before. When small-scale sculpture of this period does show traces of external influences, in heads and faces for example, it comes from the Orient rather than from Mycenae. Early gold reliefs include splendid friezes of stags and lions which are directly copied from the best Oriental ivory animal reliefs (Arslan Tash).[14] The ivory statuettes from Athens, too, are pure Greek, although modelled on Oriental prototypes.

So it is not possible to trace any real continuity between the Mycenaean Greek period and the eventual integration of the peoples of Greece during the dark age, except in certain distant outposts. During this period, however, the Greek world completely changed. In the Ripe and Late Protogeometric periods, the Greek people of the Iron Age, now enlarged and settled, prepared for their world mission, of which Geometric art was the first step. The heroic age of Mycenae had faded into legend and its art, based on Minoan art, had disappeared.

Decoration of everyday utensils with incised or painted geometric designs, such as groups of lines, zigzags, triangles and circles, can be found everywhere, in all periods, from the earliest times onwards. Sometimes it is the result simply of a playful instinct to 'doodle', aroused by the shape of the object. Sometimes it is closely associated with the function of the vessel, as when carrying-nets are painted or scratched onto the surface. Sometimes the vessel is treated as a living thing, with a geometric pattern hung round the neck. In other cases, images from nature are captured in formal geometric shapes; or intellectual concepts are represented by patterns with symbolic meanings. Geometric patterns have, in fact, a large number of different sources. They begin at about the end of the Early Stone Age (Mesolithic or Miolithic). Ivory plaques from Mezyn in the Ukraine already have continuous series of meanders and parallel zigzag bands as surface decoration.[15] But it is not until the development of leather-work, weaving, and pottery in the Neolithic Age that the necessary preconditions are created for real geometric ornament to appear in certain places. The size and variety of the shapes of vessels begin to increase, always producing large empty surfaces, and inviting the potters' instincts for form and experiment to emphasize the shape and function of the decorated objects. Geometric ornament, however, is seldom found by itself without other types of decoration. One of the many versions of this kind of mixed geometric decoration is the so-called 'band pottery', pottery decorated with spiral meanders, found over a large area from Central Europe through the northern Balkans to the Black Sea. This has been connected with the settled, farming way of life of the time, in contrast to the naturalistic art of the Palaeolithic Age.[16]

Early stages of Geometric in Minoan and Mycenaean ornamentation

Within the range of Aegean art, we can distinguish between Minoan ornament from Crete and Helladic ornament from the other islands and the mainland. A rich fund of Neolithic sherds with incised decoration built up over a long period of time into a remarkably deep layer under the palace of Knossos. These have traces of links with the Neolithic cultures of Asia Minor,[17] and are more clearly Geometric than the obviously very incomplete series of fragments under the southern Cretan palace of Phaistos, where geometric patterns do not appear until the sub-Neolithic layer of painted pottery. Incised and burnished Pyrgos ware clearly carries on the Neolithic tradition of northern Crete, and belongs to the beginning of the Early Bronze Age (Early Minoan I).[18] It was here that native geometric ornament found its most concentrated form. On the fertile plains of southern Crete, the trend towards geometric decoration, which was also growing there, did not really flower until later, in the Early Minoan II period, on engraved stone pyxides and painted vases.[19] During the transitional period leading up to the Middle Bronze Age (Early Minoan III—Middle Minoan I) this gave way to a freer, livelier kind of decorative pattern which soon included plant motifs. Only the intellectual discipline and the strength of the ornamental idiom of the geometric style remained. For the first time in European art, the geometric techniques of fusing together ornament, taut shape and volume of a vessel were combined with the new naturalistic motifs to produce an important, and essentially classical style of decoration. Oriental influences were also an essential ingredient of this development (the 'Kamares style' of the Middle Minoan period II).[20] This was a step which was taken again by the early Greeks more than a millennium later in their transition from the Geometric to the orientalizing style. The circumstances were, of course, different, and the change more dynamic and radical.

The Greek mainland was subject to quite different influences. Ever since the Neolithic period, it had lain at the crossroads of the great routes of cultural exchange, connected by the Aegean Islands with the

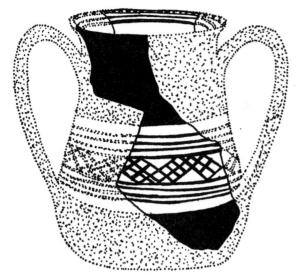

1 Patterned ware vessel from Korakou (Argolid).
Height about 13 cm. Corinth, Museum

East and by the northern Balkans with the Danube basin.[21] Towards the end of the Early Bronze Age (Early Helladic III) there developed on the Greek mainland, later than in Crete, a not particularly rich, but nevertheless disciplined Geometric style of vase decoration (Figs. 1, 2).[22] This developed further, however, during the first half and the middle of the second millennium, in the Middle Bronze Age (Middle Helladic period), in the form of the so-called Matt painting, which spread, at the same time, across the islands (except Crete) and mainland, covering pithoi, amphorae, and large and small vessels with geometric patterns (Fig. 3).[23] The basic elements of this style of ornament were geometric. Its syntax was built on associations such as, most often, that of the carrying-net. This geometric phase of Aegean art in the second millennium B.C. was not an isolated phenomenon but was the fashion of the period, and has been found over a broad belt of land from Cappadocia[24] to the Iranian uplands (where it was combined, as is best seen in Tepe Giyan, with the old Protoelamite tradition, Susa II), from Syria through Cilicia as far as Cyprus, the furthest eastern outpost in the Aegean.[25]

From the historical point of view, another point in time is of much greater significance. In about 1900

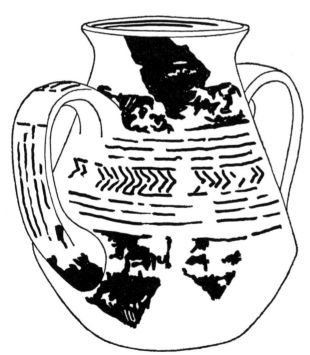

2 Patterned ware vessel from Zygouries (Argolid).
Corinth, Museum

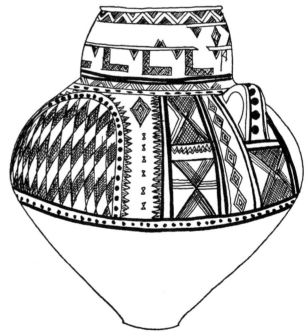

3 Matt-painted pithos from Eutresis (Boeotia).
Height 85 cm. Thebes, Archaeological Museum

B.C. there began the slow but continuous process of invasion of the Balkan peninsula by Greek tribes from the north, probably arriving in a series of individual waves. This invasion, the first territorial conquest of the Greeks, influenced all the events of the following centuries. However much the 'Geometric style' of Middle Helladic Matt painting derived from ancient Balkan and eastern Mediterranean tradition, it must also be regarded as having more than a merely chronological connection with this invasion by new tribes. In particular, the comparatively primitive nature of this style of ornament, its widespread distribution through the mainland and the islands, and, especially, the obstinacy with which it resisted the wave of Minoan influence which had long been spreading out from Crete, indicate that it was deeply rooted in a newly developing class of society. Geometric Matt painting lasted until the sixteenth century. Then it was forced to give way to the Minoan technique of glaze painting, and the Mycenaean art of decoration. It was not until the thirteenth century, in the Late Helladic III B period, and increasingly later on, that geometric trends in vase decoration began to reappear. This was certainly at least partly the result of the desire amongst a substratum of the population, which had been suppressed for a long time, to do away with the alien styles of Mycenaean court art. This time, however, their starting point — mature Mycenaean art — was completely different from before.

The Geometric style of the Greeks

The Geometric style of decoration on vases and utensils amongst the post-Mycenaean Greeks was discovered by Alexander Conze before 1870.[26] This style is radically different from all other Geometric styles of decoration found in Europe and the Near East since the Neolithic period. It is not merely the use of geometric patterns or the development of a geometric system of decoration, but a set of geometric principles of form, which were the heart and the skeleton of the first purely Greek phase of art for two or three centuries, according to whether tenth-century Protogeometric is taken as a preliminary phase or not.[27]

For the first time artists are seeking the real nature of Geometric form. A superb abstract artistic idiom is constructed, with mathematical precision, out of the basic elements of geometry. And there is other evidence that this style belongs to a new world. If we follow the morphological-historical scheme which has proved applicable to Greek art up to the end of the Classical age, Greek Geometric art can be said to have developed from a completely closed 'Early' style through a 'Severe' period, into a 'Ripe' style, going in many ways beyond the boundaries of the earlier phases, and finally turning into a slowly declining 'Late' style.[28] This Late style was not only a dissolution. Its best products had a 'baroque' exuberance, boldly anticipating forms which were later to be firmly established by the more sedate Archaic art. But from the very beginning of the Ripe period, the eye of the Geometric artist had begun to take in certain areas of sense-perception, such as animals and people, and to exclude the world of plants. This happens first in small-scale sculpture, engraved fibulae, golden relief bands, engraved gems and perhaps the completely lost art of weaving. The intention of the principle of Geometric art is to penetrate the world sense-perception, to capture important moments and events in life, and to illustrate them in narrative fashion. The formal character of Geometric art was still strong enough, even in the Late period, to encompass this world. The image of the Greeks as a youthful people, passionately devoted to beauty of nature from the earliest times, is long out of date. But these figured scenes did begin to become crowded taking up more and more space, in the Late style, weakening the formal power of Geometric art, breaking up the fixed stylized patterns and leading to a growing dissatisfaction with Geometric principles in the face of the new sense of reality in perception.

The post-Mycenaean Greeks were the first and only people to develop a Geometric art which spread through all artforms. It was the earliest great and purely artistic achievement of the Greeks. It provided the first bright light in the darkness of the centuries between the Mycenaean and Archaic art, apart from the epics of Homer. But it was not bright enough to influence all the later tremendous achievements of Greek art, which had to abandon its abstract Ge-

ometric principles in order to grow. Only a few elements of Geometric decoration, including the meander, carried over into later art. But above all, it was the powerful *ideals* of Geometric art which survived. The feeling for accuracy (ἀκρίβεια), for balance (συμμετρία) and for rhythm (ῥυϑμός) which was first developed properly in Geometric art, remained the innermost strength of all Greek art as long as it survived. Geometric art was the first important period in the history of Greek art between the alien-influenced Mycenaean art and Archaic art.

The special character of this period of art was largely determined by the historical situation of Greece after the collapse of the Mycenaean world. Full-scale migrations, which began before the destruction of the Mycenaean citadels,—the so-called Ionian colonization of the coast of Asia Minor, and the arrival of Dorian and Illyrian tribes from the northwest who conquered large parts of central Greece and the Peloponnese—brought uncertainty, destruction, and pillage to the hitherto stable world of the Mycenaean princes. The important culture of the second millennium disappeared in a fairly short space of time. Poverty replaced prosperity, trading links with the Near East, previously taken for granted, were broken, and the Aegean became intellectually and artistically isolated. A new 'prehistory', without great architecture, large-scale sculpture, painting or, at the beginning, even precious jewellery, appeared to overtake Greece. Primitive aspects of the period included the limitation of artistic achievement to weaving, pottery and bronze utensils, a uniform style of decoration and the gradual degeneration of the common artistic idiom of the Mycenaean age into purely local styles. The exclusively Geometric decoration can be seen either as a relapse into the primitive style of vase decoration of the first period of Greek domination of the Aegaean, before the middle of the second millennium B.C., or as a new beginning. For this Geometric art was in no way primitive, nor could it have been since it had foundations in an ancient culture. Even if no examples of older artistic achievements remained as a stimulus, there were still a number of craftsmen with experience, and perhaps the genius of the Mycenaean artisans. How else could the technical quality of their

pots and their decoration have rivalled, so early on, the work of the Late Mycenaean period? The most important catalyst, however, was the spirit of the newly evolving world of historical Greece. The further Geometric art developed, the less it depended on the past. It was the beginning of a new path, and it contained the seeds of a great future. It was no coincidence that Athens, with its important Mycenaean past scarcely touched by the Dorian invasion, and proud of its autochthonous Ionian population, became for the first time the centre of Greek art. In Athens two streams combined to form a powerful force—artistic talent nurtured by an unbroken tradition, and the simplicity, strength and spirit of a new age.

3 Chronology

Protogeometric and Geometric art in Greece occurs during the dark centuries between the disappearance of Mycenaean culture towards the end of the second millennium B.C., and the beginning of Greek colonization of the west and the re-establishment of artistic links with the Orient which were to lead to the non-Geometric styles of the so-called orientalizing period. Attempts to establish a firm chronology of this period, which lasted almost three centuries, must still be treated as tentative. When actual dates are given, they can only help establish the relative sequence of different stylistic phases, and can only be regarded as an hypothesis. The difficulties in dating derive from the fact that there are virtually no reliable historical data or synchronisms connecting the development of Geometric style with datable periods in non-Greek culture as a result of mutual trade. The same problem applies, as W. F. Albright recently showed, to the archaeology of the areas from northern Syria down to Palestine, which are so important because of their links with the Aegean.[29] This is a confused period during which history breaks down

into small units of time in just those countries which might have been in contact with the Greek world. There are no major historical events cutting across the whole area which can be traced archaeologically. The beginning and the end of the period must therefore be set tentatively by careful reconstruction, and inevitably there is a period in the middle which cannot be properly chronologically determined. It is only by working forwards from the earlier dates and backwards from the later dates that this period can be made to disappear and it is here that mistakes or ambivalencies have appeared in previous archaeological dating systems. Not only is Syrian and Palestinian archaeology plagued by the same lack of firm chronological dates as is Greek archaeology, but a number of the dates which researchers have hitherto believed they could use for fixing points within Geometric art have now been thrown into doubt.

The end of Mycenaean culture

The dates established by A. J. B. Wace[30] and A. Furumark[31] by different methods for the final extinction of Mycenaean culture and the end of Mycenaean pottery in the Late Helladic III C 2 period may be regarded as reasonably reliable. Both events can be placed around 1100 B.C. Whole cemeteries, with their ceramic burial gifts (the most important in Attica were those at the Kerameikos in Athens[32] and on Salamis,[33] each containing over a hundred graves) prove that the last Mycenaean phase was followed by a transitional period of some length. This was characterized by a decline in the techniques of pottery and painting, a poverty of shapes such as the stirrup jar and of decoration, and a trend towards 'Geometrization' of ornaments without any really new style developing. This pottery of the transitional period is completely dependent on the Mycenaean past and is rightly called sub-Mycenaean. The size of the exclusively sub-Mycenaean cemeteries, and the fact that sub-Mycenaean or sub-Minoan layers can be found throughout the Aegean world, lasting for different lengths of time, make it clear that it probably lasted for two to three generations rather than, as suggested by W. Kraiker, about half a century.

This theory is supported by the sequence of cultural strata found in Cilicia and in northern Syria. Here we find datable evidence of early events which formed part of the great movement of population which eventually led to the destruction of the Mycenaean world. The events in question are the invasion by the 'Sea-Peoples' into the countries on the eastern seaboard of the Mediterranean during the time of Ramesses III, before 1170 B.C. In Cilician Tarsos this invasion brought to a sudden end the import of wares from Mycenae, which lasted, as far as pottery was concerned, only up to the middle of the Late Helladic III C I period (including the 'granary style' and the beginnings of the 'close style'), and, according to Furumark, continued after 1200 B.C. It was followed by a much cruder local ware, which was derivative of the Mycenaean style, but had more geometric ornament. In spite of its marked differences from post-Mycenaean art in Greece, it can nevertheless be classified as sub-Mycenaean.[34] In Hama in Syria, this ware was characteristic of the period Hama I and has been dated by the editor of the excavation report from about 1200 to 1075 B.C.[35]

Sub-Mycenaean began here, with the cessation of imports from Mycenae, about 75 years before it occurred in Greece, where it was not until the final stages of the migrations which set the whole of the Aegean into upheaval—the Dorian invasion and the destruction of the Mycenaean citadels—that Mycenaean culture received its final fatal blow. But this chronological difference can be proved both archaeologically and historically and supports the chronology worked out by various scholars.[36]

Thus, with V. R. Desborough[37] we can date the beginnings of Protogeometric pottery in Athens during the last quarter of the eleventh century B.C. Desborough's extensive research led him to suggest that the Early phase of Geometric art began towards the end of the tenth century. In fact it was probably even a little earlier than this, since Protogeometric types of pot with Early Geometric decoration, categorized by Desborough as Protogeometric or as a special transitional style, are actually only products of older workshops, which were painting the new Geometric style of decoration on the traditional shapes of pot.

The end of the Geometric period

In the same way we can be reasonably confident in dating the end of Geometric art. Here important points of reference are given by Thucydides and other ancient authors, who give dates for the foundation of Greek colonies in Magna Graecia.[38] There is no longer any doubt that these dates are reliable. Precise confirmation is given by the earliest finds from Syracuse, founded in 734/733 B.C., and from the slightly older Megara Hyblaea. In Syracuse, there have been found, alongside several Protocorinthian Geometric vessels, some fragments of a Cycladic amphora in the Geometric style,[39] either imported or brought in by settlers, in the 'Necropoli del Fusco', which almost certainly dates from the first generation after the foundation of the town. The fragments are still derivative of the Ripe Geometric style of Athens but belong chronologically to the Late Geometric period. The oldest finds in Megara Hyblaea seem to belong to a stylistically slightly earlier phase of Protocorinthian Geometric. From the stylistic point of view they too are contemporaneous with the end of Athenian Late Geometric. The decoration on them, which is fairly thinned out, shows signs of dissolution similar to the so-called 'close style' in Athens, although the latter produced the opposite effect. Thus, it is possible, albeit with some caution, to trace after the middle of the eighth century in Sicily, a reflection, with many gaps, of the Late Geometric development on the Greek mainland. In the last quarter of the eighth century B.C., there must have taken place in Sicily the same swing away from Geometric art and transition to the early orientalizing style which can be most clearly seen in Athens. The recently published find of an original scarab with the cartouche of the Egyptian king Bocchoris (dated by Bearsted 718 to 712 B.C., and more recently 720 to 715 B.C.) in the necropolis of Pithecusa on Ischia is a further proof of the accuracy of Thucydides' dates for Greek colonization.[40] The shapes and decoration of the pots found there, which are closer to Protocorinthian than Attic, are examples of Geometric style in complete disintegration. The picture of a shipwreck on one of the big kraters,[41] although still in the great Attic tradition of ship pictures, which started in the second quarter of the eighth century, cannot, in view of its latest features, have been produced before the end of the century (this tradition lived on in central Italy until the second quarter of the seventh century). In the furthest outpost of the Greeks, in Italy, the old traditions and techniques were kept up long after the art of the mainland had developed in new directions. This dating still stands if the stratum in the necropolis in which the krater was found is taken as being older than the graves from which the scarab came, since the length of time that the scarab had been in use before being put into the grave is uncertain.

The chronology of the Geometric period

In the almost two centuries of Geometric art proper, between the end of the tenth century and the last quarter of the eighth, it is only in pottery—and in this field only in Athens, the creative centre of the period—that a continuous and meaningful chronology of stylistic developments can be traced (assuming the exception of Cyprus, which suffers from the complications and disruptions of all fringe territories). With one exception, however, there are no external dates for an absolute chronology. This exception is a Cypro-Phoenician bronze bowl, found in Grave 42 in the Kerameikos, which K. Kübler has convincingly dated in the third quarter of the ninth century (Fig. 4).[42] This dating is supported by the observation of Albright, that Assyrian influence began to spread towards the west in the first quarter of the ninth century and reached Syria around the middle of the century, but did not really spread through the coastal countries until after 825 B.C.[43] This means that the bronze bowl, which contains virtually no Assyrian elements, must have been produced before this date. It has, however, to be dated close to the last quarter of the century, since the later bronze bowl from Idalion in New York (Fig. 18)[44] is firmly dated in the first quarter of the eighth century, and both come from the same Cypriot workshop. The bronze bowl from the Kerameikos necropolis sets, therefore, a *terminus post quem* for the

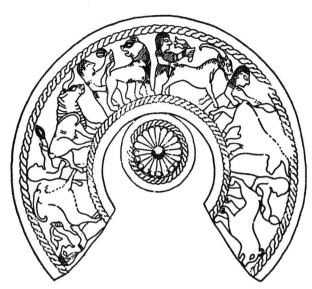

4 Cypro-Phoenician bronze bowl from the Kerameikos. Diameter about 17.5 cm. Athens, Kerameikos Museum

contents of the grave. These include bowls, flat bowls with strap handles, and a trefoil jug[45] belonging to the last quarter of the century, while the magnificent large grave amphora (Pl. 13) must be the most recent vessel. The latter cannot, therefore, be dated earlier than around 800 B.C., in spite of Kübler, who believed it to be contemporaneous with the imported bronze bowl, obviously for stylistic reasons, and dated it in the third quarter of the ninth century.

Art history between the end of Protogeometric pottery and Grave 42 in the Kerameikos and between this grave and the end of Geometric art, about one hundred years in each case, has to be reconstructed on the basis of stratigraphy (analysis of different layers) and stylistic analysis. A new basis for stratigraphy was provided for Athenian Geometric art by

W. Kraker's and K. Kübler's exemplary excavation of sixty Protogeometric and one hundred Geometric graves in the Kerameikos, and their equally careful and thorough analysis of the finds.[46] Nevertheless, the degree of accuracy of stratigraphic dating should not be exaggerated. In Athens a jug from the last decade of the sixth century could have been used for over twenty years before a fragment of it was used in Kallixenos' ostracism (about 480 B.C.).[47] In Magna Graecia as well, the period for which a vessel was used, before being put into the grave, often lasted for from twenty to thirty years.[48] In Etruria, imported Greek vases were kept on average for even longer. Cases such as a grave in Suessula, where, amongst other things, a skyphos from the fifth century, and two further Campanian vessels from the beginning of the fourth century were found alongside an early amphora by the Pan painter from the period around 470 B.C., cannot have been unusual there.[49] Corrections can be made by means of style analysis, which is becoming more and more refined as the number of finds multiplies. This analysis enables distinction to be made between earlier and later finds, with the grave vessel proper usually being the most recent pot. Given our present knowledge, we must be content merely to put dates on stylistic periods. Individual vessels or motifs can be dated exactly only in the most exceptional circumstances. This kind of chronology can be built up only around large valuable pieces. More caution is needed with smaller vessels, such as bowls and dishes, which were mass-produced by several workshops towards the end of the Geometric period, and with strictly utilitarian vessels, unless they are of high quality.

The following chronological table must be treated with considerable caution:[50]

Early Geometric Style	end of tenth to mid-ninth century B.C.
Severe Geometric Style	mid-ninth to first quarter eighth century B.C. (black ground)
Ripe Geometric Style	first quarter eighth to mid-eighth century B.C.
High Geometric Style	about 770 to 750 B.C. (clay ground)
Late Geometric Style	about 750 to last quarter eighth century B.C.

The periods which are distinguished here are really only stylistic phases. They take their names from the completely developed stylistic characteristics of the middle years of each. On their fringes they merge almost imperceptibly with each other. Mannerist and progressive workshops were functioning at the same time and are the most easily distinguished. The expressions 'black ground' and 'clay ground' do not refer to the Geometric drawing which, with a few exceptions, was always on a clay ground. But Geometric friezes and pictures up to the end of the ninth century and the beginning of the eighth were almost always in reserved strips and panels on otherwise black-ground vessels. In later stylistic phases, however, the whole vessel was left clay coloured, and was then decorated overall with Geometric patterns.

Pottery

I ATTIC GEOMETRIC POTTERY: BEGINNINGS AND NINTH CENTURY

Until now, historians and archaeologists have frequently concerned themselves with the question of whether the Geometric pottery of Athens was connected through the previous Protogeometric and sub-Mycenaean periods with a Mycenaean tradition, albeit enormously impoverished, or whether it represented a completely new beginning. In recent decades, however, this argument has become less and less significant. The answer to the problem depends on the point of view of the individual scholar. There are no mutually exclusive answers, and both positions have therefore some justification.

Elements of Mycenaean tradition in Geometric art

The twelfth century was a century of chaos. Citadels and palaces were destroyed, whole populations emigrated by land or by sea, population decreased and the survivors retreated to wretched but easily defensible settlements, trading links within the Aegean and beyond it collapsed, the level of culture was rapidly depressed and impoverished, and it was as though prehistory, which had long been left behind, had suddenly returned. All this meant a virtually complete disappearance of Mycenaean culture from the main centres where it had flourished. But no historical catastrophe has ever been great enough to destroy completely the remnants of such a highly developed culture as the Mycenaean, or to eradicate it from the memory of later generations. From time to time a vase painter by chance coming across a small piece of jewellery, a sealstone or a signet ring, or perhaps fragments of frescoes centuries later, when Geometric art had already begun to embrace the world of animals and people, would be stimulated, as can be seen in Crete, to produce a quite unusual composition.[1] But isolated influences across such a long period of time were not strong enough to form a style. The important fact is that at least a few isolated Mycenaean bronze workshops continued in operation and carried on the tradition. Simple utensils such as metal rod-tripods and tripod-cauldrons, modelled on Mycenaean prototypes, were produced virtually without interruption.[2] But whereas the tripod-cauldrons were developed on the Greek mainland, probably in Corinth, the metal rod-tripods, which retained their Mycenaean decoration, belonged to a different stream of tradition. One of these tripods has been found in Tiryns, another in Megiddo, three on Cyprus, four on Crete, and only one on the Pnyx in Athens. The latter has, however, been classified as non-Attic in view of the interrupted decorations on the carrying-ring, in the form of a frieze of horizontal double spirals between cable-pattern bands. Cypriot wheeled stands, which have affinities with these tripods, prove that one of the most important workshops producing them must have been in Cyprus, and another in Crete. The manufacture of jewellery from precious materials survived after the Mycenaean period, in outlying areas of the Aegean forming a large crescent from the islands in the north, through Samos and Rhodes, to Crete and Cyprus. Thus Mycenaean ornamentation did survive to a significant extent in both the north and the east. As far as Geometric art on the Greek mainland is concerned, however, the remnants of Mycenaean styles did not become a fertile influence until the decline of the Geometric style with the arrival of Oriental motifs in the late eighth century.[3]

In pottery it was above all the traditional technical skills which survived between the Mycenaean and

Geometric periods. The old methods of preparing clay and throwing vases on the potter's wheel continued to be used, although the quality of the work varied enormously. The techniques of painting, the use of the so-called 'black glaze', and its treatment with heat, producing a reddish and then a brown or deep-black shiny colour, were not lost.[4] Craft workshops and traditions tended to be more stable than the changing patterns of power or the fickle demands of each new ruling class. Even more durable was the fund of experience of the craftsmen themselves. Technical expertise must have survived in small, sheltered potters' workshops after the main workshops of the Mycenaean palaces had stopped production. From them, the remnants of earlier skills must have expanded again when demand for high-quality pottery revived. This happened with the beginning of the production of Attic Protogeometric, at the end of the eleventh century and the beginning of the tenth. A hundred years later, Early Geometric potters were able to draw on the skills which had been passed down to them, and to develop vases which gradually achieved the Mycenaean level of quality again.

The stylistic change from Mycenaean to Geometric art

The stylistic change produced by the beginnings of Greek Geometric art, as reflected in new shapes and ornamentation, was another matter altogether. It is only here that one can see what really took place. The events which occurred during the long sub-Mycenaean and Protogeometric periods point, increasingly clearly, to a decisive turning point in the history of early Greek art. This is emphasized, even more vividly than by the transitions from period to period, by the signposts marking the points at which complete, mature styles of sculpture and vase decoration crystallized. In addition to the *koine* of Late Mycenaean pottery these are: Ripe Protogeometric pottery around the middle of the tenth century, and the flowering of Early Geometric pottery in the first half of the ninth century. Here one can observe a deeper, more wide-ranging flow of events which

reveals the important basic truth that there is an entirely new relationship between the Geometric potter or painter and the world, quite different from Late Mycenaean pottery.

Vase shapes and vase decoration come onto the new Geometric stage at different times. The disciplined shapes of Protogeometric pottery announced the arrival of a new art several decades before the foundations for real Geometric painting were laid with Early Geometric.

As far as the shape of vessels is concerned, according to Furumark, no fewer than sixty-eight different shapes of vessel can be distinguished at the zenith of Mycenaean civilization in the second half of the thirteenth century.[5] This reflects the sophisticated requirements of people at that time. The extent of the catastrophe which took place at the end of the twelfth century can be judged from the fact that, of sixty-eight Mycenaean shapes, only ten survive. No innovations have been found in sub-Mycenaean art. Such is the inheritance of Protogeometric pottery.[6] And yet it soon produces innovations—rapid improvements in techniques, quality, shapes and painting. The number of different shapes grows again to seventeen.[7] Certain Mycenaean shapes, such as the stirrup jar, still dominant in the sub-Mycenaean art, disappear. Their function is taken over by narrow-necked or trefoil-lipped jugs. A new leading shape, exclusive to Protogeometric, is developed: the two-handled cup (skyphos) with a tall conical foot (Pls. 1, 2). A most significant fact is that large vases, such as the various types of amphorae, the hydriai and kraters, become predominant and begin to occupy the position of importance which they continue to hold from the Geometric period onwards.

The ornamental motifs, however, which are reduced presumably for artistic reasons to a minimum, are all derived from sub-Mycenaean and Mycenaean tradition. But the central motif, the concentric circle and semicircle, does seem to anticipate later Geometric patterns (Pl. 3). These compass-drawn circular motifs replace the main Mycenaean motif, the spiral, which Protogeometric systematically avoids. A closed static form succeeds an open dynamic form. The strict tectonics of this Protogeometric decoration differ from the principles of both Mycenaean and Geomet-

ric art. Certain patterns belong to specific types of vessels and similar or related motifs appear on only certain parts of the vessel—belly, shoulder or handle. They are part of the overall form of vessels. Shapes of vessels are tautened while decoration becomes disciplined. Simplicity and limpidity replace the carelessness and lack of clarity of the sub-Mycenaean style. The whole appearance of the vessel is expressive of a new spirit.

This Protogeometric style may, as Desborough believes,[8] have started in Athens itself, spreading out subsequently to other parts of Greece, or it may have started simultaneously in various parts of the formerly Mycenaean world and then fallen under the influence of Athens. Whichever was the case, it is certain that in the tenth century the destinies of Greek art were decided for the first time in Athens. The unbroken strength of the Athenians, which enabled them to shake off the narrow-mindedness and torpidity which are usually the aftermath of great artistic movements, should probably be considered in the light of the exclusive claim of the citizens of Attica to be autochthonous. The Attic population seems to have remained relatively intact throughout the upheavals of the Dorian invasion, and to have retained some of the artistic talent of the Mycenaeans.

The stylistic change is best seen in the change of shape of vessels between the Mycenaean and Early Geometric periods. The special character of Mycenaean vase shapes, always found in large vessels in spite of various countervailing forces, is of Minoan origin. The interior of the vessel widens immediately below the neck and narrows towards a point at the base, as indicated by the shape of the exterior (see Pl. 4). In the three-handled jar (Pl. 4, end of the fourteenth century) it is impossible to identify a front and a back. Three shoulder handles emphasize the many-sidedness, the spatiality, and the circular dynamic of the volume of the vase. The foot and the neck at the extremities of the vertical axis accentuate the effect of volume, giving it firmness and stability within the concrete exterior space, while forming as far as possible an integral part of the total system of expression.

The decisive change in the shape of vessels, so far as Geometric art is concerned, takes place in the course of barely a century of Protogeometric pottery. Instead of the three-handled jar, which survived into the sub-Mycenaean period, we now find the amphora with two upright handles on the shoulder, diametrically opposite each other. This type is, however, not particularly common. Much more common is the amphora with two neck handles (Pl. 5), which was rare in the Mycenaean Age. These handles were called 'ears' in Greek, expressing the newly developed double bilaterality of form: the separation front and back and the affinity of the vessel with the human body, with its pairs of limbs and visible organs around a symmetrical axis. The sense of verticality in vessels increases in Ripe and Late Geometric. The vertical axis begins gradually to predominate over the dimensions of volume and depth. The whole vessel is constructed around the vertical. The changing proportion of foot, belly, shoulder and neck becomes the main parameter of vessels. The principle of organic shape had existed, more or less, since the Early Bronze Age in the Aegean. But here it becomes the opposite of the Mycenaean principle of voluminosity, and produces a preponderance of physical, sculptural, anthropoid structure over the expression of volume. In the tenth century this principle becomes increasingly important in Geometric art. Here we see that prevalence of the sculptural form over the feeling for space and painting which characterizes the entire art of historical Greece.

The tectonics of Geometric vases

Ninth-century Early Geometric and Severe Geometric styles of vessels are built on this plastic-organic Protogeometric principle. It runs through virtually all vase forms. At the same time, a *law of tectonics*, which applies to the plastic body of the vessel and which can already be seen in Protogeometric, begins to develop. The amphoriskos with horizontal belly handles, equally common in sub-Mycenaean and Protogeometric, seems condemned to die out. Its handles, parallel with the sides of the vessel, its stereotyped motifs in the handle zone and the wavy lines on its belly, all tend to emphasize the old Mycenaean principle of dynamic volume. In the last phase

of the Protogeometric style, however, this vessel increases to the same height as other forms of amphorae. The amphoriskos becomes an amphora with belly handles. The wavy lines disappear and are replaced by a frieze of concentric circles running round the belly like a tight horizontal belt (Pl. 3). A horizontal axis emerges. Then, in the transition to Early Geometric, the decisive change in the principles of form takes place. The whole amphora is covered with shiny black glaze, with the exception of the handle zone, which thus emphasizes the horizontal axis (Pl. 8). Protogeometric patterns borrowed from high-footed goblets (skyphoi), namely the triglyph flanked on both sides by concentric circles, are still used (cf. Pl. 1). But now the triglyph is also part of the vertical axis of the amphora. This produces a crossing of axes, clearly visible. The belly-handled amphora emerges as the latest variant of the amphora, alongside the neck-handled amphora and the shoulder-handled amphora, whose future was to be at least as significant as that of the neck-handled amphora.

The significance of the axial crossing in Geometric pottery cannot be over-estimated. Without breaking with the physical-plastic principle, it loosens the connection with anthropoid vase structure, giving the vessel a new harmony. The vase takes on a personality of its own. In the first Early Geometric graves[9] we find this axial crossing equally emphasized on both neck- and shoulder-handled amphorae, on jugs (Fig. 7) and on globular pyxides. The tectonic form of the vessel is set by the two co-ordinates, the vertical and the horizontal, which become virtually a framework and produce the most important shape of vase of the ninth century—that of the high-footed krater (Pl. 15). The vertical axis runs up from the foot while the horizontal is emphasized by the shape of this mixing bowl. New variants of the Protogeometric globular pyxis develop—the pointed (Pl. 9) and particularly the flat pyxis with its dominant horizontal axis,[10] which remains the leading type throughout the whole of the Geometric period. In the former, the horizontal is usually emphasized by the decoration, whereas in the latter the vertical counter-axis is firmly located in the early stages by the tall knob. Variants or new types are produced

by differing axial emphasis, the one or the other predominating. In the next century, a rich multiplicity of vase forms emerges from the basic Protogeometric inheritance, each following strict rules. Whether amphora, krater, or bowl, each variant gains its special character from its tectonics.

With the development of intersecting axes in the ninth century, the vase, while remaining a physical-plastic object, develops from being primarily an anthropoid shape into a personality of its own with a tectonic structure. In addition to its statics, there is a balance of its parts and between the counteracting upward and downward thrusts in its body. Up until the High Geometric period in the second quarter of the eighth century, the necks of the big amphorae become taller or heavier, far beyond the requirements of function, and thrust upwards more and more (Pls. 21, 30, 35). In the kraters, the feet become taller and more massive and the bowls deeper and fuller (Pls. 34, 40, 41). The more function is dominated by form, the more the vessel expresses a formal artistic idea typical of the period. This ideality implies monumentality at the same time. The height of the large vessels increases up to the High Geometric period. In some cases they are as tall as a man (1.75 metres) (Pl. 35). This tectonic development parallels the development of vases from funerary urns, containing the ashes of the dead, into grave monuments which stood on top of the grave. In the eighth century the latter become media for pictures of the dead man and his funeral.[11] The vase becomes a memorial. As it loses its original function, its plastic form is adapted to the requirements of a grave monument.

There is no monumental sculpture or architecture in Geometric art. Thus it is understandable but nevertheless remarkable that since its beginnings in the ninth century Greek art should have developed the plastic form of the funeral vase—the only artistic medium then available—into a monumental idealized shape. The same plastic-tectonic forces expressed themselves hundreds of years later in the columnar architecture of Greek temples and in Early Archaic statues of young men. The Geometric funerary vase is simultaneously both architecture and sculpture. The strength of the urge to sculpture can be seen in an Early Geometric bowl in Berlin, with

a handle in the shape of a bent human leg[12] and in a fragment of a handle in the same form in Athens.[13] These tectonic qualities are the first truly Greek idiom in the fine arts.

Decoration of Early and Severe Geometric vases

It is the system of ornamentation of Early and Severe Geometric pottery of the ninth century that gives a more sharply defined picture of the beginnings of Geometric art.

C. Praschniker was the first to point out 'that the process of Geometrization can already be seen in the Late Mycenaean period'.[14] This process continued without a break through sub-Mycenaean to the end of the Ripe Protogeometric stylistic phase, around the middle of the tenth century. All Geometrically stereotyped motifs are abstractions of naturalistic motifs in Minoan-Mycenaean art. In Protogeometric there occurs, to mention only the most important of a number of aspects, the development of perhaps the most significant decorative motif of the Mycenaean Greeks since the Middle Helladic III period and the funerary stelai of Mycenae: the running spiral, a radical innovation. This turns into a frieze of concentric circles, sometimes separated from each other by vertical decorative strips. If one compares a Protogeometric neck-handled amphora from Athens (Pl. 5) with a Late Mycenaean neck-handled amphora, with a double spiral on the shoulder and Mycenaean characters on the belly, from Argos (Pl. 6), both form and decoration suggest that the vases belong to stylistic periods immediately succeeding each other. In fact, however, they are separated by about 250 years and by the whole sub-Mycenaean period. The latest products of the flourishing sub-Mycenaean workshops and the new Protogeometric products draw close to each other again. But a decisive change has taken place. The horizontal sweep of the spirals around the voluminous body of the vessel has turned into a fixed circle pattern, and the open form of the spiral has turned into the closed form of the concentric circles. The motif on Protogeometric goblets (Pls. 1, 2) and on amphorae with belly handles (Pl. 8)—during the transitional period leading up to

5 Development of the stylized octopus ornament of Mycenaean pottery into a Protogeometric ornament

Early Geometric—is none other than an unrecognizable, ultimate stage in the Geometrization of the octopus motif, with its body, tentacles and big eyes (Fig. 5).[15] The octopus is one of the most important images in Minoan-Mycenaean art. Even when reduced to a geometric pattern, it is still powerful enough to become the most important Protogeometric ornamental motif. The small stock of motifs of this period results from a denaturalization of the rich naturalistic decoration of the Mycenaean vases. The Protogeometric style of ornamentation is not so much a new start as an end.

The power to develop a stock of ornamental images, which Protogeometric lacked, is present in the highest degree in Early Geometric. It is when

6 Protogeometric and Geometric ornaments

Early Geometric reaches its zenith, during the first half of the ninth century, that it becomes clear that there has been a decisive move away from an old, historical tradition, towards what are obviously new principles of decoration. A new beginning really takes place. It is here that the basis of a new and completely different style of decoration is laid, a style which was for two centuries to produce a great and unique style of art.

The grammar of this new style can be clearly seen (Fig. 6).[16] Its basic elements are the dot, the straight line, and the angled line. These form the 'roots' of the new style of decoration, the bricks out of which it is built. It is no coincidence that they are also axioms of geometry: the dot whose movement produces the one-dimensional line; the straight line which, crossed with another, forms the rectangle; and the angle, which leads to the triangle, or in pairs, the lozenge. With the exception of the meander, all Geometric patterns are variants of these simple basic elements. The dot has fewest variants (Fig. 6, 1): dotted zones, single and double rows of dots, and, comparatively late, rows of dots as framed encircling bands (a–d), thus incorporated into other stripe decoration. Line patterns have a richer variety (Fig. 6, 2): isolated groups of bars or continuous rows of bars on the lips or rims of vases (a), friezes of vertical strokes as band patterns, or horizontal oblique strokes, opposed like a herringbone on handles or in triglyph zones (b). 'Woven' patterns, found from Late Mycenaean to Protogeometric, are interpreted in the spirit of the new style: groups of diagonals are placed in opposition and separated by upright and inverted black triangles (c). A checkerboard pattern is produced by crossed lines (d). The most fertile motif is the angled line (Fig. 6, 3): herringbone patterns, zigzags, and multiple zigzag lines which in early triglyphs turn the wavy lines of the earlier intermediate zone (cf. Fig. 5) into the Geometric idiom (a–c). Intersecting zigzag lines make the lozenge frieze (d). Filling in the triangles underneath a zigzag turns it into an upright saw-tooth pattern (e). An opposed saw-tooth pattern is produced by drawing a horizontal line through the middle of a tall, wide-spaced zigzag and filling in the resulting triangles which project up and down with black

glaze (f). Virtually all these friezes are used as bands that encircle the vase.

Amongst this basic repertory of linear patterns, only the meander has a ribbon-like character (Fig. 6, 4). It is the only motif not constructed from the basic elements of the dot, line and angle. It is of indigenous origin. Meanders and meander-like forms existed in the northern part of the Balkan peninsula and the Aegean from the late Neolithic Age. Meander hooks (Fig. 3) already occur in Matt painting before the middle of the second millennium B.C. The motif does not appear, however, in Mycenaean or Protogeometric pottery. The origins of the meander cannot be firmly established. It may have been derived from Thessalian or southern Balkan cultures, or borrowed from lost Greek textile patterns of the second millennium and the beginning of the first. Even in the transitional period before Early Geometric we find two variants—the running meander and the upright meander. The meander is first filled in with dots (a), later with herringbone patterns (b), zigzags (c) and finally, oblique free-hand hatchings (d, f, g). In the case of the upright meander, parallel lines soon develop, following the shape of the meander (e). The meander continues to be the main ornament in Geometric art up to the Late period. In spite of having a different origin from the other motifs, the meander also underwent variations later on. If we look ahead to the eighth century, we find, in addition to the two variants already mentioned, the two-step and three-step meanders, which developed out of the running meander, but are related to the upright meander in emphasizing movement in one direction. A fifth variant is the swastika, balanced around a central point. So here, too, the mathematical, abstract, creative technique of variation is used, developing simple basic shapes into a richer range of forms.

Early Geometric and Severe Geometric decoration is also clearly distinguished from Protogeometric by its syntax. In Protogeometric, particular types of patterns are firmly tied to particular parts of vases. The structure of the vase and the position of the ornamental motifs have a fixed relationship to each other. In Early Geometric pottery the same is true only of plastically unimportant or secondary areas, such as handles or lips of vessels. The new system of

decoration, on the other hand, consists of a series of horizontal ornamental stripes framed or separated by three parallel lines above and below running round the body of the vessel (Pls. 9, 13). Just as the ornamental motifs are truly abstract, being built up out of geometric basic elements rather than being geometric adaptations, so the decorative system is abstract and is applicable in principle to any surface and is, in theory, not necessarily confined only to the vase.

In practice, however, by the end of the Early Geometric period, ornamental zones cover most of the surface of smaller vessels such as pyxides, small bowls and kalathoi, whereas on large vessels such as amphorae and kraters, they form multiple bands of decoration running round the body of the vessel. An increasingly crowded decorative outer skin with its own laws and idioms covers the vessels. The idiom is rhythmic and dynamic. The tendency is for decorative patterns to expand upwards on a vessel. At the bottom are narrow patterns with small forms. Higher up they become larger, usually culminating in a meander, and then contracting again by similar stages. Decoration is not static and accentuated, but dynamic and rhythmic. It is not tied, as in Protogeometric, to parts of the vase, but is directly related to the internal forces in the plastic structure of the vessel. Since it has a sovereign idiom of its own it can, independently, underline and bring out the plastic tension within the body of the vessel. The unanimity in the appearance of vessels in the Protogeometric period gives way to Early Geometric contrapuntal harmony between vase and ornament.

These beginnings of Geometric art show clearly the artistic route the Greeks followed. It is amazing to consider how this return to a few basic geometric forms, and the development of them into different variants and rhythms, produced such an extraordinarily rich and powerful ornamental language. To use the metaphor of counterpoint again, the discipline of the tectonics of the vessels provides a classical balance to the figure decoration, right up to High Geometric, while the freedom of the ornamental variants brings out the inner life and the ideal nature of the object it decorates. Unlike nature, early Greek art is not sensual, but thoroughly intellectual. The

Greeks' intuitive feeling that the cosmos—the word, by no coincidence, means three things in Greek: jewellery, ornamentation and the universe—had a geometric mathematical structure was most clearly expressed in geometric decoration, the first type of ornamentation they produced. It contains the qualities of balance and accuracy, of proportion and rhythm, which were to dominate Greek architecture and sculpture respectively in the post-Geometric period. Greek Geometric art strives with splendid single-mindedness for something which was only achieved several centuries later: the ideal of demonstrating the laws of existence behind the façade of physical appearances. This gave Greek artists a feeling for the essential and the ideal. A complementary feeling for the sensuality of physical nature developed only after the decline of Geometric art. The path to Geometric art might have the same sign over it as the entrance to Plato's Academy: 'Let no man ignorant of geometry enter here'.[17]

Special features of Geometric decoration

To the above description of the roots of Geometric art from the end of the tenth century should be added a few remarks about the historical background and certain problems.

In the transitional style between Protogeometric and Early Geometric, and in the earliest phase of Early Geometric, decorative zones are often vertical as well as horizontal. This occurs mostly on certain types of Protogeometric vases, such as on a krater in Munich,[18] on one-handled and two-handled cups,[19] globular pyxides,[20] skyphoi,[21] and high-handled pyxides.[22] The motif is produced by multiplying, enriching and extending the Protogeometric triglyphs, which replaced the flanking concentric circles. The process had already begun in the Late Mycenaean period.[23] The architectural triglyph frieze from the Mycenaean period, which survived as a decorative motif up to the end of the Protogeometric period (Pl. 209), was a further influence. This also explains the upright concentric semicircles which enclose the triglyph band on the right and left on the Munich krater. Although it looks as though the original intention

was to set up a kind of rhythm in the zones around the central axis of the vase, it was not a really determined effort even in the most developed example: a large jug from the earliest phase of Early Geometric, from a grave in the Agora (Fig. 7). But the system of ornamental zones running round the body of the vase soon acquires almost exclusive importance. For the first time, the new style of decoration can unfold its full rhythmic power in combination with the plastic tension of the vessel.

This transitional period also produced one further motif: that of two circle metopes placed on the left and the right of the central triglyph. The Geometric belly-handled amphora (Pl. 8) and a krater from the same early period, from the Kerameikos[24] have borrowed this motif from the high-footed, two-handled goblet of the Protogeometric period (Pl. 1). The next example of a belly-handled amphora with this kind of ornament does not occur until the middle, or more likely, the beginning of the third quarter of the ninth century (Pl. 10). But the fact that there is an approximate balance between dark and light colours in the overall appearance of this vessel suggests that Protogeometric tradition still survived (cf. Pls. 1, 2)

and there is not, therefore, so much a temporary disappearance of the Protogeometric motif as a gap in the evidence. The splendid krater with a circle-metope frieze from the Kerameikos (Pl. 12) was produced at the same time. The vases of the transitional period between Early and Severe Geometric have completely assimilated this ancient motif which was basically foreign to their style. The circles on the krater are small in comparison with the massive central triglyph and are built into the vertical and horizontal meander zones and zigzag friezes.

Large vases of the Severe Geometric style in the second half of the century use the same ornamentation (Pls. 11, 13–16). A simple and superb relationship is established between black-ground and clay-ground ornamental friezes, as in the belly-handled amphora from the third or the last quarter of the century (Pl. 11), and the neck-handled amphora from the beginning of the last quarter (Pl. 13). Shoulder decoration (Pl. 10), which comes from Protogeometric, disappears with the exception of a shoulder-handled amphora (Pl. 14) from the end of the century, which demanded a decorative zone. Otherwise, decoration is concentrated on the neck and the belly

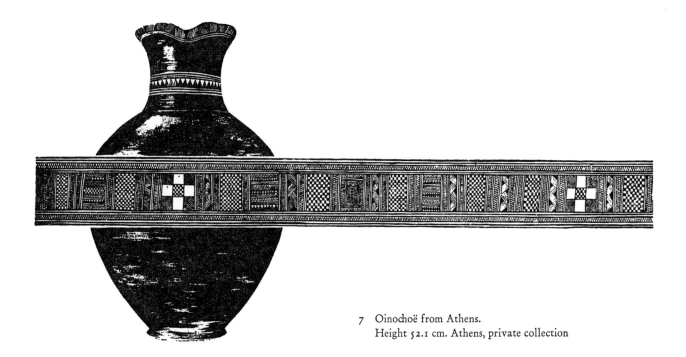

7 Oinochoë from Athens.
 Height 52.1 cm. Athens, private collection

of the vase, emphasizing the monumental effect of the vessel. But this severe contrast does not last long. It diminishes from the last quarter of the century onwards, with the black lower portion of the body being encircled more and more by bands of a lighter colour. Ornamental zones with encircling friezes tend to break down into more and different parts using a rhythmic idiom which had already been developed on small Early Geometric vessels (Pl. 9). Circle metopes disappear from the handle zone on kraters, and an area cut out of a rhythmically articulated, horizontal ornamental border, set between two side metopes, becomes the dominant central feature (Pl. 15, last quarter of the ninth century). On vessels without handles, such as the pyxis of the same period in Munich (Pl. 16), the whole of the upper part is filled with a rhythmic, delicately constructed pattern of five ornamental encircling friezes. Here, too, for the first time the triple-line dividing motif is developed and turns into framed, dividing bands, containing a plain zigzag, similar to those used in the first half of the eighth century on high-quality grave vases. Signs of the next century had already begun to appear.

Possible influences on the development of Geometric style

Did Geometric style develop only on pottery? Regarding the shape of the smaller types of vases, there can be little doubt that embossed metalwork (production of metal vessels by hammering) was an influential factor in development. Admittedly, only undecorated, simple, semi-spherical small bronze bowls without handles have been found in ninth-century graves.[25] But the horizontally ribbed feet of kraters and high-footed cups[26] and above all the clay imitations of two-handled goblets with short or tall feet and with vertical, tongue-shaped projections reminiscent of the techniques of hammering from the inside outwards, suggest copying from embossed models, as does the non-ceramic flat base, which seems to be riveted to the wall of the vessel and the foot (Pls. 17, 18, third to fourth quarters of the century). More precious metal vessels obviously did not find their way into graves. Another important question is whether the black ground of the vases, which lasted until the eighth century and which reflects the light from its shiny, dark surface, suggests that potters were attempting to imitate a highly developed art of metalworking. Obviously, the ornamental system could not have come from embossing. The Geometric style is without doubt entirely a pottery style, as it has come down to us. But a series of phenomena suggest that it developed alongside a lost textile art and that this may even have been the origin of Geometric art before 900 B.C. The early history of the meander in the tenth century can probably not be explained satisfactorily without the hypothesis that its roots lay in textile work. Surface ornaments such as the checkerboard, saw-tooth and lozenge patterns seem to be developed directly from weaving techniques. In addition to the checkerboard and cross-shaped fillings of the triglyphs on the early jug from the Agora (Fig. 7), two further fillings resemble hanging pieces of cloth, each with three horizontal ornamental bands. Geometric decoration is made up of decorative bands, seams and borders. Loom-weights and spindle-whorls from the ninth century are decorated with the more simple of the ornamental bands found on the vases.[27] Surely the character of the abstract surface style of decoration used in Early Geometric, clinging more and more to the tectonic structure of the vessel, like a garment, is best explained as being associated with a flourishing textile industry?

The dominant central zone on the vertical axis of the frequently mentioned jug from the Agora (Fig. 8), and similar central zones on kraters and shoulder-handled amphorae reflect, in all probability, the constructions of contemporary wooden architecture.[28] The ornamental beams are so intricately interlocked that they are like a coffered ceiling. There are no surviving wooden structures of this kind in Greece, although the later, adapted coffered ceilings of masonry architecture may be relevant. In Etruria and central Italy, however, where wooden ceilings and beams continued to be used for several centuries afterwards, tufa-stone imitations of wooden ceilings occur in a number of chamber tombs. A grave chamber in Chiusi (Fig. 9) provides an exact parallel to

our jug. Early Geometric wooden ceilings must have looked like this, and have inspired vase painters. This is, however, more important to the development of Greek architecture in wood than to the development of the Geometric style.

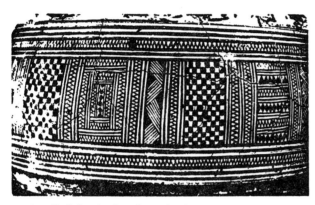

8 Detail of the oinochoë shown in Fig. 7

9 Construction of the ceiling of a chamber tomb at Chiusi (Etruria). Length 2.90 m., width 2.65 m.

The conditions for artistic activity in Athens underwent a gradual but substantial change during the second half of the ninth century. Gold bands, decorated at first only with Geometric ornaments, bronze fibulae and all kinds of jewellery begin to reappear for the first time, after a long break, in graves. They indicate modest prosperity and newly developing external trade. The isolation of Attic art, which had not spread further than parts of the northeastern Peloponnese, begins to break down. The undisturbed, consistent development of the Geometric style, which had continued without interruption from the beginning, comes to an end at the beginning of the eighth century. New, foreign decorative forms become available to vase painters, to be used or rejected. A daring new spirit of experiment contrasts with a conservative cult of the old and the familiar, amounting virtually to a renaissance of the Early Geometric style. Contrasting trends emerge. On the one hand there is the Geometric style of decoration, on the other, the pictures of figures in action, quite foreign to the traditional style. These begin to appear in the first quarter of the new century. Tremendous efforts are made to combine abstract-intellectual and representational-sensual elements. The former is concerned with stabilizing Geometric structure and extending it—even to the shape of the vases—while the latter attempts to combine figured pictures and Geometric forms and to merge them into the overall Geometric system of decoration. Paradoxes and conflicts of this sort have led to the greatest moments in the history of art. In the second quarter of the eighth century, the meeting or two conflicting trends produced the High Geometric style. But balance between them could be maintained for only a short time, and the gradual freeing of the figure image led, after the middle of the century, to a weakening, and eventually a dissolution, of the Geometric style.

1 The Ripe Geometric style

In the first quarter of the century the clay ground is gradually established and becomes more predominant in vases from the High Geometric style onwards (Pls. 30, 32, 33). The net of ornamentation now extends uninterrupted over the whole vessel. The contrapuntal contrast between decoration and shape of vase reaches its simplest and clearest stage while the rhythm of the ornamental zones becomes more powerful and yet more delicate than ever before or since. At the same time, however, the more conservative workshops continued to produce traditional background decoration, until after the middle of the century. Comparatively early, carefully painted vases, such as the neck amphora from Tübingen (Pl. 19) —probably dating from the first quarter of the century—can still be considered part of the mainstream of living art. But the body of this vessel has none of the vital power of older amphorae. It has become slimmer, rising steeply upwards, and its shape is beginning to resemble the shape of its heavy, elongated neck. This is an early phase of the Late Geometric types of amphorae and jugs. The amount of decoration is much reduced and is limited, with the exception of a number of bands of stripes, to a narrow three-step border below the shoulder. The neck, which is now the centre of gravity of the vessel, is emphasized by a five-step strictly symmetrical composition built up around the meander. The square picture areas, suspended on the shoulder and decorated with swastikas and star rosettes, are now important features. They are an unmistakable throwback to the first Early Geometric decorative forms.[1] Thus the neck amphora from the Kerameikos (Pl. 20) —which in view of its archaeological context cannot be much later than the other — can be regarded, be-

cause of its shape and decoration, as a clear example of the archaizing to which Kübler has already justly drawn attention.[2] It is reasonable to consider phenomena of this kind as reactions against the innovations introduced by the High Geometric style. As soon as this group of black-ground vases fulfilled their historical role of reviving original forms, they gradually disappeared. None of the important elements of the new style was taken from them.

Non-Attic motifs in Attic Geometric pottery

The export of Attic pottery via the Aegean Islands as far east as Cyprus and as far south as Crete,[3] and the imitation by Cycladic potters of large black-ground Attic funerary vases, such as amphorae and kraters, meant that—even at this modest level of exchange—Attic potters and painters came into contact for the first time with places with stronger Mycenaean traditions than Athens. A few motifs which were not part of the basic Attic ornamentation found their way into the indigenous vase painting. There was the false spiral, a frieze pattern of circles connected in a continuous chain by tangents. This can be taken as a Geometric version of the Mycenaean running spiral. Its origin can be traced back to the Cyclades in the Early Bronze Age, where spiral chains and spiral nets, incised on stone and clay ware, formed the basis of decoration.[4] Friezes of false spirals play a dominant role—although in a different way—only in Geometric styles in the Cyclades and the surrounding area. They are most prevalent on Thera, where they become the basic ornamental motif (Pls.

83–85).[5] Even after being introduced in Athens, these false spiral chains have no structural importance. They appear in the first quarter of the eighth century on the upper rims of kantharoi and on black-ground kraters, and as base stripes on flat pyxides. This alien motif degenerates remarkably quickly. Its last, slurred appearance is in the form of a wavy line with a thick downstroke in the Late Geometric period (Fig. 10).

From the same source comes the leaf pattern, the only plant motif which occurs in Attic Geometric art (Fig. 11). It is first found on the base of flat pyxides.[6] The round part of the pyxis, unlike the lid, needs some motif with a central point for tectonic reasons. The quatrefoil motif, in the form of a cross, is older than the six-leaf rosette, later more common. It is only in the former that the leaf shape and its fan-like ribs are represented naturalistically (Fig. 11a)

10 Slurring of the false spiral in Attic pottery

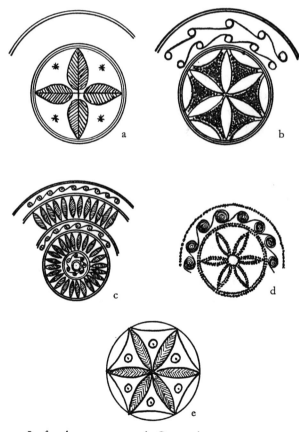

11 Leaf and rosette patterns in Geometric art

and they continue in this basic form until the middle of the century. The leaf rosette (Fig. 11b) is clearly derived from Mycenaean gold discs (Fig. 11d–e) while its combination with false spirals indicates that it probably came via the Cyclades. Alien ornamental motifs begin to merge into the Geometric world of the Attic painter. The leaves lose their stalks and become abstract, spear-shaped forms, and the ribs become hatched (Fig. 11c). In this denaturalized form, they are built up into complete friezes. This is the only kind of leaf frieze found on the external surface of large vessels up to Late Geometric (Pls. 30, 35, 50). It achieves an importance equal to that of other Geometric ornamental friezes.

The metope-and-triglyph frieze, which can be discerned in its earliest, tentative form at the beginning of the century and is not found fully developed until the second quarter, amounts to a genuine enrichment of the Geometric.[7] It appears first on smaller vessels, such as small bowls, kantharoi, high-rimmed bowls (Pl. 22) and pyxides. But it soon earns an established place in the decorative scheme of large High Geometric amphorae. According to Kübler, this development was presaged by circle-metope bands in the ninth century, and their Late Protogeometric antecedents (Pl. 10).[8] But this scheme, probably because it grew out of the Mycenaean octopus motif, only allowed for two metopes on each side of the central triglyph, and was tied to the handle zone. It was never extended to become an encircling frieze with alternating metopes and triglyphs. The metope-triglyph arrangement sprang from a new requirement for framed, enclosed areas inside the frieze decoration. Inside these panels could be placed centralized ornamental motifs, such as the swastika, lozenge, quatrefoil, leaf star, and later, animal images. It could only have been invented in a period when a rich new fund of forms, not always of purely Geometric origin, was penetrating Attic painting. It is comparatively unimportant whether this superb innovation was a purely Attic discovery or whether, as seems more likely, it was the product of eastern influences, probably mainly from Cyprus. Evidence that non-Attic influences were at work seems to exist in the fact that, from the middle of the century onwards, the strongly rhythmical frieze has the tendency either to drop the metopes and to go back to the older encircling band with merely vertical ornamental stripes, or to consist only of metopes separated from each other by thin rows of dots. The scansion of the frieze disappears, and it becomes more like the older encircling decorations of the ninth century again.

The indigenous traditional art of the islands was not the only source from which Attic Geometric art of the early eighth century drew its ideas. There was also a medley of influences, often so closely intertwined as to be no longer distinguishable, from the achievements of other artforms such as gold jewellery, embossed metalwork and small-scale sculpture, which were dominated rather less by strict Geometric canons of ornamentation. When the time was ripe, these forms—albeit at first only indirectly or in isolated instances, both inside and outside Attica—drew the attention of Attic painters to the organic world of experience. Plant motifs which were to enliven picture zones more than half a century later are used as stylized Geometric ornamental motifs. And Attic potters responded to the challenge of the equally alien animal-frieze motif with a powerful development of their own. A neck amphora of particularly high quality in Munich (Pl. 21), dating from the early part of the second quarter of the century, illustrates very well the first introduction of this new element into vase decoration. The neck is crowned by a row of does, grazing one behind the other. At the handle roots there is a frieze of reclining bucks with their necks and heads turned backwards. Above the foot runs a frieze of geese pecking at grain on the ground. The tranquility of the does, the tenseness of the bucks, and the lightning-quick pecking of lively birds are all superbly caught. Continuous repetition of the same figure round the vase makes the animal frieze approach the Geometric canons of ornamentation. A zone of individual filling ornament for each animal connects the animal frieze to the decorative bands above and below them. The simple animal friezes come from the Near East, and occur in very similar form on an old group of bronze bowls from Nimrud (Fig. 17) and on shields from Urartu.[9] They are also found on Cretan bronze shields[10] and reach their highest level of perfection in the second quarter

of the seventh century in vase painting from Rhodes, which formed the basis of East Greek decorative art for a long time. In Rhodian art it is usually grazing ibexes and fallow-deer, as well as bulls, which enliven friezes. The doe is an image from the Greek mainland, where it appears in the eighth century throughout vase painting. A group of gold bands with relief friezes,[11] of which the most important were found at Eleusis (Fig. 108, Pl. 229), show pictures of East Greek stags, closely related to the does on the Munich amphora, but freer and less Geometrized. The decoration of these gold bands is not Geometric but belongs, with its chains of spirals, spiral nets, and spiral trees, entirely to the tradition of early Mycenaean-Cycladic art. Rosettes framed by spiral bands are also found in indigenous Rhodian Late Geometric art (Figs. 49, 55). The animal frieze was probably brought to Athens as early as the first quarter of the eighth century either on imported moulds or by goldsmiths from East Greece. In Athens, the stags were turned into does, and animal figures were gradually adapted to the severity or tension of the Geometric form. The recumbent ibexes, with their heads turned, betray Mycenaean origins. The unusual position of the birds, with their bent, outstretched necks, are reminiscent of vultures tearing at their prey, as on Phoenician bowls and their Assyrian prototypes and of the eagle on the Cretan hunting shield, except that the outstretched wings are missing on the amphora in Munich.

In spite of this probably unique parallel, the bird frieze and the horse image seem to have originated on the Greek mainland, and may even have been invented by Attic Geometric painters. Both had always played an important role in small-scale clay and bronze sculpture. Birds and horses had always been important in the traditional beliefs of the people of Attica and sometimes a symbolic meaning can be given to pictures of them. The prestige of Attic horse-breeding is sufficient to explain the frequency with which pictures of horses appear in Geometric art. It is only in exceptional cases, and then right at the end of the Geometric period, that we find friezes of horses grazing. Otherwise the horse appears only by itself, in pairs with a rider or driver, or as a team of four in front of a chariot. Chronologically the horse is

also the earliest and only figured element in the otherwise non-representational vase decoration of the Protogeometric period of the tenth century. It is represented by a few simplified swinging strokes of the brush, which catch all the tension and power of the racehorse (Pl. 23). It is found on grave amphorae in the Ripe and Late phases of Protogeometric,[12] clearly demonstrating in these cases its connection with beliefs about death. From then on, Early and Severe Geometric ninth-century art has no figured images in vase decoration, but the horse lives on in clay figures such as a child's toy (Pl. 24) and as a handle figure on flat pyxides. It is not until the end of the ninth century that this tradition is taken up again, and a beautiful krater in the Louvre, which dates from after the turn of the century, revives the old horse image, and thus becomes the forerunner of the horse pictures in the new century (Pl. 25).

Narrative figured scenes

The narrative figured scenes[13] which were created in the first quarter of the century are, however, radically new and a purely Attic invention. A cup from the Kerameikos shows the earliest surviving picture of this kind (Pl. 26), of a warrior with a sword, preparing to lead a horse by the bridle to the right, while another warrior follows with a whip in his hand. Somewhat more recent is the picture on the shoulder of a small amphora with bail handles, of a man between two horses, holding them by the bridle (Pl. 29). The most important item from this small group, which still precedes the High Geometric style, is a skyphos from Eleusis (Pls. 27, 28,). On one side a battle is going on over two fallen warriors. Both sides are fighting with bows and spears. On the other side there is either a warship or a pirateship close to the shore and there is a seagull on the prow of the boat. Landing cannot be risked because heavily armed troops are standing on the shore. The helmsman is working the steering-oar and a bowman on deck attempts to cover the escape.

Pictures of horses and battles on land and sea form the beginnings of Greek figured painting more than three hundred years after the decline of the Myce-

naean wall frescoes. These pictures usher in the age commemorated by Homer's *Iliad*. Just as the verses of the *Iliad* bring to life themes from centuries earlier, Geometric illustration, too, after centuries without figured painting, deals with pictorial themes of the Mycenaean forefathers of the Athenians: horses, battles around citadels—as in the frescoes of the *megaron* at Mycenae from the fifteenth and fourteenth centuries B.C. (Fig. 12)—and defence against an attack on a fortified city from the sea, as on a silver vase found in the fourth Shaft Grave. And yet the Geometric pictures are markedly different from the literary tradition. None of the figures can be named, and none of the themes is clear enough to refer to particular events from history or mythology. The depiction of general and typical situations characterize the life of early societies and reveal their pride and glory. They are pictures of important events in life, and form a pre-mythical art.

The early phase is easily identified, since picture areas are not framed by lines but are open on all sides. Figures stand or lie freely, not on a base line. The bowman on the skyphos from Eleusis is not standing on the deck, but floats in the air above the ship. Figures are not in proportion to each other, but are fitted into whatever space is available. It is as

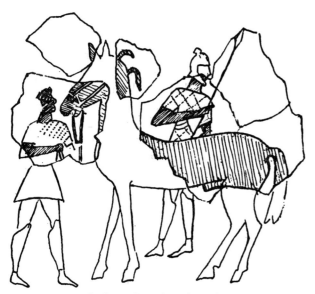

12 Fragments of a fresco from the palace of Mycenae. Height (of the fragments) 13.5 cm. Athens, National Museum

though the artist had visualized a scene mentally, but rather than painting it in detail, rendered only the bare essentials. But how different these pictures are from those on predynastic Egyptian cosmetic palettes, or prehistoric European rock paintings! The distribution of the figures reveals, in its far from primitive internal composition, traces of a kind of 'bird's eye view', the pre-perspective method of arranging figures in space characteristic of Minoan-Mycenaean art in the second millennium. It is instructive to compare the fragments of the older fresco cycle in the *megaron* of Mycenae (Fig. 12) with the cup from the Kerameikos (Pl. 26) and the skyphos from Eleusis (Pls. 27, 28). It is futile to look for the connecting link between the composition of Mycenaean frescoes and the oldest Geometric figured vases, but one can hardly doubt that such a link must have existed. Above all, these final echoes of the pseudo-perspectivist approach of pre-Geometric art demonstrates the extent to which, in adopting figured illustrations, Geometric art assimilated something foreign into its own world.

Nevertheless, these earliest narrative pictures give the appearance of being conceived afresh in accordance with Geometric visual and creative principles. The typical narrative picture, like the decoration, is abstract. This abstraction can be seen in the nakedness of warriors—men and later even women—whose bodies may be covered with large shields but are almost never clothed, and in the absence of sex organs and all weapons except those absolutely essential to the understanding of the action—even helmets are not shown. Movement, action and narrative are pared down to the simplest possible basic formulae. The dark coloured paint against the clay ground, as in ornamentation, is the only reality. Figures are shown in total silhouette. Even eyes, unlike Late Geometric pictures, are missing. Figures are hardly ever standing still, and they do not have a static structure; they are directly observed figures in action. Thus people are shown leading horses, holding a whip, carrying heavy weapons, brandishing a spear, kneeling to shoot an arrow, hurrying into battle or dying, crumpled on the ground. Their bodies seem to be boneless, soft, nimble and active. The arms are thin—only lines of movement. No

figure is identifiable. There are no individuals. They are not so much figures involved in an event as media and tools of narrative illustration. The splendid ship is just as important as the soldiers.

Equally important are the indications for the future in these early figured pictures. The painter of the skyphos from Eleusis (Pls. 27, 28) sees the moving figure with the eye of a sculptor. His silhouettes are still shown from more than one aspect at once. The hip and buttock above the leg bearing the weight of the body protrude; the shoulders of two of the bowmen are shorter on the side further from the onlooker, and arms cross bodies. The leaping bowman on the ship, and his helmsman, are real studies of movement; so is the composition of the two friezes on the skyphos. Although they are both symmetrical around a central point, both being enclosed by similar figures to the left and the right, the rigid symmetry of Near Eastern compositions is completely absent, as are the derivative pictorial images of Minoan-Mycenaean art. The composition of the skyphos has nothing to do with either. Slight disturbances of the symmetry ensure that the movement of the picture is not slowed down, and the delicate balance between the two halves of the picture is dependent on just these slightly asymmetrical deviations. Invention and drawing are freer and richer than in the figured scenes of the High Geometric style, although created only a little earlier.

2 The first phase of High Geometric style

As it spread to encompass organic nature, animals and people, the strict formality of Geometric art was extended beyond its original boundaries. There now developed that powerful, and always somewhat dangerous, tension between the old and the new which has characterized the great moments in the history of art. It was present in the second half of the fifth century, in the Augustan age, and in the High Renaissance. It also lay at the roots of High Geometric art in the second quarter of the eighth century. One is probably justified in calling this the classic Geometric period.

The reactionary forces of tradition strive to grasp

and to assimilate the innovations. The basic principles of Geometric art are taken to their logical conclusions. The new technique of clay-coloured ground, allowing the whole vessel to be covered with a network of decoration from foot to lip, is the logical consequence of these principles. It is not only the splendour of the images (Pl. 30) which indicates the approaching zenith of this artform. Both the shape and the painting of vases now begin to form a clear, superb counterpoint embracing the whole vessel, and at the same time, they are two notes in an entirely harmonious chord. The rhythmic composition of the usually continuous bands of decoration reaches its highest degree of refinement. The inventive power of new variants is greater than ever before. To the two basic forms of meander, the simple and upright, are added three new types: the antithetical meander, made up of alternating upward and downward loops, the two-step and the three-step meanders (Pl. 30). In addition to these new elements, there are also parallel unprogressive trends such as the archaizing tendencies towards Early Geometric revival[14] and the occurrence of new hybrid vessel shapes, such as the high-rimmed bowl which now appears. This is the only case of a vessel not only decorated but also shaped in accordance with Geometric principles (Pl. 22). The great popularity of this Geometrized shape in the High Geometric period, displacing the curved bowl and cup shapes, is symptomatic of the extent to which the Geometric spirit was activated in these decades. It had to assert itself in order to cope with and assimilate innovations, particularly the figured picture.

Monumental grave vases

In this fertile atmosphere of competition between the revival of traditional forms and the opening up of new horizons, the leading potters and painters achieved a new, great artform. Their pictures were almost always painted on large grave vases. In High Geometric, these were predominantly amphorae with belly handles (Pls. 30, 35) and kraters (Pls. 34, 36, 40, 41). The multiplicity of pictures, friezes, and figures on these, whose number can often only be guessed from fragments, was not achieved again until

two centuries later, by Kleitias and Ergotimos, on their krater in Florence[15] and of course in the relief pictures on the colossal cult statues by Pheidias. The amphorae stand as high as 1.55 metres (Pl. 30) and 1.75 metres (Pl. 35). The neck alone forms one third of the total height. Kraters are between 1.10 and 1.30 metres high. The axial crossing, which had previously given this type of vessel its balance, is less emphatic, and tends to be lost in the upward thrust of the steeper foot and the deeper body, which now virtually loses its previous bowl-like shape.

The grave vase has grown and turned into a funerary monument, which stands like the later grave statues, relief pillars and grave reliefs, on top of the grave. The tendency towards monumentality which started, with the grave vase used for holding the ashes of the dead, as early as the ninth century, is now taken to its logical extreme. These large grave vases lead to the development of a whole family of vase shapes. The two new jug shapes—short body with almost over-heavy neck, and handles rising above the straightforward mouth (Pl. 32), and globular body with tall narrow neck with trefoil mouth leading into a tall handle (Pl. 33)—continue to be used until well into the Late Geometric period. The former, including lid and knob, is 80 cm. high, and the trefoil jug is 89 cm. high. Their size and their fragile handles and knobs imply that they cannot have been used in everyday life. They are carefully decorated ceremonial vases produced as funerary offerings. The monumental and idealized characteristics of the vessels are merely two aspects of the same formal quality, relating, respectively, to the architectonic and plastic structure, and the determination of form by function. The true origin of these new forms is not to be found in their shape or decoration, nor in the artists who produced them, nor in the new ways of furnishing graves—although this last is an important symptom. It is to be found, rather, in the spirit of the generation which lived in the second quarter of the century. For these people, death, funerals, ceremonies, glorification of the noble dead, and all the events associated with the borders of life and death, must have had deep meaning, such as can be experienced only by vital, chivalrous, confident societies. Now a visual idiom exists through

which these emotions can be expressed. For only now do the pictures on the vases begin to deal with the great central theme which categorizes them all: the theme of the cult of the dead and its rites, the honouring of the dead and their glorification in pictures, and the ceremonies at the grave. This transition towards figured, illustrative art is a revolutionary and thrilling extension of Geometric art, which introduces an almost dangerous freedom into it. The main feature is no longer Geometric ornament but the wider scope of Geometric formal concepts which, strengthened by years of discipline, could now be extended to figured painting.

Grave amphora 804, in the National Museum, Athens

The belly-handled amphora in the National Museum at Athens, Inv. No. 804 (Pl. 30),[16] is the largest, most superbly decorated vessel of all. It must have been produced shortly after 770 B.C. The clay-ground painting, which extends from the lip to just above the foot, consists of bands of ornamentation, all of which, except the handle frieze, run round the vessel. The decoration is closely related to the forces underlying the form of the vase. The top and bottom borders, both identical, consisting of a saw-tooth pattern surmounted by a row of dots, seem to have been intended by the artist to emphasize that the vessel should be looked at as a whole, in one glance. Instead of the earlier triple dividing lines, there is now a richer ornamental pattern, always the same: a narrow chain of dotted lozenges, with three lines above and below. The same function was performed by zigzag lines as early as the beginning of the eighth century. The sequence from the bottom, of upright leaves, upright meander, single meander and then double meander, in the four friezes beneath the handles, shows a remarkably sure touch. The higher the pattern rises, the greater the distance between the axes of the individual units of the decoration, in harmony with the swelling of the belly of the vase. The sudden contraction of the shoulder above the main picture in the handle zone is reflected in the sudden contraction of the two friezes, with the frieze just below the neck repeating the delicate pattern on

the picture base. A superb artistic rhythm is developed on the neck, which would have been at eye level and which rises, slender and weighty, above the shoulder, an almost regal shape beneath the strong profile of the lip. It is interesting to compare the neck of the black-ground amphora of almost ten years before from the Kerameikos[17]: here the main motif, in the middle, is a loop meander twice as high as the upright meanders bordering it; it forms a horizontal axis of a symmetrical scheme of friezes extending upwards and downwards in identical pairs, and becoming narrower. In contrast, on the large amphora in the National Museum in Athens (Pl. 30), there is a freer, more supple rhythm. It is more obviously related to the upward thrust of the neck, not so much symmetrical as tectonically articulated. The main frieze, with its more emphatic three-step meander, seems to have slipped down somewhat. Below it are two narrower base elements, one decorated with a frieze of reclining bucks, the other with a simple meander relating to the main frieze. Above the broad central band, the animal frieze and the meander, although not identically arranged, are repeated in similar sequence. But these friezes are slightly taller, lighter and broader in appearance, like a triumphant crown for the proud neck. The animal friezes, the recumbent bucks below and the grazing does above, cannot be confused, and enliven the rhythm of the decoration. As a whole, this vase is a revival and extension of the basic laws which underlie Geometric art. The problem is to accommodate the new requirements for both figured narrative pictures and monumental form within a Geometric framework.

Figured scenes

The individual shapes and the composition of figured scenes also indicate a revival. The picture of a prothesis and the frieze showing fighting around a beached ship—on a krater in New York which is not very much older (Pl. 34)—are extensions of the style of the Eleusis skyphos (Pls. 27, 28). The 'birds's eye view' has, however, disappeared. The people fighting on the ship, the marching troops, the mourning women, and the figures kneeling at the foot of

the death bed in the prothesis scene are all set firmly on the ground, but are nevertheless figures in action. The new phase is only really introduced by the picture on the amphora 804 in Athens (Pl. 31). The illustration of the prothesis—the lying-in-state, the ritual mourning by relatives, warriors, and mourning women under (also in front of) the *kliné,* and at its head and foot—extends across the whole breadth of the picture. The *kliné* stands in the middle. A patterned blanket, of which the stepped lower seam follows the outline of the dead man, leaving the clay ground surrounding the figure empty, was for covering the corpse, and is held up by two mourners, probably a man and a woman. A little boy is standing at the head of the bed, touching it with his hand. Six mourners on the left, two warriors with swords at the end, and five mourning women to the right surround the central group. The picture is situated in the handle zone, where a continuous frieze is impossible. It is framed by upright and horizontal ornamental bars, as the main meander on kraters had been from the beginning of the century. The composition of the picture is more rigid than the much freer composition on the Eleusis skyphos (Pls. 27, 28) and related vessels (Pl. 34). The seven mourning figures on each side of the picture are focused both in their direction and in their gestures on the middle of the picture where the dead man is lying on the *kliné.* Their stances and gestures are, except in minor details, symmetrical. The basic principle is the same as in the symmetrical circle metopes flanking the broad central triglyph in the handle zone of belly amphorae and kraters from the Early Geometric period on (Pls. 8, 10, 11). The figures, standing one behind the other, seem to have been cast from the same mould. The differences between them are kept down to the minimum required by the theme of the picture. They are virtually two friezes joined in the middle, composed of repeated identical elements. The whole thing closely resembles an ornamental frieze. The model-like appearance of the limbs on the narrower frieze on the back of the vase, where there are eight mourning women, makes a very pure composition. It is set between two circle metopes, and replaces the central triglyph. In this first decade of High Geomet-

ric art, the composition of pictures is obviously intended to resemble the ornamental compositions of Early Geometric.

Filling ornament also plays an important role in this attempt to imitate the aesthetic principles of ornamental Geometric art. It is carefully composed. There are tall pillars made up of M-shaped elements which separate the figures from each other and enclose them in a kind of vertical box. Eight-pointed stars are set in the extra spaces left by the narrow waists, and small hour-glass patterns fill up the voids left by irregular or small figures. The oldest figured pictures have no filling ornaments (Pls. 26, 29, 34). This includes the ship picture on the Eleusinian skyphos (Pl. 27). But in the land battle there already occur three six-pointed stars in the voids (Pl. 28). The origin of this particular ornament is of some interest. Its development takes place on the skyphos, where it begins to appear at the beginning of the eighth century. At first it occurs only in the little spaces between the handle and the ornamental frieze. A little later, it appears as decoration in the middle of an empty frieze band, and finally it becomes a filling in metopes. All the scatter patterns on the large amphora 804 in Athens (Pl. 31) are drawn from High Geometric. On the other hand, a contemporary, quite unartistic cup from the Kerameikos necropolis[18] has a shoulder decoration without any figures but has the filling ornaments of the amphora! Filling ornament cannot be entirely explained by *horror vacui*. Geometric style does of course require that empty clay ground should be kept out of decorative schemes. But in High Geometric, at least, the lively scatter patterns have the function of connecting figures, pictures and encircling ornamental bands. These scatter patterns introduce the superbly developed ornamental aspect of Geometric into pictures, in order to reconcile the alien pictorial element with Geometric ornamentation.

The High Geometric human figure also undergoes considerable changes (Pl. 31). It no longer has the 'painterly' freedom of the figures in action in the earliest figured pictures. Figures are still only silhouetted, abstract forms without any indications of sex or dress (with the exception of dead and kneeling men, both unusual). Heads are formless, with only the pointed chin protruding. The figures are composites. But Geometric form is now more emphatic, particularly in the triangular upper bodies, horizontal shoulders, and mourners' arms, which, held over their heads, form an extension of the triangle. The human figure has begun to be Geometrized. This does not occur in the earliest figure paintings on Geometric vases, but is the result of combining figured scenes with Geometric 'vision'. The figures are in action but their repetitive gestures of mourning are ritually constrained, moderated and solemn. Wherever there is action, the figures move as little as possible from a position of rest. They are not figures in action in the earlier sense.

They are much more static. All figures are based on the same model and all stand firmly on the ground. Joints are shown. Legs set slightly apart, and slightly bent at the knees, support the upper body. Thighs and calves swell slightly. The figures on the big amphora in Athens are not so much painterly as sculptural, and may even have been based on contemporary bronze or ivory sculptures. They resemble artists' 'lay figures'. In the prothesis picture there are only four positions, standing, lying, sitting and (sometimes) kneeling. But the three main positions, standing, sitting and lying, recur a few decades after the end of Geometric art as the statue positions from which the Early Archaic sculptors used to work out the problems of three-dimensional sculpture and monumental form. But the time was not yet ripe for monumental sculpture. The pictures on the large prothesis amphora in Athens do show, however, that the first seeds of sculptural and monumental forms are already to be found in High Geometric. We should remember in this connection that the amphora was actually used as a grave monument on top of the grave.

3 The second phase of High Geometric style

The main part of the second phase of High Geometric occurs during the fifties of the eighth century. The largest extant grave amphora with belly handles, in the National Museum at Athens, Inv. No. 803, be-

longs to this phase. This is, admittedly, poorly preserved and hitherto unpublished (Pl. 35). The main pictures are in the handle zone, showing a burial procession on the front, and about ten mourners on the back. There is also a frieze of mourners running round the vessel, estimated at about ninety figures. The pictures and picture friezes are beginning to take up more and more space. Obviously there had to be some limitation to this in order to maintain balance in the large, related surfaces of the amphora, between ornamental and figured motifs. The shape of kraters was more articulated, and therefore offered more opportunities for figured friezes and pictures, the impact of which was increased by being easier to see. Kraters gradually begin to take the place of amphorae as the most important media for pictures. Kraters with three or four picture zones and friezes become quite common. Picture and narrative soon begin to dominate Geometric ornament. At the same time, the quantity of medium- and small-sized vessels produced reaches unprecedented levels. This was only one of the signs of increasing prosperity in Athens in the middle and late eighth century.

High Geometric grave kraters

An attempt to visualize kraters of the High Geometric period (with the exception of the Early and Late Geometric stragglers which are completely preserved) is made difficult by the fact that the fragments of these vessels, which were usually broken, were found in the nineteenth century and were sent to different museums without much regard for their connection with each other. The most important fragments are in the National Museum in Athens and in the Louvre in Paris. There are, however, few collections without some isolated fragments. E. Kunze[19] and F. Villard[20] have studied these *disjecta membra* in great detail without, of course, managing to find a place for every fragment, or even to establish the number of the kraters that could be put together again with any certainty. Nevertheless, we can distinguish, amongst these many kraters two groups, probably split between two different main workshops.

The first group of High Geometric grave kraters

The first group (M) is closer to the style of the large Athenian amphora 804 (Pl. 30). The decoration, so far as preserved, seems to be delineated above and below by dot friezes. The figures are divided by M pillars. Kraters A 517, A 545, A 541, A 547 and A 552 in the Louvre[21] and another krater in the Nicholson Museum in Sydney[22] can be partially reconstructed. The fragments in the National Museum in Athens have not yet been sorted out, but the fragments that Kunze dealt with[23] as well as further fragments in the Acropolis Museum in Athens[24] and in Tübingen[25] belong to this group. The second, more important group (N) includes kraters A 522, A 523, A 519, A 527 and A 530 in the Louvre.[26] Here, the upper and lower boundaries of the decorations are in the form of a chain of lozenges, and the pillars between the figures are made up of ⋏ shapes. Other important fragments are to be found in Athens, Brussels, Halle, and some were previously in Königsberg.[27]

In Group M, burial rites are still the main feature of friezes and pictures, and are shown not only in the main picture of the lying-in-state, which often has two levels, one above the other, but also in one or two further friezes (Pl. 36). The composition is richer than before and the height of the main picture has almost doubled. In the middle of the picture is the *kliné,* with the dead man laid out on it, set like a throne above the heads of the people. Above (also behind) the bier, mourners squat on stools, and under (also in front of) it there are four mourners. At each end of the *kliné* there are four relatives standing above (also next to) each other with their arms raised in mourning. The uppermost figures are holding up the shroud. The main picture falls away equally to the left and right of the dominant central square. There are two chariots facing to the right, each carrying a warrior and a shield- and spear-bearer. Both are drawn by a pair of slender-legged horses with long necks, reaching up to the level of the dead man on the *kliné.* Two warriors are walking in front of one, and behind the other, chariot. An armed groom is standing beneath (also behind) the horses. The teams of horses are leading, in full view of the dead man, the procession of chariots to the grave, which forms

the theme of the first frieze running round the vessel underneath the handle. All the kraters in this group use this linking motif. Above these two lower, frieze-like compositions, forming the main illustrations, are two more rectangular picture zones. In each of these there are eleven mourning women on the left and the right, in a linear frame, as though seen through a window. These are to some extent background figures. The inclusion in one picture of such a rich variety of motifs creates problems of which the Geometric painters were certainly not aware at the time. The most important is the difference in the sizes of the figures in the same picture. The dead man is like a giant. The other figures decrease in size in the following order: warriors in front of and behind the teams of horses; mourners in front of the bier; adult relatives holding up the shroud, and warriors on the chariots; mourning women; and mourners behind the bier. The picture has no unity of proportion, and is not intended to be seen as a whole. Proportions of figures seem to be dictated primarily by their importance and in accordance with the principle of *isokephalia*, which means that the heads of figures in friezes should all be on the same level.

The kraters in group M give little idea of the events in the life of the dead man, or of his fame. The subsidiary friezes and the back of the krater concentrate on the pomp of the burial ceremony which reflects the power and the wealth of the dead man. Here are shown the procession of chariots, men in armour, and grooms.[28] Only the zone underneath the handles seems to show scenes from the past. The splendid warship rowed by oarsmen, with a ram, shown on krater A 517 in the Louvre (Pl. 37), is the only existing example of its kind in this group. The same laws of proportion apply here as in the main picture. The oarsmen are on the upper deck instead of, as is normal, on the 'tween-deck. This leads to a crude difference in the proportions of the men and the ship, softened only by the lively drawing of the oarsmen and the tectonic harmony between the picture and the handle. The four birds are based on the seagulls which fly alongside ships. They indicate the air above the ship, just as the fish indicate the sea underneath it. Nevertheless they are not flying, and are quite out of proportion to the oarsmen and the ship. This attempt at pictorial narrative has its own features, differing from the social emphasis of the burial ceremony. Here the emphasis is on everything living. The fish, birds, men, and the ship—even the ship is splendidly alive—all have their own area. Art is becoming more open to the outside world and its predominant feature is its sense of wonder—wonder at physical things, and at the artist's own vision and ability to represent them. There is an element of pictorial writing in these pictures.

The human figure on the kraters in group M is the same static figure from the 760s with a rather more relaxed stance. When the figure is not stereotyped (as it is with mourners), shoulders and upper arms tend to be more strongly expressed. On more recent kraters (A 541, A 547 and A 552 in the Louvre),[29] the rigid triangle of the upper body is slightly loosened, curving gently from the waist to the shoulder and making a steeper angle with the upper arms. Shoulders and arms almost form the right angle found in the Late Geometric mourner (Pls. 40, 41). Horses are long-legged, with slender bodies and long, and later, shorter necks. Their manes rise above their heads, which are narrow and carefully articulated. Their trumpet-shaped mouths are not articulated until the middle of the century. Each oarsman strains at a slightly different angle against the thongs (Pl. 37); but in spite of the forcefulness with which they are drawn, none of them is really a figure in action any more. The dynamic figures have grown out of the static proportional figure of the recent past into something new, with their own internal momentum. So the first phase of High Geometric also produced innovations in figures in motion. The sexes are still not differentiated; or, at most, the female relatives of the dead men are distinguished by their clothing.

Ornamentation on the kraters in group M is limited to the bands separating the friezes. The neck usually has a two-step meander (Pl. 36) and the bottom frieze on the body of the vase usually has a leaf motif. The circular patterns on the oldest kraters after 775 B.C. (Pl. 34) are sometimes pushed right up against the handles on the back side of the vessel (e.g. on the large sherd No. CA 3382 in the Louvre).[30] Only in the latest krater (Louvre A 552),[31] with only two figure friezes, do the ornamental strips reach

from the foot of the vessel almost up to the middle
of the body. The idiom of the pattern and its rhythm
are still that of the large grave amphora in Athens
(Pl. 30). The same applies to the filling ornament.
This is enriched by the lozenge chain around the team
of horses. Krater A 517 in the Louvre (Pl. 36) is the
first great work in group M. In later kraters, the zig-
zag, the large solid lozenge, and the dotted oval also
occur. But filling ornament soon begins to lose its
compositional function. The narrow bridge which it
had formed between Geometric decoration and pic-
tures begins to collapse. It begins to become indepen-
dent and becomes virtually a random filling for
empty spaces. The danger of overcrowding can al-
ready be seen.

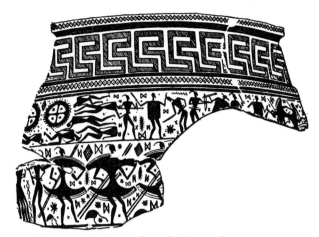

13 Fragments of a krater from the Kerameikos.
Height 39 cm. Paris, Louvre

The second group of High Geometric grave kraters

The spirit of the age is more clearly expressed in the
group N grave kraters. The break with the past is
more obvious, the innovation is more daring, and the
connection with intellectual life becomes stronger.
Ornamentation has now become a framework (Pl.
38). Broad triglyphs between horizontal separating
strips frame the pictures in the main frieze. Traces of
Geometric cauldron decoration are found on krater
A 522, which is rather earlier although probably
painted by the same artist.[32] Above the foot of the
krater is the traditional sequence: row of zigzags,
leaf frieze, meander, main frieze. In the main frieze
appears the old concentric-circle pattern, without its
metope frame, much smaller and pushed right up into
the upper corners next to the handles. The filling
ornament in group N is more sparingly and less pre-
dictably used than in group M kraters. In the pictures
under the handles of krater A 522, illustrating a
splendid rowboat with hoplites (Pl. 39), and A 527,
with three warriors carrying a spear, a sword and a
Dipylon shield,[33] the filling ornament is entirely or
largely missing. The clay ground is left empty, and
each picture is separated from the decoration. In the
battle scene on krater A 519 in the Louvre (Fig. 13)
the filling ornaments are used as a scatter pattern,
distributed freely over the clay ground. They fill up
the voids between the figures, patterning the ground,

while remaining delicate, without the overloading
characteristic of later group M kraters.

The pictures, too, are more freely composed in this
group, and have a wider range of themes than those
on group M kraters. The prothesis picture occupies
only the frieze-like main illustration, while the chariot
procession is kept for the frieze beneath it. The space
underneath the handles, however, and the back, are
reserved for illustrating the deeds and the fame of the
dead man. On kraters A 522 and A 527 (Pls. 38, 39)
and on fragments which belong together in Athens
and Brussels[34] we find a warship under sail, warriors
on the shore, the return of a victorious ship after a
hard-fought battle with warriors waiting for it on
the beach (?). On krater A 519 (Fig. 13) and on several
fragments is a murderous battle. Lower friezes are
often filled by sea battles, assembled armies or hop-
lites hurrying to help. Whether these pictures are
connected with particular deeds of the dead man is
very much open to question. And yet one cannot
explain their appearance on grave kraters without
thinking of the fame that a warrior could win for
himself in this masculine world if his bravery made
him appear to dominate fate or turn back ill fortune.

At this time, and also previously, a similar lauda-
tory function was performed by epic poems. A land
battle on krater A 519 (Fig. 13) shows a pile of
corpses and, in particular, duels between great heroes

who are fighting with spears, swords or bows. Sherds in Athens and in the Louvre[35] show wounded and dead men pierced by spears, and dying men whose bodies, necks (Fig. 14) or heads have arrows sticking in them. Can one help thinking of the detailed attention given in the epics of Homer to the nature of wounds? Two of the battle groups on krater A 519 show, in different ways, the crest of the loser's helmet being seized by the victor, and the defeated man being pulled down (Fig. 13). This was just how the duel of Menelaos and Paris between the two enemy armies ended, as described in Book III of the *Iliad* (lines 369 ff.). One cannot, of course, assume any direct connection with the Homeric epic—there were certainly plenty of real battles like this in the eighth century. On the same krater in the left corner of the frieze below, which is barely preserved, there is a

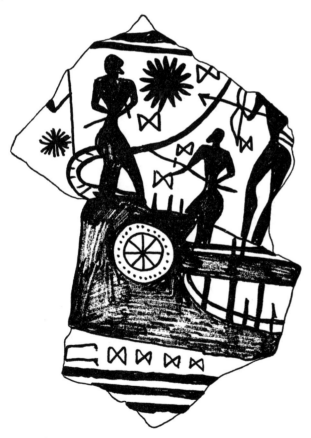

14 Fragment of a krater from the Kerameikos.
Height 18 cm. Paris, Louvre

picture of a duel between a hero and an enemy with two halves to his body (Fig. 13). This is the oldest depiction of a figure from Greek mythology, namely the twin-bodied Molione-Aktorione, who often appears later on Geometric vases. According to mythology his opponent could be either Herakles or Nestor, son of Neleus. T. B. L. Webster's suggestion, that the artist may have been inspired by Peloponnesian or Attic epics about heroic deeds of the Neleids, is appealing.[36] This is the first known contact between poetry and Greek pictorial funerary art. Nevertheless, the picture is still basically of the Geometric type. This alliance of myth, poetry, and pictorial art was one of the influences which drove painters more and more towards figure painting.

Representation of the human figure on the kraters of group N is at the same stage as on group M kraters. In spite of the fact that the pictures are full of action, standing or striding figures frequently dominate the pictures, even at the expense of clarity. It is only in hand-to-hand fights that much movement occurs (Figs. 13, 14). In the six people lying on the ground hardly a single motif is repeated. The archer strides boldy forward. We can feel the faintness which overcomes the opponent, seized by the crest of his helmet and hurled over. The warriors hit by arrows and falling to their knees, on the fragments of this group, are thrilling, instantaneous pictures. The clear lines, the assured curve of the thighs, and the huge chests of these figures in silhouette are extraordinarily expressive. Their dynamic has developed out of the Geometrical, static, clearly proportioned naked silhouettes of the beginning of High Geometric art. This commitment to the extreme simplicity and clarity of Geometric figures gives their dynamic lines and contours a forcefulness, in spite of their small size, which is truly representative of the spirit of the age.

It may be that it was the forceful extension and perfection of the abstract style of ornamentation in the transitional period leading up to High Geometric which gave the Attic painter the tremendous self-confidence needed to dare to attempt that enormous breakthrough into the world of physical reality and narrative illustration. Both these elements were far from the principles of Geometric art. With the move-

ment away from its origins came a Geometric vision and creativity, all the stronger for its roots in traditional form, embracing both man and animals. By the middle of the century ornamental and picture friezes, and soon ornamental frames and pictures, form two basic elements of style, each with a quite different source. In High Geometric they balance each other out.

Two Late Geometric grave kraters

These two contrasting elements appear in a different relationship in two completely preserved kraters in Athens and New York, stragglers from group M, belonging to the beginning of the Late Geometric period after the middle of the century. They are by the same artist. On the New York krater (Pl. 41) there is a picture of the prothesis of a dead man in the main frieze; underneath is a burial procession with chariots and hoplites proceeding towards the grave. On the krater in Athens (Pl. 40) there is a dead man's, *kliné* on a chariot, surrounded by mourners. In the lower frieze is a procession of teams of horses. Eyes are reserved out of the silhouette and breasts of the women are indicated. But the figures are lifeless. The arms, which are too short, hang listlessly with fingers outstretched. The mourners' arms form a precise right angle with their shoulders, and the figures have none of the grandeur and expressive power found slightly earlier.

Geometric ornamentation is beginning to decline. It is banished to border decoration, forming only separating strips. It continues in stereotyped decoration of neck and foot, but whenever it appears in independent friezes, it has degenerated into weak wiggly lines, like tinsel ('tinsel' style). Ornamentation could no longer be expected to undergo any revival. That meant that the well from which Geometric figured art had drawn its strength was beginning to dry up.

4 Late Geometric style

The Late Geometric phase of Attic art lasted from the middle of the eighth century up to about 710 B.C.[37] In the last quarter of the century, Geometric and Early Attic workshops were both in operation. The transition between the two periods was gradual. Vases with decoration and filling ornament primarily in the Geometric tradition are, for example, usually called Geometric. There are no firm absolute dates in this phase since neither Late Geometric nor Early Attic vases were much exported to the Sicilian colonies. But recent Geometric finds in the Kerameikos necropolis in Athens shed some light on the question of relative chronology. Not one single broad-necked jug from the last Geometric phase, in the 'tinsel' style, has been found in the Kerameikos, only an older version of the type, in Grave 16.[38] A large number of fragments of different vessels in the same style as the older version were found in the votive channels 1 and 2.[39] The latest find in this Geometric necropolis is an amphora neck with open-work handles and a spiral frieze below the lip (Pl. 48), in which the influence of the Early Attic Analatos hydria can be seen (Pls. 52–55).[40] This was found in a burnt layer above Grave 51. The last stylistic phase of Late Geometric is obviously, therefore, not present among the Kerameikos finds. Kübler remarked on the small number of graves dating from the last quarter of the eighth century, and suggested that the missing graves must be in an area which is today largely built up.[41] The finds from votive channels and place of sacrifice above the graves do not allow any firm dates to be established. Nevertheless, the date for the end of the Geometric style, which Kübler estimated as about 730 B.C., was probably about fifteen years later.

The decline of the Geometric style

The superb figure painting of the High Geometric style, which succeeded in combining the physical, perceived world with the strict conventions of Geometric style, was also the catalyst for the dissolution of the Geometric formal system, which took place in

the course of only a few decades. From now on ornamentation and pictures developed in their separate ways. If we jump forward to the end of this process we find jugs still in the same tall shape as those from the second quarter of the century. They are still covered with ornamentation but the style has changed completely. The precision of the Geometric style of ornamentation, once so important, has now disappeared. It is virtually impossible to discern whether the artist intended a zigzag, a lozenge chain, or a checkerboard pattern. Ornaments are laid on so thickly that they almost look alike. With a few strokes, the entire Geometric range of decoration is suggested. This is often referred to as the *dichter Stil* ('dense' style, otherwise known as 'tinsel' style). Now painting only pretends to be Geometric; it is no longer truthful, but rather a merely superficial impression.

The new style of picture can best be seen on a neck amphora dating from about 710 B.C. in the British Museum in London (Pl. 45). This belongs to a group of vases extending into the beginnings of Early Attic pottery. The lower part of the body of this vase is decorated in 'tinsel' style, although rather more carefully composed and clearer than usual. The subject-matter of the pictures is still predominantly in the Geometric tradition, but the heaviness of the chariots, painted in great detail, the determined stride of the horses and the tension of the two grazing deer are more Archaic than Geometric. The two pictures on the neck, of a huge lion throwing himself on an antelope, are borrowed from contemporary Protoattic art. But the most important element is the treatment of the vase ground, which remains light. The filling ornament, which has until now formed a connecting link between the pictures and the decoration, has virtually disappeared. The only traces are little hooks and meander hooks scattered widely across the surface, which tend to emphasize, rather than to fill in, the emptiness of the ground. Light ground now plays a role of its own in the picture. The figure and the clay ground complement each other. The figured image has finally been separated from the overall decorative scheme, and becomes independent. In the last phase of the Late Geometric, the light style of pictures occurs in conjunction with the 'dense' or

'tinsel' style of ornamentation. This sets the seal on the end of Geometric art.

But historical development is in general not homogeneous. While the Geometric strain becomes weaker and weaker in mass-produced vessels, one can still discern occasional struggles between progress and setback; and brilliant individual discoveries and innovations still occur. The contrasting forces which combined in the High Geometric period to produce a superb, unified style, now gradually separate again. Late Geometric art in Athens was no exception to the apparently universal rule that all post-classical art is doomed to release forces which it can no longer hold in check. It undergoes tremendous upheavals. And yet this late art, as it declined and slowly changed, did produce some rare and auspicious achievements.

Late Geometric neck-handled amphorae

Amphorae with neck handles, successors to the belly-handled amphorae and kraters, the great grave vases of High Geometric, begin to appear soon after the middle of the century.[42] After the end of the third quarter of the eighth century, they were the only media for funerary pictures. The period of continuous development of the shape of vessels is now over. At the beginning of the Late Geometric period considerable variations in shape occur. High Geometric shapes are developed further, or degenerate (Pl. 43),[43] and shapes are borrowed from contemporary, virtually undecorated, everyday vases (Pls. 42, 44).[44] The amphorae in Athens (Pl. 43), Boston and Würzburg[45] have already changed in the direction of the new Late Geometric type of grave vase, which probably began about 730 B.C.[46] A typical feature of this type is unlimited exaggeration of the neck, which grows to a size up to three quarters that of the body, so that the weight of the neck seems almost to crush the delicate body. Potters were apparently trying to imitate the monumentality of High Geometric belly-handled amphorae which also had tall, heavy necks. But here they are achieved only at the cost of violently disturbing the balance of the High Geometric vase. The amphorae from the

Kerameikos necropolis (Pl. 43) and those in Boston, Erlangen and Würzburg[47] introduce innovations which are in many ways indicative of what was to come. The snakes which were painted at the end of the High Geometric period on handles in various ways, wriggling upwards, are now replaced by three-dimensional snakes raised from the surface. Plastic decoration also begins to be predominant on hydriai,[48] the lids of pyxides, and on footed cauldrons (Pl. 63). Snakes are soon writhing round the lips and shoulders of neck amphorae. These reptiles crawling around the mouth, the bottom of the neck, and the handles of vases are signs of post-classical baroque like the over-heavy neck and the unusual proportion between the various parts of vases. The shoulder snake is sometimes close to the base of the neck (Pls. 46, 47, 50) and sometimes it is missing, leaving room for a figured shoulder frieze. On the amphora in London (Pl. 45), only the handle snake remains, and on the amphora in New York (Pl. 51) there are no snakes at all. From about 720 B.C. onwards, it is possible to trace the beginnings of a new, simpler, more severe vase structure. It is more slender than before. Body and neck are combined harmoniously in a narrower, upward-thrusting shape.[49] It is on one of these amphorae that the first open-work handles occur, as well as the first spiral ornament so popular in later Protoattic art (Pl. 48). The disappearance of overcrowded baroque decoration, and the tautening of the shape of vase coincide with new trends in pottery, the first seeds of post-Geometric style. The body of the vase is taut, the proportions are less disturbed and more uniform, and the whole expresses a relaxed self-assurance (Pls. 46, 50).[50] The crisis is over, but the forces which survive are no longer pure Geometric; they are the beginnings of Early Archaic art.

Painted decoration fits easily into this development. It is only at first that the completely ornamentally decorated grave amphorae occur (Pl. 43).[51] This category includes an amphora in Amsterdam with a frieze of figures in a round-dance in an unusual position above the foot, borrowed from contemporary jugs with tall, narrow necks.[52] The pictures are on the belly of vases.[53] They spread all over the belly and neck (Pls. 44, 46)[54] and finally even find a place on the shoulder (Pls. 45, 47, 50, 51).[55] Prothesis pictures appear at first in the traditional position, as enclosed pictures, or as friezes on the belly of vases (Pl. 44).[56] Later, in the form of a *pinax*, a kind of 'easel picture', they move up to the neck (Pls. 46, 47).[57] Finally, the pictures of lying-in-state with which the High Geometric grave vases had begun half a century earlier, completely disappear. The splendid funeral processions, crowds of mourners, processions of chariots and now, also men on horseback (Pl. 50)[58] and marching warriors, equipped with round shields (Pl. 46)[59]—all these are still shown. Only one of the vases certainly used as a grave amphora has a completely different type of picture.[60] This shows a procession of centaurs on the belly frieze. The neck is decorated with pictures of a fight starting between a hero and a centaur, and of a meeting of two centaurs holding hands out to each other. Either this vase (like some hydriai showing women's round-dances)[61] belonged to a different chthonic cult, or the centaurs, part-horse, part-man, are directly connected with funerals. At all events, there are no pictures celebrating the deeds of men in battles on land or sea, which were so widespread on High Geometric grave vases. Less attention is given to the general funeral ceremony, and much more to specific strictly cult aspects. The snakes around the neck, creeping up the handles and lying round the mouth are signs of this trend.

During this last phase Geometric ornament loses much of its importance. It does still appear in stripes separating pictures and on necks,[62] and later it occurs at the base of the neck and, more often, underneath the lip (Pl. 47) and above the foot. But only a small part of the ornamental repertory of the large grave vases of High Geometric is used. The most common motif is the simple lozenge chain. Patterns really only suggest the presence of decoration. They are no longer connected to the triple-line bands, but float between them like filling ornaments (Pl. 45).[63] It is interesting to note that in a few Late amphorae before 710 B.C., certain High Geometric belly-amphora motifs, such as friezes of leaves or cross-hatched lozenges, reappear carefully drawn above the foot (Pl. 50).[64] This classicist throwback may be connected with the tautening of the shape of vases, after the

earlier baroque extremes, which was taking place at the time. The 'tinsel' style, which starts roughly at the beginning of the last quarter of the century on large hydriai and jugs,[65] does not occur in cult neck amphorae.

Late Geometric figured scenes

The true character of Late Geometric is to be seen in its figure painting. Its media, apart from amphorae, are squat jugs with trefoil mouths,[66] deep dishes[67] and kantharoi. The jugs still belong to the third quarter of the century. It is on them that the typical pictures of scenes from daily life begin to appear. During the Late Geometric period these are separated from the funerary scenes. They show horse-leaders (Pls. 56, 59), fighting on land and sea (Fig. 15, Pls. 58, 59), shipwrecks, (Pls. 60, 62), foxes which have broken into the poultry-run being driven off by the farmer (Pl. 61), and jugglers (Pl. 57). The main picture is always on the belly, although a base frieze may be added (Pl. 56) or a figured illustration may be put onto the neck (Fig. 15, Pls. 58, 59). Eventually an animal frieze is added to the shoulder (Pls. 59, 60). Only on the jug in Munich (Pls. 60, 62) is the main picture on the neck. Attic painters often imitate in their decorative schemes the so-called 'pilgrim flasks' from Cyprus,[68] which Attic potters had tried to copy as early as the transitional period before Early Geometric.[69] Now, however, the vase painters are not trying to combine pilgrim flasks with Geometric decoration; they tend merely to borrow the large concentric circles for the side surfaces of their flasks[70] with only the style of the pictures remaining Geometric. Thus filling ornament, too, begins to lose its significance. From now on it is used only sparingly (Pls. 56, 61) and is mostly not present at all. This is a first step towards lightening the pictures. Even when they are still in the great High Geometric tradition, figures begin to stand out clearly against a light ground although artistic exploitation of this innovation is incomplete. One of the influences here was the connection, established in many cases by iconography, with early figure painting from the beginning of the century, where filling ornament had not yet been developed. This connection was never completely broken, even in High Geometric.

The so-called deep bowls on which Oriental picture motifs are first found[71] are produced well into the last quarter of the century. Here too, filling ornament becomes lighter, more playful and fleeting, until, as in the warrior bowl in Munich,[72] it disappears completely.

This apparently simple change in style from Late Geometric to Protoattic did have its counterpart in a group of large and stylistically important vessels from about 720 B.C. and after, in which a last great reaction by Geometric art against the new trends can be seen. Nevertheless, by this time all Geometric

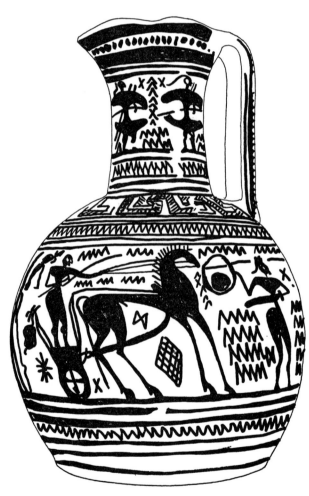

15 Oinochoë from Athens.
 Height 22.8 cm. Athens, Agora Museum

forms, both ornamental and figured, had changed their character. There is a new way of looking at the world which cannot be described merely as a reaction, but which, for a short time, gave Attic art of this early period unprecedented freedom and daring.

This new vision becomes apparent in changes in figures and composition. The silhouette begins to be 'two-coloured'. In fact, as early as late High Geometric, terrified warriors facing death were not always shown in unadulterated silhouette; the big round eyes with a pupil were usually reserved in the black forms (Fig. 13). This practice becomes the rule on the Late Geometric large grave kraters (Pls. 40, 41), followed by grave amphorae where size allows it (Pls. 45, 46, 48–51)[73] and smaller vessels like jugs (Fig. 15, Pls. 57, 59, 62) and bowls (Fig. 16). Women are shown with patterned costumes. From the waist downwards 'chitons' are drawn in outlin with decorations picked out against the clay g und. The pattern is usually cross-hatched (Fig. 16, i ls. 46, 47, 49, 50),[74] although there is a bowl (Pl. 66) where a checkerboard pattern is used. Torsos drawn in outline are less common (Pl. 51).[75] On the Munich jug (Pls. 60, 62) the shipwrecked men have cross-hatched chests. Eventually the silhouette figure is almost completely replaced by the outline figure in the mourning women on the amphora in the Benaki Museum in Athens, where the chiton is uniformly decorated with a trellis pattern from shoulder to foot (Pl. 46). Decoration on shields begins comparatively late. Spoked-wheel and lozenge motifs occur on the shield (clay ground inside a black outline) of a warrior standing between horses, on an amphora in New York[76] and on the round and rectangular shields of dancing warriors on a bowl in Munich.[77] The amphora from the Benaki Museum in Athens (Pl. 46) and another in a private collection[78] represent a later phase. The patterns on the shield on the first amphora, where a horse and a Dipylon shield can be distinguished, are painted in white on a glaze base (this should not be connected with the white overlaid Geometric ornamental stripes on the bows of warships on High Geometric kraters). On the second amphora, the shields are painted in red. Thus the two-colour effect achieved by breaking into the sil-

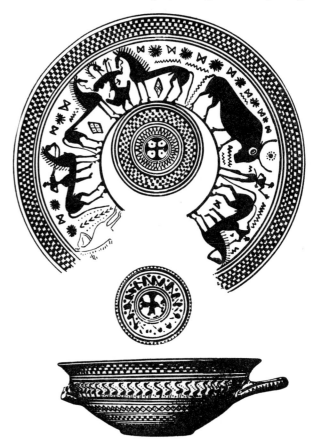

16 Bowl from Thera.
Height 5.4 cm., diameter 15.8 cm.
Athens, National Museum

houette develops into polychrome painting, presaging the colourful Early Archaic vases. More conservative, with only two colours, is the picture of an aristocratic warrior on the neck of an amphora in New York (Pl. 51). On this vessel there are no snakes, but a splendid chariot procession in the main frieze, and a grazing horse on the shoulder, filling up the whole picture area. This vase must come from the same workshop as the amphora in the British Museum (Pl. 45) and must be dated around 710 B.C. The silhouette, although still pure Geometric, is now completely broken up. The torso of the figures is now shown only in outline and in clay ground in order to emphasize the light colours of the chiton. The same occurs between the curved lines of the legs, which are

drawn as though naked. The intention here is to represent the movement of loose material. The outlined cloak on the shoulders spreads out before dropping on both sides almost down to the feet. It is richly decorated with large tassels on the lower hem, with a light zigzag band between cross-hatched triangles. Cross-hatching also covers the remaining area of the cloak.

Nevertheless, this warrior figure is merely a mannerist echo of the great reaction, previously mentioned, against the decline of Geometric. This reaction begins in the last quarter of the century and lasts until after 720 B.C. The Geometric silhouette is restored wherever possible. The reserved eye disappears, with the sole exception of a few mourning women on the amphora neck from the Kerameikos (Pl. 48). Outline drawing is limited to well-established formulae such as decorated costumes of mourners and dancing women (Pls. 47, 48)[79] and decorations on shields.[80] Classical filling ornaments appear again, particularly the upright pillar between figures composed of a number of horizontal zigzag lines, and the horizontal hour-glass motif, used either to terminate or to interrupt pictures.[81]

But the real significance of this trend in Attic Late Geometric was not so much the Geometric reaction which was bound, in the end, to fail, but that the Late Geometric version of the human figure reached, here, its highest development, for which a new, freer style of painting had to be invented.

The precision of classical drawing disappears. Instead of the strict linear precision, dark varnish colour is more freely applied in the limbs of figures, the outlines of clay-ground costumes, horses' legs, and filling ornaments. A broad, brush-like instrument appears to have been used. It would not be correct to describe this technique, which is found on grave amphorae and the main cult vases, as superficial. It does of course mean that painting can be done more quickly; it also means the artist can think more quickly. The idea that this is in any way degenerate is disproved by the richness of invention, the subtlety with which the important lines of the silhouette are established, and unity of technique and artistic intention. It is a sketching technique, still entirely Geometric, but more that of painter than draughtsman. It

suits the new, empirical artistic vision of the physical world, which has an explosive force driving it far past the boundaries of Geometric and which will, paradoxically, destroy the very tradition on which it is dependent. Filling ornamentation is no longer used in columns to separate figures, but connects them to each other, in the form of ornamental background surrounding the figures almost like a halo. But the biggest changes are in the figures themselves, both human and animal. Bodies seem to be built from the inside outwards, conceived as a whole, whether standing still or in movement. The play of costume and body is typical of the style. Dancing women on the Athenian bowl (Pl. 66) still grow out of the base formed by their peploi-like sculpted Xoana. Soon however, their costumes billow out like bells, reflecting more clearly the body movements of mourning women and dancers underneath. Arm movements are co-ordinated with those of the body, as in the man mounting a chariot on a jug in Athens[82] and the superb, long-legged, naked women in front of or around a griffin-bowl on the krater in Athens, where the movements are rhythmical (Pl. 63). From the twenties onwards charioteers do not merely stand still on the floor of their chariot, but are poised on its moving surface, leaning forward to give rein to their horses[83] or backwards to make them change direction, pulling in one set of reins, slacking off the other (Pl. 47).[84] The horses, sometimes delicate racers, sometimes great stallions, do not stand in groups as before, but stride powerfully forward (Pls. 45, 47, 50, 51),[85] as does the mounted horse (Pl. 50).[86] Step by step, one can trace the artists' growing understanding of how limbs are co-ordinated, and the shape of individual bodies; women's narrow waists are separated from the abstract triangular torso (Pl. 47)[87] and the long bodies beneath the costumes become one organic unit (Pl. 46). In male figures, the triangular torso loses its points; these are replaced by curves (Pl. 48).[88] Rounded shoulders contrast with the slightly dropped neck (Pl. 69). A new world of physical expression has come into being. The great strides of the round-dancers on the inside of a bowl (Pl. 66) which dates back to the middle of the century, turn into the quick steps of the armed dancers of the later bowl in Munich, and the easy paces of the heavy weapon-

bearers on the amphora in the Benaki Museum (Pl. 46).

In spite of its mobility, the figure is no longer a 'figure in action' as it was at the beginning of the century. The static 'lay figure' of the second quarter of the century comes between the two. This is the prototype from which all the variants developed. Even when these appear to be in violent motion, such as in battle scenes on grave kraters in which the figures are falling down or sinking to their knees, they are still Geometric silhouettes; they are stereotyped figures constructed out of separate parts (Fig. 13), made into living units by their abstract proportionality, and with their movement expressed primarily in the theme or situation illustrated. But now, barely a generation later, the silhouette has changed completely. It is conceived and executed as a whole, with an inner life all its own (Pls. 59, 61). The stereotype is replaced by an organic creature. Movement is derived not only from the theme, but also from the unified body. The figure has become active. At the same time as the silhouette figure is breaking into colour, during the transitional period leading up to the orientalizing style of the seventh century, a remarkably advanced plastic sensitivity comes into the conservative Geometric style. It is one of the paradoxes of this turbulent period that it was out of this last Geometric reaction that the Archaic figure developed.

This means that the fetters of Geometric canons are loosened, and the body as a whole becomes a richer means of expression. Has the vivacity of a dance ever been more vividly expressed than in the round-dance of long-legged women on a large cauldron in Athens (Pl. 63)? Similar dance scenes in roughly contemporary Protoattic art, on the Analatos hydria (Pls. 52–55) and its group, do not have the same force. Scenes of battle games or 'Dromena' around a griffin-cauldron can be seen on fragments found in the same place.[89] In these pictures, rather like artists' preliminary studies, figures in motion, both male and female, form striking groups. The same was subsequently achieved again only after a long period of development, in the following century. The relationship between the composition of the figures and the edge of the picture, no longer in accordance with Geometric principles of rhythmic ornamentation, and yet dynamically subtly balanced, is also quite remarkable. The legs of the support for the large cauldron, connected only by thin struts, are in the shape of tall equilateral trapezoids, as unsuitable as could possibly be for figured compositions. Nevertheless, they are all covered with pictures, although not, as previously, split into several easily filled picture areas. Each tall trapezoidal frame is filled with a narrow composition, developed vertically. Perhaps the most daring feature is a leg of which two-thirds is still preserved (Pl. 64): a helmeted warrior is trying to control an unnaturally thin horse, which is rearing up almost vertically. There is a thick mane on the horse's enormous neck, and its outstretched head reaches into the upper-right corner. The severe diagonal of the extended body and neck dominates the whole picture area, filling it with drama. The horse's raised front legs and the daring rider, grasping in his left hand the reins which lie along the mane, form a nodal point at the centre of the picture. The format and powerful dynamic of this unusual composition make it a superb artistic achievement.

The disproportionately large necks of Late Geometric grave amphorae, and the plastic snakes wriggling along their handles, lips and shoulders, have been regarded as post-classical, baroque phenomena. There are also the broad, sketch-like painting technique, the Geometric figures brilliantly adapted into organic figures in motion, and the daring compositions— all products of the movement which took place after 725 B.C., and which attempts to adhere to Geometric principles and use them to produce the figured painting of the future. There were of course too few artists involved—perhaps only one workshop or even only one important painter—for it to develop into a new phase of art in competition with the flood of Oriental influences which were beginning to invade Greece. It has, nevertheless, left its mark, and its influence can be seen the in the Hymettos amphora in Berlin[90] and other vessels.

Late Geometric art is by no means a fading final echo. It is more like a chorus of many voices. If High Geometric art can be called harmony between opposites, primarily ornamentation and illustration, then

Late Geometric might be described as having freed the opposites and abandoned the harmony. While Geometric ornamentation was gradually declining, it was those artists who were most passionately concerned with conserving tradition who achieved a great breakthrough in figure representation, and created baroque effects. Their work was an extension of the Geometric tradition in very different form. They were building the road to the future with the stones of the past.

Oriental motifs in Late Geometric art

There is, however, one phenomenon in Late Geometric art which is closely connected with the decline of the Geometric style: the use of Oriental forms by Greek artists. Objects imported from the Near East are seldom found before this. The Phoenician bronze bowl with reliefs on the inside (Fig. 4)[91] found in Grave 42 in the Kerameikos necropolis, and probably dating back to the third quarter of the ninth century, had no influence on contemporary Geometric art. It is not until amost a century later that Oriental influences begin to take effect.

One particular type of vessel is affected first—the (more or less) deep dish with a narrow foot and two horizontal handles. This is a completely non-Geometric form of vase which first appears after the middle of the century. It is often, rather inappropriately, called a skyphos. In two characteristics these dishes closely resemble Oriental bronze bowls. Firstly, their shape is similar—the earlier, the closer—in so far as is possible in a clay vessel; secondly, they use the completely non-Geometric technique of placing the most important figured pictures on the inside. This is an imitation of embossed metalwork in which the relief frieze is hammered from the outside inwards. The frieze frame, which consisted in the Orient of a cable pattern, is replaced by Geometric decorative bands of checkerboard or zigzag patterns. Instead of the rosette in the central medallion, there is a quatrefoil, wheel or star motif. Near Eastern bronze bowls from this period have been found in Athens, Crete, Delphi and, above all, Olympia.[92] We can be reasonably sure that it was Syrian, Phoenician, and Cypriot embossed metalware which were the models for the whole family of so-called deep bowls.

On these bowls, the range of fauna depicted now includes Oriental animals. Whereas at first, these give way to the usual Geometric animal friezes—rows of birds,[93] grazing deer (Pl. 67),[94] and horses[95]—now, bulls (Fig. 16, Pl. 70),[96] gazelles (Pl. 67), panthers[97] and lions (Pl. 70)[98] also begin to appear. This entire zoo can be found on an early Assyrian-type bronze bowl from Nimrud (Fig. 17). A frieze, of gazelles walking to the right, runs round the central rosette on the bottom. The top frieze on the outside consists of bulls walking to the left. In the central frieze are ibexes, gazelles and bulls in a meadow, and two griffins, being attacked by lions and panthers. It is interesting to compare a bowl from the Kerameikos (Pl. 67): round the middle there is a frieze of standing gazelles, looking to the right, and round the outside edge are grazing deer facing in the same direction, but both external friezes run in the opposite direction; in the lower external frieze there is a bull. The influence of the Oriental bronze dish on deep bowls can be seen in details like this. An alien animal world—of huge, demonic bulls with rolling eyes (Fig. 16),[99] awe-inspiring pouncing panthers, lions with wide-open jaws and horrific animal fights—is introduced into Geometric art.

The practice of depicting other religious ceremonies in addition to the traditional burial rites came to Late Geometric art by the same route, from Eastern bronze bowls to Attic deep bowls. Bronze dishes such as the one found at Idalion in Cyprus, which is now in New York (Fig. 18), had an incalculable influence on the illustrations on deep bowls. The picture on this bowl, of temple servant girls dancing, for instance, passed on its composition, and the quantity and massiveness of the figures in it, to a bowl in the National Museum in Athens (Pl. 66). In the latter, the illustration shows choruses of women only, and a mixed chorus of men and women led by two warriors with swords strapped to their waists. The choruses are conducted by two warriors playing a primitive kind of lyre *(chelys)*. One of these lyre players is separated from the choruses by lozenge filling pattern. He seems to be standing in the middle. Behind him are four isolated women, the first stretching out her right arm

towards the other three. Are these perhaps the three muses and their mother Mnemosyne? Is the lyre player Apollo? On the outside the decoration consists of four tripod-cauldrons between wide triglyphs

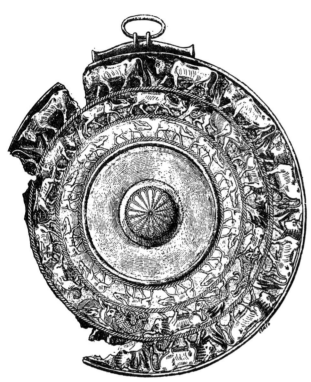

17 Bronze bowl from Nimrud.
 Diameter 28 cm. London, British Museum

(Pl. 68). These are probably the prizes presented by the successful choruses in the temple. It is tempting to interpret this cult scene, with S. Papaspyridi-Karouzou,[100] as the choruses on the second day of the old Attic festival, the *Thargelia*, when victors in the games used to put the tripods they were awarded in the *Temenos* of Apollo Pythios. But the *Thargelia* choruses consisted of men and boys. Women are never mentioned. Can the lyre-playing warrior with the sword really be Pythian Apollo? Pictures of gods, particularly of Zeus and Poseidon, in Late Geometric art have often been suggested but never really proven. It would be more typical of the generalizing character of Geometric pictorial art if the Attic

painter, influenced by Oriental cult scenes, had illustrated cult ceremonial games from his home town, and then added a few colourful touches from other festivals. At all events, the theme of this picture is hellenized, and the formal idiom has been translated into Geometric.

Another, slightly later bowl in Athens (Pl. 65) is very different. The picture shows four women dancing, holding hands with each other, and carrying branches. In front of them is either a goddess sitting on a throne with her feet on a footstool, or a cult image of the same. The goddess's torso has disappeared, but she seems to have been holding a branch. Behind the throne, between two men in armour, there is a man kneeling on a podium, again with a branch in his left hand, and a harp-like instrument in the right. This is a simplified version of the cult scene on the bronze bowl from Idalion (Fig. 18). The table for offerings, and the altar, have disappeared. The priestess has merged into the leader of the dance, who is offering the goddess a wreath. Behind the throne sacrificial music is being played. The harp is not a Greek instrument, but it appears on the bronze bowl, in the middle, between the flute player and the girl beating the tympanum. This subject-matter is

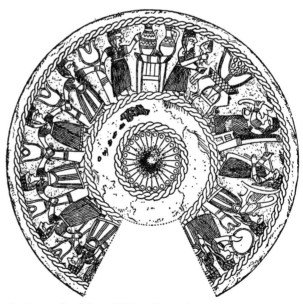

18 Bronze bowl from Idalion (Cyprus).
 Diameter 13.25 cm. New York, Metropolitan Museum

largely derived from Oriental models, although the style is Geometric. The weapon-dance on a Munich bowl[101] is also a cult ceremony. No Oriental prototypes need to be assumed for this internal picture; it is obviously descended from the old motifs of marching soldiers and dancing men. The way is now open to all kinds of different types of picture of cult events. The 'transparent style' occurs on deep bowls and oinochoai earlier than on the ritual grave amphorae.

Picture friezes and occasionally animal friezes, are often interrupted by almost heraldic compositions where antithetical groups of two or three figures stand out against the even pattern of the friezes because of their picture-like structure (Fig. 16, Pls. 65, 69, 70). These are reminiscent of typical features of Near Eastern art, where this type of antithetical pictorial composition had been developed very early on into symbols of supernatural powers.

There is, however, no reason to derive the motif of the man leading the horse (Fig. 16) from the East. The horse played no role in Oriental religions. But the horse image never disappears from Attic pottery, from Late Mycenaean painting and small-scale sculpture, to Protogeometric and up to the end of the Geometric period. The group of horses on each side of a man holding them appears, like the antithetical birds, fully developed before the High Geometric period (Pl. 29) and lasts into Late Geometric. These heraldic compositions can, however, be treated equally as revivals of the Master of Animals motif from the Minoan-Mycenaean period, allowing one to be certain only of an indirect Oriental connection from a long time earlier. And the fact that antithetical composition spread quickly to multiple-figure pictures in prothesis scenes of High Geometric amphorae and kraters suggests also that the motif was not directly copied from the Orient.

Nevertheless, the picture is full of allusions, like other heraldic groups which were certainly copied from the Orient. The horse played a leading role in Attic religion and the cult of the dead.[102] It was closely connected with the Ionian Poseidon religion and with the god of Death, who appears in various guises and under several names.[103] The bird alighting on the head of a man holding a horse, on an oinochoë

of the Late Geometric period in Berlin (Pl. 56), is the same idiom as the naked Mistress of the Birds and the holy shrine, with birds on the horns of consecration on the figured gold band from the third Shaft Grave at Mycenae, and the birds sitting on a double-axe pillar on the sarcophagus from Hagia Triada—all indicate the deity's presence.[104] And double axes above, behind or underneath horses on Cycladic, Attic and Boeotian Geometric vases must be religious 'determinatives'.[105] These symbols, and later on wings, indicate that the horses are supernatural. In view of the way the frieze on the bowl from Thera is interrupted by the heraldic group (Fig. 16) it is likely that this picture, and probably the picture on the Berlin oinochoë (Pl. 56) show one of the rulers of the Kingdom of the Dead. Alternatively, they may be of one of the several Attic Poseidon-like heroes, who were always armed with the double axe in Greek legend and early art.[106]

The heraldic group of two mythical creatures in the frieze inside the Athens bowl (Pl. 65) is, however, obviously of Oriental derivation. There is no Greek word to describe them. Their lion tails and wings are like sphinxes, while their horse bodies and arms are like centaurs. One could hardly expect that the form of these mythical creatures which were now introduced to Greek mythology by artists from the East, and which for the Greeks opened the door to the fantastic symbolism of the East, would have been firmly established as early as this. Probably the earliest prototype of these sphinx-centaurs is the pair of sphinxes on either side of a tree of life, with front legs stretched up the tree, as found on Cypro-Phoenician metal bowls.[107] This image has been adapted to Attic ideas, and the static Oriental picture turns into a dramatic confrontation—a symbol becomes a picture from mythology.

The lion-tamer group on the internal picture of another Athens bowl (Pl. 70), surrounded by a bull frieze, is of great importance. It is the first evidence of the widespread influence of a monumental heraldic group from the post-Hittite aristocracies of northern Syria in the eighth and seventh centuries. The group occurs on two almost identical statue bases found in Sendshirli (Pl. 71) and Carchemish. On both sides of these cube-shaped bases are lions in high relief pro-

jecting forwards at the corners. In paintings, they are of course two-dimensional. But in both the statue bases and Greek bowls, the same huge snarling lions appear, with a tiny demon holding them by bands round their necks—a size difference which is exaggerated on the bowls. The weapons used to keep the lions under control can just be made out. It is impossible to say how Greek painters came to know this Syrian motif, which originally came from Syrian small-scale sculpture. But, as one can see from its influence on Early Archaic art, and even Archaic Greek relief bases,[108] the Greeks were obviously very taken with this symbolic and apparently eternal image. A similarly derived image can be recognized on two bronze shields from the grotto of Zeus on Mount Ida, in Crete.[109] On one of these, the naked Syrian-Canaanite goddess is shown standing between two enormous lions, much larger than she, holding their heads, which face forwards, by the mane. On the other, the same goddess, holding lotus flowers in her hand, is flanked by crouching sphinxes. And it may be only coincidence that this motif from northern Syrian relief bases does not occur on any extant Phoenician bowls. This argument is supported by variants of the motif. One of these is on a Late Geometric kantharos in Copenhagen (Pl. 69),[110] which cannot be High Geometric if only because of the extent to which the metope-triglyph idiom has degenerated on it. Another is on Geometric gold reliefs found in Attica, all made in Attic workshops but from moulds imported from a part of the Aegean which is particularly interesting in this context— probably Rhodes. Alternatively they may have been brought in by travelling goldsmiths (Fig. 106, Pl. 223).[111] In all of these variants, the Master of Lions has become the victim of the man-eating lions attacking him from right and left. His head, and on the kantharos his posterior as well, are inside the animals' wide-open jaws. The fixed Oriental symbol of the power of the gods or the supernatural is here, too, set in motion, becoming a dramatic picture of the death of a hero out hunting. But has the symbolic content of the picture completely disappeared?

It has been adapted to fit in with Greek ideas. In ancient times there were no lions in the civilized parts of the Aegean. D. Ohly has therefore suggested that the scenes on the Copenhagen kantharos and Attic gold bands are 'allegorical representations of death', and that the lions are 'elemental supernatural powers'.[112] This assumption is based on similes about lions in Homer, and is supported by certain historical factors. Lions and sphinxes, for instance, are very similar in Assyrian art and late mixed art from the Syrian and Palestinian seaboards. In the pictures described above, of the Master or Mistress of Animals, they also appear to be interchangeable. On Cretan shields, naked Syrian goddesses are accompanied by either lions or sphinxes, and in Greek art up to the end of the seventh century and the beginning of the sixth, they appear to mean the same. On Cypro-Phoenician bronze bowls there is either the Egyptian king lion which strikes down the enemies of the people of the Nile, or the king sphinx which stretches out over a vanquished foe.[113] The motif of a man-killing sphinx often becomes one of lions on Cretan hunting shields.[114] In Greece the sphinx, the demon of death which threatened Thebes in the Oedipus legend, is portrayed in the form of an Egyptian-Oriental lion-maiden; and as late as the fifth century, Melian clay reliefs show the unfortunate predecessors of Oedipus hanging under the body of a sphinx, being carried away to the land of the dead.[115] In Greece, interchangeability of lion and sphinx, which must have been derived from Egypt, applies even to iconography. Sphinxes and lions were both *keres*, or spirits which carried men off to their death. In the Archaic period, they became less hostile figures, and were even benevolent watchers over graves. On the Copenhagen kantharos, the lions are still shown as mighty *keres*, killing a man and carrying him off to the underworld. This is no longer abstract symbolism, but a living early Greek mythological image. Only the shape of the spirits and the composition of the picture are derived from the Orient. Thus begins, in Late Geometric art, a process which largely shaped Greek mythological images in the Early Archaic period.

The death scene is so dominant in the middle of the main side of the Copenhagen kantharos (Pl. 69) that a connection with the other scenes on the vessel is established. This was almost certainly the first illustration of funeral games. On the left two warriors are fighting each other with swords and a female

slave is being carried off as a prize; on the right youths are dancing, carrying filled jugs on their heads, accompanied on the lyre. (Who can fail to be reminded here of a Late Geometric jug in Athens with the oldest scanning Geometric Greek inscription on its shoulder [Fig. 19]: ὅς νῦν ὀρχηστῶν πάντων ἀταλώτατα παίζει τοῦτο δεκᾶν μιν?[116] Was the oil in the jugs perhaps the prize?) On the other side of the vessel, there is a mock battle, with warriors armed

19 Inscription on the so-called Dipylon jug.
Athens, National Museum

with shields and swords, two men preparing to wrestle with each other, and a lyre-dance, urged on by men clapping rhythmically. So we have battle games, and athletic and musical competitions, but it is difficult to identify particular funeral games in honour of some important man who had died. It is more likely that the artist painted fairly typical funeral celebrations, adding a few local touches, such as the two dances, to epic events like the battle games.

The first mythological pictures

In the later period the range of subjects treated in Geometric pictures, strictly limited in High Geometric to funerary rites and associated themes, expands considerably. Scenes of religious festivals, dances, choruses, hunting or shepherds protecting their flocks against small predatory animals, begin to appear.

Illustrations of mythological themes also increase.[117] The Geometric pictures of hero myths, recently listed, have not yet been discussed. Many of them are in sub-Geometric style, and do not belong to the Geometric period. The illustration of a shipwreck on a jug in Munich (Pl. 62)[118] does not necessarily represent the shipwreck in which Odysseus' comrades were drowned and he was saved; the capsized ship merely illustrates a typical shipwreck,

as could even be the case with Homer's description in the Odyssey. But the great sea battles characteristic of the period before the middle of the century now give way to peaceful sea journeys, or battles with the elements. On the other hand, pictures of the Aktorione-Molione are certainly based on mythology.[119] According to the legend, this creature consisted of two Elian twins, sons of Poseidon, who had grown together. The young Nestor dared to fight it, and Herakles killed it. This is the earliest mythological theme in Geometric art, although it had already begun to appear on High Geometric grave kraters before the middle of the century (Fig. 13). It has been suggested, and it is indeed very likely, that the origin of this story was an old Peloponnesian poem which decribed the war of Neleus against the Elians. Neleus, the father of Nestor and Lord of Homer's Pylos, was supposed to have made his home in Athens after leaving Pylos. He was, therefore, closely connected with Athens and was the progenitor of three prestigious Attic tribes: the Alkmoneonides, the Paionides and the Medontides. Battles between heroes and centaurs, which first appear in the Late Geometric period on a Copenhagen neck amphora and a bronze group in New York (Pl. 185),[120] also almost certainly illustrate mythological events. A hero's abduction of a woman onto a ship, on a Late Geometric bowl in the British Museum is also a mythological scene (Pl. 72).[121] This motif recurs frequently in early heroic legends. The particular picture probably shows Theseus and Ariadne fleeing from Crete. Theseus, the son of Poseidon, was certainly already revered as a hero in Athens in the eighth century. It is possible that the picture of a man grasping the last of a flock of birds by the neck while the rest fly on, on a narrow shoulder frieze on a jug of the beginning of the third quarter of the eighth century, in Copenhagen, may illustrate Herakles and the Stymphalian birds.[122] Animals hunting or being hunted are often shown on shoulder friezes. On a contemporary jug from the Kerameikos necropolis, for example, a picture shows a man thrown to the ground by a lion,[123] but he is not necessarily Herakles. Although one cannot claim that Late Geometric figurative art is entirely involved with mythology, this fertile Late period does provide the beginning of Greek mythological illustration,

which was soon to become the central preoccupation of Greek art.[124]

This trend was undoubtedly reinforced by Greek artists' increasing acquaintance with Oriental art, although at first imports from the East were few. For these early Greeks, images of spirits and demons in the form of lions, sphinxes and other strange creatures must have been very exciting. Cypro-Phoenician 'mixed art', containing elements of Egyptian, Syrian and Assyrian art, was another, less influential, source. While the Greeks were creating their own pictures of centaurs, they discovered these superb images from the wonderful world of the supernatural which in their own legends still had no established physical form. The closed heraldic images of the Orient, a fertile source for Geometric painters, were a catalyst in the growth of the intellectual content of figurative art—a process in which creative misinterpretation and native originality both played a part.

The development of a new style of ornamentation during the declining Geometric style shows how radical these changes were. As Geometric ornamentation disappeared, only meanders and checkerboard patterns were carried over into the new style, in a linear form. The new style was based on the lotus and the palmette, which had been created, stylized, and stereotyped over centuries in the Orient. Inventive Greek artists borrowed these motifs, but adapted the stereotyped models to a new world of nature, in which plants and ornaments were increasingly combined.

The new style, developing as Geometric art declined, was Archaic art proper.

In the Late Mycenaean period a uniform style of vase, technically excellent, was the dominant feature of culture throughout the Mycenaean world and beyond it. All the variants of this vase, wherever they occurred, were basically similar. In this, sub-Mycenaean and the Protogeometric continued the Mycenaean tradition. In Protogeometric, apparently based in Athens, the new centre, a *koine,* or common formal idiom, was established for the last time, although it never achieved a level of quality or self-sufficiency comparable with Mycenaean. Clearly, one of the roots of Protogeometric art was a deliberate attempt to revive traditional forms. But thereafter, during the course of the Geometric period, special local forms of Geometric art sprang up in various places, each adapted to local conditions. This fragmentation into different Geometric 'dialects' has been connected, probably correctly, with the change from the court culture of the Mycenaeans to the city-state. But this is only part of the truth. The different regional styles were less the result of new political arrangements than the result of the decline in earlier links of trade and transport, followed by the rise of the various local artistic traditions to greater predominance. Local styles do therefore reflect the increasing isolation of individual city-states, although many of these were founded long before.

It is not possible to determine exactly when all individual local Geometric styles developed after the decline of Protogeometric pottery. The Protogeometric style seems to have lasted longer on the fringes of the Greek world than at the centre, which we can consider Athens and the northeastern Peloponnese. In the northern Aegean it lasted well into the eighth century. More accurate dating is not yet possible, since the essential excavation and study have not

been done. It is certain, however, that clearly definable local Geometric styles cannot be distinguished before the beginning of the eighth century, but a complete historical development cannot be traced anywhere except in Attica.

For this reason, only a short, provisional description of the major features of non-Attic Geometric styles can be given.

1 Corinth[1]

The transition from Protogeometric to Geometric occurs in Corinth and the Argolid at approximately the same time as in Athens. But large amphorae are rare and large kraters—not found at all until the eighth century—are comparatively rare during the early part of that century. The most common vessel is the jug with trefoil mouth, followed by the bowl with two horizontal handles (skyphoi). In the early period, shapes are similar to Attic, but fuller and heavier.

Decoration of Corinthian Geometric vases

Decoration continues to be black-ground until about the middle of the eighth century. The meander appears early on, but is never as important as in Athens. Its equivalent is the broad band of parallel zigzag lines which cover the neck area of the oinochoë and the belly area of the jugs, often joined to the horizontal framing lines by extensions of the apices. In spite of many similarities with Early Geometric Athenian art, this style does not consistently develop any rich decorative scheme out of the basic Geometric ele-

ments. Ornamentation remains very simple, is very much tied to the vessel, and lacks any rhythmic counterpoint between the painting and the body of the vessel. It is basically conservative. The Athenian Severe Geometric style left Corinthian pottery almost untouched. Saul S. Weinberg thus rightly distinguishes only two stylistic phases in Corinthian Geometric vase painting: Early Geometric in the ninth century and Late Geometric in the eighth century.[2]

This conservative and self-sufficient Corinthian Geometric style of decoration seems to indicate that Early Corinthian artists looked for fulfilment to other forms of art, particularly embossed metalwork and production of metal utensils. Until the Late period their vases were completely or almost completely covered with glossy glaze, and must have looked very much like bronze vessels. This may be one of the reasons why the Corinthians kept producing black-ground clay vases for such a long time. Around the middle of the eighth century, however, black-ground pottery becomes much less common, being replaced by clay ground over the whole vessel. Now comes the development called, in contrast to orientalizing Corinthian pottery, Protocorinthian Geometric. This surprising change in the overall appearance of vases suggests a strong influence from Attic art in its High Geometric phase. New Attic vase shapes such as the steep-sided krater were copied in Corinth at this time. Broadly, Protocorinthian Geometric coincides with the end of High Geometric and with Late Geometric in Athens. But it has none of their inventiveness, or their problems. These vases have a well-organized, tectonically based clarity of appearance, but very little originality. The lower part of the vase, previously black, is now covered down to the foot with a simple stripe pattern. This does not mean that Geometric decoration has spread over the whole vessel, as in Athens, but merely that the areas which were previously black are now made lighter. The traditional Athenian feeling for, and understanding of, rich background is absent in Corinthian ware. Only the neck and the shoulder of oinochoai, and the upper edge and handle zone of kraters and skyphoi are Geometrically decorated. Dynamic effects such as the boxed areas on Attic kraters, are avoided. Corinthian pottery is characterized by simple, repetitive patterns such as the hook rosette, the true spiral chain as a border decoration, and whole areas filled with floating zigzags, one above the other, carelessly applied.[3] The Protocorinthian Geometric spiral chain is a very simple non-Geometric motif, markedly different from the many much richer patterns invented by Late Geometric Athenian artists as border decorations. It must have been imported from the eastern islands or from Crete. In general, however, the vessels are technically better made and painting is neater than in Athens.

Figured scenes

On Corinthian pottery, unlike Athenian High Geometric, decoration does not expand into large narrative figured pictures. The only exception to this is the bird frieze, in the form of a closely packed row of long-legged, rapidly sketched birds (Pl. 74). On later skyphoi these birds turn into a continuous row of upright zigzags, without any figure content. On two Late Geometric vases, an oinochoë in Berlin (Pl. 75)[4] and a krater in Toronto (Pl. 76),[5] there is a picture of a ship on the shoulder. The style and technique of the impressive ship on the krater in Toronto and also the white meander on the bow, suggest copying from earlier Athenian High Geometric pictures. But the ornamental rhythm of the nineteen identical oarsmen is completely non-Attic. In Corinth, tectonic principles of vase decoration completely control and subordinate the pictorial element. This is quite unlike the independent, narrative figured pictures developed two or three decades earlier in Athens. A strictly subordinated figured picture occurs on a later, well-preserved, cauldron-shaped krater with ring handles from the North Cemetery of Corinth (Pl. 74).[6] The vessel is covered—except for the very low neck, the picture zone and the handle—with a brown-black glaze. Like a number of similar kraters from the same cemetery, none of which has much decoration, it is obviously an imitation of a bronze cauldron. On the belly are white painted stripes with two snakes crawling between them. Next to the handles are isolated lozenge zones. On the neck is a linear upright meander of the latest type. On the main side a reserved central

rectangle is suspended from the neck like a painted *pinax*. Surrounded by broad ornamental bands, this picture shows three women dancing, holding hands and carrying branches. The dance is an Argive Geometric type. This has reached the Corinthian painter via the neighbouring Argolid, rather than directly from Athens. The figures are static rather than moving. They echo the verticals of the frame, with the middle dancer exactly in the centre of the picture, which coincides with the central axis of the vessel. Here an observation may be made which would not be relevant to Athenian art of over a generation earlier: in conservative Corinth, the tectonics of the vase still affect the composition of the picture, something long since abandoned in the much freer Attic compositions. The same dance, but in the later style of the second quarter of the seventh century, occurs again on a clay relief, probably from Magna Graecia, in Naples.[7] It is used as decoration on the peplos of a standing goddess, whose upper body is lost. Again, the middle dancer is on the central axis of the whole figure. It has long been recognized that this relief was copied from a Corinthian bronze-relief *pinax*. So here is evidence, from a later period, of the tradition of embossing which influenced pottery during the Geometric period in Corinth, and caused it to develop so differently from Athens.

A conservative strain, hostile to all kinds of experiment and innovation, runs through the whole history of the Geometric style in Corinth. Its strength is its discipline and the noble reserve of its sparse decoration. Its weakness is that it lacks the firm Geometric foundation of Athenian Early and Severe Geometric. Geometric principles apply less rigidly in Corinth, so that potters are able to start using the true spiral chain comparatively early without passing through the intermediate stage of the 'Geometrized' false spiral. Obviously the importance of the metal industry in Corinth was a key factor, since it must have been primarnly concerned with straightforward shapes and tectonic form. But the most important factor of all was undoubtedly the Dorian individualism of the Corinthians. The Corinthian Geometric style was the foundation on which the Corinthian Early Archaic art of the orientalizing period was built.

2 The Argolid[8]

The Corinthian and Argive Geometric styles both grew from a common root. The two places are next to each other, and their histories are intertwined. They both had a Mycenaean past, a tenth-century Protogeometric phase of pottery, and a population of a distinctive Dorian character. Nevertheless, it is still possible to distinguish the original heartland of Mycenaean culture in spite of all these similarities. That the imagination of the Argive potters was richer than the Corinthians' can be seen in the tremendous, almost capricious range of types of vessels in the ninth century and the beginning of the eighth. When the routes to the sea were opened at the beginning of the eighth century, the potters learned that the coast of the Argolid looked out towards the Aegean Islands and beyond them to the Saronic Gulf. They had usually been more open than the Corinthians to influences from Athens, and a relationship developed between the Argolid and the Aegean Islands, though we cannot be sure quite how extensive this was. It was the Athenian High Geometric style which sparked off the local Argive style. Rivalry with Athens lasted into the Late Geometric period.

Ninth-century Argive pottery differs little from Corinthian. Much the most common type of painted vase is the oinochoë, a jug with a trefoil mouth. Grave offerings are almost always cups and bowls with vertical or horizontal handles, early kinds of skyphoi. Less frequent are kantharoi of an obsolete Minyan type and kalathoi and tall pyxides with upright handles. Large decorated amphorae, hydriai and kraters seem to be completely missing between Protogeometric and the end of the ninth century. Virtually undecorated vessels, usually pithoi, and, on one occasion, shortly before the beginning of the eighth century, a tall, decorated pyxis, were used for interments.[9] Funeral rites must have been simpler than in Athens. It is not until the opening of the sea routes, at the end of the ninth century, that a trend towards the more luxurious Attic type of grave appears to have taken place. As regards the decoration of the vases, it is difficult to distinguish from Late Protogeometric. It is still simple and conservative as on Corinthian vessels. The flowering of Early

and Severe Geometric in Athens is not reflected at all in the Argolid. The only exception is the tall pyxis from the end of the ninth century mentioned above, which is an almost perfect example of Athenian late Severe Geometric. But although its composition and style are undoubtedly Attic, the same cannot be said of the decoration. And the fact that this is the only one of its kind found in the Argolid suggests either that the vase was produced and painted by an Attic potter who was banished to the Argolid, or that an Argive who had worked in Athens applied here the lessons he had learnt.

The later Argive Geometric style begins in the early eighth century, at the same time as Attic pottery begins to exert a strong influence. The large Athenian types of vessels are copied, starting with the slender black-ground neck-handled amphora,[10] and the large wine amphora of the second quarter of the century, with its black-glazed body[11] and stamp-like ornamentation on the neck only, together with imitations in miniature. Belly-handled amphorae are rare. It is probably a coincidence that no amphora of this kind is found until Late Geometric.[12] In the High Geometric period, the Attic krater with its tall foot is also adopted, but it never really takes root. The only completely preserved krater is the one in Berlin[13] found on the island of Melos, exported from an Argive workshop. It is the footless krater which is typical of Argos, with a ring base and simple or ring handles.[14] The 'sacrificial plates' from about the middle of the century are also typically Argive, of which fragments have been found in Aegina and on the Acropolis in Athens.[15] Of the smaller vessels, Attic kantharoi or copies of them are worth mentioning. The Argive potters did not adopt the extravagantly Geometrically shaped high-rimmed bowl from Athens, but altered it elegantly by flaring out the upright sides.[16]

The ornamentation of Argive Geometric vases

An individual style of decoration develops in the Argolid in the eighth century. Previously, the meander had been virtually unused, and ornamental friezes tended, as in Corinth, to consist of parallel zigzag lines. Now the meander is introduced into the Argolid[17] but this Attic pattern does not become the dominant motif. The changes which occurred about the middle of the century are best illustrated by a large amphora with shoulder handles from Asine (Pl. 77). The vase is 80 cm. high, and its size suggests an attempt to emulate contemporary Attic vases. But with its corpulent proportions it achieves something a good deal short of the classic monumentality of Athenian vases. Earlier, the naïve parallel zigzag line had been developed into parallel bands, as on the shoulder of this amphora. In the frieze, the meander appears in the form of individual right-angle hooks, or in zones of step meanders without hatchings. The diagonally ascending ladder meander and the normally horizontal parallel zigzag bands, which often appear together, are the typical features of the Argive style.[18] There are also the lozenge nets, normally filled, and used as area fillings;[19] concentric circles, Protogeometric in origin, in friezes or zones; and wheel motifs surrounded by cross-hatched squares or lozenges. The leaf frieze also arrives in the Argolid in the first half of the eighth century, but quickly degenerates. Finally, it should be noticed that only the Geometric false spiral is used in the Argolid, as in Athens, although the real spiral is fairly frequently imported from Corinth.[20] The Argive system of ornamental decoration imitates Athenian High Geometric. Examples of this are the amphora from Asine (Pl. 77) and a large pithos from Argos, with upright shoulder handles, and three East Greek loop feet (Pl. 78). There is a counterpoint on the bottom half of the vessels between decoration and shape, in that the ornamental friezes become taller and heavier higher up. But at the point of maximum circumference this principle is abandoned. On the shoulder and the neck the decoration becomes a generous tectonic articulation of the rounded surface, richer on the former, simpler on the latter. These have a certain undeniable splendour of their own. But there are no unifying separation lines between the friezes as found, usually decorated with lozenge chains, on the major Attic vases. The distinction between frieze and metope area is blurred, with metopes often containing frieze patterns. There is nothing in Argive art as perfect as the Attic metope-triglyph band with zone-filling

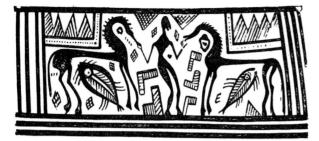

20 Detail of a krateriskos from Melos.
 Overall height 22 cm. Athens, National Museum

21 Fragment of a vessel from Argos.
 Height 9 cm. Athens, National Museum

patterns (Pls. 12, 22)—not even the beautiful pots from the Mycenaean finds of graves.[21] Argive art lacks the feeling, developed by Attic potters over the course of a century, for a hierarchy of Geometric elements and forms. It has neither the self-assured richness of Attic, nor the self-sufficient limpidity of Protocorinthian pottery. The same style continues in the Argolid until well into the Late Geometric period, primarily on kraters and krateriskoi, although the ornamental system becomes less important and the pictures take up more and more space. The last phase ends with a counterpart to the 'tinsel' style in Athens.[22] The large surfaces on kraters and pithoi become monotonously covered with alternating groups of straight and wavy lines, first vertical, then horizontal, except where space is left for a small figured picture.

Figured scenes

Figured scenes, which are on the whole absent from Corinthian pottery, are much more common in Argive Geometric, and appear not much later than in Athens.[23] Does are portrayed sniffing and looking backwards on a sherd from the Argive Heraion, and reclining on sherds from Argos.[24] Sherds from Mycenae with a procession of helmeted warriors carrying spears[25] belong to another group, as do sherds from the Heraion with parts of four men fighting, including a bowman and a man with an arrow in his leg.[26] These battle scenes are still in the High Geometric tradition and clearly come from large Attic grave kraters.

But the themes of figured scenes are different from Athenian ones. Pictures of funerary rites, prothesis, ekphora, and sea battles, are completely absent. Or, at most, if we assume a connection with funeral games in the chariot-driver sherds from the Heraion and the Larisa, the citadel of Argos,[27] a fragment showing a parade of warriors from Mycenae, and another sherd from the Heraion showing men wrestling above a tripod,[28] they play only a minor role. There were no large grave vessels in the Argolid on which these kinds of pictures could have appeared.

But two main themes do occur in Argive painting. One is the horse, in various situations[29]—alone, the mare and the foal, the horse led by a man, the Master of the Stallions between two horses (Fig. 20). The space under the horse is sometimes filled by a Geometrically painted board or plate on a stick. This might have represented a votive *pinax;* it can hardly be a manger.[30] Otherwise the horse is surrounded by birds. Curiously enough, it is almost always accompanied by fish under its body, pointing up at an angle, or sometimes the fish appear under the neck.[31] Fish must have been 'determinatives'. Near pre-Dorian Amyclae in Laconia, a bronze fish from the Archaic period has been found with the word *Pohoidanos* (Poseidon) on it.[32] On a sherd from the Heraion there is a horizontal double axe in the gap above the back of the horse.[33] This is the characteristic weapon of the sons of Poseidon, one of whom was the wonder-horse Pegasus. The double axe as a determinative recurs alongside the clearest picture of the Aktorione, also sons of Poseidon, on another sherd from the Argive Heraion.[34] The twins are supposed to have been buried in Phlius, next to Argos. The fish is

another clue. Pausanias, visiting Phigalia in Arcadia, also next to the Argolid, describes the ancient cult picture of Demeter of Phigalia (VIII, 42, 3–4). It showed the goddess on her throne, human except for her head, which was that of a horse. In her right hand was a dolphin, in her left a bird. Her husband was Poseidon. This picture was inspired not only by the Argive tradition of horse-breeding, but also by a pre-Dorian, Ionian, Achaean substratum of belief, which is shown here to have been still alive, and to have involved the worship of a powerful, though not clearly defined, god, chthonic Poseidon, Master of the horses, Lord of springs and waters, and Father of many heroes.

The second main theme in Argive figured scenes is dancing women, holding hands and carrying branches.[35] Two groups can be distinguished. In the earlier group the female figures move delicately with peploi decorated with oblique cross-hatching or filled lozenge nets (Figs. 21, 22).[36] In the later group the figures are more severely composed, and are still or walking slowly. The peplos is unpatterned and is shown in silhouette.[37] In both groups, one to three vertical folds project in the direction in which the person is walking on the front side of the peplos, looser in the earlier group, more disciplined in the later. The earlier pictures of dancing occur on vessels decorated in older style after the middle of the eighth century. The later ones belong to the 'tinsel' style period. The earlier, dynamic dance style is without doubt Argive. It is found in the same form in embossed relief on a gold band in Berlin from the beginning of the early Archaic period[38] where the front fold, which follows the outline of the peplos, fits better. This is said to come from Corinth, although the pattern of the peplos on the vase fragments indicates that it was produced in the Argolid. The later group of dance pictures has, on the other hand, its closest counterpart in the krater from Corinth (Pl. 74). The severe tectonic form of the picture is alien to Argive figure painting, and is basically Corinthian. In the last phase of the Geometric style, Argive painters must have copied this type of picture from neighbouring Corinth. It may be derived, ultimately, from bronze relief, and it replaced the earlier Argive style. On individual fragments from the Argive Heraion and from Argos itself, male dancers can also be discerned.[39] The point where a chorus of men and a chorus of women come together can be seen on one of these sherds.[40] The woman is wearing a dress of a type otherwise unusual in the Argolid, with a checkerboard pattern. The connection with Attic vases such as the deep bowl in the National Museum in Athens (Pl. 66) can be clearly seen here.

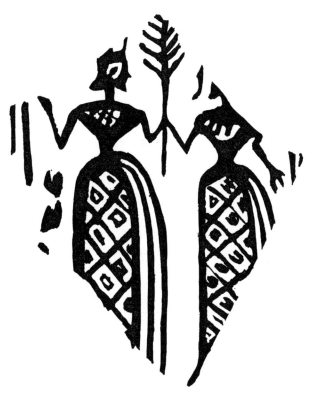

22 Fragment of a vessel from Argos. Height 5.7 cm. Athens, National Museum

3 Laconia[41]

Until a Geometric necropolis is excavated in Laconia and thoroughly studied, knowledge of Laconian Geometric pottery will remain very incomplete, more or less limited to random items from the considerable finds of sherds from the Sanctuary of Artemis Orthia, the Menelaion, the Heroon, the acropolis at Sparta[42]

and the Sanctuary of Apollo at Amyclae.[43] These finds are very different from each other. The fragments from the acropolis, for instance, are from large and fairly crude vessels, whereas those from the sanctuaries are almost exclusively from smaller, more delicate, vessels. It has not yet been possible to give a complete account of the Laconian Geometric style.

Unlike Corinth and the Argolid, there are no signs of the Early or Severe Geometric phases amongst the thousands of Laconian sherds. The Protogeometric style is simple, almost primitive, and is used only to decorate small vessels of traditional types such as the small hydria with a double conical shape in the museum at Sparta. The painting, which is limited to cross-hatched bands and triangles with small concentric circles in between, has virtually no connection with Mycenaean art and is unaffected by the flowering of Protogeometric in the northeastern Peloponnese and in Attica. It is reasonable to describe this pottery as 'peasant pottery'. It is a stereotyped provincial imitation of the Geometric fashion, on a lower level and without any artistic pretensions. A later extension of this style seems to have predominated throughout the ninth century, and perhaps into the eighth. The large, carefully painted sherds with circle decoration or with partly overlapping concentric circles (also Cycladic) belong to this later style, some of them to the eighth century.[44]

It is not until the Late Geometric phase, which is approximately contemporaneous with the Protocorinthian Geometric, that we have a more detailed picture. Clay-ground vases become predominant. The surface is often covered with a slightly whitened slip. A new trend on the Greek mainland at this time was to cover the surface of the grander vessels with a preliminary coating of white slip, also used to pick out patterns on the black glaze.[45]

Late Geometric Laconian shapes of vases

The few Late Geometric shapes of vases which can be reconstructed from sherds have been assembled by E. A. Lane.[46] In addition to two-handled cups, bowls and dishes, there is a deep dish of the type copied by Attic potters at that time from metal Oriental dishes,[47] although in Sparta the decoration is not double-sided. An early version of the *lakaina*, the typical Laconian drinking vessel from the early orientalizing style onwards, was probably developed from embossed metalwork. Its closest counterpart is the more elegant single-handled Attic Late Geometric cup.[48] A Late Geometric jug, found almost complete in the Heroon at Sparta,[49] is pure Laconian and a delightful piece of pottery. The foot, and the equal curve of the body above and below the middle line, are basically Protogeometric, but the heavy neck is Ripe Geometric, and the mouth and decoration Late Geometric. The shapes of the mouth and the two raised bands at the joint of the neck and the body indicate that it was copied from a metal vessel. A vase like this could have been developed only on the foundations of Laconian tradition. It has the charm of improvisation.

Little is certain about the larger vessels, amphorae and kraters. The upper part of a large-bellied, neck-handled amphora from the Sanctuary of Artemis (Fig. 23) has been preserved. Its shape must have been similar to that of the shoulder-handled am-

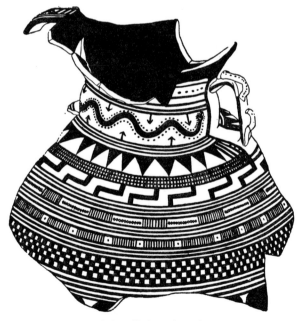

23 Fragment of a neck-handled amphora from Sparta. Height about 30 cm. Sparta, Museum

24 Fragments of Laconian pottery from Amyclae (Laconia). Height about 9.2 cm. Sparta, Museum

phora from Asine (Pl. 77), but one handle ends on the neck, the other on the lip. This again is an improvisation, although hardly a happy one. Three-dimensional snakes crawl along the handle, and a snake is painted on the neck. The decoration is reminiscent of Argive and Protocorinthian vases, while the snakes are Attic. Comparatively thick sherds from Amyclae and from the acropolis at Sparta, mainly decorated with concentric circles, must be from kraters. Next to the circle pattern on the upper right of a sherd from Amyclae (Fig. 24) one can discern the same square-latticed square, and above it, the same lozenge frieze as on the large Argive krater from Mylos,[50] in the same position and performing the same function. If the fragment does not come from a monumental Argive krater, it must be from a Laconian imitation.

From the second quarter of the eighth century, the borders of Laconia are thrown open to Argive, Corinthian and Athenian influences. But there was no substitute for the slow, organic development of pottery which had taken place in those areas during the previous century. So, in the Ripe and Late Geometric periods, artists in Sparta had to rely on improvisation of contemporary embossed metalwork.

Decoration of Late Geometric Laconian vases

E. A. Lane has given a comprehensive account of Late Geometric decoration in Laconia and its patterns (Figs. 25, 26).[51] The transition to clay-ground pottery took place here at the same time as in the rest of the Peloponnese. The spread of Protocorinthian Geometric does affect Laconian pottery, but the strongest influence is from Argos, through which certain Corinthian characteristics may have been transmitted. But the discipline of Corinthian pottery and the system of Argive painting remained unknown to Laconian potters. Their decoration seems old-fashioned with its simple encircling ornamental friezes, without any rhythm, even in the large amphorae. The Laconians did not use alternating ornamentation in their friezes, nor the complicated subdivisions of zones of Argive pottery. The simple meander is rare. The Argive separated individual meander hooks are more common. Laconia also copied the Argive step meander (Fig. 25) and zigzag band,[52] but the Argive combinations of the two

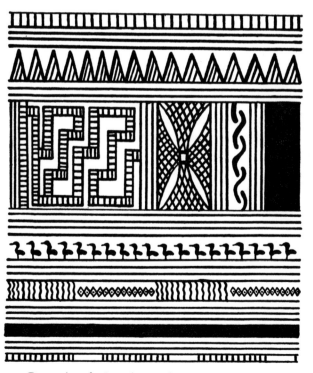

25 Decoration of a Laconian pyxis

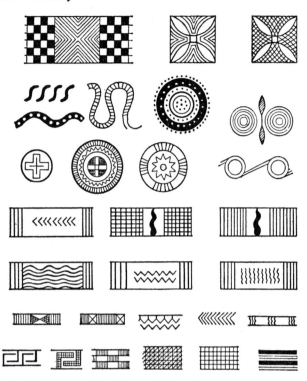

26 Ornaments on Late Geometric Laconian pottery

patterns are not found, although linear versions are common in the Late phase, as in the northern Peloponnese. Curvilinear patterns such as the 'running dog' are introduced. But Attic influences are comparatively rare. In the case of a globular trefoil jug from the Sanctuary of Artemis Orthia, which must belong to the second quarter of the eighth century, Attic influence is discernible in the shape with its protruding ribs, and in the decoration with triglyphs in the recesses and twin pillars of inverted triangles.[53] Triglyph-metope friezes occur in their pure form in Laconian Geometric pottery as rarely as they do in the Argolid. The quatrefoil motif occurs as filling ornament but with the voids filled with cross-hatched triangles (Fig. 26).[54] As a result of this, and of the 'leaves' being reserved (that is, ground and pattern are reserved), a new, almost improvised motif is created—the Maltese cross. Another, originally Attic motif is the barred wavy band with large loops. It is, of course, not known whether this came directly from Athens, or via Boeotia, Corinth or the Argolid.

Figured scenes

The significance of Laconian figured scenes, which are barely in existence, is illustrated by a small number of thick fragments of large vessels from Amyclae (Fig. 27)[55] showing men in different positions, obviously fighting. None of these figures is complete, but one can still recognize in them something of the power and grandeur of the battle scenes on Athenian monumental kraters from about the middle of the eighth century. The sherds from Amyclae are somewhat later and belong to the third quarter of the century, as indicated by the raised heel of a backward-stretched leg on a walking figure. One or two features of the painting suggest that this Attic theme may have been transmitted via Argos. But the massive hands, almost like claws, are entirely

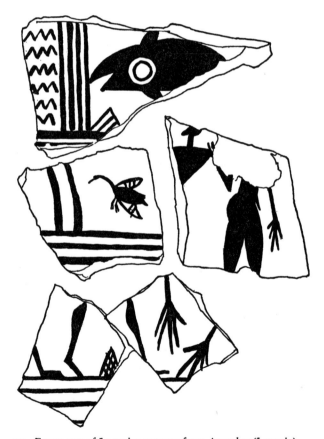

27 Fragments of Laconian pottery from Amyclae (Laconia). Sparta, Museum

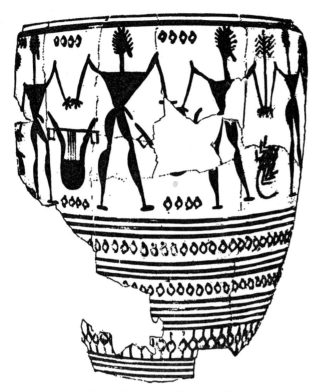

28 Fragment of a cup from Amyclae (Laconia).
Height 22 cm. Athens, National Museum

figures, with their legs apart and their over-long necks. The artists' tendency to improvise is evident in bird friezes and animal pictures. Many of these occur on fragments from Amyclae, including a water-bird with flapping wings (Fig. 27), a swan, a goose fighting with a snake in its beak, a frieze of running ducks and strutting cocks, and a massive fish of prey (Fig. 27).[57] All are much superior to the otherwise dull bird friezes of Late Geometric art.

4 The Cyclades[58]

The local Geometric styles of the islands cannot be distinguished as accurately as on the mainland. Only in the case of the two largest Cycladic islands, Paros and Naxos, have vase groups been suggested which probably represent pottery actually produced on these islands.[59] On Melos and Siphnos, which later developed local styles, no Early Geometric phase can be identified. The Protogeometric style seems to have reached the Cyclades about 900 B.C.[60] A large number of Protogeometric hydriai and neck amphorae from Rhenia can probably be connected with Paros, although sherds have been found on almost all the islands.[61] The style of decoration has no Geometric or foreign influence, and is simply a less disciplined version of Protogeometric, adapted for a later period. This is the origin of the later tall-footed Late Geometric amphorae with shoulder handles and circle metopes, which in turn lead directly to the early orientalizing 'Parian' amphorae. But the same group also includes local imitations of black-ground Attic and Corinthian trefoil jugs with Geometric decoration, a specifically mainland type of vessel which must have been copied.[62] From the third quarter of the ninth century up to the beginning of the eighth century, in this case, extensions of Protogeometric and imitations of Severe Geometric from the mainland develop side by side. This single instance has to be taken as applying to all the other islands of the Cyclades. Imitations of Attic black-ground, belly-handled amphorae of the type which became the monumental grave amphora in the High

Laconian. In a later group of pictures, the eye is reserved, and in one of the latest of all, the face is clay-ground with the eye drawn in. Horses, antithetical groups of horses, horse-leaders, Master of the Horses—all motifs which appear frequently in Argive art—are rare in Laconian. The horse-fish combination does not occur at all. Of the ethnic and religious groups from the pre-Dorian period in Laconia there are only faint traces, such as the Helot Sanctuary of Poseidon Hippios on Cape Tainaron. On the other hand, the second main theme in Argive Geometric, the dance-choruses of woman and men, often appears in the same form as in the Argolid and Corinth.[56] The best preserved of these, if not the finest, is on a cup found in Amyclae (Fig. 28). In the gaps between striding men are lyres and a scorpion. The three dancers leading the chorus are carrying branches. This must have been a picture of a round-dance in honour of the Apollo of Amyclae. The local style of drawing is easily recognizable in the rigid

29 Foot of a krater
from Athens.
Height 32 cm.
Munich, Staatliche
Antikensammlungen

Geometric period, are found on various islands from the beginning of the eighth century onwards. Several amphorae of this type have been found on Thera, although one of them, as pointed out by E. Pfuhl, is an Attic import.[63] Virtually identical imitations come from Thera, Melos (Pl. 79), Naxos, Rheneia, Crete and Nauplia.[64] They are characterized by their Attic shape, their delicate lip profile, and their circle-metope decoration. The Cycladic version is distinguished by its simple arrangement of friezes, with three circle metopes, from Attic vases which have two circle metopes on either side of a different middle triglyph. The import of jugs and amphorae in the Severe Geometric and early Ripe Geometric styles to the Cyclades, their imitation, and their initially isolated position within island pottery, indicate that the vessels must have been imported primarily because of what they contained, or for religious purposes. At first they have no influence on Cycladic art. Imitations of Attic black-ground, slender, neck-handled amphorae from the first half of the eighth century, as found on Thera, Melos and Rheneia,[65] and imitations of Attic black-ground, early eighth-century kraters, like those from Melos in Leiden (Pl. 81) and Sèvres,[66] are rare. An Attic original from Amathus in Cyprus[67] shows that Attic kraters of this type were exported. But here one can trace a later development through the second quarter of the century and up to the Late Geometric period. A krater from Melos, in Athens,[68] and another in Amsterdam (Pl. 80), show how the vertical axis begins to be extended in the body and feet, just as on the mainland. The feet, of which in both vessels only a few pieces are extant, can be reconstructed after a fragment from Melos, in Munich (Fig. 29). A clay-ground Argive krater from the middle of the century from Melos, now in the museum in Berlin,[69] allows us to assume that this later shape must have been imported to Dorian Melos via Argos, also Dorian, and imitated there. The imitation extends down to the details of the decoration, as the frieze of concentric circles shows on both the Munich foot fragment and the Argive krater.

The two groups of Cycladic Geometric vases

On this foundation, which led to close contact with mainland styles, particularly Attic and Argive, was built an individual local Geometric Cycladic style during the second quarter of the eighth century. Two closely related systems can be distinguished. Both develop out of the earlier imitations and attempt, in one bound, to achieve the same effect as the monumental High Geometric vessels in Athens. In the first group (Ac from Rheneia), a krater with a pourer and a belly-handled amphora are almost completely preserved. Large fragments of two more amphorae are extant, as well as a number of sherds.[70] The patterns and the figured motifs are Attic, but the Attic triple-line system is not used. The decoration is given a character of its own by formal values, such as the size of the patterns, the broad-brush style of painting, the strongly emphatic large areas of ground, and the mannered animal pictures. On the amphorae, a further contrast occurs in the handle zone, where the drawing is done with very thin linear strokes; concentric circles are turned into concentric cog-wheels, and central metopes become thin-armed swastikas filled with checkerboard patterns, or a complicated cross shape with a lozenge in the middle. Attic metope fillings are made bizarre and exaggerated, and the different styles of drawing on the handle zone and on the belly contrast rather artificially, a far cry from the more straightforward compositions of Attic vessels. The effect is more bombastic than harmonious.

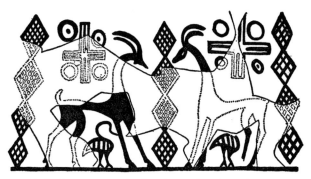

30 Neck picture on an oinochoë from Rheneia (Delos). Overall height 39 cm. Mykonos, Museum

The second system is found in group Bc from Rheneia.[71] Again the main pieces are amphorae and kraters. This system is contemporaneous with the first system and has the same roots. But its ornamental vocabulary is slightly different. The triple-line system is rigidly preserved, and the dominant frieze pattern is the false spiral, with several variants. This motif even occurs on the double handles on the shoulder. In its subdivision of zones, its compositions and the fineness of its drawing, the style is strongly atticizing. There is none of the broad-brush technique and bombastic features of the first group. Of those which are completely preserved, the important vessels are the large krater from Kourion in Cyprus, now in New York (Pl. 82), long believed to be Attic but recognized as Cycladic by Kontoleon,[72] an oinochoë from the same place, also in New York,[73] and the krater in Amsterdam already mentioned (Pl. 80). A Boeotian krater in Munich, on the other hand, is an imitation of a Cycladic forerunner of this group.[74]

Figured scenes

Figured motifs on Cycladic Geometric vessels include recumbent bucks and birds, mostly used as filling figures and seldom or never in friezes. In the metope scenes there are horses, standing alone or in front of a manger, with a double axe above their backs; also grazing animals of various kinds. The motif on the New York krater (Pl. 82) and the neck fragment

from a Rheneia oinochoë (Fig. 30)—two stags, rearing up on either side of a tree of life—is rare. But B. Graef saw this basically Oriental motif on an Attic Geometric pyxis, subsequently lost.[75] A Late Geometric sherd fround on Naxos, from a large vessel, showing a battle scene like those on large Attic kraters,[76] is to date the only one of its kind. Equally isolated appears the women's dance, as in Athens, above the foot of an amphora from Rheneia.[77] All these pictures and picture friezes are copied from Athens. Figured pictures were probably quite insignificant before this in the Cyclades.

There is a lot to be said for E. Buschor's theory that the first group came from Paros and the second group from Naxos, although one cannot be certain. The krater reconstructed by Buschor (Fig. 31) belongs to the 'Naxian' group, although the birds under the handle are 'Parian'. The amphora showing dancing women, from Rheneia, is 'Parian' in shape, 'Naxian' in ornamentation and in figured decoration, and 'Parian' in its broad-brush painting. Obviously later on both workshops were producing at the same time. Is the close proximity of Paros and Naxos sufficient explanation? Probably one can be sure only that both groups are of Cycladic origin. Although individual local characteristics are discernible in the

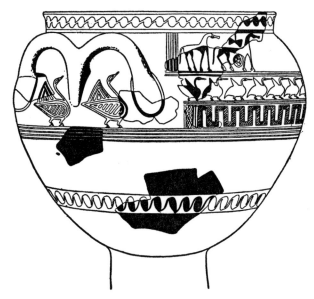

31 Reconstruction of a Naxian krater

decoration of both types of vases, the pictures are copied entirely from Athens, and they even appear to have been borrowed among the islands. Thus, for instance, the pictures on the krater in Amsterdam (Pl. 80) belong to group Bc (Naxos?), while the patternwork suggests a different origin (Melos?). Obviously there were no figured pictures in Cycladic pottery before Attic influence took effect, with the exception of so-called island-gems and the metal and jewellery industry. The Geometric style matured on the Cycladic islands at the climax of Attic High Geometric, from the second quarter of the eighth century onwards.

5 Thera and Crete

The southern islands of Thera and Crete form a separate cultural province, even though their historical background is closely involved with the Cyclades. That they were both occupied by Dorians is quite evident in their culture. Until about 850 B.C., Protogeometric predominates. This is followed, on the rocky island of Thera, by an uninspiring extension of Protogeometric (Protogeometric B), which lasts up to the first quarter of the eighth century. This leads into Geometric rather earlier in Crete. Belly-handled amphorae from Attica begin to be imported, as in the Cyclades around the end of the ninth century, in larger quantities in Crete than in Thera. In addition to the belly-handled amphora, the neckless pithos from Crete forms the second basic type in Thera.

Thera[78]

From the second quarter of the eighth century onwards, an individual and unmistakable Geometric idiom develops in Thera. This is a sober, mainly linear style, without much originality, but which uses the false spiral as the main frieze decoration (Fig. 33, Pl. 83). It should be noted that the Geometric style in Thera is the only island style to attempt to imitate the subtle rhythms of Attic High Geometric with its own patterns. Also common from the second half of the century onwards, are the circle and circle metope

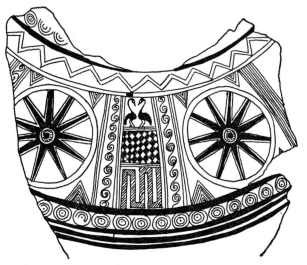

32 Fragment of an amphora from Thera. Thera, Museum

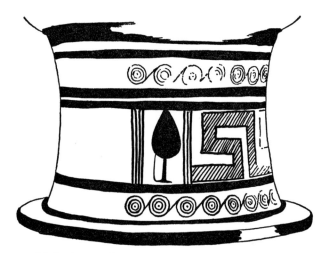

33 Neck of an amphora from Thera. Height 20 cm. Thera, Museum

(Fig. 32), ultimately derived from Protogeometric. They appear in several, sometimes lighthearted versions, with triglyphs becoming light but Geometrically stereotyped images, as in Attica from the beginning of the third quarter of the eighth century. But Thera is unaffected by the difficult and yet productive problems of Late Geometric in Athens. Figured scenes are consistently avoided, with the exception of birds (Pl. 83). Geometric decoration continues, however, until the first quarter of the seventh century. (Compare Figure 33, where a slender aryballos

of Protocorinthian type, probably of metal, is painted in the end triglyph.) At about the same time, the revival of Mycenaean, orientalizing and architectonic ornamentation was bringing about the collapse of the Geometric style. It is virtually certain that these influences came from Crete.

The highly individual character of Theran Geometric art shows by its idiosyncrasies and its delay in introducing pictures, an inbred and insular production, cut off from the wider routes of trade.

Crete[79]

The nature of Cretan pottery is determined by the geographical situation of Crete, on the edge of the Greek world. The Protogeometric and with it the Mycenaean tradition never quite disappears, and Minoan continually reappears—as in the fairly common practice of painting the decoration in added white on top of a black glaze. The fact that the island lay at the junction of the routes between Egypt, the Near East and Greece, also helped to disturb the development of vase painting, even when trade was virtually nonexistent. Since graves seem frequently to have been reopened after the first burial to put in more corpses, the Geometric phase is difficult to define accurately. One may take it as lasting from the beginning to about the end of the eighth century, but exclusively Geometric style occurs only during the few decades of High Geometric.

Mainland and Cycladic shapes of vases arrive in Crete before the beginning of the Geometric style proper. As in the Cyclades, the earliest vessels are imitations or imports, like the two Corinthian trefoil jugs from Knossos and Fortetsa[80] from about the end of the ninth century; a skyphos with dark overpaint, also from Fortetsa, from the beginning of the eighth century;[81] a krateriskos from Chaniale Tekke;[82] and three Cycladic kraters.[83] These are followed by imitations of large grave amphorae with belly handles, of Cycladic (Pl. 86)[84] and Theran types,[85] and very inadequate imitations of the Attic type.[86] Although the structure of the decoration on the last vessel is still Protogeometric with elements of Attic Early Geometric, its profiled lip dates it not earlier than the first quarter of the eighth century. In all, ten

neck-handled amphorae of an Attic type, also copied from the Cyclades are known,[87] stretching from the first quarter of the eighth century until well past the middle of the century. Specifically Attic types do not occur in Crete before the High Geometric period. They include the flat pyxis, the high-rimmed bowl and the large-bellied jug with a tall, narrow neck and trefoil lip.[88]

The decoration of Cretan Geometric vases

As the connections with the centres of the Geometric style, finally with Athens, became closer, the Geometric style of decoration reached Crete. It had only a few decades to develop. It had even less chance of being extended in Crete than in Thera. It is tempting to describe Geometric decoration in Crete as a passing fashion. It can only be found in its proper form on the leading typically Cretan type of vessel, the neckless pithos with two or four handles of different shapes, a simple ring base (Pls. 84, 85), tall open-work foot or looped feet.[89] It is a dry, linear style not unlike the Theran, but lacking Theran discipline and consistent logic. In Crete, friezes of concentric circles in the Protogeometric tradition replace the Theran rows of false spirals. The Geometric principles are more loosely applied, and the style is eclectic. Spiral motifs in the oval tradition, and the 'woven' band copied from the East, are combined with Geometric syntax. As in Thera, there is no Late Geometric phase.

By the end of the eighth century the new orientalizing fashion begins in Crete. The exteriors of the vessels become brightly coloured, blue and red on a pale slip; lotus ornaments, trees of life, and cable pattern replace Geometric patterns. A lush, colourful imagery develops, which borrows to a considerable extent from embossed metalwork and from architecture.

Figured scenes

Crete is also differentiated from Thera by the comparative rareness of figured scenes. On the shoulder of an amphoriskos from Andromyloi there are two friezes showing a frontal view of dancing (or squat-

34 Figure friezes from the neck of an amphoriskos from
 Andromyloi (Crete).
 Overall height 13.5 cm. Heraklion, Archaeological Museum

36 Fragments of a krater from Vrokastro (Crete).
 Heraklion, Archaeological Museum

35 Frieze of figures and ornaments from the shoulder of an
 amphora from Fortetsa (Crete).
 Diameter about 15 cm. Heraklion, Archaeological Museum

ting) women and a round-dance of men and women
(Fig. 34). A belly amphora from Fortetsa shows
women with raised arms, alone or in pairs, squeezed
into the shoulder frieze. In the middle, between
them, are two acrobatic scenes: a man standing on
the raised hands of a woman, and a woman doing a
handstand on the left hand and the head of another
standing woman (Fig. 35). The clothes, gestures, ac-
robatics, and style of drawing on the amphoriskos
are traditional Minoan. On the amphora, however,
which belongs at the earliest to the beginning of the
eighth century, we have a Geometric version of the

original Minoan prototype. A number of sherds from
Vrokastro (Fig. 36), with the exception of fragment
E, probably come from one krater. The rim of the
vessel is decorated with wild geese in flight, and the
main frieze, round the body, has a picture of a pro-
cession of teams of horses with chariots carrying
warriors with Dipylon shields. This picture is unmis-
takably copied, right down to the details of the
filling ornament, from the large Athenian grave
kraters from between 760 and 750 B.C. Thus, in the
third quarter of the century, Cretan pottery comes
very close to Attic Geometric.

Finds to date are not sufficient to define separate local Geometric styles and their development on the eastern Greek islands and the Ionian towns of Asia Minor. The graves excavated by Italian archaeologists between the two world wars in the cemeteries around Ialysos and Camirus on Rhodes and on Cos did produce some rich material, and were gratifyingly quickly published,[1] but their finds were insufficiently analysed. Only the finds from the graves at Exochi near Lindos have been properly studied, by K. Friis Johansen.[2] The finds from the island of Cos have been only partially published, and the necropolises on Samos have not yet been dealt with. Sherds from the Sanctuary of Hera have been thoroughly analysed by W. Technau and particularly by R. Eilmann.[3] In Çandarli, Old Smyrna (Bayrakli), Phocaea and Miletus (Aköj) a few closed grave complexes have produced more or less rich finds of sherds. These can be quoted only with caution, however, since they have not yet been completely published. Obviously, in all these places the key period is the middle of the eighth century and the Late Geometric phase, as in the Cyclades, Thera and Crete. It appears that the island of Rhodes played the leading role in the development of the East Greek style of decoration, which spread to the Greek colonies in western Asia Minor. This rich island, on the main trade routes, was a source of artistic influence in both the Geometric period and, to a much greater extent, in the so-called orientalizing style of the Archaic period from the second quarter of the seventh century, until past the middle of the sixth century. Thus Rhodes twice put its stamp on the East Greek style of vase in early Greek history.

1 Rhodes and Cos

a The Protogeometric tradition

In contrast to rich Mycenaean finds of graves, sub-Mycenaean pottery is hardly found on Rhodes. Only the contents of one grave in the Kalavarda necropolis (Grave 50) can be certainly dated in the eleventh century to the tenth.[4] The same marked lack of sub-Mycenaean also occurs in the Cyclades and Thera,[5] although not in Crete.

The Protogeometric finds show a steep increase in the amount of painted pottery. This begins in the later period of Protogeometric, perhaps not until the transitional period before Geometric, as Desborough correctly pointed out.[6] The importance of the Protogeometric style in East Greece, far from Athens and the other centres of Protogeometric art, can for the time being only be judged on Rhodes. More detailed studies than Desborough was able to make now suggest conclusions substantially different from his own, indicating for the first time the special position of Geometric art on Rhodes.

The sherds and fragments found in the settlement of Lindos by the Danish excavators are not very helpful.[7] The earliest Protogeometric finds come from Graves 36 and 38 in the Patelles necropolis near Camirus, both child graves without any other offerings. In addition to this there is an isolated find from the acropolis at Camirus, from the same workshop.[8] All three vessels are grave vases. The ones from Grave 36 and from the acropolis are belly-handled amphorae with double handles; the one from Grave 38 is a hydria. The profiled mouth of the amphora

from Grave 36, as reconstructed in the drawing, does not belong to this vessel. Two belly-handled amphorae from Graves 26 and 38 (south of the Eridanos) in the Kerameikos necropolis, the former with three looped feet,[9] are the closest Athenian counterparts, and probably the stylistic source.

But the tauter shape of the Rhodian amphorae and hydria, with their disproportionately heavy necks, suggest that they were produced later. This is supported by the greater discipline of the decoration on the amphora from the acropolis, and on the hydria. They must be products of a workshop which was active well into the first half of the ninth century.

Vases from Graves 43 to 45 in the Marmaro necropolis

This first group is followed by another from Graves 43 to 45 in the Marmaro necropolis,[10] near Ialysos. All three graves contained grave vases. The first was a beautiful belly-handled amphora with painting in the Protogeometric B style (Pl. 89). The two others were undecorated urns in the form of neck-handled amphorae. The only offering in Grave 44 was a slender trefoil jug in the style of the Early Geometric jugs from the Kerameikos,[11] which indicates that it was made, at the earliest, in the first quarter of the ninth century. Early Geometric oinochoai from Corinth, of which one is probably Argive,[12] are closer in shape although more squat. The group also includes an as yet unpublished trefoil jug in the Museum of Cos (from Grave 18). This and the jug from Grave 44 have Protogeometric decorative patterns with concentric semicircles on their shoulders. The only offering in Grave 45 is a small, simple and crudely decorated trefoil jug with semicircles on the shoulder.

The most recent grave in the group is, however, Grave 43. The grave amphora (Pl. 89) shows a marked advance in the Protogeometric amphora. The body rises from the narrow foot in a taut curve; the shoulder with the double handles below is high, and merges in a final gentle curve which marks its edge clearly, into the neck. This seems far beyond the usual Protogeometric amphora, but this is no help in establishing the actual gap between normal Protogeometric and this vase. Clearly, East Greek sensitivity to form produced these variants of Protogeometric shapes remarkably. The simple, limpid decoration also includes Protogeometric motifs. On the high handle area, between the two broad bands accompanied by narrow lines, are two concentric circles with Maltese crosses inside an open area, framed to the left and the right by vertical lozenge chains between double lines. Thus a double row of lozenges is placed on the central axis of the vessel. On the shoulder there is a lighter decoration, but with the same elements. This amphora has a later counterpart in Athens, a belly-handled amphora from the Kerameikos (Pl. 10) which we have dated early in the third quarter of the ninth century.[13] Here too, the handle-zone decoration lies between the two black bands, above and below, each accompanied by two lines. But the concentric circles, with a wheel pattern on the inside, undoubtedly relics of the Protogeometric tradition, are here surrounded by a firm framework of severe Geometric ornamental stripes. The overall appearance is much richer. This might suggest that the amphora from Grave 43 dates from the middle of the ninth century. P. Jacobsthal, following Desborough, dates the bronze pins found in the same grave at the end of the Protogeometric period.[14] But it is not really possible to date everyday objects as accurately as this. The pins can indicate only that the date should not be put too far forward.

Eight vases out of the eleven ceramic offerings from Grave 43 form a set. They comprise two amphoriskoi with shoulder handles and six cup-like small bowls with two handles. The shape of the amphoriskoi is Late Protogeometric.[15] The Rhodian items are obviously slurred simplified later versions of Protogeometric. The form of the small bowls, which have flat feet and S-shaped curved walls, is not Protogeometric but, clearly, a later repetition of the elegant sub-Mycenaean cup shape.[16] From the sherds found on the island of Rheneia it was possible to reconstruct a small bowl decorated with concentric circles, exactly the same shape as the Rhodian cups. Unfortunately it is not possible to date it accurately, although it must have been earlier.[17]

The eight vases from Grave 43 share the same monotonous decoration, reduced to its simplest

possible form, consisting only of friezes of upright cross-hatched triangles and lozenges, and friezes of upright hour-glass patterns, separated by double lines. All these ornaments come from Protogeometric. The fact that only these patterns were used suggests a workshop making mass-produced pottery without any artistic pretensions. The unusual commercial constraint limiting the decorations to only two of the rich range of Protogeometric patterns fits the date around the middle of the ninth century suggested by the analysis of the grave amphora.

The same workshop can be traced elsewhere. In Grave 141 of the Ialysos necropolis were two amphoriskoi with shoulder handles, and a flat flask. Both shapes are Protogeometric. The cross-hatched triangles are suspended, upside-down instead of upright, from the clay-ground shoulder; on the body they are upright in a clay-ground band, pointing towards the circles in the centre. The costume of a terracotta statuette is decorated with a border of cross-hatched hour-glasses between double lines, with a cross-hatched rectangle on the chest. The hour-glass frieze recurs on an askos in the shape of a bird from the same grave in exactly the same form, except that the hour-glasses are not cross-hatched.[18] This last motif is also found on the neck of an Attic Geometric hydria from the first quarter of the eighth century. This date provides a *terminus post quem* for the contents of the grave.

A further grave (45) from the Camirus necropolis contained vases from the second half of the eighth century: a flask with a Cypriot shape, globular with one handle, decorated with cross-hatched triangles pointing towards the middle; a small oinochoë with cross-hatched triangles on the shoulder; and two of the small bowls with tall flared feet already described, on one of them concentric circles, on the other an hour-glass frieze.[19] Genetically, the most recent vessel is a small aryballos from the transitional phase before the orientalizing style, which has exact counterparts in an aryballos from Grave Z in Exochi and another aryballos from Rhodes in Lund.[20] Fragments of vessels of this type were also found amongst the sacrificial offerings found in the area of what was probably the Temple of Athena on the acropolis at Camirus.[21]

These workshop products are the foundations of a slender but firm tradition of shape and decoration from Protogeometric to the end of Geometric. One wonders where it came from. Surprisingly enough this trend indicates not so much Attica as the Argolid,[22] as regards both shape and decoration. The vocabulary, apart from the concentric circles, consists mainly of cross-hatched triangles and hour-glasses. There are, amongst the few published vases, two on which these two patterns alternate on the same vessel.[23] Is it only coincidence that the Dorian occupation of Rhodes after the 'return of the Herakleidai', was carried out, according to Greek legend, by Tlepolemos of Tiryns?[24]

First influences of Attic Geometric vases

In the second quarter of the eighth century the great Attic belly-handled amphorae used as grave vases were known on the island of Rhodes, although no imports have been proved. Perhaps the Rhodians found out about them via the Cyclades. But an atticizing imitation has survived in the form of a Rhodian amphora from around the middle of the century, found in the Camirus necropolis (Fig. 37).[25] Something of the splendour and the mature vocabulary of the mainland has reached the Dorian island. But its spirit is either rejected or not understood because the preconditions were lacking. Here the shape is more squat. The delicately everted round mouth, developed in Athens since the beginning of the century, is imitated. The rich zones of lozenges from High Geometric and the colourful alternation of light clay-ground and black glaze are also enthusiastically copied.

As a result of the mixing of Rhodian and Attic Geometric, Rhodian Geometric becomes richer but less uniform. The Protogeometric tradition survives in the large grave vases. The shape of the amphora with simple belly handles from Grave 43 from the grave area at Patelles near Camirus[26] puts it in the group connected with the amphora described in detail above from Grave 43 of the Marmaro necropolis near Ialysos (Pl. 89).[27] But its everted mouth puts it in the first half of the eighth century. The

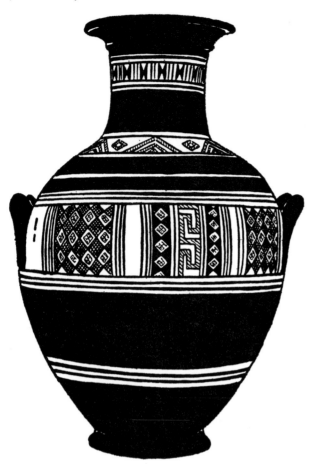

37 Belly-handled amphora from Camirus (Rhodes).
Height 63.2 cm. Rhodes, Drakidès Collection

Geometric period.[30] The Protogeometric vase style in Crete, and in the whole of the East Greek area, on the islands and in Asia Minor, does not indicate any historical period (normally the tenth century), but is a style of decoration which, with its extensions and simplified forms, extended across the whole of the ninth century and into the first half of the eighth. Thus it stretched across the whole of the Early and Severe Geometric periods on the mainland. It can be best studied in its stereotyped form in grave vases. But as the influence of Ripe und High Geometric mainland pottery grows in the east, producing there a local Geometric dialect, the Protogeometric tradition begins to decline. Grave 58 in the Ialysos necropolis illustrates this well. The contents of this grave date from the end of the third quarter of the eighth century.[31] The amphora has simple belly handles and is a clumsy imitation of one of the last Attic belly-handled grave vessels from the period shortly after the middle of the century, in Brussels.[32] The lip is strongly everted. The masks on the jug necks found in the same grave are later successors of the terracotta statuette in Grave 141 in the same necropolis.[33] In the handle zone of the amphora there are only five concentric circles, and a semicircle with a spoke-cross inside. On a pithos of Cretan type, also found there, are four-and-a-half concentric circles without any filling in the middle. On both vessels, the exterior circle is twice as heavy as the others. The last stages of this style are characterized by exaggerated and undisciplined shapes of vases, a return to the limited vocabulary of Protogeometric, and uncontrolled drawing. Hybrid vase shapes, such as the combined belly- and neck-handled amphorae of which two were found at Camirus (Grave 203),[34] and one in the cemetery of Patelles near Camirus (Grave 39),[35] begin to occur. On the first of the two amphorae from the Camirus necropolis, there is an utterly weak ornamental system in the main area between the handles, as on the amphora from the middle of the ninth century from the Marmaro necropolis (Pl. 89),[36] a second frieze of concentric circles and rings, and pathetic relics of a meander. The Patelles amphora, on the other hand, has, apart from line decorations, only a frieze of cross-hatched triangles on its shoulder.

decoration is pure Protogeometric with semicircles on the shoulder, tassels hanging down into them from the neck band (which can be traced back to the sub-Mycenaean period), and concentric circles between the handles, connected to each other and to the handles by zigzag bands. The only offering is a trefoil jug with cross-hatched triangles, apparently modelled on Argive and Corinthian jugs from the transitional period between Protogeometric and Early Geometric.[28] An obviously more recent jug, with a more advanced shape, found in the Late Geometric Grave 39 of the same necropolis, is the closest counterpart as far as decoration is concerned.[29] The loop decoration on the handle of this jug, which can hardly be dated before the second quarter of the eighth century, appears first in Attica in the Late

The slow death of the Protogeometric tradition does not, however, occur without a reaction, particularly on vessels intended to hold valuable objects. A Cretan-type pithos with a conical lid, which has survived only in fragments, from the same Grave 39 in the Patelles necropolis, has a decoration of very carefully drawn rings which goes directly against the trend.[37] Two Rhodian pyxides are equally carefully shaped and decorated. One is from the late Grave X in Exochi,[38] the other from Grave 85 in the Camirus necropolis.[39] The first still has traces of Protogeometric, such as a frieze of concentric circles with Maltese crosses on the body of the vase, with small circles similarly filled in the gaps, and a band of smaller circles on the shoulder. The pyxis from Camirus, including the completely preserved lid, has no less than five friezes of small concentric rings, and a strongly emphasized rim. The lowest line on the body corresponds entirely to the two lines on the shoulder and the lid. Above it are richer variations and in the middle there is a frieze of alternating large and small circles. On the upper rim there are circles which combine to make a superb 'woven' pattern. This new spate of circles in the last phase of Geometric ornamentation on Rhodes is, however, derived not only from the old Protogeometric tradition on this island. It is more at home on Cyprus, where for a long time afterwards a 'snowball' decoration formed the basis of a style of ceramic decoration mostly used on amphorae and globular oinochoai, the so-called pilgrim flasks.[40] Its influence spread to the west, including Rhodes, where its effect was neither long-lasting nor deep. But it did nevertheless produce a brief Rhodian variant of high quality.[41] It is followed by what Friis Johansen called the 'circle and wave-band style', which lasts beyond the Geometric period into the seventh century.[42]

The Protogeometric tradition does not disappear, however, until the Late Geometric period, in the second half of the eighth century.[43] Here the last relics of the style, with nothing more left to say, finally disappear.

b The atticizing wave

It is not until the beginning of the eighth century that the mainland styles, particularly Attic Geometric, begin to reach, directly or via the Cyclades, the eastern islands and Cyprus. This brings new ideas into Rhodian pottery and painting, and while Protogeometric quickly declines, Rhodian Geometric art, from the end of the second quarter of the century onwards, reaches a zenith which lasts for barely half a century. But this does not mean dependence on Attic or mainland Geometric art.

Western influence is very strong at first, from the end of the first half and past the middle of the century. Admittedly, very few imports have been found, which may be coincidence. But two kraters of the Attic type did find their way along the shipping route via the Cyclades and Rhodes to Cyprus.[44] Three large kraters from Exochi (Fig. 38) and one krater in Oxford from the same workshop, probably produced in Lindos before and after the middle of the century, reflect the Attic influence most obviously.[45] Their shape is Attic, with the simple stirrup handles and flared, not very tall feet, fluted at the top. Only the latest of the four kraters has a pro-

38 Krater from Exochi (Rhodes).
Height 35.6 cm. Formerly Rhodes, Archaeological Museum

jecting bulge on the foot. The Attic meander, care-
fully hatched, as was common in Attic workshops
up to the end of the High Geometric period, appears
in the handle zone on the oldest of the kraters from
Grave Y in the Exochi necropolis (Fig. 38). This is
the only 'coloured' meander, with the flanges filled
with black-glazed bar hooks, fixed above and below.
The meander floats between a strip of saw-tooth
pattern below and zigzag on top. This three-level
image is flanked to the right and left by two
triglyphs, filled with oblique hatching opposed to
the central panel. The system of boxing in with hori-
zontal and vertical ornamental border, which was
developed in Athens during the ninth and up to the
middle of the eighth centuries, is here simplified but
intelligently executed.[46] In the upper corners hang,
on the left and right, small flag-like reserved squares
decorated with an eight-pointed star, often found in
the first half of the century in Athens (Pls. 14, 19).
There is a band of dots on the lip of the krater, typi-
cal of a whole class of High Geometric Attic kraters
before 750 B.C. (Pl. 36). The Attic triple-line system
is carried right through, except on the lip. The
Oxford krater is limited to the meander only, which
is less carefully arranged and hatched. Its flanges are
not floating, as on the Attic vases and the krater from
Grave Y (Fig. 38), but attached at the upper and
lower edges. The 'coloured' effect of bars is partially
substituted by the double frame of the meander
band. Later kraters from Graves M and D at Exochi,
which are roughly contemporary, tend to be more
simple. In the vessel from Grave M, the meander is
taller, more crudely drawn, and open to the left. The
box motif is still present, but smaller. The only
ornaments are rows of dots, and the flag areas have
become simply saltire crosses. The triple-line system
begins to break down. A projecting ring runs round
half-way up the foot. On the krater from Grave D
there are no floating double or single triglyphs, and the
process of debasing the Attic prototype is carried
even further.

A splendid krater now in London, found in Cami-
rus and obviously made in a local pottery, is much
richer (Pl. 88).[47] This is the most strongly atticizing
piece of eighth-century Rhodian pottery and one is
tempted to call it the best Rhodian krater of this
kind. But in spite of the old Attic double stirrup
handles, the shape of the foot militates against this.
The foot has two parts: the grip, which is ribbed and
slightly concave, and the stand, which is convex.
This foot shape is typically Rhodian and is obviously
derived from embossed metalwork. Similar vessels
from Camirus start after the middle of the century
at the earliest, and cannot be far distant in time from
this krater.[48] Also typically Rhodian are the drawing
of the chain of lozenges and the 'coloured' effect
produced by the contrast of the light borders of the
meander triglyph, containing only small eight-
pointed stars, and the dense texture of the decora-
tion. Only the meander on the krater from Grave Y
(Fig. 38) is a truly Attic meander floating in the
frieze without touching the edges except at the be-
ginning. On all other atticizing kraters, as on the
Camirus krater, meanders are connected to the
borders of the frieze.[49] The same meander, with three
members, the opening to the left, and simple oblique
hatching, recurs on the Grave M krater. It can hardly
be dated before the middle of the eighth century. Its
apparent antiquity is only superficial. It is modelled
on one of the older, purely ornamentally decorated
Attic kraters, such as the one from the end of the
ninth century from the Kerameikos (Pl. 15), or the
one of which fragments have been found in Hama
in Syria.[50]

Attic decoration is adopted on the other shapes of
vessels from about the middle of the eighth century
and before. This applies predominantly to tall jugs.
The extreme forms of this type in contemporary
Attic pottery—the globular oinochoë with narrow,
tall neck and trefoil mouth, and the heavy-necked
pitcher with round mouth—do not occur. As in the
Cyclades, the less monumental, tectonically struc-
tured type of jug is preferred to the Corinthian-
Argive type developed from Protogeometric.[51] The
two tall jugs from Grave V in the Exochi necropolis
are black-ground with three or four light reserved
lines on the belly. Only the strong neck, the shoulder
and the lower limit of the shoulder have mainly
Attic clay-ground decoration.[52] The two broad jugs
from Graves Y and Z, with low girths and narrow
necks are, on the other hand, clay-ground and
decorated from the foot up to the lip with an en-

circling ornamental line of the Attic type. The four jugs belong to the same period, as can be seen from their similar handle motifs: above the strokes on the clay-ground handles is a framed rectangle with an eight-pointed star in the middle.[53] The Attic triple-line system is properly executed on the low jugs from Graves Y and Z, but is wider spaced on the jugs from Grave V. The meander on the neck of one jug from Grave V and on the shoulder of another from Grave Z is floating with Attic alternating hatching as on the krater from Grave Y (Fig. 38). The rhythm of high and low ornamental bands is an Attic feature, from the ninth century onwards, reaching its zenith in Attic High Geometric. The ornamental band on the shoulder of the one jug from Grave V, with alternating groups of bars and horizontal hour-glass motifs, is old Attic. The row of dots, very frequent on the jugs from Graves Y and Z, is High and Late Geometric. The shoulder frieze with upright cross-hatched triangles, on the jugs from Graves V, Z and Y, is common to Attic and Rhodian ware and the dot-stalk, surmounted by a star or a dot-rosette, is Attic.[54] The archaeological contexts as well as their style date these jugs and kraters from Exochi around the end of the second quarter and the middle of the eighth century. As on the krater from Camirus in London (Pl. 88), old features are combined with new.[55]

Small bowls, skyphoi and kantharoi are also influenced by the fashion for Athenian styles. The small bowls from Grave 83 in Camirus and from Grave V in Exochi, decorated with herringbone patterns and eight-pointed stars in the corners, are imitations of Attic vessels. Both must have been produced before the middle of the eighth century.[56]

The decorative system from Attic small bowls from the second quarter of the eighth century—metopes with birds and quatrefoils, and flowers on dot-stalks—is also copied in Rhodes and Samos, as well as in Delos, on kantharoi (Figs. 39, 40).[57] Two similarly shaped kantharoi with ring bases, also from Grave V, are decorated only with patternwork. One is black-ground with only a floating simple-hatched meander running to the right in a reserved area. The other has a clay-ground handle zone and lip, with a complicated boxing of horizontal and vertical orna-

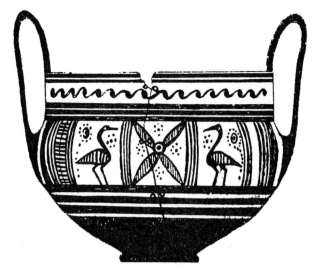

39 Kantharos from Ialysos (Rhodes). Height 17 cm. Rhodes, Archaeological Museum

mental stripes, as on Athenian kraters. It is very similar to the oldest krater from Grave Y (Fig. 38). The same eight-pointed star recurs in the central stripe, although the meander is replaced by rows of upright wavy lines. This motif is derived from the Attic herringbone patterns on small bowls.[58] A fine black-ground skyphos with a narrow foot from the same grave is worth remarking on. The shape is derived from the Corinthian Geometric skyphos refined under the influence of Attic two-handled cups. The dot frieze on the clay base lip, which is the only decoration, is Attic.[59] The whole group belongs to the period around the middle of the century.

40 Decoration on a krater or kantharos from Samos

41 Plate from Exochi (Rhodes).
 Diameter 38 cm. Formerly Rhodes, Archaeological Museum

A splendid flat-bottomed plate with a low ring base on the outside edge is from the same period (Fig. 41). The horizontal plate curves subtly upwards at the rim, to which three handles, pointing obliquely upwards, are attached. On the outside there is a floating meander with double hatching. The plate is richly decorated on the inside with an eight-leaf rosette in the middle, with leaves on short stalks; in the gaps are upright dot-stalks with dot-rosette flowers. The central medallion is surrounded by four ornamental bands: oblique strokes, two dot friezes, and a saw-tooth pattern. The decoration is copied from the bottoms of Attic pyxides. But whereas from the end of the ninth century on, these pyxides have leaves of quatrefoils and later also eight-leaf rosettes with carefully drawn stalks, central ribs and side ribs completely rendered, and only stars or swastikas in the gaps, here only the ends of the side ribs are indicated, while the middle of the leaf is reserved out of the light clay ground and the gaps filled with flowers. The drawing is 'coloured' and is another step towards embracing the plant world.[60] It is, however, doubtful whether this step was taken by a vase painter. Was the rosette in the middle perhaps copied from contemporary embossed metalwork?[61]

With the exception of the richly furnished Graves D and Z in the necropolis of Exochi, the grave finds discussed here are all contemporary. The atticizing fashion which predominated around the middle of the century on Rhodes, most noticeably in Lindos, cannot have lasted very long—one or two decades at most. The spread of the High Geometric style eastwards did probably lead to greater precision and delicacy of drawing in the east. But there was certainly no repetition of the great historical development of contemporary Attic Geometric art. At first not even the High Geometric development of pictorial art was reflected. But one effect that the wave from the west did have was to break the back of the Protogeometric tradition which had survived there. A local Rhodian style of Geometric decoration did develop, but it had only a fairly brief period of fashion.

c The second half of the eighth century

First phase of the Rhodian style

The rapid decline of the atticizing trend can best be traced in the development of the meander band after the middle of the century. It becomes static rather than moving or floating. The hatching no longer alternates from flange to flange, and towards the end of the Geometric period it is replaced by cross-hatching, long popular on Rhodes.[62] The tendency is towards maximum simplicity of motif, and simple linearity. New variants of the meander are also tried, not entirely successfully, as will be described in more detail later on. But the style never became degenerate as it did on the Ionian coast of Asia Minor.

At the beginning of this development, in the early third quarter of the eighth century, a local Rhodian dialect of Geometric begins to crystallize, combining traditional Rhodian features with influences from local Protogeometric, and from Argos, Corinth and Attica in the west and from Cyprus and the Orient.

But since the ability to select and refine all these and make out of them an organic whole came from the zenith of Attic Geometric before the middle of the century, Rhodian art, too, can be said to be an off-spring of Athenian High Geometric. It was not until the few decades of the Late Geometric period that early Rhodian art managed to develop a character of its own.

The steep ascent to this peak is most clearly dem-onstrated in the three tall jugs from Camirus (Figs. 42, 43), with shapes directly connected with the atticizing jugs from Grave V in the Exochi necrop-olis.[63] This group of related vessels, produced in the early third quarter of the eighth century and ranging in height from 38 cm. to 48 cm., is distinguished by the special shape of the handles. These consist of two separate rails running from the shoulder to the lip of the trefoil mouth. They are connected by the coils of sculptured crawling snakes with dotted bodies and with heads either projecting above the mouth or lying on it. This baroque type of handle has its closest counterparts in the Attic neck-handled grave am-phorae and hydriai, which took over the functions of shoulder-handled amphorae and grave kraters after the middle of the century. Here, too, snakes wriggle up the handles and lie round smooth mouths—later also on shoulders.[64] There is no doubt that these jugs were made on Rhodes specifically for funerary pur-poses and that they contained the ashes of the dead.[65]

The most important of the three jugs is the one found in Grave 200 in the Camirus necropolis (Fig. 42). Its decoration is a unified whole from upper-neck to foot. It is predominantly clay-ground like Attic vases from High Geometric on. The well-balanced proportions of the four encircling friezes follow the tectonic structure of the vessel. Under the handle, a double ornamental band runs round at the point of greatest circumference emphasizing the horizontal axis. The patterns are derived from the atticizing Rhodian kraters. In the broader band are opposed meander hooks which can, however, be read on the light clay ground as a reserved meander running to the left. After every three elements the movement is interrupted by a triglyph with an upright cross-hatched hour-glass, an ancient Rhodian motif. The effect is that, as on the kraters, the meander is

seen, from any point of view, as an enclosed image. Beneath it is a narrow band with small cross-hatched triangles, simply an adaptation of the Attic saw-tooth pattern into the Rhodian idiom. This, too, establishes the derivation of the double band from Attic-Rhodian kraters such as those from Grave Y in the Exochi necropolis (Fig. 38). But the vertical axis is emphasized by the upward-pointing triangles on the shoulder and

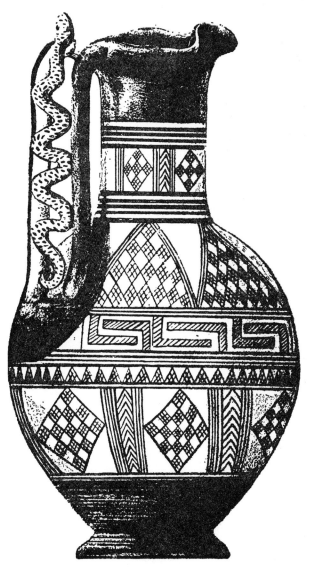

42 Oinochoë from Camirus (Rhodes).
Height 38 cm. Rhodes, Archaeological Museum

the lozenges in the metope zones, larger on the belly than on the neck. The shoulder triangles and the lozenges are both not simply cross-hatched but have a splendid filling of lozenges in a checkerboard arrangement.[66]

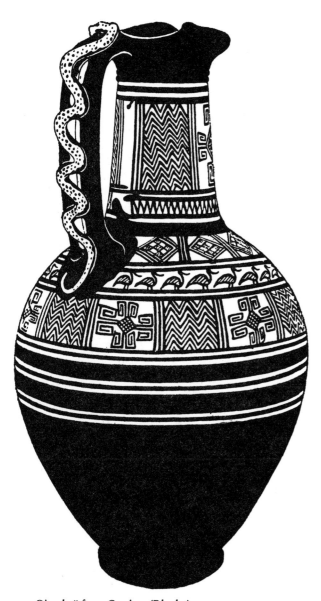

43 Oinochoë from Camirus (Rhodes).
 Height 48 cm. Berlin, Staatliche Museen

The two other jugs, which are in Berlin (Fig. 43) and London, are still in the black-ground tradition but are not necessarily any older than the vessel described above; they simply come from a different Camiran workshop. The composition of the Berlin jug is similar to the previous vessel. At the base of the handle, a single encircling bird frieze separates shoulder and belly. On the shoulder is a metope-triglyph frieze with filled lozenges. The neck ornament is repeated on the belly: between broad triglyphs, filled by parallel zigzag lines, are tiny cross-hatched lozenges with pairs of opposed meander volutes growing out of each apex, making the lozenge into a cross. On the jug in London, the neck has the same metope band as the Berlin jug, but below it is a bird frieze. The shoulder decoration begins with a second encircling frieze with small cross-hatched triangles. Underneath this are two metope bands; on top, a bird metope between zigzag triglyphs; below, metopes with cross-hatched lozenges between groups of bars.

On both jugs, only the neck and the upper part of the body are decorated, as is the case with almost all Rhodian jugs and oinochoai. It is not surprising, therefore, that the obvious rhythm of the decoration on the jug from Grave 200 (Fig. 42), based on the horizontal and vertical axes, does not appear on the jugs in Berlin (Fig. 43) and London. On the other hand, in all the metope bands on these jugs, the Attic triple-line system is strictly preserved in the vertical dividing lines. In these three grave vases can be seen the beginnings of a specifically Rhodian Geometric style: the predominance of the metope-triglyph band, cross-hatched or lozenge-filled triangles and lozenges, and small meander hooks on the apices of lozenges and triangles. These, and the bird friezes and bird metopes, gradually become the distinguishing features of the pottery from Rhodes and eastern Ionia.

The Rhodian variant of the meander, which undoubtedly came to the east from Athens, has an importance of its own. The simplest example is on a single-handed cup with a low, 'lathe-turned' foot, and straight oblique sides, a shape which suggests wooden-tub or metal-vessel prototypes (Fig. 44).[67] The cup has three panels between four circle metopes, with the inside and outside rings emphasized by a

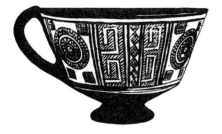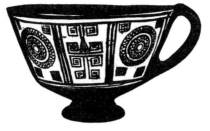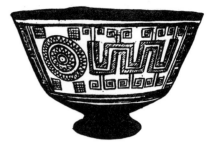

44 a–c Cup from Camirus (Rhodes). Height 12.5 cm. Rhodes, Archaeological Museum

zigzag pattern, and the corners filled with cross-hatched squares. These metopes are of Argive derivation.[68] Two of the central areas are filled with meander images, the third with a cross-type composition of meander hooks. The first is a broad triglyph, with vertical meanders flanking a chain of lozenges, both running to the left. But the flow is interrupted. Each meander is really two four-part meander hooks on the same stem, attached to the frame. The second centrepiece is horizontally arranged, as on a krater, with interlocking hatched upright meanders. These are contained by double meander hooks above and below the horizontal beams. In both cases the meander is somewhat changed. The one-directional nature of the meander is upset in the meanders on two late Cypriot-style jugs from Grave X in the Exochi necropolis (Fig. 45), where the flanges point in both directions.[69] In the handle zone of an isolated krater found in the Camirus necropolis[70] the meander band is enclosed in such a way that individual elements are almost completely broken up. This also occurs, though to a lesser extent, on a sherd of a kantharos from Lindos (Fig. 46) and a barrel jug with two necks from Grave D at Exochi (Fig. 47). Here, a vertical standing 'meander tree' grows out of a calyx shape, with upward-pointing branches left and right. Both calyx and branches are rendered by meander hooks. The pattern is produced simply by right-running and left-running linear meanders being placed next to each other, with the area between filled with hatching. On a beautiful Geometric gold sheet from Grave 82 in the Camirus necropolis this pattern occurs in such a way that, seen horizontally it looks like alternate-running meander bands, but vertically it becomes a meander tree.[71] The development of the

Rhodian meander tree on pottery is obviously closely connected with the inventiveness of goldsmiths' work on Rhodes.

Encircling ornamental bands also occur on kantharoi, skyphoi and jugs, ultimately reminiscent of

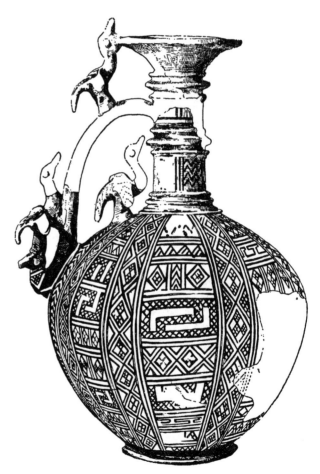

45 Cypriot jug from Exochi (Rhodes).
Height about 29 cm. Copenhagen, National Museum

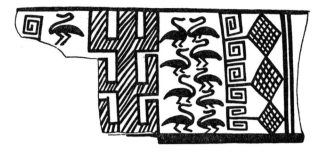

46 Decoration on a fragment of a kantharos from Lindos
 (Rhodes).
 Istanbul, Archaeological Museum

membered parts of meanders (Fig. 48). These occur
on vases from the necropolises of Camirus and Exochi
and continue through the Late period in the second
half of the eighth century.[72] Modifications occur on
jugs and skyphoi. In the case of jugs the encircling
stripes under the neck can be regarded as 'pectorals'.
On skyphoi, there is what could almost be called a
clay-ground decorative bib. On jugs, kantharoi and
skyphoi, a hatched zigzag band is combined with
a frieze of opposed bars; a zigzag band of the same
kind, with apices suspended from the frame ('cobweb
motif') with a simple zigzag; clay-ground zigzag
bands with saw-tooth bands (Fig. 49); a suspended

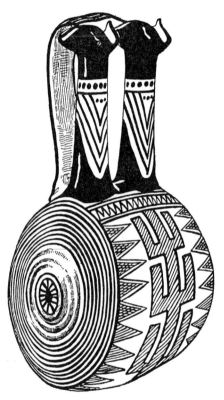

47 Barrel jug from Exochi (Rhodes).
 Height 24 cm. Copenhagen, National Museum

the superb development of encircling ornaments in
Athens in the ninth and eighth centuries. But indivi-
dualistic, specifically Rhodian decorative features
are always present. Particularly popular is the com-
bination of two friezes: the zigzag and a zigzag
pattern of hatched bars, the latter being simply dis-

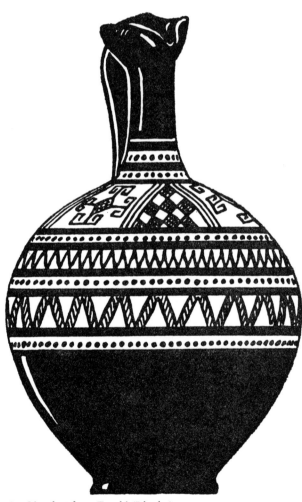

48 Oinochoë from Exochi (Rhodes).
 Height 22 cm. Copenhagen, National Museum

clay-ground zigzag band ('cobweb motif') with a linear upright meander and saw-tooth bands; a clay-ground zigzag band with meander hooks on the apices with a normal zigzag; and a zigzag of joined hatched bars with an upright meander and suspended hatched triangles made by a zigzag.[73] On jugs from Camirus there also occur linear or hatched-braid or 'woven' motifs.[74]

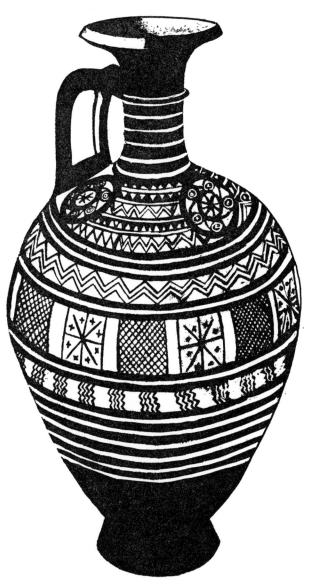

49 Jug from Camirus (Rhodes).
Height 46 cm. Rhodes, Archaeological Museum

The broad base of the Rhodian style in non-ceramic products

The fact that the Rhodian Geometric style flowered late, not developing until the purely ornamental core of mainland Greek Geometric art had already begun to decline, explains why Rhodian art remained unaffected by the superb system of truly Geometric art which reached perfection in Attic High Geometric figure work. But a typical feature of Geometric fashions on Rhodes was the cross-fertilization from associated industries. Influences from metalwork and goldsmiths' work have already been mentioned.

Let us start with a splendid krater from Grave 82 in the Camirus necropolis, which belongs to the beginning of the third quarter of the century (Pl. 87). The main decoration is on a reserved clay-ground area between the handles, framed on the longer sides with a saw-tooth pattern, and on the shorter sides with triple lines. The main accent is the three concentric circles, or 'wheel ornaments' with painted-in rims on the outside edge and four wedge-shaped black 'spokes' in the middle. In the upper corners are some long-necked birds, alighting on the wheel rims. The lower corners are filled with eight-pointed stars. The drawing is simple, with a strong contrast between light and dark. This triple repetition of identical motifs is very rhythmical. Its unusualness suggests that it may have originated in some craft other than Rhodian vase painting. This impression is strengthened by the reserved squares between the handles and the central panel. These have a frame of simple lines and are decorated with a cross-like emblem which although Rhodian, never otherwise occurs in this form in vase painting. The whole structure of the decoration on this krater is similar to marquetry, with dark wood inlaid in lighter wood— not, of course on the curved sides of a vase. This marquetry technique can be studied in the original in a superb wooden throne in the Phrygian Geometric style which was found by American excavators at Gordion, King Midas's capital, in a royal grave (Fig. 50).[75] The inlays are dark yew-wood against a light boxwood background. The large surfaces on the backrest are filled with twenty-six squares, mostly framed by simple lines, and decorated with swastikas

50 a–b Ornaments from a wooden throne from Gordion
(Asia Minor)

via bronze cups. The painting is, however, native Rhodian Geometric. It is closely related to a Cypriot vase, inscribed with a Phoenician owner's name, found in Idalion.[76] Here the Cypro-Rhodian decoration in the handle zone is simply a ceramic imitation of Geometric marquetry. It is framed on the sides with lozenge bands and has a large lozenge in the middle decorated with an oblique cross with two half-lozenges to the left and the right. Strong dark diagonals framed by light stripes run through the zone enclosing the lozenges. This is an old, typically Cypriot, motif. The whole stands out against a ground covered with an oblique checkerboard pattern. The strong contrasts of light and dark produce a 'colourful' effect. This decoration is certainly derived from marquetry panels. So the vases from Grave 82 at Camirus are strongly influenced by Geometric marquetry, which was native to Rhodes and Cyprus and at least the south of Asia Minor, and which in any case spread as far as Phrygian art.

Two cylindrical pyxides should be mentioned at this point: from Camirus and Exochi near Lindos.

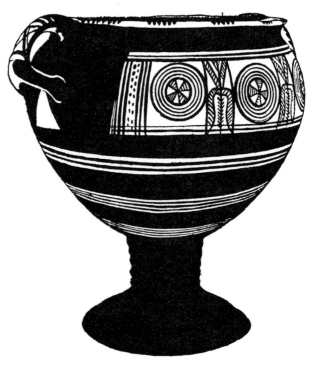

51 Krater from Camirus (Rhodes).
Height 34.5 cm. Berlin, Staatliche Museen

or a large number of meander variants. Furthermore, concentric-wheel motifs and concentric semicircles appear in prominent positions. On the wide borders of the back there are simple lozenge chains. The throne is considerably more recent than its Rhodian counterparts and should be dated around the turn of the eighth century to the seventh. So both this throne, the style of which makes it clear that it was produced in Rhodian-East Greek workshops, and the Rhodian krater, are derived from older prototypes.

These can perhaps be identified by clues from a cup found with the krater in Grave 82 (Fig. 44), and its counterpart from Cos. The shape of this vessel with its lathe-turned foot and funnel-shaped sides may have been copied from wooden tubs, perhaps

These can be recognized as clay imitations of ivory pyxides by their yellowy, slightly pink slip, and notched feet and shoulder rims.[77] On the originals,

52 Kantharos from Camirus (Rhodes).
Height 13 cm. Rhodes, Archaeological Museum

the decoration, which consists only of circles, would have been rendered only by incisions and paint. The main frieze on the Exochi pyxis, with its large concentric circles, Maltese cross in the middle, and corner filling, is very similar, as is the pyxis from Camirus with its thick-rimmed circles, to the vases from Grave 82.

The Berlin krater from the Camirus necropolis (Fig. 51) is from the same workshop as the beautiful krater from Grave 82 (Pl. 87). This can be seen from the similar form of the foot, which only occurs otherwise on the krater from Camirus in London (Pl. 88), and from the three concentric circles with emphasized rims and Maltese cross in the middle. It is, however, important to notice the completely non-Geometric motif in the three triglyphs which separate the three circles. This is certainly a stylized palm tree. It often occurs in Rhodes: on, for example, two kantharoi from Camirus in the Louvre (Pl. 92) and in the museum in Rhodes (Fig. 52), and a small jug in Copenhagen (Pl. 90). It also occurs on at least four hitherto unpublished vessels in Cos: the single-

handed cup which has already been mentioned several times, the counterpart of the cup from Grave 82 in the Camirus necropolis; on a jug (C 1017) and a little jug of Cypriot shape; and on a beautiful jug which, from the cable pattern on the neck and the body, can be dated during the rise of the imaginative, precise style of drawing which marks the transition to the Early Archaic style (Pl. 91). The motif was copied after the middle of the eighth century from Rhodian vase paintings. Its ultimate version was in the ivory carvings that flourished in Syria at this time. Several small ivory plaques with the same

53 Decoration on a krater from Exochi (Rhodes).
Copenhagen, National Museum

stylized palm trees, intended as inlays in wooden furniture, are found over a wide area, including Arslan Tash, Carchemish and Samaria.[78] Items of furniture of this kind—chests, thrones or beds—may have come from Syria to Rhodes and have influenced the vase painters there. On a later krater from Exochi tree motifs also occur, again in the border triglyphs, although very different from the severely stylized Oriental form (Fig. 53). Here, in contrast to the Mycenaean-Syrian palm-tree motif, an independent, fairly primitive attempt is made to turn the tree proper into an ornamental motif. The trees on the krater are not much different from the tree, which was supposed to be completely naturalistic, in front of the centaur on the fragment of a sub-Geometric Rhodian pithos from Camirus in London (Fig. 54).[79]

We have seen how the Rhodian Geometric fashion affected several related crafts, including wood and ivory marquetry and Oriental ivory carvings. There is a further observation to be made. A later krater from Grave 201 in the Camirus necropolis (Fig. 55) has a quatrefoil ornament in the middle of the handle

54 Fragment of a pithos from Camirus (Rhodes).
Height about 32 cm. London, British Museum

zone, to which is attached, to the left and right, a wheel pattern without the usual dividing lines. Round the hub of the wheels is a six-pointed star, and inside the rim, instead of concentric circles, there is an empty band in which a counter-clockwise false spiral chain is painted. One notices in particular that

55 Krater from Camirus (Rhodes).
Height 42 cm. Rhodes, Archaeological Museum

the wheels overlap the boundary lines of the reserved clay-ground zone and are painted with a broader brush, as though they had been overlaid on the ornamental zone. The meaning of this anomaly is explained by similar, rather clearer phenomena on two late jugs, one from Camirus (Fig. 49) and the other, the beautiful jug in Cos (Pl. 91). On the first, almost identical broad-painted wheels overlap the five encircling bands of the pectoral, which are extended so that the wheels seem to be attached to the pectoral. On the second, the wheels are set on metopes between palm-tree triglyphs, and appear to cover a meander-like ornament of which only the corners can be seen. Finds of the Geometric period have now made it clear that these late motifs must have been copied from the products of goldsmiths' workshops. For here we find circles, leaf rosettes, once even a Dipylon shield—sometimes with inlays of coloured enamel, soldered with gold wire on Geometrically decorated grounds, including circles, zigzags, and upright meanders, mostly finely granulated. On the finest gold plaques the pattern on the ground continues unseen underneath the overlays, so that both layers, the ground and the rosettes, etc., which are soldered on top, are clearly separated from each other. On a gold band from Athens, in Amsterdam, with a hammered relief of centaurs and riders, a round gold sheet with a quatrefoil is riveted onto the middle regardless of the figured relief (Pl. 224). Perhaps the small gold plaques from a superb necklace found at Eleusis (Pls. 225–228) illustrate best the double layers of Late Geometric gold jewellery and the borrowings that Rhodian vase painters made from it.[80]

The second phase of the Rhodian style
The cult vessels

Finally we come to a group of vessels which appears to be closely connected with the death cult. This begins with small vases, skyphoi and kantharoi from the middle of the century onwards, but quickly develops richer forms, crystallizing, in the last quarter, into a style which spread from Rhodes to several points west. It was from these Rhodian roots that

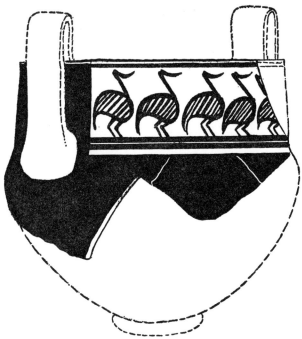

56 Fragment of a kantharos from Camirus (Rhodes).
Height 17 cm. Rhodes, Archaeological Museum

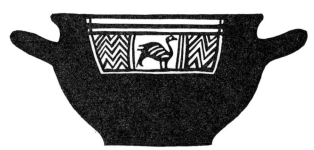

57 Skyphos from Camirus (Rhodes).
Height 6.5 cm. Rhodes, Archaeological Museum

the so-called bird-bowls of East Greece developed in Early Archaic times. The sites in which these have been found are spread across the whole of the Greek world. The distinguishing features of this group are the bird frieze and the bird picture, which found their way to Rhodes around 750 B.C.

These were preceded before the middle of the eighth century by atticizing kantharoi with two bird metopes flanking a central metope with a quatrefoil, in the Cyclades, Rhodes, and Samos. These copied ornamental bands from Attic bird-bowls (Figs. 39, 40).[81] They gradually develop into the Rhodian Late

Geometric syntax.[82] Fragments of two kantharoi from Lindos show meanders between continuous bird friezes, above and below.[83] Bird friezes, in combination with meanders or linear-meander variants, are also found on a krater and two skyphoi. A splendid bird frieze occurs, by itself, on a kantharos (Fig. 56). All of these come from Grave 200 in the Camirus necropolis.[84] In the course of the third quarter of the century, however, a typically Rhodian combination begins to appear: the bird metope and broad-flanking triglyphs filled with parallel zigzag lines. This simple basic motif is found on unpretentious, black-ground skyphoi, with the motif in reserved clay-ground areas between the handles (Fig. 57).[85] There are a number of variants of this on kantharoi and skyphoi. A comparatively early kantharos from Exochi has two elongated metopes under the lip, each with two birds. Beneath these there are two similar areas with zigzags, forming a kind of base (Fig. 58). In another kantharos from Siana, the much larger area to be decorated is treated differently (Fig. 59): here there is a tall metope picture with two birds, one above the other. Between this and the zigzag fields are linear vertical meanders as well as the usual separating lines. Skyphoi, with elongated panels in the handle zones, have two bird metopes between three zigzag tri-

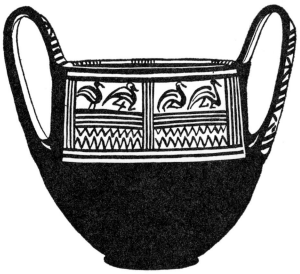

58 Kantharos from Exochi (Rhodes).
Height 17 cm. Formerly Rhodes, Archaeological Museum

glyphs. Above them is a bird frieze which reaches up to the lip (Pl. 95).[86] A kantharos fragment from Lindos, which also uses the techniques of the Oxford kantharos, is later, probably dating from around the last decade of the eighth century (Fig. 46). On it is a central meander tree with at least four antithetical pairs of birds one beneath the other to the right, a column of individual birds to the left, and cross-hatched vertical lozenge chains with meander hooks at the apices and inside closing off the pattern. The origin and the development of this whole group of skyphoi and kantharoi fall in the third quarter of the century. Two funerary jugs with snake handles from Camirus, in London and Berlin (Fig. 43), are closely connected with this group. The birds and bird friezes and the broad zigzag triglyphs, form the main accent of the decoration. On the London jug the basic motif becomes a continuous frieze.

Obviously, this mainstream does not entirely exclude the older bird-and-meander combination. A beautiful example of the latter is a Rhodian kantharos in Copenhagen (Fig. 60), dated by its cross-hatched meander and 'woven' band in the last decade. But this combination remains rare. During the last quarter of the century, on the other hand, the trend is not so much towards variety of composition as stereotyped choice of motifs: less variation, more concentration. The skyphos drives the kantharos from the field. Decoration becomes uniform: three or four metopes on an hour-glass band, which is later sometimes replaced by a zigzag band. The outside metopes are each filled with a cross-hatched lozenge. In the middle there is usually a bird metope or, if there is room for four zones, there is a cross-hatched triangle with two meander hooks at the apices, and a bird. The lack of variation in these bird-skyphoi (Pl. 96) suggests that they were popular mass-produced goods.[87] The delicate Rhodian-East Greek bird-bowls of the post-Geometric period, which were vast in number and even more widespread, carry on the bird-skyphos tradition, except that Geometric narrowness gives way to a new breadth, and the triangle metopes with meander hooks disappear.[88]

This Rhodian 'trademark' was the most successful and influential composition pattern from the end of the local Geometric style. It also obviously had con-

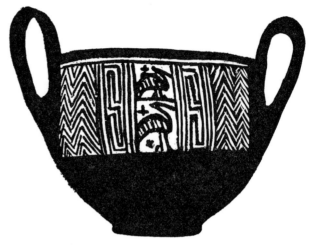

59 Kantharos from Siana (Rhodes).
Height 18 cm. Oxford, Ashmolean Museum

siderable influence on other types of vessels and their decoration. Two squat jugs with round mouths, one in the British Museum in London (Pl. 93), the other in Munich, are relevant here.[89] On these jugs the pattern from handle zones of the skyphoi, with its hour-glass band, is used on the shoulder, extended with one or two ornamentally decorated metopes because of the larger area to be covered. The influence of the bird-skyphos trademark can also be seen in four contemporary Rhodian kraters.[90] The most

60 Kantharos from Rhodes.
Height 19.5 cm. Copenhagen, National Museum

closely related is a krater from Myrina in Athens, where an almost square field has made necessary a reorganization in the traditional krater style—the boxed system. But next to the two metopes, border metopes with lozenges recur in the end triglyphs with lozenge chains. The bird metope, however, is replaced by a metope with a quatrefoil. The same happens on a krater from Exochi, also closely related, with four regular metopes. Finally, on two kraters from Camirus, in London, all three metopes are decorated with quatrefoil motifs. The bird picture is not used on these kraters.

But it is, however, used very emphatically on the jug from Grave X in the Exochi necropolis, now in Copenhagen with its sister-vessel (Fig. 45) from the same grave.[91] Both jugs have Cypriot shapes with raised rings at the joint of the neck, in the middle of the neck and underneath the lip. The composition of the Geometric decoration has precedents in the nets which covered early Cypriot gourd-pitchers from foot to neck. But the seven vertical bands with lozenge chains, and the horizontal ornamental strip, belong entirely to Rhodian vase painting. The cross-hatched meanders and Geometric variants indicate a Late Geometric date. The S-shaped handle set on the shoulder, with a sculptured animal protome, now has two sculptured birds with flapping wings. The lower one, up against the protome, is stretching upwards, while the upper one has reached the mouth and is taking a drink. A third bird is sitting on the shoulder, with its wings spread to fly up to the mouth.

The group of vessels dealt with in this section, from the second half of the century, consists of two early kraters—one with birds alighting on wheels (Pl. 87), the other with a bird frieze[92]—kantharoi and skyphoi, tall and squat jugs, and jugs of Cypriot shape. All these are obviously vessels made for funerary use: grave kraters (?), tall jugs with snake handles—certainly grave urns—open drinking cups, and storage vessels such as the Cypriot jug with its sculptured decoration. This group reveals the moving force of the zenith of Rhodian Geometric pottery, which at first seems confusing. Three phases can be distinguished: the atticizing one in the middle of the century, the phase of tall jugs with bird friezes and

compositions of bird metopes and zigzag zones in the third quarter, and the concentrated 'trademark' phase in the last quarter of the century.

The meaning of the bird motif

The bird shape, always present in this group, is very important. It is the only Geometric element to penetrate Rhodian figure painting. No horse, human figure or any other kind of animal appears on Rhodes in pre-Archaic times. At least on Rhodes, the bird figure represented the bird of death. The snakes crawling up the handles to the mouth of the tall jugs undoubtedly represent, as they do on the grave vases on the Greek mainland, the form the dead person was believed to take on after death. But on both the vessels from Camirus there are also painted bird friezes and bird metopes. As time goes on, the bird frieze becomes less important, with, eventually, only single birds remaining. Finally there is the Cypriot jug with sculptured birds (Fig. 45) flying from the handle or the shoulder to the mouth to share the funeral meal, as did, about a generation earlier, the snakes on mainland Greek jugs. An offering tube connected with the death cult, probably from Camirus, now in Berlin, has four sculptured snakes crawling upwards, as on the tall jugs, and a ring of sculptured fluttering birds under the mouth.[93] It is seldom that an archaeological find reveals anything as clearly as the fact that the Rhodian and probably also the East Greek birds were birds of death.

None of the vessels can be dated before the middle of the century. They are complemented by bird-askoi (Pl. 94), with bird bodies and sometimes bird feet, and by completely animal-shaped bird vases such as often occur in the Seraglio necropolis in Cos. The series of askoi begins in the sub-Mycenaean period, is copied in the Geometric period, and is continued around the middle of the ninth century in an askos from Grave 141 in the Ialysos necropolis. It can be traced down to the end of the Geometric period. Bird-shaped vases begin after the middle of the century. Seven of this type of vase come from Cos alone.[94] The latest of them are table centrepieces with two or three birds next to each other on one tall

foot. The bird-askoi and the bird-vases, like the jugs, kantharoi and skyphoi with bird pictures, were undoubtedly used to contain funerary gifts. The quantity of birds-vases on Rhodes and Cos is not matched anywhere else in the Greek world. Only on Crete were similar quantities found.[95] There appear to be none from Thera or Melos, or in the contents of graves taken from Delos to Rheneia. There are, however, not enough Cycladic finds to draw firm conclusions. And it does look as though the transition of the Attic bird-bowls to kantharoi took place on the Cycladic islands.[96] On fragments of a large, probably Naxian krater (Fig. 31) there is a frieze of birds flapping their wings surmounted by a frieze of standing horses with the latter obviously representing the metamorphosed bodies of distinguished dead Athenians.[97] On the other hand, only a few bird-skyphoi and two clay birds[98] have been found amongst the huge range of Attic finds of graves. With the exception of two Protogeometric bird-askoi, all the birds found are from Graves 50 and 49 in the Kerameikos necropolis and come from the Late Geometric period. In Grave 50 a 'death horse' was found with four small neck-handled amphorae on its back.[99] The sepulchral significance is obvious here. But these two graves form a kind of island in the Kerameikos necropolis. Although their offerings all come from Attic workshops, they suggest a funeral rite not found anywhere else in Athens. May it not have come to Athens from the east, from Rhodes and Cos, perhaps via the islands, in the Late Geometric period? There are in fact a few clues to this in, for instance, the 'Rhodian motif' of cross-hatched, framed triangles on the splendid birds in Grave 50 and the double askoi in Grave 49. But the horse and the style of the figured askoi are pure Attic, and the evidence is too weak to prove anything conclusively.

Are there also clues about the East Greek bird of death in Greek literature? This period was about the time of Homer's epics, which are the only sources of information on contemporary ideas about death. After the dying Patroklos has uttered his last words, his 'psyche leaves his body and flies away to Hades, jabbering about its fate, and the loss of its manliness and its youthful strength'. After Patroklos appears in a dream to Achilles, in the thirteenth book, he

61 Oinochoë from Rhodes. London, British Museum

'disappears into the earth like a wisp of smoke, with the shrill cry of a bird'. In the Nekyia in the *Odyssey*, the eidolon of Herakles is 'surrounded by the screaming of dead men, like startled birds'. And in the last book of the *Odyssey* the dead suitors follow Hermes 'with shrill cry, as when night birds scream and flutter inside a dark cave'.[100] Dead men fly, but their ghosts are only *compared* with birds, even if they do voice their complaints with the shrill voices of birds. How could this be otherwise? But in early popular beliefs and early art, dead men *are* birds of death. It was not until the arrival of Egyptian and Syrian-Phoenician myths that more sophisticated ideas were introduced. This was how the Egyptian spirit Ba, a bird with the head of a man, came into Greek art. This phase, already on the threshold of the orientalizing style, is characterized by birds with bearded human heads on a squat jug from Rhodes, now in London (Fig. 61).[101] These were widely illustrated in Greek mythology. When the dead drag the living over to the other side, it is a human bird which

carries them off, a male or female 'snatcher' ('Harpie'), one of the *keres* which bring or announce death to a man.[102] The Sirens, with their mournful, enticing songs, who tried in the *Odyssey* to draw the sailors over to their kingdom on the other side, are the same type of creature. Again, in later classical tradition, underworld nymphs which were half-human, half-bird appear above graves or on grave 'stelai' singing their songs of mourning to the lyre. Popular early fifteenth-century beliefs about the dead are illustrated by the eidola fluttering around an open pithos sunk into the earth, directed by Hermes, escort of the dead (Fig. 62), on a white-ground lekythos in Jena. They are human bodies which have lost their strength, with huge wings on their shoulders. This is what remained of the Geometric bird of death which appears in mythology and in art in many forms.[103]

62 Belly picture on a white-ground lekythos from Athens. Overall height 19.5 cm. Jena, University Archaeological Museum

d Summary

The Protogeometric tradition lasts on Rhodes and Cos into the eighth century, as it does in the Cyclades, Thera and Crete (Protogeometric B). Alongside it develops a sober, more Peloponnesian contemporary style of Geometric decoration, found on smaller vessels from the middle of the ninth century onwards. This uses cross-hatched triangles, lozenge chains and lozenge metopes, simple zigzag friezes, antithetical groups of bars and upright or horizontal hour-glass patterns. This does not progress, compared with the great achievements of Geometric art on the mainland, beyond the transitional phase from Protogeometric to Geometric.[104] The Protogeometric tradition does not, however, completely disappear in the decades after 800 B.C. It survives particularly in the large grave amphorae with shoulder handles and in small oinochoai.

Later, towards the end of the eighth century, there is a modest revival of basic Protogeometric patterns on certain newly revived traditional shapes of vessels: amphorae, pithoi, kraters, bowls and tall-footed cups.

Nevertheless, the strong influence of Attic High Geometric before the middle of the eighth century, which came via the Cyclades to Rhodes, broke the back of the old Protogeometric tradition and paved the way to a local Geometric style on the Dodecanese. This introduced, above all, the Attic meander, which on Rhodes underwent a process of painterly sophistication, and later, all kinds of individual variants. Encircling bands with pure Attic dot, line, and zigzag patterns were also introduced, with both the Attic precision of drawing and the Theran rhythmic harmony between shape of the vessel and decoration. But this 'Atticism' lasted only a short time and only influenced ornamental painting. There was no systematic build-up of Geometric for more than a century, such as the Attic Geometric painters produced, and for which there was no substitute. Thus the transition from the pot to the monumental grave vessel, which the Athenians were able to make, and their daring mastery of organic pictures and of epic themes within the canons of the Geometric style,

were things the Rhodians could not participate in. Horses, grazing animals, recumbent bucks, prothesis, funerals, battles—none of these appeared in Rhodian Geometric painting.[105] But although the atticizing fashion around the middle of the century was only a short interlude, it did assist in the birth of an independent local Geometric idiom in the second half of the eighth century.

The Rhodian vase painters of this late zenith sought their roots in local tradition. Cross-hatched triangles, lozenges and lozenge chains were still *leitmotive*. Opposed groups of bars become antithetical beams with hatching, like the elements of a meander. The hour-glass frieze was already part of the tradition. To these motifs were added triglyphs and zones filled with parallel zigzag lines, perhaps from Attica. Encircling ornamental bands, from the same source, survive especially on the 'shoulder pectoral' of a certain type of jug. Concentric circles and wheel motifs, the latter with strongly emphasized rims, on belly-handled amphorae and kraters, are the last vestiges of the Protogeometric tradition, as in other Geometric styles. It is a sparse, sober style of decoration, certainly inherited from the Dorian colonizers of Rhodes, who came from Tiryns in the Argolid. It can also be seen in Early Geometric pottery.

In the few decades of the Late Geometric period Rhodian pottery developed a remarkable richness of its own. This was partly the result of contact between Rhodes and Athens, which introduced to Rhodes the Attic idea of developing endless variations of a few simple motifs. But this tendency towards variations produces not so much a systematic build-up of ornament as play on basic forms. The meander variants have already been described. Filling triangles, lozenges and zones with oblique checkerboard patterns are used to rich effect, while the straightforward checkerboard pattern in line with the axes of vessels, is not used at all. The severity of the metope-triglyph band is relaxed in several ways. Triangles, otherwise used to make friezes, are so arranged on the curve of shoulders that narrow rectangular triglyphs can be drawn in between them. Alternatively, the triangles are separated from each other so that trapezoidal or square areas are produced between them, and triangles take over the

dividing function previously performed by triglyphs. And the original triglyphs, typically tripartite and vertical, become so broad that they can barely be distinguished from the metope panels. When separated by clay-ground vertical stripes the triglyphs actually become metopes.

This play of variations can be seen particularly in the extension of triangles and lozenges by meander hooks—so much so that one can almost describe this type of variant as the trademark of Rhodian pottery. Figure 63 helps to illustrate this. The simplest combination is, perhaps by chance, only found on a late jug (a). Triangles with oblique hatchings form a frieze with one meander hook only at the apices. A balance is established by the hatching leaning to the right and the hooks pointing left. This frieze could be regarded as the forerunner of a post-Geometric motif, the 'running dog', were it not equally a translation of the motif into Geometric idiom. One-dimensional hooks are also placed on the apices of a double zigzag band, pointing to the left above and to the right below, to produce rhythm (b). The most common feature is the cross-hatched or lozenge-filled triangle with a double outline and double-hooked lozenges at the apex (c, d). On a krater from Myrina in the Louvre, there is a floating double hook without a stalk above the triangle (e); in a lower strip the central lozenge is set, logically, between two brackets (f). The motif of enclosure with floating meander hooks is repeated on the shoulder of the jug with

63 Ornaments of Rhodian Geometric pottery

motif a, in a flared form (g). Repetition below and on either side of the axis of symmetry produces the lozenge-cross with meander hooks. On a comparatively early cup the lower triangle is omitted because of the way that the panel narrows lower down (i). To complete the vertical and horizontal symmetry, the double hooks are broken down and replaced by two hooks pointing in opposite directions on stalks. The lozenge-cross is certainly contemporary with, if not earlier than, the unique example just described. It is already completely developed on the early tall jugs with snake handles, at first with borderless lozenges with two meander hooks at each point, eight in all (k). The stalks of each pair are not connected to the apices. Thus soon only bordered lozenges are used, but their outlines do not run into the apices, being bent instead to run straight into the stem of the hooks (l). One can read the drawing so that each of the four sides of the lozenge forms the base of a trapezoid with each open side having two meander hooks drawn into it. The effect is airy, linear, almost playfully imaginative; the only anchor is the axial crossing. But a little later in the Exochi krater the game is abandoned, and the image becomes firmer, with the lozenge borders and the space between the stalks of the meander hooks hatched (m). The cross becomes more concrete. The latest example is on a high-footed kantharos from Exochi. The oblique checkerboard filling of the lozenge, the dots in the framework of the edge of the lozenge and the crossed arms are drawn with assurance and are very effective (n). The dotting and the newly assured drawing suggest borrowing from metalwork, probably from gold jewellery.[106] There is also a horizontal lozenge-cross which can be reconstructed from the sloppy, cramped drawing on a late bird-jug (h). The side double hooks are single-stalked whereas the top and bottom ones, without stalks, are directly joined to the open border lines of the lozenge and make triangular, not square, shapes. The outside edge is aligned with the edge of the frieze, and the hooks with the lozenge.

The playful and yet precious character of Late Geometric decoration on Rhodes is to be seen nowhere quite so impressively as in this 'trademark', which gradually conquers all the important shapes of vessels. But a weakness remains within this logical syntax; the triangle is developed with meander hooks and lozenge-crosses, but the system never becomes a great Geometric artform reflecting the basic laws of the universe, as it did on the mainland, particularly in Attica. But such art as could be achieved at this late stage, without a great past, became an idiom, a short-lived fashion, already affected by the impending change in Greek art towards the orientalizing style, that is, the curvilinear Early Archaic style. The high-footed kantharos, from which the last lozenge-cross is taken, is typical. On both sides, each of the two lozenge-crosses on the long axis has spirals instead of meander hooks.[107] The borrowings made so often by Rhodian vase painters from other techniques, including marquetry, ivory carving, metalwork and goldsmiths' work, and the rapid change of fashions which can be traced on Rhodes, unlike Thera and Crete, suggest a creative discontent and growing dissatisfaction with the Geometric style.

It should be noted in this connection, however, that the forerunners of the orientalizing wave before and after 700 B.C., which in the west and in Crete were such important factors in the decline of the Geometric style, barely affected Rhodian vase painting. Even when the curvilinear style makes itself forcefully felt in the last quarter of the century, during the phase of the Analatos hydria (Pls. 52-55),

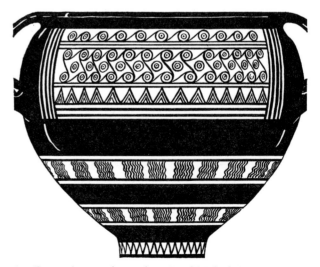

64 Decoration on a krater from Exochi (Rhodes). Copenhagen, National Museum

with spiral nets and spiral bands on the neck-handled amphora from Grave A in Exochi and on a krater from Grave B (Fig. 64), the vase painter still uses tangential circles. Innovations are still contained within the Geometric circle style.[108] But there are no bowls painted inside and out, in imitation of the Phoenician bronze bowls, which introduced a complete range of Oriental images to Athens, including lions, heroes between lions, bulls, winged lion-centaurs, and women in front of enthroned goddesses.[109] This probably demonstrates the conservative nature of Rhodian pottery. Only one Oriental motif, the palm tree, took root in Rhodes in the third quarter of the century, but this stylized plant ornament produced no successors.[110]

2 Samos and the coast of Asia Minor

The early pottery from the island of Samos[111] is only partly known to us. The first progress was made by J. Boehlau, who examined the western necropolis of the town of Samos (Tigani) and a part of the northern necropolis, in 1894. Geometric graves were not discovered, however, and the finds came only from the second half of the sixth century.[112] It was not until the excavation of the Sanctuary of Hera on Samos, near Pythagorion, begun before the First World War by the Berlin Museum, under T. Wiegand and M. Schede, and carried on by the German Archaeological Institute in 1928 under the direction of E. Buschor, that the picture really changed.[113] It was above all systematic excavation below the level of the large buildings which explained the history of the sanctuary, with the small finds giving a rich picture of Samian life in early times. Two reservations should be made however. Since the sanctuary is right on the flat beach and since, therefore, no graves could be expected to be found close by, the finds consisted almost entirely of sherds from which only a few vessels could be partially or completely reconstructed. Also no sherds have as yet been found which can be dated with certainty before about the middle of the eighth century. There could be various explanations for this: either the sanctuary was not built until the eighth century, or the older offerings

were removed to the smaller sanctuary before the beginning of the century, or a Samian Geometric style may not have been developed before the middle of the century, as in Rhodes. This last explanation seems the most likely.

R. Eilmann attempted to distinguish between Samian and imported vessels by studying the colour and the quality of clay, and by comparing the clay round the town of Samos and the sanctuary.[114] Samian clay is reddish brown or grey with a touch of blue. A brownish-yellow ware was also found, although only towards the end of the Geometric period. The better vessels of reddish-brown type often have a whitish slip on the outside. But without actually analysing the clay of the sherds and the local clay-pits, no certainty can be achieved, since the same reddish-brown clay is frequently used on Rhodes and in Asia Minor.

Eilmann was able to identify only a few imported items. The most important of these is a krater or kantharos, with bird metopes and quatrefoil metopes (Fig. 40).[115] If a tall, open-work foot belongs to this, it could be of Cycladic origin.[116] The krater can be dated at the earliest around the middle of the eighth century. Imported Geometric vessels would be less likely to occur in the Sanctuary of Hera at Samos than in graves, of which, however, there are none from the Geometric period. Imports can therefore be traced indirectly, but with greater certainty, through Samian imitations of foreign pots. The evidence here of an open-minded attitude towards the rest of the Greek world is in clear contrast to Rhodian pottery, which is orientated more towards the east, namely Cyprus and the coast of Asia Minor. The Cyclades, Crete, perhaps also Melos and Corinth, and particularly, Rhodes and Athens, are the prime sources of Geometric influence over Samian art.

The epochs of Geometric pottery which are missing on Samos can be filled in from the finds from the west coast of Asia Minor, where all the phases from Mycenaean up to Late Geometric are clearly discernible. Admittedly, work began here only during the last decade. The finds of sherds from nearby Miletus and Old Smyrna are particularly relevant, but excavations are not yet complete.

a Miletus

Miletus appears to have been the site of the oldest town on the Kalabaktepe, dating back to the Middle Helladic period. It was near the sea, where the Temple of Athena was later built, and in the Mycenaean period it was surrounded by a fortifying wall. Sub-Mycenaean sherds of large kraters have been found directly on top of the ruins of the wall and in the destruction level.[117] In a slightly higher layer, above the ruins of the wall, was a 'Protogeometric-sherd stratum'.[118] Under the 'Geometric house' were two small trefoil jugs of the Protogeometric type with tall feet.[119] Under a Geometric wall next to this house was a jug with a conical foot, broad neck and round mouth, which could be reconstructed from sherds. Neck and shoulder are clay-ground with only two bands decorating the neck. The semicircles on the shoulder have been drawn without a compass. The body and the tall foot are black-glazed, up to a broad clay-ground band which runs round the body. The jug is Early Protogeometric of a rare type which has previously been found only in Eleusis and in the Argolid.[120] Protogeometric in Miletus lasts well into the ninth century, and the style can still be seen in the first half of the eighth century;[121] circle and semicircle decoration even has something of a revival in the Late Geometric period.[122] The sequence of styles and the extended survival of Protogeometric are obviously the same in Miletus as those already encountered in Rhodes.

At the beginning of the eighth century Attic influence begins to make itself felt. It is most clearly indicated by a number of still unpublished Attic lips from belly-handled amphorae with increasingly strongly articulated and everted shapes. A lovely little sherd, also unpublished, has a double row of opposed saw-teeth with dotted interstices—an Attic motif which started around the beginning of the century.[123] A fragment of a black-ground bowl of Attic type with a reserved ornamental field (triple zigzags) belongs to the second quarter of the century, as does the sherd of the two-handled cup which is an imitation of Attic cups with ribbed sides.[124]

But in view of the comparative scarcity of finds of sherds to date in Miletus, one cannot really talk of a consistent native style after the middle of the century there, as one can in Rhodes. But one can discern a clear trend towards a Geometric fashion of its own which must ultimately derive from the Athenian High Geometric style, but which must also have been influenced by both Corinth and the Argolid. Fashions would have spread eastwards via the Cyclades; the influence from Rhodes is unmistakable. Various meander variants started in Miletus at the same time as they did in Rhodes. Floating meander friezes, like those found on Rhodes at the beginning of the 'meander style' do not seem to have appeared in Miletus. All meander friezes are firmly attached. Hatching of the band sloping in opposite directions, as on the early Exochi krater from Rhodes (Fig. 38), occurs on only two Milesian sherds, but not with a regular change of direction in the corners. In one case, on a small trefoil jug, the direction of the hatching alternates from the lower to upper band of an upright meander; in the other instance, on a fragment of a cup or krateriskos, the direction changes only once in two loops on a narrow part.[125] The floating meander comes from the mainland and spreads to the Cyclades; but alternating hatching is pure Attic. Both phenomena occur at the same time on Rhodes and in Miletus, although the Milesian treatment is less careful than the Rhodian. Other similarities also suggest a close connection between Rhodian and Milesian pottery. In both places there is a marked preference for the upright or wave meander, which is Early Geometric in Athens and out of date by the first half of the eighth century.[126] Another common feature is the decoration of large cups. This takes the form of a reserved area between the handles. Here, horizontal friezes of meanders, zigzags and other patterns, or vertically or horizontally enclosed meanders appear between triglyphs with cross-hatched lozenge chains.[127] But the Rhodian meander variants degenerate into crude and frivolous patterns in Miletus.

The fragment of a Rhodian bird-skyphos which was found in the Late Geometric burnt layer of the 'Geometric house'[128] still belongs in the third quarter of the century. Two metopes of the frieze are still preserved—a bird and a cross-hatched triangle with a border and double meander hooks at the apex—both

65 Fragment of a vessel from Miletus.
 Length 9 cm. Smyrna, Archaeological Museum

over an hour-glass band. A simply painted, deep, two-handled small bowl from the burnt layer of the 'Geometric house' belongs to a very widespread type which appears in Corinth, Athens, the Cyclades and Rhodes, where earlier versions, lasting into the first half of the century, occur.[129] A vessel of the same shape is in the 'dense' or 'tinsel' style, which was most consistently developed in Athens[130] and was reflected in the Cyclades and in East Greece, although not on Rhodes.[131] The light style, a reaction in the direction of sub-Geometric, is also represented in Miletus.[132] The 'circle and small-circle (ringlet) style', which is ultimately derived from Protogeometric roots, and which flourishes again at the end of the Late Geometric period, is further evidence of the close connection between Miletus, Rhodes and Cyprus, in spite of indigenous Milesian art.[133] Finally on a very late kalathos with white ornamentation superimposed on a dark ground—metopes with St. Andrew's crosses—there is a colourfulness which goes beyond Geometric.[134] This ware is significant because it also appears on Samos.

Two thick sherds from large closed vessels, decorated with figured scenes, belong at the end of the eighth century or the beginning of the seventh. On one of these are swimming ducks (Fig. 65); on the other, a row of fat-bellied dancing demons, of which five are visible (Fig. 66). Both pictures are painted surprisingly freely on the vase surface. Pictures like this of animals and people had been used earlier by Samian painters, influenced by the important figure painting of Athenian High Geometric but remarkably independent of the canons of Geometric form which Attic painters carried through into their figure painting. This row of fat-bellied demons, the oldest known in Greek art, forms the prototype, until well into the sixth century, of the typical round-dance pictures in East Greece. Here, although still in the Geometric period, the eastern Ionian character begins to emerge. This can perhaps also be seen in the clay torso of a rider with Geometric decoration on his clothes (Fig. 67), where the lifelike shape is so un-Geometric. How different is a similar terracotta torso, admittedly somewhat older, from Dorian Rhodes (Fig. 68)![135]

b Old Smyrna

The important finds, mostly sherds, from the excavations begun after the Second World War in Old Smyrna (Bayrakli) under the direction of E. Akurgal, J. M. Cook and J. K. Brock, and in Pitane (Çandarli) and Phocaea under Akurgal, have not yet been published, with the exception of a preliminary report about the work at Bayrakli.[136] The Geometric vases and sherds from Bayrakli are in the Museum of Antiquities at Izmir (Smyrna), in the town's Old Museum, and in the Archaeological Institute at the University of Ankara, where the finds of pottery from Çandarli (Pitane) and from Phocaea are also kept. The author has been able to examine only samples from this material.[137]

Since the largest crop of Geometric finds comes from Old Smyrna, we will concentrate mainly on them. They begin with Ripe Protogeometric. A jug

66 Fragment of a vessel from Miletus.
Length 6.3 cm., height 4 cm. Smyrna, Archaeological
Museum

67 a–b Torso of a terracotta statuette of a rider from Miletus.
Height 7 cm. Smyrna, Archaeological Museum

68 a–b Torso of a terracotta statuette of a rider from Lindos
(Rhodos).
Height 12 cm. Istanbul, Archaeological Museum

or neck-handled amphora, about 45 cm. high, has been almost completely reconstructed. Its shoulder is decorated with concentric semicircles with an hour-glass motif inside. The shape of the vase is unusual. The foot has a narrow base, the neck is small and contracts sharply, while the surface of the vessel expands into a large sphere and then gently curves back down to the narrow foot. This shape is unique in the whole of Protogeometric pottery. But without doubt it can be derived from the Late Mycenaean shape of jar (Pl. 4). The only area of Protogeometric art where similar shapes occur is in post-Minoan and post-Mycenaean Crete, where traces of Late Mycenaean lasted longer than on the mainland and the other islands. Here, in groups of vases from a few graves in the Fortetsa necropolis, there are the same spherical, expanding shapes, then contraction into a narrow foot after a gently curving plunge of the outline, and small neck. This is obviously a kind of renaissance of Late Mycenaean shapes.[138] According to the very plausible Protogeometric chronology established by Brock, which is valid only for Crete, these groups of vases can be dated in the last quarter of the tenth century and the first third of the ninth.[139] For various reasons, we cannot assume any direct Cretan influence on Old Smyrna, but in view of the deep strata of Mycenaean pottery in the important colonies of the Mycenaean Greeks on the coast of Asia Minor and the offshore islands, we can assume that there was a widespread revival of Mycenaean forms in the Late Protogeometric period. The jug or neck-handled amphora from Old Smyrna can therefore probably be dated in the first half of the ninth century.

A large bell krater with a strongly everted lip and a simply curved, broad foot, no less than 52 cm. high, is more recent. On the zone between the two handles is a richly decorated band with a broad three-part triglyph in the middle consisting of a checkerboard pattern between two cross-hatched areas. To the left and right there are two metopes filled with concentric circles arranged vertically one above the other, each with an hour-glass motif inside. The metopes are enclosed by a cross-hatched triglyph. The decoration is from the transitional period between Late Protogeometric and Early Geometric. Fragments of an

Attic krater from the Kerameikos necropolis (Pl. 12), which Kübler dates, probably too early, at the end of the first half of the ninth century,[140] are closely related not only in shape but also in the arrangement of the decorations. The everted lip is Mycenaean (compare, for instance, the warrior vase from Mycenae) but continues into sub-Mycenaean and Protogeometric.[141] It has, however, a second groove, so that two encircling ribs as well as the lip protude from the vase. So far as is known to this author, the only exact equivalents are to be found amongst the large number of kraters from the Tholos tombs at Marmariane in Thessaly.[142] This very rich necropolis includes, according to the very careful studies of the excavators, finds from a period spanning 150 to 200 years. It is essentially Protogeometric, although its vases, while keeping to the Protogeometric style of ornamentation, extend into the second half of the ninth century. The dating of this extension of the traditional Protogeometric style in Thessaly is made easier by the appearance of Attic Early Geometric and Severe Geometric ornamental motifs such as the upright or battlement meander, parallel lines, and the four-spoked wheel instead of concentric circles.[143] The shape of the krater from Bayrakli is best seen in Marmariane in three kraters. Another one has the same shape of mouth, but with two necks.[144] These vases are amongst the most recent found there. Bearing in mind that the Marmariane pottery is probably further from the centre of events than that of the Aegean and East Greece, the krater from Old Smyrna would appear to belong roughly in the middle of the ninth century, give or take a quarter of a century.

The Protogeometric tradition of circle ornamentation can be traced in Old Smyrna in small bowls and small kraters well into the Late Geometric period. Sherds of small bowls of the Cycladic type with concentric semicircles suspended from the upper rim seem in view of their delicately shaped lips to be eighth century. A series of sherds of this kind, made of red clay, are painted on the inside with a light-red glaze similar to *terra sigillata*. They can hardly have been produced before 750 B.C. Sherds of large vessels, made of red clay and with concentric circles with a Maltese cross in the middle, can be recognized as comparatively late because of the way they are

drawn, with a fairly large gap between individual circles. A small black-ground krater which has a frieze of concentric circles in the handle zone has close parallels in Samos and Rhodes,[145] and it cannot be dated before the middle of the century.

There is a remarkable lack in Bayrakli of fragments of large imported Attic grave vases of the first half of the eighth century, or of native imitations of them, such as found in Rhodes and Miletus. This cannot be a coincidence. But in the third quarter of the century large fragments of Rhodian or Rhodianizing kraters appear, with decoration in the handle zone which it has been possible largely to reconstruct.[146] The base of the decoration of the first fragment (Fig. 69) is a carelessly drawn checkerboard band. The composition is strictly symmetrical. In the middle are two metopes, one on top of the other, each containing a cross-hatched triangle surmounted by a double meander hook at the apex. To the left and right there are two vertical borders containing a lozenge chain and a battlement meander with hatched bars in the recesses.[147] At both ends is an oblong metope with a hatched swastika standing on the checkerboard base. The main feature here is the central division of the panels, as on the krater from Myrina, whereas the handle zone on the other krater (Fig. 70) is dominated by five horizontal ornamental bands. The bottom band running under the handles is decorated with double-line zigzags. Starting at the bottom, the five friezes are: horizontal cross-hatched hour-glasses, with an upright hour-glass at each end;[148] open meander (interlocking meander hooks from above and below); hatched triangles; double-line zigzags; and open meander, with an upright hour-glass at each end. The broad central zone is flanked by identically constructed triglyphs on each side, containing an open meander, three panels, one above the other, with a swastika between two leaf stars—an atticizing feature—and a cross-hatched lozenge chain.

The last quarter of the eighth century is represented in Old Smyrna by two large amphorae with double belly handles, both the same shape, in the Museum in the Park of Culture at Izmir. The first is decorated in the circle and small-circle (ringlet) style from the beginning of the century, with its

69 Fragment of a krater from Old Smyrna.
Height 16 cm. Smyrna, Archaeological Museum

closest relative being a krater from the necropolis at Exochi near Lindos on Rhodes (Fig. 64). The main patterns are a 'woven' band, with a crown made up of small concentric rings on the neck and in the vertical frames of the middle zone in the handle area; concentric circles between which similar circles are suspended from encircling bands of strokes on the shoulder;[149] and, in the main zone between the handles, a net of four true spirals,[150] across which runs diagonally, like a sash, a wavy band which rolls up in the middle, into a small spiral. The panel is enclosed on top by a bar containing a cross-hatched lozenge chain, and underneath by a bar with a linear meander. The second obviously contemporary amphora is an example of the Geometric style in complete dissolution. On the main panel on the front

side there is a shoal of tunny fish, and on the back there is a metope with a bird, in a style well beyond the bounds of Geometric discipline; there are two owls to the left and right. The Geometric ornament—cross-hatched triangles with a border, and an eight-pointed star—is no longer self-sufficient, but serves as a scattered filling ornament in the picture panels. The orientalizing style has arrived.

The vases found at Old Smyrna begin in the Ripe Protogeometric style. It is possible to construct a rough chronological sequence, admittedly with certain gaps, as one can for Miletus. From the middle of the century onwards, a strongly Rhodian influence can be traced, a catalyst of a Late Geometric style. As in Miletus, however, at the same time as the gradual dissolution of the Geometric syntax is taking place, new eastern Ionian features can be seen for the first time in the freer approach, more attuned to the physical world, particularly in the animal pictures.

c Phocaea, Pitane and Chios

The few Geometric sherds from Phocaea give us very little information. A sherd of a rim with suspended concentric semicircles and a typical profile belongs to a small Cycladic bowl from the eighth century. Another sherd of a rim is technically highly sophisticated with a white slip. Parts of two metopes can still be recognized on it: a cross-hatched triangle with double meander hooks and two interlocking cross-hatched meander bars, perhaps a local imitation of the Rhodian bird-skyphos. More important, because certainly indigenous, is the thick sherd of a large vessel, probably a krater, with red on the inside. On the upper rim there is a frieze of individual meander sections, suspended from the upper frame, arranged like a spiral. Underneath are the remains of metope zones with 'meander spirals', zigzags and triglyphs with an oblique-hatched band in the middle. The unusual thing is that the individual zones are alternately white- and red-ground. This is, without a doubt, an early instance of colour in Geometric

70 Fragment of a krater from Old Smyrna.
Height 22 cm. Smyrna, Archaeological Museum

71 Fragment of a jug from Kato Phana (Chios).
 Chios, Museum

72 Handle of an amphora
 from Kato Phana (Chios).
 Chios, Museum

vase decoration, although this form of alternate-ground zones had no successors in orientalizing colour work. But more than a thousand years earlier, in the nineteenth and eighteenth centuries, Early Hittite pottery, which was derived from Cappadocian, used differently coloured decorative zones.[151] It is therefore reasonable to wonder whether an ancient practice from Asia Minor had not perhaps found its way to the Phocaean Greeks. But no connections have actually been established so far.

From Pitane (Çandarli), there is a Rhodian import worth mentioning, a squat jug with a bird metope which is undoubtedly even older than the squat jug in London (Pl. 93); also a very much later, richly decorated krater. The ornaments are all still pure Geometric, but the syntax has completely collapsed. In the area between the handles are metopes containing widely different motifs: a framed panel with checkerboard pattern, a cross-hatched triangle with double meander hooks on the apex, a quatrefoil with stars in two concentric circles, and a panel consisting of four meander squares. Only a few traces of the triglyphs remain. But there are no metopes nor symmetry in the design. The double frieze around the belly underneath the handle sits all the firmer for this. It consists of a hatched zigzag band and an hour-glass frieze. The two vases span the period from the middle of the eighth century until the turn of the century. No information has been forth-

coming as to whether even earlier stages of Geometric have been found at Pitane. Meanwhile, it appears that the Rhodian influence was fundamental in the Aeolian area, too, in the Late Geometric period, although without any native style developing out of it as it did in the Ionian towns.

On the island of Chios, in ancient Phanai, the small finds from the Geometric period also consist only of sherds.[152] Only a few of these belong to a period earlier than Late Geometric. The fragment (neck and shoulder) of a jug (Fig. 71) is still in the Protometric tradition, with a glazed neck and spoked wheels flanking a central triglyph with a cross-hatched area on the shoulder. This vessel would probably have been produced around the end of the ninth century.[153] An amphora handle (Fig. 72) and a sherd of a small bowl probably come from imported Attic vessels.[154] The amphora could probably be placed, leaving a good margin of accuracy in either direction, around the turn of the ninth to the eighth century. The small bowl belongs in the first half of the eighth century.

Late Geometric begins on Chios around the middle of the century. Attic Geometric style retreats into the background and the Geometric idiom of the Dodecanese begins to exert its long-range influence over Chios as it did over Ionia. Cross-hatched triangles, lozenge chains with or without borders, double or triple-line zigzag bands making friezes (with recesses

sometimes filled with dots) or filling whole zones, hatched or battlement meanders, linear meanders or interlocking right-angled bars—these are the dominant motifs of the new style. Dotted meander bands characterize the latest phase of Geometric. But the Chiot sherds, in spite of their derivation from the eastern Ionian style and ultimately from the Rhodian, do have a consistent character of their own. As well as red-clay vessels with brown-black painted decoration, there is a more technically sophisticated type, with vases covered with white slip. Smaller thin-walled open vessels are particularly fine; in these, both the outside and the inside surfaces are slipped in a light cream-white colour.[155] The brown geometric patterns stand out with freshness and clarity against this light ground. The Chiots avoid using the numerous but not always successful variants of the meander, triangle, lozenge and lozenge-cross which occur in the East Greek style. They limit themselves to a selection of basic elements. Exceptional care is taken over the positioning of geometric patterns in their zones, and triglyphs against the white background. Dominant features of the decoration are simplicity, clear arrangement of elements and precise drawing. But it is not the precision of Athenian High Geometric. It is not, as in Athens, based on Geometric principles, but is striving for a delicate and perfect sublimation of East Greek ornamentation as ornamentation. This sublime rebirth of Geometric becomes a fashionable decoration which then develops without a break into the plant motif of the orientalizing style.[156]

As in the whole eastern Ionian area, the figured picture found its way, not entirely independently of Athens, into Chios. Of course, bird friezes and bird metopes, perhaps also the ibex, are common in the East Greek style.[157] But horses, striding warriors with round shields, a helmeted warrior with jagged crest, a warrior with a shield and a spear fighting a lion, and a rider on a horse, all seem ultimately to be derived from the Cyclades and Athens.[158] The pictures are all later than the middle of the century. Absurdities such as the battle with the lion in which the warrior turns his back to the animal, and the confusion between left and right in the weapons indicate the derivativeness of this figured art. Nevertheless

the way that the long spear projects beyond the picture area well into the geometric decoration of the triglyph is a particularly fresh feature.

d Samos

After this conspectus of eastern Ionian Geometric art, let us go back to the Samian finds. The only completely preserved vessel is an oinochoë with a trefoil lip and a wide body on a comparatively narrow ring base. This probably did not come from the Sanctuary of Hera. It appears to have found its way into the museum at Vathy without any record of

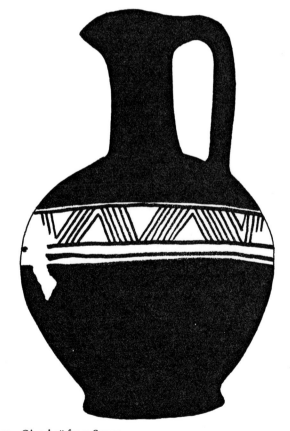

73 Oinochoë from Samos.
Height 27.5 cm. Samos, Museum

where it came from (Fig. 73). This type of jug, with its strong contrast between the narrow neck and the almost spherical body has virtually no predecessors in Protogeometric. No parallels have been found in Geometric either on the mainland, or in the Cyclades, Crete or Thera. But later versions of it do often occur in the area around Rhodes (Fig. 48).[159] It appeared in Attica before the middle of the century in monumental form, with globular body and exaggeratedly long neck and handle, without any indigenous precedents.[160] But on the basis of its decoration the Samian jug can be dated earlier than these parallels. On a reserved area opposite the handle there are extremely precisely drawn parallel zigzag lines, and at the point of the maximum circumference of the body there are opposed groups of bars, without black paint in the gaps; both ornaments are enclosed by double lines. The black-ground style of the jug continues, in Athens too, into the second quarter of the eighth century, as does the zigzag zone on the neck. The frieze of opposed groups of bars, on the other hand, is specifically Protogeometric and Early Geometric. But the jug as a whole, with its brownish-red clay and light coloured slip on the outside, is obviously made by Samian potters. The ornaments suggest an older style, without any sign of influence from the High Geometric art of Athens with its articulation of patterns, and still a long way from the finely divided compositions of Late Geometric Rhodian art and its eastern Ionian version. This vessel should probably be dated at the earliest in the first half of the eighth century.

The rich finds of sherds from the Sanctuary of Hera begin around the middle of the eighth century and are obviously connected much more with the Cyclades and the mainland than with Rhodian pottery. It is possible to discern here, around the middle of the century and well into the third quarter, an atticizing fashion which is not limited to the large vessels, the kraters and the jugs, as it is in the Rhodian area, but which extends across various types of vessels, both large and small. Whereas the Rhodian painters concentrated on Attic types, the Samians pluck the blooms of Attic decoration wherever they can use them. They are altogether more flexible in the way they adopt Attic patterns.

Attic elements in Samian Geometric vases

The oldest approximately datable evidence of the appearance of Attic elements in Samian pottery is found on a sherd of a krater (Fig. 74). Its simple composition fits into the East Greek Protogeometric tradition of metope zones between three-bar triglyphs. But the concentric circles have turned into 'mill wheels' with a Maltese cross in the middle. Mill wheels like this, but with four spokes in the middle, are also found from the late ninth century onwards on Attic kraters (Pl. 12).[161] The closest detailed parallels, however, are the mill wheels on a krater from Athens in New York (Pl. 34), which can be dated amongst the first of the large grave kraters, at the latest in the middle of the second quarter of the century.[162] There can be no doubt that the Samian painter was copying, any more than there can be doubt about the fact that there was a slight delay before the appearance of this motif in Samos. Thus the Attic fashion would have arrived here about the same time as in Rhodes.

A fragment of a plate is related to the krater sherd, but is slightly later. It has a Maltese cross in the middle and a ring of rays, rather than paddles, around two concentric circles. These also replace the paddle rim in the Attic style on a later parallel of the New York krater and on many later Attic kraters.[163] A ring of rays surrounds the wheel motif on another plate, with a ten-pointed star in the middle and alternating filled lozenges and pointed leaves instead of the eight spokes.[164] Eight-leafed stars also appear on the inside of plates as decoration, either red-

74 Decoration on a krater fragment from Samos

figured on a black ground, or with the points of the leaves joined together by garland-like cross-leaves, with interstices filled with swastikas. Here, it is circular compositions on the bottoms of the flat Attic pyxides which the Samian painters have copied.[165] The Attic prototypes all belong to the second quarter and the middle of the century. Simpler, more severe pyxis bottoms of the same kind, last in Athens up to the end of the ninth century.[166] In Samos, however, these preliminary stages are missing. A large plate fragment has a more austere decoration, with encircling bands with zigzags, and strokes from above and below, interlocking like teeth. The closest parallels to this, although obviously older in view of the care with which they are drawn, are pyxis lids in Athens.[167]

Also imitated around the middle of the century are Attic bowls with simple star metopes, and those whose only decoration was identically shaped bird metopes in the handle zone. These latter may probably be assumed to have been contemporary predecessors of Attic high-rimmed bowls. The identical frieze of individual bird metopes appears in Samos on a kantharos (Pl. 98). The pictures, with their tall birds with Geometric wings slightly raised, have a liveliness of their own.[168] Eilmann was probably right in identifying a large kantharos or krater, of which sherds came to light in Samos (Fig. 40), as a Cycladic import; two bird metopes and a quatrefoil metope were reconstructed from these sherds. However, a number of bowls around the middle of the century, with two opposed bird metopes flanking a quatrefoil, are Attic, and they indicate the origin of the decorative motif on the Cycladic vessel described above. Now there is a sherd of a bird-bowl of this type from the Sanctuary of Hera. This would be obviously Attic, to judge by the filling ornaments and the drawing of the birds and the frames, were it not for the fact that the clay and the workmanship suggest that it is more likely to be of Samian origin. This sherd must be either from an exact copy of an Attic bowl, or by a painter familiar with Attic techniques who worked in Samos.[169]

Bowls and kantharoi with uninterrupted outlines, without projecting lips or feet, belong in the third quarter of the century. On the exterior they have delicate vertical strokes across the curvature, or more commonly, groups of strokes separated by club-like black ribs. Fragments of a bowl and a kantharos of this type have been found in the Heraion in Samos.[170] Also found in Samos, from the end of the atticizing period, were indigenous sherds of a typically Attic type of bowl of the Late Geometric epoch, the so-called deep bowls, which were usually painted inside and outside. The connection with Attic bowls is established by the fact that, as on the Attic bowls, the painted ornaments and animal friezes on the outside around the foot are standing 'on their heads'. The deep bowls were obviously stored upside-down so that one saw them, as it were, foot first; what remains of a bird metope in the lower frieze is upside-down.[171] The shape and use of these ornaments are copied from Attic art, although the ornaments are no longer pure Attic but a mixture of Attic and Rhodian influences: the inside is only black-glazed and unpainted.

We need not be surprised that specifically Athenian grave vases—monumental amphorae with belly handles and the large kraters—are not reflected in the Heraion finds. But not even the key shapes of vessels produced by High Geometric potters of the second quarter of the century in Athens, huge jugs with heavy necks, globular jugs with narrow necks and high-rimmed bowls—the ultimate in Geometric shapes—or the Attic meander and its main variants, or the Geometric version of the human figure, had any influence on Samian potters and painters. These achievements of a truly great art, developed during the course of a whole century, never reached the Samians. It did not, however, prevent them copying, comparatively late, the subjects of figured pictures, such as the death cult and battle scenes.[172] But it was not until the post-Geometric period that figured art achieved its zenith in East Greece.

Rhodian influences on Samian Geometric vases

From the third quarter of the century onwards in Samos, as everywhere else in East Greece, the formal idiom developed on Rhodes begins to penetrate and push the Attic prototypes into the background. The extent to which this took place can be seen from a

75 Pyxis from Samos.
 Height 11 cm. Samos, Museum

quick glance at the decoration on four sherds put together by Technau: we find a cross-hatched triangle with double meander volutes at the apex, a cross with meander volutes around a central lozenge, and —already sub-Geometric—concave and convex curved triangles and lozenges filled with oblique checkerboard patterns.[173]

We begin with an almost completely preserved flat handleless pyxis (Fig. 75), with high, slightly concave rim and sloping bottom angled sharply away from the upright sides, leading down to a wide, low conical foot. The lid is missing; there is no light-coloured slip. The pyxis was found in 1954 in the Sanctuary of Hera. The shape is like that of a lathe-turned wooden vessel and is without a parallel in the west in the Geometric period. Similar types of vessel were developed on Cyprus and Rhodes in the southeast (Fig. 44),[174] where we believed that we had discovered a derivation from non-ceramic models

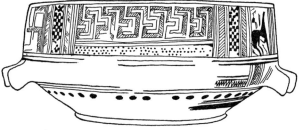

76 Bowl.
 Height 10 cm. Athens, National Museum

such as wooden tubs inlaid with different coloured woods.[175] But older and equally simple basic types such as the Samian pyxis do not yet appear to have been found there. Amongst the numerous Attic high-rimmed bowls, a product of the High Geometric, there is only one with the simple structure of this pyxis, with its contrast of almost upright walls and sloping bottom (Fig. 76).[176] The lower part of this bowl, with its noticeable bulge, is stunted so that the handles point downwards without producing a sharp angle. There is also a ring base instead of the low foot. The similarity between this vessel and the Samian vessel may be coincidence. Nevertheless it should be noticed that the checkerboard zone, or the checkerboard triglyph alternating with meander sections, lozenges or leaf stars, dominates the side decoration of the high-rimmed bowl from its first appearance onwards (Pl. 22).[177] Thus we should probably assume that high-rimmed bowls were copied from East Greek pyxides rather than vice versa. On the Samian pyxis, checkerboard zones alternate with a complicated meander composition. Antithetical meander spirals grow downwards and upwards from a central meander beam. The painter worked from right to left, so that the meander elements have diagonals pointing to the left. The squares which were left at the top right and bottom left were fitted with extra meander sections. This is reminiscent of Rhodian ornamentation and Phrygian marquetry, such as the throne from Gordion (Fig. 50).[178] The pyxis cannot be older than the first appearance of the meander in Rhodes and was probably produced around the middle of the eighth century, or at the latest at the beginning of the third quarter of the century. But older and more primitive influences are easy to recognize.

Eilmann succeeded in reconstructing from sherds a series of clay-ground ornamental panels from Rhodianizing skyphoi. These panels appear between the handles on vessels which are otherwise black-glazed (Figs. 77, 78). This is the type of vessel which we have previously called 'trademark ware'.[179] The base of the panels is usually a frieze of hour-glass motifs, although on two skyphoi it consists of a

77 Ornamental systems on skyphoi from Samos

78 Ornamental systems on skyphoi from Samos

simple zigzag and lozenge chain respectively. Four metopes usually surmount the base (there are three metopes in one case and five in another). In all the panels the outside metopes contain lozenges; in one panel, the lozenges are divided into four. On four of the panels the light-bordered, cross-hatched triangle with a meander volute appears. The rest of the space is taken up by a bird metope in two panels, interlocking meander hooks in two others, and a zigzag filling in one.

All the patterns on Samian skyphoi are of Rhodian origin, where they are also found on kantharoi and kraters. Only one of the Samian skyphoi, which is particularly finely worked, corresponds to Rhodian 'trademark ware' in every detail, including the N-shaped filling ornament (Fig. 78). Three examples of this uniform type were imported to Thera from Rhodes.[180] But this skyphos cannot have come to Samos as a Rhodian import in view of the fine workmanship and the replacement of the stereotyped

79 Decoration on a krater from Samos

hour-glass frieze by a simple zigzag band. One must assume it to be a remarkably accurate copy by Samian potters. Another sherd of a bird-skyphos[181] can be regarded as a copy of a Rhodian vessel with more painstaking workmanship. On the other hand, an isolated skyphos fragment[182] seems to have belonged to an imported vessel from Chios. Dotted meander hooks, typical of Chiot pottery, turn up on a Samian skyphos again; but in both this metope filling and the Rhodian zigzag zone on another Samian skyphos (Fig. 77), a distinctive Samian touch can be discerned which is different from both Rhodian and Chiot examples.

A second, albeit non-funerary variant of Rhodian vessels is seen on Samos in two skyphoi and a krater. Their decoration consists only of patternwork. On the first skyphos, above the hour-glass frieze and between the outside lozenges, are two friezes of linear meander hooks and a zigzag respectively (Fig. 78). On the other skyphos, between double lozenges, one above the other, there runs a triple zigzag band, twice as tall, with antithetical meander volutes[183] rolled up to the right or to the left. On the krater there is a veritable tableau of Rhodian patternwork (Fig. 79), with three continuous friezes of increasing compactness and detail: a broad clay-ground zigzag band with gaps filled to make cross-hatched triangles; an hour-glass frieze with similarly filled gaps; and a black-glazed zigzag band with gaps which can be read as framed triangles. Above these is a taller frieze composed of five metopes, with alternately zigzag zones or lozenge nets, the latter forming the outside and central metopes. Here it is not only the

patternwork but also the system that is copied. It is found already fully developed on a skyphos from Ialysos on Rhodes.[184]

The Samian painters do not, however, merely copy Rhodian skyphoi. Of the three bird-skyphoi from the Heraion of Samos, only one is an exact copy of the Rhodian type (Fig. 78), which made a particularly successful export because of its uniformity. The range of new variants in the others demonstrates the lively imagination of the Samians. Transference of the skyphos decoration on to the larger surfaces of the krater, as found on Samos, also occurs on Rhodes, especially in the metope areas near the upper rim.[185] The closest parallel is a splendid, strongly Rhodianizing krater fragment from Old Smyrna (Fig. 70), on which five friezes, framed on the sides by broad triglyphs, decorate the middle of the handle zone. The Samian fragment excels all other parallels, however, in the inner structural balance of the friezes, the compactness of the system and the fine rhythm of the structure. The painter must have had some idea of the great Attic High Geometric artforms even though it may have been

80 Decoration on a krater from Samos

81 Decoration on a fragment of a krateriskos from Samos

not Attic but Rhodian patterns that he assimilated.[186] The urges towards simplification of the often overly complicated Rhodian metope zones and towards monumental enclosed compositions, are undoubtedly the basic features of Samian pottery and can be seen in every piece which rises above the mediocre.[187]

The Samians' emphasis on simplicity and clarity in their selection of Rhodian ornamental vocabulary is also demonstrated in their individual patterns. The transition from the hatched to the cross-hatched meander is found in Samos as in Rhodes (Fig. 88).[188] But the numerous and often undisciplined variants of the meander which were typical of Rhodes and Miletus[189] do not occur amongst the finds from the Samian Heraion. The battlement meander on a Samian krateriskos (Fig. 81), where the openings are filled on one side with zigzags and on the other with narrow triangles, does occur in similar form on an as yet unpublished krater fragment from Old Smyrna, but is derived from a thoroughly Attic prototype.[190] So the Attic tradition was obviously not completely driven out of Samos by the Rhodianizing fashion. This is perhaps best demonstrated by a large fragment from one of the most beautiful Samian vessels, a krater (Fig. 80). In the central zone there is a perfectly drawn two-step meander such as is found in Attic High Geometric. The meander zone is framed above and below, and probably also on both sides, by a zigzag band, as is often found on still unpublished Samian krater sherds. These horizontal friezes are flanked by narrow upright metope zones which are symmetrical. A narrow triangle with a checkerboard pattern projects downwards, with its apex touching the base; next to this are two pedestals, with square and checkerboard patterns respectively; on each is a bird facing inwards. This composition is not unique. Its closest relative is in the shoulder decoration on an amphora from Thera in the Nomikos collection (Fig. 82).[191] Here the motif does not make a metope, but is used as a divider between the large medallion-like circles on the shoulder, like a triglyph completely given over to figures, filling the whole of the open space. Between two standing birds is a zigzag column, like a gnarled tree trunk, with hooks at each apex being pecked by birds. Above this is a cross-beam with two hour-glasses, like a capital or treetop, above which is an inverted patterned triangle with its apex on the cross-beam.[192] This positively baroque composition is probably Theran, although it uses Rhodian elements. The triangle is filled not with a checkerboard pattern but with an oblique lozenge net spherically formed. It belongs to the squat Rhodian jugs of which fragments were also found in Thera. The Theran composition is certainly not derived from Samos, but from much simpler Rhodian antecedents which have been lost. But if one compares the Samian krater sherd, in which Attic and Rhodian are mixed,

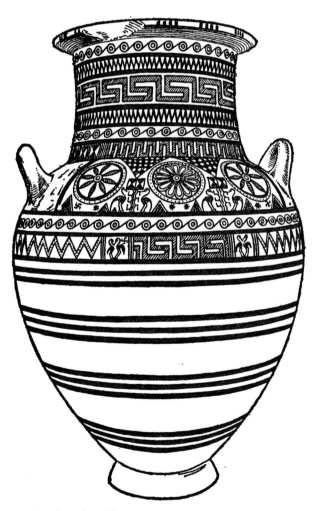

82 Amphora from Thera.
Height 77 cm. Thera, Nomikos Collection

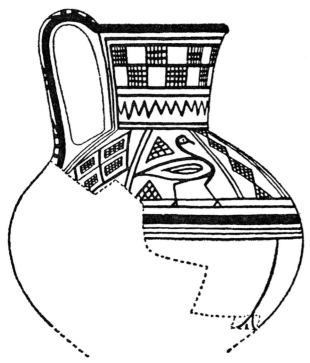

83a Fragment of a jug from Samos.
Overall height about 27 cm. Samos, Museum

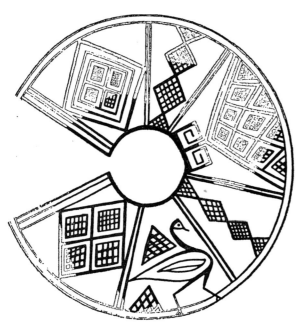

83b Shoulder decoration of the jug shown in Fig. 83a

with the Theran amphora, the classic simplicity and monumental rhythms of Samian vase painting are again highlighted.

The Late style of Samian Geometric pottery

The specifically Late style of Samian pottery, the remnants of which belong mostly in the last quarter and around the turn of the eighth century, takes on a new appearance. For a time, while Rhodian Geometric carries on, eastern Ionia and the Cyclades are also flooded by the circle and small-circle (ringlet) style from Cyprus, the southwest of Asia Minor and the Dorian Islands. This style can also be seen as a last revival of a simplified and ossified Protogeometric tradition. At the same time, imitations of Protocorinthian small bowls and kotylai, coming probably via the Cyclades, arrive in Samos. But the apparently rich Geometric style of decoration is also the beginning of the complete collapse of Samian Geometric.

A Samian jug approximately 27 cm. high (Fig. 83), a development of the Rhodian squat jug, is still in the Rhodian tradition. The shoulder curve is smoothed out and the handle rises somewhat above the mouth. The body below the middle, and parts of the neck, are not black-glazed, indeed the whole vessel has a light slip glaze. Whereas neck and shoulder are decorated Geometrically, the lower part is virtually undecorated apart from the widely spaced lines which are drawn from the base up to the middle of the body, encompassing the vase like a calyx—early forerunners of the coming orientalizing style. The same trend can be seen in the way the Samian painter has used, as the base of his shoulder frieze, not the stereotyped hour-glass pattern found on blackground Rhodians jugs, but a simple stripe with parallel lines. The shoulder decoration is, as it is on Rhodian squat jugs, borrowed from bird-skyphoi. There are four metope zones with subdivided lozenges at both ends, and in the middle on the left, a proud strutting bird, and on the right a triangle filled with a lozenge net, with a double meander volute at the apex, flanked on each side by a triglyph containing a vertical lozenge chain. The neck decoration, a double row of cross-hatched checkerboard

zones on top of a zigzag band, has the same wide-spaced layout. The decoration is consistently linear, gaily applied in the bird, avoiding any 'colourful' contrast between black and white surfaces. On the other hand the subdivision of the light areas—it is only in the typical bird metope that there are any filling ornaments—gives a delightful effect from the checkerboards on the neck to the wide, airy and shiny surface between the lines running up from the foot. This jug is gradually moving away from Geometric form and can probably be dated, at the earliest, in the last decade of the eighth century.

A new 'circle style' also occurs in this Late period, a style which spread from Cyprus through southern Asia Minor, Crete, Rhodes and eastern Ionia. It is remarkable in that it goes back to the simplest type of Protogeometric circle decoration. It fulfils the desire for large surfaces, for light areas undisturbed by filling ornament, and for lighter, less complicated patterns, all typical of gradually declining Geometric in East Greece. An amphora with neck and belly handles from Camirus on Rhodes, with cross-hatched meander hooks on the neck which are an unmistakable sign of a late date, a kalathos from Crete, and two large krater sherds from Samos and Bayrakli are entirely black except for a reserved handle zone with concentric circles.[193] These are distinguished from Protogeometric by being limited to four circles rather further apart than in Protogeometric. Other sherds have only three circles with, sometimes, the inner and outer rings—'hub' and 'rim'—painted more heavily than the intermediate circles. Three of these sherds are decorated at the top with snaky lines which are incised, another clue to a later date.[194] In another version of this concentric-circle frieze decoration, only hub and rim appear, with clay ground between them. This occurs on sherds of rims from clay votive shields and on a fragment from the shoulder of a jug.[195] The same ornament, enriched by small lozenges connecting the circles, is found on a krater, one of the few almost completely reconstructed vessels from Samos (Fig. 84). Like the jug fragment mentioned above and the squat jug (Fig. 83), this is clay-ground. The whole lower part is predominantly decorated with horizontal lines, with two narrow friezes of groups of wavy strokes on the lower part of the bowl, and with vertical strokes at the foot and on the upper rim. The decoration, including the circle frieze, is reminiscent of Protocorinthian. Only the shape of the vessel, with its slightly concave stem and the convex foot, connects it with the series of Rhodian kraters from the eighth century.[196] It is the most recent vessel of its kind and was found with other relics from the same period, the beginning of the seventh century, near the shore. It may have been produced around the turn of the century.

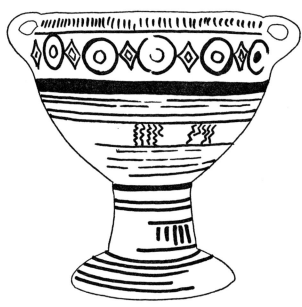

84 Krater from Samos.
Height 27 cm. Samos, Museum

A variant, which we will call the 'ringlet' style, is closely related to the circle style and was originally connected with it. It first appears in its most simple form on sherds of kantharoi from Samos (Fig. 85), found under the paving of Altar VII. The ringlets consist of, at the most, three small concentric circles. These form low frieze bands often connected by tangents. They function as filling patterns between large four-spoked wheels connected by tangential groups of lines. On metopes and handles they also appear connected in chains by oblique groups of lines.[197] On the inside of bowls, complete ornamental

systems are made up of ringlets which overlap each other and which can also appear as semicircles.[198] That this ringlet style comes from the east and spreads from there through the Greek towns in Asia Minor and the offshore islands can no longer be doubted. In the museum at Vathy on Samos there is an unpublished ivory plaque on which are engraved a larger and a smaller 'woven' band in minute and painstaking detail. The rim is decorated with an encircling frieze which consists of circles with only rims and centre points, with a ringlet filling the interstices on top and underneath. It is a motif which often appears on Milesian pottery.

The island of Cyprus was one of the main centres of the circle and ringlet style at the end of the eighth century and beyond, so far as we can deduce from pottery.[199] According to E. Gjerstad's classification the ringlet style begins in the so-called 'White Painted III' phase. In 'White Painted IV' it achieves richer compositions, such as the combinations with the circle style, and the chains of overlapping ringlets.[200] The groups 'Bichrome III' and 'Bichrome IV' are similarly related. In 'Bichrome V' the distinctions are less clear and the ringlet is no longer subordinate to the circle, with the overall picture having a clear tectonic structure.[201] The ringlet is predominant on vessels in the group 'Black on Red II' (IV), while the richest combinations are on 'Bichrome Red I' (IV). In the 'Black on Red III' (V) group, the ringlet craze dies down as the first orientalizing motifs begin to appear, and calmer tectonic interrelationships begin to be established.[202] One can see how Samian potters, in spite of influence by eastern fashions, shunned exaggeration and reduced the circle and ringlet style to tectonic decoration.

The loosening of the system, the crippling of the Geometric inventiveness and its reduction to a few stereotyped formulae also occur, particularly often on small vessels, especially on bowls, skyphoi, and plates from the last quarter of the eighth century. Only the handle zone is decorated, with a narrow clay-ground band. Broad metope panels are set between multi-line triglyphs with only two zigzag lines or herringbones floating, as it were, in the air. The closely packed patterns of Geometric give way to light decorative-tectonic compositions. Vessels of this kind are often found on the Heraion of Samos.[203] The richest composition is on the inside of a bowl (Fig. 86). In the middle there are concentric circles,

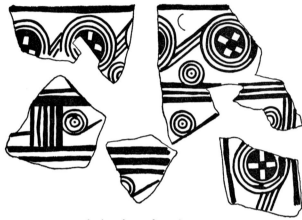

85 Fragments of a kantharos from Samos. Samos, Museum

thicker towards the outside edge. Around these is a floating frieze of herringbone chains angled outwards, similar to the paddles on a mill wheel. The second frieze consists of the familiar metopes with herringbones and line triglyphs. It hardly needs proving that this heralds the arrival of the influence of western, mainland, originally Corinthian-Protocorinthian Geometric art.[204] This straightforward and, in the better cases, elegant style of decoration spread beyond Corinth to, for instance, Athens.[205] A few less accurate imitations have been found in the Cyclades.[206] Thus we can trace a style rippling out from Corinthian Geometric to reach Samos. So it appears that Samian pottery, in the phase of the beginning of the decline of Geometric, was subject to new influences from the east and from the west. These enabled it to evolve, with Geometric tools, a simple, lightened type of ornament which it reduces to something purely decorative at the same time. *Mutatis mutandis*, Athens, the home of the Geometric style, also followed the same path, during the last phase of Late Geometric, although the process was more radical.[207] This was a widespread phenomenon towards the end of Geometric art. The time had come to make way for orientalizing pictures and patterns.

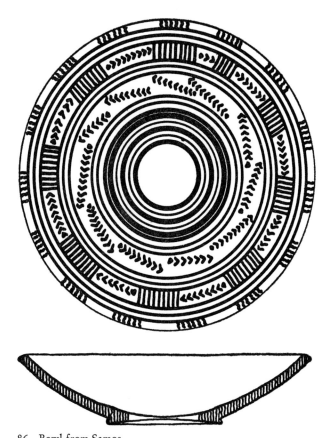

86 Bowl from Samos.
Diameter about 19 cm. Samos, Museum

Figured scenes

Even though very much in retreat in comparison with the ornamental decoration of vases, figured pictures do find their way into Samian pottery in the Geometric period, more so than in other centres of East Greece. Here it is only the west—the Cyclades and indirectly, Athens—which influenced the Samians. The new motifs were mostly used on small amphorae, kraters and kantharoi in the Late Geometric period.

The comparatively common pictures of horses, either by themselves or grazing in herds, are particularly noticeable. A shoulder fragment from an amphoriskos is revealing.[208]: the horse is tied up, probably in a stable, indicated by a manger; its haunches are strongly emphasized; the mane, indi-

cated with horizontal lines, covers the high neck; the eye is reserved, taking up almost the whole cheek; a double axe is suspended above the back, flanked by two dot-rosettes. The double-axe motif in the horse metope also appears in Athens, Boeotia and the Cyclades. The closest parallels to the Samian amphoriskos are, however, the horse metopes on the large Geometric krater from Kourion on Cyprus, in New York (Pl. 82). The type and the drawing of the horses are the same. Next to the double axe, instead of the two dot-rosettes, are two stars. The krater found in Cyprus, which was for a long time thought to be Attic, is clearly attributed by Kontoleon to the 'Naxian' group.[209] A number of kraters in Amsterdam (Pl. 80), Athens, Sèvres and Munich,[210] with very similar types of horses, are also Cycladic. The Kourion krater probably dates from the middle of the eighth century or shortly before that, which puts the Samian amphoriskos sherd in the third quarter of the century.

This fragment of an amphoriskos is the earliest example of a horse picture on Samos and the only one which is clearly of Cycladic origin. Other pictures are of a type which has never been proved to exist outside Samos and must undoubtedly be regarded as Samian (Figs. 87-89).[211] These horses are fairly heavy and squat, with heavily developed hindquarters and shoulders. The neck is not exaggerated. The strongly emphasized mane is shown in contour, hatched or cross-hatched, set on the neck and head like a wig. The large reserved eye is correctly placed. The horses plod forward with heavy hooves. The age of long-legged mythical stallions with enormous necks, as in the Homeric epics and High Geometric, is past. Representation of ideas gives way to representation of reality. This change first occurs in Athens in the last quarter of the eighth century.[212] The horse appears not only by itself in metopes, but also in herds, grazing (Figs. 87, 88). The grazing horse is comparatively late in Athens as well.[213] On a kantharos which is virtually complete (Fig. 87), the decorative patterns consist of the Rhodian lozenge-crosses with meander volutes (Fig. 63, l) and columns of inverted triangles as on sherds from the beginning of the ringlet style.[214] Finally, on three fragments of a Samian krater (Fig. 89), a grazing long-legged horse

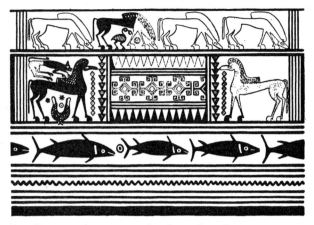

87 Ornamental system on a kantharos from Samos

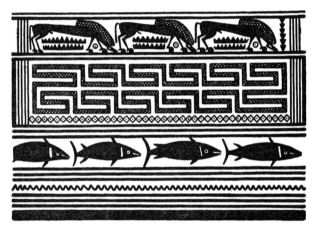

88 Ornamental system on a kantharos from Samos

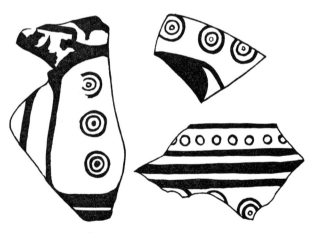

89 Fragments of a krater from Samos.
Samos, Museum

of the Cycladic type, with a wig-mane, appears. This must have been part of a frieze. The filling ornament, however, indicates developed ringlet style. The Cycladic type of horse picture obviously lived on and was adapted to the Samian style. This all proves that the more natural Samian type of horse developed in the last phase of Geometric.

A lion leaping in attack appears above the back of the horse in the surviving metope of the kantharos (Fig. 87). On sherds of a pyxis[215] a powerful lion is stalking its prey. Here, too, the animal frieze continues round the vessel. There was probably more than one beast of prey breaking into this herd. Pictures of the lions and lion fights appeared considerably earlier in Cretan embossed metalwork and Attic pottery as a result of the import of embossed Syrian-Phoenician bronze bowls. But Samian workshops first became acquainted with these images in the last phase of Geometric via Attic and Boeotian pottery, where scenes of stalking and attack were portrayed with the chase taking place in the middle of the open zone, well above the bottom line.[216] The most exact parallel to the pyxis sherds above, as Eilmann has pointed out, is a Boeotian jug with a trefoil lip, in the 'tinsel' style (Pls. 99, 100). Here there are even the framed cross-hatched triangles on the base.[217] The close links between Boeotia and the Cyclades make them the most probable route followed by the earliest Oriental influence to arrive in Samos.

The human figure is also found on the sherds from the Samian Heraion. A fragment of a large kantharos (Pl. 97) depicts the lying-in-state of a dead man. On the *kliné*, of which only the right part is still extant, the dead man is lying full face to the onlooker. Both legs, the right shoulder and the arm are still recognizable. The corpse is lying on a mattress raised at the head. Like the corpse, the shroud, decorated with dots, is also in the same plane as the picture, the whole being visible. Underneath (that is in front of) the *kliné*, two mourning women are kneeling. At the end of the picture, to the left and right, are two warriors with Dipylon shields, spears and helmets; one of them is raising his arm in a salute to the dead man.[218] Another sherd, probably from an amphora, shows part of a frieze of teams of horses being driven.[219] Bits of two teams can be made out. The

90 Fragments of a skyphos from Samos. Samos, Museum

same high, heavy wheels are found on Attic grave amphorae from the last quarter of the century. Two sherds are also comparatively late (Fig. 90); according to Technau, these come from a large skyphos. On the first sherd are the remnants of three running or marching warriors with round shields; on the second, part of one soldier. They obviously belong to a frieze of warriors marching in a line.[220]

The themes of the figured pictures—prothesis, chariot processions and marching warriors—are all associated with the funerary rites which are also depicted on Attic neck-handled amphorae from the second half of the eighth century.[221] So here we can clearly recognize derivation from the great Attic grave vases from the middle of the century onwards. But the find is ambiguous. The *kliné*, corpse and the two Dipylon warriors were probably contemporary Attic types. But it was only the *type* which was copied. The daring, superb conquest of the human figure in the context of Geometric formal syntax, achieved in High Geometric before the end of the century, did not occur again on Samos. The way the Athenians turned static 'lay figures' into striding, kneeling and lying forms must have seemed strange to the Samians. It cannot have been Attic antecedents, such as the skyphos from Eleusis (Pls. 27, 28) with moving figures in open space, apparently copied from old Mycenaean frescoes, which led to the later more dynamic figured fragments from Samos, where there is a different approach, without the plasticity or the visual expressiveness of Athenian figured art.

The mourning women in front of the *kliné* on the kantharos fragment (Pl. 97) appear to be kneeling, like the corresponding figures on a number of Attic pictures of protheses. But their knees are not touching the ground. Was this an illustration of the act of kneeling down, caught half-way, to bring out the inner dynamic of the scene? Is it some kind of ceremonial gesture? The warriors with round shields on the skyphos fragments (Fig. 90) are not so much walking as running or dancing, with knees bent. Again, on the above-mentioned krater sherd (?) from near-by Miletus (Fig. 66), the fat-bellied dancers all have bent legs, almost in the sitting position.[222] These pictures, which can be traced down into the Late Archaic period, show a special world which distinguishes eastern Ionia from the mainland. This expressively exaggerated pantomimic gesture can probably be classified as Dionysian.

e Summary

Of the places where Geometric finds have been made, it is only in Miletus that examples (often only a few sherds) are found from the end of the Mycenaean period onwards, through all the stylistic phases of East Greek pottery. The final Mycenaean stratum is followed by sub-Mycenaean and then by Protogeometric, which seems to break off suddenly at the transition to Early Geometric. Large regular-shaped jugs such as were found in Athens in the Protogeometric and Early Geometric graves had no successors in Miletus.[223] The prototypes of the vessels produced in Miletus were, as in the Cyclades, more Corinthian than Attic.[224] The stratum may be interrupted, but the break is more likely to signify a rejection of the Attic style after Protogeometric. While Attica progressed from Early Geometric through Ripe Geometric to High Geometric, rising to ever greater heights of artistic achievement, other places, like the Argolid, Corinth, Boeotia, Laconia, and later the Cyclades, Thera and Crete, all imitated Athens to a greater or lesser extent. But the East Greeks, Dorian Rhodians and eastern Ionians remained, until well into the eighth century, prisoners of an extension of traditional Protogeometric (Protogeometric B), although occasional Attic touches did, from time to time, occur—as in, for instance, the development of con-

centric circles into four-spoked wheels with or without paddles on the rims. The same extension of Protogeometric is to be seen on small vessels and on the large grave vases in Rhodes, Miletus, Old Smyrna and Phocaea. The same can also be assumed to be true of Samos. The characteristic feature of the East Greek Geometric idiom seems to have been the way that it continued to use Protogeometric decoration right up to the High Geometric period.

Finds show that during the course of the first half of the eighth century, Attic and Cycladic vessels, or imitations of them, appear again in Miletus. Small and large vessels, small bowls[225] and amphorae[226] are amongst them. The necessary dating is provived by amphorae necks with typical eighth-century lip profiles that are still unfortunately unpublished. There are no traces of Attic High Geometric style, which never really took root in East Greece, at least as far as the structure of decoration was concerned. This is not surprising, since the essential preconditions were lacking.

The breakthrough of the Rhodian style in the third quarter of the century is, however richly in evidence.[227] This is equally marked in Samos, Old Smyrna, Chios, Myrina, Phocaea and Pitane (Çandarli). But the Protogeometric tradition seems to have survived all these innovations, for in the last quarter of the century, in Miletus, Rhodes, Samos, and Old Smyrna, the spirit of the age produced a special circle style which we can cautiously call a neo-Protogeometric style.[228] This did, of course, quickly turn into the ringlet style.

Whereas in Miletus we find all the stages of an eastern Ionian town represented in its pottery, from sub-Mycenaean right up to the end of Geometric, on Samos we have as yet no remnants from phases before the eighth century. In spite of this, Samian finds do demonstrate well how the Samians responded to the challenge of the great Attic art of the middle of the century and the Dorian style from the island of Rhodes. They are the best illustrations we have at the moment of the development of eastern Ionian Geometric art.

The Attic fashion of the period before the middle of the century was not copied as wholeheartedly as it was on Rhodes. Adaptation to foreign influences took place without any sacrifice of independence. 'Paddle wheels' and 'cogwheels' were copied from Attic High Geometric grave amphorae and grave kraters but were incorporated into the traditional Protogeometric system (Fig. 74).[229] The large and heavily decorated Athenian kraters were not used, and it is on plates that cogwheels appear on Samos. Six-leafed rosettes and their variants, found on plates, are copied from the bottoms of Attic flat pyxides, which were a type of vessel not found on Samos. Attic pyxis lids also provide motifs for plates. The smaller the vessels, the more literal the copying of Attic decoration, as in the bowls with star metopes, and Attic bird-bowls.[230] The decoration of an Attic bowl with three bird metopes is used on a large kantharos with at least six bird metopes (Pl. 98),[231] with the long-legged birds with their flapping wings giving an even more lively effect. Simple, closely spaced parallel vertical lines, occasionally interrupted by broad club-like stripes, cover the sweeping curvature of Attic kantharoi; on Samos the same decoration is used for bowls and flat kantharoi.[232]

Some of the themes from the large figured pictures of Attic High Geometric were used by Samian potters although the later neck-handled amphorae from the second quarter of the century were the first to be copied. But, quite apart from the chronological disparity, the pictures of prothesis, chariot processions, and striding warriors (Fig. 90, Pl. 97), are very different from the severe compositions of Attic painting. The movements of limbs are exaggerated, and the mute figures are picked out almost too distinctly, as though in pantomime, held together only by the Geometric artifice of lining up similar figures and groups. This internal tension is a pointer, in a world still dominated by Geometric form, to the East Greek styles of the future. Similar features can be found in the fat-bellied dancers on the sherds from Miletus (Fig. 66). In Chios, where only a few figured fragments have been reported, including a frieze of striding warriors with round shields, the style remained closer to the Attic prototypes, of which detailed copies have been found. The independence of the Samians in dealing with Attic pictorial influences can again be seen in the fact that none of the

Attic funerary types of vases was used as a medium for pictures. Samian painters preferred to use large kantharoi and closed vessels, probably jugs.

Animal pictures demonstrate even more clearly than figured pictures the direction taken by Samian vase painting. The Athenian 'demonic stallion' with long legs and excessively long neck found its way, shortly after the middle of the century, into Samos in the more subdued version found on Cycladic pottery.[233] Later there developed an obviously indigenous type of horse with heavy build, powerful rump and hooves and a wig-like mane (Figs. 87, 88). All exaggeration is done away with; the horse, in front of its manger or in the meadow, is realistic—not a wonder animal, but a natural creature. Fanciful touches do occur, like the bird about to alight on a horse's back.[234] Whole shoals of fish, old and young, are depicted, as in Old Smyrna, or fill a frieze, as in Samos (Figs. 87, 88). A row of proud swans makes up a frieze on a kantharos. On one sherd there is the head, short horns and neck of a splendid buck. All Geometric constraints appear to have been abandoned here,[235] and we can discern the path, or at least one of the paths, towards the Early Archaic animal friezes of the eastern Ionian type.

Meanwhile, the Rhodian fashion in decoration had already reached Samos, having completely overrun East Greece. In Samos it probably began in the third quarter of the century. It was no mere coincidence that Rhodian Late Geometric style spread across frontiers. It had drawn on a rich variety of areas beginning with Early Geometric patterns from the related peoples of the northeastern Peloponnese, including friezes of cross-hatched triangles and hourglass motifs. It also adapted the Attic meander style and copied motifs from the Aegean Islands. Later on, eastern idioms, particularly from Cyprus and southwest Asia Minor, were also adopted. In this case, not only vessel shapes, but also foreign techniques such as goldsmith work and ivory and wood marquetry were copied. The creation of an individual and well-defined Late Geometric style out of all these sources was the great achievement of the Rhodian vase painters. They used simple basic elements—the triangle, lozenge and lozenge chain, zigzag checkerboard pattern and meander. Rhodian features such as the me-

ander volute on apices of triangles, lozenges and crosses, formed the trademarks of this pottery. Stereotyped Rhodian bird-skyphoi sailed, as it were, under the same fashionable Rhodian flag.

Samian pottery did not copy everything. It did not, for instance, adopt the more daring meander forms or the dismembered meander sections used in the phase of the decline of the Rhodian style, as found in Miletus, Old Smyrna and Myrina. Samos Rhodianizes and yet continues to develop. This phenomenon can best be traced on large kraters. The middle of the handle zone is sometimes filled by a faultless two-step Attic meander often framed, as on Rhodes, by two zigzag bands. But on the left and right, where triglyphs might be expected, we get tall metopes with birds and hanging triangles decorated with checkerboard patterns (Fig. 80)—a motif obviously derived from shoulder friezes on Rhodian squat jugs.[236] Nevertheless, an inspired whole is created out of these different parts. It is instructive to compare three krater decorations: one produced before the middle of the century on a krater from Camirus, now in London (Pl. 88); two krater sherds from Old Smyrna (Figs. 69, 70); and a krater fragment from Samos (Fig. 79). The motifs on the Rhodian krater are markedly atticizing although the composition presages the kraters from Old Smyrna. Here the horizontal friezes and broad triglyphs on both sides have purely Rhodian motifs. On the Samian piece, on the other hand, the side triglyphs have disappeared, being replaced on each side by triple lines. Above the three friezes are five almost square zones like metopes, decorated alternately with cross-hatched lozenge nets and parallel zigzag lines. The zigzag lines are horizontal, like the friezes, establishing a connection between the friezes below and the metope zones above. The whole composition is made up of Rhodian basic elements—the triangle, the zigzag, and the lozenge. In the lowest frieze there is a clay-ground zigzag between opposed triangles, while in the top one there is a black band between the triangles. There is a lively contrast of light and dark between the bottom two friezes. A delicate tectonic rhythm runs through the friezes and the metope zones, all different heights. The whole forms a compact system, made up of simple Rhodian

elements with Attic-Ionian inspiration. There is also a certain monumentality contrasting with the simplified effect. Nowhere is Samian art's closeness to Attic Geometric (of an earlier phase) so clear as on this krater fragment.

Another version of Rhodian appears on the island of Chios. Here, Rhodian patterns are even more selectively chosen than on Samos, and the workmanship is better. Thin-walled jugs are most popular. The white background is more carefully applied and fine-line drawings are more precise. In the case of open vessels (cups, bowls and kantharoi) the decoration appears on the inside as well. Ornamentation is lighter. Geometric is the fashionable style of decoration, and continues to be used for decades for certain parts of vessels, such as a jug neck around 650 B.C. The Chiot sherds belong to the last phase of Geometric, at the latest around the end of the eighth century or the beginning of the seventh.

In eastern Ionia, too, the decline of the Geometric style begins in the last quarter of the century. This is not as sudden as in Athens. Its development into a fashionable decorative style and the tendency, common throughout Greece, towards a lightening of decoration by abolition of Geometric filling ornament, already points the way to the end of Geometric art.[237] At this time, admittedly, Samos is being pulled in two different directions: on the one hand influence from the east in the form of the circle and ringlet style, leading to a revival of the Protogeometric tradition, and on the other hand ideas from the west, primarily from Corinth, making for lightened borders of the Protocorinthian Geometric type, especially on open vessels such as small bowls and skyphoi. But the result was never in doubt. The eastern influx was quickly brought to a halt, the numbers of concentric circles were reduced, and the motif considerably lightened. With a few exceptions, ringlets were stripped of all excesses, and the whole eastern system was reduced to mere tectonic decoration. It was the Greek west which advanced again for the last time, even though the Geometric style had lost its force.

Local Geometric idioms did not develop in East Greece until the period classified as Late Geometric on the mainland. Whereas in the areas where they originated in the west, Geometric decorative elements were banished by the Geometrically based figure style to peripheral zones and reduced to filling ornaments, on the islands of the Dodecanese and in the Ionian colonies, a clearly defined indigenous style developed. But this was no longer (except for short periods) true Geometric so much as a decorative fashion spreading out from the west, above all from Athens, which was its centre. It was quickly superseded by new styles, although it did survive on certain parts of vessels for quite a long time afterwards. But broadly speaking, the end of the eighth century brought the rapid and almost unresisted decline of Geometric in East Greece as elsewhere.

Small-scale Art

Before dealing with small-scale art from the Geometric dark ages in detail, it is worth remarking on a curious fact about the countries around the Aegean in the second millennium B.C., which, if seen in the right light, makes it clear that there was a significant difference between the art of Minoan Crete and Mycenaean Greece. It concerns the small statuettes of youths and men usually making a gesture of prayer in front of an altar of an invisible god in a sanctuary.

A large number of clay and bronze statuettes of this type were found on Crete. They can be traced from the time of the older palaces in the Middle Minoan period up to the destruction of the later palaces (Late Minoan III). The basic 'adorer' type develops a rich variety of variants whose spontaneous shapes approximate more and more accurately to the true form of the human body without trying to freeze the flow of life into stiff sculptural forms. In this respect Minoan Cretan art is quite different from Egyptian and Near Eastern art, and may be regarded as a kind of early forerunner of later Greek art. In the Middle Minoan period, clay figures predominate. At first, the body is rendered in the most general way only, without sexual organs or limb joints. The outlines are not expressive, and the third dimension of the body is neglected (Pls. 101-103). These are human images seen, as it were, from a distance, or through a veil. The use of kneaded damp clay favoured slightly splayed legs and arms arranged plastically in front of the body, giving a sudden touch of spatiality. These statuettes, incidentally, are reminiscent of very much older marble idols from the Cyclades, such as the two harp players from Thera in the Badisches Landesmuseum at Karlsruhe,[1] although the latter are spatially more dynamic. This Cycladic art should be regarded as an early phase of Aegean art. Minoan art is more light-hearted, free and playful. Even in its early stages, several different plastic forms are exploited. In the late Middle Minoan period, terracotta sculpture enters a new phase. The trunk takes on a more realistic three-dimensional shape. Thighs, calves, upper arms and forearms, elbows and knees are distinguished, the joints indicated and the stance is more relaxed. Proportions, the third dimension, and sculptural effect are all more self-assured. The clay figure from Kanniá near Gortyn[2] which is almost 50 cm high, and which would probably have been produced at the end of the Late Minoan I period, exemplifies the end of this development. Its massive, powerful upper body, clothed with a jerkin, and its comparatively short legs, are those of a thick-set, stocky man, superbly sculpted. A second type of clay sculpture is seen in the more two-dimensional, painterly approach of the Middle Minoan period (Pl. 104). The feet are set closer together. The legs, slightly bent, lead up like two arches to the narrow waist. The arms open out like a flower, with hands against the chest. Elbows and knees are shown. The taut outline emphasizes only the frontal aspect of the figure, making a clear axial intersection, and forcing the statue into a two-dimensional form, emphasized by the brownish-red painting on the naked body.

The art of casting statuettes in bronze does not appear to have developed before the beginning of the Late Minoan I period. The frontality of the figure, the intersection of axes and the positioning of at least one hand on the chest, all continue in bronze figures. But the outline is relaxed considerably, the figure becomes more slender, and the legs are together or parallel. The figures have self-confidence and pride (Pl. 109).[3] A figure of a youth with a helmet[4] heralds

the rise of a new workshop, obviously attached to the palace of Knossos. This workshop produced a new type of adorer. Its products spread as far as Tylissos in the west, and the coast of Asia Minor in the east. In a new 'gesture of adoration' the right hand is raised to the forehead with the left flat against the body. This lasts, on Crete, up to the post-Minoan period.[5] The 'Flute Player' in Leiden is different. This is said to have been found in the vicinity of Phaistos (Pl. 106).[6] The figure has a flat hat, and the usual apron, which reaches down, behind, to the backs of the knees. The forearms are together in front of the chest. The hands, which are missing, would almost have touched the mouth. It is just possible that they once held flutes, like the flute player on the sarcophagus of Hagia Triada. But the figure could just as well have been holding a bowl up to its mouth. Alternatively, the hands could have been clasped against the chin. From the waist upwards, the upper body of the figure is bent backwards, with the head leaning slightly forwards. This backward bending of the body and forward tilted head recurs in the bronze adorers in the Late Minoan I period (Pls. 107, 108).[7] The snake-like line of the 'Flute Player' in Leiden, from the knees to the forehead, is repeated in the curving profile of the adorers, from the feet up through the stiffened knees, pelvis thrust forward, and upper body bent backwards, to the upright neck and head. This dynamic yet balanced tension of the body occurs not only in the bronze statuettes of adorers, but also in male and female figures carrying vessels or leaping over bulls; in boxers, wrestlers and bull-fighters; in the chieftain standing at attention in front of his superior; and in the 'Prince with a feather crown'.[8] The bodies shown in these bronze statuettes of the sixteenth century B.C. are trained in athletics. Even in rest, they take on snake-like shapes which emphasize the trunk, limbs, muscles and joints, with the stiffened knees, backward-curving upper body and head making a superb, dynamic pose. Movement in rest and rest in movement combine to make truly sculptural form. The powerful 'inner movement' produces, particularly in the case of the 'Flute Player', more or less multi-aspect figures. Front, back and side views combine to make a figure in the round, emphasizing the three-dimensional quality of the figure and bringing out its uninhibited articulation.

This truly baroque phase of the Cretan statuette probably spread out from Knossos, flourishing for only a fairly limited period. The figures of female adorers from Hagia Triada[9] and, most superb of all, the 'Praying Woman' of unknown provenance now in Berlin (Pl. 105), also belong to this phase, as does the bronze group of a bull with a bull-jumper swinging himself over the horns onto its back (Fig. 91),[10] with his own body bent right back. A splendid sword

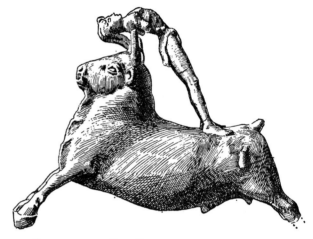

91 Bronze statuette from Knossos.
Height 11.4 cm. London, British Museum

from Mallia with a gold relief of a cartwheeling acrobat is earlier, perhaps from the end of the Middle Minoan period. Head and feet join to make a closed circle. The contortion is quite impossible and the picture is purely ornamental.[11] Ornament and human anatomy have not yet been reconciled to make a plastic image. The statuette from Hagia Triada is from the end of this phase. Its legs are together, with the left a little in front of the right. The curving line is still present but strongly muted with frontality correspondingly more emphatic.[12]

Contemporary with, or perhaps later than, the baroque development of small-scale sculpture in central Crete, are two statuettes from eastern Crete, one from Gournia, in Heraklion,[13] the other in Berlin.[14] The athletic, wavy shape is lacking in both, their movements are unaffected, and they appear to

have developed out of eastern Cretan clay sculpture. The Berlin bronze particularly has an emphatically frontal composition. These two adorers were produced some distance from the superb central Cretan bronzes, and can therefore only tentatively be assigned to a later date. In the case of two other bronzes, however, from Knossos[15] and in Vienna,[16] we are on safer ground. The first of these does away entirely with the wavy, third-dimensional movement, having a stiff, columnar structure, around a central axis. In both the proportions have changed. The body is slender, with overlong legs close together. Static form replaces the tremendous tension in the forward thrust of midriff, rib-cage and chest, particularly in the Vienna statuette, where the limbs are firmly assembled to make a columnar frontal aspect, including the head. The clear modelling of the face, already significantly different from the flowing, painterly lines of the baroque bronzes, shows that this is a new phase.

A series of bronzes, of which the main piece is in Berlin (Pl. 110), comes from another workshop and, clearly, yet another later phase. The athletically built body of the figure is completely naked, with broad, raised shoulders. The right arm is across the body. The left is bent at the elbow with the hand on the hip. The collar-bones and chest project from the otherwise flat trunk. Shoulders and arm and leg muscles are vividly modelled. The legs are slightly apart, with knees a little bent. A roll-like belt surmounts the narrow hips, and the sex is shown clearly. The stance, from head to toe, is strictly frontal. The left leg, carrying the weight of the body, pushes up the left shoulder, supported by the arm resting on the hip. The trunk is well proportioned but is flat, almost like a board, a mere silhouette compared with the limbs. A statuette in New York[17] is older than this remarkable piece. Bronzes from the Dictaean Cave are contemporary and later.[18]

A final phase is seen in a bronze statuette of an adorer recently found in a grave near Mylopotamos in western Crete (Pls. 111, 112).[19] The praying position is similar to that of the Berlin bronze which we have just discussed (Pl. 110)—right hand in front of the chest, left arm hanging free. From the roll-like belt above the hips hangs a short kilt with a cod-

piece. The head is set straight on the shoulders facing forwards, with two thick plaits falling over the chest and the back, curled up like snakes. But the relaxed stance of the older bronze, its contrast between the weight-carrying and the free leg continued up through the body although without, as yet, any coordinated rhythm, its broad shoulders and compact muscles—all these have either disappeared or been very much played down. The trunk down to the low belt is flat, as in the older figure, but is conventionally rendered without collar-bone or chest being picked out. The proportions have changed: the height of the trunk is one third of the height of the legs and the hips. In the older bronze the corresponding proportions are 1:2.5. The most striking difference is, however, the total frontality of the composition of the western Cretan bronze as far as axial symmetry is concerned. It is reminiscent of the simple wooden figures still produced nowadays for religious festivals and as toys for children and adults by, for instance, woodcarvers in the Erzgebirge. The head is part of this frontality. It is narrow, excessively high, cube-shaped, with front and side aspect separate. The face is dominated by a long, narrow nose on the main axis of the statuette.

The chronology of Cretan clay and bronze statuettes can only be guessed at. The eastern Cretan clay figures belong, almost without doubt, to the Middle Minoan period. The baroque statuette phase probably coincides with the zenith of the later palaces in the Late Minoan I period, with perhaps a few of the bronzes having been produced at the end of the Middle Minoan III period. The remaining three phases can be spread, roughly, over the Late Minoan II and III periods. Only the last phase can be more accurately dated. The closest parallel to the Mylopotamos adorer (Pls. 111, 112) is in the head and face of a painted stucco head of a sphinx (?) from Mycenae.[20] The four-sidedness of the head, the axial importance of the long narrow nose and the conchoidal hollow of the mouth area are identical in both cases. Both the sphinx head and the bronze can be dated in the thirteenth century B.C., perhaps even at the beginning of the twelfth.

Cretan statuettes developed a long way from early efforts in clay to the superb bronzes of the sixteenth

century B.C. and from them to the late adorers of Mylopotamos. One tends to imagine an ascent from primitive beginnings to an extraordinary baroque phase, followed by descent to a stereotyped classicizing form and then a return, after the destruction of palaces, to the primitive. As to this last, the finds from the Phaneromeni[21] and Dictaean Cave[22] leave little doubt. But the Berlin bronze and its counterpart in the Cave of Zeus (of which at least the first has no Cretan kilt and must belong at the end of the fifteenth century B.C.) and the bronze from Mylopotamos do not fit into this scheme. The naked athlete in Berlin, with virtually no third dimension even in the trunk, draws its power from the contrast between its wide, muscular upper body and limbs, and the way the form is firmly contained within the two-dimensional outline. The somewhat later counterpart of this Berlin bronze from the Dictaean Cave lacks this inner balance between living strength and expressive outline. The muscles have disappeared and only the external outline is expressive, making the statuette something of a silhouette figure. There is another source of tension in the Berlin bronze. Its pose is frontal as can be seen from the flat back, but is mitigated by limbs slightly out of line. The weight-carrying leg pushes out the left hip; and the left arm, with hand on hip, pushes up the left shoulder. The right hip, however, carries no weight and the right shoulder is in its normal position. This is not counterpoint in the classical Greek sense, but merely rhythm of weight-carrying and free leg continued in the arms and disappearing in the shoulders. A. Furtwängler has called this the 'Old Argive canon'.[23] The only difference in the Cretan bronze is the raised shoulder on the side of the weight-bearing leg. This, however, is also found in the statue of Poseidon at Livadhostro.[24] Were it not for casting technique, modelling and head of the Berlin bronze, all so completely Minoan, its nakedness, mitigated frontality and contrapuntal movement running up from the legs would make it similar to statuettes from the Late Archaic period, about a thousand years later. The same trend can be traced further in the Mylopotamos adorer from the end of the Mycenaean period. The severely frontal stance is quite rigid, completed by the cube-shaped head and flat face. Its structure with the nose on the central axis and the conchoidal hollow of the mouth beneath the cheekbones is a Late Mycenaean form which recurs from Geometric to High Archaic sculpture in, for example, the ivory figure from the Geometric period in Athens (Pls. 146–148), the Attic kouros in New York, the head of Hera from Olympia, the Nike of Archermos on Delos, and a kouros head from Thasos.[25]

Nobody would suggest that there was any conceivable connection between Late Minoan or Late Mycenaean bronzes and their echo in the Early Greek and Late Archaic sculpture. The two worlds of art are separated not only by centuries. Much more important is the fact that the two formal problems occur in the Minoan-Mycenaean world during a period of decline after a zenith of great, uninhibited art (differentiated poses and kouros types), while the large-scale sculpture of the Greek world was associated with a period of artistic innovation and growth, proceeding with systematic, patient steps (kouros and differentiated poses). But the naked bronze youth in Berlin, and the western Cretan adorer from Mylopotamos introduce an alien element into Minoan art. Even though both statuettes were probably produced in a Minoan workshop, they indicate the presence of Greek tribes and Greek people on Crete, as does the writing on the linear-B tablets from the palace of Knossos. The Berlin bronze, a Minoan product from around the turn of the fifteenth to the fourteenth century B.C., may actually represent one of the foreign invaders on Crete who settled in the ruins of the palace of Knossos and who used the Minoan linear-B script to write Greek and to carry on the existing administrative system. The statue is an image from the period which the Greeks later called heroic. The Mylopotamos youth, which can be dated, at the earliest, in the thirteenth century B.C., is wearing Minoan dress and was produced by a Cretan workshop. But its style is Greek Mycenaean and its head has counterparts only on the Mycenaean mainland. This head structure is best known from Greek Archaic sculpture. There are only a few, albeit important, clues to Mycenaean influence in Crete, but they seem like a short early spring of Greekdom on ancient Minoan territory.

One would expect Minoan bronze statuettes to have continued in the centres of Late Mycenaean art. Up to now, however, no cast bronze figures from Mycenaean workshops have been found, although in embossed metalwork, frescoes, painted vases, and on gold seals there are pictures of fighting, hunting, and horses being harnessed in which youths appear. The silver rhyton from Shaft Grave IV at Mycenae[26] illustrates the storming of a besieged town by Mycenaeans. The citadel stands on a rocky hill near the sea, and the attackers are landing on the beach, with a ship arriving on the shore. The helmsman, dressed in a chiton and a Mycenaean helmet, is directing the manoeuvre with a barge pole. Naked men are swimming in the sea. In the open space in front of the citadel is a deep phalanx of the besieged, with slingers, bowmen and warriors with tower shields in the background. All are naked without helmets, although the warriors may be wearing chitons behind their shields. The walls of the citadel teem with gesticulating figures. Only fragments of the attackers survive. The men who are fighting are wearing, at most, Minoan kilts and a kind of helmet. The attack must have taken the people in the town by surprise so that they had no time to reach for more than their weapons. Other fragments with battle scenes come from a large silver vessel from the same shaft grave.[27] On these the fighting men are wearing short kilts held up by a metal belt. They are naked from the waist up, and are wearing Minoan-Mycenaean helmets. Except for more or less elaborate kilts and the occasional Minoan or Mycenaean helmet, men are also naked when slaying lions, duelling and hunting. Such figures occur on gold seals and gold rings, negatively engraved in intaglio. They also belong to the early period and are certainly the work of Minoan artists.[28] These splendid pictures of heroic scenes show martial and dramatic events beginning to break into the hitherto peaceful work of the Aegean. And not only heroic motifs, but a new heroic style begins to develop in these pictures. Heroism and tragedy are now associated with grandiose compositions and strong, naked bodies. The appearance of the first Greek tribes in the Aegean area around the nineteenth to the seventeenth centuries B.C. must have made a deep impact on the Minoans. In the Shaft Grave period at the end of the seventeenth and beginning of the sixteenth centuries B.C., heroic epics may already have been circulating, and Crete and Mycenae may have been on friendly terms. The storms of conquest would have passed. This was the background to the growth of an heroic style of illustration, as occurred again a thousand years later, in the Archaic and Classical periods of Greek poetry and art. In both periods, costume was entirely unrealistic. A late example of this trend on Crete is the athletic bronze youth in Berlin (Pl. 110).

The later frescoes from Mycenaean citadels are more realistic. Warriors fighting, falling down or hurrying by, are now wearing helmets and chitons with sleeves at the top of the upper arm and hems high on the thighs. They are often wearing puttees or bronze greaves. Greaves like this have recently been found in Mycenaean graves from the thirteenth century B.C. at Enkomi, and near Patras.[29] Hunters, on foot or in chariots,[30] are similarly attired, although often without the greaves. New work in the rock-cut chamber-tomb 12 in Dendra in the Argolid, previously opened, has brought to light for the first time a well-preserved Mycenaean cuirass, which, according to the report of the finds, must have belonged to the turn of Late Helladic II to III.[31] Cuirasses like this may also have been worn by the departing warriors on a late warrior vase from Mycenae, over their chitons.[32] But the heroic period of earliest Hellenism is over. The Mycenaean world has already been overtaken by fierce fighting which lasted for almost a century, and during which time both the Mycenaean world and the first states set up by the Greek tribes in the Aegean were to disappear. The adorer figures in Cretan sanctuaries, in the form of bronze statuettes, belong neither to the heroic period of the first Greek tribes nor to the time of the long wars which threatened the survival of the Mycenaean-Late Helladic citadels at the end of the thirteenth and during the twelfth century B.C. Cretan bronze sculptors obviously found no suitable base for their activities in the Greek princes' domains on the mainland. This may explain why Minoan votive bronzes, inextricably connected with Minoan cult practices, did not spread beyond Crete, and found no echo on the Mycenaean mainland.

Between the heroic period around the middle of the millennium and the civil wars at the end of the Mycenaean epoch, from the thirteenth century B.C. on, there is a comparatively peaceful period, the zenith of Mycenaean culture, which we can describe as the courtly period. In this period fall two statuettes in Minoan style, a woman and a youth, found in 1891 in a grave near Kampos in Laconia (Pls. 113, 114). They are made not of bronze but of lead and were probably cast in Laconia, where it was the practice in later historical times to produce small lead figures. They are considerably smaller than the Cretan bronze figures; the woman is 8.4 cm. and the youth 12 cm. high. The youth is naked except for a short kilt between his legs. Above his hips is a narrow concave belt with a suspended cod-piece, both probably made of metal. Round his head is a decorated band probably also made of metal. His hair flows in a compact, wavy mass over the nape of his neck and spreads out on his back between his shoulders in gentle curves. His arms are held in front of his chest in such a way that the open palms are almost one above the other. They must have been holding some object, perhaps a little box for precious jewellery. The woman is wearing a bell-shaped skirt, slightly pleated, and a bodice which leaves her breasts free. She is holding her arms in a wide gesture in front of her hips, with the hands flat. She too must have been carrying some large object. Both figures obviously belong to some kind of procession, in which they were bearing presents. The only method of dating these lead figures, since the few sherds which were found with them were never published, is by stylistic criteria. The youth clearly dates from well after the baroque phase of Cretan art, but the mannered body proportions and strict frontality of, for instance, the Cretan bronze statuette of a youth in Vienna[33] have not yet developed. The ivory figure of a woman from Mycenae, of which only the back is preserved, is a forerunner of the woman from Kampos, and can be dated around 1500 B.C.[34] The head, and its position, in the statuette of the woman have their closest parallel in a likewise slightly older female dancer from a fresco fragment from the palace of Knossos[35] which can be firmly dated in the Late Minoan II period. The figure has a general similarity

to the woman on a Cretan steatite seal found in a stratum of the Late Minoan III A period.[36] The head of the youth can only have been produced a little earlier than the painted stucco head from Mycenae[37] and proves that the lead figures cannot be dated too early. We must be content with comparatively inaccurate dating until further finds of small-scale sculpture come to light on the mainland. The lead figures, then, can be dated at the earliest in the late fifteenth or beginning of the fourteenth century B.C.

A few bronze statuettes from the Mycenaean world must also be mentioned, even though they are neither Minoan nor Mycenaean in origin (Pls. 115, 116). These are figures of warriors with raised spears, probably with a shield in the left hand. The figures are clothed with a folded kilt held up by a belt, and have sandals or shoes on their feet. The upper bodies and legs are naked, without greaves. The head is protected by a conical helmet which, when not broken off, ends in a spherical shape or similar decoration.[38] The four warrior statuettes are part of a long history in the Aegean area. It begins with a small bronze of a god from the old Hittite kingdom in the sixteenth century B.C.,[39] which already has all the characteristics of Mycenaean warrior figures. This is followed by a relief of a god on the so-called 'king's gate' of Bogazköy,[40] a bronze statuette, also from Bogazköy, from the period of the great Hittite empire[41] and a small bronze from Konya from the fourteenth century B.C.[42] The close connection between the Late Hittite empire and northern Syria caused this type of bronze figure to travel to Syria, where Hittite traits mixed with Egyptian forms. Three statuettes in Beirut and Ras Shamra demonstrate this transformation, typified particularly by the raised right arm. The 'warrior' is no longer hurling a spear but a thunderbolt and these figures have probably been correctly identified as the god Reshef.[43] At most two of the Mycenaean bronzes have these Syrian features—certainly the Thessalian statuette in the Ashmolean Museum in Oxford, and perhaps also the warrior figure from the cave of Patsos in the same museum.[44] The bronzes from Tiryns and Mycenae are, however, still of the older Hittite type. Nevertheless, they scarcely belong any more to the sixteenth/fifteenth centuries B.C. A fine variant of the

same type, previously in the Vorderasiatisches Museum in Berlin,[45] has the same helmet, with spherical finial, as worn by the warrior from Tiryns, very similar face and eyes, back leg bent in the same way, and a ring-shaped buckle on the belt like the bronze from Mycenae and the same stance as the Reshef from Thessaly. The Berlin statuette must be dated very late, in the thirteenth century B.C. or even in the period of the 'Hittite' small states of Syria. Thus the only possible dates for the Late Mycenaean warrior statuettes of the Hittite type are the late fourteenth century or early thirteenth.

VI SMALL-SCALE SCULPTURE OF
THE GEOMETRIC PERIOD

1 Introduction

The technique of bronze casting of statuettes which had been so widespread in Minoan Crete, was not copied in the Mycenaean period on the Greek mainland. When the curtain which fell after the occupation of major areas of the Peloponnese by the Dorians gradually began to rise again, and conditions slowly began to improve, the mainland was still a *tabula rasa* as far as small-scale sculpture was concerned. The earth had long since swallowed up the sculptural efforts of the Neolithic prehistoric period, mostly female idols in marble or terracotta from Thessaly, Central Greece, Laconia or the Cyclades.[1] On the other hand the great empires in the East, with their ancient cultures, had been locked in bitter warfare since the beginning of the migrations in the thirteenth and twelfth centuries B.C. The Hittite empire in Anatolia sank under pressure from the East, and invasions of Phrygians and related tribes. The trading links between Greece and the East were broken, from the Greek side as well as from Asia Minor and Syria. The balkanization of the new Greek world and its return to a primitive condition broke the connections between Asia and Europe for a long time. Greece, finally reunited after upheaval and fierce wars, faced, as far as small-scale sculpture in bronze and terracotta was concerned, a completely new problem. But it was just this lack of contact at the beginning which turned out to be such a stroke of luck for the whole development of Greek art.

Amongst a very large number of tiny bronze figures found in Olympia, Delphi, Delos and Dodona, a group of five statuettes can be isolated as the earliest yet found from post-Mycenaean Greece (Fig. 92, Pls. 117-121). They were found in Olympia and may well have been produced there.[2] The figures stand on casting-sprues. On one of them these have joined together like a branch (Pl. 118). This corresponds with ancient Oriental techniques. How and when it came to Greece cannot now be determined. The statuettes are very small. The first two are about 7 cm. high, the last three about 10 cm. Their shapes look primitive, doll-like, like first attempts to progress from kneaded clay to bronze. The two smaller figures (Pls. 117-119) probably antedate the larger ones, but come from the same workshop. The body is naked and both arms are raised, rather like shortened stumps. The head is a spherical mass with only on exaggerated chin and the ears indicated. Nose, eyes and mouth are not shown. The heads of the figures on the older Attic grave vases from the High Geometric period (Pl. 31) still have the same featureless faces with projecting chins as these much earlier bronzes. On their heads both figures have a kind of petasus—a hat with a large flat brim.[3] The other three statuettes (Fig. 92, Pls. 120, 121) form a special group. They are wearing tall Geometric helmets tipped well back. Their arms are also raised, although the upper arms, forearms and hands are distinguished, with the palms turned ceremonially forward. Head and face are still not properly formed but the mouth is slit wide open. The knee-cap is indicated, while the back of the knee is marked by a pointed projection.

Are these statuettes really merely primitive? Their character really lies in their extremities; in, for instance, the splayed legs and the raised, stumpy arms. The body, the point where these join, is where the lines of force meet, but it is not so much a body as a composite of shoulder-blades, pelvis and large

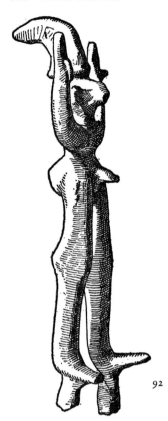

92 Bronze statuette from Olympia. Height about 10 cm. Olympia, Museum

penis in the middle. The legs, set well apart, and the raised arms, radiate tremendous power. They show a tiny spirit, perhaps the hurrying messenger of the gods, Arcadian and Elian Hermes, whose arms, raised in a semicircle, announce his appearance or 'epiphany'. They are a final trace of a great sculptural concept from the zenith of Minoan art—the god on the top of the mountain appearing between suppliant and shrine; the tiny goddess who appears between the clouds while women dance in a flowery meadow and raise their arms in delight to her; and the god and goddess who descend from the sky above a holy shrine or grave, while a man greets the goddess in wonder and ecstasy, and a woman receives the god deep in prayer.[4] In the epochs of Mycenaean and post-Minoan art, this idea of epiphany is debased, but the motif of the two hands raised to indicate the presence of a god spreads, and occurs in countless Late Mycenaean terracotta idols with raised arms and in later idols from Karphi and Gazi on Crete.[5] In both the little figures from Olympia (Pls. 117-119)

with their splayed legs and outstretched arms, there is still a feeling of supernatural epiphany enhancing the limbs of the shrunken body. The three larger statuettes, obviously from the same workshop (Fig. 92, Pls. 120, 121), have less extended limbs, and their arms, bent sharply at the elbows, are like those of female idols from the sub-Minoan period from Karphi and Gazi. It is very unlikely that bronze casters in Olympia were aware of these Minoan forerunners. But there can be little doubt that the gesture of the god's epiphany still lived on either in old Cretan pictures or in plastic clay idols. This means that the suggestion made by Kunze, that the three early bronzes from Olympia (Fig. 92, Pls. 120, 121) and their successors were images of Zeus, may be correct. They would be like the statue of Zeus Areios, which also had a helmet and which stood next to the cult image of Hera in the Heraion at Olympia.[6]

The statuette of a standing man with a peaked hat tipped backwards, unseparated from the crudely shaped narrow head (Pls. 122, 123)[7] belongs to a third phase but is, perhaps, still from the same Olympian workshop. The torso is made up of chest, belly and hips. The limbs no longer run out from the middle of the body. The exaggeratedly longs legs without feet are set at a slight angle to the body and the knees are indicated by completely unnatural points, as on the images of Zeus. It is significant that the same points occur on the legs of animals. The arms stretch straight out from the shoulders; thighs and calves are barely distinguished. The human figure has now undergone certain slight changes. Whereas head and helmet, shoulders and arms, and penis and buttocks are massive sculptural units in the statuettes of Zeus, partly for deliberate effect, here the artist has attempted to achieve a simpler formal unit. The size of the torso has been increased. The outline of the narrow head continues down the neck and round the shoulders, through the armpits along the slender trunk to the hips and thighs. From the side, the figure has an uninterrupted outline from the head and cap through the nape of the neck, slightly curved back, pelvis and legs. The most significant feature is that the figure does not exhaust itself in action but is articulated in a simple space, giving it solidity. It is strongly frontally orientated. The outstretched

arms form a vivid horizontal axis which intersects the firm central axis. These are, of course, crude efforts, but they are the beginnings of a new approach to the human figure.

2 The Argive school

This new concept of the human figure can be clearly seen in a ring-handle figure from the Argive Heraion (Pl. 125), which is also about 10 cm. high and can probably be assigned to an Argive workshop.[8] The proportions of torso and straight legs, close to each other, are almost normal. The penis was broken by the excavator's pick. A tiny head surmounts the tall neck, with a large mouth-slit in the projecting chin. No one has previously noticed a clearly indicated hair-line marked quite clearly on the nape of the neck. The first publisher of the statuette, however, identified two obviously deliberate hollows as eyes. In good pictures they can now be seen to be round with pupils in the middle. One can also make out the outlines of a short nose, and distinctions between eye-hollows and forehead, all chased after casting. Chasing of eyes and nose like this, as well as the cap of hair, also occurs on primitive terracotta figurines from Olympia. Horizontal arm stumps, as on the bronze statuette from Olympia (Pls. 122, 123), also occur, as do the suggestion of hands.[9] Even if one or two of the clay figures are more recent than the ring-handle figure, the technique of the bronze statuette and the terracotta figures belongs to the same stylistic phase. It develops from the figure from Olympia, already attempting something new, to the clear, firm form of the ring-handle figure from the Argive Heraion, with its assured frontal composition, dominant vertical axis from crown to space between the feet, and deliberately emphatic horizontal axis of the arms. The figure is given self-assurance and solidity by its spatial co-ordinates, while also having more depth than before. Its outline runs down from the neck in an almost imperceptible curve over the shoulder-blades, past the waist and the pelvis to the thighs and calves and down. No sculpture had pre-

viously achieved the self-confident masculinity of the Argive statuette, and none had managed to suggest such size in a small format.

The statuette had an upright plaque and two holes for attaching it to the ring handle of a tripod-cauldron. As F. Willemsen noticed,[10] precisely corresponding holes occur on a fragment of a ring handle, perhaps also Argive, in Olympia. According to revised chronology, this handle is dated at the end of the group of fully cast tripod-cauldrons or, more cautiously, around the turn of the ninth century to the eighth, with some latitude either side. Our ring-handle figure also falls in this period, during which the first figured scenes also occur in Attic pottery. An early type of cup, an isolated find from the Kerameikos (Pl. 26) which, from its decoration, can certainly be dated in the first quarter of the eighth century, is from the same period. On its main frieze, between two swastikas, is a picture of a horse led by a warrior with a sword. Behind the horse is a second warrior with a whip. The horse-leader and his stallion were the most common figures on the ring handles of tripod-cauldrons. The figures on the cup, like figured illustrations almost up to the end of the Late Geometric period, are, however, a combination of front and side views. Only the trunk and the arms are shown frontally. The upper arms form a straight horizontal from the shoulders to the elbow. The forearms of the horse-leader hang down vertically, equally straight. Only one of the forearms of the second warrior is hanging down. The other, holding the whip, is slightly raised, as on the ring-handle figure from the Argive Heraion, which is a tremendous step towards simplification and consolidation of the plastic form, clearly reflected in the unpretentious cup from the Kerameikos. Even the closely cropped hair on one warrior is discernible above the forehead. Of course the picture on the cup is later but is a product of the same sense of form. It is, on the other hand, difficult to date the first preliminary stages (Fig. 92, Pls. 117-123). E. Kunze guesses that they antedate the Argive bronze by about fifty years. They might have developed over a generation, say thirty years. But we are not really yet in a position to give an exact date for this early phase of Greek bronze figures.

The superb ring-handle figure from the Argive Heraion (Pl. 125) is followed by a whole group of horse-leaders and warriors, which represent a break with the traditionally monumental size of Argive figures and clearly belong to a later phase. Amongst the figures that are certainly to be interpreted as horse-leaders is a warrior from Olympia, distinguished by the uniform thickness of the limbs (Pl. 126).[11] It belonged to a hammered ring handle which meant that the upper body and the position of the arms had to be flattened. Buttocks and legs have some depth but lose it lower down. The frontal pose is full of tension; the whole figure is lither from helmet to feet, so different from the clumsy mass of the Argive handle figure. The legs are one-and-a-half times the length of the trunk from the bottom of the neck to the penis, or crotch. The penis is half way between the top of the head (not of the helmet) and the soles of the feet. As after the first efforts around the turn of the ninth to the eighth century, the shape becomes that of a 'lay figure'. The bending of the knees is part of this. The same proportions and bent knees are also found in the ivory figure of a goddess from the Dipylon in Athens (Pls. 146-148). In the earliest 'lay figures' in Attic vase painting, on the large amphora with a prothesis, Number 804 in the National Museum at Athens (Pl. 31), the trunk is half the length of the slightly bent legs. This ratio becomes even more extreme during the High Geometric decades. As on the earlier figure of a horse-leader from the Heraion at Argos (Pl. 125) an excessively long neck with a broad base surmounts the shoulders. The shoulder joint is thickened so that the upper arm has no armpit and its outline runs down obliquely into the narrow trunk. The chest is no longer an intersection of vertical and horizontal but is closer in shape to a square standing on one of its corners. In the successors of this workshop, the lozenge shape standing on its apex, for the chest, develops further, as will be seen later. On the neck is set a narrow, tall head. In early bronze works of the post-Mycenaean Greeks the face and its various expressions were dealt with in a number of different ways. In this case the head is fused with the helmet, which protrudes at the nape but is not distinguished from the face, which develops as a reclined oval with

a projecting chin or beard. In the middle is an enormous, slightly lop-sided nose above a thick-lipped mouth. The eyes are bored above the nose. On this head the face is considerably more developed than on the ring-handle figure from the Argive Heraion, but it has certain features which have hitherto not been explained. What are we to make, for instance, of the 'mask-like' treatment of the face?

One is tempted to compare a series of bronze statuettes from the area from the Lebanon to Cilicia, which last up to about 800 B.C. The material, containing a large proportion of copper, comes from Cyprus and reached the Lebanon via the ports on the Phoenician coast, in barter transactions. Syrian bronze statuettes of this kind may also have reached Greece in the Geometric period via Phoenician trade. We have already come across Rhodian gold reliefs (Fig. 106) as early as the beginning of the eighth century, and later, paintings on the Attic kantharos in Copenhagen (Pl. 69), which were probably derived from images from the group of post-Hittite states around the Gulf of Issos, Cilicia and the Lebanon.[12] The earliest statuettes, from the middle of the Bronze Age, a warrior with spear and silver helmet, naked down to his mitre, and a naked woman with folded arms from Tell el Judeideh, establish a basic connection.[13] Another pair like these[14] belongs to the second half of the second millennium. The man is wearing a kilt, the woman a dress down to her feet (Fig. 93). The face of the man, with a goatee beard, is like a 'mask' in front of the face. The face of the woman is unnaturally large, projecting forward and downwards. This type degenerates in the following period, in both female and male. The body shrinks, losing its three-dimensional quality, while only the head keeps its size and its characteristic shape.[15] A renaissance begins in the ninth to the eighth centuries. Here, the only pieces that are preserved are warriors without helmets, carrying a spear in their right hand (Fig. 94).[16] The body has almost no third dimension, a pointed head surmounts the flat body, with a 'face mask' almost as if stuck on, without giving the head any three-dimensional quality.[17] The statuettes are completely frontal in structure, so that there is a unified image from the front. The nipples are almost always indicated sculpturally. A selection

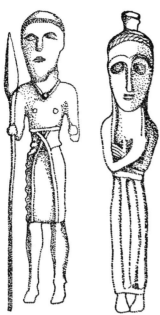

93 Hittite bronze statuette from Cilicia (Asia Minor). Height 30.9 cm. Berlin, Staatliche Museen

94 Syrian bronze statuette from the Lebanon. Height 35.7 cm. Geneva, Musée d'Art et d'Histoire

of these late bronzes from the Lebanon will demonstrate this.[18] We can, however, also trace a direct connection between the late Syrian bronzes and the earlier Greek products in a bronze statuette, found on Ithaca, of a tall naked woman. This might as well be a man if the penis were not missing (Pls. 128, 129).[19] The chest is in the form of a lozenge standing on its apex. The figure has projecting nipples like the bronzes from the Lebanon. The head is also pointed at the top and the face projects some distance forward. The expression is livelier than the Syrian statuettes. But the large, deeply sunk eyes are unique in Greece. In Syria, they would have been filled with semi-precious stones or enamel. Thus the Oriental technique of making the eyes, as seen in the bronzes from the Lebanon, is also in evidence in at least one instance in Greece. Two later female statuettes from Delphi are connected with the bronze from Ithaca.[20] The first (Pls. 130, 131) is naked, with legs together and shoulders slightly hunched; the hands are placed against the upper thighs; the nipples project; the long neck and head are Oriental in structure and the composition of the body is severe and clearly axial. The second bronze (Pl. 124) is clothed with a peplos which cannot be seen on the upper body; the arms are in front of the body; the chest makes a lozenge standing on its apex; the

breasts are set high and close together and on the thick neck is an imposing head with big eyes, straight nose and closed mouth. So from the horse-leader from the Argive Heraion (Pl. 125) to the latest female figure, or from the end of the ninth century until around the middle of the eighth century, runs a uniform group probably produced by an important local workshop.

But first we must identify the grooms and warriors connected with the tripod figure from Olympia (Pl. 126). Two 'warriors' from Athens (Pls. 132-135) and Delphi[21] are contemporary with the elegantly polished handle figure and come between it and the similar figure from the Argive Heraion. The nipples are still indicated on both bronzes. The warrior from Olympia in the Louvre (Pl. 127) probably comes from a ring handle either of the same tripod or of another similar one[22]. Four more statuettes from Corinth, Delphi, Olympia (in Athens) and Olympia (in New York) are more recent, and are versions of the same type, but without the flowing, lively limbs. They are more solid, squat and compact, giving a new twist to the old stereotype, so much so that in the latest statuette in New York, form seems almost to burst out.[23]

The Master of the Horse-leader B 4600 from Olympia and his circle

This new approach could not be properly executed in the old workshop. It needed an outstanding master to produce a completely new version of the human figure, although the basis of the school remained the same. The new version can be seen for the first time in a warrior leading a horse found in 1960 in Olympia (Pls. 136-139).[24] The proportions are radically altered. The length of the head down to the chin is one fifth of the total height. In the earlier horse-leader (Pl. 126) the head, without the helmet, amounts to only one seventh of the total. The body is squat and stocky. The proportions are virtually those of the second half of the eighth century.[25] The lozenge standing on its apex which forms the torso is clearly visible although no longer flat. The chest curves slightly out between the neck

and the mitre. The back is imperceptibly off-vertical from the shoulder-blades down. The right arm carrying the spear thrusts forcefully forward into space in front of the figure, with the hand clearly modelled. The short left arm is slightly bent at the elbow. The left hand, holding the horse's bridle, is not modelled, as on older warriors and horse-leaders from the same school. The mitre consists of three rolls and sits directly above the hip. The top of the thighs springs out in powerful tension from under the mitre. The buttocks are no longer pointed but round and firm. Thighs and calves are superbly rendered, with kneecaps and hollows in the right place. An almost imperceptible elastic movement runs from the legs to the slightly forward-tilted chest, through the whole figure. If one compares it with the almost contemporary warrior in New York, from the 'old' workshop, it becomes quite clear that a new master is indeed at work. In the New York figure, in spite of the left leg being set out in front, the axis from the side still forms a rigid vertical, and the fleshy thighs lack assurance. The new piece is a tremendous breakthrough by a 'new master' who has realized that a sculptural figure cannot become solid without being clearly related to the space around it. The creator of this statue has been very careful here. The frontal view, although also the main view, is not the richest. All the forms—thighs, hips, upper body, shoulders, and arms—are compact, reduced to a minimum, and yet full of inner strength. Only the head is an exception. Here there is barely any trace of Oriental prototypes. The face is merged completely into the rounded dolichocephalic head. A large cap of hair runs round the forehead and down to the nape. It is composed of several locks. A receding forehead, high eyebrows arching above the round eyes, a straight nose between them, lips on the mouth, a beardless chin and ears make up a face full of life. The hair on the nape of the neck, and the ears, which project beyond the hair, lead up to the face, which ends at the point of the nose. The head is almost the full depth of the figure. The front view of the bronze is a powerful yet static starting point, with the head the only interesting feature. But the side views reveal a rich interplay of parts with the trunk inclined slightly forward, the legs a

little bent, a curved chest and back, and movement in the arms and shoulders. Stillness and movement, pent-up strength and rich expression, crystalline form and sculptural space are combined; a great master of Geometric bronze art has emerged. Surely it was a similar inspiration that produced the beautiful bronze youth in Delphi (Pls. 144, 145), even if it were made more than a century after the simple horse-leader, after a tradition of monumental sculpture in marble had begun.

Around this masterpiece are grouped more or less closely related warrior figures, such as statuettes from Thebes in the Louvre and from Delphi, both probably from a later phase of the same workshop, but far removed from the work of the master.[26] Two other fragmentary figures of helmeted warriors, with only the torso preserved, from Olympia and Amorgos, come (or at least the first one does) from the workshop at the time of the master but have none of his greatness.[27] Two statuettes of warriors without helmets are, however, fairly close to the master's style, although they would not have been his own work. They also are broken off at the narrow mitre. One is in Munich, the other in Delphi (Pls. 140-143).[28] Mitre, chest and head are the same as on the statuettes of the master. So are the cap of hair and chiselled strands of hair falling down from the top of the head. But the side-boards and beard are additional. The face is also modelled in the style of the master but is crude and lacks assurance. The head is narrow, elongated and—in the old tradition—has a low chin. The neck is long and the upper body very wide. The arms do not really grow out of the shoulders, and although they are well proportioned, they are absurdly thin and look mannered compared with the broad chest. One can assume that these two fragments were produced by people working with the master, but who were in the workshop before, and sought their development in the mannerist style.

The series of ring-handle holders, horse-leaders and warriors leading from the early ring-handle figure around 800 B.C. up to the 'new master' covers half a century. We have tried to regard them as products of a self-contained workshop or school which would have been mainly concerned with the pro-

duction of large bronze tripod-cauldrons. The archetype—the oldest handle figure—comes from the Argive Heraion. There is an external clue which connects all the products of the workshop to an Argive source. We have often pointed out that in these figures the chest is basically shaped like a square standing on its corner, and that with later products, the whole upper body takes on the shape of a lozenge. Attic vase painting, even at its zenith, uses only the triangular body. Later, too, shoulders are always horizontal unless they disappear in the neck. Only in Argive vase painting, when the Master of the Horses predominates, does the lozenge-shaped body occur fairly frequently.[29] But the connection between this body structure in both bronzes and Argive vase painting is not the only evidence of the locality of the workshop. The famous Argive tradition of horse-breeding and the heraldic images of the Master of the Horses or 'leading the horse by the bridle', which appear again and again in Argive pottery, also seem to indicate a close connection between the workshop and Argos.

The chronology of the workshop can be established within fairly close limits. The horse-leader from the Argive Heraion (Pl. 125) can be dated around 800 B.C. The second horse-leader from Olympia (Pl. 126) belongs to a hammered cauldron-tripod; this group can therefore not have begun before the second quarter of the eighth century. The horse-leader must therefore probably be dated in the early part of the second quarter of the century. Warriors in this style last until around the middle of the century. The third horse-leader by the 'new master' (Pls. 136-139) must have been produced around 750 B.C., which is the date already suggested by Kunze.[30]

3 The Attic school

Alongside the important Argive school we can trace with certainty a second large workshop associated with figured tripod-cauldrons. This probably did not emerge until the end of the Late Geometric period.

The bronze art of Athens, with its tectonic play of utensil and figure, gradually reached a stature never attained by Peloponnesian bronze sculpture. Here a short preliminary note must be inserted to explain the relationship between the great figure style of vase painting in the metropolis and its small-scale sculpture.

The human figure in Attic Geometric vase painting

In Athens the first breakthrough to great figured painting took place on pottery. By the beginning of the second quarter of the eighth century richly figured pictures showing dead men lying in state had developed on large grave amphorae and kraters. Here the simple, Geometric silhouette of the 'lay figure' which dominated the whole Late Geometric period, first occurred. But painters continued to allow themselves freedom in the proportions of their figures, particularly in the men, women, youths and young boys in their prothesis pictures, standing around the massive bier. These variations in proportion were by no means arbitrary.

The pictures have their own special perspective. Mourning men grow into gigantic heroes in order

95 Fragment of a krater from Athens. Height 22.2 cm. Paris, Louvre

to reach up to the vast *kliné* bearing the corpse. At the same time, towards the end of the Geometric period, bronze figures with unnatural proportions developed, fascinating, tense, representations of boyish youths.

On an early krater in the Louvre, of which only two fragments are extant, tall figures of mourning men are standing by a high bier (Fig. 95).[31] They are close behind one another. Under the bier is a boy who is supposed to wail with woe in front of the *kliné*. The mourning men have overly long legs, almost three times as long as their trunks (the natural ratio is 0.50:0.90 metres). Nobody could be offended by these tall figures. Closest relations had to stand in front of the *kliné*, but they are actually shown underneath. The procession of 'heroic' men and the high *kliné* with its corpse belong together, just as later, also in Athens, the 'heroic' youths which formed ring-handle holders on tripods belong to the ring handles themselves. A few decades later we find the brilliant painter of the krater from Piraeus Street (Pls. 63, 64)[32] achieving even more freedom. Only the larger areas of the vase—the foot with its upright, uniformly composed picture strips, and the main frieze around the curvature of the cauldron— are certainly by his own hand; perhaps also the ring handles (?). The most daring composition is the horse rearing upwards almost vertically, apparently under control of its rider. This picture fills out the whole depth of the foot (Pl. 64). The massive neck, enormous thighs and elongated extremeties of both rider and horse produce a picture full of tension and grandeur. But only a few of the laws of Geometric picture structure are obeyed in the proportions of the figures. The whole picture is part of a world of heroism and mythology. Another piece of the foot of the same krater has a similar kind of picture. The narrow space is filled by two warriors with a helmet, two spears and a decorated round shield. The lower one has collapsed on the ground; the victor stands over the vanquished. Again the victor's legs are overly long, superhuman. The upper part of the fragment, where the head, helmet and huge plume would have been, is lost. On the main frieze next to the ring handle one can still see a metope with a pair of similarly equipped warriors fighting each other. Their dimensions are different from those of the warriors on the foot, but they are also tall and still heroic. The reverse of the krater is, however, quite different (Pl. 63). Here there is a man-high cauldron with a stand, an Oriental type. On the rim are plastic animal heads with jaws wide open, in which teeth and tongue can be seen. The ears incline backwards. These are certainly protomes, possibly griffins' heads. In front of the cauldron naked girls are dancing in a ring. In this late period, mourning women tend to be fully clothed, as they are on the same krater in the procession of mourners beneath the partially preserved ring handle. In ritual dances and choruses, too, women no longer appear unclothed. Was this cauldron, perhaps, intended as a prize for victors in athletic games? And were the dancing girls, perhaps, slaves who formed a supplementary prize? The fragment of another cauldron by the same painter[33] also shows a cauldron with griffin protomes (?) with games being played to the left of it and a winner taking off a naked female slave as a prize on the right. Perhaps the painter simply chose to illustrate the dancing girls naked in the old High Geometric manner. Neither interpretation is necessarily correct. At all events, the round-dance of girls with very long legs was never before, and hardly ever again in the decades immediately following, illustrated so effectively or charmingly. This is an heroic, greater world, a world of the cult of the dead and the gods, a world of mythology. In this area Attic painters were unquestionably the best. Neither Corinthian, Laconian, Argive or Cycladic art used the massive dimensions of Attic painting, or its heroic style. Only Protoattic vase painting in the first half of the seventh century carried on this great Geometric style without a break. The Hymettos amphora in Berlin from the first quarter, and the amphora from Eleusis in Athens from the second quarter of the seventh century are the most striking examples of this.[34]

The painter of the krater from the Piraeus Street produced his works very much under the influence of Geometric painting, although contemporaneous with the first Protoattic group of vases associated with the Analatos hydria (Pls. 52-55), around the

ninth decade of the eighth century. It is in this last period of Geometric that the Attic bronze workshop described above must also be dated, where bronze tripod-cauldrons with figure attachments on the ring handles were produced. The Attic spirit is as clear here as it is in painting. Nevertheless we must first look at one more outstanding piece of Attic art from somewhat earlier.

The ivory statuettes from the Dipylon

The item in question is a figure of a naked goddess 24 cm. high carved out of ivory (Pls. 146-148), which was found in a Geometric grave near the Dipylon in Athens,[35] with two heavily damaged, similar, slightly smaller statuettes (18 cm.), fragments of feet and parts of a thigh, and a complete statuette only 11 cm. high. The vases found in the grave belong to the late second quarter of the eighth century, but a storage vessel decorated only on the neck indicates a date at the beginning of the second half of the century. For the ivory statuettes this date can serve only as a *terminus ante quem*. Egypt and the outlying areas on the coasts of the eastern Mediterranean in Palestine and Phoenicia were the classical countries for ivory carving. The zenith of this art lasted from the sixteenth up to the seventh and sixth centuries. Statuettes, reliefs, ivory vases, utensils and bedsteads with inlaid reliefs were the main products. The most important treasures were found in the palace of Megiddo (about 1350-1150 B.C.), in the southeast palace of Nimrud (834-703 B.C., 'Loftus group') and in the northwest palace (first half and end of the eighth century, Layard series).[36] Very little ivory and the technique of carving it reached Greece during the Geometric period. Apart from the statuettes found in Athens, R.D.Barnett mentions only one Egyptianizing relief from Samos with an almost precise counterpart amongst the finds of Nimrud.[37] It is not until the Early Archaic period that ivory finds begin to multiply, in Perachora, Ephesus, the Sanctuaries of Hera at Argos and Samos, and in Sparta. But they are pure Greek work, quite independent of the Orient.[38]

The small ivory statuette from the Dipylon

It has been common practice to separate the small statuette from the Dipylon grave[39] from the large and equally well-preserved one and to assume that it was an Oriental product. The most important argument in favour of this theory has been its polos, which has no meander decoration like the other but a metope-like frieze, not unlike the classical egg and tongue, surrounding it. This occurs on the polos of figures of naked goddesses in the Layard series from Nimrud at least as often as the garland of rosettes. Among early Greek pieces of ivory or bone more or less similar polos decorations occur,[40] although the specifically Syrian ornament on the small statuette from Athens is nowhere to be found. But if one looks at the stylized hair which falls freely below the shoulders and the shape of the body, the connection with the Orient which has been suggested seems to collapse. The naked goddess or woman has a long

96 Ivory statuette from Megiddo (Palestine).
Height about 23 cm.
Chicago, Oriental Institute Museum

history in the Orient, and originally came from Egypt. An ivory figure of very high quality comes from Megiddo (Fig. 96), but only the back is completely preserved. It is crowned with a polos, which is decorated with a lotus-flower ornament. The hands of the figure are not resting on the thighs. The statuette is 23 cm. high and cannot have been produced after 1150 B.C. at the latest. It probably belongs to the New Kingdom.[41] The centre for the production of figures of naked goddesses with polos and arms at their sides seems to have been Syria, where a rich group—part of ivory furniture overlays—was made from the ninth to the eighth centuries. This group found its way somehow to Nimrud (Pls. 149, 150).[42] All these naked bodies are very curvacious, with strongly emphasized sexual organs. Even where the shoulders are narrow, the lower body and the hips are wide. This is the traditional idiom of the Orient. Except for the polos and the basic religious image, no Oriental features occur on the small statuette, which has great simplicity in contrast to exaggerated lines of Oriental figures. The neck is narrow and delicate. The shoulders, delicately modelled, and broader than the hips, form a base for the head and the divine crown. The body is slender, like that of a youth, contracting gently above the hips. The breasts and hips are as delicate as a girl's. The legs are pressed close together, slightly bent at the knee, with only a small gap at the ankles. The shallowness of the torso from the side is a sign of Geometric restraint. The idiom of this ivory figure is pure Greek. It can be best compared with a bronze statuette of an unclothed woman with a tiny polos on her head from Delphi (Pls. 130, 131),[43] which cannot be much older. The head and face of the bronze, and the hint of a polos, are Syrian features translated into Greek form. Its shape is Peloponnesian, and it comes from an Argive workshop. But the ivory figure is neither Peloponnesian nor Attic. The body shape is not as strictly Geometric as on the mainland and it still has an Oriental polos. It is tempting to attribute it to an ivory carver from East Greece, although no satisfactory counterparts have yet been found among the few Greek ivory statues from the east. The most relevant piece is probably the small ivory statuette of two naked goddesses standing back to back from

Camirus on Rhodes. The hands of these figures are on their thighs. This double-sided type also occurs often among the Nimrud ivories.[44] The polos on the figures from Camirus is not Oriental, but the work is no longer Geometric; it is more a mixture of Oriental and eastern Ionian. But they are too clumsy to compare with the small statuette from the Dipylon. We must therefore regard this small statuette as the work of an East Greek master who was working in Athens alongside the master of the larger statuette. Otherwise it can only be an import from the east, brought in perhaps by the latter master.[45]

The large ivory statuette from the Dipylon

The best preserved large ivory statuette is an Attic masterpiece. The front (Pl. 147) shows a vertical axis emphasized by the nose, with a strictly balanced symmetry between the two halves. (This is muted in the small goddess by the slight turn of the head to her right, with the hair also following the movement.) The shape of the body is subject to clear and conscious proportioning. The width of the shoulders is equal to the height of the head from the top of the polos to the base of the neck. This modulus can be divided into the height of the statuette four and a half times. The body narrows sharply under the rib-cage producing a trapezoidal shape which broadens out towards the top, like the almost triangular torso of the Geometric human figure in Attic painting. But the narrowing of the waist and even the chest and rib-cage do not fit in with the simple system of moduli in the statuette. The narrowest point of the back is slightly lower, as can be seen by comparing the back with the front. The distance from the polos to the small of the back, or to the beginning of the vertebrae on the sides or front, is two moduli, and it is another two and a half moduli to the plate at the base of the feet.

The proportions of the small goddess are comparatively simple. The length of the head from the top of the polos to the base of the neck is not significant, and the width of the shoulders is fortuitous. The key to the proportions is the navel, which is exactly in the middle, both on the vertical axis—where the distance from the top of the polos to the

middle is exactly the distance from the middle to the soles of the feet—and on the horizontal axis, where the lengths of the limbs on the left and right are exactly the same. One might expect to find amongst the Oriental prototypes of naked goddesses from Nimrud, which must have been familiar at least to the master of the small goddess, a similar simple system of proportions suitable for the Orient. Unfortunately whole statuettes are not available, but the one statuette with feet (assuming that it has been put together correctly)[46] seems to bear this out. Other ivory figures from Nimrud[47] and a statuette from Tell Atshana,[48] certainly later, may also be adduced. This does not lessen the probability that the small goddess, however close to the Oriental style, was an East Greek work.

Let us return now to the masterpiece of ivory statuettes (Pls. 146-148). The modular proportions from the side and back views, measured to the small of the back (2 + 2½ moduli), do not apply to the front because of the division of the upper and lower parts of the torso. What is the significance of the narrowing of the waist beneath the rib-cage, which is not caused by a belt? The frontal view reveals Geometric basic structure more clearly than the other views. But sculpture and painting are different. Whereas the former gradually developed from the front, side and rear views, towards height, breadth and depth, that is, three-dimensionality, the latter, in two dimensions, begins with what we have called the 'combination figure'. The painted figure has a head in profile, arms and the torso frontal, and the legs in profile again. Thus the torso, down to the waist, of mourning or wailing men or women on the large grave amphora 804 in Athens (Pl. 31)—the oldest large figure painting—is a triangle on its apex. Of course the apex is not a true point, but a tongue which joins up with the top of the thighs. This technique gives way to side views of straight backs found on the Argive bronzes at the beginning of the second quarter of the eighth century.[49] So this is the point where the lower part of the torso of the figure runs into a side view of the legs striding to the left or right. The upper torso of the ivory goddess to the narrowest point of the waist divides four times into the total length of the figure. The same ratios occur

in the mourning men and women on the large Athens grave amphora (Pl. 31), with some inevitable small differences. In the major works of the classical Geometric period, two different stages in the human figure can be distinguished. The first lasts from the large grave amphora to the big krater (Inv. No. A 552) in the Louvre. Here the narrow lower torso becomes elongated as chest and rib-cage move up; the whole torso can be divided three times into the legs.[50] The second stage begins with the large grave kraters around the middle of the eighth century and lasts down to the late kraters in the early third quarter of the century (Pls. 40, 41).[51] The triangle of the upper part of the body now rests on the thighs; the buttocks gradually disappear altogether; the massive thighs are shown from the front like the torso; the knees are not bent but straight, and only the calves and the feet turn slightly sidewards. So the frontal figure is also in evidence in painting except for head and feet, and the 1:3 ratio between torso and legs recurs.

Can painting give us a more accurate date for the large ivory goddess? Two-dimensional art and sculptural form are very different and some *tertium comparationis* should be looked for. But it is the first stage of the Attic human figure, particularly on the large grave amphora 804 in Athens (Pl. 31), which has most points of similarity with the statuette—the static pose, with slightly bent knees, the narrow waist and comparable proportions in the frontal aspect of the statuette and in the prothesis figures on the grave amphora. If we date the latter in the sixties of the eighth century, we can probably put the large ivory goddess in the same decade. This implies that the second stage of the monumental vessels may have lasted beyond the middle of the century.

A simple right-running meander encircles the goddess's polos. This is an Athenian trademark. Nowhere else does it occur as early and as the central feature of ornamental zones. It is a ceremonial band on the polos and it shows the master of the statuette to be an Athenian citizen. But there are still remnants of Syrian techniques in the powerful, tall head: the high, deeply furrowed eyebrows, the protrusions under the eye-hollows, and the bored pupils which

on the larger Oriental statuettes were filled with enamel or semi-precious stones. But here the eyes with their wide-open lids, gaze brightly out at the observer. The gentle, almond eyes of the Orient have become a fixed stare. The nostrils of the nose merge imperceptibly into the delicate cheeks, and the curling lips suggest the granting of one's request. The ears are extraordinarily well carved, far ahead of their time. Curled hair falls behind the ears in a broad mass below the shoulders, with the plaits tied together in pairs, similar to, although less heavy than the bronze horse-leader from the Argolid, which is already Late Geometric.

The main view is from the front (Pl. 147). Here the static shape is tectonically composed around the intersection of axes in the head, shoulders and middle line. The figure is given hidden life by its simple, obvious proportions. But behind it is more than a century of Attic potters' sculptural experience with their clay vessels, including, at the time of this master, grave amphorae, of almost human size; and the experience of the creators of the figured scenes on these vases. In this statuette, Geometric ornament and Geometric figure drawing are combined, achieving an early peak of Attic art and a short-lived balance between the two. The talented master of the ivory statuettes was one of those artists who were laying the foundations of the future while High Geometric was still at its zenith. From the front the different parts of the body make up a majestic but somewhat unapproachable whole. But from the side and back (Pls. 146, 148) the figure blossoms into girlish delicacy. The taut breasts and the simple beauty of the slender body are unprecedented. A relaxed curve runs up the legs, with their slightly bent knees. The upper thighs run into a gently rounded belly. The waist above this joins the small of the back, tipping the upper body almost imperceptibly backwards. The vertical axis from the head to the ankle-bones passes in front of the ear. There are gentle curves in the upper part of the body seen from the side, and the soft curves of the rib-cage flow more freely from the back view than from the front. The neck grows delicately out of the beautifully shaped shoulders. The exquisitely curved cheeks and chin are charming.

The craft of the ivory carver continued without interruption in Asia Minor and the towns of East Greece. The techniques also survived on the Greek mainland. Early forerunners include the bronze of a horse-leader in the Argive style from Olympia (Pl. 126),[52] which is not much later than the ivory statuette. But the style, superbly developed, is still in evidence as late as the seventh century in the wonderful ivory youth from Samos, crouching in the frame of a *kithara*.[53]

Attic Geometric bronze sculpture

Attic bronze art does not appear to have developed until some time later. It is represented by statuettes made as ring-handle holders (Fig. 97) for large hammered tripod-cauldrons. The statuettes fall into a single, well-defined group and may have been produced in the course of only one generation and in one workshop, which can scarcely have begun work before the last quarter of the eighth century.

The statuettes of bull-men

Let us begin with the statuette (18 cm. high) of a man with the head of a bull, in the Louvre (Pl. 152),[54] holding up a ring handle from the right with his two raised arms, turning his head over his left shoulder, as if to threaten the onlooker. The body is not Geometric but is much more supple; only the details, such as chest muscles and navel, are deliberately left out. Penis and buttocks are half-way between the horns on the bull-head and the soles of the feet. The body is not flat but solid, four-sided, almost imperceptibly curved in front and more obviously around the shoulders, small of the back and buttocks. The line of force runs through the arms, into the wiry body and down the left leg which is set forward. The bull-head, with its open mouth and lips, is turned to the left. The right, weight-carrying leg is on the outside of the ring handle. On all other ring-handle holders in this group the forward leg is on the inside of the ring handle, producing a static, natural form. The bull-men are very different—brute force stepping aggressively forward.

A fragment of another bull-man (Pls. 153, 154) was found on the Acropolis in Athens. It cannot come from the same tripod-cauldron because it is somewhat larger and the upper body is more detailed (with powerful chest muscles and navel both indicated) than the completely preserved figure in the Louvre. But it is probably a later piece from the same Attic workshop.

One cannot be certain whom or what these bull-men represented. Minotaur obviously springs to mind here, but there is no sign of Theseus, who defeated the Cretan monster, in any of the ring-handle holders. Anyway, the idea that a fight was supposed to be about to take place between a pair of supporting figures on a ring handle is surely rather ridiculous. But no mythical image from the Geometric period has as yet been entirely satisfactorily explained. Only mythical figures like the bull-headed Minotaur or the twin-bodied Molione-Aktorione are really clear. The latter occur by themselves on a late sherd from the Argive Heraion, underneath a bronze horse from Phigalia and in the middle of a frieze of horses and chariots on a large Attic krater in New York. Opponents of the Aktorione are found at the end of a long procession of warriors with Dipylon shields on a frieze on an early krater in the Louvre (Fig. 13); in a frieze of horses and chariot on a Late Geometric jug in Athens (perhaps the young Nestor); and on two sub-Geometric Boeotian plate fibulae from Thorikos and Crete in the National Museum in Athens,[55] on which the opponent is for the first time identifiable as Herakles. But if the figure opposite the Minotaur on the other side of this handle cannot be Theseus, it may be one of the fourteen Attic boys and girls intended as the Minotaur's victims, whom Theseus had to take as tribute to King Minos of Crete. The bronze statuette of a boy from Olympia (Pl. 151),[56] from the left side of a ring handle, is in every respect a counterpart to the Minotaur. It is by the same craftsman who produced the Minotaur, only the proportions are more like those of a boy. The joint between the base of the statuette and the rim of the cauldron is the same as on the Minotaur in the Louvre, including the two widely spaced rivet holes, as can be seen in the otherwise useless sketch of the boy in the old Olympia publication. After being taken to Athens, the base was removed. Here too, the left leg is forward, but is on the inside of the ring handle. The position of the arms and the way they hold the ring is the same as in the Minotaur but less rigid, like a boy. A further important point is the way the hands were attached to the ring handle in both bronzes: the outside hand is completely modelled, while the invisible inside one has only a crude palm pierced by the rivet hole. This also indicates the same workshop and probably connects the Minotaur and Attic boy with the same ring handle. The heights of the two figures, without base, are 15 cm. for the Minotaur and 14.8 cm. for the boy. The slight difference may be because of the slightly up-turned horns on the bull-head. Another figure of a boy or youth in the form of a ring-handle holder was found in Olympia and is now in Berlin.[57] Its proportions are more elongated and the execution cruder than the bronze from the Minotaur handle, but the style is similar. The simple rendering of the torso, without details, and the out-turned head are very like the boy with the Minotaur and prove that both are from the same school. The height is 17.5 cm. without base. Since the right foot is forward and the front ring handle must have been occupied by a Minotaur, this bronze statuette probably comes from the back handle of another tripod-cauldron, probably also with a Minotaur and his victims. The upper part of a Minotaur from the Acropolis in Athens (Pls. 153, 154) must belong to a third tripod-cauldron of considerably later date. This vessel, which must have been one of the most precious items produced by its workshop, would have been dedicated as a votive offering in Athens.

The bull-man can almost certainly be interpreted as the Cretan Minotaur, even though not yet engaged in mortal combat with Theseus. This does not occur in Attic art until the sixth century. At the end of Geometric art, the tributary youths—no girls—and the Minotaur are found together attached to tripod handles. It is typical of the Geometric approach that, although the death of the Minotaur and the saving of the boys do not yet take place, this potential outcome is inherent in the pairs of figures.

The three tripods discussed seem at first sight to have little connection with Athens. But a late fragment of a Minotaur probably from a lost tripod-cauldron from the Acropolis in Athens does suggest a connection. And the legend of Androgeos, son of Minos, who was supposed to have died in Attica, whereupon the powerful King Minos demanded that every nine years fourteen boys and girls be sent to Crete as victims for the Minotaur, is an Attic story. Moreover, Athens was the first place in Greece where painting and sculpture, as well as legend and poetry, were used to make lasting memorials of funerals, heroic deeds, and myths. It was presumably a combination of these factors which produced the Minotaur figures on the three tripods.

Two pairs of ring-handle holders from the Acropolis and Olympia

Two more Attic tripods follow the above chronologically. The upper body and head of a bronze statuette was found on the Acropolis a long time ago (Pl. 155). The torso is four-sided and long. The chest is more curved than the Minotaur, with the chest muscles strongly brought out and the vertebrae visible on the back. The shoulders are very narrow. The left arm stump is extended almost horizontally. The right runs down at an angle. As in the Minotaur, the head looks over the shoulder to the left. The hair, which is not chased, comes low over the forehead, covering the ears on the sides like a cap, and falling over the nape of the neck down to the shoulders. The face seems almost to be cut out from between side-boards, beard and hair. The face is serious, with large features. The nose is straight and runs out from the forehead between the eyebrows. The nostrils are broad. The large eyes are almond-shaped and slightly inclined, with chased pupils. The lips are strongly modelled and closed, the mouth firm and decisive. It is not surprising that people thought that this bronze was Perseus or Theseus.[58] The riddle of the true meaning of this figure was solved by S. Papaspyridi-Karouzou.[59] Amongst the bronze fragments on the Acropolis were two pairs of legs, which begin at the waist above the hips and

are broken off below the knees. One of these two fitted this torso, and the other belonged to another corresponding figure. Both bronze figures held up the ring handle of an Attic tripod-cauldron (Fig. 97).

97 Reconstruction of a ring handle of a tripod-cauldron

The proportions are extremely elongated, with the tall, slender torso half the length of the legs. The overall height is about 27 cm. This elongation of the body began with the large kraters around the middle of the eighth century, and it reached its peak in the last two decades of the century, at the time of the important Protoattic pictures of the Analatos-hydria phase (Pls. 52-55). In the first quarter of the seventh century it develops, on the Hymettos amphora and the Polyphemus amphora from Eleusis, into a harmonious style.[60] The people are of positively heroic dimensions. S. Papaspyridi-Karouzou also believes that she has discovered the name of the Attic ring holders, by an ingenious insight: they are the 'Telchines'.[61] These were goblins, wizards, smiths and the first producers of metal god figures, long before the Zeus religion. They were supposed to have made Poseidon's trident, as Hephaistos made the thunderbolt for Zeus. Their business, according to the ancient mythologists, was conducted on the island of Rhodes, which they left when the cult of

Helios started there. They were also known on Crete and Cyprus. On the Greek mainland, the town of Sikyon was originally called Telchinia and traces of the Telchines are also found on the island of Keos and in Boeotia. Mme. Karouzou is credited for having identified these ring-handle holders. There is of course some doubt whether calling them Telchines is quite correct. The Telchines were said to have been sons of the sea and could turn their limbs into fins. They were not always friendly, being sometimes represented as evil and mischievous, ruining crops, flooding the countryside with sea water and causing large parts of the islands to sink into the sea as a result of earthquakes. Many of their activities might be classified as 'Poseidonian', belonging to an area of religion which was not yet dominated by Zeus alone. But even if the Telchines were active in the northern Peloponnese, on Keos and in Boeotia, there is no trace of them at all in Attica, although religious relics are more plentiful in Attica than anywhere else in Greece. They had obviously been combined, in Athens, with the god Hephaistos, who had many of the characteristics of the Telchines. Or did, perhaps, some memory of these ancient Telchines last, after all, into the Geometric period? This is one of those cases that do not seem to be capable of any conclusive proof. Mme. Karouzou's discovery is nevertheless delightful, even if one must put a question mark after her interpretation of these figures as Telchines. They seem to me to be rather more Hephaistean.

Two more ring-handle holders (Pls. 156-158) are not much later in date. They have recently been found in Olympia. They were made by the same workshop which produced the 'Telchines' tripod and belonged to the two handles of one vessel.[62] Casting errors can be seen: the arm stumps and the base beneath the left leg are bent, and the body is covered with bumps and indentations. But nothing can detract from the impact of these superb proud youths. They are hardly statuettes any more. They have a touch of the monumental about them already. The height of the complete bronze (Pls. 157, 158) is 36 cm. But the torso and shoulders are still narrow, with the chest muscles only barely modelled. The arms are also thin and boyish. But the unnaturally slender legs

are very long and set apart. This is the 'restrained, economic style' of the Telchines from the Acropolis in Athens (Pl. 155), but 'it asserts itself only with difficulty over the new dynamic in figures, which can be seen in the more gentle flow of the outline over the caesurae, giving the figure an organic appearance'.[63] The heads are a more developed version of the Telchines' heads. But they are not twisted sharply over the shoulder towards the onlooker; they are turned slightly outwards, away from the raised shoulder (Pls. 157, 158). The elaborate hair is parted in the middle and flows down with grooves onto the shoulder, held back by the ears above the temples, to reveal the profile of the face and youthfully delicate cheeks. Here—and particularly, in the complete statuette (Pls. 157, 158)—we see, probably for the first time, real facial beauty.[64] The daring proportions, narrow body, delicate arms and the unnaturally long slender legs must have been intended to match the elaborate, baroque rod metalwork of the vessel, which was certainly monumental. But this structural requirement also produces marvellous images of beautiful youths. Only in an Attic workshop could this daring flexibility of proportion have been created. This superb freedom of proportion developed predominantly in painting, as early as the middle of the century, between the Attic krater A 545 in the Louvre and the baroque excesses of the late krater from Piraeus Street (Pls. 63, 64). The two ring-handle holders must have been produced slightly later than the latter krater, probably about the end of the eighth century, when the last late flowering of Geometric was already being killed by the victorious advance of the Protoattic style.

Should one try to identify these youths? Were they, perhaps, torch bearers in the festival of the Lampadephoria in honour of Hephaistos in Athens? Or competitors in the games at Olympia? One cannot answer this question with any certainty.

Four ring-handle holders from the Acropolis

We will end our survey of small Attic bronzes with four more bronze statuettes which lead progressively into a new, less restricted phase. They are two war-

rior figures and two youths from a fourth tripod-cauldron. Let us begin with the warrior found on the Acropolis (Pls. 159-161). The figure is wearing a Geometric helmet and would have had a shield on its left forearm and a spear in the right hand, ready to throw.[65] Basic Geometric form is largely preserved—triangular-shaped torso, somewhat elongated, narrow waist, legs apart and slightly bent at the knees, both in the same plane, and comparatively long, thin arms. The torso is flat, without details on the front. From the side, the heavy thighs, head and shield-bearing arm project markedly. Structurally, this statuette is still largely based on the human figures on the large Attic painted kraters, from around the middle of the century. The ivory goddess from the Dipylon (Pls. 146-148), which is decades older, had already progressed beyond this. There is a lot of Geometric mannerism and idiom in this bronze. But the back is surprising (Pl. 161). It forms one large unit from the head down to the calves. The shoulder-blades stand out clearly. The backbone runs from the shallow depression between the shoulder-blades down to a deep furrow at the small of the back. The buttocks are stretched by the parted legs. Thighs, knee-hollows and calves complete a unified back composition, the product of a clear sculptural concept. The sharp front edge of the shin-bone continues along the thigh ending at the pelvis. Old and new seem to have been deliberately combined in this warrior figure. It is surmounted by a heavily featured head, with hair—as in the Olympic youths (Pls. 156-158)—falling down onto the shoulders, leaving the ears free, with the crown disappearing under the helmet. A clay head from Amyclae (Pls. 162, 163), 11.5 cm. high, part of a large clay statuette of Apollo of Amyclae, is the closest stylistic and chronological counterpart of the statuette.[66] Its helmet has a painted frieze on it, with a right-running meander, like the polos of the ivory goddess from the Dipylon (Pls. 146-148). It is, however, at least half a century later. Common to both is the piercing look in the eyes—'A look which seems to dominate the whole form' as Buschor puts it. The splendid profile (Pl. 163), has an explosive power which seems to be restrained in the body, held back by the ritual Geometric constraints, par-

ticularly seen from the front. The head from Amyclae and the bronze statuette are both gods. Apollo perhaps? Or Ares? The style of the statuette exemplifies the transition from Geometric to freer sculptural form. This lasts into the first half of the following century. It must date from the very end of the eighth century, perhaps a little later than the youths on the above-mentioned tripod-cauldron (Pls. 156-158). The height of the warrior, including the lost feet, must have been about 21.6 cm.

The second warrior (Pls. 164, 165) is about the same height, 21.2 cm.[67] The upper part of the body is inclined slightly to the right from the hips. The complete right arm, which held a spear, and the left arm, without a hand, which probably carried a shield, are both bent. The back is similar to the first warrior. The side views are more curved and the front is modelled more. The collar-bones project below the neck, with a depression beneath them running from the powerful chest as far as the shoulders. The face, particularly in profile, is calmer, and has a character of its own, with the hair divided into six plastic rolls of curls. Geometric structure, which still dominated the frontal composition of the first warrior, has disappeared. All the parts of the body form an integrated, living totality. The transition to Protoattic is now complete.

Two tripod-cauldron ring-handle holders, about 28.5 cm. high with the lower legs, which are missing, come from the same workshop as the second warrior above.[68] Both arms of one statuette (Pls. 166, 167) have lost their hands. The left forearm is turned in to the right. The arms of the other figure (Pl. 168) are mere stumps. The hair of both statues is parted at the crown and falls in eight rolls of curls down to the nape of the neck. The head and the face of all four statuettes—the two warriors (Pls. 159-161, 164, 165) and the two ring-handle holders (Pls. 166-168)—form their focal point. Two different artists can be distinguished in the same workshop. The explosive rendering of the eyes, nose, mouth and chin of the older warrior (Pls. 159-161), and the neglect of bone structure, are modified in the first ring-handle holder (Pls. 166, 167) by the curve on the temples, the cheekbones, and the lower jaw and

chin. The magical sparkle on the face of the older warrior gives way to calm, integrated features with large almond eyes, slightly off-centre nose, jutting lower lip and firm chin. The later warrior (Pls. 164, 165) and the second ring-handle holder (Pl. 168) seem both to have been produced by a second artist. Typical touches include almost circular wide-open eyes. The head is modelled in accordance with the internal bone structure. The profile of the warrior with its slightly crooked nose and tightly shut lips has a static, almost gentle clarity. The first ring-handle holder, on the other hand (Pls. 166, 167), which is probably slightly later, has a face modelled with mature sculptural assurance and with the gravity and simplicity of genius.

The Attic school begins towards the end of the Geometric period and progresses through various phases towards the Protoattic style of the early seventh century. It starts with the tripod-cauldrons with the Minotaur and the 'Telchines'. Then come the beautiful youths on the tripod in Olympia. This transitional phase includes both warrior statuettes and both ring-handle figures from the Protoattic cauldron-tripod, which is a little later. The period stretches from approximately the beginning of the penultimate decade of the eighth century until the end of the first decade of the seventh century.

4 The Corinthian workshop

In Corinth, production of bronze figures, particularly of ring-handle holders and perhaps also of twin-figure groups on tripods, began comparatively late, although earlier than in Athens. But Geometric composition did not develop here as it did in the Argolid in the first half of the eighth century. Of course, there were echoes of the Argive style, such as a warrior with an upright spear in his hand, or a man with a broad chest, nipples and a mitre round his waist, from Delphi.[69] One has the lozenge-shaped chest and a slack body, the other is a successor to the splendid horse-leader from Olympia.

Both figures attempt to avoid narrowing the waist sharply. The first has a pillar-like shape gently widening above the hips. The second has a large midriff with a belt. The neck of the later statuette is so long that the central axis dominates, forming an intersection with the line of the broad shoulders. The individual details borrowed earlier by Corinthian bronzes from Argive art disappear almost completely in the later period, in the last quarter of the eighth century. Instead, a basically Corinthian style emerges, which we have already studied, with less rigid human figures and increasingly dominant central axes. As in Athens, although perhaps less violently, a new non-Geometric approach breaks through in Corinth too.

The oldest Corinthian statuette is a warrior from Delphi (Pls. 169, 170), which must have had a spear in its raised right hand, although the hand is now broken off, and its left, bent arm appears to have been leading a horse which is now lost. Beneath the feet is a protrusion with two holes, one beneath the other, through which the bronze was fastened to a ring handle.[70] The form seems to be copied from Argive horse-leaders and warriors. The long, supple neck, and the head and face, are ultimately Syrian influenced. The figure has no separate upper arms. The legs are parallel in a loose stance similar to the latest warrior figures of the Argive school (Pls. 126, 127). But in spite of these details the statuette is not from an Argive workshop. The ears are only indicated, and the arms are wretched little things. The torso is broad but contracts beneath the rib-cage into a finely chased mitre, then widens out at the hips. This is obviously a completely different view of the human figure to that of Argive sculptors.

This is directly followed by another male statue, also from Delphi (Pl. 171) by the same sculptor.[71] The face is modelled more. Both arms are bent. The upper arms, still thin, are more clearly distinguished. The legs, broken off below the knee, are set more apart. But the thicker torso, wide shoulders, breasts, and midriff no longer pinched in but simply encircled by a wide mitre, are all new features. For the first time the triangular figure, typical of Attic painting, has been discarded in Corinthian art and the significance of the midriff in the human figure has been recog-

nized. The first statuette would have been produced around the middle of the eighth century, the second around the end of the third quarter of the century.

Two statuettes from Delphi and Dodona

Two bronze statuettes, one from Delphi now in the Louvre, the other from Dodona now in Athens (Pl. 172), the former preserved down to the lower torso, the latter complete apart from the feet, are considerably later.[72] The complete statuette in Athens is somewhat later than the Louvre fragment but both come from the same workshop and are certainly Corinthian products. One was found in Delphi, where most Corinthian vases, terracottas and bronzes were dedicated from the earliest years of the temple's existence. The other comes from the ancient Sanctuary of Zeus at Dodona, near a number of Greek towns on the west coast which grew rich by trading with Corinth. The products of this workshop reached as far as the Sanctuary of Artemis at Lusoi near Kleitor. Both bronze figures from Delphi and Dodona (Pl. 172) and the terracottas from Lusoi[73] have the same type of head, a thick cap of hair reaching down to the nape of the neck and the chin, leaving the forehead and the cheeks more or less free. On the bronzes the 'wig' has engraved irregular zigzag bands as decoration. The face has a heavy nose, little round eyes and a mouth right underneath the nose. Since the Dodona bronze was a ring-handle holder on a hammered tripod and the head was turned over the left shoulder, only the side view is seen by the onlooker, with a clean, faultless profile. It is something quite new.

The two bronze statuettes from Delphi and Dodona used to be considered crude, primitive pieces and are occasionally still treated as such. Only Sylvia Benton has recognized their 'excellence'.[74] On the fragment from Delphi, the face looks straight out from inside the 'wig', the arms make the same gestures as the earlier statues from Delphi (Pls. 170, 171) and the torso is integrated into the body. But the mitre has disappeared. The nakedness is no longer primitive but expressive. The right shoulder is raised with the right arm and seems short, while the left shoulder is broader, with the left arm lowered. This rhythm

continues down to the hips. The calm of Geometric form is enlivened by movement. A new style, Geometric and yet not entirely so, has emerged. It is part of the development towards the Protoattic human figure visualized by the master of the krater from Piraeus Street in Athens (Pls. 63, 64) in the middle of the last quarter of the eighth century.

The Corinthian bronze statue from Dodona (Pl. 172) was produced somewhat later. Let us begin with the side view, which is the direction in which the head is turned. It is still the same as on the two Corinthian bronzes in Delphi around the middle of the century, except that the face is looking over the left shoulder and one leg masks the other. The basic pose is as simple as possible and seems conscientiously Geometric. Then something wonderful happens. The legs take a firm stride. Posterior and slit of the buttocks are displaced from right to left, with the latter running in a fine curve up from the thigh to the base of the vertebrae. From the side everything appears to be in movement. From the back, the right shoulder seems to be lifted up by the raised arm and pulled forwards, while the lowered left arm extends the shoulder to its full width, pulling it back. This important bronze figure, midway between two worlds, has developed out of simple Geometric two-dimensional, side-view figures by the use of daring techniques of perspective. The naked body forms a perfectly integrated whole with a life all its own. Above the neck is a mature profile of a bearded man. The reader will already have guessed who this is. The statuette is undoubtedly of Zeus, the god of Dodona. This is the first appearance of the basically Geometric version of Zeus which was to dominate images of the god and come to perfection in Early Classical sculpture.

With the statuettes from Delphi and Dodona, a new generation of bronze sculptors has taken over the Corinthian workshop. Almost all their figures also belonged to bronze tripods being used as supports and decoration for the ring handles. They have obvious connections with Athens, such as heads turned sideways, as in the Minotaurs (Pls. 152–154) and 'Telchines' (Pl. 155). They have the same wig-like cap of hair as one of the Telchines, where it reaches down to the shoulder leaving more of the

face free than in figures from Corinth and Lusoi, which usually have a shorter, more modest head of hair, reaching down only to the beginning of the neck. Another close connection with Athens is the choice of mythical and immortal figures, such as the Artemis on horseback from Lusoi, and the Zeus from Dodona (Pl. 172). This gives approximate dates for the Corinthian statuettes: around the last decade of the eighth century for the older one and around or just after 700 B.C. for the Zeus.

An even closer connection between Athens and Corinth is established by two bronze statuettes, a warrior with a Corinthian helmet (Pls. 174, 175) and a youth (Pl. 173), both probably handle figures on tripod-cauldrons. Both are from Delphi.[75] The youth resembles the Attic youth (Pl. 168) in detail, except for the position of the arms. The hair is identical, falling in eight separate locks down to the nape of the neck and shoulders and parted on the forehead. The Delphi face, however, is spoilt by faulty casting. The collar-bones are strongly emphasized, seeming to lie on the chest almost like a necklace. It is not impossible that this youth actually came from an Attic workshop. But the poor casting of the head and collar-bones would scarcely have been allowed to pass by an Attic bronze craftsman as an offering at Delphi. The only remaining possibility is that the Delphi tripod was cast by a craftsman who had learnt his trade in Athens.

The statuette of a warrior with a Corinthian helmet from Delphi

The second bronze figure, also found in Delphi (Pls. 174, 175), is slightly taller and must have belonged to a larger tripod-cauldron. It is a much better piece. The slender warrior is wearing a Corinthian helmet of on early seventh-century type[76] although the helmet alone does not fix its origin in any particular area of the Peloponnese. Only the wide-open, round eyes, wide nostrils, mouth and chin can be seen between the side pieces on the helmet. The rim runs round the nape, level with the chin. The face looks out as if from the wig of an older Corinthian statuette. From under the helmet, six spirally

rolled locks hang down to the shoulders, with two thicker ones running down the neck into the angle made by the arms. Two Attic warrior statuettes, one somewhat earlier, one more recent, and two youths, all found on the Acropolis (Pls. 164-168), have the same hair style but are wearing Attic helmets of Geometric shape. The neck of the figure from Delphi is too long for Attic style. A straight, proud line runs through the nose, mouth, chin and long neck, continuing down the main axis through the sex organs and the delicately movemented body, down to the feet.[77] The distance from the peak of the helmet to the bottom of the neck is a quarter of the total distance along this axis down to the feet. The arms, of which only stumps remain, have slightly lowered the right and slightly raised the left shoulders. Thus a slight movement runs through the body which, while not absent in Attic statuettes, never reaches down as far as the midriff. From the left side, this movement is expressed by a slight raising of the torso beneath the shoulder and a corresponding narrowing above the hip of the weight-carrying leg. From the right, the outline of the torso begins lower, with a sharp angle under the arm. It runs more obliquely and straighter, ending with a slightly more marked narrowing above the hips, and a more relaxed leg. The interplay of limbs can be clearly seen on the back of the figure. On the left side, under the raised shoulder, the body contracts slightly above the hips. The buttock above the weight-carrying leg is taut. On the right, the side of the torso is an oblique straight line with a rather lower waist and lower buttock above the free leg. There is a delicate S-shaped furrow above the backbone and buttocks. One can see the movement in this delicately poised figure quite clearly.

Contemporary Attic ring-handle holders and warriors, similar to the Corinthian bronze figures in many details, are larger, more open in form, like the large figures in Protoattic painting. In Attic art the upper body is set quite crudely on the pelvis. But the important master of the bronze figure with the Corinthian helmet (Pls. 174, 175) has more insight than this. He discovers, for the first time, the technique of producing movement in the sculpting of the waist—although the Corinthian Zeus from Dodona (Pl. 172) has progressed a certain distance in this

direction—and manages to breathe life into the whole body.

The nearest counterpart to this is miniature painting of Protocorinthian vases. Matz correctly identified the master and his work as Dorian.[78] P. Perdrizet believed the Delphi statuette to be Corinthian because of a small rosette on the left upper thigh, probably a tattoo. This is also sometimes found on Corinthian clay *pinakes* in the same position, admittedly a century later, also on a Boeotian relief pithos in the Louvre.[79] The same emblems also appear, at the same time as this statuette, on Protoattic vases. They occur, for instance, on the Polyphemus amphora in Eleusis, on the amphora with the killing of Agamemnon now in Berlin and on the mitre from Rhethymno on Crete[80] which is slightly later. In fact the motif is widely distributed, occurring in Crete, Athens, Boeotia and Corinth. The early occurrence of the rosette on this statuette can therefore not strictly be taken as proof of Corinthian origin. Nevertheless, in view of the other connections of the statuette to Corinth and Athens, it is an important clue, since it apparently occurs in Athens and in Corinth at the same time, and particularly since it then lasted for about a century in Corinth. At all events the Delphi figure, with its distinction between weight-carrying and free leg, its continuation of movement through the whole body, and its emphasis on the central axis, can only have been produced in Corinth in the first quarter of the seventh century.

5 Racing-chariot offerings from Olympia

Remnants survive of about seven small bronze racing chariots dedicated as offerings by the victors in the chariot races at Olympia.

The oldest chariot

There is no doubt as to which of these racing chariots is the oldest (Pl. 178). It has a wide chariot-box containing two men, a chariot driver, and on his right, the owner who must have been armed.[81] The chariot has no bottom. The two occupants are standing on the axle-shaft, which runs under the middle of the chariot-box. The upper rim of the box is like a rail in front of the two men. From here a thick forked support slopes down to join the lower front edge of the box. In the middle of this the end of the broken shaft can still be seen. The rail runs down backwards on to a third cross-beam, probably a step for mounting. The chariot is rendered only in skeleton, as it were, in order to bring out the two figures. The axle must in fact have been underneath the floor of the box, and the first and third cross-beams part of the floor. Both wheels, the shaft, and the two horses are missing. The chariot is an abstract framework of rods. The men in the chariot standing on the axle have short, wide-set legs. Both are leaning against the upper rim of the box, touching it between crotch and thick belt above the hips. The complete chariot driver has an overly long upper body with clearly defined chest muscles. He is holding tight onto the upper edge of the box with his left hand. The left shoulder is dropped and the right raised to grip the two reins in its right hand. The ends of the reins touch the rail. The long narrow neck is twisted towards the raised shoulder and the middle of the chariot-box. This small piece is crude and clumsy, but it is not a primitive work from the beginnings of Geometric bronze sculpture. The chariot driver has a wider stance than the owner, who is standing more firmly and balanced. The former is holding onto the outside rim while throwing the weight of his body inwards to manipulate the reins and see the horses. This is all crudely rendered, but is nevertheless modelled on the grooms and warriors of the Argive school (Pls. 124-145): the narrow head, with its wide mouth and the projecting nose, to which large ears have now been added, the Geometric helmet and the broad belt, later worn by warriors from the same workshop. The short, splayed legs and the low penis had to be fitted in under the chariot rim.[82] The chariot cannot come from the very disciplined Argive workshop, nor is it one of the *incunabula* of Early Geometric art. The borrowings from the Argive bronze industry indicate the date of the chariot fairly accurately as the late second

quarter of the eighth century. But there are various possible sources for the racing chariot. One is suggested by its distant connection with the Argive bronzes. The raw modelling of the occupants of the chariot rules out any direct connection with Argive art, but may indicate an origin somewhere between Argos and Olympia, such as Arcadia. This location may be supported by some new find still to be unearthed.

Argive racing chariots

On the other hand two single-occupant racing chariots (Pls. 182-184), another charioteer and the helmet crest of a fourth[83] can be clearly located chronologically and geographically. Here the chariot-box has a floor consisting of a semicircle pointing in the direction of travel.[84] The framework of the chariot-box has three legs and is extremely elegant. The centre leg, with three struts like the bowsprit of a ship, projects slightly forward. The three struts, with the middle one rising slightly higher, support a curved rail which runs round flat on both sides, and then turn sharply down into two concave legs at the back. The centre leg runs into the pole, unfortunately broken off in front of the floor. A second version of the same racing chariot, now in Athens, still has its pole, with a double yoke.[85] It is therefore very unlikely that the chariot, as suggested by Kunze,[86] had no wheels. The knobs beneath the feet of the charioteer go through the floor, and an axle could well have been connected to them.

The charioteer in this racing chariot is short and stocky. The chest swells out; the back follows the vertebrae in a delicate curve; the waist is clasped by a broad belt. The figure is full of life. Buttocks and thighs are short and strong, and calves thick. The upper body, forming a rhombus on its apex as in Argive bronze statues,[87] is unmistakably Argive, although the shoulder joints have become independent and the arms in front of the body have a life of their own. The hands, which originally held reins, are particularly fine. The massive neck and waist held in by a belt are channels through which life flows into the whole figure. The head is a late coun-

terpart to those of the horse-leaders in Olympia (Pls. 136-139), with a very similar profile. As on them, the cap of hair starts above the forehead, but it is closer around the back of the head and reaches down past the nape of the neck. The form of the ear is the same as on the horse-leaders. There can be no doubt that this racing chariot, particularly the charioteer, must have been produced by an Argive workshop. It is probably a later period, produced in a phase of freer sculpture than the Argive horse-leaders. This enables a fairly accurate date to be established.

The massive legs of the charioteer are not wide apart, but neither are they at rest. They are slightly bent at the knee and loose to cushion the bumps of racing. Leg stances like this never occur on large grave kraters in Athens. But a similarly relaxed stride or stance occurs on two comparatively late kraters from the 'Hirschfeld workshop', in the mourning women (Pl. 41) in front of the prothesis, and in the slow gait of women and men processing to the grave (Pl. 40), with the legs slightly bent and thighs and calves strongly emphasized. Both kraters are amongst the latest of their kind and probably date from after the middle of the century.[88] So we find large Attic pictures of figures with similar leg positions to the roughly contemporary charioteer. This must therefore have been produced in the early third quarter of the eighth century. The thickly set proportions of the bronze are, however, a non-Attic feature which developed shortly before the middle of the century in the Argive workshop but spread in the Late Geometric period.

A similar chariot and a rider are related to the Argive racing chariot and driver.[89] Charioteer and rider are both wearing a petasus. They are redolent of country air and wide horizons, suggesting Arcadia as a source.

Argive racing chariots with East Greek influences

There are two other racing chariots from the same workshop, with drivers, which should be described. The first was found at the Pelopion in Olympia and taken to Berlin (Pl. 179). The second was found

in a Roman stratum in Olympia (Pls. 176, 177).[90] The heights of the two chariots are 9.7 cm. and 8.7 cm. respectively. The elegance of the Argive chariot (Pls. 182-184) is missing. The metalwork is complicated by a cross-support half-way up the chariot-box. The lower zone has two oblique struts and the upper zone a pattern of zigzag rods instead of a 'bowsprit' with two or three struts. The rendering of the chariot-box is considerably more sophisticated than in the earliest piece (Pl. 178). It has, however, no bottom, only a strong semicircular frame. The now broken pole ran out from the 'bowsprit'. On the counterpart in Berlin the pole is complete with yoke. The left axle, wheel hub and spokes of the Olympia chariot (Pl. 177) are preserved. The wheel would have reached more than half-way up the box.

Although this type of chariot was obviously typical of Olympia, the drivers of the two chariots do pose various problems. The driver in the Berlin chariot (Pl. 179) has sloping shoulders, a well-proportioned body and well-shaped legs, with the looser left up against the rigid right.[91] More important is the somewhat smaller figure in the Olympia chariot (Pls. 176, 177). Here we come across a phenomenon already seen in, for example, the late warrior from the Acropolis (Pls. 164, 165). From different viewpoints, different aspects of the figure unfold, developing from the Geometric type into a freer pose. The side view (Pl. 176) is very similar to the same view of the Argive charioteer (Pl. 184) except that the modelling of the limbs is more distinct, as, for example, the plump thighs which are proportional, stronger and more muscular. From the front view (Pl. 177) the shoulders merge more easily into the movement of the upper body and arms. The forearms touch the rail just below the elbow. The massive paws are holding reins, of which the right one is still in the hand. The back view is a break with traditional Geometric form. Nape and shoulders move with the arms. The upper body is no longer tied to a rhomboid chest area but is developed freely as part of a naturally shaped body. The right leg supports most of the weight, with the left set loosely to one side. The traditional character of this period is clearly demonstrated here.

The head of the chariot driver, more detailed than that of the Berlin counterpart (Pl. 179), is a surprise. Its form is more intense (Pls. 176, 177). The long skull runs straight down from the crown into the forehead without a bend. The massive nose is separated from the forehead only by a small wrinkle. The bulbous nose is simply a continuation of the sloping forehead. Its tip is on the same level as the back of the skull. The largest circumference of the head is round the back of the head and the tip of the high nose. The lower part of the face is narrower and elongated. The high upper lip, lower lip and chin form a line with the underside of the nose, and lie almost at right angles to the bridge of the nose. Over the skull, down to the base of the neck, is an unchased cap of hair following the contour of the back of the head to the nape. The round eyes, at different levels, are part of the nose zone. The ears, also at different heights, are set between the nose and upper-lip zones. The lips themselves are slightly open with the (?) tongue visible between them.

It has long been known that this type of head is of Oriental origin, deriving in fact from Syrian bronze sculpture, as exemplified, for instance, in the bronze statuette of a 'god on the bull' from Carchemish (Pl. 181) now in the Copenhagen National Museum.[92] The type is, however, considerably older than this particular bronze, as is shown by the superb ivory plaque with a picture of a Mycenaean warrior (Pl. 180) in a Mycenaean boar-tooth helmet, with spear and huge figure-of-eight shield in the background, found with many other ivory fragments in the Artemision on Delos.[93] The head, thrown well back, is like the Syrian bronzes, with nose and forehead almost horizontal and lower face vertical. The wide face and full cheeks have been, not unreasonably, compared with Hittite large-scale sculpture and small bronzes from the New Kingdom.[94] But the Syrian form is closer, although it is no longer stereotyped. The movement of the whole body forwards and backwards is brought out. The throwing back of the head onto the nape and the upwards gaze are no longer symbols of gods, as in the Orient, but free instantaneous movements, even if they do have some ritual or military significance. The Syrian type of head still occurs in the Mycenaean period

but it is more freely handled with a new, non-Oriental approach. But this is only one of the aspects of the transition from Oriental to Mycenaean, which probably took place in the fourteenth, or at the latest, the thirteenth century. For unmistakably Greek, in fact eastern Ionian, features are recognizable not only in the stocky body with its Minoan pose but also in the somatic type and the heavy head with its full cheeks. A few years after the publication of the ivory relief from Delos, the syllabic script Linear B on clay tablets from the palace of Knossos and the Mycenaean palace at Pylos was deciphered. This proved that the inventory-like drawings were in fact basically Greek. So this important ivory relief may already be the product of Greek Mycenaean art. It is not until after the revival of figure painting in the east that, in the seventh century, the typically eastern Ionian body shape and an adopted version of the characteristic Syro-Ionian skull, develops again. Examples are the so-called Naukratite and Chiot ware;[95] Fikellura vessels such as the amphora in Altenburg with wine-drunk dancers;[96] Caeretan hydriai; in particular, the Busiris vase in Vienna,[97] the master of which was eastern Ionian; and 'Pontic' vases, also produced in Italy.[98] Above all, however, it is the island of Samos and the Heraion there, where, from the beginning, a number of straightforward offerings and, eventually, superb works by sophisticated artists accumulated near the sanctuary, including a clay kernos with a whole wreath of cups, pomegranates, and animal and human heads, of which one is a gentle head completely adapted to the Greek style. This is in fact the old Syrian type adapted for a human image.[99] Amongst the oldest bronzes from the Heraion is one which can be regarded as a prototype eastern Ionian shape,[100] a completely human form connected over the centuries with its predecessor, the warrior on the Greek Mycenaean ivory relief.

Let us return to the chariot driver in Olympia. There can be no doubt here that the physiognomic characteristics of the head are ultimately derived from the Orient and can only be eastern Ionian. Beyond this we cannot go with any certainty. But sufficiently numerous examples of this type of head have been found in the Samian Heraion, from an earlier period as well as from post-Geometric, to establish the existence of a significant concentration there. The sanctuary was always a place where votive offerings collected, but not all necessarily from Samos. And the body structure of the chariot driver gives no clue to an East Greek-Ionian origin. This accords with the fact that all the chariot models from Olympia are built on the same system showing, at most, a development from primitive to more complicated, richer structures. Thus it is possible to locate the home of the chariot dedications within the Peloponnese; it could be the Arcadian-Elian or Elian-Pisan areas. The head is admittedly eastern Ionian. Whether the sculptor travelled to eastern Ionia when he was young, or visited the Samian Heraion or even, perhaps, worked there, cannot be established for certain. It is also conceivable, though improbable, that eastern Ionian statuettes found their way to Olympia earlier on and that this unusual treatment of the head was copied from them.

An approximate date for this chariot offering is now not difficult to establish. It must have been produced in the late third quarter of the eighth century or at the beginning of the last quarter.

6 Sculptural groups

With the beginning of the Late Geometric epoch, about the middle of the eighth century, small-scale bronze sculpture enters a new phase. Ring-handle holders and horse-leaders had existed for a long time but they had been structurally integrated with the vessel, growing out of cauldrons or tripods and drawing from them their strength and assurance. Later, up to the end of Geometric art, they were associated with figures from mythology, the Telchines or other Hephaistean characters, the Minotaur and Attic youths. But they were always part of the vessel, and developed as such. The first loosening of this strict structural connection appears in the chariots and drivers. The racing chariot, with its driver, has become a votive offering, with the human figure only a part of a whole which includes both chariot and

horses. It is significant that the size of men and animals has become noticeably smaller.[101] It is consistent with the daring of Late Geometric form that, in a second phase, sculptural groups should start to become independent of structural combinations. Their mastery of the techniques of bronze casting and terracotta modelling inevitably tempted the Greeks to try this. Mythical songs and vivid Homeric similes demanded some form of depiction beyond painting. Early multi-figure group compositions should not be dismissed as primitive or doll-like, nor should they for this reason be assigned to an early period. They all belong to the third quarter of the eighth century and exemplify the daring which started in the Late Geometric period and which brought great changes in the following decades. But the further the transition to Archaic develops, the less Late Geometric sculpture groups are in evidence. Greek art chose to follow another route, and it was almost three decades before the sculptural group revived, this time in large scale.

The centauromachy group in New York

Let us first compare three groups with each other. All three come from the same period but cannot be dated absolutely accurately. The first group, in the Metropolitan Museum in New York (Pl. 185), shows an encounter between a hero and a centaur,[102] both wearing Geometric helmets. The centaur has, as was common earlier, a human body with the back half of a horse's body growing out of the small of the back. On the back of the horse is engraved a herringbone pattern. With its left arm the centaur is grasping the right arm of its opponent. Their other arms are intertwined. The hero is more than a head taller than the centaur, so that the wrestling match about to begin seems to have a foregone conclusion. Without any doubt the centaur is Pholos, the mountain spirit of the Pholoë, a wooded plateau on the southeast border of Elis towards Arcadia. He would have welcomed the hero, the exhausted Herakles, into his cave hospitably. The opponents are standing still opposite each other, wrestling with legs together, in one plane, as though they had been physically taken out of a vase painting. Indeed, on the neck picture on a con-temporary Attic neck-handled amphora in Copenhagen, the hero and centaur appear holding pine branches with which to fight each other, while a whole procession of centaurs with branches in their hands hurries by on the belly frieze.[103] The encounter of Herakles and Pholos, and the invitation to the hero into the cave of the centaur to eat and drink, as well as the hurrying crowd of centaurs attracted by the smell of wine, are consistent features of the earliest Pholoë centaur iconography, which begins with the above-mentioned Geometric grave amphora in Copenhagen, and Protocorinthian and Corinthian representations. This is also the basis of the ancient image of Apollodoros.[104] The form of the Herakles-Pholos group shows, in the legs, Herakles's mitra and the profiles of the faces, a connection with the workshops of Argos. But the assurance and power of the Argive school are not present. The flatness of the upper body, the thinness of the long arms, the round head and fleshy round buttocks seem mannered. Borrowings from the older neighbouring Peloponnesian workshop indicate a somewhat later date. The spherical shape of head of both figures, particularly Herakles is, however, not alien to Olympia. Both Herakles's eyes are deeply bored and obviously had a silver iris, a technique which came from the Orient. In the Pelopion area in Olympia, near the old excavations, excavators have found the figure of a warrior with a raised spear, a shield in his left hand (although only the handle of the shield is preserved) and a Geometric helmet, of which the two-sided finial is to be thought of as a crest.[105] The head has the same spherical form and the same deeply bored eyes as the head of Herakles. The body has, albeit in a cruder and probably later form, all the features of our group, including the horizontal shoulders, flat chest slightly inclined forwards, thin, long arms, mitre above the hips, and the powerful well-shaped legs. Finally, from Olympia, we have a 5.4 cm. high bronze of a squatting man in the Ortiz collection,[106] his hands on his knees, whose base shows the outline of a horse. This figure also has a spherical head with deeply sunk eyes, but it belongs to another type which we will deal with later on. We can therefore assume with a fair amount of certainty that our group comes from Elis.

The grouping of the two figures is extremely simple. They are set on a narrow strip, with the Herakles-centaur encounter taking up no more space than an up-ended tile. The scene is copied from a painted vase picture, merely adapted to sculptural form. The base is a rectangular plaque for the centaur, decorated in the middle with two interrupted zigzag bands, with a narrow tongue behind the centaur for its horse's tail and a wider tongue for the Herakles on the other end. The group should be looked at from both sides and from the corners between the tongues and the centaur's base. Seen from the side, the richness of the sculptural form, far beyond that of painted pictures, emerges. Similar groups do not occur in large-scale sculpture until the pediment compositions from the end of the seventh century, and later in free-standing sculpture and bronze casts, as, for instance, the group with Athena and Marsyas by Myron, from the fifth century. Our group is the simplest solution of the group problem, which by no means implies that it is necessarily the earliest.

Two lion-battle groups from Samos and 'Pisa'

Two more group compositions of a fairly complicated nature follow closely on the Herakles-Pholos group in New York. In both, the men have spherically shaped heads and a size reminiscent of the Argive charioteer from Olympia (Pls. 182-184). The first group (Pls. 186, 187) was found at the end of the twenties in the Sanctuary of Hera on Samos, but was lost during the Second World War.[107] It was not produced on Samos, but was brought to the Samian sanctuary as a votive offering. The second group is known only from a short note by G. P. Stevens.[108] It is said to have been found in Pisa in Etruria, and then to have fallen into private hands and later into the Zaimis collection in Athens. A Greek bronze group from the eighth century in Pisa in Italy could only be an export, but it would in fact be highly unlikely to have travelled so far west. It is much more probable that some modern dealer took the group to Italy giving as its source the ancient town of Pisa near Olympia, or the whole area known as

'Pisatis' south of Elis. Perhaps he also used the confusion with the Italian town of Pisa to get around the antiquities law in force in Greece. At all events, the source 'Pisa' does seem a useful clue to the origin of this group, in the Pisatis-Elis area.

The group from Samos includes a helmeted, but otherwise naked warrior fighting with a lion who has invaded his herd. The lion is attacking its opponent aggressively, and is ripping into the man's thigh with its massive paws. But the warrior's sword has already entered the lion's body at the fatal point between the neck and the shoulder, driving to the heart. The piece of flesh lodged in the lion's jaws has lured him to death. A courageous dog is pawing the front leg of the lion and biting into its thigh. The rectangular base which supports both animals must have been decorated with an interrupted Geometric pattern. On the central axis, a tongue projects with the warrior standing on it. On the other end is a broader strip to which is attached the thrashing tail of the lion. This lion is a far cry from the splendid lion on the older gold relief (Pl. 223) by a Rhodian master, from the early second quarter of the eighth century, still closely related to Oriental prototypes. By this time there were only a few, isolated lions in northern Greece. But they lived on as long-legged, fantastic monsters with massive crocodile-like jaws in vase paintings, forced into the rigid Geometric idiom as expressionistic images. The lion in our group is, however, in proportion to the man, and is very similar to a lion on an Attic kantharos in Copenhagen (Pl. 69), even down to the raised paw on its intended victim's leg. This dates the production of the bronze group from Samos in the middle of the third quarter of the eighth century.

The three-figure group is constructed, probably deliberately, in the form of a semi-pyramid. The apex of the pyramid is the hunter's helmet, which is on the central axis of plinth and tongue. From this point, the backs of the animals recede downwards, in divergent lines. At the arithmetical centre of the whole structure, the sword drives into the shoulder of the lion. The group is obviously deliberately composed, with the two animals carefully positioned so that the victory of the warrior is emphasized. Early versions of this approach occur in animal sculptures

like a comparatively early stag surrounded by three dogs (Pl. 190), two attacking from behind, one from in front on the tongue off the broad plinth. All are in one plane like the Herakles-Pholos group.[109] More important are young animals placed at an angle to their mothers, like the dog to the lion, a foal nuzzling up against its mother to suck, or a fawn with a hind (Pl. 189), looking for food or gnawing playfully at her front leg.[110]

The third group, from 'Pisa',[111] contains the same elements as the group from Samos, a dog biting the leg of a lion with, this time, a whole small calf in its mouth[112] and a hunter wearing a small hat. But the composition is a good deal more naïve and less realistic than the Samian group. The hunter is seizing the lion not from the front but from the side, while trying to rescue the little calf with his left hand. His right arm is broken off at the elbow, but it could not have been holding a sword, although it could well have held a hunting spike with which he could have stabbed at the lion's chest. The semi-pyramid is even more clearly recognizable here, running in steps down from the hat of the hunter, over the back of the lion, to the dog; and likewise, from the hat down over the hindquarters of the lion to the tail which hangs some distance over the tongue of the plinth. But this group has far less life to it than the Samian one. The plinth, decorated with a plastic meander motif on the underside, consists of a rectangular plaque carrying the hunter, the lion and the dog, and a tongue, probably meant to support the hunter, but which is taken up by the tail of the lion. One is almost reminded of a lion tamer in a circus. At all events the man who cast this little work is certainly not the man who created the group which ended up in Samos.

The beginnings of group compositions in bronze were obviously inspired by the rapid spread of epic poems. This was the source of the 'encounter of Herakles and the centaur Pholos', on the Pholoë plateau on the eastern border of the Elis-Pisatis, a country which had from ancient time been the home of the mythological centaurs and where songs were certainly sung about these wise but evil creatures. The groups showing men slaying lions must have been inspired by the numerous lion similes in Homer's *Iliad*. An example from the 'Diomedia' of the fifth book

(V 554-558) is only one of many: 'like two lions, which left their mother on the peak of the mountain and plunged down into the depths of the dark forest, to seize cattle and plump sheep and destroy the huts of men until they themselves were destroyed at the hands of men with sharp weapons . . .'.

7 The earliest lion figure

The earliest lion figure in the Geometric period occurs on a ring handle which belonged to a thin-walled cast tripod-cauldron from Olympia (Pl. 188).[113] The handle, unlike the cauldron itself, is comparatively massively cast. Its framework consists, from the inside outwards, of five ribs between which run two open-work ornamental bands. At the top of the ring is a lion lying on the three outside ribs. The open-work ornamental friezes are, in the outer circle, a zigzag band, and in the inner circle, a spiral chain with lines running alternately up and down. Under the recumbent lion the spiral wave—as if to form a firm base for the animal figure—turns into a regular ascending spiral chain. The ring handle, of which almost half is preserved, is remarkably heavy and massive, reminiscent of the fully cast tripods of group II. The monumental nature of the lion is significant. The spiral ornamentation of tripods in group II is sometimes used in the classic Geometric group III, particularly the spiral waves on legs and handles.[114] Three more ring-handle fragments have come to light in Olympia, all decorated with the same ornamental bands, including one with a spiral wave on the outside and a zigzag on the inside. All three are more delicate in structure than the lion handle. A horse on the double ring between the ornamental friezes on one of these ring handles which is almost complete and is now in Athens, gives an impression not so much of power repressed as of power reined in somewhat, as the horse steadies itself with its front and back legs on sloping terrain.[115] We can probably date the lion ring handle, according to our tripod chronology,[116] as early first quarter of the eighth century.

This recumbent lion on the ring handle from Olympia has until now been the only one of its kind from the eighth century. It is by no means merely a crude early attempt to recreate the lion image which had arrived from the east. Rather, it is an early form of Greek lion figure, with splendidly supple movement of the extremities, tense, elastic stance of the body with its huge mane, slightly opened jaws, and avoidance of all details, even paws. The base of the lion is in the ornamentation, at the end of the spiral wave. No recumbent lions occur in the Near East, except for a few examples from the ninth and eighth centuries which will be dealt with later. The real home of the recumbent-lion image was Egypt. It begins with two ivory lions from the Predynastic period found in the Djer area, a forerunner of the classical lion type which lasted for three thousand years.[117] This is the 'royal lion'. On a grave painting in Thebes from the time of Rameses there is a lion lying on the flat top of a royal grave.[118] In Egypt, recumbent lions have horizontal bases. The 'royal lion' develops during the Middle Kingdom, and even more so in the New Kingdom, into the recumbent sphinx, with a human face and a massive lion's body, while the original 'royal lion' gradually disappears. Whole avenues of sphinxes and rams were built in front of the great temples, with recumbent lions and rams on individual bases. The most splendid of these was in front of the Temple of Amum in Karnak, built in the thirteenth century B.C.[119]

It is extremely unlikely that there was any direct connection between the Early Geometric lion on the ring handle from Olympia and Egyptian large-scale sculpture. The world of the lion from the Near East, resounding with the roar of the beast of prey, had no place for the recumbent lion, which only appears in two instances. One is in the flourishing town of Byblos on the coast of Phoenicia, beneath the mountains of the Lebanon, a place with a good deal of trade with Egypt and, later, in the products of Mycenaean culture. Here, on the Ahiram sarcophagus, usually dated in the thirteenth century, but equally well datable in the eleventh to tenth centuries, lions of the Egyptian type support the heavy coffin. They are four massive animals, decorating the two long sides of the sarcophagus in pairs. The bodies are in relief but the heads and front paws are fully sculpted, projecting from the sides.[120] The subservient function of these lions is completely un-Egyptian. These stone-sculptured lions, partly relief, partly three-dimensional, come from the periods of Late Hittite art and the states of the post-Hittite Empire in northern Syria. Only the striding lion occurs in sculptured pillar or statue bases.[121] Recumbent lions also occur in Carchemish on relief plaques. As on the Ahiram sarcophagus at Byblos, they have a subservient function, with the massive animal having submitted itself to a goddess and acting as her footstool. But it is only on two reliefs that recumbent lions occur with the goddess Kubaba, enthroned, or a winged god above them,[122] while striding bulls or lions are very common. In the Hittite Empire these are always carrying statues of gods in religious processions. It is not until the earlier phase of Late Hittite development, which lasts, according to Akurgal, into the ninth century, that the recumbent lion with Kubaba occurs in Carchemish. The relief with the two gods on the recumbent lion belongs then to the later phase, and should be dated well into the eighth century. So we can begin to discern a thin path leading through Palestine and Byblos into the post-Hittite Empire states in Syria, bringing in the recumbent lion of Egypt, albeit now with a different significance. The lions on the Ahiram sarcophagus and in Carchemish are particularly close to the Greek lion on the ring handle of the Argive tripod-cauldron.

Another route to the recumbent lion on the tripod from Olympia can be traced from a different direction: rather surprisingly, from Greek works of the second half of the seventh century. There are two stone basins of Laconian marble, with bowls carried by three godlike figures standing on lions and holding the tails of the lions in their hands, against their drapery.[123] The figures are Artemis and her companions. Again, Oriental influence is in evidence, with Egyptian lions having come by the route which we have tried to describe above. But now they are Greek. These lions, along with a funerary lion from Corfu which must belong to the turn of the seventh century to the sixth,[124] give us the period to which

the early ring-handle lion belongs. The trail runs, then, from the recumbent Egyptian 'royal lions'; through the Near Eastern base lions on the sarcophagus at Byblos and the recumbent lions on the reliefs in Carchemish, above which gods are standing or sitting; to the Greek marble basins in Olympia and Rhodes, where the iconography of the supports is the same as the Near East; and, finally, to the funerary lion from Corfu. The lion on the ring handle has a particularly tense body, curved in a slim arch over its legs, and a mighty mane separated by a thin line from its head, with a slit of a mouth. Only the two lions on the Carchemish relief have the same features, although they are Late Hittite and Assyrian in form. The lions on the figured Greek marble basins, which are almost one and a half centuries later, and the grave lion from Corfu, are all very similar to the bronze lion from Olympia, with their narrow slit mouths and their manes, although they are lying more inertly. It is not until the recumbent lions from Miletus and Didyma[125] in the sixth century that this tradition is broken, with the development of superb Ionian lions by artists obviously familiar with Egyptian art. These sculptors lined the approach to the temple with recumbent lions, like the temple avenues in Egypt, although the latter had much more variation.

The recumbent lion on the ring handle from Olympia is a very unusual figure, different from the other lions which appear in gold relief from the second quarter of the eighth century onwards and, more commonly, in Late Geometric paintings and bronze statuettes, always fighting.

Our interpretation of this piece has been along an only half-trodden route. If finds from the ancient Orient were more plentiful, the puzzle of this lion would be easier to solve. Nevertheless, it remains clear that the areas of Byblos, Carchemish, Send-shirli, Ras Shamra and the coast of Cyprus opposite them, were exciting, rich and deeply problematic sources of early Greek sculpture.

8 Small-scale sculpture from Arcadia

Most tripod-cauldrons come from the Argolid. On one or two, at the top of the ring handle, there are small *acroteria* —birds, bulls, horses and, in one case, a man holding the horse as well. These are not riveted but welded on, like the recumbent lion on the ring handle from Olympia (Pl. 188). The tripod-cauldrons themselves are obviously products of the Argive workshops, whereas the welded figures seem to have been made in neighbouring Arcadia.[126]

The group of a man with a foal on a ring handle from Olympia

The most important group is an *acroterion* on a splendid, almost completely preserved ring handle from Olympia. It includes a foal and a naked, bareheaded man, reaching underneath the muzzle of the young animal with his left hand, and stroking its mane affectionately with his other hand (Pls. 191, 192).[127] The group is only 6 cm. high. 'The close, indeed intimate, relationship of man and horse is striking and lively. It is shown with expressive drama. The substantial, squat shapes of the figures show the strong feeling of the period for the body.'[128] The stocky shapes of both figures are quite unaffected by any Geometric stylization, either in proportion or in structure. There is no characteristic narrowing above the hips nor any marked contrast between thin arms and broad chest. The torso runs down quite naturally to the tops of the thighs. The raised arms bring out the shoulders. The right shoulder is raised slightly by the arm holding the mane. The left, with the arm under the mouth of the foal, is lower.[129] The torso has a unity, if not very obvious. The back, with its broad shoulder-blades, small of the back and small buttocks at different levels above the weight-carrying and forward legs, is like the veiled glory of beauty to come. The remarkably short legs, set well apart, have thighs, calves and knees uncertainly defined. One leg is almost straight, the other slightly bent. In contrast, the head, in the old manner, is spherical, with a thick neck. The

mouth is a wide slit above the chin. Above it is a flattened nose with eyes swelling out to left and right and ears set well back. Two locks of hair fall down to the nape but there is no indication of hair on top of the head. In contrast to the primitive nature of the head, without any trace of the style which developed in the second quarter of the century, the fine open-work ring handle is very elegant, and one is inclined, therefore, not to date this figured *acroterion* too early. It probably belongs in the first quarter or perhaps the beginning of the second quarter of the eighth century. This late date is supported by the suggestion that the small group is not Argive like the ring handle but is probably the work of a caster from the forests of Arcadia. There is also the fact that the group is obviously merely translated from simple terracotta figures into bronze.[130] The recumbent lion on the ring handle from Olympia (Pl. 188), which is very close in technique and style but older than this group, must be a similar special case amongst Argive tripods.

98 Bronze statuette group from Olympia.
Athens, National Museum

Groups of round-dancers

This 'terracotta style' of the bronzes is particularly well represented in Olympia, where bronze groups have been found of, respectively, seven, five and four naked women dancing in a circle (Fig. 98).[131] They are on a base and face inwards in a circle. The arms of the women are intertwined at shoulder height making a second ring at this level. The legs are remarkably short, and are moving in a slow dance. The bodies are not Geometrically stylized but long and only slightly modelled. The breasts are plastically more emphatic than in the Argive female figures, and the heads are virtually unmodelled. Curious features are the smallness of the figures—they vary between barely 7 and 4 cm.— and the fact that they occur only in Olympia. The women dancers certainly belong with the man with the foal on the Argive tripod-cauldron (Pls. 191, 192), except that the former are much more crudely worked. But they are both direct translations from clay to bronze. It is significant that a similar round-dance was found in the heart of Arcadia, between

Maguliana and Methydrion. The difference is that instead of women, stags or rams are doing the dancing (Pl. 193),[132] and in place of a circular ring there is a round plate to which the four upright stag creatures are joined in a round-dance. The bodies are like those of the dancing women of Olympia, except for their sex; also the forelegs of the dancing stags are not, as in the other group, on each others' shoulders, but are beating out a lively rhythm. Since they have no tails, the only sign that they are animals is the hair above the penis. The head is modelled like the ring-handle *acroterion* of the tripod-cauldron, with a broad slit mouth widened into an animal's, and a flat nose between button-like round eyes.

The location of the place where this round-dance was found in Arcadia is particularly important. It was on the big road running through the Peloponnese from Argos via Chinoe, Mantinea and Methydrion, thence on to Thisoa and Heraia, along the Alpheios to Olympia, and across the Pisatis to Elis.

The bronze groups dealt with here occur in three places: Argos (unless the early Argive tripod was made in Olympia), Methydrion, where the stag dance was cast and Olympia, where the six groups of women dancers were found. These places all lie along the main cross-route through the Peloponnese described above. The Arcadian group of stag dancers (Pl. 193) and the man with the foal on the Argive tripod (Pls. 191, 192) are closely connected by the stylization of the heads, although the quality of the bronzes is quite different. All the bronze figures from the various groups are direct copies of terracotta statuettes. The centre of their production appears to have been in Arcadia.[133] At all events, there is a good deal to support the suggestion that in the early period casters from Arcadia helped to make figured decorations for Argive tripod-cauldrons. The recumbent lion (Pl. 188), the group with the man and the foal (Pls. 191, 192) and ring handles with horses would all have been produced in this way.

These bronze ring dancers have a counterpart in a terracotta round-dance group, almost seven centuries older, found in Palaikastro on Crete.[134] Three dancers in Minoan costumes are preserved, with their arms extended horizontally, possibly clasping each other by the hand. In the middle stood a somewhat taller, larger figure plucking the lyre, which must have been decorated with precious jewellery around the neck and over the chest. Remains of a round disc, on which the figures may have stood, has also been found. Whether fragments of a dove flying up in front of a woman or goddess making music belonged to the same group is doubtful. But this find in Crete of girls and women dancing round a lyre player seems to have no connection with the bronze dancing women from the Peloponnese.

There are, however, a number of ring dances from the Peloponnese with girls and women in the service of Artemis. The best known of these are the girls' choruses from the Sanctuary of Artemis Orthia at Sparta, which may originally have had clay masks similar to the grotesque terracotta masks found as votive offerings in the same temple. Later on, Alkman wrote a poem, the *Parthenion*, about girls dancing in honour of Artemis Orthia, which by that time was certainly danced without any grotesque masks. We also have the later dance of the girls of the cult of Artemis Karyatis, the so-called Kalathiskos dancers, from the village of Karyai on the border between Laconia and Arcadia, with ecstatic but well-proportioned dancing figures. Finally, in the Sanctuary of Artemis Limnatis on the border of Laconia and Messenia, tympana have been found which show that girls used to dance in connection with higher rites. The dancing women from Elis and the Pisatis are much more old-fashioned. There was a Sanctuary of Artemis Kordaka in Elis; the second name refers to a lascivious dance, the *Kordax*, which was certainly danced by girls or women. In Letrinoi in the Pisatis, Artemis Alpheiaia was worshipped. Mythology relates that Alpheios wanted to win the goddess as his wife and tried to possess her during a *pannychis*. Artemis and her nymphs covered their faces with soft clay, so that the goddess was no longer recognizable. This *pannychis*, as related by Pausanias, is not, however, a consistent ancient myth. But the clay masks worn by Artemis and her nymphs in Letrinoi must be the same as those once worn by the girl dancers in the Temple of Artemis Orthia at Sparta. In Elis and in the Pisatis, old rites certainly lasted a good deal longer than in Laconia, Karyai or Sparta.[135]

So the bronze round-dancing groups of women and girls originated on the banks of the Alpheios, in the Pisatis and in Elis. Whether they were produced in Olympia we cannot any longer say. Nevertheless, the bronze stag dance was found in the middle of Arcadia.

9 Statuettes of female riders

Two tiny statuettes of female riders on horses or mules were discovered in Lusoi (Pl. 196), a few kilometres north of Kleitor, and in Tegea in Arcadia. Another was found during recent excavations in the second southern wall of the stadium at Olympia (Pl. 195).[136] The women are naked and are sitting side-saddle on a wooden saddle with raised rests for the arms and a step below the body of the

horse, used as a footrest while riding. The piece from Lusoi (Pl. 196) is reminiscent of the Argive style and may belong in the early second quarter of the eighth century. The little rider figure from Tegea, barely 3 cm. high, is so similar to the Lusoi statuette that it is virtually a duplicate. The piece from Olympia (Pl. 195) is different. Here the woman, if she were standing, would be taller than the horse. Her legs are short, like the women in the round-dance from Elis (Fig. 98), but her torso, neck and head are exaggeratedly elongated; all three parts are about equal in length. The arms extend horizontally forwards from the shoulders. Eyes, nose and mouth are clearly indicated. Above the forehead is a bun of hair. The body has obvious vertical and horizontal axes, like certain terracotta figures from Olympia.[137] Over the breast and rib-cage is a protrusion in which some people maintain that they can see an animal's face with two hollow eyes, a forehead and a nose. The head of a lion, perhaps, a companion of Artemis? Kunze saw only 'lumpy breasts'.[138] He may well be right.

The two female riders from Lusoi and Tegea sit firmly in their low saddles well down on their huge horses' backs. Whether humans or goddesses, they seem content simply to be in control of their horses, whereas in the group from Olympia, the woman positively dominates her beast, with her high saddle and outstretched arms.

Statuette of a female rider from Samos

Another bronze woman rider, from Samos, probably an immediate successor of the above, was found in the Sanctuary of Hera south of the large altar (Pl. 194).[139] The horse (or mule?), apart from its thin neck and narrow head with halter, is a typical Peloponnesian beast from the first half of the eighth century, with its thick, bent legs, and even a drawn-in tail. Everything else, however, is different: the high basket-seat on the saddle, with a backrest; a tall virtually naked female rider, who would be taller than the horse she is riding if she were standing; a baby in her arms. The group with the female rider from Olympia (Pl. 195) is similarly composed to the

group from Samos, except that the latter is more Geometric, more concentrated, and more painterly while the one in Olympia is looser, more freely established in sculptural space. There could well be some indirect link between the Samos and the Olympia groups.

But where does the Samian bronze group come from? Immediately after it was found, E. Buschor declared himself sure that it was 'un-Greek'. It was certainly not produced on Samos, but nor is it Oriental. Even though the female rider from Samos is wearing a necklace of metal rings which can be proved to have occurred in late Sumerian and early Babylonian periods up to the end of the Bronze Age, and even after this in Syria,[140] her huge right hand which also joins the left arm is quite alien to the late phase of purely Oriental art. Hands like this occur only on Geometric vessels and bronzes in Laconia, Olympia and Boeotia.[141] There must be some kind of connection with the Greek mainland, if only in certain details. May this bronze group come from Cyprus? Bronze statuettes were admittedly rare in post-Mycenaean times on Cyprus. On the other hand bronze utensils, with whole figures or busts in their frameworks or 'windows', were much more common; also bronze bowls with insides decorated with relief friezes and drawings using Egyptian and Phoenician motifs; and three-legged stands. Cypriot bronze art is virtually confined to utensils. There are some statuettes, but clay figures from statuette size up to half or full life-size are much more common. The Samian Heraion was positively flooded, in Geometric and Archaic times, with small-scale Cypriot clay figures.[142] The extraordinarily large quantity of Cypriot figures, with fragments found in all Archaic ruins and deposits, indicates that this Cypriot ware from Samos was bought for the cult trade or was imported by Cypriot traders themselves into the town and the sanctuary. I estimate that there is one Cypriot figure for every Greek Geometric or Archaic figure.[143] D. Ohly's remark shows how extensive importation of clay votive offerings from the island of Cyprus to the Temple of Samian Hera was. In the Early Iron Age it was virtually the only type of import. Cypriot clay models of a naked goddess are very similar to models from the Syrian coast, like the great goddess

Ishtar from Babylon, or Ashtoreth, or Astarte who, according to mythology, ventured down into the underworld. One of these mother-goddesses from Cyprus which found its way with the Cesnola Collection to the Metropolitan Museum has the same ancient metal-ring jewellery around her long neck, hanging down to her shoulders, as the female rider in the Samian group. She is also carrying a little boy against her left breast.[144] The naked goddess on the mule undoubtedly represents the great mother-goddess from the Orient, Ishtar-Astarte, although she has taken on a Greek Geometric form. The head, face and huge long neck of the Samos rider recur in a female clay idol from the Iron Age temple at Ayios Iakobos on Cyprus,[145] with both arms raised in the gesture of epiphany. The figure is clad to the feet with a transparent costume which is decorated with a lozenge-like pattern of bands. Its belly, legs and feet can be seen through the transparent cloth. The face has a low flat forehead with wide nostrils, and round eyes in the angle between forehead and nose. The face is still like a flat mask, ending at the cheeks but extending into a wide chin, less distinct in the clay idol than the bronze statuette. The former is also a naked goddess like Astarte, but hardly Aphrodite. The idol was found on the bottom floor of the temple where only older clay figures occurred. In the opinion of the excavators, it probably dates from the end of the Cypro-Geometric I period. In the necropolis at Lapithos, in Graves 415 and 419, two further idols of the same type[146] were found, with costumes with a more advanced Geometric pattern and without the body showing through. The older one has a face which can scarcely be much later than the Samos bronze. The ears are stylized in the same way. Both terracottas belong to Cypro-Geometric II.

The bronze group from Samos (Pl. 194) must, therefore, have been produced by a Cypriot workshop strongly affected by early Greek and orientalizing influences, but not, as yet, represented by any eighth-century finds from the Greek settlement on Cyprus. It is only in the modest terracotta figures from the temple at Ayios Iakobos and the graves at Lapithos that traces of it are found. Perhaps other post-Mycenaean bronze statuettes, like the Geometric group imported to Samos, may still be uncovered

in deeper strata in the area of Greek settlement on Cyprus. But the links between the naked riders on horseback from Arcadia and the Cypro-Samian bronze group of Astarte riding are, for the time being, more important. The composition of the statuettes from Lusoi (Pl. 196), Tegea and Olympia (Pl. 195) leads directly to the Samian group (Pl. 194), which is similar to the last rider statuette from Olympia. The sculptor of the Samian group must have known of the Olympia bronze. There is evidence that the earliest post-Mycenaean settlements on Cyprus used a language close to the Arcadian dialect. So connections between Arcadia and Cyprus are established, in spite of the distance between them, and Attic Geometric vases were exported to Cyprus.

But the identity of the riding woman from Arcadia remains a problem. The Cypro-Samian group may be taken as being Ishtar-Astarte, but not the Arcadian group. On the western border of Arcadia a number of primitive-cult sites have been found, relics of a lost world. These include a cave near Phigalia and the mysteries at Thelpusa and Lykosura. In Phigalia, Demeter Melaina, who was believed to have a horse's head, wedded Poseidon in the form of a horse. The product of this divine marriage was Despoina. In Thelpusa, it was Demeter Erinys who married equine Poseidon. She gave birth to a horse, Areion, and a daughter whose name the uninitiated were not allowed to hear. In Lykosura, Demeter mated with Poseidon Hippios. Their daughter was, again, Despoina, whose name also occurred in the mysteries at Thelpusa.[147] Noteworthy is the animal form of the gods; the way they turned into super-horses during the act of sex; and the bearing of a divine stallion first, then Despoina. The names are derived from the Demeter cult, although the name 'Kore' did not last. In Trapezus (Arcadia), Megalopolis and Andania (Messenia) they were called simply the 'great goddesses', the 'mistresses', or the 'saviours' (*Soteira*). The horse, man's helper in war and peace, could scarcely have been widespread in the Balkan peninsula before the Late Bronze Age. But Poseidon was a god in the Peloponnese before the Dorian migration, more powerful than Zeus. So, in the heart of Arcadia, a religious system survived which went far back into the Mycenaean age and the later centuries of the

second millennium. But by the Geometric period it had borrowed a lot from the cult of Demeter.

May the riding girls from Lusoi, Tegea and Olympia be daughters of Demeter and Poseidon—Despoina or Soteira, sisters of Areion the horse? On the bronze statuette from Olympia both arms are stretched out. This is more a cult image than a figure from mythology, like the Cypriot bronze group from Samos, which represents a goddess. The nakedness of the female rider is something taken for granted in the Geometric style, for both men and women. But can the female riders really derive from primitive cults only surviving in a small border zone of Arcadia? Their provenances do not suggest this. But in terracotta figures the female-rider image continues in the Peloponnese right into the sixth century. Three terracotta figures of female riders, seated side-saddle, have been found in the Sanctuary of Artemis Orthia in Sparta: a naked girl from the early seventh century, and two richly clothed goddesses from the following century.[148] A terracotta figure of a goddess, clothed to the feet, on a horse—or perhaps a dog?—was found in the Sanctuary of Artemis at Lusoi with the bronze female-rider statuette.[149] It dates from the first quarter of the seventh century, and is clearly Corinthian in style.

Finally, amongst the terracottas in the Sanctuary of Hera Akraia and of Hera Limenia at Perachora was a goddess seated astride a horse,[150] from the first half of the sixth century. This terracotta figure of a goddess is not Hera, but one of a number of bronze reliefs and statuettes of Artemis, dedicated in Perachora to Hera.

The later Archaic riders from the Peloponnese are obviously something to do with Artemis. The commonest Artemis cult on the Peloponnese was that of Artemis Soteira. This occurred in Megara, Troizen in the Argolid, Pellene on the eastern border of Achaea, in Boiai in Laconia, opposite the island of Kythera, and in Megalopolis and Phigalia in Arcadia. Here we find a much older stratum of religious belief, including horse-headed Demeter, the nuptials of an equine Poseidon and mare-form Demeter, the birth of a super-stallion and of a daughter called Despoina (or unnamed in Thelpusa). In Megalopolis, a comparatively late foundation, the appellation was 'great goddess'. But Pausanias relates that the daughter 'Kore, was called Soteira by the Arcadians'.[151] So there was a horse-form goddess in ancient times, wife of Poseidon, later equated with central Greek Demeter, given the epithets of Melaina and Erinys. She gave birth to a super-stallion and then a human daughter, Despoina, the mistress of the underworld, or Soteira, the 'saviour' like the Kore of the Eleusinian cult. In a third stage, the Soteira finally becomes the Artemis Soteira of the Peloponnese. Images of Artemis Soteira on horseback now continue to the end of the Archaic period.[152] The bronze statuettes of Geometric riders from the early eighth century can probably, although not certainly, be identified as Artemis Soteira. The durability of Graeco-Roman iconography is well demonstrated by the fact that the horse-god of the Celts, Epona, was still represented, even in Roman times, in the same form as Artemis Soteira.

10 Various miniature statuettes

A number of miniature statuettes, all from the Late Geometric or sub-Geometric period, are remarkable for their free form and daring extension into three-dimensional space. With their more lifelike forms, these boldly active little statuettes mirror the developments made during a period of almost a century in large figures on the tripod-cauldrons. They have circular bases with holes in them, like the horse statuettes and sculpture groups, or horizontally grooved base-drums, as, later, on Ionic columns. Another type of base is the pomegranate. One cannot be sure what these little figures on their wide bases were for. Only one type of statue has so far been satisfactorily explained.

A naked man on a tall peg with a base-drum with two grooves was found in Olympia, ending up in the Louvre (Pl. 198).[153] He sits with legs apart and is ithyphallic. Both hands are on his knees, and his arms curve round from the shoulders in such a way that the elbow joints disappear, with only the forearms running down to the knees. The simple space,

open above and to the front, produced by the splayed legs and arms running out in front of the seated figure, seems expressive of some indistinct, unconscious desire for something unreachable out in front. The statuette is relatively early, from the third quarter of the eighth century, and appears to have been produced under the influence of the Argive workshop.

Three statuettes of seated goddesses

Two goddesses seated on massive thrones, and fragments of a third and its throne, all of terracotta, are counterparts of the seated man from Olympia. They all come from Attic graves—the first, now in New York, from an unknown grave, the second from Grave 1 at Kallithea in Attica and the third from Grave 12 in the Agora at Athens.[154] The seat of the enthroned goddess in New York is decorated with running zigzag bands or stacked zigzag elements. Underneath the backrest, as decoration, is a small figure of a serving girl, whose head disappears inwards. The goddess's hands are on the knobs of the armrests. In the somewhat more recent version of the enthroned goddess from Kallithea, she has a chiton reaching down to her feet. The arms, which are now broken off, lead down to hands on the knobs of the armrests. The throne is like a monumental, architectonic cube-shaped hollow block, whose arms enclose the goddess, who must be Kore, because of the grave rites, but the figure definitely has a life of its own and stands out against the huge throne. On the 'closed' back of the throne is an impatient horse with a mouthful of hay. This splendid horse is also one of the animals of the grave cult.[155] The goddess from Kallithea is more recent than the one in New York and dates from the last quarter of the eighth century.

Two statuettes of men drinking

Interpenetration of co-ordinate space and human form is developed further in a number of statuettes of naked men, of which only two need be mentioned.

Both are sitting on stool-like bases. The torso is long. Raised knees support elongated arms at the elbow, with forearms running back to the neck zone and hands clasped. The first little bronze figure (Pl. 197)[156] comes from Sparta. It is holding something, perhaps a flask. The rounded head, turned slightly to the right, has a face with an expression of ecstasy, if the indistinct features have been correctly interpreted. The little statue is composed as a four-sided pyramid —a difficult technique, only feasible in small-scale pieces. Large-scale art took centuries to achieve comparable multi-aspect form. The round base has a few holes in it. Was the statuette, perhaps, made to be used as a weight, having to be drilled out after being cast in bronze to bring it down to exactly the right weight?

Another seated man (Pl. 199),[157] found in the Alpheios valley, comes from the same workshop as the seated man from Olympia. The head is identical down to the length of the forehead and the distance between the ears. Both have the same wide shoulders. Elbows are resting on the knees, and hands are clasping a bottle, with the spout in the man's mouth. The bottom is T-shaped, with the legs on the cross-piece and the stool on the upright. The man's legs and arms are unnaturally long and of uniform thickness, making a clearly defined framework. From the side, the bottom and top halves of the figure are like two irregular rhomboids, one on top of the other. From the front, the parallel calves are like a column, with the outwards-curving arms forming a Doric capital. Thus the statue forms an abstract geometric shape, to be looked at from several points of view. This abstractness is mirrored in the rod-like legs and arms.

Figure-decorated bottle stoppers

Both men in these miniature statuettes, the first self-contained on its round base, the other perhaps part of some larger group, are holding a wine bottle to their mouths. They may be Dionysos' companions or early satyrs.[158] The fact that they come from Olympia and its surroundings, as well as from Sparta, indicates a Peloponnesian origin. But these figures

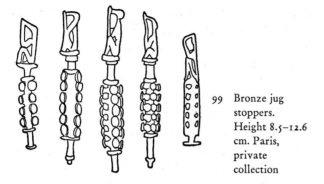

99 Bronze jug stoppers. Height 8.5–12.6 cm. Paris, private collection

also appear in very large numbers, seated, on the top of bottle and wine-jug stoppers (Fig. 99) in Macedonia, Chalcidice and Thessaly. U. Jantzen discovered forty-six of this type of stopper and recognized them as such.[159] They were used on bottles and jugs and consist of a rod with, usually, four rows of buttons. Tow or some other sealing material was wound round this bronze base. Wine jugs sealed like this were unsuitable for transportation. The weight of the bronze, and its value, suggest some connection with wealth and banquets, perhaps Dionysiac festivals, which would explain the frequent occurrence of these stoppers in graves. A stopper from Olynthos has a wine jug on top, a clue to the contents of the vessel for which it was used.[160] Apart from this there is a large number of seated drinking satyrs which form handles on top of stoppers, all from northern Greece. The original image is the seated, drinking figure now in Baltimore (Pl. 199), made in the Alpheios valley near Olympia in the central Peloponnese. This particular figure has nothing to do with stoppers. But the type of figure must have spread from the Peloponnese to the northern part of Greece, where it became a stereotyped figure image. The majority of these uniform figures are no longer lively satyrs, just a monotonously similar series of handle figures on top of stoppers. The human figure later became much less dominant. The sculptural form was borrowed from the more inventive south by the bronze workshops of the north which could not yet produce anything better than mere industrial products.

These wine-jug stoppers extend from Macedonia to Thessaly in the Geometric period. It was from neighbouring Thrace, however, that the wine-god Dionysos fled to the bosom of Thetis to escape the Thracian king, Lykurgos, who offered battle to the gods. But Zeus and the gods punished the king with blindness. This myth is the earliest and only evidence of the young god in the *Iliad*,[161] and the first clue as to his home, from where the Dionysiac religion spread out across northern Greece. The dates of the stoppers can be established fairly accurately: from the second quarter up to the end of the eighth century. The Phrygian and Lydian areas of Asia Minor can also be regarded as early cradles of the Dionysiac cult. In the early Sanctuary of Hera on the neighbouring island of Samos, three similar bronze stoppers were found.[162] Two of them are obviously later than the other, and are worked into a beautiful 'woven' pattern. But there is no sign of handles of seated, drinking satyrs, as found in northern Greece.

Statuettes showing scenes from everyday life

Gradually during the course of the Late Geometric period these small-scale bronze statuettes drew away from the large figures on the tripods and became a world of their own, embracing the human, religious, even daily life, showing men in various situations. We have, for instance, two squatting figures. The first (Pl. 203), which comes from the third quarter of the century, shows a man on a low stool with thin bent legs and a naked flat body, leaning forwards. He has a huge head and beard, open mouth and a thick head of hair. He is singing, and holding a four-stringed lyre between his arms. The right hand is plucking the strings. The statuette is in the Heraklion Museum and is obviously Cretan.[163] The second bronze figure is also of a man playing music[164] and is a later version of the first. The man is sitting on two tree stumps. Legs, lively body, vertebra furrow at the back, pointed beard and hat with a pointed top all indicate a date around the middle of the century. The figure is holding a syrinx with both hands, coaxing sounds from it. The origin of the statuette is not known. It is certainly Peloponnesian, and perhaps Arcadian.

Between these two music-makers falls a statuette which is more daring in conception than anything else. The sculptor who made it is like a 'Lysippos' of inner-developed Geometric form. The bronze, which shows a man stringing a bow (Pls. 201, 202),[165] is almost complete. Only the top of the bow and the strings are broken off. It comes from Delphi and was formerly in the Martin von Wagner Museum at the University of Würzburg. The goatee-bearded bowman is clad only in a mitre or some similar binding round his waist. The bottom of the bow is resting against the top of this binding. The left hand holds the middle of the bow and the right hand attaches the string, already made fast below, to the top of the bow. H. Bulle may be correct in suggesting that there were two notches at each end of the bow so that it could be strung extra tightly. But it is not only the bow which is taut. The whole body is bent like the bow, bringing out the invisible tension of the bow and bowstring. The slender legs are bent at the knee. On the leg taking most of the weight the foot is flat on the ground. On the other leg, the calf runs backwards and only the toes are on the ground. The wide, springy stance of the legs is necessitated by the strong pressure of the bow against the mitre. Above it the narrow upper body, neck and small head are inclined forwards. In the old Geometric tradition, the man has a short goatee beard, small mouth, large nose, round eyes, raised eyebrows and a small cap on his head. The bow is the centre of the composition, held at an angle between the left hand and the mitre, while the right hand is trying to attach the string to the other end of the bow. This produces a superb tension which runs through the whole figure. The piece is in many ways sketchy, almost superficial, but something new has broken through the traditions of Geometric. This statuette stands between the world of Geometric and Archaic, a wonderful object which belongs to neither the one nor the other completely, a flash of talent which could not be repeated. It probably dates from the last quarter of the century.

In addition to this picture of the stringing of a bow, we have another complete statuette from the Geometric period, showing a workshop scene. A craftsman, probably an armourer, is squatting on the ground (Pl. 200), putting the final touches—probably the crest—on a helmet.[166] The curious thing about this figure is that there is no sign of any plinth or base of any kind. The bronze caster is also the armourer, sitting on the ground where he, too, does his work and creates his art. The figure does not even have a little stool, of the kind typical of Egyptian and later Greek images. Perhaps the statue symbolizes some purist Greek notion of simplicity, showing the man, his work, and nothing else.

The centre of the group is the helmet on a small anvil. All the attention of the armourer is directed to his work with his upper body and neck leaning forward, looking down at the helmet. The arms reach forward, the left hand steadying the helmet while the right hand, in almost the same position, is about to attach something to the helmet. The arm movement is similar to that of the man stringing his bow. The right knee is drawn up between the arms with the right foot steadying the anvil. The leg from foot to knee makes a line which runs up in the direction of the head. The other leg is flat on the ground, bent so that the shin runs behind the right foot. The legs form static co-ordinates from the seated workman, one upright and the other horizontal, like a firm internal framework around which the assured movements of the man making the helmet take place, just as the spatial co-ordinates of the throne are arranged, vice versa, around the seated Kore.[167] The body narrows at the waist, higher on the right side where the leg is raised and lower on the side where the leg is on the ground. The pelvic furrows run down on both sides to the crotch. The torso is slender and unmodelled on all sides, but the upper arms and forearms are much more clearly distinguished than in the man stringing the bow. The head, with its pointed goatee beard, the long neck, round skull and simple cap of hair, is almost identical to the head of the syrinx blower. This armourer must have been produced around 700 B.C. or later.

So a series of small-scale bronze statuettes and terracottas from the Late, mostly very Late, Geometric period, opens up a new world of sculptural form—seated, squatting and drinking men, early satyrs, lyre players, syrinx blowers, bowstringer and

armourer. Figured votive offerings on tripods and cauldrons and horses-and-chariots are much bigger than they were at the beginning of the eighth century (to which period, strictly speaking, the enthroned goddesses from Attic graves also belong). But after the middle of the century, very small bronze figures begin to appear again, the range of subjects treated increases and a new breath of freedom seems to blow through the world of figured art, bringing with it singers and shepherds, the rustic idyll, and workshop scenes showing the helmets and bows being made for war and hunting. Everything is still in the Geometric tradition although often almost estranged from it; in transition to the Archaic style, but still closer to Geometric. It is in this transitional period that true small-scale art flourished, a rare flower which bloomed between the Geometric and Archaic periods. One might call this the foundation of Greek bronze sculpture. But it was not until after the last traces of Geometric form had been eradicated that the true flowering occurred, during nearly two centuries of Archaic art.

VII BRONZE TRIPODS AND OTHER UTENSILS

Along with potteries and the vase painters, the bronze workshops also continued to function after the end of the Mycenaean period. With a few exceptions, the only surviving products of these workshops are tripods. There are two concurrent types: the so-called rod-tripod, a three-legged base on which a cauldron could be set,[1] and the tripod-cauldron, where the cauldron and the three legs are all one unit.[2]

The two types are quite different in origin, function, significance and sites where they were found. Rod-tripods occur comparatively late in the Near East: Urartu and Palestine (Beth-Shan); they are more common on Cyprus and Crete; and from the decline of the Mycenaean culture onwards, they occur in isolated cases throughout the rest of Greece. The rod-tripod flourished for a long time in southern Italy and Etruria. Workshops producing rod-tripods have as yet been conclusively established only on Cyprus,[3] but it is pretty certain that a similar workshop was operating on Crete. The centre of production was originally East Greece. The tripod-cauldron, on the other hand, was based on the Peloponnese, spreading later to central Greece and Attica, eastwards to Crete and westwards as far as Ithaca in the Ionian Sea, where local bronze workshops may have sprung up later. Rod-tripods never reached the same height as tripod-cauldrons. Most of them were found in graves,[4] which explains their excellent condition and indicates some connection with funeral rites. This again clearly demonstrates the difference between the two types of tripod. Tripod-cauldrons occur in large numbers only at the sites of major festivals and in inter-regional sanctuaries such as Olympia, Delphi, the Argive Heraion, Ithaca, Delos, and the Idaean Cave in Crete.[5] They served as prizes in funerary or festival games and were offered on the spot as votive gifts to the god. Of course only fragments of tripod-cauldrons of this kind have been found and it is rare that a whole tripod can be reconstructed.[6] A history of the development of both types of tripod during the Geometric period, from the post-Mycenaean to the Late Geometric phase, can only be worked out by comparing the tripod-cauldron with the rod-tripod, the chronology of which is based on grave finds. Even then, the picture can only be roughly painted.

1 Rod-tripods

a The eastern group

The last list of extant rod-tripods was made by P. J. Riis.[7] Let us begin with the eastern group, predominantly from the island of Cyprus.

1 Rod-tripod from Kourion (Cyprus). Height 37.4 cm. New York, Metropolitan Museum (Cesnola Collection).[8] (Pl. 204)
2 Rod-tripod from Kourion (Cyprus). Nicosia, Cyprus Museum[9]
3 Rod-tripod from Kourion (Cyprus). Height 13.5 cm. Nicosia, Cyprus Museum[10]
4 Rod-tripod from Kourion (Cyprus). Height 40 cm. Nicosia, Cyprus Museum[11]
5 Rod-tripod from Enkomi (Cyprus). Height 43 cm. London, British Museum (97.4-1.1571)[12]
6 Rod-tripod from Tiryns. Height 34 cm. Athens, National Museum (6225).[13] (Pl. 205)
7 Rod-tripod from Beth-Shan (Palestine)[14]

The oldest tripod stand from Kourion (1) (Pl. 204) is a fully developed version of the rod-tripod which subsequently changed remarkably little. It consists of four parts, all heavily cast: a carrying-ring for the cauldron; three legs with 'Ionic capitals'; three arched struts attached to the lower part of the legs and supporting the carrying-ring between the legs, with one or two rings at the joint; and horizontal ties between legs and centre point, usually a circle. Individual parts are soldered together.

On the outside of the carrying-ring is a relief frieze, which shows lions chasing after ibexes. The legs run down almost vertically from the carrying-ring, while the arched struts lean outwards somewhat. The lower part of the legs, up to the beginning of the struts, are solidly cast, ending in bulls' hooves. Higher up they get wider and flatter. The ornamentation is not Geometric herringbone pattern but rings running downwards on the front and upwards on the back, apparently an attempt to make the leg look rounded like a column, although in fact it is flat, to soften the transition to the carrying-ring. The utensil, with its orthogonal structure and the outward-reaching struts, has an inner tension and demonstrates assured artistry and craftsmanship. The frieze on the carrying-ring belongs to the final phase of Mycenaean art. This rod-tripod is part of a final flowering of Mycenaean art on Cyprus. No precise date for its production can be postulated, but it would not have been made after the twelfth or eleventh centuries.

A group of three tripods, also from Kourion (2-4), is of later date. The largest of these tripods (4), 40 cm. high, is distinguished by its widely splayed framework. The cross-tie, about half-way up the legs, is supported by voluted struts soldered to the legs. The transition from flat leg to the fully cast leg below, at the level of the cross-tie, is concealed by sculptured protomes—a bull's head and two goats' heads. The legs end in animal feet. The low carrying-ring is decorated with two ridges beneath a larger ridge on which the cauldron rested. The smaller tripod (3), 13.5 cm. high, has a less splayed framework. The cross-ties have no struts. The high carrying-ring is cast and decorated with a frieze of double spirals between two ridges.[15] At the level of the

cross-tie, on the legs, are the neck and head of an ibex, whose massive horns, like handles, run into the framework. The feet are carefully modelled hooves. The third tripod (2) seems to be somewhat smaller, without sculptural decoration.

There are no stirrup jugs amongst the vases found in the same grave. These vases are Geometrically decorated with cross-hatched and framed triangles and hour-glass motifs, indicating the post-Mycenaean phase on Cyprus which on the Greek mainland was already the advanced Protogeometric phase. On the large tripod a bud or pomegranate has been fastened with wire, obviously by the excavators, to one of the rings on the struts. This is too small for the large tripod and probably belonged to one of the smaller bases. Pomegranates like this occur on the capitals of both bronze columns in front of the portal of the Temple of Solomon and on metal lustral basins from the same building. Lustral basins like this appear to have had low tripods with curved animal legs. Examples have been found in Enkomi and Ras Shamra. The latter has five pendent pomegranates between the legs on the loop of the carrying-ring.[16]

It is tempting to date this group of rod-tripods in the tenth century. But the end of the eleventh century and the beginning of the ninth cannot be entirely ruled out. To the same period belong, however, the rod-tripods from the Tiryns treasure, now in Athens, and from excavations at Beth-Shan (6-7). The structure of the former (Pl. 205), apart from the less splayed legs and absence of struts on the cross-ties, is like the large tripod from Kourion (4): its low carrying-ring, heavily cast lower third of the legs, flattened upper legs, heads of goats and a bull on the legs at the point where they become round. But there are no hooves at the ends of the legs. The ornamentation on the carrying-ring and legs—a simple 'woven' pattern—is, however, carried right down to the foot-plates. From the rings hang four birds without feet and four pomegranates. The rod-tripod from Tiryns is undoubtedly later than the utensils from Kourion, and probably belongs in the first half of the ninth century.

This tripod is followed by the tripod from Beth-Shan (7). The change is considerable. The animal

protomes on the legs have disappeared, as have the rings between the arched struts and the legs. The latter, as on the tripod from Tiryns (Pl. 205), are decorated with a simple 'woven' pattern. The fully cast carrying-ring is higher and is decorated with eight encircling grooves. This tripod appears not to have had the hanging decoration on the rings of the struts typical of older rod-tripods. Without doubt it belongs to the late ninth century.

Equally simple, with only strictly structural elements, is the tripod from Enkomi in the British Museum in London (5). Its height is 43 cm. The carrying-ring is decorated with six encircling ribs between two frame ridges, as on the tripod from Beth-Shan (7). The Ionic capitals have no abacus, as they usually do; instead, the volutes develop out of bunches of lines with the middle one carrying the circle. They quickly merge into the rectangular leg, which is less flat below than above. The cross-ties seem to have been broken off. Only one of the pendent attachments, probably a pomegranate, survives. The capitals are like those of the town gate of Samaria in Israel,[17] which must have been built around the middle of the ninth century. The tripod from Enkomi is, however, probably later and would come from the second half of the same century.

b The Greek group

8 Rod-tripod from Vrokastro (Crete), Grave 1. Height 37.7 cm. Heraklion, Archaeological Museum.[18] (Fig. 100)

9 Rod-tripod from Knossos (Crete), Grave 3. Height 45 cm. Athens, National Museum[21] seum[19]

10 Rod-tripod from Fortetsa near Knossos (Crete), Grave 11. Height 17 cm. Heraklion, Archaeological Museum[20]

11 Rod-tripod from a grave on the Pnyx in Athens. Height 45 cm. Athens, National Museum[21]

This group is certainly later than the eastern group. There are no animal protomes or hooves at the feet of the legs, which are typical of the eastern group.

The feet now have plates which get smaller and smaller until finally (11) they are reduced to rudimentary endpieces. The legs of the rod-tripod from Vrokastro (Fig. 100) are flat right down to the foot with thick ribs on the edges running into the feet below and the volutes of the capital above. The thin middle rib forks at the top and runs over the volutes, making a connection between legs and carrying-ring in the form of a sort of capital, more developed than the Cypro-Palestinian ones in Samaria,[22] and a forerunner of 'Proto-Ionian'. The carrying-ring is huge, with thick ribs at the edges. The ceramic offerings in the chamber grave from which this tripod came are not uniform. The most recent appear to be from the end of the ninth to the beginning of the eighth centuries. The rod-tripod could therefore be dated in this period.

The small tripod from Knossos (9), 18 cm. high, is very similar. The foot is beginning to disappear. The leg is shaped similarly to No. 8 except that the middle rib is thicker than the edge rib and runs up to the abacus on the capital. The carrying-ring is iden-

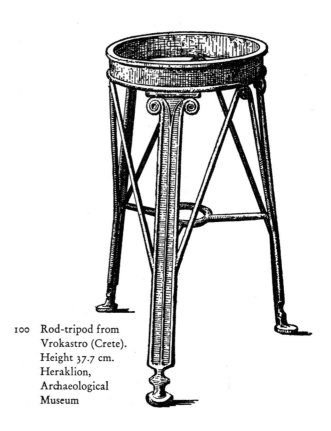

100 Rod-tripod from Vrokastro (Crete). Height 37.7 cm. Heraklion, Archaeological Museum

tical to the tripod from Vrokastro (Fig. 100). The tripod from Knossos probably comes from the same workshop and is slightly later. An amphora from the same grave, to judge by its shape, was probably produced in the same period as some neck-handled amphorae from the Kerameikos in Athens, and can almost certainly be dated in the first quarter of the eighth century.[23]

The rod-tripod from Knossos (9) is directly connected with the rod-tripod from Grave 11 (10), 17 cm. high, from the Fortetsa necropolis near Knossos, now in the Heraklion Museum. The legs are flat, but more heavily cast than on the tripods from Vrokastro (8) and Knossos (9). The two edge ribs, which run together above the feet and spread out above into volutes, do, however, correspond to the other Cretan tripods. The carrying-ring has the same structural form as the tripod from Vrokastro (Fig. 100), with an edge rib below and a protruding lip above. The additional ornamentation is new. Spiral chains run up the legs; the top element is independent, with one spiral starting and the second one running into the ends of the volutes. The wide carrying-ring is decorated with two opposed spiral chains so arranged on either side of a central rib that the spiral heads coincide in opposed pairs. One might describe the motif as a stalk with flowers growing out of each other.[24] The date of this rod-tripod cannot be fixed for certain. The contents of the grave, which covers three burials, are fairly uniform and span Late Protogeometric and Protogeometric B. According to J. K. Brock's calculations,[25] this means a date between 870 and 820 B.C. But the rod-tripod cannot be allocated to any of the three burials; it was found in a stratum 13 cm. above the floor of the grave. It is remarkable that bronze cauldrons and gold jewellery appear at all in this relatively early grave. Were the valuable utensils and jewellery put in subsequently? At all events, the rod-tripod belongs to the same family as the tripods from Vrokastro (Fig. 100) and Knossos (9). It cannot have been produced before the last quarter of the ninth century and could as well be dated around the turn of the century.

The tallest rod-tripod in this group, 45 cm. high, is the one found in a grave on the Pnyx (11). The top parts of the legs are flat. At the point where the arched struts and cross-ties meet the legs, about 15 cm. above the ground, the legs become wider and triangular down to the foot-plates. The cross-ties are supported by curving struts. The outsides of the legs, up to the abacus on the capital, are decorated with a 'woven' pattern. The carrying-ring is richly decorated. Between the edge ribs runs a frieze of double spirals bordered above and below by thick lines. There is a new technical sophistication: the double-spiral frieze on the carrying-ring[26] is in open-work, as are the 'Ionic capitals' on the legs. The rod-tripod from the Pnyx is the most recent of its type, as is also indicated by the associated finds. The vases found with it all belong to the second and the beginning of the third quarters of the eighth century.[27] The tripod may have been produced at the same time, but, to be cautious, one should date it in the first half of the eighth century.

A check for the dating of the rod-tripod is given by the clay imitations of this kind of tripod base, which are only found in Attic pottery. The earliest of these (Pl. 206) was an isolated find from a stratum not precisely datable in the Kerameikos necropolis.[28] The ornaments suggest that the tripod belongs to the transition between Late Protogeometric and Early Geometric. It must therefore have been produced, at the latest, around the middle of the first half of the ninth century. It has the same wide-splayed legs as the large rod-tripod from Kourion (4), which we have already dated between the second half of the tenth century and the first quarter of the ninth century.[29] After this terracotta tripod came two more clay tripod bases, one with less splayed legs. The one from Grave 2 in the Kerameikos necropolis (Pl. 207)[30] is still Early Geometric; the other, from a Geometric grave near Thorikos,[31] is decorated, on the stand-ring and legs only, with meander bands. To judge by the offerings from the graves, both should be dated around the middle of the century or in the third quarter of the century. In this period stereotyped rod-tripod bases mostly decorated with meander bands begin to appear.[32] The verticality of the later of these terracotta tripods approaches more and more closely the tectonic simplicity of the latest bronze rod-tripods of the eighth century.

2 Tripod-cauldrons

a Earliest examples

The first of a long series of tripod-cauldrons, produced in the Geometric period and later for the great Greek sanctuaries and festivals, are two almost complete pieces in Athens and Berlin, the legs of a third, and two clay imitations from Grave 4 in the Kerameikos necropolis in Athens (Pl. 209). The complete pieces come, respectively, from Mycenae and from the market. The legs come from Tiryns.[33] The cauldrons are in the form of a deinos without a foot. The legs are multi-sided and heavily cast. Cauldron and legs are connected by a spoon-shaped element fitted to the curve of the vessel, soldered to the leg and riveted to the cauldron. Two double handles, each consisting of an undecorated pulling handle and a simple lifting ring handle with a braided pattern, correspond to the three legs on the tripod-cauldron from Mycenae.

The tripod-cauldron in Berlin and the legs from Tiryns were believed to represent an older type than the cauldron from Mycenae,[34] because they have no oblique cross-struts between legs and cauldron and the Berlin cauldron has a finely worked inward and then outward curving lip. But there cannot be much difference in the dates since the Berlin tripod-cauldron has eight-sided legs while the supposedly later example has six-sided legs. Of the two early clay imitations from the Kerameikos in Athens,[35] one has the in-and-out curved lip of the supposedly earlier type, but the other does not, and both have oblique cross-struts. Both come from the same grave and the same workshop. On the other hand, on a considerably later tripod-cauldron from Olympia (Pl. 208)[36] the oblique cross-struts are missing, which first reappear on substantially larger and later tripod-cauldrons, in a new, more artistic form.

The contents of Grave 4 in the Kerameikos,[37] which included the two clay tripods, can be accurately dated. They belong to an early phase of Attic Protogeometric, but can probably be put as early as the tenth century. The large rod-tripod from Kourion (4), imitated in Attica in clay during the transition from Late Protogeometric to Early Geometric,[38] was produced at the earliest in the second half of the tenth century, or perhaps even at the turn to the ninth. It is the only rod-tripod with oblique struts; here they are of course low down, by the cross-ties. The small group of extant tripod-cauldrons should therefore be put in the tenth century.

The three examples, two of which come from Mycenae and Tiryns, are probably all from Peloponnesian workshops. But the type was widespread, as the clay imitations from Athens prove. The height of the two almost complete tripod-cauldrons in Berlin and Athens is 29 cm. without ring handle. The three legs from Tiryns are taller—37.5 cm., 38 cm. and 42 cm.—and probably somewhat later. These simple tripod-cauldrons are undoubtedly functional objects, and have nothing to do with the great games. S. Benton rightly calls them 'cooking pots'.[39] It is arguable that the above-mentioned tripod-cauldron from Olympia (Pl. 208) with a rim height of 49-52 cm. (63-65 cm. with ring) was also functional, but nothing can be proved one way or the other.[40] We are on firmer ground with the two tripod-cauldrons from Ithaca (Fig. 101)[41] with rim heights of 19.65 cm. and 21.90 cm., which are still smaller than the Protogeometric examples from the Peloponnese. These already have open-work struts under the leg rivets. The three tripod-cauldrons from Olympia and Ithaca must, therefore, date some way back into the ninth century.

The crucial question is, when does the function of the tripod-cauldron change from a simple everyday object to a prize in the games and votive offering at

101 Reconstruction of two tripod-cauldrons from Ithaca

the festival? The question has been answered in various ways. F. Willemsen assumes a slow, continuous development of the tripod type through three centuries, from about 1000 B.C. to the end of the eighth century. With impeccable chronological logic, he distinguishes only two technically different types of tripod-cauldron: one with heavily cast legs and ring handles, the other, also cast, but with thin-walled legs and open-work ring handles. The hammered sheets he puts in the second group. He believes the centres of production were in the Peloponnese, in Argos and Corinth, and he tries to explain the various stylistic phases by comparing them with Attic Geometric jugs and amphorae, using the extended chronology of Kahane.[42] The Attic vases have, however, no connection, as far as ornamentation goes, with the tripod-cauldrons, and they all belong in the eighth century. In the course of detailed reviews of Willemsen's book on tripod-cauldrons from Olympia, S. Benton and P. Amandry go into the question of the chronology and come to almost exactly the same conclusions.[43] Miss Benton, the excavator responsible for the superbly published tripod-cauldrons from Ithaca, cites the almost complete lack of rich finds between the Mycenaean epoch and about 800 B.C. and considers it unlikely that large decorative tripod-cauldrons began before 800 B.C. Amandry relies on the finds at Delphi, where even Early Geometric ceramic is poorly represented. Votive offerings of all kinds, origins, and materials are not traceable to any important extent there before the eighth century. 'Et, à ma connaissance, la situation ne se présente pas autrement à Olympia.'[44]

b Chronological parallels between rod-tripods and tripod-cauldrons

As far as the larger, richly decorated tripod-cauldrons are concerned, there are some chronological clues, although there are no datable grave finds and what evidence there is can give only broad indications of date. The evidence comes from comparisons between tripod-cauldrons and rod-tripods of the Geometric period, the composition of Geometric ornamentation and the length of the legs, so far as this is known.

Let us consider, to begin with, a few of the chronological clues which are given by the points of contact between rod-tripods and cauldron-tripods.

The rod-tripod (10) from Grave 11 in the necropolis of Fortetsa at Knossos, 17 cm. high, is the smallest in its group. No firm date can be established from the grave finds.[45] The smallness of the tripod suggests that it was produced specifically as a funerary item. It may belong with the comparatively rich finds from this grave— two lebetes and a footless bronze bowl, a bronze cauldron, bronze and iron weapons, a ring, a round disc and a necklace with gold wire spirals, an ivory pendant, a fragment of an ivory needle and a little lead lion (?). We have dated the tripod between the last quarter of the ninth century and the beginning of the eighth.[46] It has decoration which also occurs on tripod-cauldrons: a spiral chain on the legs and two opposed spiral chains around a central rib—calyxes on a stem—on the carrying-ring. This combination of simple and double spiral chain is found again on a leg from the final group of heavily cast tripods in in Olympia.[47] The opposed spirals on one leg in the early thin-walled group have slipped around to the inside.[48] Late heavily cast tripod legs may provisionally be dated at the end of the ninth century, and early thin-walled ones probably at the beginning of the eighth. This chronology is supported by the later forerunners of the meander-decorated clay bases in Attica,[49] where meander friezes certainly take the place of the spiral chains of the tripod-cauldrons. These also run from the last quarter of the ninth century to the first quarter of the eighth.

The rod-tripod from Kourion (3), only 13.5 cm. high, must be regarded as a decorative item. It belongs to a group starting at the end of the tenth century and continuing with the latest finds, including this miniature tripod, up to the first half of the ninth. The carrying-ring is decorated with a frieze of double spirals enclosed by two heavy ridges. Similar ornamentation occurs on the ring handle of a heavily cast tripod-cauldron from Olympia (Br 218).[50] Here, however, the chain of double spirals

is a good deal more elegantly worked, with two simple enclosing lines, the inside one a smooth ridge, the outside one with a loose braid pattern. The larger rod-tripod (4) from the same grave, with splayed framework, can be dated at the end of the tenth century or the first quarter of the ninth[51] in view of the fact that an Attic clay imitation from the Kerameikos, similarly splayed, belongs to the latest phase of Protogeometric and the transition to Early Geometric. The miniature tripod (3) is undoubtedly later than this and can almost certainly be dated around the middle of the ninth century, allowing for a considerable margin of error on either side. This suggests a date for the technically much superior ring handle (Br 218) from Olympia in the second half of the ninth century, and about 800 B.C. at the earliest, or in the following quarter of the century, for the rod-tripod from the Pnyx in Athens (11), 45 cm. high, with a carrying-ring with the same ornamentation, but richer and in open-work. The pottery found with it belongs in the second and beginning of the third quarters of the century, and the tripod is probably a generation older than the vases.

This preliminary review of the obvious parallels between rod-tripods and tripod-cauldrons has produced a few points of reference which give a sketchy chronology but no accurate dates. Let us now go on to try to interpret the ornaments and decorations on tripod-cauldrons. We will use five groups, beginning, in reverse order of chronology, with the last.

*c Hammered tripod-cauldrons and
the tangential-circle style (V)*

With the splendid tripod-cauldrons with strictly Geometric ornamentation and composition, it is sensible to begin with the group of hammered tripods because there is a certain amount of agreement among researchers about its dating. S. Benton puts it between 750 and 700 B.C.; Willemsen seems to regard it as Late Geometric and therefore pushes it into the early seventh century.[52]

The legs and ring handles were probably shaped on a stone matrix. The front and sides of the legs would have been nailed on to a wooden core. The ring handles were riveted to the rim of the cauldron.

Ornamentation

The basis of the ornamentation is triple, quadruple or quintuple horizontal or vertical bands of tangential circles and parallel zigzags (Pl. 211). The motif of the 'flower on a stem' is common, with the 'stem' usually replaced by two undulating and close-set zigzag lines. When the stem is not framed and the tangential circles are opposed, the motif should be taken as single-track, otherwise as triple-track.[53] The circles are often connected by two crossed tangents. The two opposed tangential-circle strips are fused to such an extent that they look like one track.[54] The edge lines usually consist of chains of S-hooks (Pls. 211, 212). These also occasionally occur as central ribs between two tangential-circle chains. Later variants should obviously be regarded as hybrid extensions, with little balls between the S-hooks, rows of balls without S's and oblique groups of strokes with slurred connecting hooks—a truly impressionistic pattern.[55] Friezes of semicircles with separating lines, opposed in two rows, are rarer. In one case a chain of semicircles is inverted and so designed that its points fit into the hollows of the other, upright, chain. This makes what can also be seen as a wavy band.[56] Less rare are horizontal or vertical strips with large, spacious, double-line zigzags (Pl. 210), corresponding to the silhouette or thick zigzag bands on Geometric vases, particularly on the Cyclades and in the East Greek style.[57] These silhouette bands—zigzags and forerunners of the cable band— are undoubtedly late features of the group of hammered tripods.

In the group of hammered bronze sheets are a few pieces where one cannot be sure whether they come from the main workshop with which we have been concerned so far. This applies to the upper part of a tripod leg in the Museum of Nauplia,[58] which has a broad central strip with a lozenge chain with overlapping elements. The other strips do have orna-

ments of the main workshop, but the S-chain is now set away from the edges and is now a strip on its own. The tangential circles on the edges become discs without a centre, with only a double rim. We have also a fragment of a side wall with the whole surface filled by a lozenge chain;[59] in the side interior angle of each lozenge is a single-rimmed disc, almost a breaking up, as it were, of one of the motifs from the main workshop, that of concentric circles enclosed by double tangents. Among the sheets from the main workshop is also a unique fragment from the side wall of a tripod leg,[60] where the tangents of the 'false spiral' are intersected by a cross-line, from which two smaller concentric circles are suspended. This enrichment and refinement of the motif would not be worth mentioning were it not for the fact that on a fragment of a tripod-cauldron leg from the Acropolis in Athens, the pattern is relaxed even more.[61] More important is the fact that the technique used on this fragment is obviously the new one of engraving and chasing. This new technique is also in evidence in quite a few examples in Olympia.[62]

The concentric circles are, here, discs with a single or double rim and—with a few exceptions—are without a centre point. The patterns on the edges of front and side walls are connected with the late phase of the main workshop, and develop pseudo-'woven' bands. The earliest examples are a tripod-cauldron leg (B 1580) with double lozenge chain on the sides and finely grooved, horizontal parallel zigzag lines, as in triglyphs and filling ornaments between figures on Attic grave vessels in the second quarter and the middle of the eighth century; and a fragment of the side wall of a similar leg (Br 12492) (Pl. 212).[63] Down the central track are horizontal parallel zigzag lines, as on leg B 1580. To the left and right, on each side, are two opposed tangential-circle chains. Actually, these are double-rimmed discs, and the tangents are only lines running out from the lower disc to support the disc above. This means that the flow of the tangential-circle chain is interrupted at each stage; it builds up, bit by bit, like an acrobat's pyramid.

The remaining fragments in the same group allow three phases to be distinguished.

(1) Fragments Br 11661, B 2227, Br 4047 and Br 4940, of side walls.[64] Their ornamentation and composition show them to be imitations of hammered tripod legs of the main workshop, retaining the special features above, such as discs, separation of elements within opposed tangential-circle chains and various other features. They last into the later periods.

(2) Fragments B 1575, Br 7628, un-numbered, and B 2433, of side walls.[65] Their common feature is having one track out of three left blank. The central track is decorated with a tangential-disc chain, the outside one with a stepped zigzag band, a normal zigzag band and a strip of inverted triangles pointing downwards, with apices one above another. The drawing and arrangement are disciplined and accurate but undoubtedly Late Geometric. The triangle track of the last-mentioned fragment occurs from time to time in Attic pottery from the end of the ninth century up to the Late Geometric period (Pl. 10).[66] Side fragment B 2433 has, in the second track, ten rectangles separated by two lines, filled with two elongated tongues. The fragment is late and may belong to the transition to the sub-Geometric period.

(3) Fragments Br 7008, Br 1364, Br 6925, of side walls, and front wall Br 1425 which does not belong with them.[67] The main motif consists of two counter-running tangential-disc chains joined on the front wall by a central axis with unidirectional semi-arches, but set on the outside edges on the side walls, leaving the middle free. The discs are hammered out from the inside, like knobs. The tangents are drawn with assurance, slightly S-shaped, with an engraver's burin. This assurance in the engraving and chasing puts these fragments right at the end of the Geometric period. The left external edge of fragments Br 1364 and Br 6925 is decorated with upright wedge-shaped leaves. The same border motif occurs on the edge of a side-wall fragment from a tripod leg from the Acropolis in Athens.[68]

One must ask oneself whether the whole group, with its engraving and chasing techniques, was not strongly Attic-influenced, and whether, even in phases 2 and 3, we are not dealing with Attic imports or an Attic craftsman working in Olympia.

The composition on the hammered legs consists of upright ornament-filled tracks and rectangular areas with similarly decorated cross-tracks at the top and bottom (Pl. 210).[69] The upright tracks, defined by separating lines, develop a rhythmic syntax of their own, ever more sophisticated. Three-track sheets apparently occur only on side walls. On the fronts, there are compositions of five (Pl. 211), seven and, on one splendid piece, even nine tracks.[70] The only exception to this is a monotonous front wall with six identical tracks.[71] On ring handles, compositions of three and five tracks are preferred, although one has two, and another four tracks.[72]

Connection with the decoration of Attic and Theran pottery

The same syntax also occurs on the neck of Attic black-ground amphorae with upright and round shoulder handles, and on large Attic belly-handled amphorae from the phase of transition from black-ground to clay-ground. It can be traced up to the transition from High Geometric to Late Geometric on clay-ground neck-handled amphorae. The strictly symmetrically arranged ornamental strips on the shoulder-handled amphorae make three or five encircling tracks (Pl. 14).[73] On one belly-handled amphora and one clay-ground neck-handled amphora there are seven tracks.[74] The ornaments on these vases are those of Attic pottery. Tangential circles do not occur, although they were already known in Attica. They are replaced by the meander and its different variants. Only the frieze of horizontal parallel zigzag lines also appears in this pottery. In spite of the fact that rhythm is gradually refined on the large grave vases and runs into the plastic form of the neck, axial symmetry is occasionally retained. This is not to suggest that the development of Attic pottery was not original and self-generating, but simply that these phenomena in Attic pottery provide a *terminus post quem* for the production of hammered tripod-cauldrons which cannot be dated before the beginning of the second quarter of the eighth century.

Thera is the only other place in the Greek world where this rhythmical and usually symmetrical decoration of the necks of large amphorae with shoulder handles occurs. And ornaments in the frieze tracks of Theran vases are more similar to hammered tripods than Attic vases. Indeed tangential circles are virtually the trademark of the Theran style.[75] But they never occur as central decoration, only on edges and as separating friezes. The broad zigzag band often occurs with them. Occasionally, in edge friezes, a linear spiral band appears, related to the S-chains on the tripods, probably copied from Cretan vases.[76] The central main band always contains Attic left-running meanders, apart from two instances of battlement meanders, but this seldom occurs on larger compositions.[77] This proves once again the derivation of Theran Geometric vases from the rhythmic power of High Geometric in Athens.[78] It must have been in the course of the second quarter of the eighth century that the large Athenian grave vases really began to influence Theran potters and painters.

It is extraordinary that the connection between Theran vases and the rhythmic compositions of these hammered tripod legs has never been noticed before. Neck decorations do include three-track compositions: tangential circles—meander—tangential circles (Fig. 33),[79] but more common, as in the tripods, is the five-track composition: tangential circles—zigzag bands, and vice versa around a central meander (Fig. 82).[80] The seven-track composition is rare on Thera, again like hammered tripod legs. As a symmetrical composition it only occurs once, on a large Theran amphora in Paris.[81] Enrichment is achieved by two double rows of tangential circles on either side of the zigzag bands above and below the meander. A second seven-track composition occurs on another amphora in Paris, but this is not symmetrical, and repetition of the two lower strips of a five-track composition pushes the meander somewhat above the middle.[82] A better asymmetrical solution to this tectonic problem, which is demonstrated on the superb composition of the large Attic grave amphora 804 in Athens (Pl. 30), is for a five-track composition to have an additional sixth strip of tangential circles with, perhaps, an extra battle-

ment meander slotted in between, as a base (Fig. 82).[83] But this is leading us away from hammered tripod-cauldrons.

The origin of hammered tripod-cauldrons

In spite of several connections between Theran potters and painters, and tripod-cauldrons, these tripod-cauldrons cannot have been produced on Thera, proved by the fact that the central motif on them, the flower-stem of tangential circles, does not occur on Thera, where it is replaced by the Attic meander. Nor can the hammered type have been produced in Corinth, as suggested by Willemsen, since only a few fragments of this group were found in Delphi, even though Protocorinthian vessels are the most common imported type.[84] On the other hand, of the seventeen remains of tripod-cauldrons from Delos, no less than seven are hammered. Apart from Olympia this is the largest number of fragments of this kind. On Delos they are more common in comparison with cast tripod-cauldrons than in Olympia.[85] One is tempted to locate the main workshop for hammered tripods on one of the large islands. Eastern rod-tripods and tripod-cauldrons were produced on Crete. But the style of the Cretan products, although indigenous, is provincial, without any connection with hammered types. Could the origin of hammered tripods from shortly before the middle of the eighth century have been Athens? Could an Attic workshop also have made products for Olympia in the second half of the century?[86] The Athens-Thera-Delos triangle and the hammered tripod-cauldrons do seem to suggest this. Then there is the splendid discovery by S. Karouzou of an Attic ring-handle holder (Pl. 155) which was found on the Acropolis and belongs to a hammered ring handle.[87]

This hypothesis must, however, remain unproven until some more solid evidence for the location of hammered tripods is found. Meanwhile it remains only a clue. It is, however, certain that this group began during the second quarter of the eighth century and continued to be produced after the end of the Geometric period. Rejection of the casting tech-

nique, simpler production, and functional adaptation of the product as prizes in games and as votive offerings, explain the popularity of this group.

d Tripod-cauldrons with fanned grooves (IV)

Only a few fragments of this type have been found, in Olympia, Delphi, the Argive Heraion and Ithaca.[88] The workshop was producing during the Late Geometric period, but probably only lasted about a generation.

Tripod leg B 1730 from Olympia, with two figured reliefs

To date this small group, it is sufficient to concentrate on the best of the leg fragments, indeed all the fragments of tripod-cauldrons from Olympia (Pl. 213). This leg fragment has two figured reliefs.[89] Only the upper part of the leg, with the attachment to the cauldron, approximately a quarter of the original height, is extant. Whereas on side fragments lines run along the whole length, on this front wall, rectangles with figured scenes in relief alternate with grooved patterns. The interplay of linear ornament and picture area is similar to late large Protocorinthian Geometric vases.[90] The essence of the Geometric style, the superb use of ornamental syntax, has now degenerated completely, and the picture has triumphed.

The upper relief shows a fight between two warriors with typically Geometric helmets. They are fighting over a tripod-cauldron which both have grasped with their left hands, lifting it up. One has to imagine spears in the men's right hands. Both types of helmet, the slenderness of the two men, their proportions, with long legs and short triangular upper bodies growing out from narrow waists, the thin arms and long necks, the forward-projecting heads without profile or eyes are all derived from the classic Geometric figure on monumental grave vessels from the middle of the century. Legs and

head are shown from the side, bodies from front or back. But the High Geometric figure is somewhat distorted here, bent knees and front feet down flat, but back feet with heels raised, ready to jump. The bodies are different, and yet the left one must be frontal, and the right one shown from the back. One can see that the left shoulders are extended by the left arms which have to carry the weight of the tripod. Arms and neck grow out of the torso in a beautiful curve. The two fighters are standing in mirror image on either side of the tripod, in 'sculptural antithesis', as it were.

The Geometric figure is here deeply infused with organic life and a growing sensuality bringing out individual figures in a new way. The age of great funerary pictures and battle scenes is almost over. The hero image is crystallized in these figures at approximately the same time as the splendid three-dimensional warrior statues from the Acropolis (Pls. 159-161).[91] The pictorial motif of antithetical groups, which had reached Greece from the Orient a few decades earlier[92] is, as it were, the perspective within which this new figure developed.

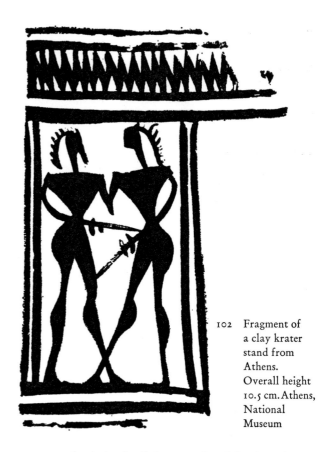

102 Fragment of a clay krater stand from Athens. Overall height 10.5 cm. Athens, National Museum

Other duelling groups in Geometric art

A date very different from this author's has recently been given to this tripod leg.[93] Let me therefore make a short review of the development of similar warriors and duelling groups in Late Geometric vase painting leading up to the stylistic phase to which this relief leg belongs. A krater stand in Athens (Fig. 102),[94] shows a duel between two heroes, by now at the moment of truth, the combat with swords. This is the last round, and both their feet are flat on the ground. The wide-apart legs are a first unobtrusive sign of new freedom. Otherwise everything is in accordance with the classical model: arms are linear curves without joints or hands; shields are omitted for the sake of clarity (where they would have been, there are only two interlocked arm stumps); faces have no profiles; helmets are only indicated by moving crests, typical of the period around the middle and third quarters of the eighth century. The group is static. Only the wide-set stance of the legs,

more emphatic in the fighter on the right, is a clue to things to come. He is larger and more active. His chest is no longer just a triangle but grows up in a long curve from the narrow waist. The shoulder line is set at an angle to his opponent as he looks down at him. This man, who has already stabbed his opponent in the thigh, must be the winner. The individual is beginning to emerge from the anonymous plurality of figures in High Geometric battle scenes. Since the picture is not symmetrical, the krater stand probably still dates from the early third quarter of the eighth century.

This is followed by a base with four legs (Pl. 214), an isolated find from the Kerameikos necropolis.[95] Its legs are tapered. On the tops of them are picture areas which are wider at the top. Below this are two frieze zones with Geometric decoration, forming a base. The composition is the same, if more compressed, as the tripod leg from Olympia (Pl. 213). The picture, which fits splendidly into the irregularly shaped picture area, shows a helmeted warrior with

a spear in his left hand and a sword in his raised right, fighting a lion which has leapt at him. The feet are set well apart on the ground. The knees are slightly bent, as in the fighters on the Olympian tripod leg, ready to turn in a flash. The waist is thicker than on the other stand from Athens (Fig. 102). The chest curves out on both sides. Elbows can be seen in the arms. The shoulder line is oblique. Head and crest are rendered as on the other Attic tripod. As there, one of the back legs of the lion crosses the forward leg of the fighter. The two stands are obviously connected by a common pictorial tradition, but the style is clearly more developed. The lion-fight group on the Kerameikos stand should, therefore, be dated roughly in the last part of the third quarter of the century.

Late Geometric figures

We have not yet, however, reached the phase of the relief on the Olympia tripod leg, which, with its considerable departure from the classical figure, and its 'organic' life, brings us close to the boundary of Geometric and the type which reached its high point in vase painting in the creations of the important master of the two kraters from Piraeus Street in Athens (Pls. 63, 64). Compare the procession of men raising their arms above their heads in sorrow on the neck of a neck-handled grave amphora from the Kerameikos,[96] the procession of mourning women on a similar amphora in Toronto,[97] and the man getting into a chariot in a chariot procession on a large trefoil oinochoë from the Kerameikos.[98] Either the back or both heels are raised. Knees are bent and shoulder lines oblique. The man getting into the chariot on the jug from the Kerameikos is touching the ground only with his toes.[99] The left arm of the mourners, hanging down inactive and following the contour of the torso on the neck fragment from the Kerameikos[100] and other vases from the same workshop, is an imaginative innovation. The right arm of the man getting into the chariot is the same. It is no longer just the action which is expressive, but the total figure, including all its movements. Considerable sculptural sensitivity

has developed, sensitivity which was to characterize large-scale sculpture for more than two centuries.

We have acknowledged above[101] the almost incredible creative genius of the master of the kraters from Piraeus Street in Athens. Let us concentrate now on the superb fragment from the second krater.[102] In the middle of the extant fragment is a high-footed krater with animal heads on the rim. Two pairs of figures, to left and right, can be seen. On the right, a slave girl is being led away as a prize by a victor. He is threatening her with a sword, and she is begging for mercy with outstretched arms.[103] The games begin on the left of the krater, starting with a wrestling or boxing match. Only one of the contenders is complete; only the leg of the other survives. As in earlier pictures, in both groups the legs cross each other. The Late Geometric tradition is still intact. But the aggressor in the battle group, attacking his opponent with the heel of the non-weight-carrying foot raised, is like a younger brother of the warriors on either side of the tripod on the relief on the tripod leg from Olympia (Pl. 213). Both must have been produced within a very short time of each other. In both of them, in the bronze as well as the painting, there is still the unprofiled head without eyes. But the master of the krater from Piraeus Street moves further away from the High Geometric prototype. The upper bodies in his figures are longer and more massive than in the relief. Shoulders, upper and lower arms are distinguished. Proportions are different and more natural.

If we have dated the two kraters and their master correctly, at the beginning of the last decade of the eighth century,[104] then the tripod leg from Olympia must be dated early in the last quarter of the century. Kunze[105] argued for this chronology fifteen years ago, without making any detailed comparisons. It is supported by the lion type on the second, incomplete, relief on the same leg. Its huge neck and wide-open jaws showing tongue and rows of teeth can scarcely be much later than the lion in the fight scene on the stand from the Kerameikos (Pl. 214).[106] This means that, as possible dates for the grooved tripod-cauldrons (our group IV) we have at least two to three decades of the Late Geometric period up to the last quarter of the eighth century.

The group of tripod-cauldrons with legs with fanned grooves develops from tripod-cauldrons of the Ripe style and the High Geometric decades. The next group (III) of thin-walled cast tripod-cauldrons is closely connected with Geometric vase decoration at its zenith, in the eighth century.

e Tripod-cauldrons in the classic Geometric style (III)

Willemsen undertook a detailed analysis of this group of tripod legs and ring handles in an attempt to trace the development of the type.[107] But considering the comparatively small number of fragments found, the continuing uncertainty about the location of the workshop or shops and the resulting ignorance of corresponding local Geometric pottery, it is doubtful whether this group can be reconstructed using stylistic principles from Attic pottery. We shall deal here only with the length of time the workshop lasted.

The formal vocabulary of Geometric decoration is consciously limited, in this group, to columns of horizontal zigzags, zigzag bands, herringbone patterns, spiral chains (but not tangential circles), S-shaped borders (but no knots as in the hammered tripods) and double or triple semicircles (mostly on the edges). Motifs which are Geometric in the narrow sense of the word predominate—zigzags, pillars of M's, herringbone patterns. These occur in combinations of three, four and five tracks.[108] The legs in the best examples are so accurately and sharply cast—one might almost say, so grandly conceived—that they can confidently be compared with the most splendid vases of the High Geometric period.

Special features include rectangular ornamental areas with wheel-like discs with six-leaf rosettes and cogwheel rims or a surrounding zigzag frieze as a border, and wheels with a Maltese cross or normal spokes (Fig. 103).[109] Tripod leg Br 5103 from Olympia, with boxed upper zone (Fig. 103, left) is comparatively early. Leg 241 from Delphi (Fig. 103, top right) is somewhat later. This gives a chance of establishing a more accurate dating for these tripods. In the Late Geometric deposits in front of the Geomet-

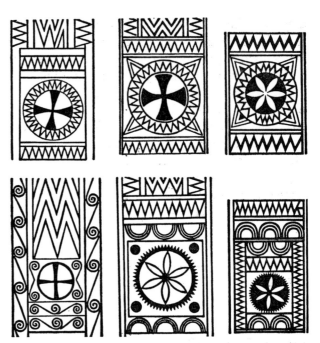

103 Ornaments on the legs of tripod-cauldrons from Olympia, Delphi and the Argive Heraion

ric Temple of Hera Akraia in Perachora, a clay imitation of our type of tripod-cauldron has been found. The ornamental filling of the leg with horizontal zigzag lines and a wheel with four spokes in the upper rectangular picture area prove that it belongs to the classical Geometric group of tripod-cauldrons.[110] The unframed wheel on the clay imitation can be considered an abbreviation. But it is worth noting that a whole frieze of similar unframed wheel shapes next to each other, without any dividers, occurs on a large krater fragment from the Kerameikos in Athens, the wheels as independent as the one on the clay tripod from Perachora.[111] This, like the sherd, would have been made and painted in the third quarter of the century, and gives us a fixed point for dating the later products of the workshop.

Wheel and rosette motifs in Geometric decoration

The boxing-in of the rosette on the relatively early leg Br 5103 from Olympia (Fig. 103, left) and the lighter, more open framing of the wheels on the

later legs in Delphi and the Argive Heraion (Fig. 103, centre and right) are connected with the rich composition of the handle zones of belly-handled amphorae and kraters of the first half of the century, predominantly in the second quarter.[112] Most important is a krater in New York (Pl. 34),[113] which must be from before the middle of the century since it has cogwheel rims around its concentric circles and carelessly drawn stars, like the rosettes on one of the Delphic legs, in the corners. The middle circle contains a Maltese cross, as does an amphora in Athens.[114] A Maltese cross surrounded by a zigzag frieze, as on the tripod legs, also occurs on an Attic bowl of Oriental type painted inside and out from Thera (Fig. 16),[115] on the underside. On the inside, the bottom is decorated with wheel spokes with an encircling zigzag band. This cup belongs in the early third quarter of the century. Of course bronze tripods cannot be directly connected to vase chronology. But we can assume that the bronze workshops were somewhat behind the potteries. Wheels with spokes in rectangular picture areas already occur around the middle of the century and in the late second quarter on Attic neck-handled amphorae and on grave kraters.[116]

Leaf rosettes and leaf friezes begin to occur in Attica in the first half of the eighth century.[117] But cogwheel rims such as are found enclosing rosettes on tripod legs are almost completely absent. On the other hand, the zigzag wreaths which decorated the rims of wheels with Maltese-cross spokes are also used with rosettes. More important is the fact that Attic vases, with a few late exceptions, have only four- or eight-leaf rosettes (Fig. 104, Pl. 40), whereas on tripods, at least those found to date, only rosettes with six leaves occur.[118] The number of six-leaf rosettes will certainly increase, particularly since painted undersides of pyxides have rarely been shown in publications to date. Still, a tremendous predominance of four- and eight-leaf rosettes in Attic art has been established. The decoration on the underside of a pyxis from the Kerameikos (Fig. 104) is an unusual Attic exception, completely outside the scope of normal vase painting.[119] The pyxis, which was an isolated find, was dated by Kübler at the end of the first or in the second quarter of the century. Unusual features are the areas between the leaves, carefully

dotted in, and the tangential circles around the rosette, counter-running and made up of elongated S's joined together. These do not belong to the vocabulary of pottery motifs, but they are found in similar form on heavily cast tripods[120] and as a border decoration on a hammered tripod-cauldron, although somewhat degenerated. The central motif recurs in exactly the same form on gold sheets in the third Shaft Grave at Mycenae (Fig. 11). It also occurs on a sixth-century cup with 'merry-thought' handles with a picture of a battle, now in Berlin, as a shield

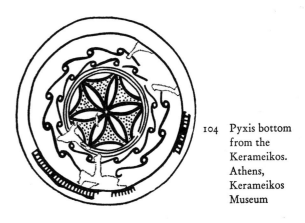

104 Pyxis bottom from the Kerameikos. Athens, Kerameikos Museum

device. The remains of a shield from the Stadium in Olympia also appear to have had the same motif on them.[121] The central rosette and the frieze of matched double tangential circles are enclosed in the pyxis from the Kerameikos (Fig. 104), not by groups of painted lines but by raised ribs. The clarity and accuracy of the drawing is unusual for such a small vessel. There can be no doubt that motifs on the underside of this pyxis are copied from a metalwork workshop using a style which must have been at least similar to our tripod-cauldrons.[122]

A tripod leg with a relief scene

On a fragment from the top of a tripod leg in this group (Pl. 215),[123] at the attachment of the cauldron support to the straight leg, there is a rectangular area with a relief picture, half of which recurs at the same level on the side. A horse, facing to the right, is stand-

105 Bronze disc from Tegea.
Diameter 7.1 cm. Piali-Tegea, Museum

ing in front of a tall manger which just reaches up to
its mouth. On its back is a man with raised arms. This
figure has to be small to fit the small amount of space
left. Arms bent upwards like this signified, from the
late Minoan and Mycenaean periods on, the super-
natural power of some deity. Here we have a Master
of the Horses, perhaps Poseidon. Standing on ani-
mals was a characteristic feature of Oriental gods
(Pl. 181). On a bronze disc of the Geometric period,
from Tegea (Fig. 105), only half preserved, a naked
goddess with arms raised is standing on the back of
some animal, probably a bull or horse.[124] The style
of this bronze relief looks old-fashioned and it has
been dated in the ninth century. But in Attic pottery
no example of this kind of horse picture occurs, al-
though one might regard the horse in a metope on a
krater from Grave 22 in the Kerameikos necropolis—
dated by Kübler, probably too early, in the last quar-
ter of the ninth century—as an early antecedent of
the bronze relief from Tegea.[125] This type of horse,
with bent front legs, occurs in Argive pottery, almost
exclusively on small kraters,[126] from the middle of
the century up to the last quarter. The bronze relief
from Tegea is older than this but can probably not be
put back much before the second quarter of the cen-
tury. This may be another argument in support of
Willemsen's suggestion that the bronze workshop
was located in the Argolid. But the strong head of
the Mistress of the Horses, with hair, nose and eyes
clearly visible, suggests that the relief should be
dated rather later. The only thing that is certain is
that the figure type from Attic High Geometric
vases has had no influence in the bronze relief. We can

probably take a cup from the Kerameikos (Pl. 26) as
approximately contemporary with the relief. On it
are men carrying swords on either side of the horse.
These also have clearly indicated foreheads and
noses. But their forearms are pointing straight down,
not up. Kübler probably dates the cup, an isolated
find, rather too early in the first quarter of the cen-
tury.[127]

Clues for chronology

We have a number of fixed points for the chronology
of the third group of tripod-cauldrons in the classic
Geometric style given by the rectangular 'metope
fields' at the top of the leg and above the place where
the foot starts, containing circle and wheel patterns.
The former, with Maltese crosses and cog-wreaths,
begin around the middle of the second quarter of the
century and last for about thirty years, up to the third
quarter. The cog-wreath turns gradually into tri-
angle, and eventually, zigzag rims. Somewhat later,
about 760 B.C., it is joined by wheels with realistic
spokes and rims. This motif becomes increasingly
slurred during the third quarter up to the terracotta
tripod from Perachora. This development is par-
allel with contemporary Attic vase painting. The
splendid chariot processions on Attic amphorae and
kraters appear to have influenced bronze workshops.
Or was it the chariot races in the great games which
inspired the bronze casters? Six-leaf rosettes appear
to begin somewhat earlier than circle and wheel
motifs, perhaps as early as the end of the first quar-
ter. They too gradually change from the cog-wreath
to the surrounding zigzag band. Finally, the relief
picture of the Master of the Horses (Pl. 215) gives
us the earliest possible date for the group, between
the turn of the first to the second quarter and at the
latest the 760s.

Monumentalization of tripod-cauldrons

An important supporting argument for the chrono-
logy developed here is based on the size of classic
Geometric tripods, which increases enormously: so-

called 'monumentalization'. This must be connected with the monumentalization of Attic grave vases from the beginning of the century onwards, particularly in the second quarter of the eighth century (Pls. 30, 35).[128] Although the tripod legs from Olympia are largely fragmentary, in ten examples height can be measured or guessed. Seven of them, like the vases, are between 60 and 70 cm. high.[129] The only two complete legs of the classic Geometric examples reach heights of 96 and 100 cm. To this we can probably add the height of the ring handles with a diameter of 24.6–26–28 cm., giving an overall height for the tripod-cauldrons of 120 to 128 cm.[130] There is also a recently discovered leg from Olympia, of a superb tripod-cauldron (Pl. 216) of the same group, of which unfortunately the bottom part is missing. The delicately ribbed upper joint has proportions of 1:4 (breadth: length) compared with the usual 1:3. This means that this leg would also have been more than one metre high overall.[131] On the upper part is a six-leaf rosette surrounded by a cog-wreath. The leg therefore belongs to the time of the large Attic belly-handled amphorae and the beginning of the massive grave kraters which we have dated in the 760s.[132] This was the age of a growing tendency to the monumental, and of the High Geometric style on the Greek mainland, in the second quarter of the century. The classical Geometric tripods were obviously part of the same trends.

The classic Geometric tripod-cauldrons from Ithaca

Ithaca is another place in Greece where, thanks to the painstaking studies made by S. Benton, a similar trend towards monumentality can be traced. Another workshop was obviously active here. Only two fragments from the classic Geometric group, two hammered fragments from a leg and a handle, and a fragment from the later group with fanned grooves have been found.[133] The dominant type is the tripods with chains of simple and counter-running spirals. Two tripods are 83 cm. high up to the rim of the cauldron. One of them, allowing for the ring handle it would have had, is 107 cm. high.[134] They are of the thin-walled variety. Ornamentation consists of developed spiral chains. The ring handle, with the double open-work zigzag friezes and a horse, indicates a date around the turn from the first to the second quarter of the century.[135] Two more tripods from Ithaca can be dated somewhat later. The first[136] has four-sided heavy legs, large enough to have bearings for the bronze wheels at the bottoms. The ring handle is decorated with parallel ribs. The height, to the rim of the cauldron, is 96 cm.; with the handle and the horse, 124 cm. The second[137] has a developed spiral-chain ornament and ring handles with double open-work zigzag friezes, the external one narrower than the inside one. The horse is like the first one. The height is 98 or 134 cm. Such tripods from Ithaca as can be reconstructed are then from the early phases of monumentalization. Even though fragments of hammered, fan-grooved and classic Geometric tripods exist, no examples from later phases have been found on Ithaca.

The third group of classic Geometric tripods, with their ribbed, capital-like attachments to the cauldrons, run without interruption into the fourth group of tripods with fanned grooves at the end of the Geometric epoch.[138] But the earlier second group of decorated tripod-cauldrons with single or double spiral chains overlaps the beginnings of classic Geometric tripods to a considerable extent.

Spiral chains sometimes occur on side walls, but the fronts of legs have classic Geometric decoration, as on Delos and in Olympia and Delphi.[139] They also sometimes, although infrequently, have zigzag lines or an S-chain on the edge of the legs.[140] On a five-tracked leg, probably of later date, the horizontal zigzag is split in the middle, with a spiral chain inserted, baroque style, into the gap.[141] So spiral ornamentation does not disappear at the beginning of this phase, but continues alongside classic Geometric. A splendid leg in Olympia,[142] which certainly belongs to the classic group, has a main pattern enclosed by zigzag strips which derives from the zenith of spiral ornamentation. On the side wall is a spiral chain with a zigzag edge, on the front are two opposed spiral chains around a central stem —the motif which we have interpreted as several flowers growing out of a single stem[143]—enclosed here by zigzag bands. This tripod-cauldron belongs

in the second quarter of the century. The revival of spiral ornamentation would be contemporary with the appearance of tangential-circle friezes in pottery on the Greek mainland.[144]

f Heavily cast tripod-cauldrons with spiral ornamentation (II)

The first of the three types defined by Furtwängler in his publication of the Olympia excavations, heavily cast tripods, has always been accepted as the earliest phase of tripod-cauldrons. In this group the technique remains the same, but hollow three-walled legs develop.[145] The second family then introduces a new technique suitable for thin-walled tripod legs. The fully cast process also made the development of vertical ribbing possible.[146] This lasted through the classic Geometric phase, eventually giving way at the end of the Geometric epoch to fan-grooved relief. Spiral ornamentation begins in the massive tripod family, following 'knotted' ribs; it then becomes a secondary feature at the beginning of the third group, the Geometric classical tripods, but later re-emerges with emphasis equivalent to other elements. By the middle of the century it forms the basis of the important tangential-circle ornament on hammered tripods.

With groups classified by technical criteria only, the first two groups—heavily cast and then thin-walled—overlap only slightly, while the third hammered type joins the second after about a quarter of a century. Analysis of decoration, however, reveals rich stylistic variety within individual groups, and allows us to trace the different, competing workshops.

In the spiral ornamentation of the heavily cast tripod-cauldrons there are clear traces of contact with the group of Cretan rod-tripods and its examples on the mainland. This relationship with the later Greek rod-tripods produces chronological clues for the second group of spiral ornamentation which spans from the beginning of the eighth century to the ninth.

We have allowed a wide margin of dates for the rod-tripod from Fortetsa (10) which, in view of its small size, was probably only a decorative item or a toy. We were only able to put it around the turn of the ninth to the eighth century.[147] An early cauldron leg from the group we are dealing with, from Olympia (Pl. 217)[148] has, like the rod-tripod from Fortetsa, a spiral chain on the front, between two border ridges which turn into a cord pattern at the level of the cauldron. Since the chain is unidirectional, a way had to be found of connecting it to the flaring zone where the cauldron was attached. This was done simply by putting two cord-like tangents on the uppermost spiral. These run into the border ridges to make double cords. The man who made the miniature from Fortetsa did not solve the problem so simply. He put an extra spiral above the top spiral in the chain, from where a tangent runs out to the left spiral volute of the capital.[149] The master of the leg fragment from Olympia (Pl. 217) found a more ingenious solution to the problem. The carrying-ring of the tripod from Fortetsa is filled by two opposed spiral chains around a central stem, making a circular wreath of flowers. Circles like this occur on tripod-cauldrons only on the handles. A ring handle in our group, in Delphi (Pl. 220),[150] with a similar 'flower wreath' is an exact counterpart to the Cretan miniature tripod, but in view of the uncertainty over the date of the miniature from Fortetsa, dating the related items in Olympia and Delphi is difficult. But since we can work from the basic Cretan rod-tripod, it is reasonable to set a date in the first quarter of the eighth century.

The connection between spiral ornamentation on the heavy tripod-cauldrons and Cretan rod-tripods goes further. On the latter, the 'Ionic' volute capital on the joint between legs and carrying-rings is important. On tripod-cauldrons it does not appear. But drawing handles connecting the rim of the cauldron with ring handles are a different matter. On a late ring handle on a tripod-cauldron of the heavy type, from Olympia,[151] the drawing handle is simply decorated with double ribs on the edges in the middle. From the front view, the middle ribs spread out on both sides to become volutes as on the 'Ionic' capitals on Cretan rod-tripods. From above,

double ribs end in similar capitals on the outside rim of the cauldron. Surely tectonic elements from Cretan tripods are being used here in a playful way.

A further connection between the carrying-rings on rod-tripods and ring handles on the second group of tripod-cauldrons is given by their spiral ornamentation. The carrying-ring of the small rod-tripod from Kourion (3)[152] is decorated with a frieze of double spirals alongside each other, each framed by two ridges. The same motif occurs on the carrying-ring of a rod-tripod from the Pnyx in Athens (11),[153] except that it is set between two cords, and the spiral frieze is in open-work. We have tentatively dated the tripod base from Kourion in the first half of the ninth century and the rod-tripod from the Pnyx in Athens in the first quarter of the eighth century. On tripod-cauldrons the double spiral frieze recurs twice on particularly splendid ring handles: once on handle Br 218 from Olympia, where the upper edge is a cord ridge as on the rod-tripod from Athens, although the frieze is fully cast. The other instance is on a ring handle in Delphi, where a double open-work encircling wreath runs between three thick ridges with two snakes holding up the ring handle.[154] The handle from Delphi can probably be dated in the first quarter of the eighth century, as can the rod-tripod from the Pnyx in Athens. The handle from Olympia is older. Its exact date will be established later.

Towards the end of this series of heavy tripod-cauldrons, ribbed legs and ring handles begin to occur (Pl. 219).[155] Parallels to these ring handles occur in the carrying-rings on late rod-tripods such as those from Beth-Shan (7) and Enkomi (5).[156] But these are older than our tripod-cauldrons and it is no longer possible to establish when or how contact might have been established between these distant Cypro-Oriental rod-tripods and our tripod-cauldrons. The ribbing on legs and handles (Pl. 219) becomes more sophisticated in succeeding groups of tripod-cauldrons up to the last quarter of the eighth century, so that copying from Cypriot rod-tripods may not have occurred until the Late Geometric period.[157]

The spiral decoration on fully cast tripod-cauldrons was not long confined to one workshop. It was imported from southern East Greek areas and quickly adopted by mainland workshops, such as the

ones which produced the thin-walled classic Geometric groups and the ones which made hammered tripods. The ornament begins as genuine spirals in the area where the leg is riveted to the cauldron. At first it is crude, but then becomes refined (Pl. 221). It spreads to the smooth-ribbed handles where it appears in the form of 'flowers' on a central stem (Pl. 218).[158] It finally reaches its zenith in the form of twin-tracked spiral chains on the front of legs, and single tracks on the sides.[159] True spirals gradually decline, leaving only an outline filled with concentric circles. Our second group of heavy tripods overlaps considerably with the third group of classic Geometric tripods. One of the largest and most developed tripod-cauldrons, in Ithaca, with double spiral chains on the front of the legs and a simple spiral chain on the side walls,[160] was made in the new thin-wall technique. The open-work ring handle belongs to the second quarter of the eighth century.

A corresponding tripod from the third group in Olympia[161] integrates developed spiral decoration not only with the new technique but also the new style of decoration. Mutual borrowings prove that the two groups develop alongside each other for some time. Thus, on a fully cast leg from the second group, there are two strips of triple opposed semicircles, which are used in the third group only as border ornaments. On the other hand, spiral chains in the second group are used as border strips and, less often, as central strips in thin-walled vessels from the third group.[162]

In view of this overlapping of the two workshops, the second and the last group of heavily cast tripod-cauldrons can hardly go much beyond the year 800 B.C.

g Functional tripod-cauldrons with appropriate decoration (I)

The majority of the heavily cast tripod-cauldrons fall into a first group which is connected with the tripod from Mycenae mentioned above, now in the National Museum, Athens,[163] and is ultimately de-

rived from Mycenaean prototypes.[164] The tripod from Mycenae is now known to have been produced in the Protogeometric, perhaps even in the Early Protogeometric, period. The technique of the tripod-cauldrons in this group—heavily cast with an oval plate on the upper part of the leg riveted to the wall of the cauldron—is the same as in the Protogeometric vessel from Mycenae. But there is a gap between this archetype and the early tripods from Olympia. When, then, do the earliest tripods found in Olympia begin?

There are almost two centuries between the Early Protogeometric tripod from Mycenae and the first items in the second group of tripod-cauldrons with spiral decoration. Even if the tripod legs from the Tiryns treasure[165] with their six-sided legs tapering to a point at the foot, curved so slightly inwards that they are almost vertical, belonged to the Ripe or even the Late phase of Protogeometric, even if the sparse decoration of the Protogeometric continued for almost a century, and even if the few vessel types develop less in external decoration than in internal plastic form, it is still almost a century to the end of this first group of tripod-cauldrons. The tempo of progress of sculptured vessels during the Early and Severe Geometric periods may have been considerably slower than in the eighth century, but the problem as to the date of the beginning of the early Olympic tripods still remains.

Willemsen assumes a small gap between the Ripe Geometric tripods and the tripods from Olympia which he, if I understand him correctly, dates at the beginning of the Early Geometric phase.[166] The leading tripod-cauldron from Mycenae has a ring handle with cable decoration, whereas none of the legs of Protogeometric tripods have this. One is tempted to assume that on older, simpler, functional vessels, the lifting apparatus was actually cable, and that this motif was subsequently transferred to ribs and edges of the legs. But there are no intermediate stages in the finds from Olympia. So three quarters of a century is left for the first group of heavily cast tripods from Olympia. Willemsen analysed this period extremely—almost too—precisely, identifying a whole series of phases.[167] There are virtually no external chronological fixed points, find complexes or historical dates, for relative or absolute chronology in the ninth century.

The first group of tripod-cauldrons is markedly, almost radically, different from the four groups which we have been dealing with so far, all from the eighth century. It has no ornamentation of its own: no spiral system, classic Geometric syntax, tangential circles, zigzag bands, ridges with fanned grooves, or relief scenes. Such decoration as does occur in the first group is purely 'functional': ring handles based on the cable lifting handle, legs spreading on top where they have to fit the curve of the cauldron, splitting into separate ridges in the form of cords matching the cable handles. It is a simple system of decoration which one can well believe lasted a long time. But the ring handles are extraordinarily rich. Let us adopt Willemsen's terminology of cable handles, notch handles and wreath handles. Ladder handles and isolated open-work handles lead up to thin-walled vessels and thus into the eighth century. But in the first group of tripod-cauldrons, from Late Protogeometric, through Early Geometric to Severe Geometric, the main accent is on the vessel itself, with the sparse decoration of individual parts strictly subordinated to the overall structure. One might cite as a parallel the shapes of vessels from the Early Geometric period, not so much the Attic as the non-Attic. At all events the history of the tripod-cauldron from the Protogeometric period up to about 800 B.C. is a continuum at the beginning of which the functional vessel achieved a more developed form. One can, perhaps, envisage some kind of progression from the purely functional utensil, through cult vessels to the victory prizes and votive offerings. But one should not try to impose this pattern too forcefully on to individual finds, in view of the extraordinary variety of early Greek cult sites.

Can we now put a rough date on the beginning of the tripod-cauldrons from Olympia? Let us look back first at the tripod stands with separate cauldrons: the rod-tripods.[168] This group lasts from the end of the Mycenaean period up to the beginning of the eighth century, and was found almost excusively in graves. This means that they must have had a special significance in the burial of the dead and in grave cults. In Grave 4 in the Protogeometric necro-

polis south of the Eridanos in the Kerameikos, two terracotta imitations of early tripod-cauldrons have been found (Pl. 209).[169] These take up, if only symbolically, the old burial rites, but in the new form of the tripod-cauldron. It is significant that this innovation was not continued in any of the large number of Protogeometric graves in Attica and in the entire Aegean area. From the Early Geometric period onwards, we find terracotta imitations of rod-tripods in Geometric graves until the eighth century.[170] It is not until the so-called Isis grave at Eleusis, dated late in the first half of century, that primitive terracotta miniature tripods of the cauldron type are found, obviously symbolizing the grave rite.[171] A terracotta copy of a tripod-cauldron from the late third group, a votive offering, was found in a deposit next to the Geometric Temple of Hera Akraia in Perachora.[172] It dates from the third quarter of the century.

The Protogeometric rod-tripods from Mycenae now in Athens, and from the treasure of Tiryns, in Berlin, never belonged to a grave find.[173] Only on the piece from Mycenae is a simple cable handle 7 cm. high still preserved. The legs are stumpy and six-sided; in the Berlin piece, eight-sided. The legs of the one from Tiryns taper towards the foot. On one, there is actually a foot while the other two run into a point. The tripod from Mycenae and the one in Berlin are very similar. Both are 29 cm. high, to the rim of the cauldron. The legs from Tiryns are somewhat longer. With their attachments they are 37.5 to 38.5 cm. and 42 cm. respectively. Here we have straightforward functional form without ornamental decoration, except for the simple cable handles. The six-or eight-sided legs are slightly splayed out from the cauldron, so that the fire did not reach them. The lowness of the tripod is also a functional feature. These are simple, functional, everyday objects.

It is difficult to trace the transition from functional vessel to votive offering. It would not have been sudden. Normal tripod-cauldrons would have been dedicated at first. We can assume that the abandonment of the multi-sided, undecorated leg of the Protogeometric period and the transferral of the simple cable pattern from the ring handle to the front side of the legs were steps in the development. By process of minute analysis of every early tripod fragment

from Olympia, Willemsen worked out an order of development through the ninth century, and tried to bridge the gap between the Protogeometric type and the Early to Severe Geometric forms.[174] He cited particularly leg Br 12285 which is multi-sided but has no cable decoration and only a minimal extension at the top, and Br 13408, with five laddered tracks on the front, the second and fourth decorated with beautiful relief zigzag bands.[175] But Willemsen's scheme is contradicted, on the first leg, by the cauldron attachment which is curved and indicates a rim markedly inverted at the top; also by the cauldron struts which always run in the early period from outside inwards, whereas, later, they run from inside outwards, with the hooks on the legs beneath the cauldron attachments for the ladle. The struts belong to a considerably later phase. The legs cannot therefore be relevant to a study of the 'beginnings' of tripod-cauldrons from Olympia.[176] The same applies to the other leg fragment, which belongs to the preliminary stages of our third, Ripe Geometric, group.

There is, therefore, a fairly large gap between the functional tripod-cauldrons of the Protogeometric period and their terracotta imitations, as yet found only outside Olympia, and the earliest finds from Olympia itself. Let us now turn to the finds from Ithaca. From the fragments it appears that the oldest tripod-cauldrons were probably three in number.[177] They have the same measurements as the Protogeometric functional vessels. Their height, to the cauldron rim, is about 20 cm. or, with the ring handle, 26 cm. Two similarly shaped tripods obviously made a pair. The third was 22 cm. high, or 28 cm. with the handle. The same functional form occurs, the vessels being even lower than before. The legs have a stereotyped decoration of three parallel cords running along the narrow front band and splitting into pairs on the angled, wider upper edge, with the middle cord divided into two. This decoration should not be regarded as an ornamental system but as something derived from the cable handle. It could have developed equally well on functional vessels as on votive offerings. This decoration dominates most of the early tripod-cauldrons in Olympia (Pl. 208), although the

earliest type of functional vessel, from Ithaca, is not represented there.[178] The next tripods from Ithaca[179] are more than two and three times as tall—75 cm. (with ring handle 100 cm.), 83 cm. (with ring handle 111 cm.), and 83 cm. These were certainly specifically made as votive offerings. But there are no tripods between 50 and 60 or between 60 and 70 cm. high on Ithaca,[180] as are so common in Olympia.[180] Perhaps tripods Nos. 4 and 5 from Ithaca, which cannot be reconstructed, were of these heights. No. 6 has an eight-sided leg, with three concave sides on the front and three on the back. The cauldron supports are of the older type. The ladder handle with horse is decorated with an irregular zigzag in relief between two pairs of circular ridges.[181] Tripod No. 7[182] is later, with supports from the first phase of the later type. The surviving fragment of the leg of this tripod has a fairly crude early version of the spiral ornament, as on leg fragment B 1241 in Olympia.[183] The ring handle has two open-work zigzag strips between double cord ridges, a horse and probably a horse-holder. No. 8[184] survives only in two fragments, the upper part and one other piece from the leg. The cauldron supports are the developed version of the later type. Both sides of the cruciform leg are decorated with spiral chains. This is the first chronological clue, indicating the early period of spiral ornamentation, around 800 B.C. This is also the date, or a little earlier, for the tripod-cauldron with wheels, No. 3,[185] 96 cm. high, 121 cm. with ring handle. The spiral decoration on the upper part of the leg indicates the early phase of the second group and has parallels, with similar protuberances, in the upper parts of legs B 1241 and B 746 from Olympia (Pl. 221).[186] This tripod is followed by the fully spiral-decorated tripod from the first quarter of the eighth century, No. 9, which is 98 cm. high, 125 cm. with the handle.[187] On each side wall of the leg is a spiral chain. On the front are two counter-running spiral chains between which is an empty track. The cauldron supports are of the late type. The parallel ribs divide on the angled, extended upper zone. The ring handle has two ridges with open-work zigzags; the top one is narrower than the lower one. There is also a horse on it. This tripod No. 9 is close to the zenith of spiral ornamentation, the second group.

To confirm these conclusions, let us look again at the Cretan rod-tripods,[188] where there was obviously cross-fertilization with the mainland. A significant tripod is the one from Grave 1 in the necropolis at Vrokastro (Fig. 100),[189] 37.7 cm. high. The cast legs between the separately worked foot and the ' capital' form a flat rail, with only one ornament on the front. Two edge ridges and a centre ridge, forked under the 'capital', joining the edge ridges in the two spiral volutes, form a simple but assured decoration. This is the only rod-tripod with this form of decoration.[190] Since the Cretan rod-tripods, as shown above,[191] influenced the early phase of mainland tripod-cauldrons with spiral decoration—our second group—there can be no doubt that the latter, including its early phases, also had some influence on Cretan workshops.[192] In particular, the legs to two contemporary tripod-cauldrons from Delphi[193] are very similar to the rod-tripod from Vrokastro (Fig. 100). The first, preserved to a height of 77 cm., has three parallel upward-running rounded ridges on the front side of the legs. At the beginning of the upper zone, the centre ridge forks, so that two tapering bands framed by rounded ridges run out to each side. After the early cord ornamentation of our first group, a mainland workshop has produced an original innovation, the nearest thing we have to a prototype of Cretan tripod stands. The cauldron supports of the leg are of the more recent type, indicating a date around the turn of the century. On the somewhat later fragment of the upper part of a leg from a second tripod,[194] one can still make out the two tapering bands framed by rounded ridges running out at the top. Beneath this one can still just see the beginnings of spiral chains. The rounded ridges are four, not three, in number, with spiral decoration only in the two outside tracks. The beginnings of spiral ornamentation can be quite clearly seen on this fragment.

We have dated the rod-tripod from Vrokastro (Fig. 100) at the end of the ninth or beginning of the eighth century.[195] Since a not unimportant feature, namely, the transition from functionally appropriate decoration to spiral ornamentation and to the flat rail leg, now filled with ornaments, has turned out to be an imitation from the beginning of the spiral ornament group—or, to put it another way, since

the tradition to the thin-walled tripod-cauldrons has taken place—the Vrokastro rod-tripod can be dated with certainty at the beginning of the first quarter of the century.

h Summary

The period around 800 B.C. may be considered as the most important turning point in the history of Geometric tripod-cauldrons. This is the time of the transition from functional decoration based on cord patterns to ornamental decoration based on the spiral system, the rapidly developing ornamentation of the classic Geometric group and relief pictures. Before this date, the form of the tripod-cauldrons is stereotyped, with splayed legs running in and up towards the cauldron. As the height of the vessels increases, the co-ordinates of vertical legs and horizontal cauldron make a fixed and imposing structure. Immediately afterwards, and by no coincidence, the thin-walled vessel developed in contrast to the heavy and often crude fully cast legs. This type of vessel consists of several individually cast parts. The tripods grow to munumental sizes. So far, decoration has been functional or technical, consisting of cords, strictly tectonic and part of the plastic form of the vessel. Soon afterwards, we come across the ripe ornamental systems of the period: the spiral ornamentation, probably from the east; Attic High Geometric ornamentation, which also reached non-Attic bronze workshops; and mixed ornamentation on hammered tripod-cauldrons. Ornament becomes decorative, and a rich counterpoint of vessel and decoration develops. A more developed structural phase has arrived, and with it tripods acquire monumental dignity.

No exact date for the beginning of the tripods in Olympia or Ithaca can, however, really be established.[196] It is interesting that a relatively large number of fragments of our first group has been found in Olympia.[197] The similarity of these tripod parts should, however, not tempt us to assume that they were too closely contemporary with each other. Early periods tend to have a slower rate of development, although in this case probably not more than half a century at the outside.

i Chronology

Furtwängler's classification of tripod-cauldrons into three types, using technical criteria, is still valid today, with a few modifications. Heavily cast tripods predominate up to around 800 B.C., followed during the first quarter of the next century by the thin-walled cast vessels. These are joined, at the beginning of the second quarter of the century, by the thin-walled hammered vessels. The last two types run together up to the end of the Geometric epoch and the hammered tripods continue beyond this. A more accurate relative and absolute chronology can be established by an overall analysis of the technical structure, form and shape, decoration and ornamentation. The following table is based on the preceding account.

1 Functional objects and votive offerings with functionally appropriate decoration = Group I[198]: at the earliest, 850-800 B.C. Perhaps the beginning should be brought down to 830 B.C.

2 Spiral ornamentation = Group II[199]: first quarter of the eighth century.

3 Classic Geometric ornamentation = Group III[200]: beginning of the second to the third quarter of the eighth century.

4 Ridges with fanned grooves = Group IV[201]: end of the third into the fourth quarter of the eighth century.

5 Tangential-circle and Geometric ornamentation = Group V[202]: beginning in the second quarter of the eighth century, lasting up to the end of the Geometric period and beyond.

The dates given here should be regarded as schematic since the transition from one group to the other is continuous and individual groups overlap.

1 Grouping and dates

The vast majority of gold sheets of the Geometric period found in Greece come from Attic graves.[1] In the second quarter of the eighth century Athens was approaching its zenith. Its navy was powerful and confident of victory over all enemies. Trade was expanding. The town and its leading families had become more and more prosperous. Expensive gold began to appear, and the self-confident aristocracy induced foreign goldsmiths to settle in the city.

Ohly has classified the twenty-nine gold reliefs so far found into four groups. We prefer to classify them into only two groups. Both are stylistically distinct and were produced by workshops which, although they probably overlapped in time to some extent, can nevertheless be clearly divided into earlier and later. Our first group includes Ohly's groups I and II and the gold bands A 15 to A 17 from group III. Our second group includes gold bands A 18 and A 19 from Ohly's group III, A 20a and A 20 to A 28 from group IV. The arguments for the simpler grouping are explained below.

a Dating of gold sheets of the first group

First of all we must establish the dating of the groups. Most of the gold reliefs which are extant were found with other grave offerings. But since the first discovery of Geometric gold reliefs by Furtwängler eighty years ago,[2] the ceramic grave offerings have found their way to various museums and can in many cases

no longer be traced. Ohly assembled what he could and illustrated some vases very well, but did not manage to reassemble complete grave finds. But this can now be done in the case of Grave 50 in the Geometric necropolis of the Kerameikos, where gold band A 6 was found in a wooden coffin, next to the body. The four fragments form an animal frieze, predominantly grazing ibexes with lions stalking them.[3] The grave finds[4] form a set. First, there is a neck-handled amphoriskos from, approximately, the middle of the second quarter of the eighth century; then, a two-handled small bowl with two quatrefoil metopes, as on the neck of the amphoriskos; a small bowl with ribbed walls; and a delightful little basket from around the middle of the century. The remaining offerings are from the beginning of the third quarter of the century: a jug with a round mouth, a kantharos, a tall cup with quatrefoil metope, a two-handled small bowl with careless drawing, and two splendidly decorated cocks modelled in the round. The vases together make a complete set of household utensils, collected over perhaps two decades. The gold band may have been produced during this period and have formed the decoration of a small wooden box, being put into the grave with the other household items. But it could just as well have been an old heirloom of the dead man's or his family, and be older than the rest of the items.

Another gold band (Pl. 222), with a frieze of alternate stags and lionesses (?), was found in Grave 72 in the Kerameikos necropolis.[5] The span of this grave is shorter than Grave 50.[6] Apart from a beautiful, carefully painted High Geometric neck-handled amphora, with handles decorated with painted snakes slithering upwards, the grave offerings consist of four high-rimmed bowls, on one of which the gold

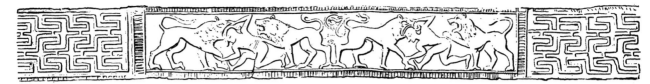

106 Gold band from the Kerameikos. Length about 39.7 cm. Copenhagen, National Museum

band was lying, folded up. The vases all come from one workshop, and spread across, at the most, a decade. They probably belong in the 750s. The gold relief would have been put in the grave around this time.

Gold band A 1[7] can hardly have been buried much later. From the earliest grave finds from the Kerameikos, only one large jug with a wide neck and round mouth can still be traced,[8] stylistically connected with the phase containing the set of offerings from Grave 72. The burial must have taken place around the middle of the century.

In another grave in the Kerameikos necropolis, the contents of which are now in Copenhagen, two gold bands were found. The first splendid relief, A 11 (Pl. 223),[9] belongs to our first group. In the middle part (Fig. 106) of this well-preserved band are two warriors, each fighting two lions. The vases found with it[10] are the well-known kantharos with the warrior being torn apart by two opposed lions and scenes from funeral games (Pl. 69); and a spouted krater with rows of hoplites on one side, stallions in a stable on the other side, and a recumbent ibex underneath the spout. The vases date from after the middle of the century.

These are the external dating criteria for our first group. Figure decoration is limited to animal friezes, including the antithetical lion-fight scenes. Ibexes, stags, lions and lionesses all appear, introducing, in the middle of the High Geometric period, East Greek,

ultimately Oriental, motifs which even Attic Geometric workshops seem to have been reluctant to adopt. Perhaps the lion group on the kantharos in Copenhagen (Pl. 69), well into the Late Geometric period, was directly inspired by the gold reliefs of the first group. This group would have been buried over approximately a quarter of a century at most, which implies the appearance of goldsmiths in Athens considerably earlier, perhaps in the first quarter of the century.

b Dating of gold sheets of the second group

Let us now turn to the clues which the few undisturbed grave contents give for our second group of gold reliefs. This group introduces a new world of people, figured scenes and movement. Here is the full Attic spirit: High Geometric Attic daringly extending to the world of the human being, pushing forward the boundaries of Geometric, taking the first steps towards pictures of death, funeral ceremonies, celebrations of famous men, mythology and poetry. The second gold band in Copenhagen, almost completely reconstructed from four fragments (Fig. 107)[11] from the grave mentioned above in the Kerameikos necropolis (A 20), belongs to this group. It has four pictures separated by 'triglyphs' of artistically combined lozenges, squares and triangles. The first picture is of a lively dance, with men with branches in their

107 Fragments of a gold band from the Kerameikos. Overall length about 32 cm. Copenhagen, National Museum

hands. It extends over the dividing 'triglyphs'. In the middle is a centaur probably inserted here only because it too is carrying a branch, the usual weapon of the centaurs. The second, smaller picture, separated from the dance by a saw-tooth bar, is of a fleeing rider who has let drop his reins to turn round to face a warrior threatening him with a spear. These two scenes are repeated in the third and the fourth pictures. The end of the band is not closed off by a 'triglyph' but has another rider fighting with a spear —separated by a zigzag line—but this time facing forwards. The front part of the horse is cut off for lack of space. Since both the vessels from the grave belong to the third quarter of the century, the gold band would also have been put into the grave after the middle of the century.

Recently, a closely related gold band (A 20a)[12] came into the Stathatos Collection. It is divided into panel-like triglyphs and small picture areas like relief A 20 in Copenhagen (Fig. 107). The two first pictures are new. On the left is a rider with a crested helmet but no weapons. Above the back of the horse is an arrow, pointing downwards. Then come two pairs of wrestlers or boxers fighting each other. Is this, perhaps, a funeral game picture as on the Copenhagen kantharos (Pl. 69)? The second picture is peculiarly short. It shows three youths or women carrying jugs on their heads with their upraised arms. Between them are filling ornaments. This dance also appears on the kantharos and could be another incident from funeral games. The next two pictures also occur on band A 20 (Fig. 107), but are better preserved in this case: dancing men carrying branches, again interrupted by a centaur with a branch, led by a woman (?) moving wildly; and between her and the men is a small idol with bent arms, reaching upwards. Is this meant to be a picture of Leto and Apollo?[13] The picture, as on gold band A 20, is continued beyond the 'triglyphs', with two dancers in the next section. The rest of the band has a fleeing rider fighting a spearmen, and a final frame which repeats the first.

The gold band was found with a neck-handled amphora of Late Geometric style in a grave near Koropi in Attica,[14] inside the vessel. The amphora was made specifically for funerary purposes. Sculptured snakes writhe round the shoulder and mouth

and climb up the handle. It belongs in a large group of Attic grave vases which run from the end of the third quarter of the century to the beginning of the last.

The long gold band in Berlin (A 22)[15] was found in a grave near Menidi in Attica. It was lying in a large jug with a wide neck and round mouth. The band belongs to the family which includes gold reliefs A 20 (Fig. 107) and A 20a. The panel-like 'triglyphs' are similar. The predominant images are fights between riders and one, two or three spearmen. Certain scenes are new: on the left end, a dead man is being carried from the field by a warrior for burial; then there are two riderless horses, one grazing in the foreground, the other coming out of the background towards the one which is grazing, putting its head over the other's back; and finally, three seated mourning women. The last picture on the right repeats the burial scene at the beginning and the horse group. A remarkable feature is the startling contrast between the assured, audacious treatment of the scenes from the edge of a battlefield and the mourning women, and the degeneration of the other picture and the triglyphs. The gold band is certainly more developed and later than its counterpart, but its craftsman has certainly not mastered the use of the matrix-stone.

The jug in which the gold band was found[16] is more supple in form than the tall jug type, with wide neck and round mouth, of the High Geometric period. But there is certainly a connection between this type and the more recent jug from Menidi in Berlin, although it may be via several parallel routes. The proportions of the jug are less monumental and more balanced, like the vase in Karlsruhe.[17] Its squat body is similar to functional ware with the neck lower and wider.[18] The handles have no sculptured snakes climbing up them, but three other jugs also have similar early Late Geometric omissions: a jug from the Kerameikos[19] comparable with the Karlsruhe jug; a jug in Brussels, very different from the High Geometric type;[20] and the jug above from Menidi[21] with the most developed shape in this series. The gold relief, on the other hand, exemplifies the clash between the liberation of the human figure and the confused Geometric patterns. It belongs to the turn to the last quarter of the century, while the jug, an

'old' piece when it was buried, would have been produced at the beginning of the third quarter, but probably not buried until fairly late.

Exact dates for the two groups of gold bands can be given by grave offerings in only a very few cases since the spans of the graves can vary enormously and treasures may have been in possession of the family for a long time before being put into the grave. But we can at least deduce from the finds that the first group, characterized by the animal-frieze style, began at the latest at the beginning of the second quarter of the century, if not somewhat earlier, and lasted into the beginning of the third quarter. The second group begins around the middle of the century. It derives from the figure and action pictures of Attic vase painters, and can be classified as the Attic group. The two groups overlap, shortly after the middle of the century, in the Copenhagen grave find, with the gold bands A 11 (Pl. 223) and A 20 (Fig. 107).

2 The first group of Geometric gold bands

The techniques of gold-relief production have been fully explained by Kunze, Reichel and Ohly.[22] Since the friezes on gold bands, or parts of them, have repeated identical images, matrices must have been used to make these rows of animals. Animals or groups of animals were probably cut into stone blocks in negative. The actual animal figures in the ornaments would then have been hammered in positive into the thin gold plate with a soft hammer. The gold bands of the second group are certainly the work of Attic craftsmen, who would have made both the matrices and the pictures of people in action. The relief friezes of this later group are based on the greatest and most daring achievement of High Geometric Athenian art—cult and epic figured illustration. They are full of the Attic spirit.

Can the first group also be regarded as Attic in this sense? Friezes of grazing animals, mostly does, occur at the same time in this workshop and in Attic vase painting. But there are no lions about to break

into the herds. Animal-fight groups come from the east, ultimately the Orient. On vases, lions do not occur before the Late Geometric period. Gold sheets of the first group apparently come only from Attica. But any deduction *ex silentio* would be rash. Athens and Attica are, after all, the most extensively studied parts of the whole Greek world. Indeed, shortly before the appearance of Ohly's book, a gold band 32 cm. long turned up in the market without any clue to its origin. It shows a stag confronted by two lions and has spiral ornamentation. R. Hampe, who published it, classified it as Attic, in view of its obvious similarities with our first group.[23] But the band is considerably later than the gold sheets from Attica in our group, and must have been produced long after the workshops of the first group in Athens had closed down. It must therefore have been produced outside Athens.

Ohly, working from gold plates found in Eleusis (Pl. 229) and in Athens—the largest is 14 cm. high, 24 cm. broad—which were obviously used to cover small wooden boxes,[24] produced a reconstruction drawing of such a box, completely covered with gold plates (Fig. 108).[25] On the side and front the structural framework is emphasized: on the side, the legs and the cross-pieces are decorated with spiral patterns, and on the front, with vertical and horizontal running meanders. In the middle of the side is space for a frieze of rosettes, with an animal frieze above and below, showing grazing stags, recumbent ibexes, does, lions stalking and attacking, and the death of a warrior overcome by two lions. The matrices of the first group, or parts of them in various combinations, were used for making other kinds of gold strips: for decorating objects, or as jewellery, or for funerary purposes. There was a theory that the matrices were imported to Athens, where they were used, and their products mounted, by local craftsmen.[26] This is not only improbable but almost impossible in view of the now greatly increased amount of gold found in Attic graves. A gold industry appears to have been established in Athens in the first half of the eighth century. In the Minoan-Mycenaean period, goldsmiths were peripatetic craftsmen who collected in centres of power and wealth. With the spread of Attic trade beyond the Cyclades and to East Greece, and

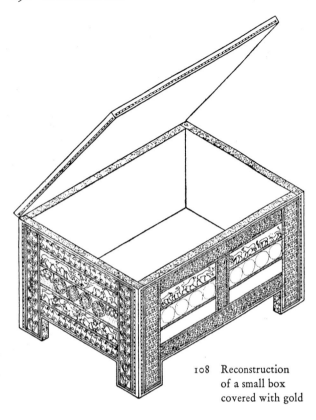

108 Reconstruction of a small box covered with gold

the arrival of the animal frieze and rosette, a gold-smith's workshop would have set up in Athens and worked there for about a quarter of a century. Can one trace the origin of the master of this workshop, if only in broad outline?

a Ornamentation

Let us begin with the ornamentation of the first group of gold reliefs. This consists of spiral patterns and complicated meander patterns. On bronze tripod-cauldrons spiral ornamentation begins in the second group around 800 B.C. and reaches its full flowering in the third group at the beginning of the second quarter of the century, when it connects with the High Geometric style of the mainland.[27]

The origin of spiral ornamentation

It is worth going back even further. The real source of spiral ornamentation is Minoan and Mycenaean art, which lasted several centuries. A clear, linear pattern of symmetrical spirals around a central stem is one of the earliest features of spiral decoration. This occurs on a red polished Early Helladic I (?) sherd from Eutresis in Boeotia, with incised ornament.[28] On a kantharos with white paint on a black ground from eastern Crete and the Middle Minoan I period,[29] the pattern is less strict, and plant-like features begin to develop. The 'flower' is opened a little. Instead of the pistil, there is a spear-shaped leaf or 'heart' of a blossom, pointing to the middle of the spiral. A large pithos from Pseira[30] introduces the zenith of plant decoration in the Late Minoan I A period. Here, one flower grows out of another, the central stem has disappeared, and a rich wreath covers the vessel. There is an important new feature: a curve indicating the bottom of each flower. This also occurs on the gold sheet from Eleusis (Pl. 229). Merging of natural and ornamental motifs means that the wreath pattern can be read from left to right and vice versa. The same ambiguity occurs on the pithos from Pseira. A tall contemporary jug with a wide mouth from Gournia[31] has the same features, including the round base under the spirals. But individual elements are separated and each is suspended on a stalk from the upper rim. The wreath of flowers has become a series of individual ivy leaves. On a funnel-shaped rhyton from the Late Minoan I B period, from Palaikastro,[32] there is a return to purely linear form: six friezes from right to left, with a series of ivy-leaf flowers growing out of each other. The spiral net would have come from the Cyclades to Crete where it first occurs in periods Middle Minoan I—II.[33] From there it spread to Byblos in Syria.[34]

The spiral net is adopted in Mycenaean art by the beginning of the sixteenth century, on one of the gravestones in the later grave circle in the citadel of Mycenae.[35] More important for us is the chain of double, inward-rolled spirals making either a series of flowers on a stem, or a wreath of ivy leaves. On one of the sherds from Phylakopi on the island of Melos there is a right-running double spiral chain,

with small blossoms on the spirals and with semi-circular bases in the interstices,[36] probably from Late Middle Minoan II. A new trend, basically more primitive, begins in the Late Helladic III A 1 period of the time of the shaft graves in the grave circle. Its bases are the abstract spiral ornaments found on the stone grave stelai, weapons, bronze and gold vessels, and pottery. It is the essence of Mycenaean art. Like the spiral net, the double spiral chain with rolled-up spirals develops into a large surface pattern on a gold breast-plate from Grave V in the later grave circle.[37] Two double chains of rolled-up spirals run from right to left alongside each other with a leaf-shaped loop growing out of the apices in the direction of the pattern. The two inner spiral chains also form, together, a right-running, double spiral chain with loops pointing to the right. A sherd from Korakou[38] has a frieze of right-running ivy leaves based on rolled-up spirals connected by a curve. A krater from the Late Helladic III A 2 period, from Enkomi on Cyprus,[39] may have a frieze of ivy leaves on its shoulder, but it is more like a loose garland on a framework of double, rolled-up spiral chains, on the inside of which a semicircle runs from spiral to spiral. Through all these variants and plant-like versions over the centuries, the basic abstract shape of the double spiral chain with rolled-up spirals persists. It still occurs in Late Helladic III A 2 on the shoulder of a jug with a beak-shaped mouth from the necropolis of Schoinochori in the Argolid.[40] It also appears in completely non-linear form, with merely differently coloured areas, in a frieze above the striding woman and on the edges of her bodice as well as underneath a woman driving a chariot, on Tiryns frescoes.[41]

Rosettes

In addition to the spiral net and the double spiral chain on the gold sheet from Eleusis (Pl. 229), there is a frieze of close-set rosettes in a border, surrounded with interlocking S's—a motif which also appears on the rim zones of hammered tripod-cauldrons,[42] but as a secondary pattern, a slightly shortened spiral chain. Note that a frieze of rosettes occurs on the upper edge of the relatively late fresco of women from Tiryns without borders, between double, more painterly, 'spiral chains';[43] also on the gold sheet from Eleusis (Pl. 229), where the rosette frieze is between two spiral-net strips above and below. Rosettes belong primarily to architecture, painting and goldsmiths' work. Multi-leaf rosettes are very common on gold objects from the graves in the later grave circle,[44] but without borders. There is only one round sheet with a spiral wreath around a six-leaf rosette, found in Grave V.[45] They are also rare in pottery: there is a cup with a plastic whirl rosette in the middle and a spiral chain on the offset rim, probably from Middle Minoan II—III;[46] a high-footed bowl with multi-leaf rosette in the middle and huge spiral round it, from Phylakopi;[47] a gold bowl from the Aegina Treasure from the Late Mycenaean period;[48] and an indigenous sherd from Thera, from the second half of the eighth century,[49] belonging to the bottom of a bowl. The rosette certainly survived in the goldsmiths' work. The form adopted on the gold sheet from Eleusis (Pl. 229) probably started in the second quarter of the eighth century, in view of the obvious parallels with hammered tripod-cauldrons.[50] The closest parallels to the rosettes on the gold sheet from Eleusis are round gold discs with eight-leaf rosettes and a spiral chain of three intertwined ridges round the rim, which come from the Aegina Treasure and which can be dated in the ninth and eighth centuries.[51]

The gold band in the market published by Hampe,[52] which comes from a later gold workshop than the first group in Athens, and can therefore hardly come from Attica, also has spiral ornaments. But the patterns do not form individual and independent friezes; instead, they alternate as four separating ornamental sections with the three animal-fight pictures. The motif is composed of a flat, hatched 'hill' with lines running out and joining to form a triangle and then breaking out into two outward-rolled spirals. Where two animal pictures come together, this basic motif faces out both ways. This motif is still Late Mycenaean and occurs in its original form on a krater from Enkomi on Cyprus, with a bird scene on the other side.[53] The spirals on the gold band, with their double lines, are somewhat crude compared

with the gold sheet from Eleusis, but one can still recognize the style. The hatching of the 'hill' is the same as used by the Athens master in separating bars between friezes. Could the master of the new gold band give a clue to the origin of the older workshop in Athens?

All traces of things Mycenaean seem to have virtually disappeared on the Greek mainland in the Geometric period. But on the Aegean Islands and in East Greece, a slender heritage from Mycenaean art can be traced. Pottery, however, is comparatively unimportant here, unless one regards Protogeometric circle decoration—which occurs in varying quantity on the northern, eastern, southern fringes of the Greek world, alongside Geometric, up to the end of the period—as a repository of many of the Mycenaean spiral elements. But the real media in which Mycenaean art survived were jewellery, utensils of gold, silver, bronze and ivory inlay, and probably weaving and carpets. These define, broadly, the possible areas from which the workshop of our first group of gold reliefs may have come to Athens. We are primarily dealing with the triangle formed by Cyprus, Rhodes and Crete, although Crete itself, where many relics of Minoan-Mycenaean art survived, must be excluded because it had no major gold industry. Other sources include Ionian towns on the western coast of Asia Minor, up to Ephesus and the islands of Skyros and Lemnos.[54]

Connections between the first group and Rhodes

Of many possible sources for the matrices and also the master goldsmith, Rhodes must be given serious consideration. In the seventh century the island had a flourishing gold industry,[55] although gold jewellery also occurs in Geometric graves.[56] But in the finds to date, gold offerings in graves do not occur until the last phase of our workshop in Athens, that is, around the middle of the eighth century. There is no spiral ornamentation on Rhodian gold pieces. It is only in pottery that the spiral net, in its Geometric version with concentric circles instead of spirals, occurs, on the late krater from Grave B in the necropolis of Exochi, probably dating from the last quarter of the

century.[57] The phase of the double spiral chain on a central stem—with a base beneath each pair of spirals—and the splendid, ultimately Mycenaean ornament used on the legs of tripods and gold-covered boxes, is obviously over.

On the other hand the unique variant of the meander on the gold bands A 11 (Pl. 223) and A 12—which Ohly in reconstructing his gold box put on the front of the legs—is particularly significant.[58] The simple pattern consists of three linear meanders, one below the other. The first and third run from right to left, the middle one from left to right. The two spaces between the linear meander friezes are not blank but are crossed by vertical connecting lines. The eye is compelled not to follow the flow of the three meanders but to look at the pattern as a whole.[59] From the three linear meanders emerge two simple meanders running parallel to each other, which we could call 'meanders trees'. If Ohly was right in assuming that the ornaments were set vertically on the legs of a little box, then two meander trees would be next to each other, the one on the left with branches pointing downwards, the one on the right with branches pointing upwards. In the area of the central right-running linear meander, the downward-and upward-pointing branches interlock. This imaginative play of variants does not occur in mainland Geometric or in the Cyclades.[60] But one of the two gold diadems from Grave 82 in the necropolis near temple A in Camirus,[61] where the grave contents should be dated directly after 750 B.C., is very similar. Here two meanders are set one above the other, running to the right on top, and to the left below. The flanges are filled with dotted hooks. But if one looks along the gold band, one sees, depending on one's viewpoint, a meander tree with branches turning either upwards or downwards. This would not be particularly significant were it not for the fact that both types of meander tree also occur in Rhodian pottery: on a kantharos sherd from Lindos, now in the museum in Istanbul (Fig. 46);[62] and on a barrel vase with two mouths from Grave D in Exochi (Fig. 47),[63] where both types of meander tree, as well as the inward-pointing triangle border on both ends of gold band A 11, occur. Outside Rhodes, only one example of a

meander tree with downward-pointing branches is known to this author: on a cup with a tall neck and exaggerated handles, of the Attic type, in the Allard Pierson Museum in Amsterdam, probably from a Boeotian workshop.[64] The simplest explanation of this would be that Rhodian variants were imported via the Cyclades, to Boeotia. If the meander tree were copied from an Attic vessel, that vessel would be an isolated exception among the enormous number of Geometric vases found in Athens. Amongst the relatively few Geometric vases from Rhodes, however, it occurs no less than three times. It could have been copied from the meander ornamentation on the gold relief in the first group in Athens where both types of meander tree are combined.

The row of rosettes on the gold sheet from Eleusis (Pl. 229), which is still spiral ornamentation, has no exact parallels on most of the later vases from Rhodes, where central motifs have rosettes of eight, six or five leaves. Rims are decorated with a wreath of tangential circles on a krater (Fig. 55) and a jug (Fig. 49), and with a zigzag wreath on a sub-Geometric oinochoë from Cos (Pl. 91).[65] The rosettes on the krater (Fig. 55), which deliberately run over the edges of the handle zone, and even over the outlines of the quatrefoil in the middle, appear to have been put on afterwards. The rosettes on the jug (Fig. 49) are in a Geometrically patterned zone on the shoulder. The pattern continues on both sides of the apparently 'superimposed' rosette. The shoulder of the oinochoë from Cos (Pl. 91) has a splendid metope-triglyph frieze. The triglyphs are filled with Rhodian palm-tree motifs. Only parts of the metope—the hatched double-line frame of a rectangle—can be seen in the lower corners. Apart from an upper strip which is decorated with Argive-Rhodian hour-glass motifs, the rest of the metope area is taken up by the large 'superimposed' rosettes. There can be no doubt that this series of Rhodian vases reflects the new Rhodian goldsmith's technique of soldered-on relief.

In the second group of purely Attic Geometric relief bands with figured action pictures, there is a gold band (Pl. 224)[66] where purely ornamental gold sheets are soldered on at three points: two rosettes with a quatrefoil in the middle, and in the centre of the relief band, a large square separated from the figured scenes by cross-lined strips and decorated Geometrically. The rosettes cut crudely into the pictures as on the Rhodian vases. The large middle square is formally separated by the lines from the picture. But the right part of the superimposed sheet is damaged, showing that the frame originally continued underneath. One can also make out part of an archer in the figured picture which was underneath. The superimposed, or soldered-on, gold sheet had a series of narrow triangles pointing inwards from the edge with two circles in the middle. Triangles and circles both had raised rims with rows of dots outside. The hollows inside these shapes were filled with coloured enamel. The two older diadems from Camirus[67] have a simpler version of this on the catch and can be regarded as forerunners of our gold-band enamels. On the diadems there are four or six narrow triangles pointing in from above and below, which were filled with punched dots rather than enamel.

Although we can establish similarities in style and the new soldering technique between the second, later, group of gold sheets from Attica, and Rhodian goldsmiths' work, soon similar results are also produced on gold bands by the old local matrix technique. This is demonstrated by two gold bands, A 20 in Copenhagen (Fig. 107) and A 20a in the Stathatos Collection in Athens, obviously by the same hand.[68] Here too, individual figured pictures are separated by square decorative areas. But these are not soldered on but are beaten out, like the pictures, on matrices. The motif in non-Attic. This simpler method is also used on Rhodes, on, for instance, the jug cited above, from Grave 22 in the necropolis at Camirus (Fig. 49),[69] with a metope-like square area divided by two crosses, one orthogonal, the other diagonal, superimposed on top of each other. The difference between these and the Attic 'metope' designs lies only in the joining of the points of the orthogonal cross by oblique lines. This produces a smaller square touching the metope frame at the corners, to which four tiny squares in the angles of the orthogonal cross and corners of the metope border correspond. Instead of the eight triangles of the jug metope, this further subdivision makes sixteen triangles, with convex surfaces like the enamel which is clearly missing here.

Jewellery pendants from Eleusis

The time has come to define the second wave more exactly. Five bits of one or more breast pendants were found in the 1880s in the debris between some ancient foundations in Eleusis (Pls. 225-228).[70] Most of the loops are still preserved on the pendants, of which three are square and one is trapezoidal. The work is exquisitely soldered. The recesses for the enamel are almost completely intact and strengthened with fine granulations on the outside. The enamel is still preserved in four places. The background in granulated. The main ornamental motifs from the more primitively soldered superimposed sheets on Attic relief band A 19 (Pl. 224) recur on four out of the five pendants from Eleusis: a four- or five-leaf rosette[71] and two square areas with five inward-pointing narrow triangles with three circles between them. The four-leaf rosette in the trapezoidal pendant (Pl. 227) is framed above and below by four and two triangles respectively. The fifth pendant (Pl. 228) has a central oval Dipylon shield (?). This and the pendant with the five-leaf rosette (Pl. 225) have small circular recesses for enamel in the corners. Indeed, all these motifs were for enamel. The background is lightly granulated, least carefully on the trapeze with the quatrefoil. Of the two squares with the motifs of rows of opposed triangles, one has an Attic upright meander with parallel lines, the other opposed chevrons which are in the gaps between the triangles and which run out past the row of circles (Pl. 226). On both sides of the square with the five-leaf rosette (Pl. 225) are double zigzag lines. Above and below are interlocking S's like the borders of the rosettes on the gold sheet from Eleusis (Pl. 229). The remaining motifs are circles, most of which are concealed under the rosette. The Dipylon-shield pendant (Pl. 228) has a zigzag between the suspended semicircles on the top, and a spiral chain ('running dog') below. On the sides are Geometrized 'woven' bands with small 'eyes' with dots in the middle. This 'woven' band is the first clue to the origin and date of this gold jewellery, since it also appears on a Rhodian kantharos in Copenhagen and on a pyxis from Camirus,[72] both of which belong to the end of the Geometric period and can be dated in the last quarter of the century.

Close study of gold sheet A 19 (Pl. 224) and the breast jewellery from Eleusis (Pls. 225-228) gives a clear overall picture. The soldered-on rosettes and triangles on the Attic gold band are superimposed without regard to the figured pictures on the gold relief, just as the rosettes on the krater from the necropolis of Camirus (Fig. 55) seem to be painted without regard to the boundaries of the handle zone. The jewellery pendants from Eleusis also have two 'levels', a background covered with granulation and Geometric ornamentation, and the recesses for enamel with rosettes, triangular motifs, the Dipylon shield and the circles in the corners. On the five-leaf, upright-meander pendant and on the trapezoidal pendant, the decoration of the background is arranged so that it seems to disappear under the rosettes and circles. This relationship between background and superimposed enamel corresponds exactly to the vase painting on both jugs from Rhodes and Cos.[73] Then we have the triangular motif—rows of narrow triangles touching at the apex—on the older gold diadems from Camirus[74] with the decorative pieces added afterwards. And the brilliantly ingenious method of getting sixteen triangles into one square on gold bands A 20 (Fig. 107) and A 20a comes from East Greece and is at least fairly close to Rhodes.

These clues connecting the square gold pendant from Eleusis with Rhodes may not be immediately convincing. Fortunately there is a relatively early gold plate in Copenhagen, produced by the soldering technique. It is also square and comes from Grave Z in the necropolis of Exochi near Lindos.[75] The span of this grave must be from the middle to the end of the Geometric period in the last quarter of the eighth century. The square is filled by a raised round disc on to which the bases are soldered. There is an upright lozenge in the middle with two small circles attached by short stalks to each apex. The enamel inlays are no longer preserved. The motif can probably be dated Late Helladic III B.[76] Its spirals have become circles; on Geometric vases in Rhodes it appears with meander hooks on the apices of the lozenges, almost as a 'trademark'.[77] There is no granulation yet. Punched dots run round the rim and the circles in the corners. The soldered relief from Exochi

is certainly a forerunner of the breast pendant from Eleusis. This still ungranulated early phase of gold relief does not occur in Attica, and proves that the later group of gold jewellery from Eleusis is of Rhodian origin.

The early workshop of a Rhodian goldsmith who introduced the animal frieze, spiral ornament, complicated meander variants and wheel rosettes to Athens stopped work after the middle of the century. Attic assistants must also have used his matrices, since impressions of very different quality exist. The first totally Attic pieces are the gold bands in our second group, which begin after about 750 B.C. Where else can the figured action pictures of this group come from but the repertory of Attic vase painting? It is at this point that the first, fairly primitive attempts are made to combine soldered with impressed reliefs (Pl. 224). Granulation of the background is still absent, but the main motifs from the splendid breast pendants from Eleusis, triangular and rosette motivs, recur. Were it not for the gold jewellery from Eleusis, it would have been impossible to come to the now obvious conclusion that after the end of the animal-frieze workshop, a second, younger, master, also from Rhodes, came to Athens to excel in the craft of making jewellery.

b Animal friezes

What can we learn from the animal friezes from the workshop of the first group? The main figures are stags with splendid antlers, followed by the much less common recumbent or grazing ibexes. There is one fawn (A 5). The more savage side of the rustic idyll is represented by lionesses (or panthers?) slinking after unsuspecting stags, and lions crouching to leap, or sinking their teeth into the back leg of some animal. Pairs of lions seem to be coming at herds from all sides, and yet the herd is undisturbed. No animal seems to be running away,[78] and the lions almost never attack. The gentleness of the grazing animals and threatening strength of the stronger beasts are simply contrasted; but the law of the jungle and the steppe dictates coexistence.

The stag image in Oriental and Early Geometric art

Animal friezes came from the Orient. This is particularly well demonstrated in stag pictures, which first occur in the second half of the third millennium B.C. The finest is inside a 'sun disc'; two others form the crown of a 'standard' from Alaca-Hüyük in Asia Minor.[79] The material used here is copper. It is a long time before this animal, with its great hooves and narrow body, is rendered again so vividly and sculpturally as on the sun disc where it conjures up the forests and steppes of central Asia. The stags made in rectangular clay moulds, from the palace of Mari,[80] are quite different. The palace is firmly dated in the first two centuries of the second millennium B.C. The plastic, rounded body of the beast seems so real that one can almost smell it. The style is Near Eastern. On the shoulders of vases from Hama there are whole herds of bulls, ibexes, horses, stags and a few lions, painted in red.[81] These vases belong to a stratum dated by the excavators between 1200 and 900 B.C. (?). But more significant than these hieroglyphic-type animals of vase painters are the ivories from Samaria and Arslan Tash, with friezes of stags grazing peacefully, of the same basic type as on the Rhodian gold bands from Athens. The style is Syro-Palestinian, but considerably developed. The fragments from Samaria[82] are the older ones, dating from the ninth century; the two grazing stags from Arslan Tash[83] can be dated around 800 B.C., on the basis of rulers' names and epigraphic evidence. Egyptianizing elements have almost disappeared. Both stags are in relief, and in one case the ground is cut out, so that the animal looks almost like a free-standing model. The drawing is similar to the other relief. But the body, transition to the neck, the neck itself, the head, the rounded, muscular legs, and the ears, are all filled with organic life, using the grain of the ivory in masterly fashion. This is a foreign accent of Near Eastern art. M. Dunand, who published the ivories from Arslan Tash, correctly assumed 'Aegean' influence to explain this remarkable piece.[84] This can only mean, given the date, that the craftsman was west or south Anatolian, perhaps even Greek. So at least one pre-condition necessary for the work of our Rhodian goldsmith seems satisfied.

Comparatively few stags have been found in Greece itself. In Zygouries in the valley of Kleonai in the Argolid, remains of one or two stags' antlers were found in the Early Helladic stratum, dating from the second half of the third millennium.[85] These must have been designed as dagger handles or chisels. But finds like this are rare. Among the offerings in Grave IV in the large grave circle at Mycenae, there was a stag made of an alloy of silver and lead with a pouring vessel on its back.[86] G. Karo realized that this stag was not Minoan or Mycenaean, but was imported from the interior of Asia Minor. A predecessor occurs in a clay stag with a large vessel on its back, from Kangal near Malatya, now in the museum in Istanbul; it dates from the end of the third millennium.[87] Another representation of a stag, in the form of a clay vase, was found in Protogeometric Grave 39 in the Athenian necropolis, south of the Eridanos.[88] The grave is from the end of the Protogeometric period, and one can already recognize the transition to Early Geometric. The body of the stag is in the shape of a barrel, with front and hind legs attached directly, without joints, to the barrel, as though hammered on. The neck projects straight upwards. The high, proud head with its short horns captures something of the animal's grandeur, but apart from this, realism is sacrificed to a strictly orthogonal structure. This stag marks the end of a phase. Animal vessels, which otherwise show bulls, rams and horses, begin with superb shapes in the Cretan Minoan period but by Late Mycenaean, sub-Mycenaean and Protogeometric, they take on the shape of a barrel.[89] This type of animal vessel continued to develop towards organic form only in East Greece up to the end of the Geometric period, as surviving Mycenaean styles were gradually driven further east.[90] Stags seem to have played no role on the Greek mainland between the Protogeometric period to the middle of the eighth century. This may of course be a false impression, produced by the coincidence of survival. But it is not only in vase painting that stags are missing. Of the several thousand animal bronzes from Olympia, there are only three stags, and these are from the Late Geometric period,[91] when pictures of stags revive anyway in vase painting: for instance, the young stag being

chased by a lion,[92] the rather horse-like stag in Munich, or the bronze group, in Boston, of a hind suckling her young (Pl. 189).[93] All these deer, most of which are Late Geometric, have the abstract stamp of Geometric art, whether they occur on vases or are modelled in bronze. The master of the animal friezes on the gold band in the first group stands alone with his early workshop in Athens, and has no immediate successors.

Cretan bronze shields

Before going on, we should glance at the embossed bronze reliefs from Crete which were so excellently analysed by Kunze.[94] It can no longer be doubted that these are of Greek origin. They include several friezes of grazing stags. The reliefs belong to a small group consisting mostly of shields produced in the course of only a few decades. They are examples of fully developed orientalizing style. A chronological clue is given by two bronze shields found in a small tholos tomb at Afrati near Arkades on Crete, full of rich grave offerings[95] spanning a fairly long period and lasting into the second quarter of the seventh century.

The friezes with stags on these reliefs run between 'woven' bands or simple ridges. Two different hands can be distinguished: there are stags with large bellies and thighs, marching in step;[96] and, more delicate long-legged creatures, with alternating step, grazing.[97] None of these animals can match the stags in the East Greek gold reliefs in Athens, over half a century earlier (the closest would be the stag on shield 54), or the splendid stag in the open-work relief from Arslan Tash.[98] Both series quickly become mannered. The latest shield in this group, with an omphalos in the middle,[99] dates from the second quarter of the century. Its only pictorial frieze shows stags galloping amongst trees—probably willows. The herd must be racing towards a spring; or perhaps, startled at the waterside, they have run away. There are new features here. The massive hindquarters of the animals, with their great thighs outstretched, their narrow bodies, muscular forelegs, narrow necks, fine heads and heavy antlers are all

rendered with superb plasticity and great feeling for movement. These animal pictures are of a quality comparable to the Attic gold bands of a hundred years before, although now freer. Since the friezes need a rhythmic pattern of elements, trees and stags are only very slightly different from each other. Compare, for instance, the antlers of the stags and the branches of the willow trees. In the same period a vase style develops in Camirus on Rhodes with a similar frieze style containing identical individual elements, usually rows of ibexes and fallow deer. One of these early vases from Rhodes was found in tholos tomb L near Arkades on Crete.[100] The omphalos shield from this Cretan group (26) must obviously be included as one of the widely scattered origins of the Rhodian Camirus vases.[101]

The 'Master of the Lions' motif, and the lion-fight groups

The group of a pair of fighting lions (Pl. 223),[102] with a helmeted warrior as their victim, needs some explanation. This invention originally came from the hinterland of the Gulf of Issos, from the successor states of the Late Hittite empire in Carchemish and Sendshirli. Two massive relief statue bases were found here. The one from Carchemish is the base of a statue of a seated god; the one from Sendshirli is of a statue of a standing god or king (Pl. 71).[103] Two lions, with jaws wide open, are, as it were, sunk into the solid block so that only their sides project in relief; their fronts are fully sculpted. Between these lions are their demonic masters. The figure from Carchemish has an eagle's head; the one from Sendshirli is human. They are holding the beasts by the mane, or by a rope thrown around their necks. The size of these lion tamers, who are only about as tall as the animals themselves, is interesting. These Masters of the Lions appear only three times in early Greek art, always with small hero figures contrasting with huge animals. Vase painters, ivory carvers and stone masons can hardly have seen this in real life. On one of the bowls painted on both sides (Pl. 70)[104] from the third quarter of the eighth century, which could not have been produced without

acquaintance with Phoenician bronze bowls and their raised relief friezes, and which often have Oriental motifs, there are a herd of four bulls and two lions opposite each other with wide-open jaws and a figure between them, tiny in order not to disturb the animal frieze, an armed hero figure about to bring them under control.

There is a broken fragment of the front paw of a recumbent lion facing right, of marly limestone, with a thin, shod foot on top of its claw, from the Heraion at Olympia.[105] The fragments were found on the floor of Heraion I and in the ash stratum above it. The claw has only four toes. The tiny human foot is set right back and was connected to a back-plate which no longer survives. The whole thing would have been a relief about 60 cm. high and over 200 cm. wide, part of the base of a cult statue: two great recumbent lions, with their 'master' between them (perhaps the older Herakles and Idaean Daktyl, the companion of Rhea and guardian of newly born Zeus, who was important in the pre-Dorian foundation legend of Olympia).[106] The picture can be reconstructed with some accuracy since the foot on the animal's claw occurs several times in pictures of heroes between antithetical lions, griffins or sphinxes.

An ivory sculpture of a recumbent lion with the head of a young bull in its jaws is probably later and is more freely sculpted. It comes from the Temple of Artemis Orthia in Sparta.[107] In front of the lion between its front and hind legs, a hero is kneeling, wearing shoes and a short chiton. His head is lost. He has sunk his sword up to its hilt into the neck of the lion. The kneeling figure is the same height as the recumbent lion. Here is the Oriental hierarchy of power (bull—lion—hero) as in the engraving, almost two centuries earlier, on a silver vase of the Entemena from Tello[108] (stags or ibexes—lions—the eagle of Lagash).

But there is one important change in the Greek pictures. Even if the tiny Master of the Lions of the Late Geometric bowl from Anavyssos (Pl. 70)[109] is no longer a demonic ruler, something between a city king and a deity, he may, just because of his small size, be an apparition of a god, to which even the strongest mortal power must yield. This would be

the same image as used by Minoan and Mycenaean craftsmen in their seal pictures.[110] But is it the hero who is controlling the lions, or is he himself about to be killed by the two beasts? We do not know. But in Samos there is a bronze group with a warrior protecting a herd from attack by a lion (Pls. 186, 187)[111] from the Late Geometric period. This is followed in the post-Geometric period by the base relief from the Heraion at Olympia, and the ivory statue from Sparta celebrating victory over a lion. Here a mortal hero replaces the superhuman creatures and an Oriental motif has become Greek.

The lion-fight group on gold band A 11 (Pl. 223) from Athens, now in Copenhagen, is more closely connected, as is the one on the Copenhagen kantharos (Pl. 69), with Oriental prototypes from the south-eastern-most point of Asia Minor. The posture of the victim has developed from the kneeling position (*knielauf*) conventionally used to indicate flight. The corresponding picture on the kantharos (Pl. 69) was produced during the time of the gold workshop by someone who must have been familiar with this gold sheet. The picture records a somewhat later moment in the action. The head of the hero, whose sword is still in its sheath, is now actually separated from his body. The lions are lifting the dead man, each with one paw on one of his legs. Neck stump, shoulders and buttocks are inside the jaws of one of the animals. Such flexibility is alien to the static ceremonial art of the Oriental statue bases. It captures the full flavour of human experience, guided by Moira and Zeus, allotters of victory or death. Oriental images celebrating the power of a deity or a ruler develop into the Greek picture of action showing the achievements of some mythological hero, or the tragedy of death. Basic Oriental features survive, although adapted to the grandeur and the tragedy of the Greek world. Lions, for instance, appear to have been extinct in Greece by the eighth to seventh centuries. The main scene on the Copenhagen kantharos (Pl. 69) and the lion-fight groups on the gold relief (Pl. 223) were properly described by Ohly as 'allegories of death'.[112]

We have shown how the idiom of the 'Rhodian' goldsmith started and spread, before he moved to Athens, in the triangle Rhodes—Cyprus—Crete.

How could he have known about the statue bases in Sendshirli and Carchemish? As late as the Late Mycenaean period, there were important Achaean settlements on Cyprus which grew into prosperous towns such as Salamis, Lapithos, Soloi and Paphos. On the seaboard opposite the island there were Greek trading stations, such as Byblos, Ugarit (Ras Shamra) and Alalach. And there were plenty of Greek attempts to found colonies on the nearby coast of Asia Minor. The foundation of Soloi in Cilicia on the edge of the eastern part of this region is recorded. Strabo[113] says it was founded by Achaeans and Rhodians from Lindos. We have only a *terminus ante quem* for its date: the synoecism of the Rhodian towns of Ialysos, Camirus and Lindos in the year 407 B.C. The details given by Strabo make one hesitate to date this foundation in the eighth or ninth centuries B.C. The traditional story is merely a legend. After the destruction of Troy, Kalchas the seer, Amphilochos, son of Amphiaraos, Mopsos, a grandson of Teiresias and son of Manto and of Rhakios or Apollo, travelled back by land along the western and southern coasts of Asia Minor. They and their followers founded oracles such as Klaros and Mallos. After the death of Kalchas, Amphilochos and Mopsos crossed the Taurus mountains and settled in Pamphylia and eastern Cilicia between the plain of the river Pyramos and Syria.[114] The name of Mopsos survives in the two towns of Mopsuestia and Mopsukrene.[115] The name Mopsos has also recently been found amongst Late Hittite hieroglyphic inscriptions from Karatepe on the Syrian border, as the ancester of the ruling tribe of the Danuna (the Danaoi?) in the plain of Adana. The inscription is from the time of the king Asitawandas, dated by H. Bossert around 730 B.C.[116] It is quite possible that Mopsos was a common name in the royal family of the originally Greek-speaking people who lived at the extreme eastern end of Cilicia. The distance between Sendshirli and the plain of the Pyramos was about 70 kilometres. It was about 190 kilometres to Carchemish. News of the splendid statue bases from the ninth to the eight centuries in Sendshirli and Carchemish could easily have travelled this distance to the still Greek settlements of the Danaoi or Achaeans on the Syrian border. Thus these Oriental relief bases may, from the eighth cen-

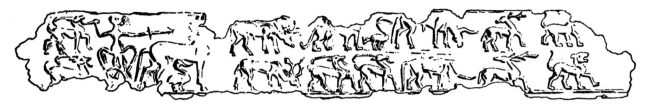

109 Reconstruction of a gold band from Exochi (Rhodes). Length about 25 cm. Copenhagen, National Museum

tury onwards have become a fertile source for early Greek art in the Aegean and on the Greek mainland, and have been an important influence in the development of relief-decorated Greek statue bases.[117]

There is one more point worth noticing. The warriors between the pair of lions, what is left of a warrior between the two fight groups, and the warrior heads on the tops of the waves at the ends of the frieze of rosettes on the gold sheet from Eleusis (Pl. 229) and also on the one from the Kerameikos, now in Copenhagen (Pl. 223), all have a type of helmet decoration which does not occur on Geometric pieces. Their helmets are semi-spherical. On top of them is a rail forming a crest, tipped up at the back. The same so-called 'Illyrian' or, more likely, Thracian-Asia Minor type of helmet is worn by the probably non-Semitic warriors on the relief on the orthostate in Karatepe. Rail and crest are quite distinct. On a relief which is only partially preserved, two warriors are hacking with their swords at an enemy fighter who is standing on a pedestal. This figure is not, as was thought at first, a goddess. The crest of the helmet runs into a point at the bottom. On a second relief, the victim is clearly shown by his Assyrian helmet to be Semitic. He is thus differentiated from the two men who are attacking him. The crest rolls up on the nape of his neck into a spiral. On a third relief, two more non-Semitic warriors, each with a spear and a similar helmet, are kneeling in front of a pillar with a palm capital.[118] This is another link between the Syrian statue bases and the Greek gold bands found in Attica.

It is highly unlikely that the 'Rhodian' goldsmith had worked in Cilicia. The triangle Cyprus—Crete—Rhodes could have drawn on orientalizing motifs from the border zone between Syria and Cilicia by many routes.[119] The precise trail from monumental Syrian sculpture to small-scale goldsmiths' art cannot today be retraced. One cannot really be sure of the exact source of the workshop which settled in Athens before the middle of the eighth century, although Rhodes is probably a good guess. But, as yet, no traces of it have actually been found there, although from the end of the Geometric period and the seventh century onwards, gold items do begin to occur in Rhodian graves. Amongst these are two gold bands (Fig. 109),[120] with two animal friezes of stags, ibexes and lions, one on top of the other. There is also a bull and a goose. On the left, interrupting the double frieze, is a hunter in a horse-drawn chariot, with six-spoked wheels. These gold reliefs show the same representation and come from the same matrix. It has been possible to make a reconstructed drawing of almost the whole thing from the fragments. The style of these gold bands, in both composition and rendering of the animals, is more free and less precise than the Rhodian-Attic master's work, which indicates the late phase of Late Geometric. The lions with their tails in the air are more light-hearted. The hunter has chased them away from the peacefully grazing herd. Two young stags are looking around to the older stags, sniffing the wind and ready to run away. The two old stags are grazing right in front of the hunter. They are successors to the stags on the gold sheets from the workshop operating a few decades earlier in Athens, whose master we have connected in various ways with Rhodes. They are grazing with the same unhurried, natural gait. Their thin bodies, and delicate necks are also similar. Only the antlers are freer and more natural. If the drawing is correct, these are red deer. About half a century later, red deer, ibexes and friezes entirely of animals recur as the main theme on painted vases from the island of Rhodes.

This is the last, certainly not the least, of the indications of a Rhodian origin for the master of the earliest gold workshop in Athens which produced the first group of gold reliefs found in Attic graves. The sheer number of clues pointing to Rhodes as the source of these oldest 'Geometric' gold reliefs is sufficient to construct a solid working hypothesis. The evidence certainly does not indicate Attica, but the Dorian islands of Cos, Rhodes, Crete and Cyprus, and the south coast of Asia Minor generally. Rhodes seems to win on points. Perhaps new finds there will finally settle the matter.

1 The origin of Geometric fibulae

There is no need to trace in detail the development in Greece of fibulae for fastening garments.[1] The implement first occurs at the end of the Mycenaean period, in the form of today's 'safety-pin'.[2] It is not until the sub-Mycenaean period that the low fibula gradually develops into a high, taut, simple, almost semicircular bow above a pin.[3] This type continues into the Ripe Geometric period. Outside Crete, which was obviously the centre of production for fibulae, in this early period, the same shape occurs in the Kerameikos, Salamis, Pherai (Thessaly), Aegina, the Argive Heraion, Olympia, Lusoi, Delphi, Ephesus, Cyprus and Palestine.[4] At the same time, a decorated version continues from the Mycenaean period onwards, with a low bow twisted like a plait; this version also develops a semicircular bow later on. Its post-Mycenaean variants occur on Crete, but it also spreads through the mainland and the islands.[5]

We can learn a lot from the distribution of fibulae in this early period. The production of fibulae continues to be centred on Crete, by now a Dorian island. But fibulae also became fashionable with the new people and classes in the *polis* and in the ancient cult sites on the Greek mainland. Crete must have continued to supply fibulae to the Aegean Islands, the Dodecanese, the Greek coastal settlements in Asia Minor, the island of Cyprus, and Palestine.

Other, later, fibulae in Crete were found in datable contexts in the large Grave II at Fortetsa near Knossos. No fewer than eighteen graves and individual burial sites contained items from the Late Protogeo-metric to the early orientalizing period. A complete find associated with pithos 19[6] includes, among other things, two Geometric bowls, two skyphoi, two aryballoi, two oinochoai and a hydria. All the pottery is Early Geometric or, to use the eastern nomenclature, Protogeometric B. The fibulae in the grave may also belong in this early period of the ninth century. An important and rare item is a fibula bent into a semicircle[7] with a pin which becomes rectangular after the spring. At one end is a knob between two small discs; the next three quarters of the bow is round again, gradually developing into a thin plate with the catch for the pin at the bottom. There are two more fibulae in the same find, with semicircular bows decorated with three balls, a larger one in the middle and one on either side.[8]

Undecorated early fibulae from Vrokastro

The largest finds of fibulae on Crete are from the settlement of Vrokastro in eastern Crete. The sherds found in the settlement and the graves extend from the Late Mycenaean to the Attic High Geometric period around the middle of the eighth century. The fibulae were found mainly in the twelve single graves. E. H. Hall organized them on two clear plates.[9] Fibulae A and B on the first plate are Mycenaean; fibulae C-F spread across sub-Mycenaean and Protogeometric; and fibula G, thicker on one side above the catch, with the greater part of the bow projecting upwards, must, as in Fortetsa, belong to the Protogeometric B period. Fibula H has a bow which stops suddenly at the highest point so that the rod with

the catch for the pin runs vertically down. This makes an almost abstract pattern of oblique bow, rising to a peak, ending in a vertical which is suddenly cut off by the flat-rolled catch. Fibulae C and F from the second plate, and perhaps also the fragmentary fibula D, are developments of the type with the drooping bow and the wider catch plate; the smaller bow part forms a kind of elastic 'bundle' held together by two knots, soon to be replaced by small balls between two discs. Fibulae A and B are probably contemporary, and both have three or four large balls on the bow.

The triangular shape of the ascending bow fibula turns, somewhat later, into the square-shaped fibula. The four elements are a pin, which forms the base, a four-sided upright above the spring, a horizontal bow, and a vertical, trapezoidal plate. The joints—that is, the catch, the spring, the small ball between two discs on the right and the ball without a disc on the left—mean the bow has to end slightly higher on the left than the right. But on the right, instead of a disc, there is the tongue of the flaring trapezoidal plate. This restores the balance. The delicate elasticity of the bow of this fibula is remarkable.

The smaller fibulae (G, I, J) are the last of the garment pins from Vrokastro: in one, the lower part of the bow runs exactly horizontally, with a tongue leading into a square unengraved plate. On the bow of another there are four balls with three discs between them. The plate of the third fibula is rectangular and the bow strictly horizontal, with a double-conical ring in the middle and two smaller rings to right and left. The fibulae in the first plate belong to the early period and span Mycenaean, sub-Mycenaean, Protogeometric and Protogeometric B. The later fibulae span a considerably shorter period, from the last quarter of the ninth century to the middle of the eighth.

2 Plate fibulae

Let us now turn to the engraved fibulae of the High and Late Geometric periods, starting with Attica.

a Attic plate fibulae

Early Geometric vases, later pyxides, and a splendid Attic fibula have all found their way to the museum in Toronto.[10] The fibula is complete. A broad tongue runs into a plate with slightly curved sides and a delicate swastika in the middle. A broad band with a lozenge ornament forms a frame round the edge, enclosed by a zigzag. The fibula may belong in the first quarter of the eighth century.

Four gold plate fibulae from the Elgin Collection are in the British Museum in London (Pls. 230, 231).[11] The simple semicircular metal bow, between two balls, the tongue and plate, from 800 B.C., has now developed into the rectangular fibula. Instead of a tongue there is a curved top (one of the four fibulae is badly bent). The plates have simple engravings on them. Two fibulae have a swastika on one side and a grazing deer on the other. Of the smaller two, one has a warship and a horse, the other a horse and lion. Without a doubt, these are Attic products, and belong to the second quarter of the eighth century. The pictures are typical of the period: the warship, only partly preserved here, also appears on an early fibula from the Kerameikos around 800 B.C. which is certainly Attic.[12] We know the stag and the lion from the gold band by the Rhodian goldsmith in Athens.[13] The horses and the two swastikas are also High Geometric, without any trace of the Late Geometric style of the last half of the century.

These items and four items from Grave 41 of the Kerameikos (Pls. 234-237),[14] which will be discussed in another context later, are High Geometric Attic fibulae. At the same time a second type was being produced where it is not the plate but the flat, hammered sickle-shaped bow which is the medium for pictures.[15] But let us begin by tracing the further development of the plate fibula. It is not until the Late Geometric period, when Geometric form was disappearing in a struggle between the new and the old, that this type of fibula really develops, with narrative pictures, realistic battles, mythical stories, and the deity. But Late Geometric plate fibulae, mostly made in Boeotian workshops, have little connection with Attic fibulae. Their Boeotian origin was

established by R. Hampe.[16] The classic form of the fibulae can be broken down into various types: the high and low bow, the square plate, the plate with upper edge curved outwards, the trapezoidal plate, and the plate with three curved edges and a straight catch on top. A new type of fibula seems to occur with the first Boeotian products. Instead of the bow, there is a low straight line with two, three or even four 'bells' in an arch above it. This produced a low, elongated fibula with a pin running parallel to the 'bells', making a kind of 'safety-pin', rather like those made centuries earlier, at the end of the Mycenaean period.

b Plate fibulae from Peloponnesian workshops

Whereas Corinth, Athens and Argos did not contribute significantly to the production of Late Geometric fibulae, which flourished in Boeotia, workshops in the central Peloponnese were making a similar type of fibula. On the plates of these fibulae, animal pictures, which were very similar but with distinct local features, were incised. A characteristic feature is a double frame around the plate; on one side there is even a 'closed door' (or 'rectangular bowl') (Fig. 112).[17] Four fibulae, two large and two small, come from Andritsena.[18] The large plates with high points are balanced by the bow. Everything is rectangular. The bow has three parts separated by four sets of three engraved rings. In the middle section is a flat disc decorated with concentric circles. On the plate of the first fibula there is a completely legible engraving of a curious bird, with long neck and beak turned back. This must be a crane. The two smaller fibulae have more heavily decorated bows: in the middle is a large, bi-conical wheel; to the left and right are two smaller, similarly shaped modules, with rings between them. On the point of the plate is a module which looks as if it were lathe-turned.[19] On all four fibulae, there is a double frame. On one of the smaller fibulae there is a triple frame.

The fibulae from Andritsena are followed by fibulae from Elateia, Olympia, Delphi and Tegea (Figs. 110-112).[20] In the middle of the bows is a bi-conical multi-faceted bead. Next to it are rings or incised lines. In one case there are more beads at the end of the bow. The plates are double-framed. On the fibula from Elateia (Fig. 110) these frames consist of dotted semicircles. On the one from Olympia (Fig. 111) they are made up of rows of double dots; on the one from Delphi, double wavy lines; on the one from Tegea (Fig. 112), dotted semicircles and

110 Plate fibula from Elateia.
Length 11 cm. Athens, National Museum

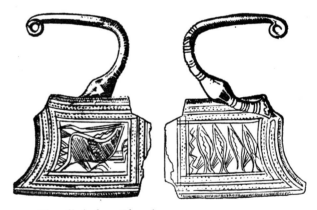

111 Plate fibula from Olympia.
Length 8.5 cm. Olympia, Museum

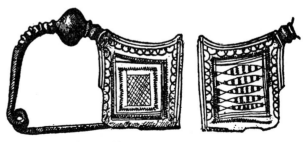

112 Plate fibula from Tegea.
Length 6.2 cm. Piali-Tegea, Museum

zigzag lines. The laboured fantasy of the incised drawings is similar to the Andritsena fibulae. There is a swan on the fibula from Elateia (Fig. 110); an almost indecipherable swimming bird and four fish swimming next to each other on the fibula from Olympia (Fig. 111); and four fish on the Delphi fibula, perhaps caught in a net (probably of later date), and a horse with two birds, one a crane as on the fibula from Andritsena. The fibula from Tegea (Fig. 112) is by another hand. Its single picture shows five fish swimming alongside each other.

Three more fibulae from sites separated by considerable distances (Olympia, Rhodes and the Temple of Zeus Thaulios in Pherai) all stem from the same workshop; at least two of them are by the same hand.[21] Only the plate of the fibula from Olympia (Fig. 113) survives. The wide frame consists of double semicircles with dots inside and a row of left-running meander flanges round the centre. The picture is immediately framed by single semicircles, dotted on the short sides only. The picture is of a wounded stag, struck in the chest by an arrow and a spear. The mortally wounded stag is superbly rendered with only a few strokes. Only the outside track, with double semicircles, is recognizable in the double frame on the back. The inner tracks and the picture frame appear to be empty. The large animal was formerly thought to be a bull.[22] But its supple body, huge mane and 'face' are surely more like those of a lion. It is more like the long-legged lions on gold bands than the 'monsters' of the Late Geometric period.

The fibula from Rhodes (Fig. 114) is complete. The frame on the front is a row of dots and a second track with double semicircles with dots in the middle. The picture shows a doe reaching up to eat fresh

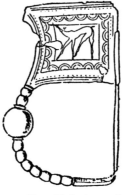

114 Plate fibula from Rhodes.
Length 7 cm. London, British Museum

leaves. The drawing here is quite remarkable. On the back side are two familiar frame motifs, including an inward-facing upright meander, and an empty strip in the middle. This fibula, like the two large fibulae from Andritsena, has a ball on the highest point.

A fragmentary fibula from Pherai has three biconical thickenings at the joint between bow and plate, and pearled rings down to the angle of the bow. Only one corner of the plate is preserved. The external frame is very wide, consisting of loosely set semicircles with dots in the middle. One can see only a little of the picture area, too little to decide what the picture showed.

Although found far apart, at least two of these fibulae, the one from Rhodes (Fig. 114) and the one from Olympia (Fig. 113) are by the same hand. The third one, from Pherai, could also well be by the same artist. Stags, does, a lion—this is the iconography of the oldest gold bands from Athens.[23] But these animals are very different from the Attic animals on the gold bands, which come from the East Greek workshops. These fibulae are of Peloponnesian origin, and their stags, does and lions are the most delicate of Geometric drawings. They may have been made around, or perhaps shortly after, the middle of the century.

This group contrasts with the eight fibulae above from Andritsena, Tegea (Fig. 112), Olympia (Fig. 111), Elateia (Fig. 110) and Delphi. They belong to the same Peloponnesian workshop, but are from a con-

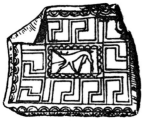

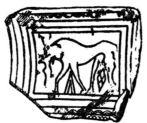

113 Plate fibula from Olympia.
Olympia, Museum

siderably later phase of it. They are similar externally to the wild Boeotian style. But the form and the characteristic, imaginative drawing of the animals give them an individuality of their own. It appears that H. G. Payne has been the only person to draw attention to certain central Peloponnesian fibulae—presumably the ones described here.[24]

c Plate fibulae from Boeotia

It is well enough known that the many fibulae which have been found in Boeotia were made in local workshops. But they do have a few foreign features. One of the earliest Boeotian fibulae, wrongly described as having been found at Chaironeia,[25] is of the classic Attic-Boeotian type (Fig. 115). It was produced in two parts. The engraved plate was

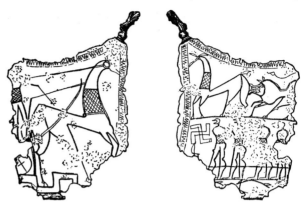

116 Plate fibula from Eleutherai. Athens, National Museum

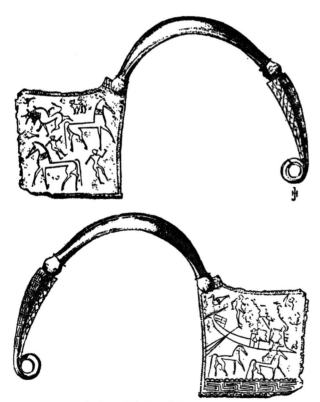

115 Plate fibula from 'Chaironeia'. Thebes, Museum

undoubtedly added afterwards, and might have been re-used.[26] The drawing is not Boeotian, but is a sophisticated engraving of the Peloponnesian decorative type described in the section above. Near where the tongue joins the ball one can see, on both sides of the plate, a strip with the familiar semicircular double circles with a dot in the middle. On the bottom of the plate is a broad ornamental strip, with a left-running meander framed, above and below, by double semicircles with dots. The strip looks rather like a beach or a quay. Two excited horses are prancing about. A ship, probably commercial but also equipped as a warship, can be seen on the beach. A large oar and three super-structures can be made out. A fight is in progress on board with a spearman and an archer battling with each other. Two birds are fluttering around the ship.

The other side of the plate is composed more simply. Two horses seem to be running off, one on either side. Stable boys are trying to catch them. On the top left there is a lion. In the background an erotic scene appears to be taking place.

So the fibulae from Olympia, Rhodes and Pherai have later parallels in these pictures on a plate probably soldered on afterwards and dating from the third quarter of the eighth century.

A fairly crude plate of about the same height with engraving on both sides was found in Eleutherai on the Boeotian border (Fig. 116).[27] The front shows a huge horse and chariot. In the chariot is the form of

a tall driver. This motif, with the tall charioteer with armour round his midriff, is obviously orientalizing. The upright meander on the bottom is interesting. The chariot wheel is on the top level, the two rear hooves of the horse are lower, in the recesses of the meander, and then the front hooves are on top again. This upright meander again indicates the work of the Peloponnesian master of the fibula from Rhodes (Fig. 114), although it is more crude and still Boeotian in style.

On the other side of the plate the picture section is split into two. Underneath, there is a flat boat with a low rail and four men standing up, clad in armour. Beneath the hull of the ship are some fish, and there is a swastika above the prow. On top, there are a doe and a lion with its teeth sunk into the doe's hindquarters. This type of lion, with huge mane and hind legs, features for only a short time in the iconography of Geometric lions. The 'Lion Painter', who produced only three large Attic jugs including two with this kind of lion,[28] was probably the first to invent the type. The fibula was made around the end of the third quarter of the eighth century.

A group of two lions rearing up, with the top half of a human figure between them, disappearing into the monsters' wide-open jaws, occurs on the plate of a Boeotian fibula once in the Antiquarium in Berlin. We will deal with this later in connection with its workshop.[29] But we should notice here the different type of lion on it. The two lion types on Boeotian fibulae, the Attic of the third and the Boeotian of the last quarter of the eighth century, are definitely associated with the Late Geometric period. To what extent can they be traced beyond the Geometric period with any certainty? Hampe believes that the Boeotian fibulae continued until the middle of the seventh century. Others believe that they lasted beyond the middle of the century. These fibulae, which were worn as jewellery, may have been used as grave or temple offerings. But where is the evidence for such late dates?

Boeotian plate fibulae, in particular those groups which can be attributed to particular hands, and which have been carefully assembled by Hampe, give us the first answers to this question.

The fibulae of the 'Lion Master'

Four fibulae in Berlin (Fig. 117), Munich (Fig. 118), Athens (from Thebes) and Philadelphia (Fig. 119) make up the uniform group of the Lion Master.[30] Three of the plates are engraved with zigzags and show lions eating the forequarters or the leg of a doe. On the back is a horse led by the halter by a man *more geometrico*, or a horse standing in front of a

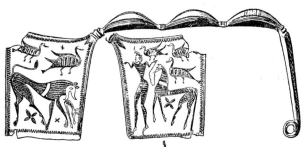

117 Plate fibula from Boeotia.
Length 19.5 cm. Berlin, Staatliche Museen

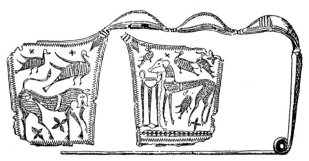

118 Plate fibula.
Length 18.5 cm. Munich, Staatliche Antikensammlungen

119 Plate fibula.
Height 14 cm. Philadelphia, private collection

tripod, tied up by its halter to the handle (Figs. 117, 118). There are two light bands at the bottom of the neck and behind the chest of the horse; also, rather surprisingly, behind the mane of the lion. The lions' jaws are bell-shaped. 'Eyes' are set at the top of the jaw in the lion and on the men's cheeks. These are obviously not ears. Late Attic grave kraters, particularly from Hirschfeld's workshop—for example, one in Athens, 990 (Pl. 40), and one in New York (Pl. 41), and amphora 18062 in Athens, and the grave amphora in the Benaki Museum in Athens (Pl. 46)—all show men with large round eyes on their cheekbones.[31] It is not difficult to understand why this method of illustration was not always used in silhouette figures; it was not until the end of the third quarter, and even then only in the orientalizing style, that the eye became a common feature, and eventually an essential one. The fibulae are still some way from this. They belong, at the latest, in the middle of the third quarter or the beginning of the fourth. Two birds are fluttering with outstretched wings above the lions. Above the horse there are three birds, with a fourth underneath the horse by the tripod. In the gaps are quatrefoils with double outlines and double crosses.

Only the plate, considerably damaged, remains of the fibula in Philadelphia (Fig. 119). The drawing here is later, and uses a superb wavy, zigzag stroke. For the first time mythical pictures appear: on one side is the story of the Hydra, on the other, perhaps Herakles and the Keryneian hind. The front shows Herakles and Iolaos standing opposite each other. Between them is the Hydra, with only two snakes left, stretching up at the heroes but held tight in their right fists. Herakles has a sickle in his left hand with which he is about to cut off the snakes' heads. Bits of snake are floating in the air or being used by Iolaos as a whip. Between the two legs is a big crab sent by the goddess Hera to attack Herakles. Behind Herakles two spears are stuck in the ground, useless for fighting the Hydra but reminders of the hero's arduous journey.

On the back of the plate there is a hind with the antlers of a stag on a rocky hill; a fawn is reaching up to its udders; and above, a bird is flying. A huge hero has grasped the horns of the hind with his right hand and is trying to drive the fawn away from the hind with a spear held in his left hand. There is another spear stuck into the ground beneath the hero's arm. This picture has been interpreted as simply a hunting scene. But is it really? A hind with horns must be some wonder-animal, the creature of Artemis. The hero is holding the sacred animal by the horns but he is not about to kill it. It must surely be the Keryneian hind.

This fibula showing Artemis' hind and the Hydra (Fig. 119) is considerably later than the other fibulae by the Lion Master. The Herakles in the hind scene does look rather like the horse-leader on the earlier fibula. But the movements are less light-hearted and playful, and the size and nobility of the figure are typically 'heroic'. The figures of Herakles and Iolaos go even further. They take up the full height of the plate. They are not moving like hunters in hilly terrain, but are standing firmly on both feet, to the left and right of the necks of the Hydra. It is not so much the silhouette-rendering of the figures as their roundness, seen clearly in the line of the men's backs, which is new. The shoulders slope down in front of the figures, with two arms on the end of them. There is a contrast between the feeling for the curves of the body and the continuance of the old silhouette figure. The emphatic buttocks and the low-set eyes are older features, whereas the tall helmets of Herakles and Iolaos are typical of a later period.[32] Unlike the three earlier fibulae by the Lion Master, the mythological pictures on this fibula in Philadelphia must have been produced in the first part of the last quarter of the century. Five more fibulae which also show the same horse and lion theme but are done by different hands, are obviously from the same workshop.[33] A small plate in London with delicate zigzag drawing is certainly by some talented pupil. Two more fibulae in Boston and Athens with three bells on the bows, have large lion pictures on them. Two fibulae, one sketchily drawn, the other crudely, mark the end of this workshop. The latter, from Thebes, probably dates from the first quarter of the seventh century. So there is a whole series of similar fibulae distributed over a remarkably wide area, all using the same motif until into the seventh century, and all associated with the Lion Master.

Another group of engraved plate fibulae can be attributed to the Ship Master.[34] One of his pieces, the Berlin fibula with two lions tearing up the upper part of a human being, has already been mentioned.[35] The lions stand upright with front legs crossed, drawn as though they were merely standing opposite each other. They are symmetrical. Only their victim, torn apart between their jaws, shows that the lions are in fact rearing up in order to tear the dead man between them to pieces. Early gold reliefs in Athens (Fig. 106), a gold band from Eretria and the Attic kantharos in Copenhagen (Pl. 69) show, in the second and third quarters of the eighth century, bodies between lions in one plane.[36] In Ephesus two reliefs, one gold and one electrum, have been found with two upright lions and a man—it can scarcely be goddess—between them. The animals' front legs are touching the outline of the man.[37] These gold reliefs are of Oriental origin, probably Phrygian. This is the prototype of the erect lion with some divine or condemned being, between them. Boeotian fibulae, following Oriental models, show lions standing quite erect; when there is a hero between the huge animals, he is already dead.

In addition to the pair of lions on this fibula, there is another pair of erect beasts, standing up on their hind legs, fighting each other. These occur on a splendid tripod leg from Olympia (Pl. 213), decorated with fan-grooved ridges. They form a lower relief picture, incompletely preserved. On top there is a picture which we have already come across, of two heroes fighting around a tripod.[38] The fighting is being done with the forelegs. The huge manes thrust towards each other; jaws are wide open, with tongues and teeth almost like those of Late Geometric monsters. Between the animals' bodies is a stylized plant—not a hero, as in the Orient, or a dying warrior. Only the stylized plant suggests the orientalizing style. This fragment of a splendid tripod may belong to the last decade of the eighth century. The Boeotian fibula, with its pair of erect lions and a warrior torn to pieces, was probably made earlier in the last quarter of the century.

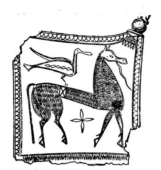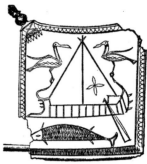

120 Plate fibula from Thebes.
Overall length 13.5 cm. Athens, National Museum

We can attribute two fibulae in London and Athens (Fig. 120) to the same master.[39] The backs of both plates show a horse which is tied up to a post or in its stable. A bird has alighted on the horse's back. Underneath the horse's belly is the only decorative feature, a simple quatrefoil. Even on these backs of the fibulae, with stereotyped horses, one can see the special style of the Ship Master in the simple quatrefoil ornament and the clear drawings. On two of the fronts there are ships. No human beings appear either at the steering-oars or in the cabin on the poop. The ship is shown by itself, without a crew, proud mistress of the sea, and superb product of human technology. The bowsprit with its huge ram and its bow decoration (showing it to be an Attic warship), the ribs running up to the deck and the poop decorated with an aphlaston above the cabin and steering-oar are all carefully drawn. In the middle of the ship is a mast with two stays made fast at the bow and the stern. Underneath, a dolphin is swimming in the same direction as the ship. Two large birds have alighted on the bow decoration and the aphlaston. The only ornament, a single quatrefoil, appears above the stern half on the ship, between mast and stay.

One can also attribute related pieces to the same Ship Master, including two fibulae in the Louvre,[40] one with three fish on one side and a large swastika on the other. The other one has a horse and a bird on the back; and on the front a merchant ship with the same mast rig, two birds above the bow and stern and two fish below the ship (Fig. 121). Six oarsmen can be seen in the ship. A large Attic dinos in London (Pl. 72) which shows a woman being carried by

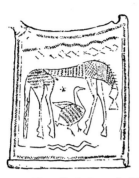 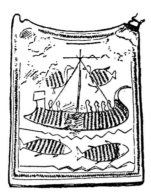

121 Plate fibula from the Thebes area.
Width 8.5 cm. Paris, Louvre

a crewman (probably Ariadne and Theseus), a warship with thirty-nine oarsmen, and an early Protocorinthian dinos in Toronto (Pl. 76) with eighteen oarsmen, has the same features.[41] These considerably later works by the Ship Master date from just before 700 B.C., if not the next decade.

The fibulae of the 'Swan Master'

Four fibulae from Thebes and Crete (Pls. 232, 233), now in London, Berlin and Athens, have been grouped together as the work of the Swan Master.[42] Here we still find the careful drawing of the Ship Master, but the zigzag line is richer. The single zigzag has disappeared. On the two swans on the front and back sides of the plate from Thebes now in Athens, a decorative motif appears in the feathers of the birds, on the edge of the plate and on the edge of the great bow. It is no longer Geometric but rather like a gentle wave. There are two parallel lines on the outside edge of the plate with the wave motif running along the inside. On one side of a fibula in the British Museum, with three 'bells', on the bow, are a splendid horse, a superb swan above it, and a quatrefoil and a double cross between them. On the other side is a doe with two swans above its back. The drawing is sloppier and the 'wave motif' is not emphasized, being replaced by a more Geometric motif.

The fibula from Crete, now in Athens (Pls. 232, 233), is the latest and best piece by the Swan Master.

The zigzag lines are superb. The frame consists of two tracks with the new Geometric motif between them. The lines of the bow of the ship, the torsos and thighs of the archers and the upper bodies of Herakles and Molione form a closely woven net. On the tapered ship, the calves of the archers and the legs of Herakles and the Molione there is a cross pattern with simple dots. The engraver seems to have been intimately involved in this engraving, giving it a life and a new kind of artistry all its own. The ship (Pl. 233) is the same as the Ship Master's, with bow decoration, aphlaston on the poop, cabin and steering-oar. Even the iron spikes in front and behind are present. But the mast is missing. The ship is out at sea without sail or rigging, accompanied by three dolphins.[43] But on the aphlaston on the poop and on the bow decoration two giant archers are crouched. Crete was famous for archers and pirates. The figures are not seen from several viewpoints in the Geometric manner, as they are on the fibulae from Philadelphia in the battle with the Hydra and the struggle with the hind (Fig. 119); these warriors are simply shown in side view. A Protoattic spirit infuses the picture, and the whole thing, with its splendid ship and its dolphins, has the charm of an earlier age. Arrows have struck one archer in the knee, the other in the calf. Bows are being drawn again, aimed at each opponent's chest. But the bows are reversed, with the arrows set against the bow and the strings towards the front! Does this picture show, perhaps, only a practice fight? This seems unlikely. But we should not forget that the engraver may have known very little about archery.

The picture on the back (Pl. 232) shows a fight between Herakles and a twin-bodied opponent, the Aktorione, also known as the Molione, whom he killed at Kleonai. The two opponents extend from the bottom to the top edge of the fibula. The sea scene on the front, with the two archers, is some mythological story; the picture on the back shows one of Herakles' many adventures. The hero's back is curved and his shoulders project forward with two arms. Above the buttocks the body narrows sharply, with a belt of rings. The massive form tapers like the heroes in the battle with the Hydra on the fibula by the Lion Master in Philadelphia (Fig. 119). The form

of the Aktorione-Molione is also old-fashioned, with the two bodies combined, as in Attic Geometric art from the middle of the eighth century on, with four arms and with four legs set on the ground like four columns. The Aktorione is trying to stab Herakles' thigh with a spear grasped in two hands, and to pierce his knee with two more spears. But the hero's spear in his right hand and huge sword in the left are being driven into his opponent's groin.

The latest Boeotian plate fibula

A large fibula from Thebes in Athens (Fig. 122)[44] is one of the last important Boeotian plate fibulae. On the edges of the plates are two lines. Between these are overlapping semicircles. Zigzags and lozenges alternate on the tongues, with five multi-line points projecting into the picture zone on each side. A rider is sitting on a huge horse, and a fallen warrior is reaching for the foot of the rider while trying to stab the horse in the chest with his sword. On the back of the fibula a violent duel is taking place. A warrior on his knees, wearing a helmet with a curved crest-holder and huge crest, is brandishing a spear pointed at his opponent's midriff; the latter, whose own sword is still in its sheath, has seized the unsheathed sword of the helmeted warrior by the handle, while plunging his spear into his neck. This young hero is certainly the victor; the man sinking to his knees, with the splendid helmet crest, is the loser. It would be useless to attempt to identify the figures. All four warriors, on both sides of the plate, are wearing a doublet (or perhaps chain mail?) which reaches from the shoulder down below the knee. They have borders at the knee and the waist. The armholes are fringed. The warriors' doublets and the horse are rendered, not with simple zigzag patterns, but in a style similar to that of the Swan Master. Greaves are not, apparently, worn. The rider on the front is probably not riding side-saddle, but normally. The duel scene on the back is enlivened by two birds on the ground. In the middle of this side of the plate, between the fighting men, is an eight-pointed star composed of four lines.

This fibula which came from Thebes (Fig. 122) must be regarded as one of the latest, if not the latest, important pictorial fibulae. Hampe dates it in the second quarter of the seventh century.[45] Figures of riders appear in Attic painting in the last quarter of the eighth century. In the handle frieze of a beautiful krater of the Protoattic school, from around 700 B.C., in Berlin,[46] are two riders on horseback bending forward and holding a rein against their horses' manes, with their whips held ready on the croupe. The bare-headed figures are training their horses. On the shoulder of the Hymettos amphora in Berlin,[47] behind a chariot drawn by a pair of horses, there is a rider with a flowing helmet crest, with his left hand on the mane and right hand on the croupe. The neck picture on the same amphora shows two heroes fighting. They have greaves, round shields and helmets with huge crests. The shields are clashing together, one seen from the inside, the other from the outside. The man on the left is fighting with a naked sword, while his opponent, whose sword is still in its sheath, is using his spear. Scenes like this probably occurred frequently. They need not necessarily be Protoattic. Nevertheless, the duel and rider scenes on the late fibula from Thebes have the same new pictorial quality as the Hymettos amphora. It must have been produced soon after 690 B.C.

Protocorinthian vase painting of the first black-figure style, primarily from the first quarter of the seventh century, is more similar to this important picture fibula. An almost completely preserved Protocorinthian kotyle, an import to Aegina like so many Corinthian items, has four riders in the main frieze,

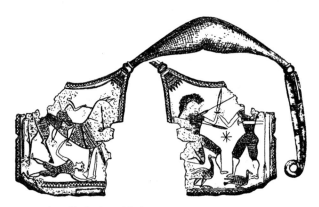

122 Plate fibula from Thebes.
 Length 23.5 cm. Athens, National Museum

trying to control two great beasts with huge hooves and croupes.[48] The rein on the halter and the whip on the croupe are the same as in Protoattic pictures of riders. The bodies of the horses curve down to the short front legs, to leave room for the rider. The horse in our fibula, too (Fig. 122), which appears to be standing on a slope, curves down towards the two short front legs, to leave room for the fallen warrior and the rider with his crested helmet.[49]

3 Bow fibulae

Bow fibulae or half-moon fibulae are considerably rarer than plate fibulae. They were usually used as large pieces of jewellery, and may have been kept for varying lengths of time. They were probably not produced in such large quantities.

a Attic bow fibulae

In the very richly equipped Geometric Grave 41 in the Kerameikos necropolis the excavators found—in addition to the vases, two large gold-plated iron pins, a bronze bowl, three gold rings, and a little plate of carved bone with two ducks' heads on it—a collection of ten bronze fibulae.[50] These were joined in two sets of five, with the pins shut. The first set (Pl. 234)[51] consisted of a large plate fibula with four smaller bow fibulae attached to it. The second (Pls. 235-237)[52] consisted of two plate fibulae and two bow fibulae, all attached to a larger plate fibula. Both sets are 'tripartite', having one large plate fibula, and two pairs of smaller items. The first set has two pairs of the same type but different sizes; the second, two different pairs. The pottery from the grave lasts from the end of the ninth century to the first quarter of the eighth. The semicircular shape of the two larger fibulae, also found on an example from the Protoattic deposit, now in Toronto,[53] is an older,

more spectacular version of the Attic fibula, which later turns into the rectangular fibula shape. The smaller bow and plate fibulae are certainly not 'Hallstatt-Illyrian rattling jewellery'.[54] They are jewellery worn on garments by girls, women and probably youths. More important is the fact that the bow fibulae begin, as it were, in a small way and then develop in Attica.

The bow fibulae from the Kerameikos (Pls. 234, 236, 237) are engraved with delicate zigzag lines In the middle of the half-moon-shaped areas is a swastika. On either side is a fish swimming towards the middle. All six bow fibulae have the same pictures, but the edge ornaments are richer on the larger pieces, consisting of a wide lozenge band, with small dots and larger central dot, running along the inside edge of the bow. It is only on the best preserved of the plate fibulae in the second set (Pl. 235) that one can make out the engraving. The composition of the ornament on the tongue is reminiscent of the decoration on tripod legs from the beginning of the eighth century. Most of the plate is now abraded; it is only on the edge and on the extension of the tongue that anything is still preserved. One can make out the front part of a warship, with a tunny fish underneath. The drawing is excellent.

There is a small bow fibula, probably from the second quarter of the eighth century, in Berlin.[55] It has a six-leaf rosette in the middle of the half-moon, surrounded by a wheel rim and with three tiny circles between the leaves. To the left of this is a swastika with a tiny circle in each hook; on the right is a bird. Within the lines are areas of fine dots. The wheel rim is obliquely hatched. The same oblique hatching also occurs on the edges of the small fibula from the Kerameikos. This fibula is certainly also an Attic product.

At this point, the traditional small Attic bow fibulae suddenly stop. This is probably simply a gap in the finds to date. It would not be surprising if more bow fibulae from a later date were to turn up in the future. For the six-leaf rosette surrounded by a wheel rim, as on the Berlin fibula, is the basis of the central ornament (by now a large emblem taking up the full depth of the bow) on the fibulae with very large half-moons which begin several decades later.

b Boeotian bow fibulae

Two of these large decorative fibulae are now in London (Figs. 125, 126) and four are in Berlin (Figs. 123, 124). They were certainly all produced in the workshop, but at least two and perhaps three different craftsmen actually made them.

The pair of bow fibulae in Berlin, 8458 and 8396

An isolated bow fibula from Greece (Fig. 123)[56] and an example from Thisbe (Fig. 124),[57] both in the Antiquarium in Berlin, are closely connected. The central ornament on the fragmentary piece (Fig. 123) is a developed version of the basic motif of the six-leaf rosette. But underneath one six-leaf star there are six more leaves of a second rosette between those of the first. There are six small double circles with a dot in the middle on the leaves of the star underneath. Twelve more are set in the gaps between the points of the leaves. Between wide bands of three and four lines and a thick wheel rim, run overlapping semicircles. There are two swastikas in the spaces on the left and right of the central emblem. In the hook of these are double circles with dots in the middle and connected by tangents. The small Attic fibula in Berlin mentioned above,[58] with a central rosette with a wheel rim and a swastika on the side, is obviously a forerunner of this later piece. The double circles in chains in the swastikas are similar to the hammered sheets of tripod legs and ring

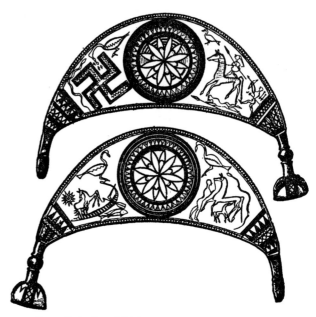

124 Bow fibula from Thisbe.
Length 14 cm. Berlin, Staatliche Museen

handles which came into fashion about the second half of the eighth century and thereafter.[59] The double semicircles with dots in the middle on the extremities of the bow, and the fish and birds around the swastika, are however neither Attic nor Boeotian in origin but more likely central Peloponnesian, probably derived from Arcadian-Elian workshops.

The large half-moon fibula from Thisbe in Berlin (Fig. 124), with only the iron pin missing, is somewhat later. The emblem is almost exactly the same, with two overlapping six-leaf rosettes with twelve points in all. The six bottom leaves each contain a double semicircle with a dot in the middle—a development of the six and twelve dotted double circles on the other older piece (Fig. 123). In the wide border of the rosette we now have a zigzag wreath instead of overlapping semicircles. The emblems are drawn with compasses, like the corresponding ornaments on large Attic kraters (Pl. 40).[60] The left half of the front side is filled with a swastika, as on the older fragmentary fibula (Fig. 123). But the chains of double circles between the hooks of the swastika have disappeared. They are now filled with thin zigzag bands. A little snake is wriggling up from

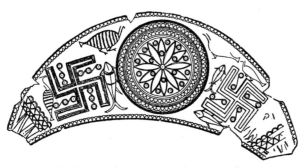

123 Bow fibula.
Length 16 cm. Berlin, Staatliche Museen

the left round the swastika. A bird is looking for food in the recess of the hook on the top right; it may be in danger from the snake which is by now so close to it. On the right is a battle scene. A warrior with a spear is stretched out on the ground. Above him is a horse, on which is a warrior with a Dipylon shield, a spear and helmet; the warrior is apparently unaware that behind him an archer with a sword and a quiver is aiming at him, about to shoot. In the top corner, by the emblem, is a small bird facing in the same direction as the bird on the left.

On the back there is a warship on the left, rather like the splendid ship on the Cretan fibula (Pl. 233), used as a horse transporter; above the bow is a star; a giant bird is perched on the aphlaston; and there are no men to be seen but there is a fish underneath the ship. The sea scene is balanced by a land scene on the right. Here a foal is being suckled by a mare, with a man holding the mare's halter. A snake is wriggling round the group like the one on the front around the swastika.

The two half-moon fibulae are by two hands. The older one is the fibula with the two swastikas (Fig. 123). This uses an older basic vocabulary of motifs. It has a rich individuality and may have been current around 710 B.C. The other fibula (Fig. 124) makes more extensive use of pictures next to the emblems. The period around 700 B.C. has begun.

The pair of bow fibulae in London, 3204 and 3205

The second pair of large half-moon fibulae, now in the British Museum in London (Figs. 125, 126), come from Greece and Thebes (?). The label 'Thebes' means nothing. But the fibulae are probably closely connected.[61] The four emblems in the middle of the bows are very similar. They have three layers: there is a six-leaf rosette in each of the top and middle layers and the bottom layer provides an extra point in each gap. Thus two six-leaf flowers and twelve extra points make a jagged wreath with twenty-four points. On the rosette in the middle layer there is a line across each of its six leaves, making a smaller circle, though the drawing is not always consistent. The six-times two points of the bottom layer make a

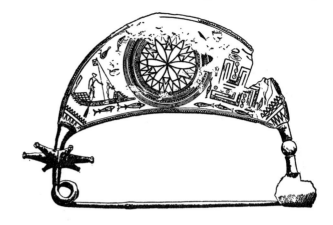

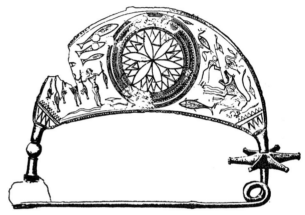

125 Bow fibula.
Length 23.6 cm. London, British Museum

larger circle. Both circles are composed, in true Geometric fashion, of straight lines; they form a mathematical, Geometric base to the larger circle made by the various elements of the different layers, with twelve leaves and twelve points combining to make a wreath with twenty-four points. On one fibula (Fig. 126), there are bad gaps. But both emblems on the other fibula (Fig. 125) are intact. Note here that one leaf in the middle-layer star has no covering leaf. On the second emblem on the same fibula, the leaf without a covering is eight points further a round.

The same ornament occurs on ivories from Megiddo, on the lids of pyxides and on the bottoms and insides of bowls.[62] G. Loud has good reasons for dating the Megiddo ivory treasure between 1350 B.C. and Ramses III (that is, about 1150 B.C.). There would have

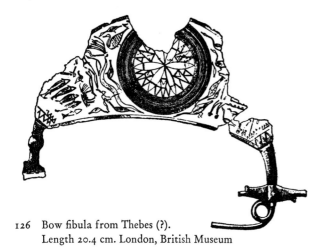

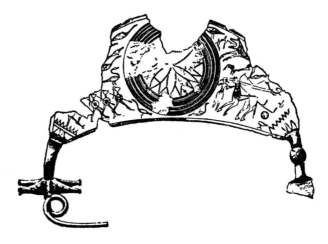

126 Bow fibula from Thebes (?).
Length 20.4 cm. London, British Museum

been plenty of opportunities in later times to come by ivory vessels from the Orient.

Let us now look at the figured pictures on both fibulae. On the front of the first (Fig. 125) to the right of the emblem, there is a large swastika with a herringbone pattern in the hooks, and three single circles with dots and tangents in the recesses. Nearby are three fish and five (?) birds. On the left of the emblem is a beautifully drawn ship with a bowsprit and ram, an aphlaston on the stern, a steering-oar, a larger cabin on the poop and a smaller one in the bow. In the middle is a mast fixed to the keel with a stay running from the bow to the top of the mast. There is also a 'crow's nest' on top of the mast. The helmsman is holding on to the mast, and a member of the crew is holding the stay. Two fish are swimming in the sea and two birds are flying over the ship.

The back shows two of Herakles' adventures: on the left his slaying of the Stymphalian birds which were ravaging the countryside, and on the right, his overcoming the Nemean lion. Herakles is holding two dead birds in his hands. The upper part of his body is almost completely destroyed. The figure next to him is not Iolaos but a female figure perhaps Athena, wearing a large chain with pendants across her bosom, with a dead bird. Two birds are flying away; another one, and a snake, are lying on the ground. Above them are four fish swimming in the lake of Stymphalos.[63] On the other side, Herakles is killing the lion

at Nemea with his spear. Behind the lion is a scorpion. A dolphin is calmly swimming in the river and five birds flutter excitedly overhead.

The second London fibula (Fig. 126) also has two mythological pictures on the main side. On the left, Herakles and Iolaos are fighting the six-headed Hydra in the Lernaean swamps. The huge body of the snake is wriggling in the swamp like a boa-constrictor. Some distance away, at the middle of the body, is the tiny form of Iolaos, who is in the process of sawing through the body of the snake with a saw-toothed sickle. The giant Herakles is struggling above him. His arms are outstretched. With his left hand he is strangling the six necks of the snake, and with his right he is swinging his sword to cut off the heads. His feet are being menaced by Hera's crab. Five fish in a row are trying to swim through the swamp and there are six birds, some lying on the ground, some fluttering round the battle scene.

On the right, even though half-destroyed, we can see what is going on. It is a picture of the 'wooden horse' which was led to the destruction of Troy. There are wheels on the front and back hooves of the horse. The horse's body is cylindrical with doors which open and little windows in the belly. There are no men to be seen around the super-horse. Is it some votive offering to the gods? A few years ago, a relief pithos 1.3 metres high was found by chance in what is now the capital of the island of Mykonos. It has been possible to reconstruct this vessel almost com-

pletely.[64] On the broad neck of the pithos is the wooden horse with windows in it, but here the windows are open. One can see heads of Greeks through the holes. Splendid helmets, a sword and some shields are being handed down. Warriors with spears, shields and helmets are climbing down out of the horse's belly. On both of the friezes, subdivided into 'metopes', above the shoulder of the pithos, there are pictures of the last battle of the Trojan heroes. This relief pithos must have been produced around the middle of the seventh century, and the simple wooden horse on the fibula must presumably be dated a good deal earlier. The horse is surrounded by a flock of eight birds.

On the back of our fibula are three different pictures: five warriors with round shields, spears and helmets are marching along with long strides on the bottom left, like a phalanx, towards the emblem. May they perhaps have sneaked out of the wooden horse at night and now be hastening to fight the Trojans? One cannot really be sure, but the warriors clambering out of the horse on the pithos from Mykonos are in fact assembling in ranks. Two birds have alighted in the path of the warriors and four more are flying away. There are two scenes on the right. In the first, there are a horse and a racing chariot with a six-spoked wheel and chariot-box above it; in it is a charioteer reining in his horse. There is also a man seen from a frontal view, with a bowl in his left hand with water for the horse. Above, there is a picture of a lion which has torn a calf to pieces. A doe or a goat is grazing unawares on the hillside. In the corners by the emblem are two pairs of birds, facing out underneath and inwards on top.

The pair of bow fibulae in Berlin, 31013a-b

Two more large bow fibulae came to light in Athens without anybody knowing exactly when they were found. They then became part of Paul Arndt's private collection in Munich, where they were published during the First World War.[65] They were later transferred to the Berlin Antiquarium. The round central emblems on the bows—more so, even, than on earlier fibulae—are drawn with compasses. In the middle of the emblem is a six-leaf rosette.[66] An inner circle circumscribes its points, while six semicircles from the outer circle intersect each other at these six points, forming six border leaves which circumscribe the inner rosette. The overlapping semicircles continue into the outer circle, and the six leaves thus produced form a continuation of the inner rosette up to the external border. This means that each overlapping circle has a corresponding half-rosette and two wreath leaves in the outer circle. The whole forms a complete round net within the emblem. This net is not a Greek invention. Like the ray rosettes on the large bow fibulae described above (Figs. 123-126), the round emblems on these two Berlin fibulae were originally Oriental idioms which occured on textiles and especially carpets. Stone and ivory imitations of woven carpets have been found in Niniveh, Khorsabad and Nimrud.[67] In all of them the six-leaf rosette occurs, with one vertical and two oblique axes, one sloping to the left, the other to the right. Highly artistic nets of overlapping rosettes sometimes form a basic motif extending over the whole of a carpet or stone floor. This is the source of the round emblem on the four sides of the two bow fibulae—certainly of Oriental origin.

The picture zones on the two half-moon fibulae have no mythological scenes. On the front side of the first fibula are two one-horse, single-axle racing chariots. In the chariot on the right is a warrior with a crested helmet, a round shield and a spear. On the left, two more warriors are similarly armed. The wheels have four spokes. The racing chariot on a fibula in London (Fig. 126) is very similar, except that its wheels have six spokes. Under each chariot are two fish and next to the emblem are three birds. On the back is a warship; on the ship's rail there is a row of round shields. Two warriors, like those in the chariot, are standing in the ship, one in the bow, the other by the steering-oar. A member of the crew is standing by the mast, with another in the crow's nest on top of the mast. A similar crow's nest, without a lookout man, occurs on the other fibula in London (Fig. 125). On the other side, a mare is suckling its foal; the mare has bands across its neck and body. This image is in a tradition going back to the third

and fourth quarters of the eighth century. Three fish are swimming above this idyllic scene. Two birds, a 'chariot wheel', and a little snake complete the picture.

The second fibula is less well preserved. On the front, there is a warship to the left. A horse is tied up to the ship with a crewman on deck holding its reins. Three fish are swimming alongside the transporter. On the right, a bird is flying towards the emblem and underneath, two warriors with round shields and spears are fighting each other. On the back there is a ship on the left containing four warriors with round shields and helmets, holding four long spears up in the air. Dolphins are swimming along-

side the warship. On the other side there is only a large swastika with a single ring and dot in each recess. Above it are some fish and a snake is wriggling along the ground.

The 'net' fibulae, as one might call these last two from their central ornaments, should probably be dated rather later than the 'star' fibulae, that is, the four other large bow fibulae (Figs. 123-126). The Late Assyrian prototypes of their ornamental motifs last from the ninth century until well into the seventh. The covering on the floor of the threshold from Khorsabad may have an even earlier date. But the net fibulae, to judge by the pictures in the corners, date from the first quarter of the seventh century.

Architecture

Very little survives of the houses, palaces and temples built during the Geometric period.[1] Where they existed, the great citadels constructed by the Late Mycenaeans obviously afforded all the security that was felt necessary. In Tiryns, for instance, after the destruction at the end of the Mycenaean period, in about 1100 B.C., the inhabitants, by then considerably reduced in number, found primitive accommodation in such parts of the palace in the upper citadel as were still standing or could be crudely reconstructed.[2]

1 Geometric houses

On the eastern slope of the acropolis at Asine, near Nauplia, amongst the ruins of Mycenaean houses, there is a rectangular Geometric house with a door set off-centre in the longer front wall, along with the remains of two more houses obviously of later date.[3] Geometric houses of this kind can usually only be identified by the extremely simple arrangement of their stone foundations, or, if we are lucky, by the occurrence of Geometric finds on the site. The superstructures of these buildings were made of beams and clay tiles dried in the sun. These materials do not last forever. This partly explains why Geometric-type houses are so rare now. Another reason applies to larger settlements, or towns such as Athens. One would expect to find Geometric houses only in the middle of such settlements, in the city centre, but these are just the areas where modern building has usually most thoroughly eradicated all traces of earlier and less sturdy constructions. How many residential houses from the early medieval period survive in our own towns?

But traces of primitive country dwellings do occur on the outskirts of towns, where the urban environment meets the countryside and where a less compact style of building was feasible. These were sometimes on the sites of what later became large public squares, such as the Agora in Athens. The best example of such a building is a house with an elliptical ground plan, flat stone paving, walls made of sun-baked brick and a wicker hip-roof, found at the bottom of the north slope of the Areopagos on the southern edge of the Agora in Athens (Fig. 127).[4] The entrance would have been on one of the longer sides, probably the north, and would have been off-centre. Under the floor was a carefully dug child's grave with offerings from the beginning of the Early Geometric period.[5] The pottery finds suggest that the house was occupied for about 75 years, up to the end of the ninth century. The ground plan of this simple shepherd's or peasant's house with one or two rooms is in a venerable tradition going right back to the beginning of the Bronze Age. It is the indigenous country-house plan which lasted through all the migrations and upheavals of early history and remained unchanged in

127 Plan of an oval house on the Areopagos in Athens

the centuries during which a flourishing Mycenaean style of architecture developed. People continued to recognize the importance of these primitive traditional buildings for centuries afterwards. Vitruvius mentions a hut of this kind on the Areopagos, with a clay-covered roof, which existed in his own day: 'Athenis Areopagi antiquitatis examplar ad hoc tempus luto tectum' (on the Areopagos in Athens there is an example of this ancient style of building, still covered today by a clay roof).[6] Vitruvius compares the building with Romulus's hut on the Capitol. The survival of the house in Athens mentioned by Vitruvius was probably nothing to do with its old age or its being a historic monument, but was, most probably, connected with an ancient sanctuary of chthonic deities on the Areopagos, the Erinyes or the Semnai. The cult of these avenging and protecting goddesses had certainly already existed in pre-Greek Minoan times, as can be deduced from the Cretan features of a votive image of the gods from around the middle of the seventh century, found in a large deposit of votive offerings near the house above.[7]

The closest parallel to the Areopagos house with its oval plan is a limestone model of a house (Pl. 239), a votive offering found in the Heraion on Samos.[8] The context dates it in the second half of the seventh century or the first half of the sixth. It is no longer Geometric. But it is, in every detail, including the off-centre door in the longer front wall, and the roof structure, just like the ninth-century oval house. Since it was a votive offering and a type of house which was by then out of date, it must be a model of some primitive religious building.

2 The origins of Greek temple architecture

As shown by the oldest large sanctuaries in Greece in the historical period, houses for cult images—temples—did not originally form an integral part of a sanctuary. Their function was fulfilled by a *temenos* or sacred area surrounded by a fence or wall, with an altar for sacrifices in the middle. There was sometimes a wooded grove inside the *temenos*. The oldest

type of sanctuary occurs in eastern Ionia: for example Ephesus, on islands such as Delos, and on the mainland in places such as Olympia and Delphi. It was not until the Geometric period that the first temple buildings were constructed, or rather, reinvented after the catastrophic upheavals which had taken place. There seem to be three sources of temple architecture: first, the oval country huts, the basis of the subsequent Late Geometric apsidal buildings; then the rectangular Geometric house, related to the Mycenaean princely palace, with a throne and sacrificial hearth inside; and lastly, the elongated Geometric large house.

a Apsidal buildings

The probably oval house on the Areopagos mentioned by Vitruvius and the later model of an oval house from the Geometric period in the Heraion on Samos were early religious buildings. The first Temple of Hera Akraia in Perachora (Fig. 128)[9] on the Gulf of Corinth, near Loutraki, already in use by the Geometric period, is a later development of this type of elongated apsidal temple. The façade is straight, without a porch. The side walls and the façade from right angles and the western wall is rounded like an apse. Measured on the exterior, the ratio of length to width was probably about 2:1 (approximately 7 x 3.5 metres). The proportions of the spacious interior (approximately 6 x 2.15 metres) do not apparently form any deliberate ratio. The excavators, without any really good evidence, estimated the life of the

128 Plan of the oldest Temple of Hera Akraia in Perachora

temple as lasting from its construction in the ninth century up to the third quarter of the following century.[10] But its apse, straight side walls and special entrance facing East suggest that it was built rather later, at the beginning of the eighth century.

The little temple was the place where the cult idol was housed. A clay model of a little round temple found in Archanes on Crete (Pl. 238),[11] with a removable door, demonstrates this. On opening the door, one sees a goddess sitting inside the temple—the great Minoan goddess, with both arms in the air. This little clay piece is in the style and technique typical of the sub-Minoan period, between 1100 and 1000 B.C. It is a curved building with a slightly arched roof. On top are a jackal or a dog (?)[12] and two guards, Kuretes or Dioscuri, with their right hands raised to their turban-like head coverings in a gesture of adoration.[13]

But it is difficult to establish any direct connection with the oval buildings constructed on the mainland in the Geometric period. Idols also occur somewhat earlier in models of grottoes and caves. The round shrine from Archanes (Pl. 238) is in fact an architectural version of the cult caves which were so important in Asia Minor and Crete. It is the end of a phase, whereas the mainland oval and apsidal buildings are the beginning of Greek temple architecture. Nevertheless, the increasing significance of idols in the Late Minoan period on Crete and the enthroned female divinities on Late Mycenaean gold rings are both evidence of an increasing tendency in the Minoan Aegean religion to make images of gods. This trend can probably be connected with the predominance of Greeks in the population. Even if no direct historical connection can be established between the round shrine and its cult image from Archanes and the curved buildings on the mainland from the Geometric period, there was a radical change in religious habits in the Late Mycenaean and sub-Minoan period, leading to the housing of idols and under-life-size cult images. The religious conditions already existed by the end of the second millennium B.C. amongst the Late Mycenaean Greeks, on which Geometric architecture was able to continue.

One of the most decisive changes in curved buildings was the construction of an open porch resting on columns or piers, in front of the portal in the east façade. Evidence of this development is given by the Geometric terracotta 'temple models' from Perachora. The best preserved of these can be reconstructed with some confidence (Fig. 129) but only fragments remain of the other three.[14] Their ground plans are unlike both the oval and the apsidal houses, the latter with round apses and straight side walls. The ground plans of these models are more like horseshoes. The

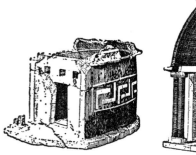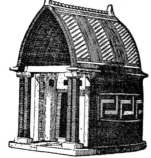

129 Model of a temple house from Perachora. Athens, National Museum

rectangularity of the porch is not, as it were, continued into the short cella. Excluding the porch, but including the antae, the ratio of width to length is 2:3. It would be rash to make any chronological deductions from this without allowing for the tendency of any potter to produce, for technical reasons, outward-curving walls. The building represented in this model is more of a 'chapel', or *naïskos,* for the cult idol, than a temple like the oldest cult building of Hera Akraia (Fig. 128). Light reaches the interior through a row of close-set triangular openings on top of the walls and three square windows above the door. A steeply pitched, slightly arched roof with a hip at the back and an open gable at the front rises above the vertical walls and the ceiling of the inner chamber. It is almost as tall and heavy as the lower part of the structure. The antae of the cella project a little into the shallow rectangular porch. In front of them, on two rectangular slab bases, are two pairs of columns, which form the front corners of the porch. On top of them are two more slab-shaped capitals which support the extension of the roof of the little temple. This is the first instance of a façade with antae, free-

standing roof supports and a gable. These bring out invisible forces acting within the structure, demonstrating the upward force of the supports, the downward thrust of the weight of the roof, the articulation of the individual elements, and their interaction. This was the starting point for the later development of the Doric temple.[15]

The painting on the walls and the roof is in the Geometric ceramic idiom: simple right-running meander, zigzag, and oblique-hatched roof areas. But these can hardly be architectural ornaments. Their style is Corinthian. The model would have been produced during the High Geometric period, not before the second quarter of the eighth century.

b Rectangular temple houses

Parallel with the development of the curved Geometric house is that of the rectangular building known as the 'temple house'. There are two clay models of this type from Argos (Fig. 130)[16] and Ithaca.[17] Traces of similar temple houses have also been found in the Sanctuary of Artemis Orthia in Sparta[18] and at Dreros on Crete (Fig. 131).[19] On three of these, there are remains of porches. And in the case of the oldest Geometric temple in the Orthia sanctuary, the existence of a porch can probably be assumed. In the Dreros temple, the porch is supported by two pairs of columns, as in the Perachora model (Fig. 128). The window-like openings have disappeared. The Argive model, on the other hand, still has four triangular openings, and instead of double columns there are two square piers. In the model from Argos and the temple at Dreros the pitched roof is set back from the porch. In the former, the gable has a large window. But making the pitched roof virtually a smoke-hole above the place of sacrifice in the reconstruction of the Dreros temple seems to me to be incorrect. The technique of adding a porch after roofing the cella, known everywhere except in Sparta, may derive from an earlier tradition—of which we have no record—than that represented in the obviously more sophisticated model temple from Perachora (assuming that the latter's

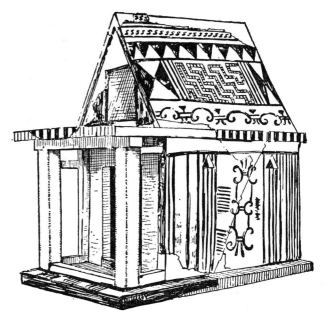

130 Model of a temple house from the Argive Heraion. Length about 37.5 cm. Athens, National Museum

reconstruction is correct). At all events, both the temple models and the actual temple at Dreros date from the transitional period leading up to the adoption of the orientalizing style, roughly the beginning of the last quarter of the eighth century.

The temples at Dreros (Fig. 131) and Sparta had central supports underneath the ridge beam. This would also have been structurally necessary in the buildings on which the simplified models were based. The proportions of the Argive model (Fig. 130) are 1:2; the Dreros temple is comparatively shorter, with a ratio of 2:3. This seems to take us back to Late Mycenaean religious architecture. The *anaktoron* on the cult site at Eleusis which dates from the Mycenaean period (Fig. 132) has a *megaron* with a distyle porch *in antis*, a central row of columns in the cella, and proportions in the ratio 2:3.[20] It looks as though Geometric architects revived, in a cruder form, the style of the Greek Late Mycenaean period, by then virtually forgotten. There is actually evidence on this site of the disappearance and subsequent revival of higher architectural forms. After the destruction of the Late Minoan *temenos* and *anaktoron*, an oval or apsidal religious building of considerable size was constructed over the ruins. This was later

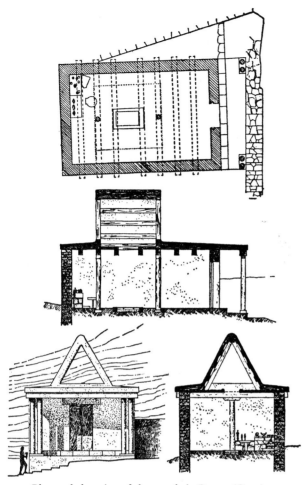

131 Plan and elevation of the temple in Dreros (Crete)

replaced by the Early Archaic *telesterion*. Only a few fragments of the apsidal building still survive.[21]

The interior of the temple cella is very simply arranged. Down the middle were bases for the wooden columns which supported the ridge beam. In the central intercolumniation was the place of sacrifice, a rectangular hearth or *eschara*. Against the rear wall of the temple in Dreros (Fig. 131), in the right-hand corner, there was a stone bench on which were placed the horns of goats which had been sacrificed and votive offerings. Next to this bench there was a stone-slab table, on which stood large fragments of half-life-size bronze statues made by an ancient technique of hammered bronze sheets. These are post-Geometric and date from the middle of the seventh century. There are a Kouros-type deity and two

smaller female statues. These would be Apollo, Leto and Artemis. One is reminded of the low benches at the back of Late Minoan and Mycenaean chapels in Crete and on the mainland, on which idols, cult objects and votive offerings stood.[22] But there is an important difference in the fact that in Dreros these sacred objects reached only from the right corner up to the line of the central row of columns. They would have formed a visual focus for people coming through the porch into the right aisle of the cella. The narrow, long cella leading up to the cult image would be the route along which the worshipper approached his gods. The same arrangements may have applied to the Geometric Temple of Artemis Orthia in Sparta, but no actual evidence of this survives.

Here we have, then, the oldest type of Geometric rectangular temple, characterized in the cella by central supports under the ridge beam, while the porch, with two free-standing supports at the front corners, shows another construction. These two parts of the building have different types of roof—the cella a steeply pitched roof, the porch a flat roof with a horizontal ceiling underneath, but presumably a slightly inclined surface on top to let rain water run off. These features can be seen in the Dreros temple and in the models from Argos and Ithaca. The two different structures clash with each other, not having yet been properly integrated.[23] But this style is the source, in the middle of the eighth century, for the development of the Greek anta-temple, to be created a few decades later by combining both parts under a single, less steeply pitched roof.[24]

The *eschara* or sacrificial hearth inside the temple has actually been found in the Dreros temple (Fig. 131). A similar arrangement was assumed by the excavators of the Geometric Temple of Artemis Orthia, and the same applies to the model temples from Perachora (Fig. 129), Argos (Fig. 130) and Ithaca, in view of the opening in the gable of the steeply pitched roof, which must have been an outlet for smoke. The altars were opposite the cult idols. Such features are obviously similar to those of the typical main *megaron* in the princely palaces of the Mycenaean period, in Mycenae and Tiryns. In these, alongside the throne which was up against the right-hand longer wall, there was a central sacrificial hearth in

the form of a round *eschara*, as well as arrangements for drawing off the smoke. The transition from the *megaron* to the cult room took place during the Mycenaean period. The *anaktoron* in the sanctuary at Eleusis, which was the seat of the (divine) 'ruler', was already a religious building. The type of temple with a porch and with a sacrificial altar in the cella, survived up to the end of the seventh century. The most important examples are the Temple of Herakles on Thasos and the Temple of Hera Limenia in Perachora, both dating from around 700 B.C.; the Temple of Prinia on Crete; the Temple of Neandreia; and the oldest Temple of Apollo in Cyrene.[25] But in the older large sanctuaries, the altar appeared long before the first cult buildings and subsequently retained its position in front of the east façade of the temple house, as for instance in the *temenos* of Hera on Samos. This practice was to become common from the Ripe Archaic period onwards, particularly in the Classical period. The row of central columns continued to be used for a long time, up to the end of Archaic architecture, particularly in Magna Graecia and Sicily, where they reached monumental proportions.

The whole group of rectangular porch temples dealt with here seems to belong to the Late Geometric period after the middle of the eighth century. The painting on the walls dates the temple models the last quarter of the century. The temple at Dreros (Fig. 131), of which the walls are masonry rather than half-timbered construction, would have been built around the same time. The oldest Temple of Artemis Orthia in Sparta appears to be somewhat earlier but can hardly have been built much before the middle of the century. Certainly the ninth or tenth centuries are out of the question.[26] Only the horseshoe-shaped model temple with a porch from Perachora (Fig. 129) could have been made at the zenith of the High Geometric period between 770 and 750 B.C.[27] Thus we have two separate datable groups. The first is associated with the oval and apsidal country and town houses from the end of the tenth century. This group includes the curved building on the Areopagos in Athens mentioned by Vitruvius and compared by him with Romulus's hut on the Capitol, and the oldest apsidal Temple of Hera Akraia in Perachora

(Fig. 128) with, as yet, no porch. None of these early temple structures can be dated before the eighth century. The second group has innovations such as ground plans similar to those of more sophisticated rectangular private houses with an open porch added, supported only by columns or piers beneath the front corners. This development must have some connection, if only remote, with the Mycenaean *megaron* in the *anaktoron* at Eleusis. The *megaron*, and only the *megaron*, was used for religious purposes. The façade of the temple is emphasized. So the seeds of the later prostyle temples, temples *in antis*, and indeed Greek temples in general, were planted in the Geometric period.[28]

c Geometric large houses

J. N. Travlos discovered the foundations of the so-called *anaktoron* (Fig. 132) above the place in the area of the later *telesterion* at Eleusis where Kourouniotis excavated the Mycenaean temple. Throughout all subsequent rebuildings, this *anaktoron* kept its position in the great hall of initiation into the mysteries.[29] Even in the Classical period it was a carefully designed stone building with an oblong ground plan (14.20 x 5.68 metres), having an entrance on the northeastern longer side near the eastern corner; the whole probably covered with a low gabled roof. The ground plan is unusual for the Classical period: an elongated building with a narrow passage-like interior room and a door set off-centre in the longer wall. The simplest ratio occurs on the outside surface of the walls (2:5), as in earlier buildings, not the walls of the room inside. It applies to the structure, not the interior space. One is bound to assume that the classical *anaktoron* was part of an older Archaic or even Geometric tradition. Was it simply an architecturally more sophisticated version of the oval-shaped religious building, remains of which were found on the same site, between the Mycenaean cult building and the Pisistratid *telesterion*?[30] This oval *anaktoron* might well be reconstructed on the lines of the ninth-century oval house at the foot of the Areopagos.[31] But the little limestone votive building

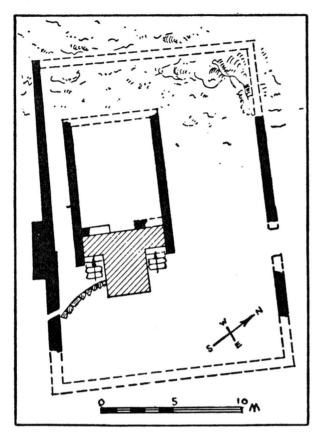

132 Plan of the Mycenaean *megaron* beneath the *telesterion* in Eleusis

(Pl. 239)[32] found in the Heraion on Samos, is the closest counterpart, with oval ground plan, narrow elongated interior, and eccentrically placed door in the longer wall, like an early predecessor of the *anaktoron.*

The *anaktoron* was the adyton of the hall of the mysteries, which no one was allowed to enter except the hierophant, whose throne, with a warning inscription on it, stood outside the building next to the entrance. Inside were the objects and symbols used in the initiation ceremony. Did people perhaps believe that the *numina* of the great Eleusinian gods Demeter, Kore and Pluto, were present here? This is suggested by the survival of the ancient name *anaktoron* surviving through all the changes in the originally pure fertility cult. The name must have referred to the holy 'rulers' of Eleusis. The Eleusinian religion, one of the strongest of all cults, was also a family

cult during the period when Eleusis was politically independent. The hymn of Demeter still mentions the name of King Keleos of Eleusis, who started the cult.[33] The name *anaktoron* must originally have referred to him. This takes us back again to the Mycenaean period, where the house of the ruler and the house of the religious cult of the royal family were one and the same, at least in Eleusis in the Late Mycenaean period. The ruler's house was also the religious centre of the town. The name *anaktoron* as applied to the Mycenaean cult house at Eleusis is a guess, but probably a good one.

The influence of the Mycenaean Greek house—the so-called *megaron*—on the structure of Geometric temples and the cellae of Greek peripteral temples has recently been disputed, but it can be so firmly established archaeologically that it hardly needs supporting by this kind of theorizing about names. The Temple of Hera in Tiryns was built during the Geometric period in the main *megaron* of the Mycenaean citadel palace (Fig. 133), actually using many of the ruins from the older structure.[34] The old *megaron,* and other parts of the palace, were crudely patched up after the final collapse of the Mycenaean civilization, probably being used at first as living quarters for the new ruler. Around the middle of the eighth century, this slapdash building was destroyed by a fire. Only its foundations survived, on which the Temple of Hera was built. In fact only half of the interior of the *megaron* was used. The east wall of the temple stood on the Mycenaean stone base of the east wall of the *megaron;* the shorter north wall used the northeast column of the *megaron* as a support; the west wall ran inside the second (west) row of pillars; and the threshold of the open south side must have been just under half a metre inside the line of the southeastern pillar. This produces an elongated

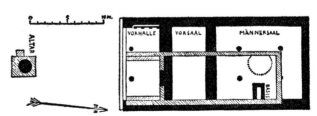

133 Plan of the Temple of Hera in the *megaron* of Tiryns

cella with the simple ratio 1:3 (7 x 21 metres) along the outside surfaces of the walls. The spacious interior room in the cella has no simple ratio. The three eastern columns of the *megaron* make a central row of columns in the Temple of Hera, running out into the porch. One cannot be certain whether the base of the Mycenaean throne, now near the rear wall of the temple and visible from the right-hand aisle, was used for exhibiting idols as in the contemporary temples at Dreros (Fig. 131) and probably also at Sparta. It seems likely. There was no place for sacrifices in the building. These were done by the round altar in the forecourt of the Mycenaean *megaron* axially aligned with it. The first sacrifices would have been made there before the great fire in 750 B.C., whenever the rather inadequately repaired *megaron* was dedicated to Hera of Tiryns. The Late Geometric Temple of Hera which followed the *megaron* survived until the middle of the seventh century. The evidence for this is a trench containing votive offerings to the goddess, which last until about 650 B.C. But the Geometric structure has a shape which is substantially different from that of the Mycenaean *megaron*, in spite of a more or less continuous architectural development. Its narrow front and elongated sides show that it was a product of post-Mycenaean Greece.

The more elaborate rulers' houses in the Geometric period must have been similarly constructed. But nothing survives which can, with certainty, be taken to be an example of such a building. The only relevant ruins are from the elongated house discovered by British excavators[35] on the acropolis at Emporio on Chios. This is a long rectangular building (18.25 metres) which must have been a palace. It has a central row of columns and twin columns in the porch. Its proportions and construction are similar to the Temple of Hera at Tiryns, although it may have been built in the sub-Geometric period. This must have been how the Geometric rulers' mansions were built. The type of temple we are dealing with here would have developed out of them.

Closely related to, but obviously older than, the Temple of Hera at Tiryns, is the 'house temple' of Apollo at Thermos in Aetolia (Fig. 134). Its ruins are some way beneath the Early Archaic Temple of Apollo and point in a slightly different direction. It must

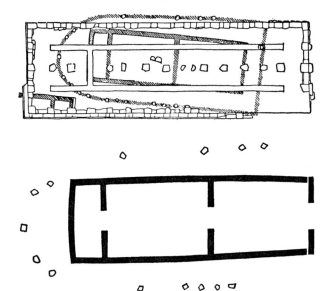

134 Plan of temple B in Thermos (Aetolia)

have been used for cult ceremonies up to about 620 B.C.[36] The surviving stone foundations are well laid, and show an elongated temple *in antis* with a deep porch, a main room, and a separate narrow room at the back (perhaps a thalamos or an adyton?). The plan is rectangular, although the north, west and east walls are almost imperceptibly curved (0.30 on 21 metres). There would have been a central row of columns as in the temple built above it in the last quarter of the seventh century. There are faint traces of a fireplace in the main room. As in the temple at Tiryns (Fig. 133), the lengths of the outside walls are in a ratio of 1:3.

Some time after being built, the house was surrounded by an oval pattern of posts, the stone bases of which still survive. These have been assumed to be part of an early, primitive kind of peristyle around the house which would have become a temple by then. The line of stone-post bases diverges from the longer walls of the house towards the south façade. Reconstructing a low-pitched roof covering the peristyle produces an impossibly complicated structure. Insufficient attention has unfortunately been paid to A. von Gerkan's suggestion,[37] which is surely correct, that the stone bases supported only a fence of posts which would have separated the sanctuary from the secular buildings nearby. The

oval shape of the *temenos* is reminiscent of the oval shapes of the old temples. This is an even clearer indication of the date when the mansion became a temple, which can be fixed here very accurately. Three small Geometric bronzes were found in the ash stratum immediately below the stone slabs of the posts.[38] The oldest of these, a man with a spear and a shield, is from the early eighth century, as is the second, also a man with a spear, although this is an import from an Asia Minor-Syrian workshop. The third piece is Greek, from the Late Geometric period. The last bronze is decisive. The house probably dates from the High Geometric period, the second quarter of the century. It was turned into a temple after the middle of the century, at the same time as the similar Temple of Hera at Tiryns (Fig. 133) was built.

The first Temple of Hera on Samos (Fig. 135) is harder to date.[39] It is a narrow building, almost a corridor, 32.86 metres long by about 6.50 metres

135 Plan of the first temple of Hera in Samos
(without peristyle)

wide on the exterior. The architect seems to have intended to produce a ratio of 1:5. The longer walls ended in antae on the east façade, with three columns or supports between them. One can probably assume (although later building on the same site makes it impossible to prove) that there was a porch with a door in the rear wall, as at Tiryns and Thermos. Down the central axis of the cella was a row of twelve columns supporting the ridge beam of the pitched roof. There seems to have been no place for sacrifices in the building. There was a sacrificial altar to the east of the façade of the building before the temple was constructed. This altar was rebuilt several times, eventually taking on monumental proportions by the end of the seventh century. The construction of any kind of smoke outlet in such an elongated roof

as this temple must have had, would have been very difficult. Between the rear wall and the last central support was a base for the cult image. This is set slightly to the north of the main axis. As in Dreros, and also probably Tiryns and Thermos, the idol

136 Plan of the first Temple of Hera in Samos
(with peristyle)

would have been visible only to someone in the right-hand naos aisle, with a long narrow route leading towards it.

Later on, the temple was rebuilt, acquiring a peristyle with seventeen columns on each longer side, six at the rear and seven in front (Fig. 136). The fact that the measurements of the stylobate produce no simple ratio between longer and shorter sides proves that the peristyle was added subsequently to an existing temple. This rebuilding would have necessitated widening and lengthening the roof. The temple cannot have lasted long in this form. In the first half of the seventh century, a second Temple of Samian Hera (Fig. 137) was built on the same site, mostly on the foundation of the first, dismantled Geometric temple. This building is an important step towards the canonical style of Greek temple architecture. The naos is slightly wider than before and shorter by one intercolumniation. The extra space is used for a double row of columns in front of the entrance to the cella. Between the antae are the normal two columns, not three as before. There are six columns across each of the narrower façades. There is no central row of supports. A row of supports with

137 Plan of the second Temple of Hera in Samos

double-width intercolumniation is introduced along the inside of the longer walls of the cella, and the cult-image base is set back against the middle of the rear wall. This first post-Geometric Temple of Hera at Samos is remarkably similar to the first Temple of Hera at Olympia, although the latter has no peristyle.[40] It would have been built in the first quarter of the seventh century.

d Summary

All the sources of Greek temple architecture are to be found in the Geometric period. We have, first of all, the rustic oval houses, including the house on the edge of the Agora (Fig. 127), the cult house mentioned by Vitruvius on the Areopagos at Athens, and the first Temple of Hera at Perachora (Fig. 128). Then there is the round, or curved house: these not only date from the end of the Minoan age at the end of the second millennium B.C., but derive from a different source from the mainland buildings, namely the ancient cave sanctuaries of the Minoan cults and the cave-like spring and fountain buildings from the Minoan period.[41] The mainland buildings last from the ninth century up to the first half of the eighth. The temple models from Perachora (Fig. 129) with their horseshoe plans come from the end of this period. These have the first porch façades with pairs of double columns, bases, wooden capitals and cornice. This type of façade was later to develop into the Doric order.

Almost organically connected with the above are the rectangular temple houses. The first Temple of Artemis at Sparta and the Temple of Apollo at Dreros are actual buildings of this type (Fig. 131). Then there are the temple models from Argos (Fig. 130) and Ithaca. All date from the Late Geometric period. All have a porch similar to that of the Perachora model (Fig. 129), a short naos, a central row of columns inside, and a steeply pitched roof. The last two features, the steep roof and the columns supporting the ridge beam, are structurally post-Mycenaean, but they are unmistakably reminiscent of the Mycenaean *megaron*.

Quite different, however, from the short, rectangular *megara* with their 1:2 or 2:3 proportions, are the longer cellae with porches, with external measurements in ratios of 2:5, 1:3 and 1:5. This group includes the Temple of Hera at Tiryns (Fig. 133), the forerunner of the Archaic Temple of Apollo at Thermos (Fig. 134)—both with proportions in ratio of 1:3—the earliest Temple of Hera on Samos with a ratio of 1:5 (Fig. 135), and the Geometric *anaktoron*, which has now disappeared, at Eleusis, with a post-Mycenaean shape which survived in the Solonian (?), Pisistratid and Periclean *telesteria* (2:5). There are clues to the existence of a predecessor of the Late Geometric *anaktoron* in the form of an elongated oval house like the one on the edge of the Agora in Athens (Fig. 127), which would date back to the ninth century. More important is the fact that this ancient building which maintained its shape through the centuries, a cult building in the middle of a huge hall of the mysteries, continued to be called an *anaktoron*, surely in memory of the royal founder of the tribal cult of the Eumolpides, to which the hierophant would also have had to belong. Deep beneath the eastern corner and the entrance to the *anaktoron* are the stone foundations of a Late Mycenaean royal hall (Fig. 132), also called *anaktoron*. Thus the name lasted through all the radical architectural changes during the early first millennium B.C., from the Late Mycenaean age up to the Classical period and beyond. But the transition from the Mycenaean ruler's house to the elongated cella of the Greek temple took place as early as the Geometric period.

The descent of the elongated cella from the house can be more clearly seen in the Temple of Hera at Tiryns (Fig. 133) and the first Temple of Apollo at Thermos (Fig. 134). The former was built after 750 B.C. in the wide royal chamber of the Mycenaean palace of Tiryns, about one third narrower. The temple at Thermos was first built as a house, and was then turned into a temple by separating off its *temenos* with a fixed oval fence. Finds on the site suggest that this change of function also took place in the Late Geometric period.

The dating of Heraion I on Samos (Fig. 135) is difficult since it is of East Greek origin and is not necessarily architecturally connected with the main-

land. H. Schleif dates the building of the temple in the period between Altar II and Altar III on the altar-court, that is, at the turn from the ninth century to the eighth.[42] This date cannot be substantiated, but it is probably somewhat too early.[43]

The 'Herzsprung' shields dedicated as votive offerings are significant here. H. Hencken, working from the early date given to the Cretan shields, recently dated the Greek family of Herzsprung shields in 800 B.C., perhaps earlier.[44] Several fragments of votive shields of this kind have been found below the level of Heraion II. Another fragment was found in the filling of Altar V,[45] dated by Schleif at the end of the eighth century. Now a central portion, precisely identical to the Samian clay fragments, occurs on a bronze Herzsprung shield from Idalion on Cyprus, now in the Louvre, dated by Gjerstad in the period Cypro-Geometric III (roughly 850 to 700 B.C.).[46] Around the middle of this shield are three concentric ornamental stripes of the simplest type: the basic rhythm is established by a frieze of embossed circles with central dots. A similarly embossed, wavy band winds alternately above and below these circles. This ornament is not vegetable, and is neither Assyrianizing nor Syro-Phoenician. It derives from the monotonous Cypriot circle ornamentation which started in the eighth century and lasted well into the Archaic period. This style uses vertical, horizontal and encircling friezes of small concentric circles, usually drawn with only two lines. The ornamental strips on the shield do not appear to occur on Cypriot vases, but this ornament does occur on the shoulder of a Rhodian amphora with vertically and radially set shoulder handles.[47] The vessel dates from the Late Geometric period, and is painted in the bichrome technique. The medallions on it are four concentric circles, the outside one thicker than the rest—a typically Late Geometric Rhodian touch. A wavy band, a belt round the belly, and a wider band on the neck are all done in red paint. The vase dates from the late part of the last quarter of the century, on the threshold of the Early Archaic period.

This gives us only a *terminus ante quem* for the building of the first Heraion on Samos. We are not in a position to say how far back Herzsprung shields go on Cyprus and Samos. But since H. Walter has plausibly associated the destruction of the temple with a second flooding of the waters of the Imbrasos towards the end of the first quarter of the seventh century,[48] the date of building must be brought down. The foundations which survive today would have been laid around 750 B.C.; perhaps a bit earlier, more likely, a bit later. This would make the building roughly contemporary with the period of the Temple of Hera at Tiryns, which also has a simple elongated cella and a porch. But the clear proportions of the Samian building (1:5), a narrow, long structure, are very different, although no chronological conclusions can be drawn from this.

The peristyle, added subsequently to the cella, giving the temple four different 'façades', is extremely significant. This extension seems to have been undertaken at a point in time not too far distant from the building of the first Temple of Hera. At all events, this peristyle is the oldest known in Greek temple architecture. This extension of the columns from the front round all four sides produces the peripteral temple which was to be the basis of all Greek religious architecture. A. von Gerkan thinks that the development of peripteral column architecture took place on the Greek mainland.[49] In this belief he is correct in so far as, over a hundred years later, primitive wooden architecture gave way to the stone columns, capitals and entablatures of the Doric order, an artistic idiom which expresses so superbly both the presence of the deity and the application of human intellect. But when von Gerkan asks 'or perhaps in Ionia as well?'[50] he can refer only to the Samian peripteros which, even if the peristyle were not added until the beginning of the seventh century, is nevertheless a continuation and a crowning of the Geometric tradition. The artistic achievement would be no less remarkable because the idea of the peripteral temple was born and developed to greatness in two different places, the Ionian east and the Doric mainland.[51]

The beginnings of Greek religious architecture are to be found in High Geometric and, above all, Late Geometric art.

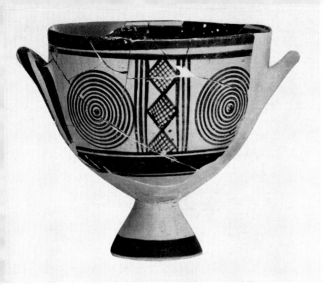

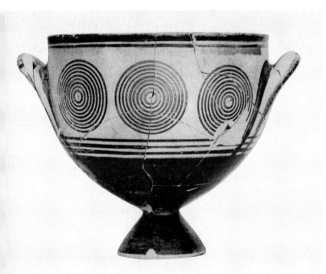

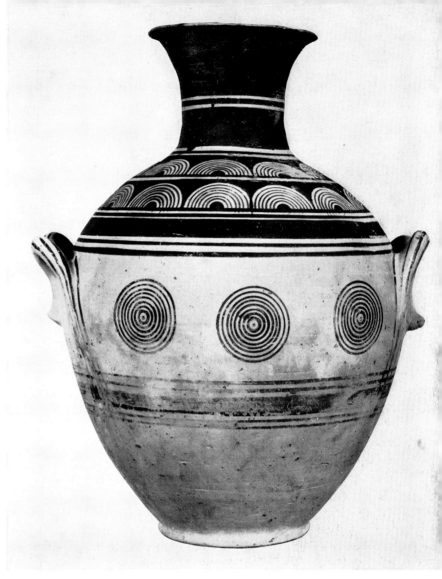

1 Protogeometric skyphos from the Kerameikos (Grave 39).
 Height 16.6 cm. Athens, Kerameikos Museum

2 Protogeometric skyphos from the Kerameikos (Grave 48).
 Height 16 cm. Athens, Kerameikos Museum

3 Protogeometric belly-handled amphora from the Kerameikos (Grave 12). Height
 52 cm. Athens, Kerameikos Museum

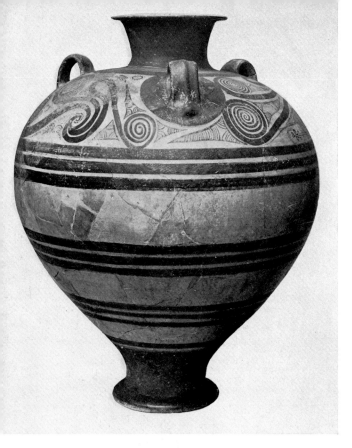

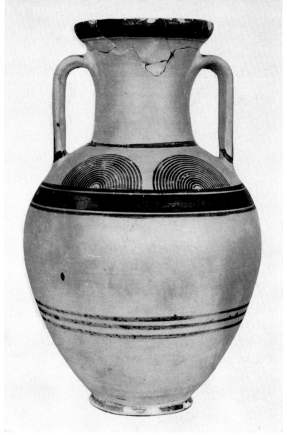

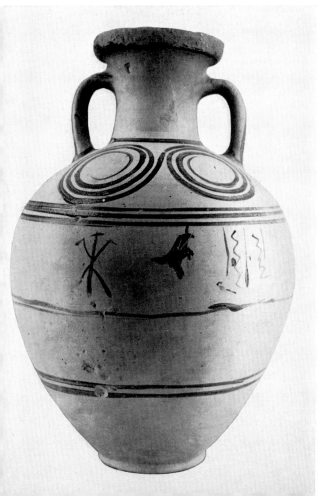

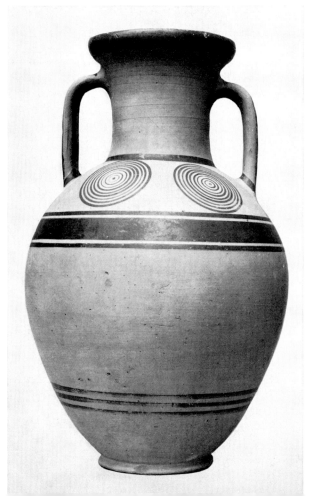

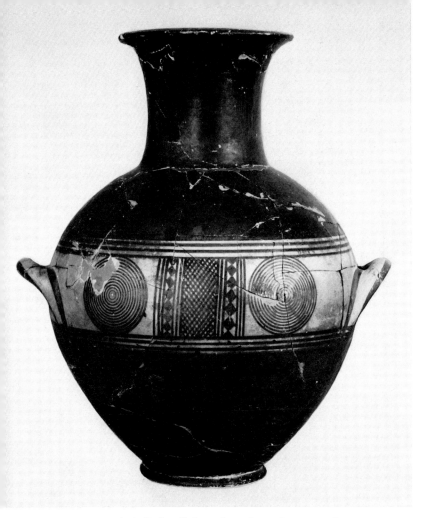

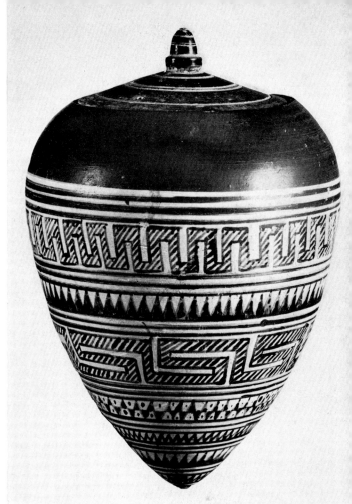

8 Late Protogeometric belly-handled amphora from the Kerameikos (Grave 20). Height 44 cm. Athens, Kerameikos Museum

9 Pyxis from Attica. Height 17 cm. Berlin, Staatliche Museen

◁

4 Mycenaean three-handled jar from Ialysos. Height 46.5 cm. London, British Museum

5 Protogeometric neck-handled amphora from the Kerameikos (Grave 17). Height 43.5 cm. Athens, Kerameikos Museum

6 Late Mycenaean neck-handled amphora from Argos (Grave XXIV in the Deiras Necropolis). Height 50 cm. Argos, Museum

7 Protogeometric neck-handled amphora from Assarlik (Caria). Height 43.2 cm. London, British Museum

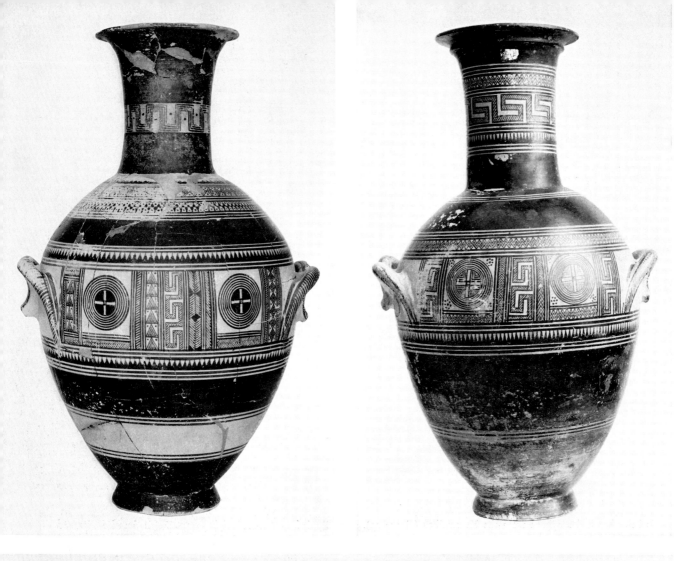

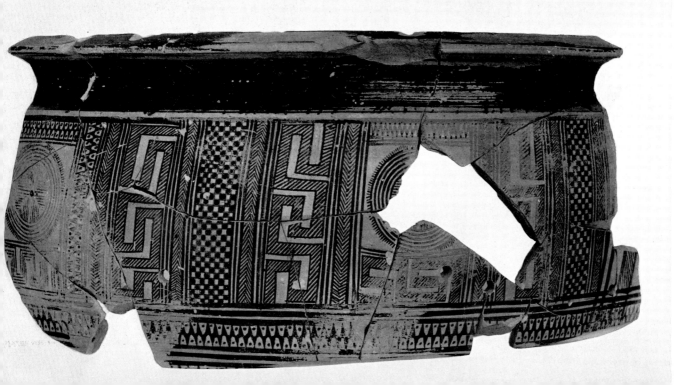

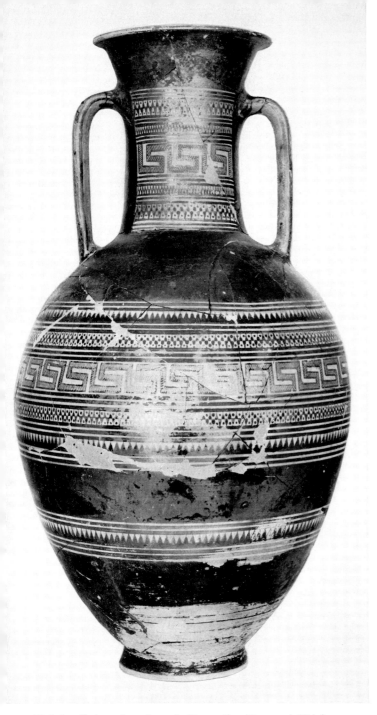

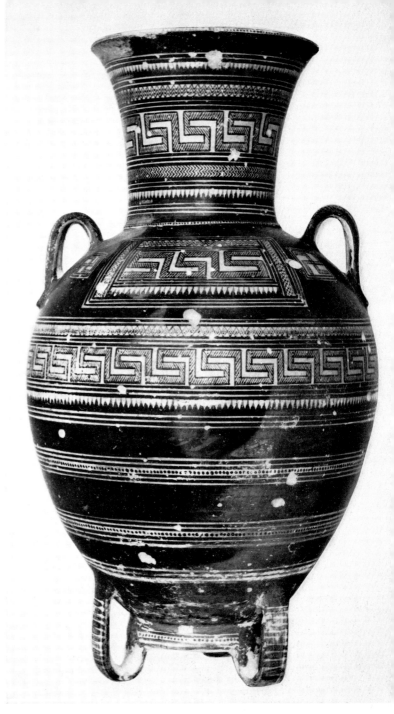

13 Neck-handled amphora from the Kerameikos (Grave 42). Height 77.5 cm. Athens, Kerameikos Museum

14 Shoulder-handled amphora with looped feet from Athens. Height 73 cm. Athens, National Museum

◁

10 Belly-handled amphora from the Kerameikos (Grave 41). Height 69.5 cm. Athens, Kerameikos Museum

11 Belly-handled amphora from the Kerameikos. Height 81 cm. Athens, National Museum

12 Fragment of a krater from the Kerameikos (Grave 2). Height 18 cm. Athens, Kerameikos Museum

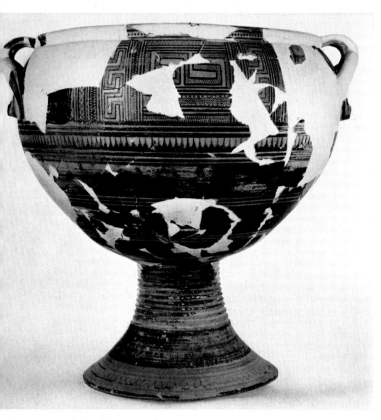

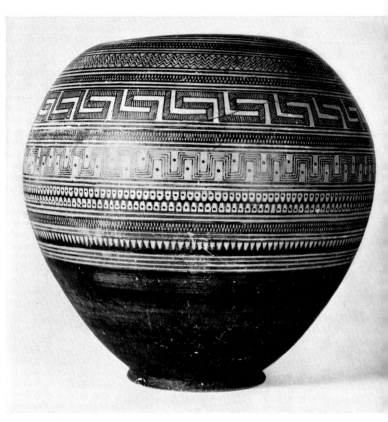

15 Krater from the Kerameikos (Grave 22). Height 52.5 cm. Athens, Kerameikos Museum

16 Globular pyxis. Height 32.5 cm. Munich, Staatliche Antikensammlungen

17, 18 Kantharos. Height 12.2 cm. Athens, National Museum

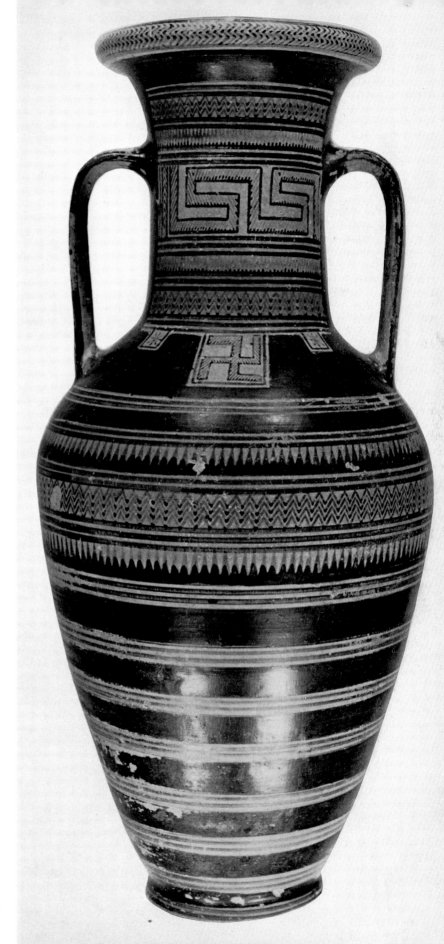

19 Neck-handled amphora from Attica. Height 51.5 cm. Tübingen,
 Archaeological Institute

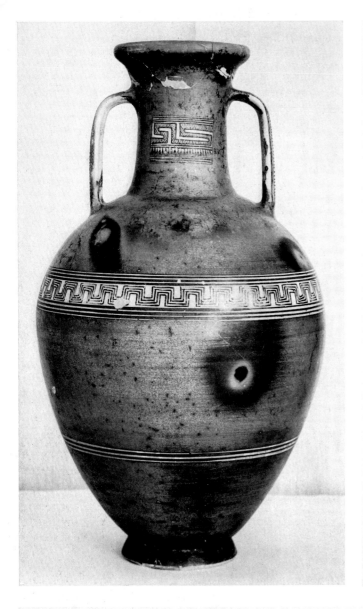

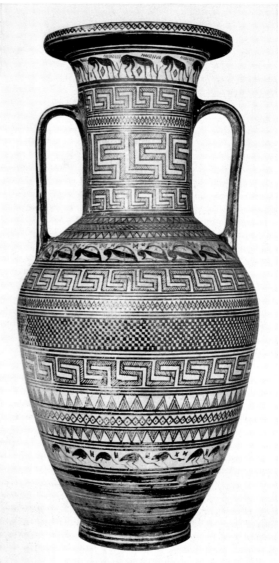

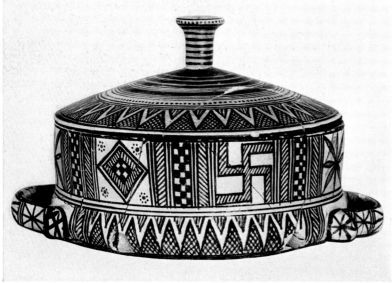

20 Neck-handled amphora from the Kerameikos (Grave 43). Height 72.5 cm. Athens, Kerameikos Museum

21 Neck-handled amphora from Attica. Height 51 cm. Munich, Staatliche Antikensammlungen

22 High-rimmed bowl from the Kerameikos (Grave 71). Height 7.5 cm. Athens, Kerameikos Museum

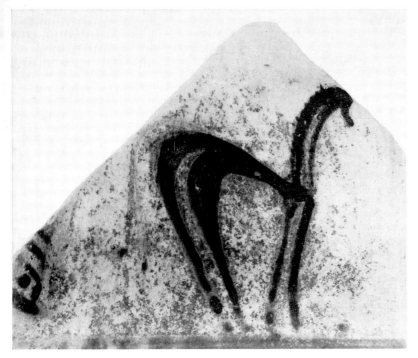

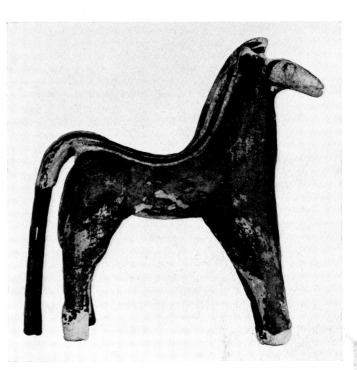

23 Protogeometric fragment from the Kerameikos. Athens, Kerameikos Museum

24 Terracotta horse from the Kerameikos. Athens, Kerameikos Museum

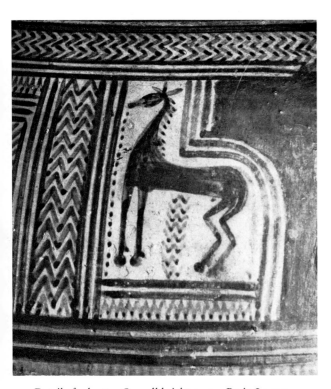

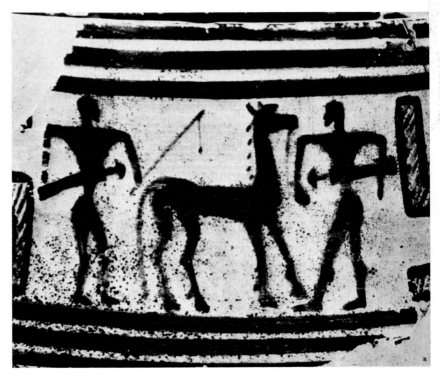

25 Detail of a krater. Overall height 33 cm. Paris, Louvre

26 Detail of a cup from the Kerameikos. Overall height 7.8 cm. Athens, Kerameikos Museum

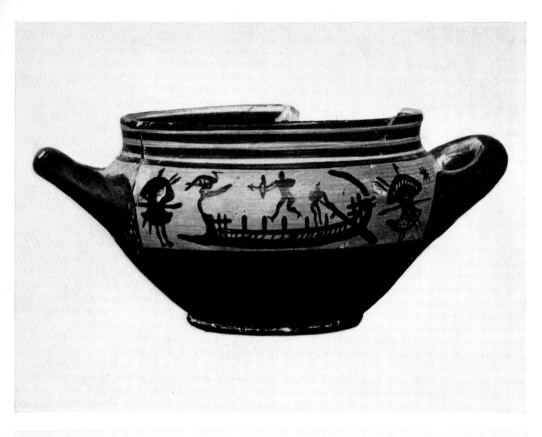

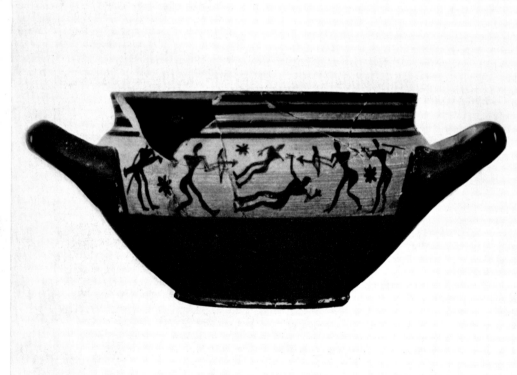

27, 28 Skyphos from Eleusis. Height 6.4 cm. Eleusis, Museum

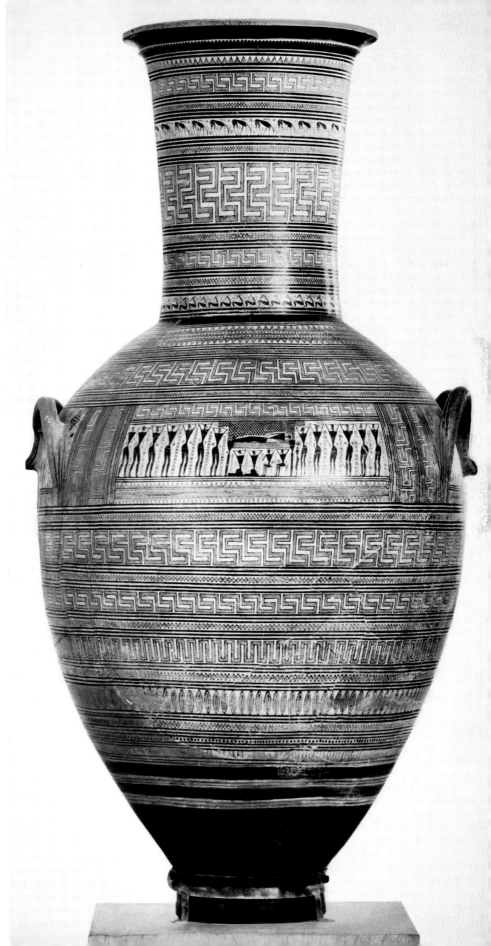

29 Amphora from the Kerameikos. Height 30.4 cm.
Athens, Kerameikos Museum

30 Belly-handled amphora from the Kerameikos.
Height 1.55 m. Athens, National Museum ▷

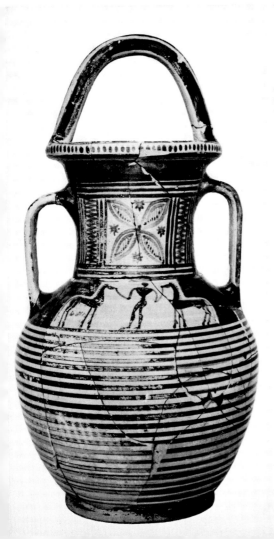

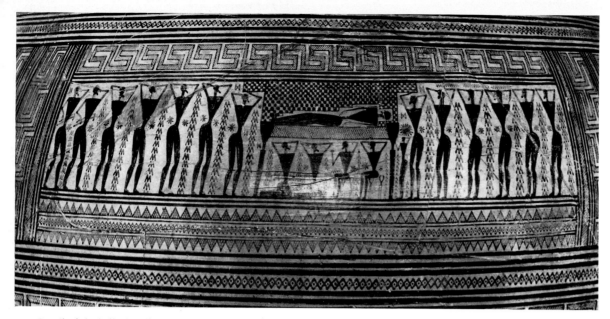

31 Detail of the belly-handled amphora shown in Plate 30

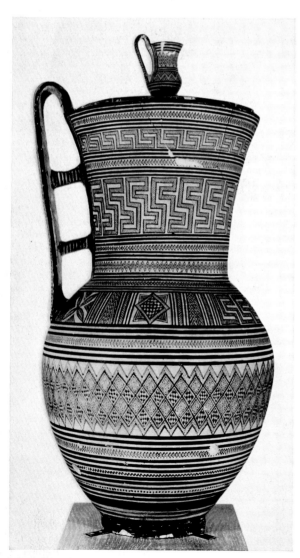

32 Pitcher from Athens. Height 80 cm. Athens, National Museum

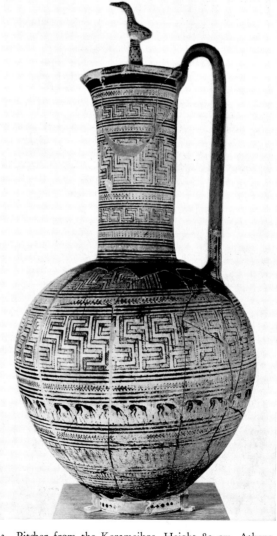

33 Pitcher from the Kerameikos. Height 89 cm. Athens, National Museum

34
Krater from Attica. ▷
Height 97.5 cm.
New York, Metropolitan
Museum of Art

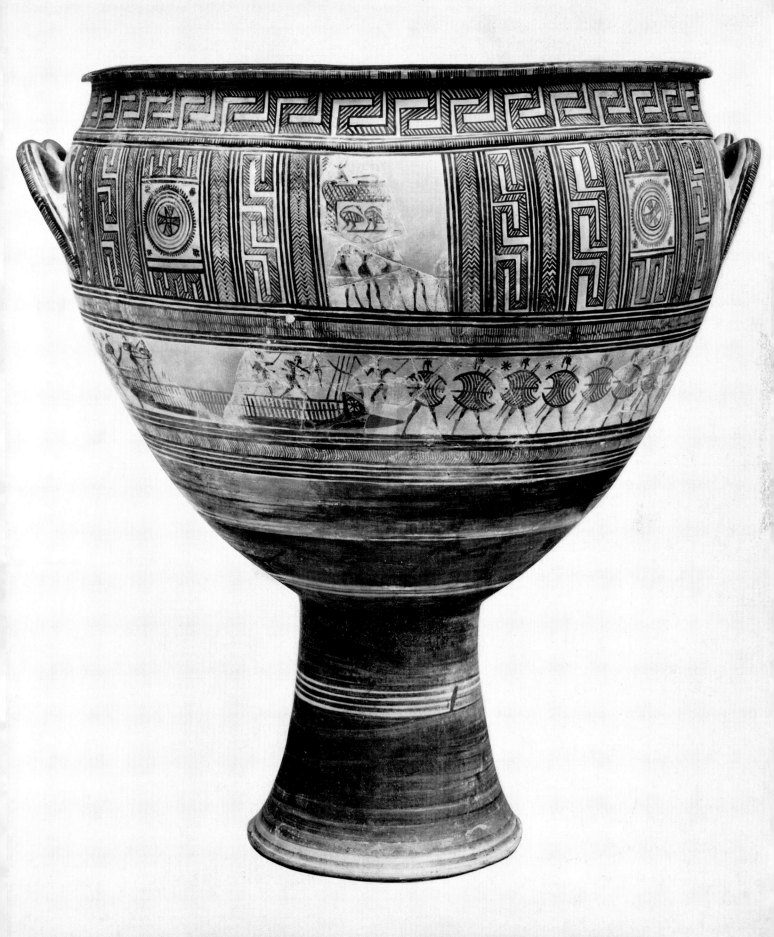

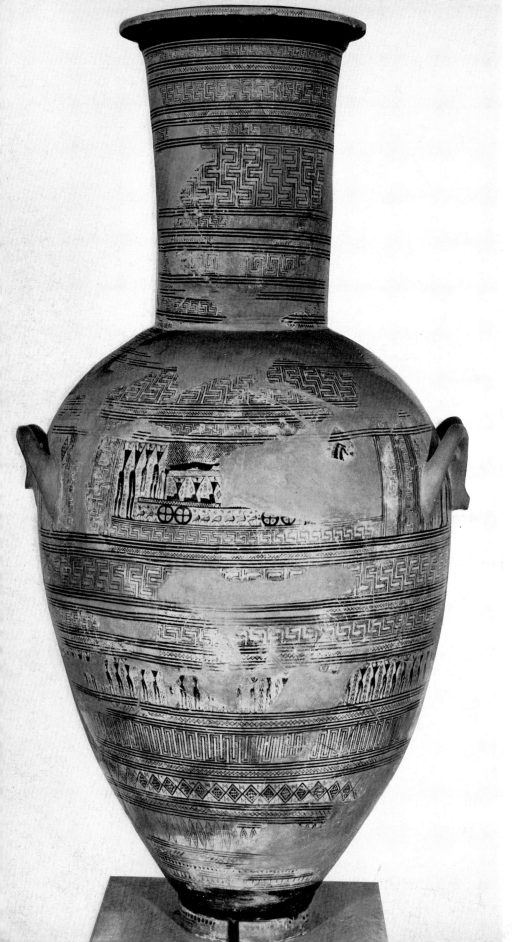

35 Belly-handled amphora from the Kerameikos.
Height 1.75 m. Athens, National Museum

36 Detail of a krater from the Kerameikos.
Overall height 58 cm. Paris, Louvre ▷

37 Detail of the krater shown in Plate 36 ▷

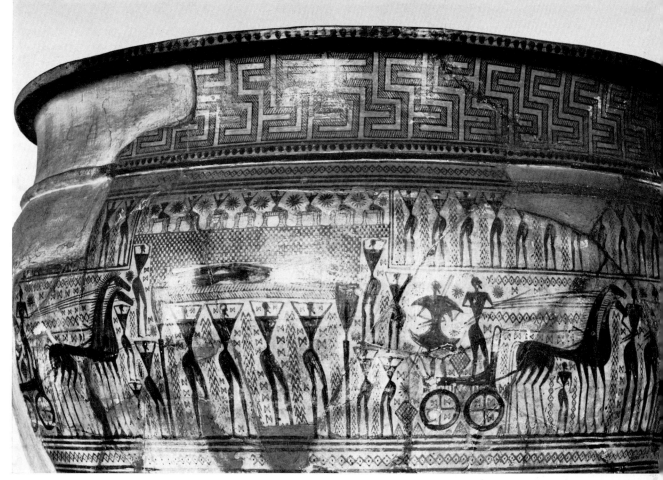

36

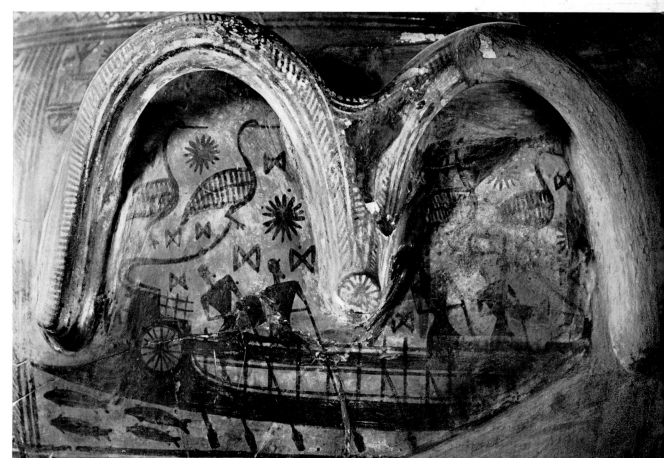

37

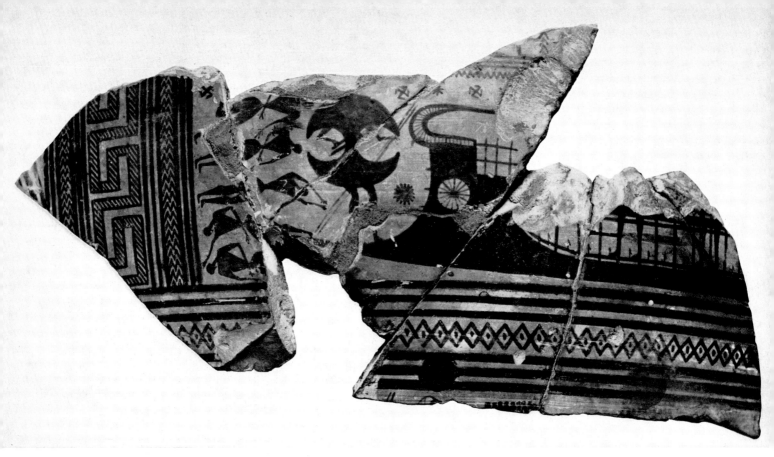

38 Fragments of a krater from the Kerameikos. Height 11.3 cm. Paris, Louvre

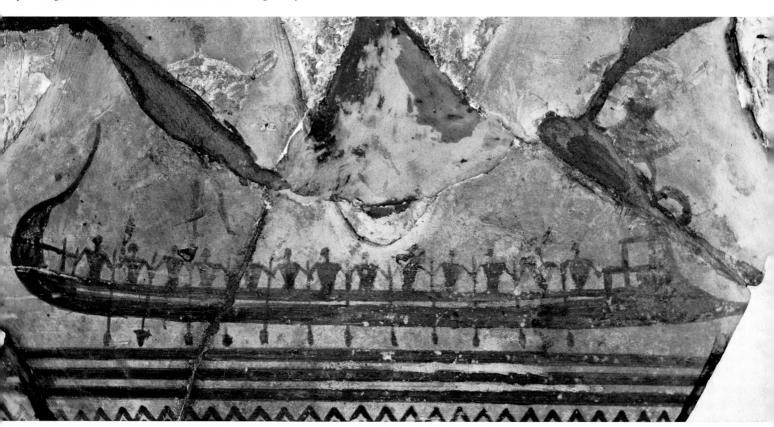

39 Detail of a krater from the Kerameikos. Overall height 85 cm. Paris, Louvre

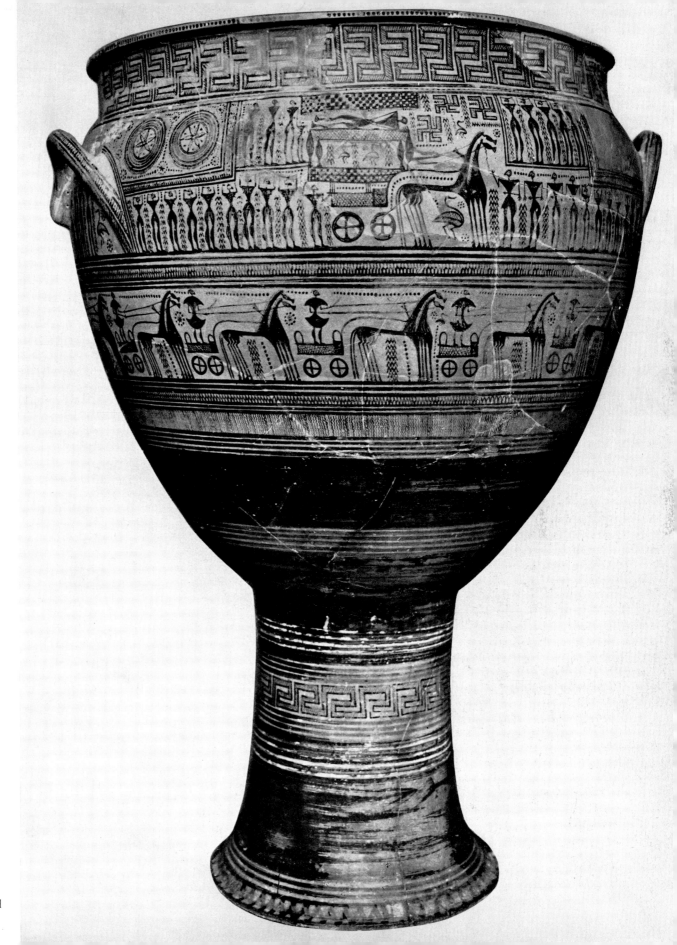

40
Krater from the
Kerameikos.
Height 1.23 m.
Athens, National
Museum

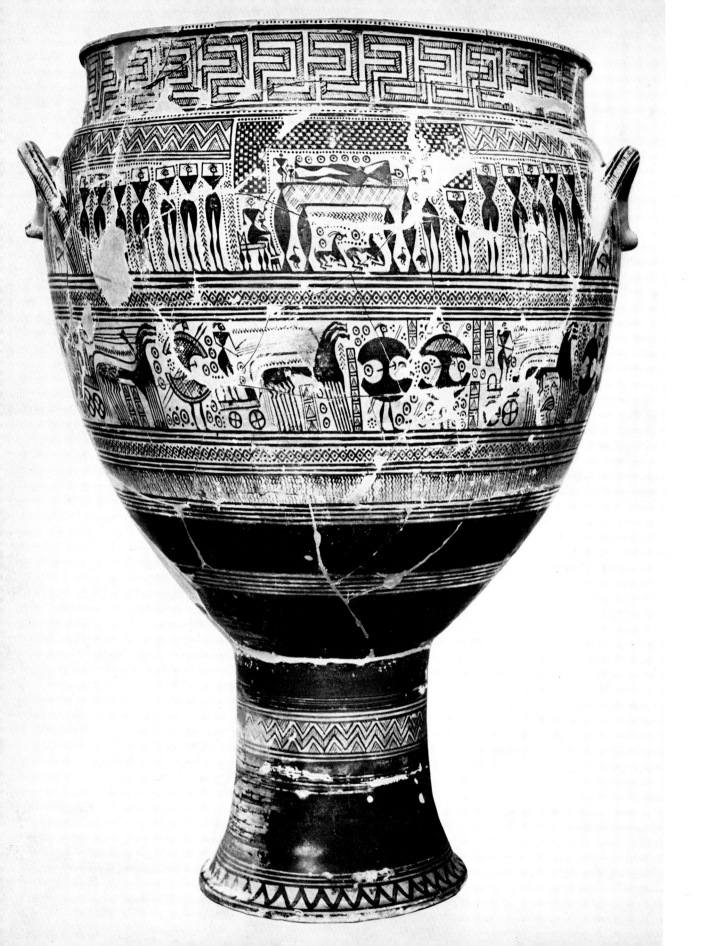

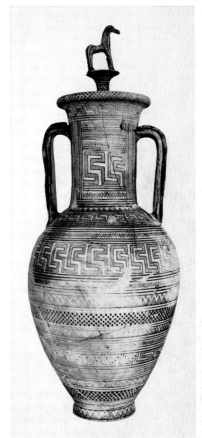

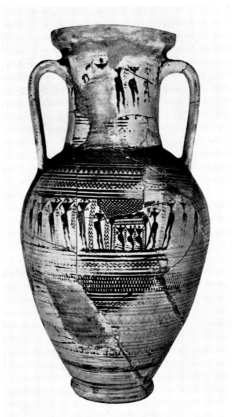

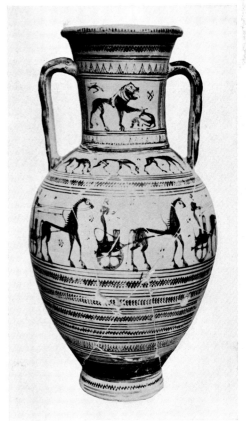

42 Neck-handled amphora from the Kerameikos.
Height 60 cm. Athens, Kerameikos Museum

43 Neck-handled amphora from the Kerameikos.
Height 81 cm. Athens, Kerameikos Museum

44 Neck-handled amphora from Athens. Height 56 cm.
Karlsruhe, Badisches Landesmuseum

45 Neck-handled amphora from Attica. Height 62 cm.
London, British Museum

◁

41 Krater. Height 1.216 m. New York, Metropolitan
Museum of Art

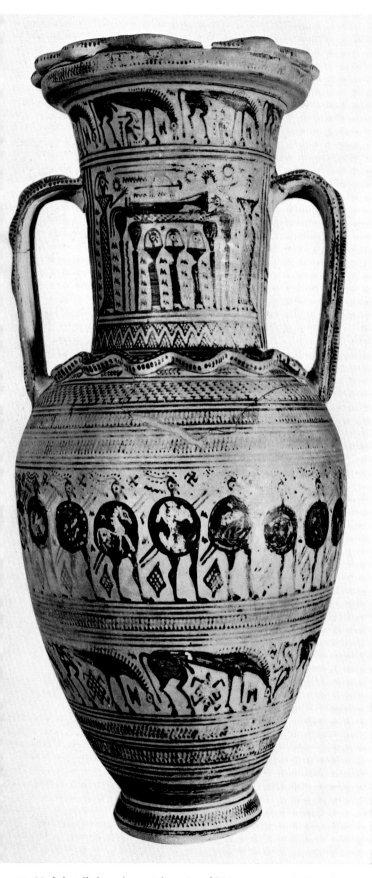

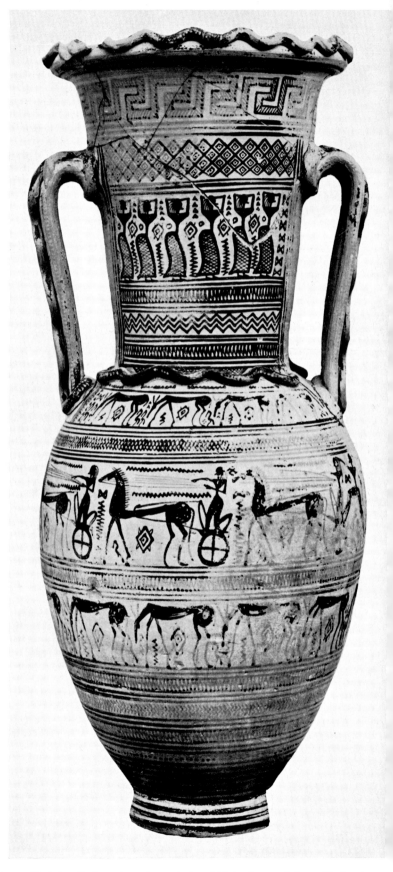

46 Neck-handled amphora. Athens, Benaki Museum

47 Neck-handled amphora from Attica. Height 60 cm. Athens, National Museum (Stathatos Collection)

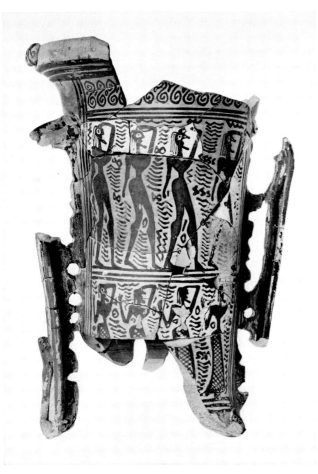

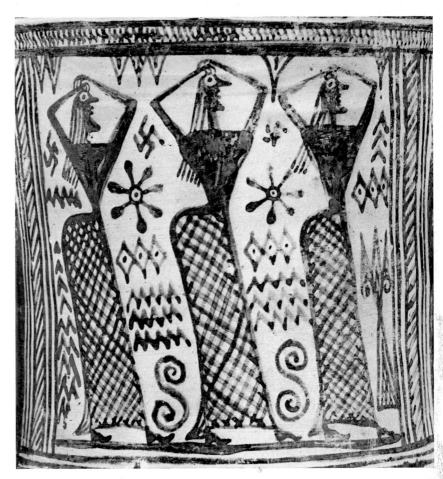

48 Fragment of a neck-handled amphora from the Kerameikos.
Height 25 cm. Athens, Kerameikos Museum

49 Detail of the neck-handled amphora shown in Plate 50

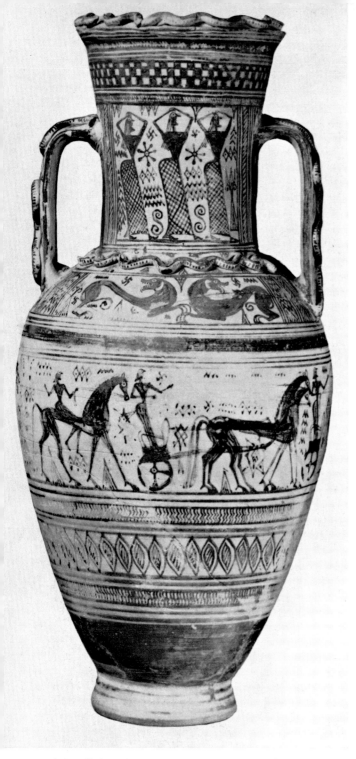

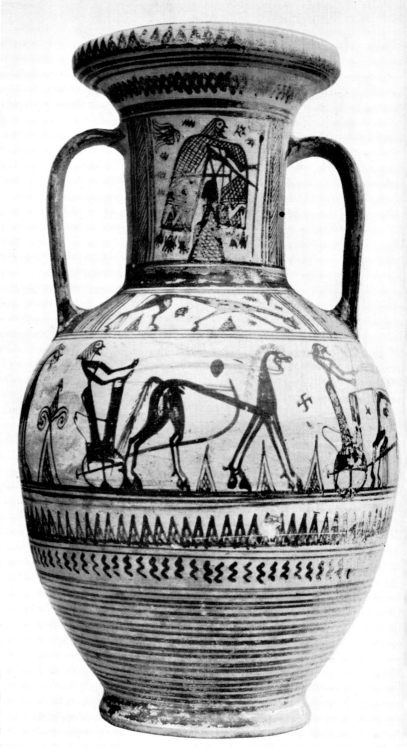

50 Neck-handled amphora. Height 77.7 cm. New York, Metropolitan
Museum of Art

51 Neck-handled amphora. Height 29.7 cm. New York, Metropolitan Museum
of Art

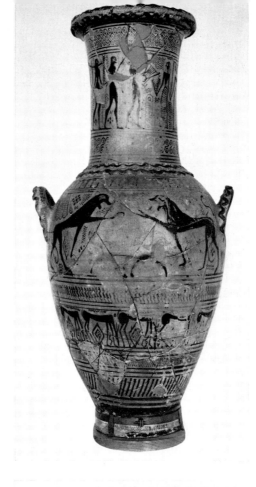
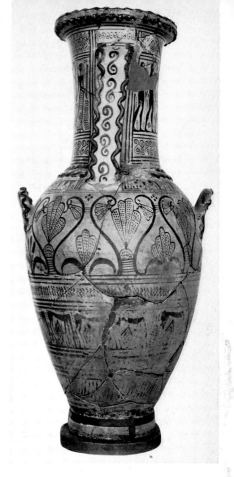
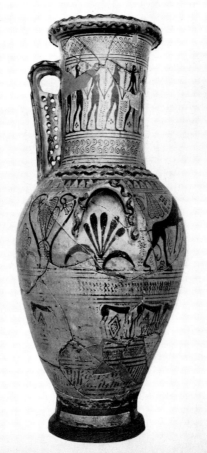
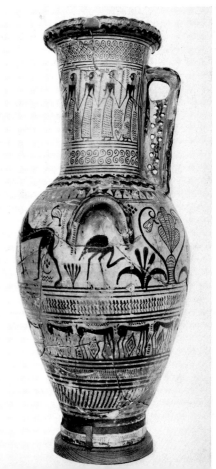

52-55 Hydria from Analatos (Attica). Height 53 cm.
Athens, National Museum

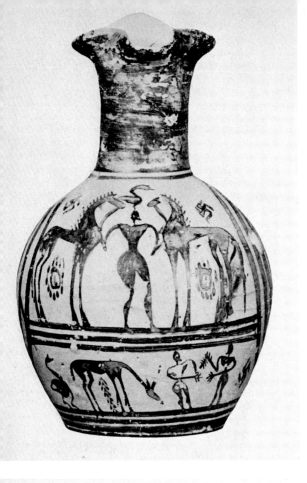

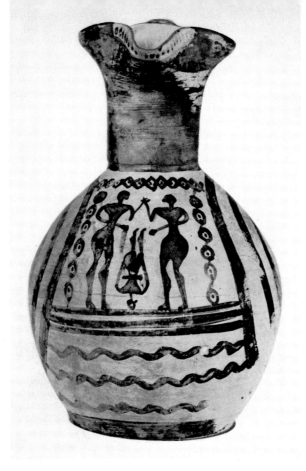

56
Oinochoë from Aegina.
Height 23 cm.
Berlin, Staatliche Museen

57
Oinochoë. Height 17.8 cm.
Boston, Museum of Fine Arts

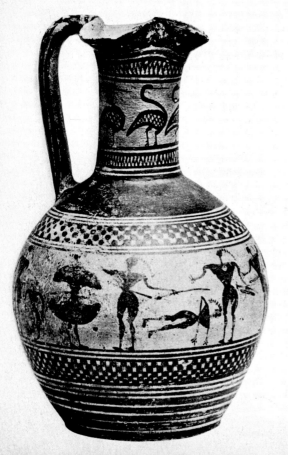

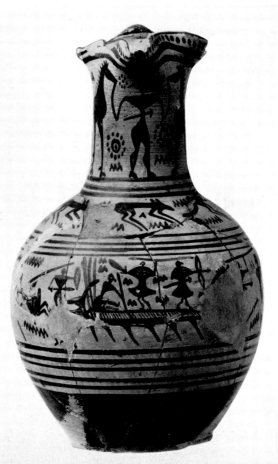

58
Oinochoë from the Kerameikos. Height 21 cm.
Paris, Louvre

59
Oinochoë from the Kerameikos. Height 23.4 cm.
Copenhagen,
National Museum

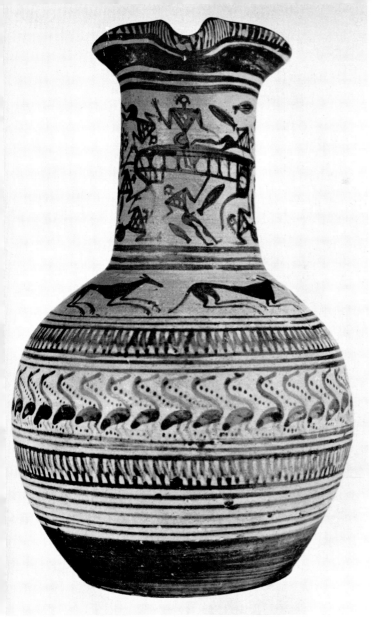

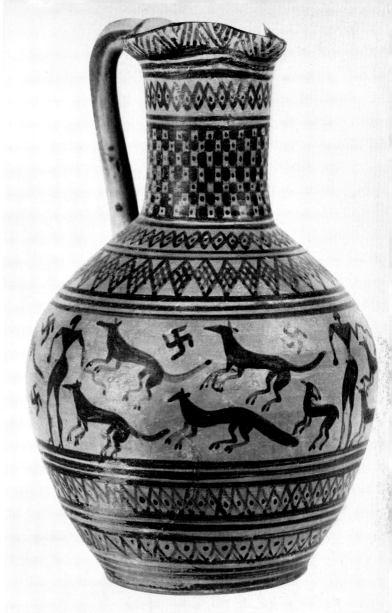

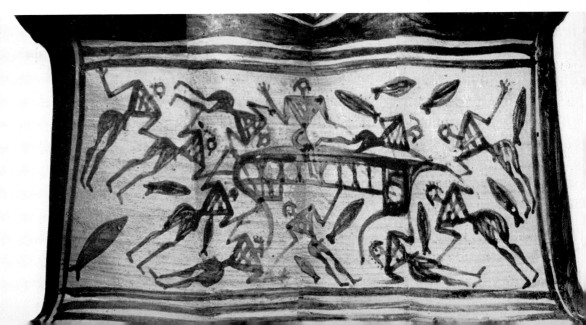

60
Oinochoë. Height 21.5 cm.
Munich, Staatliche Antiken-
sammlungen

61
Oinochoë. Height 23 cm.
Boston, Museum of Fine Arts

62
Detail of the oinochoë shown in
Plate 60

63 Detail of a krater from Athens. Overall height 59 cm. Athens, National Museum

64 Detail of the foot of the krater shown in Plate 63

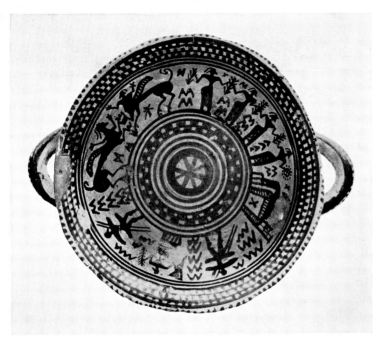

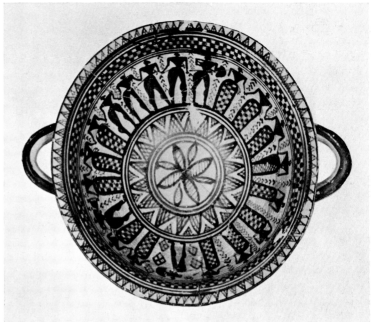

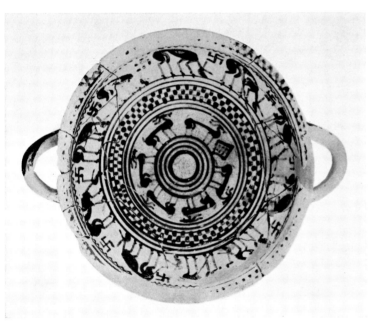

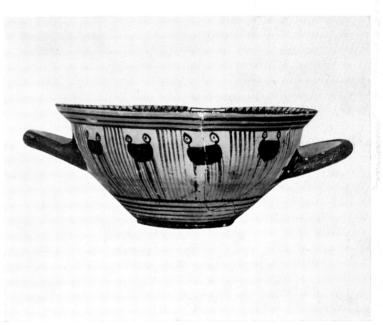

65 Bowl from the Kerameikos. Diameter 12 cm. Athens, National Museum

66 Bowl from Athens. Diameter 16 cm. Athens, National Museum

67 Bowl from the Kerameikos. Diameter 14.9 cm. Athens, Kerameikos Museum

68 Profile of the bowl shown in Plate 66. Height 6.5 cm.

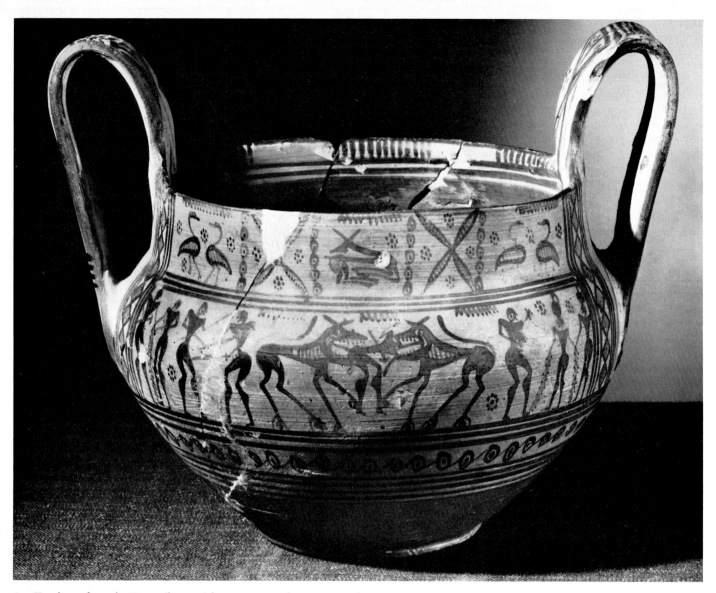

69 Kantharos from the Kerameikos. Height 17 cm. Copenhagen, National Museum

70 Detail of a bowl from Anavyssos (Attica). Diameter 14 cm. Athens, National Museum

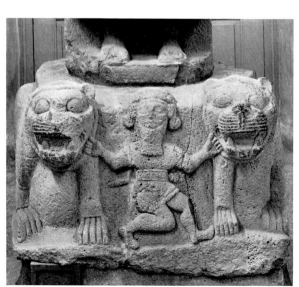

71 Statue base from Sendshirli. Height 72 cm. Istanbul, Archaeological Museum

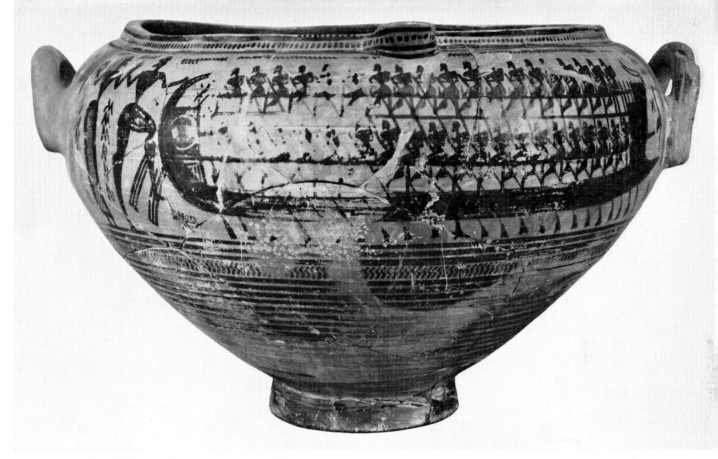

72, 73 Krater from Thebes. Height 30 cm. London, British Museum

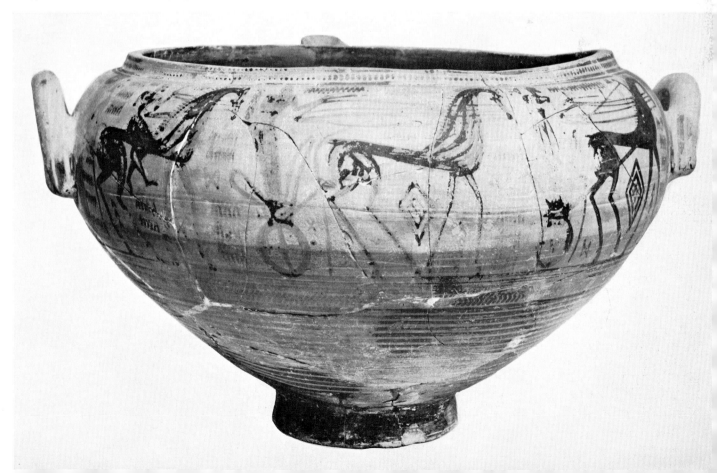

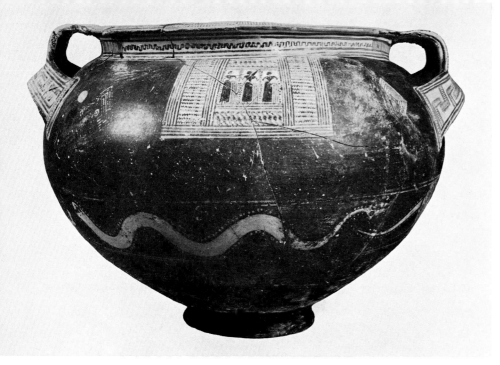

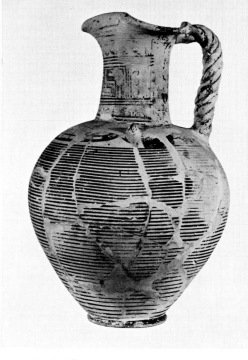

74 Krater from Corinth. Height 31.1 cm. Corinth, Museum

76 Krater from Thebes. Height 22.6 cm. Toronto, Royal Ontario Museum

75 Oinochoë from Thebes. Height 48.5 cm. Berlin, Staatliche Museen

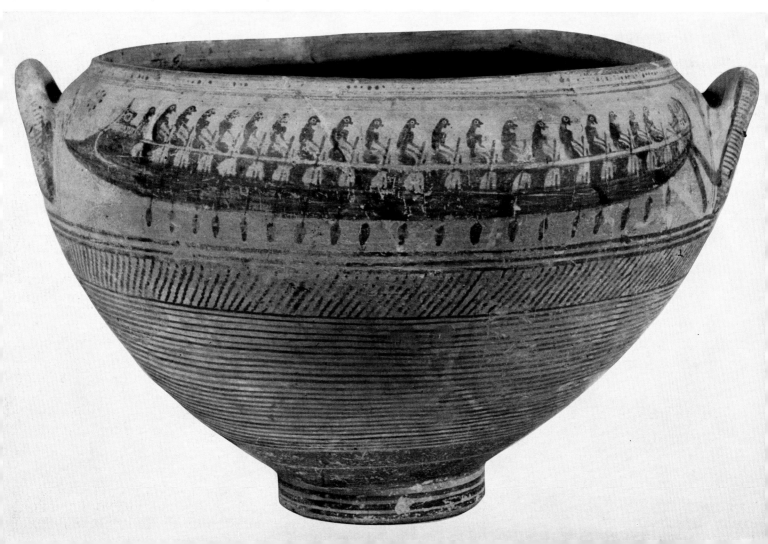

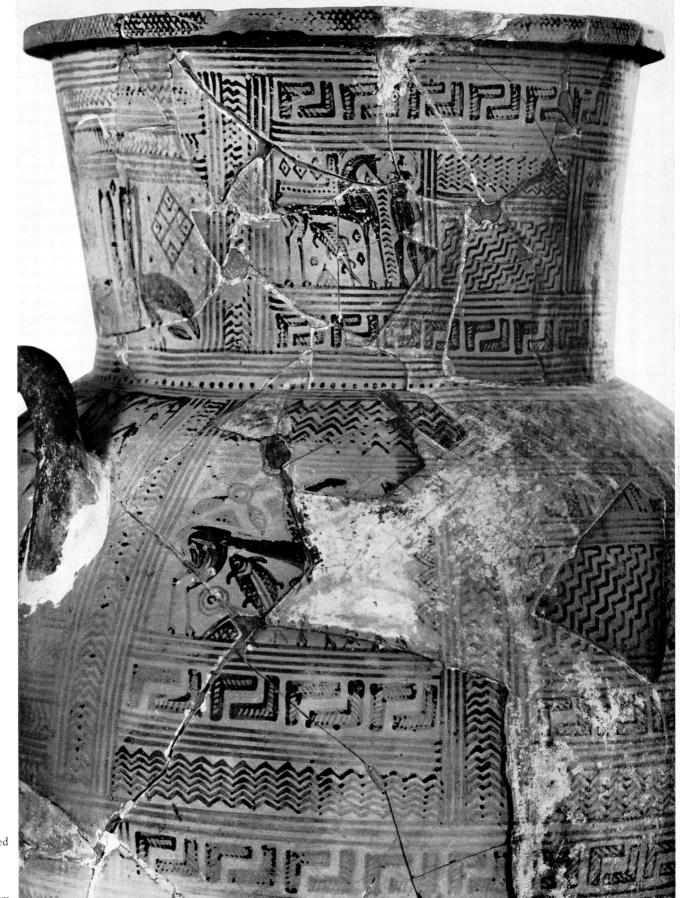

77
Detail of a
shoulder-handled
amphora from
Asine. Overall
height 80 cm.
Nauplia, Museum

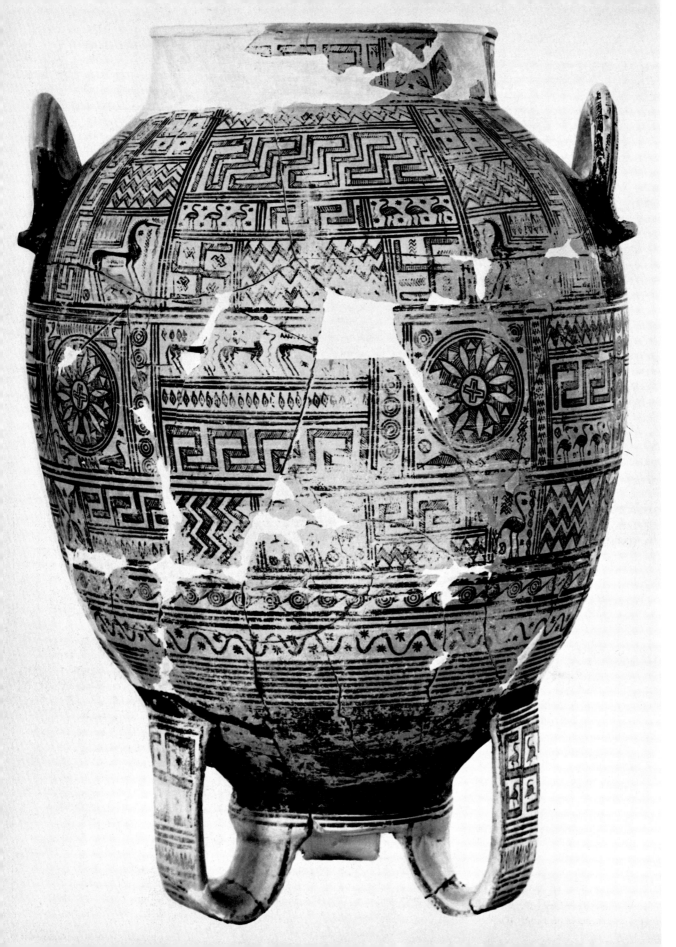

78
Pithos with
looped feet from
Argos.
Height 1.04 m.
Argos, Museum

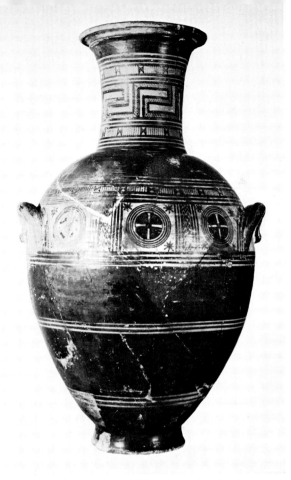

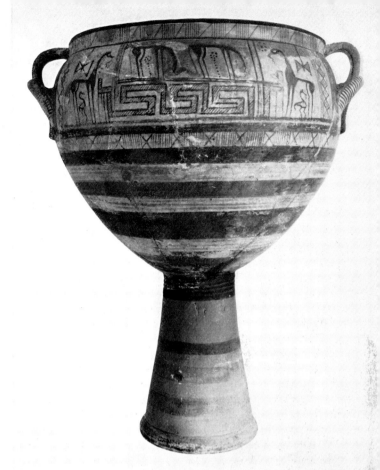

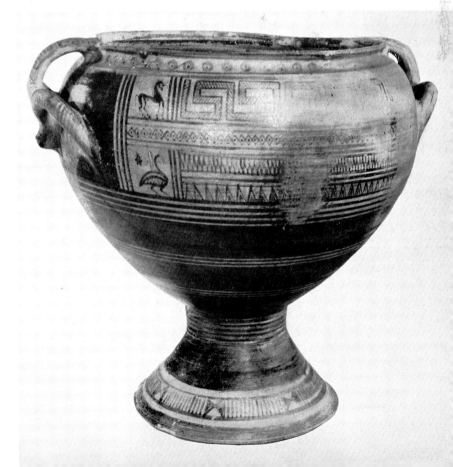

79 'Pseudo-Attic' belly-handled amphora
from Melos. Height 73 cm.
Munich, Staatliche Antikensammlungen

80 Krater. Height (without base) 41 cm.
Amsterdam, Allard Pierson Museum

81 Krater from Melos (?). Height 50 cm.
Leiden, Rijksmuseum van Oudheden

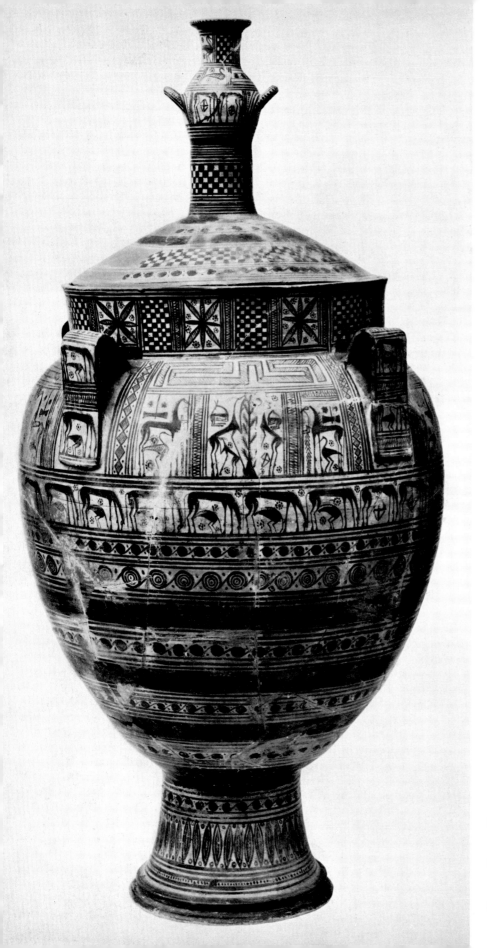

82 Krater from Kourion (Cyprus). Height 1.15 m.
New York, Metropolitan Museum of Art

83 Pithos from Thera. Height 36 cm. Thera, Museum

84 Pithos from Knossos. Height 44.5 cm. Heraklion,
Archaeological Museum

85 Pithos from Fortetsa (Crete). Height 41 cm. Heraklion,
Archaeological Museum

86 Belly-handled amphora from Fortetsa (Crete). Height
59 cm. Heraklion, Archaeological Museum

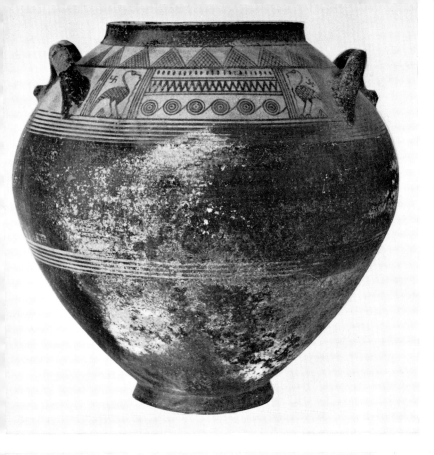

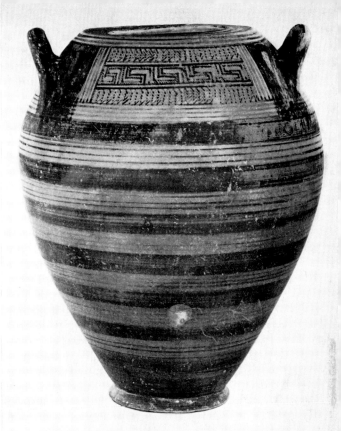

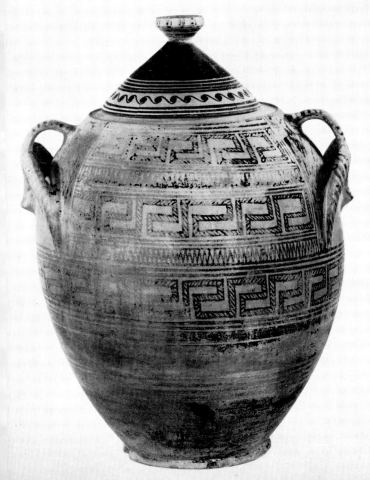

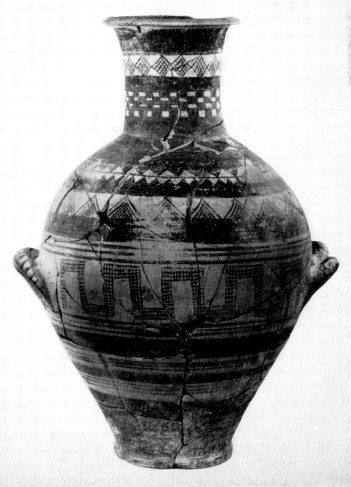

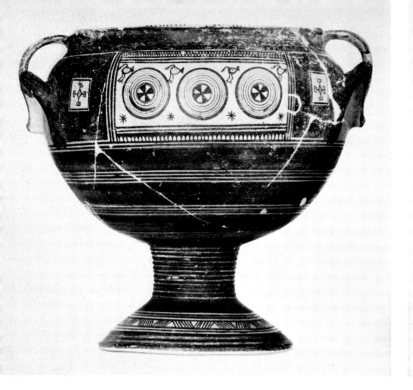
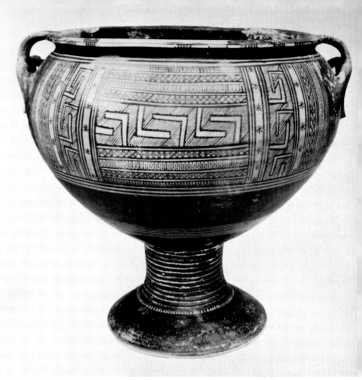
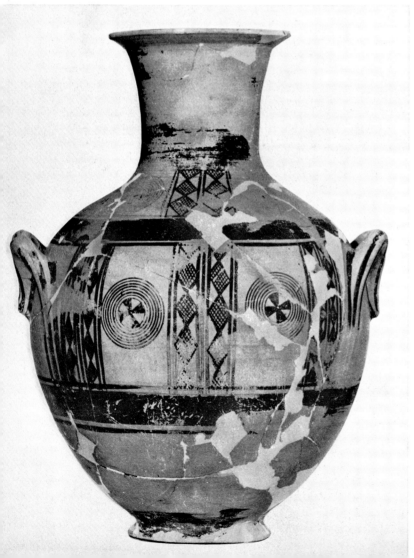
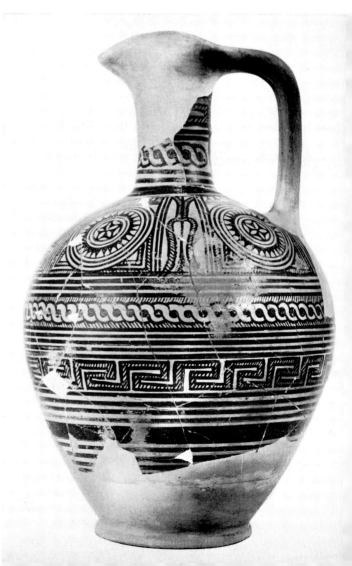

87 Krater from Camirus (Rhodes). Height 33.5 cm. Rhodes, Archaeological Museum

88 Krater from Camirus (Rhodes). Height 55.5 cm. London, British Museum

89 Belly-handled amphora from Ialysos (Rhodes). Height 56 cm. Rhodes, Archaeological Museum

90 Lekythos from Rhodes. Height 9.9 cm. Copenhagen, National Museum ▷

91 Oinochoë from Cos. Rhodes, Museum of Cos

92 Kantharos from Camirus (Rhodes). Height 19 cm. Paris, Louvre ▽

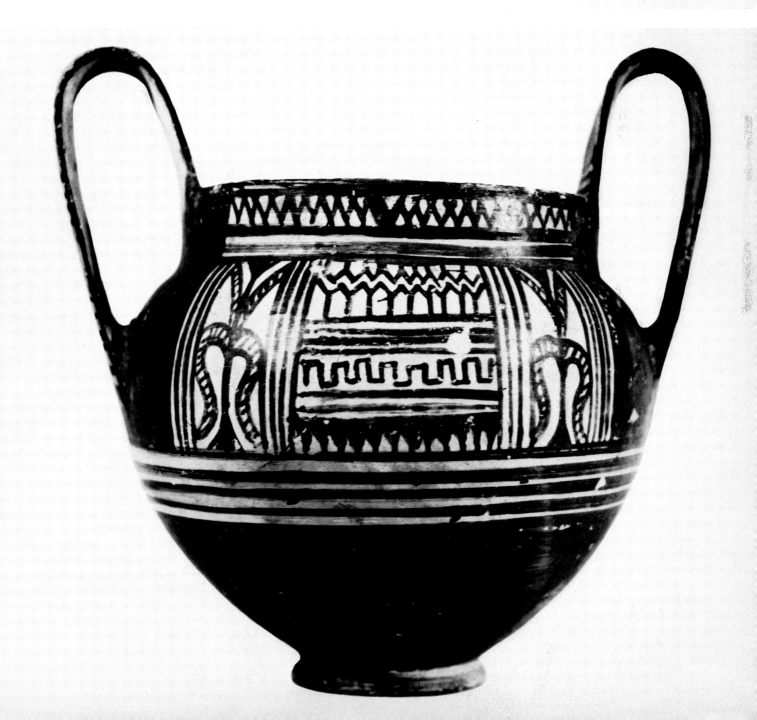

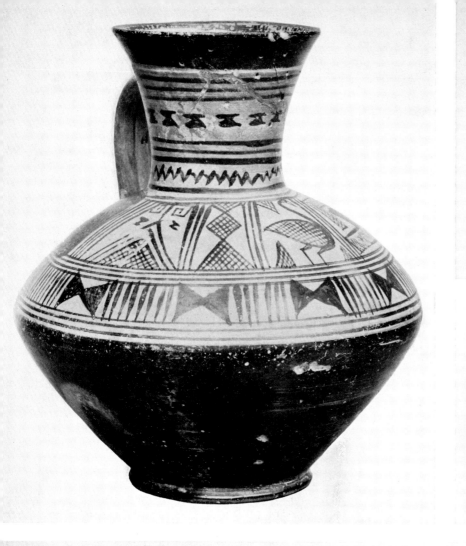

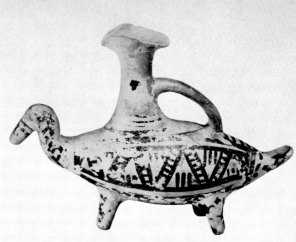

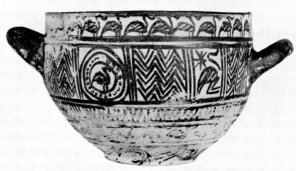

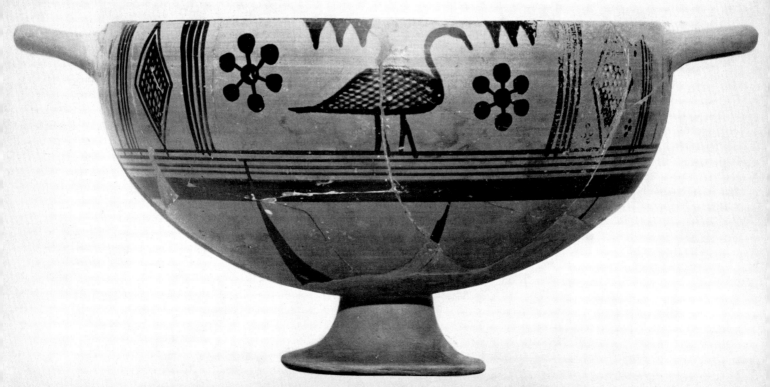

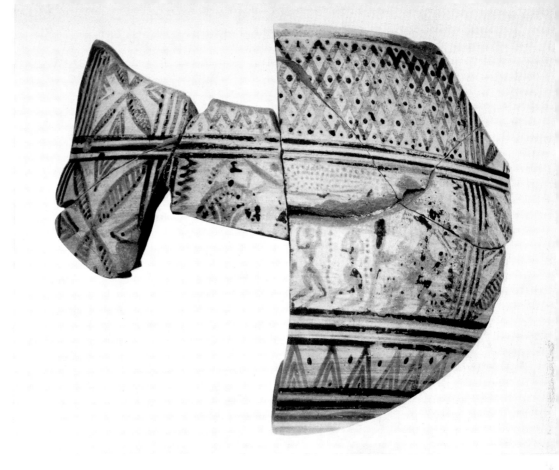

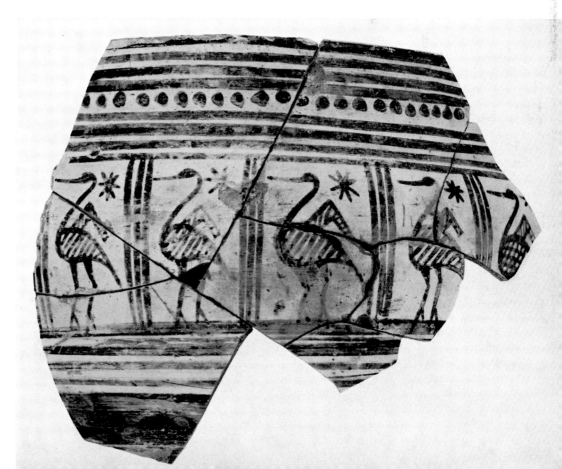

93 Jug from Camirus (Rhodes). Height 22.8 cm. London, British Museum

94 Bird-shaped askos from Vizikia near Camirus (Rhodes). Height 13 cm. Karlsruhe, Badisches Landesmuseum

95 Skyphos from Siana (Rhodes). Height 10 cm. Oxford, Ashmolean Museum

96 Skyphos from Camirus (Rhodes). Height (without base) 11 cm. Berlin, Staatliche Museen

97 Fragment of a kantharos from Samos. Height 18 cm. Samos, Museum

98 Fragment of a kantharos from Samos. Height 18.5 cm. Samos, Museum

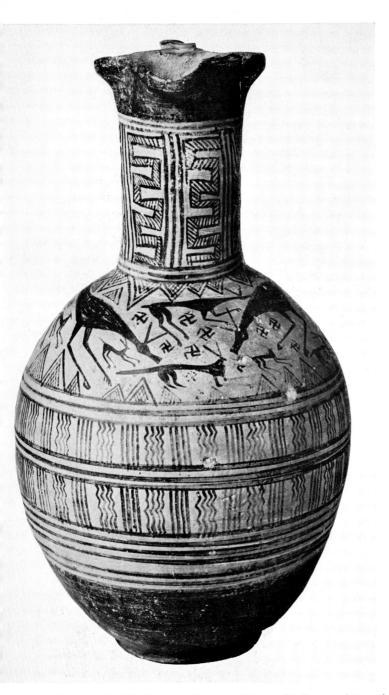
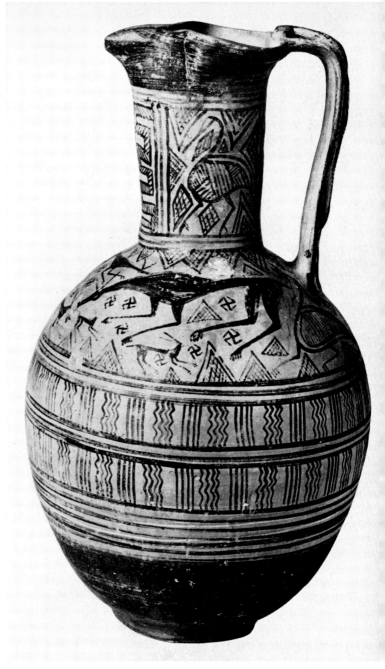

99, 100 Boeotian jug. Height 49 cm. Hamburg, Museum für Kunst und Gewerbe

101 Terracotta statuette from Chamaizi near Sitia (eastern Crete). Height 26.5 cm. Heraklion, Archaeological Museum

102 Terracotta statuette from Chamaizi near Sitia (eastern Crete). Height about 27 cm. Heraklion, Archaeological Museum

103 Terracotta statuette from Chamaizi near Sitia (eastern Crete). Height 22.5 cm. Heraklion, Archaeological Museum

104 Terracotta statuette from Petsofa (Crete). Height 17.5 cm. Heraklion, Archaeological Museum

105 Bronze statuette from the Troad. Height 18.4 cm. Berlin, Staatliche Museen

106 Bronze statuette from near Phaistos (Crete). Height 14.3 cm. Leiden, Rijksmuseum van Oudheden

107, 108 Bronze statuette from Tylissos (Crete). Height 15.2 cm. Heraklion, Archaeological Museum

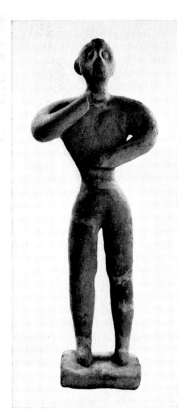

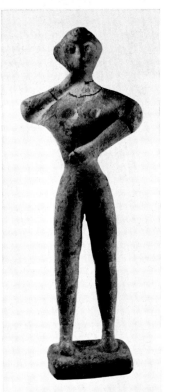

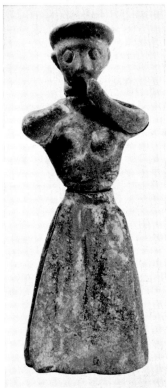

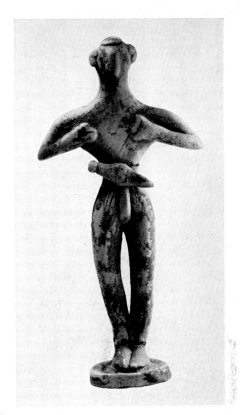

101 102 103 104

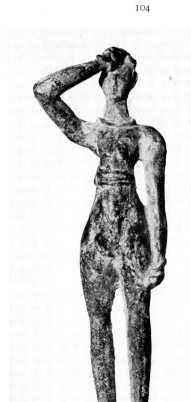

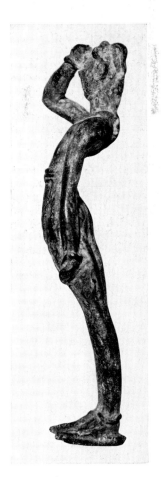

105 106 107 108

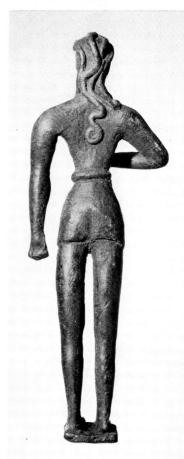

109 Bronze statuette. Height 9.4 cm. Vienna, Kunsthistorisches Mus.

110 Bronze statuette. Height 23.5 cm. Berlin, Staatliche Museen

111, 112 Bronze statuette from Griviglia near Mylopotamos (Crete). Height 25 cm. Heraklion, Archaeological Museum

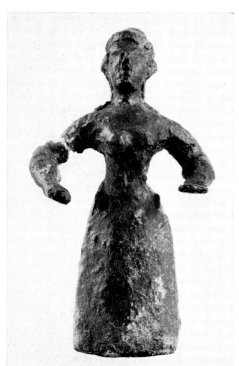
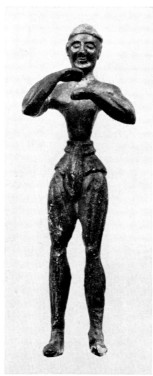
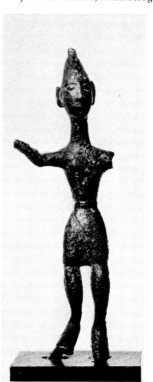
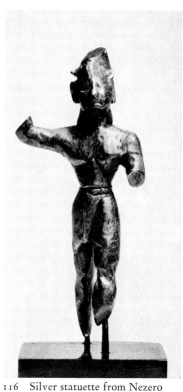

113 Lead statuette from Kampos (Laconia). Height 8.4 cm. Athens, National Museum

114 Lead statuette from Kampos. Height 12 cm. Athens, National Museum

115 Bronze statuette from Crete. Height 15.3 cm. Oxford, Ashmolean Mus.

116 Silver statuette from Nezero (Thessaly). Height 7.8 cm. Oxford, Ashmolean Museum

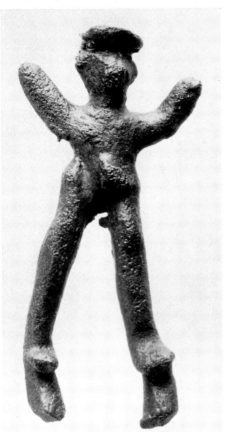
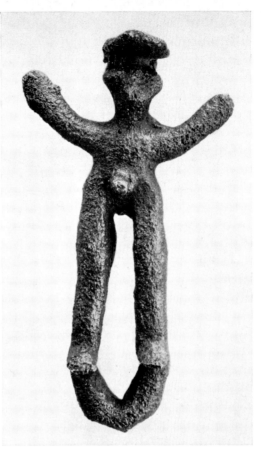

117 Bronze statuette from Olympia. Height 7.1 cm. Olympia, Museum

118, 119 Bronze statuette from Olympia. Height 6.5 cm. Olympia, Museum

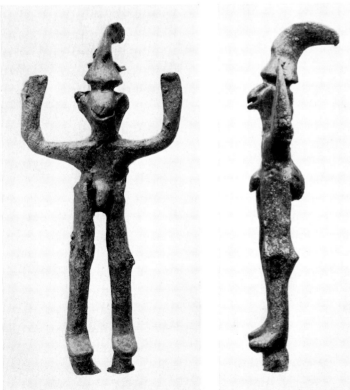
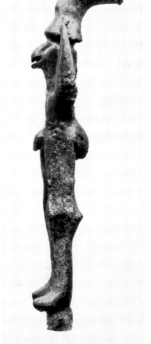
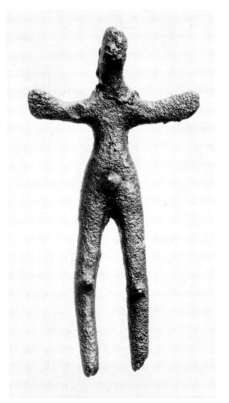
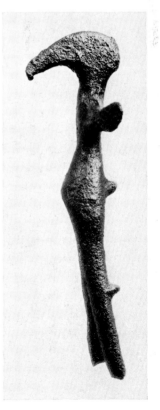

120, 121 Bronze statuette from Olympia. Height about 10 cm. Athens, National Museum

122, 123 Bronze statuette from Olympia. Height 8.9 cm. Olympia, Museum

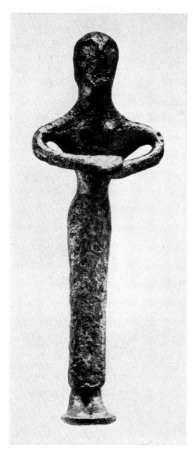
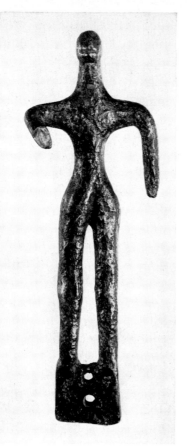
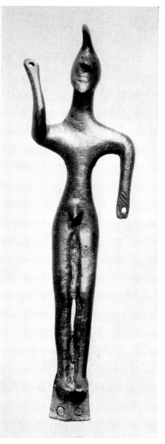
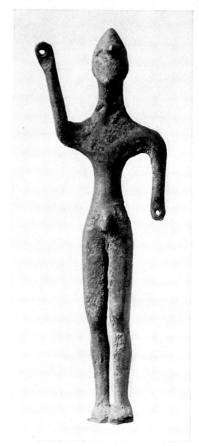

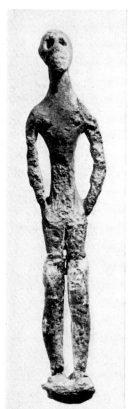
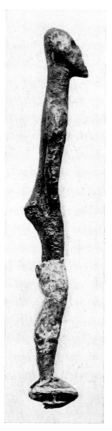
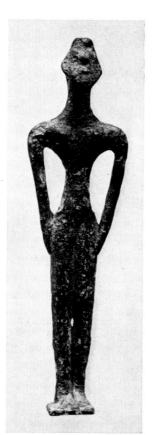
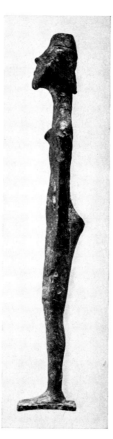

124 Bronze statuette from Delphi. Height
10.5 cm. Delphi, Museum

125 Bronze statuette from the Argive
Heraion. Height 10.8 cm. Athens,
National Museum

126 Bronze statuette from Olympia. Height
17 cm. Olympia, Museum

127 Bronze statuette from Olympia. Height
14.5 cm. Paris, Louvre

128, 129 Bronze statuette from Ithaca. Height
about 13 cm.

130, 131 Bronze statuette from Delphi. Height 16.5 cm.
Delphi, Museum

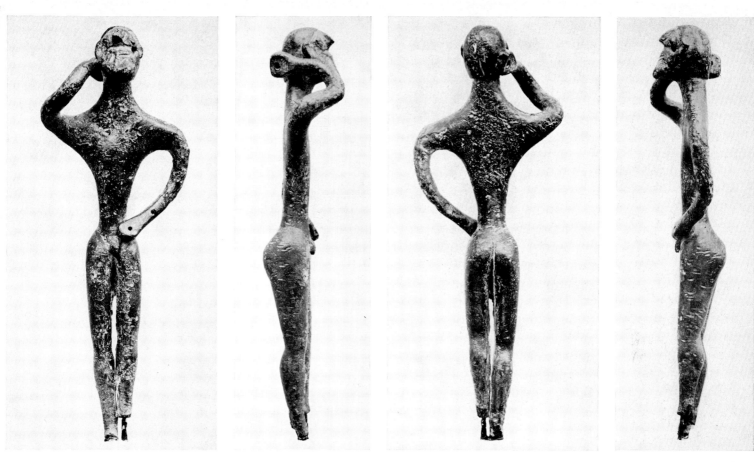

132–135
Bronze statuette from the Acropolis
in Athens. Height 21 cm. Athens,
National Museum

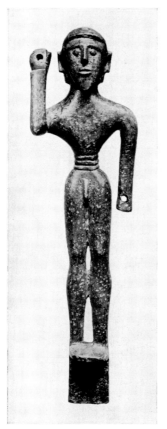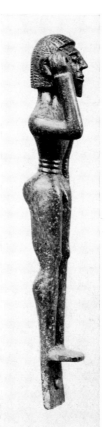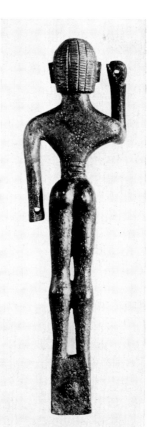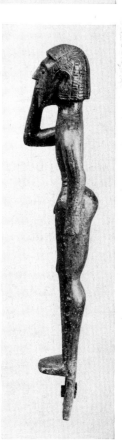

136–139 Bronze statuette from Olympia. Height 14.4 cm. Olympia, Museum

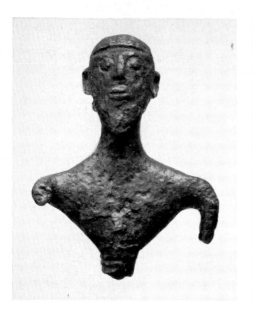
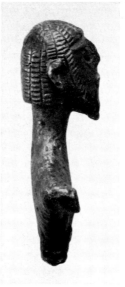
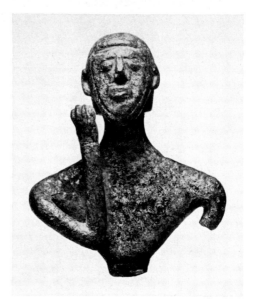
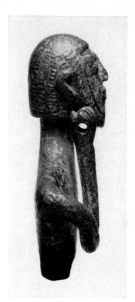

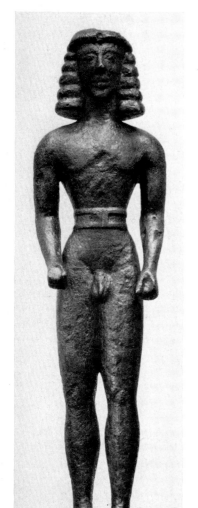
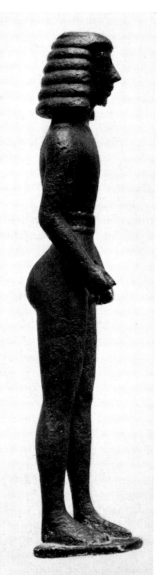

140, 141 Fragment of a bronze statuette from Delphi. Height 6.5 cm. Delphi, Museum

142, 143 Fragment of a bronze statuette. Height 7.8 cm. Munich, Staatliche Antikensammlungen

144, 145 Bronze statuette from Delphi. Height 19.7 cm. Delphi, Museum

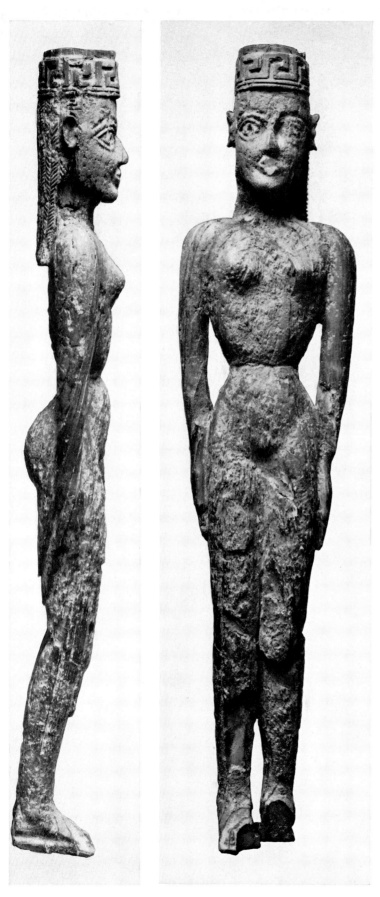

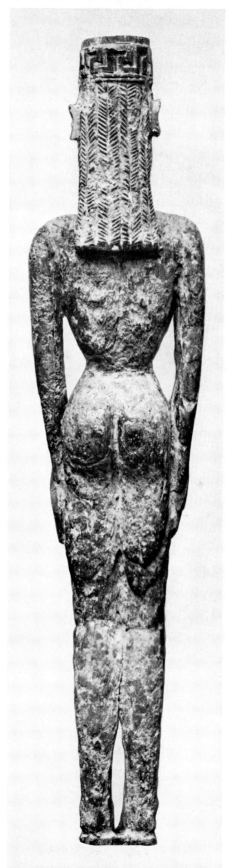

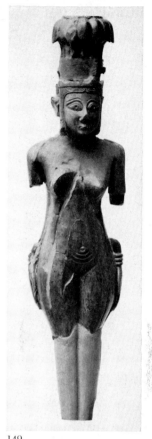

149

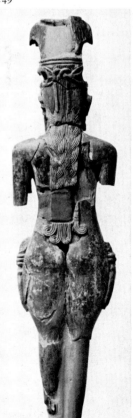

150

146–148 Ivory statuette from Athens. Height 24 cm. Athens, National Museum
149, 150 Ivory statuette from Nimrud. Height 7.1 cm. London, British Museum

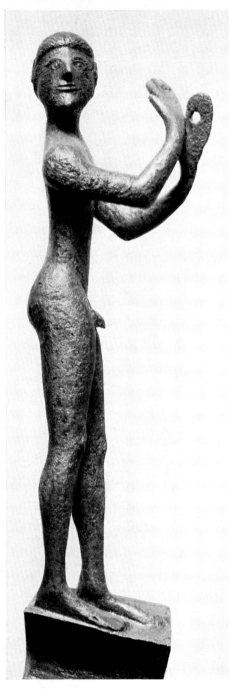

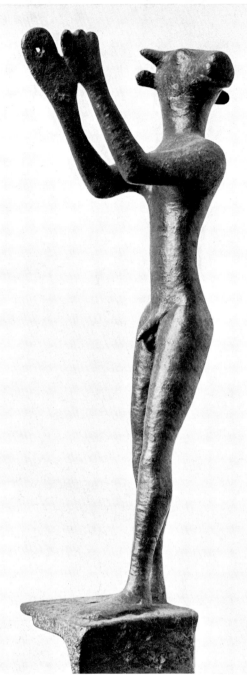

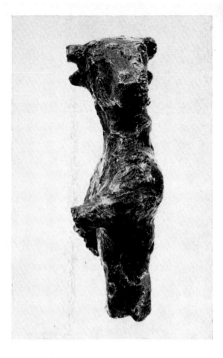

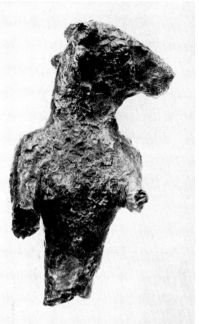

151 Bronze statuette from Olympia. Height 15 cm. Athens, National Museum

152 Bronze statuette. Height 18 cm. Paris, Louvre

153, 154 Fragment of a bronze statuette from the Acropolis in Athens. Height 8.1 cm. Athens, National Museum

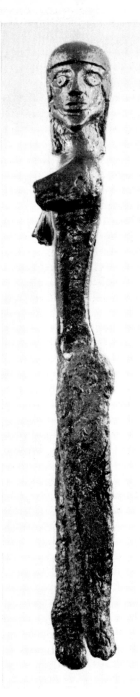

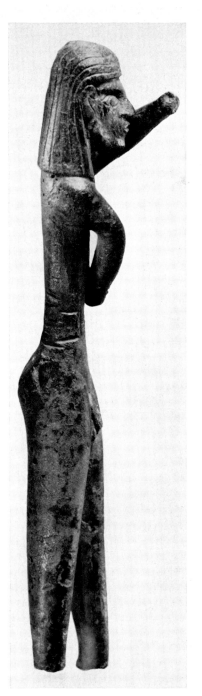

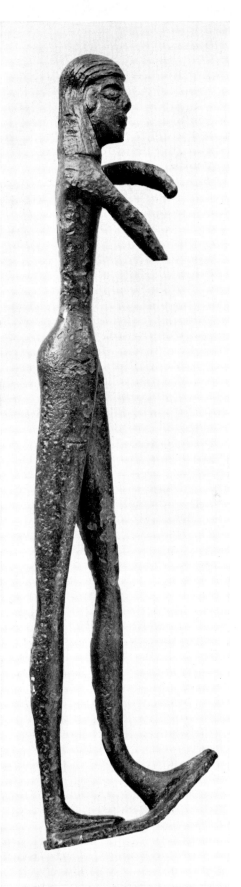

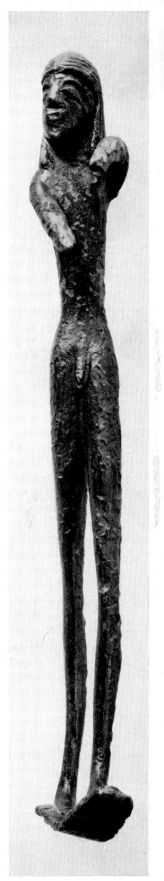

155 Bronze statuette from the
Acropolis in Athens.
Height about 18 cm.
Athens,
National Museum

156 Bronze statuette from Olympia.
Height 27.6 cm. Olympia,
Museum

157, 158 Bronze statuette from Olympia. Height 36.7 cm. Olympia, Museum

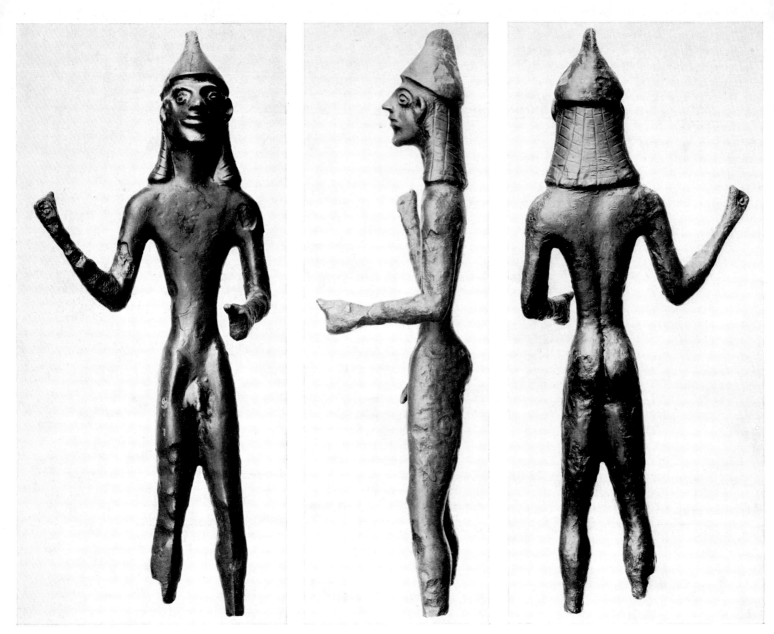

159–161　Bronze statuette from the Acropolis in Athens. Height 20.5 cm. Athens, National Museum

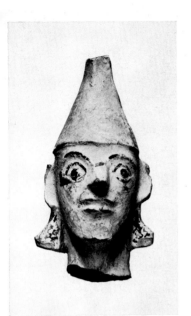

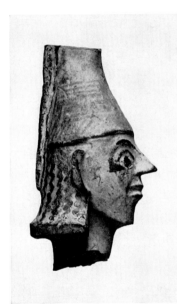

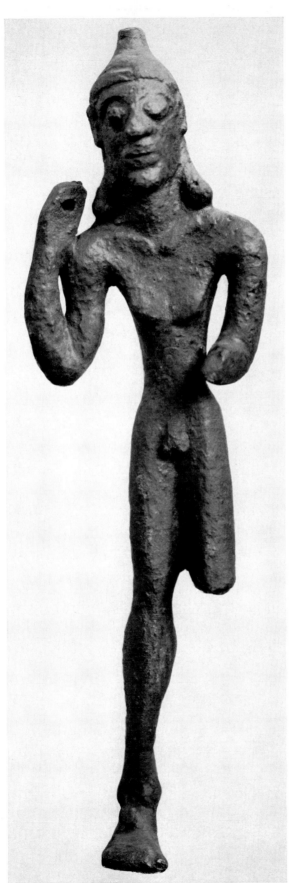

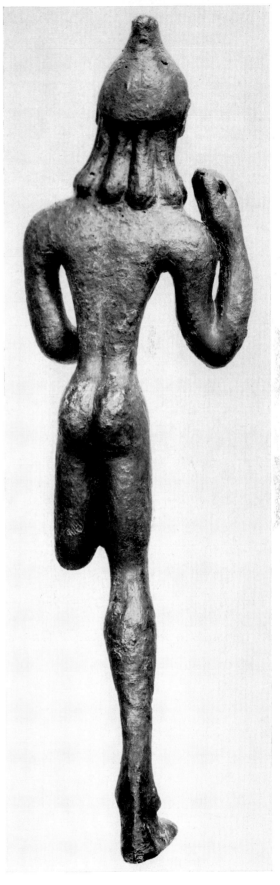

162, 163
Terracotta head from Amyclae.
Height 11.5 cm. Athens, National
Museum

164, 165 Bronze statuette from the Acropolis in Athens. Height 21.2 cm. Athens, National Museum

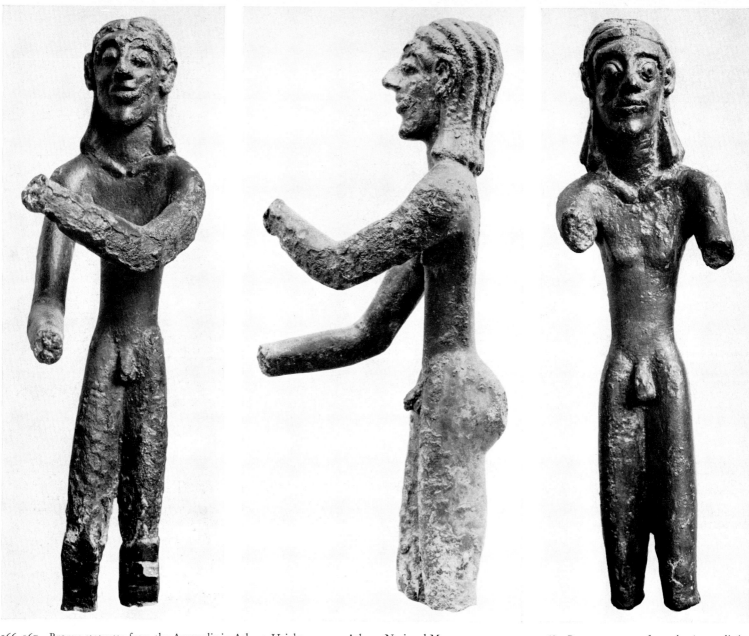

166, 167 Bronze statuette from the Acropolis in Athens. Height 21.5 cm. Athens, National Museum

168 Bronze statuette from the Acropolis in Athens. Height 20.5 cm. Athens, National Museum

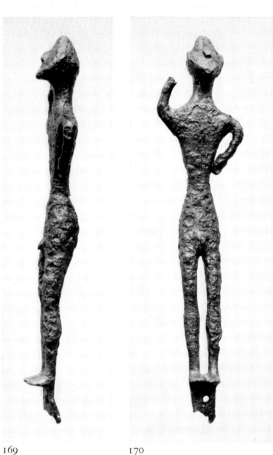

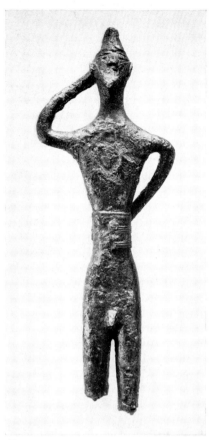

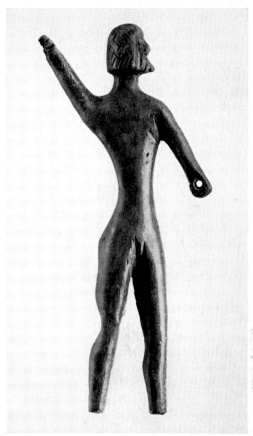

169 170 171 172

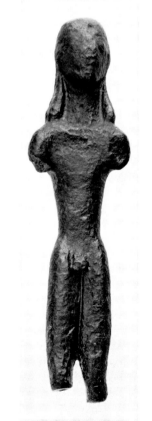

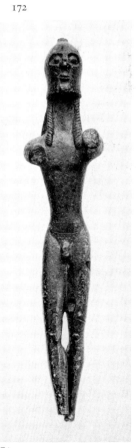

169, 170 Bronze statuette from Delphi. Height 17 cm. Delphi, Museum

171 Bronze statuette from Delphi. Height 18.5 cm. Delphi, Museum

172 Bronze statuette from Dodona. Height 13 cm. Athens, National
Museum

173 Bronze statuette from Delphi. Height 18 cm. Delphi, Museum

174, 175 Bronze statuette from Delphi. Height 22 cm. Delphi, Museum

173 174 175

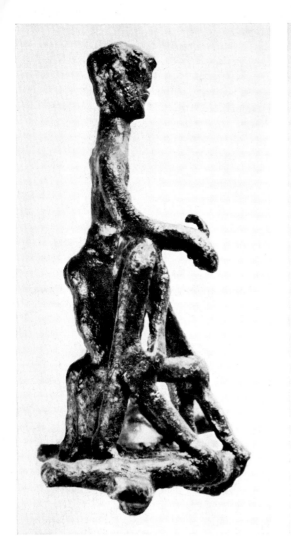

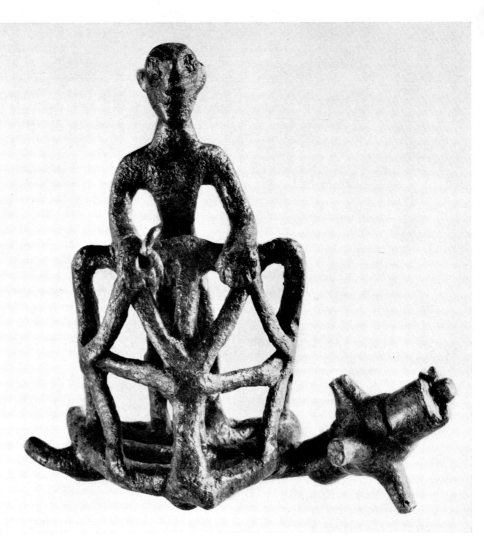

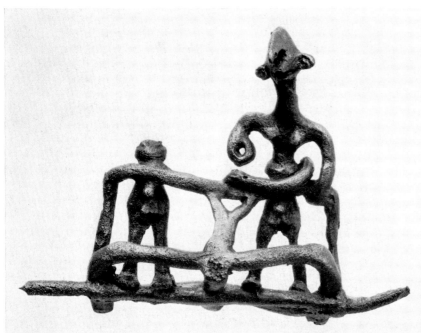

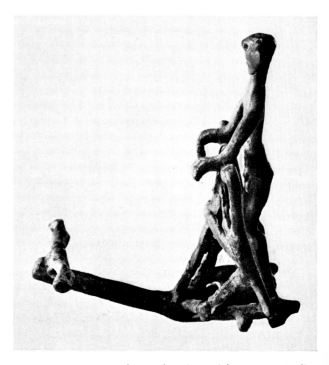

178 Bronze statuette from Olympia. Height 8.5 cm. Olympia, Museum

179 Bronze statuette from Olympia. Height 9.7 cm. Berlin, Staatliche Museen

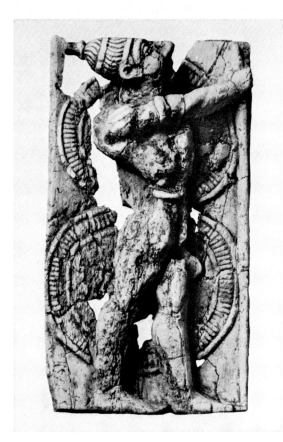

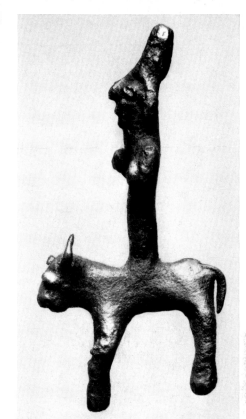

176, 177　Bronze statuette from Olympia. Height 8.7 cm. Olympia, Museum

180　Mycenaean ivory relief from Delos. Height 11.8 cm. Athens, National Museum

181　Bronze statuette from Carchemish. Height 6.2 cm. Copenhagen, National Museum

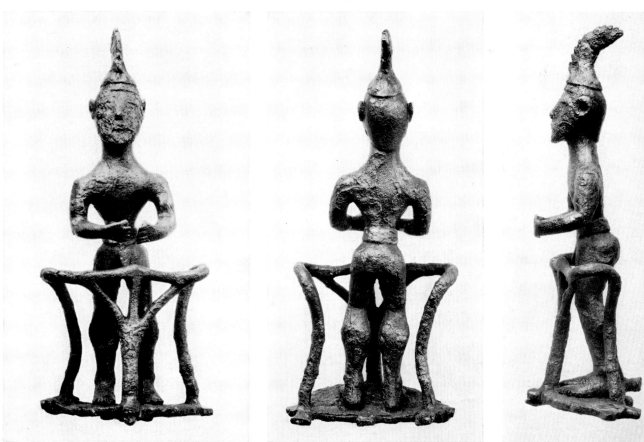

182–184　Bronze statuette from Olympia. Height 13.6 cm. Olympia, Museum

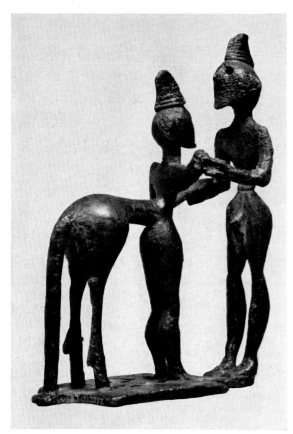

185　Bronze group from Olympia. Height 11 cm. New York, Metropolitan Museum of Art

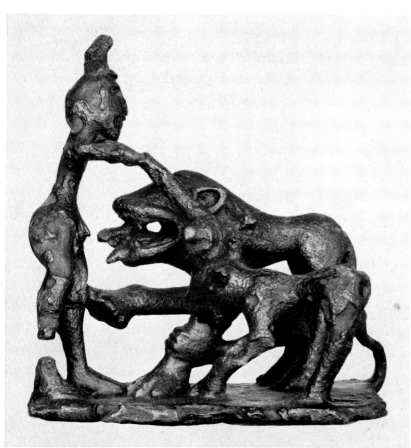

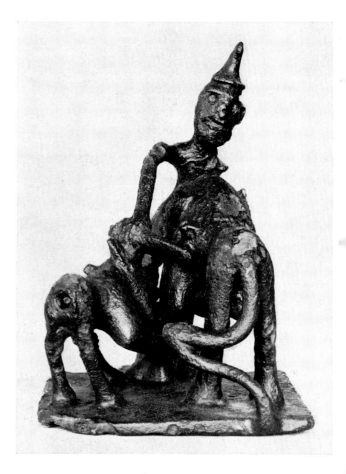

186, 187　Bronze group from Samos. Height 9 cm. Formerly Samos, Museum

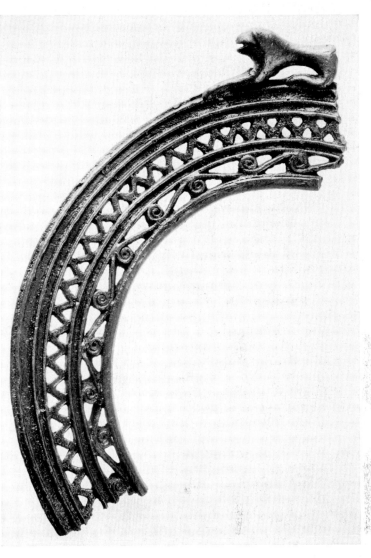

188 Fragment of a tripod ring-handle from Olympia. Height about 21 cm. Olympia, Museum

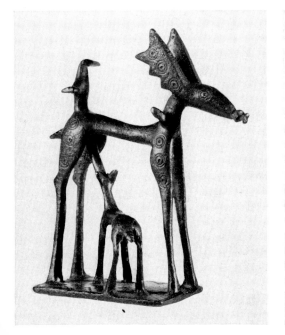

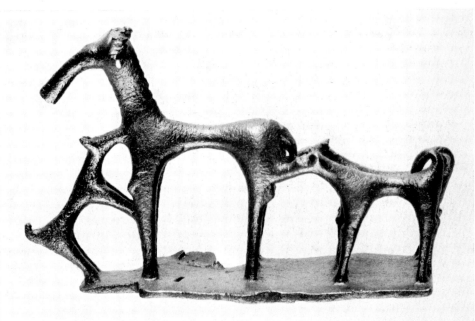

189 Bronze group from Olympia. Height 7.2 cm. Boston, Museum of Fine Arts

190 Bronze group from Olympia. Height 9.6 cm. Olympia, Museum

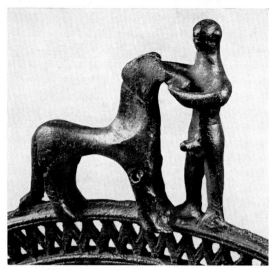

191 Detail of a tripod ring-handle from Olympia. Height 6 cm. Olympia, Museum

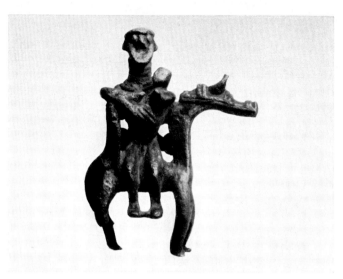

194 Bronze statuette from Samos. Samos, Museum

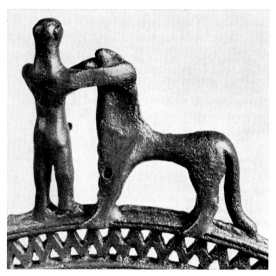

192 Detail of a tripod ring-handle from Olympia. Height 6 cm. Olympia, Museum

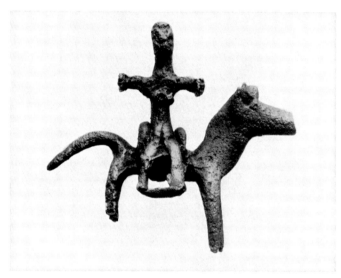

195 Bronze statuette from Olympia. Height 6.2 cm. Olympia, Museum

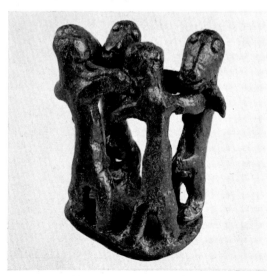

193 Bronze group from Petrovouni (Arcadia). Height 6.8 cm. Athens, National Museum

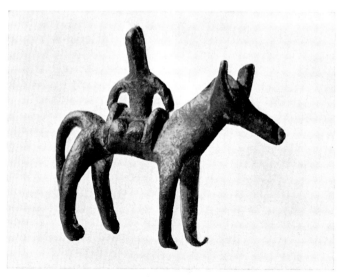

196 Bronze statuette from Lusoi (Arcadia). Vienna, Kunsthistorisches Museum

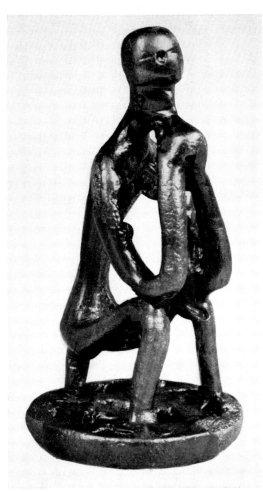

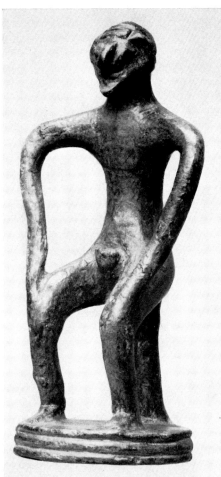

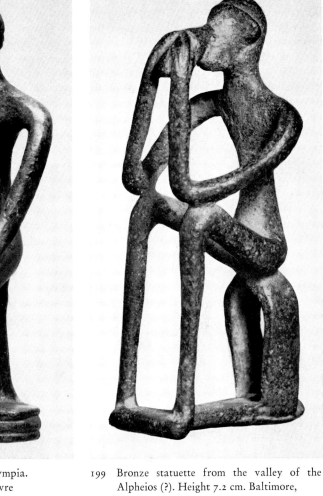

197 Bronze statuette from Sparta. Height 6.6 cm. Sparta, Museum

198 Bronze statuette from Olympia. Height 4.8 cm. Paris, Louvre

199 Bronze statuette from the valley of the Alpheios (?). Height 7.2 cm. Baltimore, Walters Art Gallery

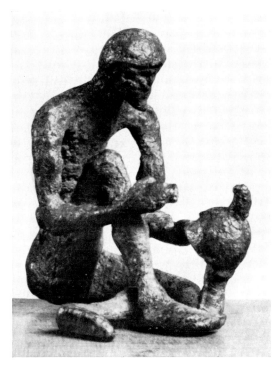

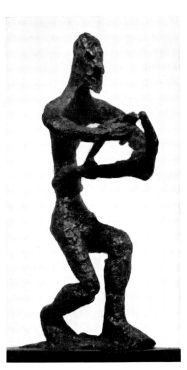

200 Bronze statuette. Height 5.2 cm. New York, Metropolitan Museum of Art

201, 202 Bronze statuette from Delphi. Height 7.2 cm. Formerly Würzburg, Martin von Wagner-Museum

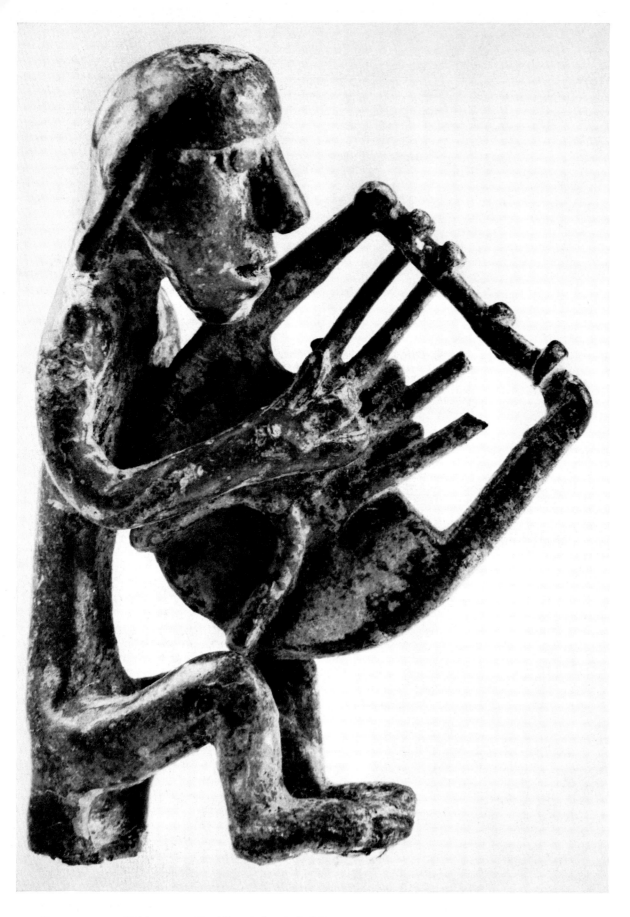

203 Bronze statuette. Height 5.5 cm. Heraklion, Archaeological Museum

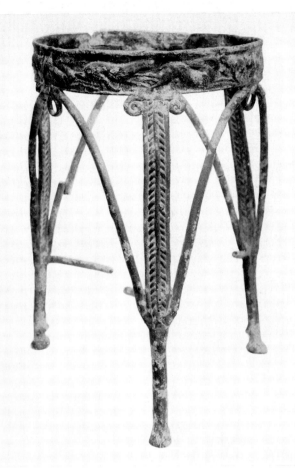

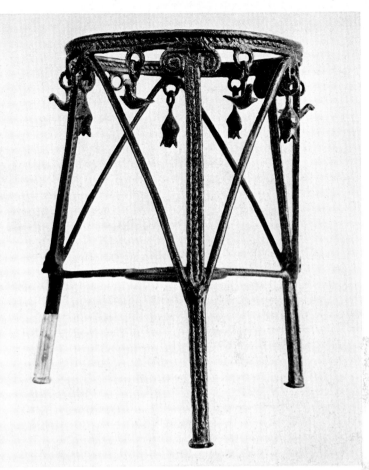

204 Bronze tripod from Kourion (Cyprus). Height 37.4 cm. New York, Metropolitan Museum of Art

205 Bronze tripod from Tiryns. Height 34 cm. Athens, National Museum

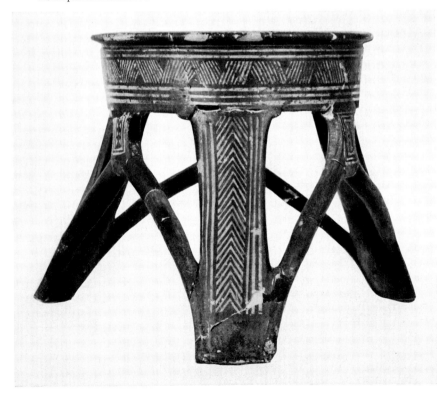

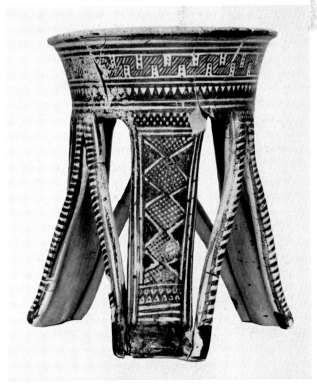

206 Terracotta tripod from the Kerameikos. Height 16.7 cm. Athens, Kerameikos Museum

207 Terracotta tripod from the Kerameikos. Height 21 cm. Athens, Kerameikos Museum

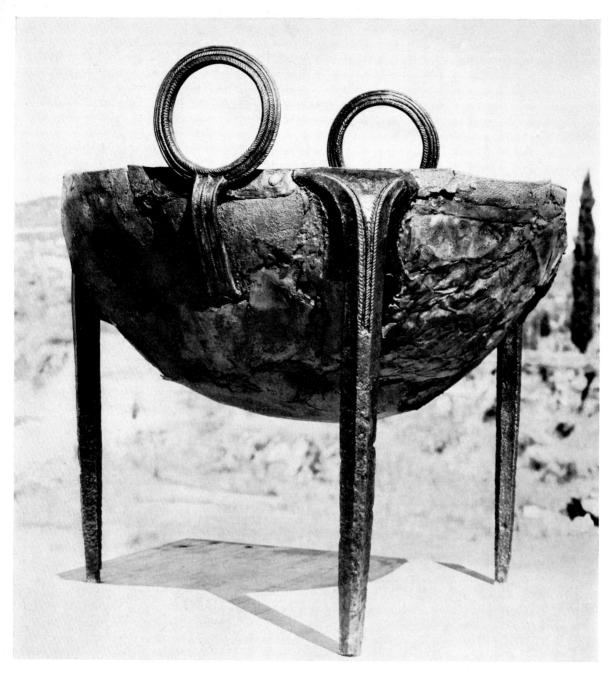

208 Bronze tripod-cauldron from Olympia. Height 65 cm. Olympia, Museum

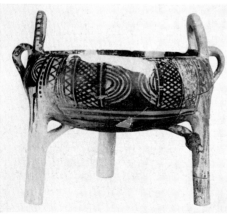

209 Terracotta tripod-cauldron from the Kerameikos. Height 14.9 cm. Athens, Kerameikos Museum

210 Fragment of a leg of a bronze tripod-cauldron from Olympia. Length 12.9 cm. Olympia, Museum

▷

211 Fragment of a leg of a bronze tripod-cauldron from Olympia. Length 26.7 cm. Olympia, Museum

212 Fragment of a leg of a bronze tripod-cauldron from Olympia. Length 26.3 cm. Olympia, Museum

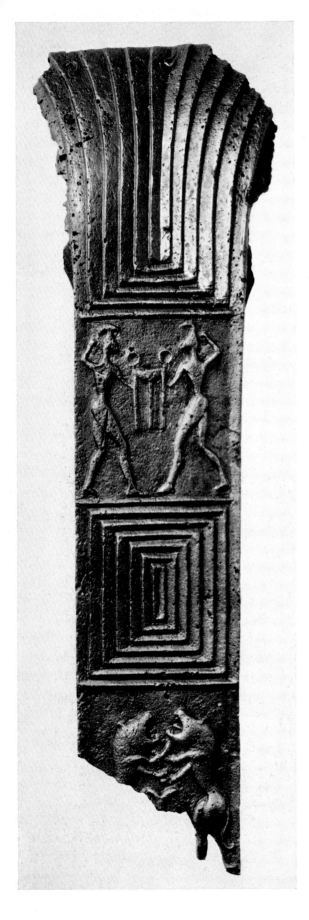

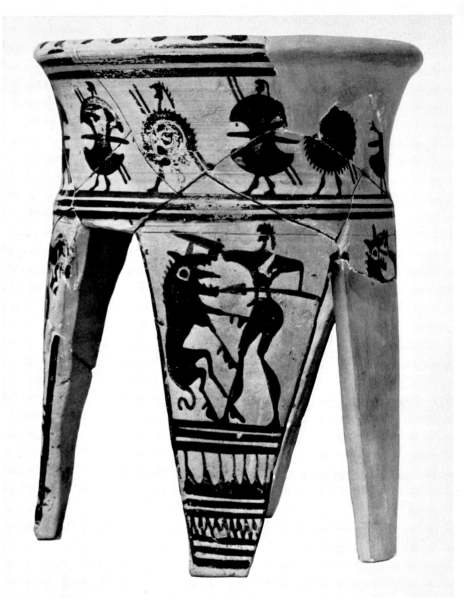

214 Terracotta stand for a krater from the Kerameikos. Height 17.8 cm. Athens, Kerameikos Museum

213 Fragment of a leg of a bronze tripod-cauldron from Olympia. Length 46.7 cm. Olympia, Museum

215 Fragment of a leg of a bronze tripod-cauldron
from Olympia. Length 18.5 cm.
Olympia, Museum

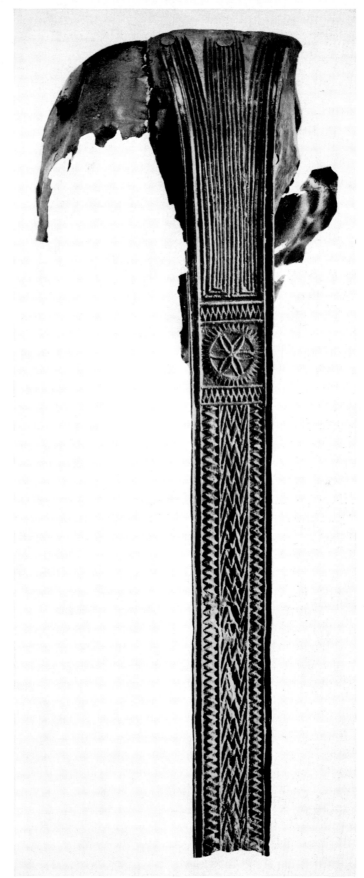

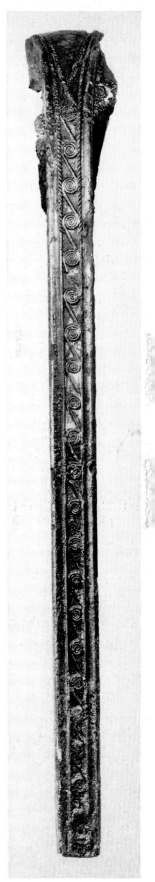

216 Fragment of a leg of a bronze tripod-cauldron
from Olympia. Olympia, Museum

217 Leg of a bronze tripod-cauldron from Olym-
pia. Length 77.5 cm. Olympia, Museum

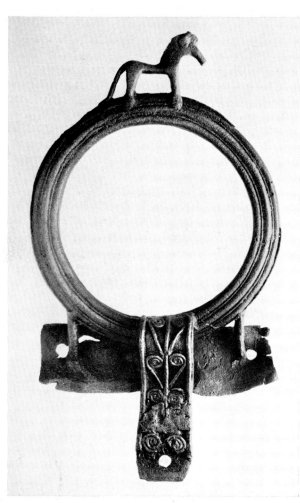

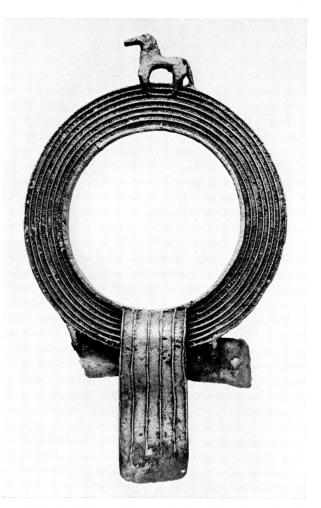

218 Ring handle from a bronze tripod-cauldron from Olympia. Diameter 15.4 cm. Olympia, Museum

219 Ring handle from a bronze tripod-cauldron from Olympia. Diameter 21.7 cm. Olympia, Museum

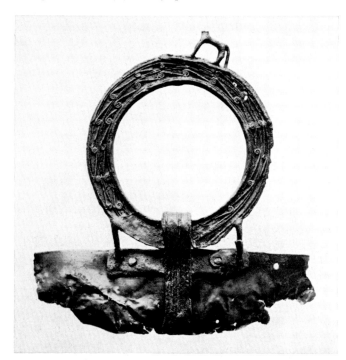

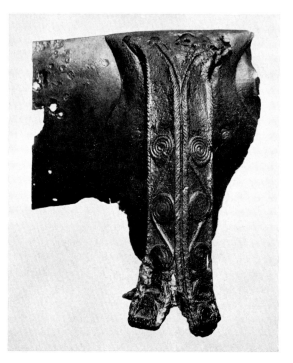

220 Ring handle from a bronze tripod-cauldron from Delphi. Diameter 25 cm. Delphi, Museum

221 Fragment of a leg of a bronze tripod-cauldron from Olympia. Length 15.9 cm. Olympia, Museum

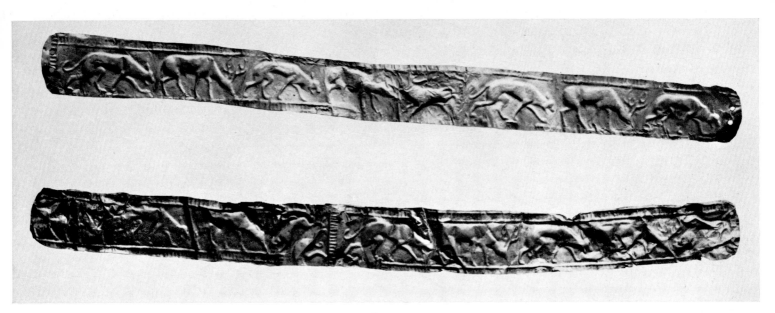

222 Gold band from the Kerameikos. Length about 36 cm. Athens, National Museum

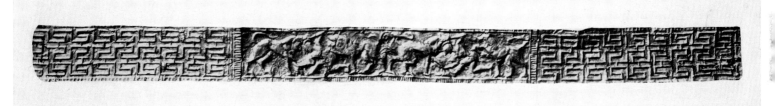

223 Gold band from the Kerameikos. Length about 39.7 cm. Copenhagen, National Museum

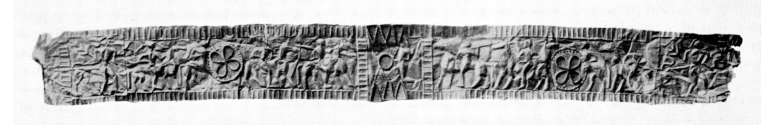

224 Gold band from the Kerameikos. Length about 37.7 cm. Amsterdam, Allard Pierson Museum

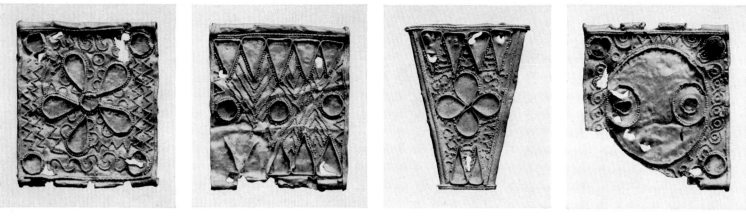

225–228 Plaques from a gold pendant from Eleusis. Athens, National Museum

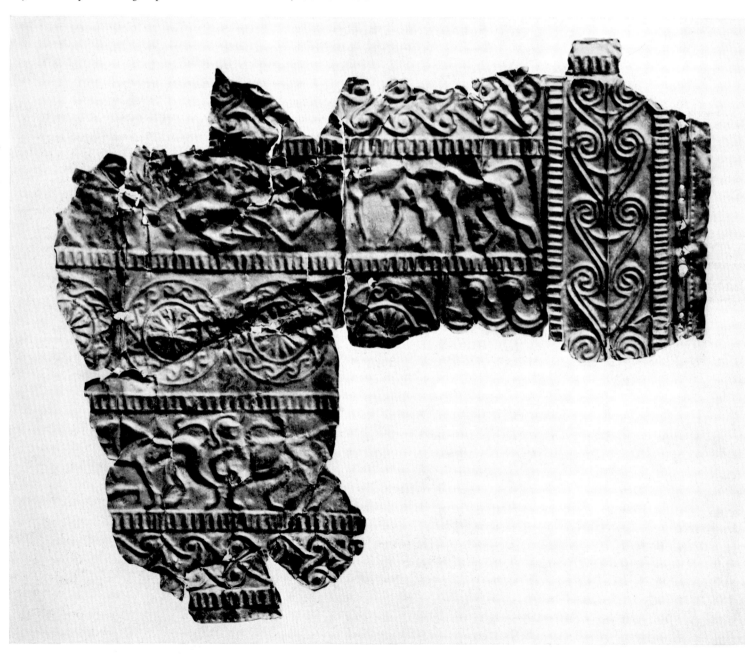

229 Fragment of a gold sheet from Eleusis. Height about 14 cm. Athens, National Museum

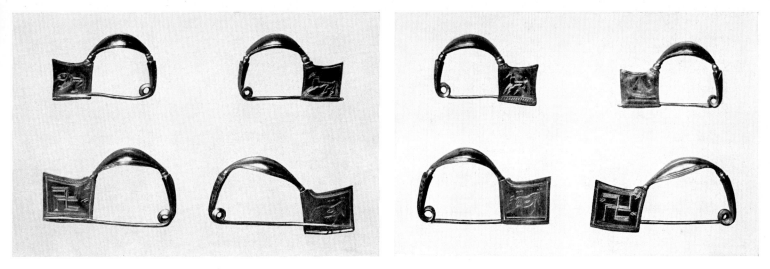

230, 231 Four plate fibulae. London, British Museum

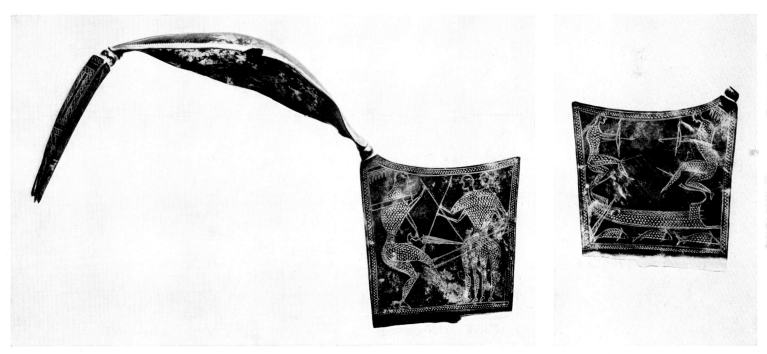

232, 233 Fragment of a plate fibula from Crete. Overall length 21 cm. Athens, National Museum

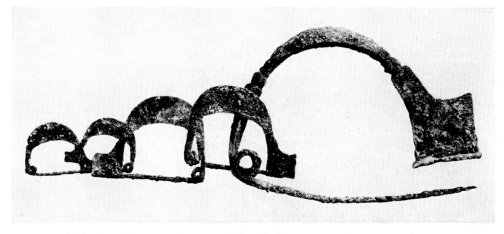

234 Five fibulae from the Kerameikos. Overall length about 26 cm. Athens, Kerameikos Museum

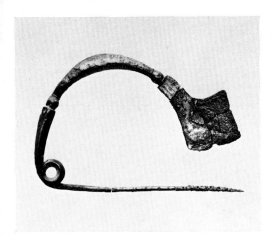

235–237 Three fibulae from the Kera-
meikos. Overall length about
21.5 cm. Athens, Kerameikos
Museum

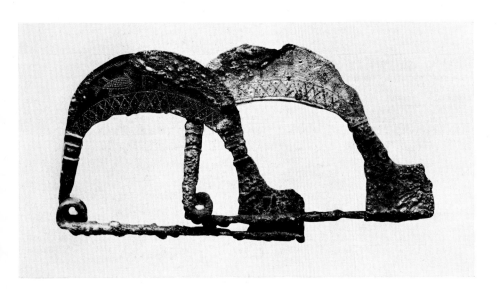

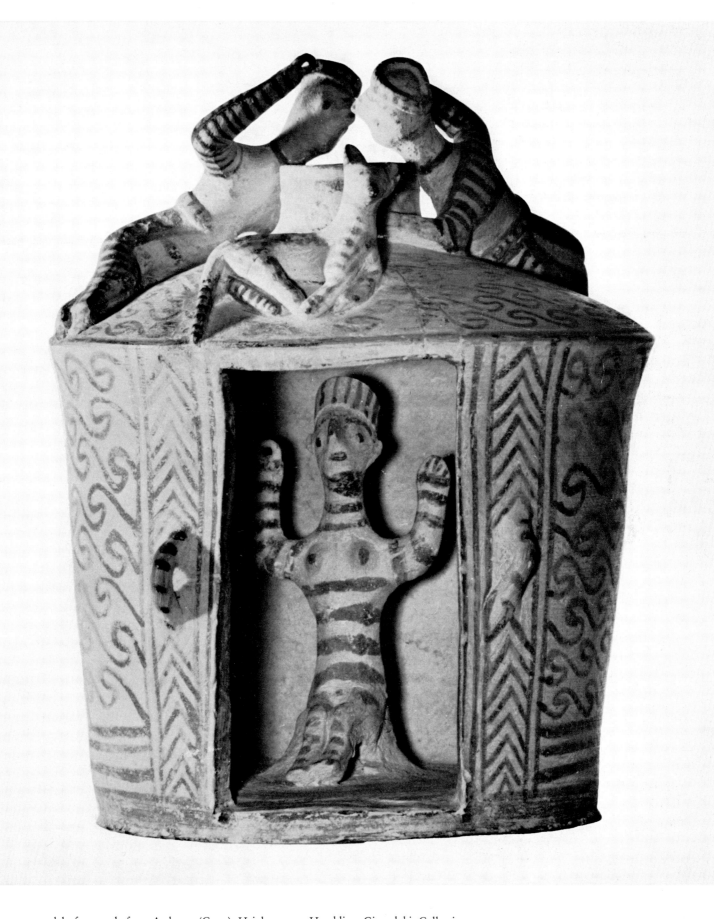

8 Terracotta model of a temple from Archanes (Crete). Height 22 cm. Heraklion, Giamalakis Collection

239 Limestone model of a house from Samos. Length about 20 cm. Samos, Museum

Editor's Postscript

This book by the late Bernhard Schweitzer, a survey of Greek Geometric art, was prompted by an invitation to contribute an article to the *Enciclopedia Universale dell'Arte* (Venice-Rome) on 'stile geometrico'. The object of the article (Volume V, 1960) was to describe the main features of the techniques and the development of Geometric pottery. This gave Schweitzer the idea of studying and describing all the artforms of the whole period, which nobody had previously managed to do, apart from a very concise article on 'Geometric Form' in the *History of Greek Art (Geschichte der griechischen Kunst)* Volume I (1950) by Friedrich Matz. In writing this book, Schweitzer was returning to a subject he first dealt with over fifty years ago in has doctoral thesis, where he had made an important breakthrough in the analysis and dating of the Greek Geometric style in pottery.

Although returning to the study of Geometric art was a continuation of studies begun earlier by the author, he had to cope with one tremendous disadvantage. Schweitzer had lost all his notes and photographs in Leipzig during the war. He had to begin again, literally from scratch, in Tübingen, and put together a completely new set of material. Working incredibly hard, he achieved this in a comparatively short time. He started work on the manuscript of the book at the end of the fifties and continued after retiring in 1960, with tremendous perseverance. At the end of 1964, he was forced to stop work by illness. He was very disappointed not to be able to complete the book with a chapter he had planned about the beginnings of early mythological pictures. This would have formed a suitable conclusion to this great theme. No notes were found amongst his papers from which this chapter could be reconstructed. Sad though this omission may be, we should be grateful for what Schweitzer did achieve. He managed to cover all the types of Geometric art with which he intended to deal. He apparently had no chapter in mind on early sealstones; at least no notes were found on this subject.

The manuscript was in the form of a checked first draft, typed by the author's wife, Frau Elisabeth Schweitzer, while he was alive. Bernhard Schweitzer was not able, however, because of his illness, to make any final check of the typed version for the printer. Apart from a number of photographs which he had obtained from museums and institutes, there was no usable picture material, and considerable difficulty was caused by the fact that he left no notes on the selection of pictures which he planned to use. Working from the obvious requirements of the text and with such photographs as could be obtained, Karl Gutbrod and the editor, in co-operation with Jochen Briegleb, compiled a selection of plates and text figures.

In the process of writing the captions for the figures, the text and the notes were revised once more, and errors and omissions which the author would certainly have put right had he been able to check them himself, were carefully corrected. Inevitably, this has meant rewriting certain passages. This has always been done with the greatest possible caution and with the intention, in every case, only of bringing out what the author really meant. A number of headings and sub-headings, intended to make the text understandable to a wider readership, have also been added. The notes have been checked and partly rewritten. They have been brought up to date when there have been important publications of new excavations or significantly new interpretations of certain pieces. Thus references to P. Courbin's publication

(Paris, 1966) of the Argive Geometric pottery have been added in the relevant notes. Schweitzer knew of H. V. Herrmann's essay on 'Geometric bronze sculpture workshops' in the *Jahrbuch* of the German Archaeological Institute, Volume 79 (1964), pp. 17-71, but he could no longer take account of its conclusions, which in places were different from his own. But as editor, I decided not to write up a balanced view of the differences between the two scholars, but only to refer to them in the book. The comprehensive publication of earlier Samian vessels by H. Walter (Bonn, 1968) is only referred to in cases where new material has been brought to light. And it has only been possible to mention briefly J. N. Coldstream's major work, *Greek Geometric Pottery* (London, 1968), but not to work it into the notes properly.

The book is neither a handbook nor, in spite of the large number of items dealt with, a mere collection of material. Where the current state of scholarship allowed it, material has been described, and where necessary, analysis and study have been undertaken. The book is an interpretation of the Geometric art of Greece, an enormously varied and yet extraordinarily uniform expression of a unique, unchangeable period in history.

Most of the exhausting and time-consuming work of producing a final manuscript and collecting the pictures was done by Jochen Briegleb. The editor is very grateful to him indeed. Without his energetic and patient help, the publishers' deadlines could never have been met.

And finally, the book could scarcely have been written without the sympathetic encouragement of friend and publisher Karl Gutbrod, who often urged Schweitzer to produce this comprehensive description of Geometric art. Its posthumous printing is also his initiative.

H. V. Herrmann, H. Siedentopf, W. Trillmich and K. Wallenstein all helped prepare the manuscript and make the list of figures. The following also helped prepare the work by obtaining and, in some cases, generously giving, photographs from museums, institutes, archives or their own collections: D. Ahrens (Munich), S. Alexiou (Heraklion), R. D. Barnett (London), G. Beckel (Würzburg), D. v. Bothmer (New York), P. Bruneau (Athens), H. Brunstig (Leiden), M.-L. Buhl (Copenhagen), J. Charbonneaux (Paris), J. M. Cook (Bristol), G. Daltrop (Hamburg), G. Daux (Athens), P. Devambez (Paris), N. Dolunay (Istanbul), H. Drerup (Marburg), C. Dunant (Geneva), W. Fuchs (Athens), U. Gehrig (Berlin), J. W. Graham (Toronto), A. Greifenhagen (Berlin), R. W. Hamilton (Oxford), D. E. L. Haynes (London), J. M. Hemelrijk (Amsterdam), H. Heres-von Littrow (Berlin), D. K. Hill (Baltimore), N. Himmelmann-Wildschütz (Bonn), M. Hirmer (Munich), P. Hommel (Frankfurt), U. Jantzen (Hamburg), G. Konstantinopoulos (Rhodes), K. Kübler (Tübingen), E. Kunze (Athens), H. Marwitz (Munich), G. R. Meyer (Berlin), G. Neumann (Athens), R. Noll (Vienna), D. Ohly (Munich), V. Poulsen (Copenhagen), A. J. N. W. Prag (Oxford), E. Rohde (Berlin), C. Rolley (Dijon), E. Simon (Würzburg), J. Thimme (Karlsruhe), R. Tölle (Hamburg), C. C. Vermeule (Boston).

And lastly, thanks are due to Herr Siegfried Hagen of Verlag M. DuMont Schauberg for his understanding and co-operation.

Ulrich Hausmann

Abbreviations

AA = Archäologischer Anzeiger

Acta Arch = Acta Archaeologica

AJA = American Journal of Archaeology

Akurgal-Hirmer, *Hethiter* = E. Akurgal-M. Hirmer, *Die Kunst der Hethiter*. Munich, 1961

AM = Mitteilungen des Deutschen Archäologischen Instituts. Athenische Abteilung

ASAtene = Annuario della Scuola Archeologica di Atene

AZ = Archäologische Zeitung

Barnett, *Nimrud Ivories* = R. D. Barnett, *A Catalogue of the Nimrud Ivories with other Examples of Ancient Near Eastern Ivories in the British Museum*. London, 1957

BCH = Bulletin de Correspondance Hellénique

Blinkenberg, *Fibules* = C. Blinkenberg, *Fibules Grecques et Orientales*. Copenhagen, 1926

Bossert, *Altkreta* = H. T. Bossert, *Altkreta: Kunst und Handwerk in Griechenland, Kreta und in der Ägäis von den Anfängen bis zur Eisenzeit*, 3rd Ed. Berlin, 1937

Bossert, *Altanatolien* = H. T. Bossert, *Altanatolien, Kunst und Handwerk in Kleinasien von den Anfängen bis zum völligen Aufgehen in der griechischen Kultur*. Berlin, 1942

Bossert, *Altsyrien* = H. T. Bossert, *Altsyrien, Kunst und Handwerk in Cypern, Syrien, Palästina, Transjordanien und Arabien von den Anfängen bis zum völligen Aufgehen in der griechisch-römischen Kultur*. Tübingen, 1951

Brock, *Fortetsa* = J. K. Brock, *Fortetsa. Early Greek Tombs near Knossos*. Cambridge, 1957

BSA = Annual of the British School at Athens

Cl. Rhodos = Clara Rhodos, *Studi e materiali pubblicati a cura dell'Istituto Storico-Archeologico di Rodi*. Rhodes, 1928 ff. III: G. Jacopi, *Scavi nella necropoli di Jaliso 1924–8*. (1929)
IV: G. Jacopi, *Esplorazione archeologica di Camiro. I: Scavi nelle necropoli Camiresi 1929–30*. (1931)
VI/VII: G. Jacopi, *Esplorazione archeologica di Camiro. II*. (1932)

Corinth = Corinth. Results of Excavations conducted by the American School of Classical Studies at Athens. Cambridge, Mass.; Princeton, N.J., 1929 ff.
VII 1: S. S. Weinberg, *The Geometric and Orientalizing Pottery*. (1943)

Courbin, *Céramique* = P. Courbin, *La céramique géométrique de l'Argolide*. Paris, 1966

CVA = Corpus Vasorum Antiquorum

Davison, *Workshops* = J. M. Davison, *Attic Geometric Workshops*. New Haven, 1961

Dawkins, *Artemis Orthia* = R. M. Dawkins (Ed.), *The Sanctuary of Artemis Orthia at Sparta*. London, 1929

Délos = Exploration archéologique de Délos faite par l'École Française d'Athènes. Paris, 1909 ff.
XV: C. Dugas-C. Rhomaios, *Les vases préhelléniques et géométriques*. (1934)

Deltion = Archaiologikon Deltion

Desborough, *Protogeom. Pottery* = V. R. d'A. Desborough, *Protogeometric Pottery*. Oxford, 1952

Descamps, *Ivoires* = C. Descamps de Mertzenfeld, *Inventaire commenté des ivoires phéniciens et apparentés découverts dans le Proche-Orient*. Paris, 1954

Ephem = Archaiologike Ephemeris

FdDelphes = Fouilles de Delphes exécutées par ordre du Gouvernement Français. Paris, 1902 ff.
V: P. Perdrizet, *Monuments figurés. Petits bronzes, terrescuites, antiquités diverses*. (1908)

Festschr. Schweitzer = Neue Beiträge zur Klassischen Altertumswissenschaft. Festschrift zum 60. Geburtstag von Bernhard Schweitzer. Edited by R. Lullies. Stuttgart, 1954

Friis Johansen, *Exochi* = K. Friis Johansen, *Exochi. Ein frührhodisches Gräberfeld*. Copenhagen, 1958 (= ActaArch 28, 1957, 1–192)

Frödin-Persson, *Asine* = O. Frödin-A. W. Persson, *Asine. Results of the Swedish Excavations 1922–30*. Stockholm, 1938

Furumark, *Myc. Pottery* = A. Furumark, *The Mycenaean Pottery. Analysis and Classification*. Stockholm, 1941

Hall, *Vrokastro* = E. H. Hall, *Excavations in Eastern Crete. Vrokastro*. Philadelphia, 1914

Hampe, *Sagenbilder* = R. Hampe, *Frühe griechische Sagenbilder in Böotien*. Athens, 1936

Hampe, *Gleichnisse* = R. Hampe, *Die Gleichnisse Homers und die Bildkunst seiner Zeit*. Tübingen, 1952

Hampe, *Grabfund* = R. Hampe, *Ein frühattischer Grabfund*. Mainz, 1960

Himmelmann, *Bemerkungen* = N. Himmelmann-Wildschütz, *Bemerkungen zur geometrischen Plastik*. Berlin, 1964

IM = Istanbuler Mitteilungen

JdI = Jahrbuch des Deutschen Archäologischen Instituts

JHS = The Journal of Hellenic Studies

Karo, *Schachtgräber* = G. Karo, *Die Schachtgräber von Mykenai*, Munich, 1930, 1933

Kerameikos = Kerameikos. Ergebnisse der Ausgrabungen. Berlin, 1939 ff.
I: W. Kraiker-K. Kübler, *Die Nekropolen des 12. und 10. Jahrhunderts*. (1939)
IV: K. Kübler, *Neufunde aus der Nekropole des 11. und 10. Jahrhunderts*. (1943)
V 1: Kübler, *Die Nekropole des 10. bis 8. Jahrhunderts*. (1954)

Kunze, *Bronzereliefs* = E. Kunze, *Kretische Bronzereliefs*. Stuttgart, 1931

Kunze, *Meisterwerke* = E. Kunze, *Neue Meisterwerke griechischer Kunst aus Olympia*. Munich-Pasing, 1948

Lamb, *Bronzes* = W. Lamb, *Greek and Roman Bronzes*. London, 1929

Lindos = Lindos. Fouilles de l'Acropole 1902–14. Berlin, 1931 ff.
I: C. Blinkenberg, *Les petits objets*. (1931)

Marinatos-Hirmer, *Kreta* = S. Marinatos-M. Hirmer, *Kreta und das mykenische Hellas*. Munich, 1959

Matz, *Geschichte* = F. Matz, *Geschichte der griechischen Kunst*. I: *Die geometrische und die frügarchaische Form*. Frankfurt am Main, 1950

Matz, *Kreta* = F. Matz, *Kreta Mykene Troja. Die minoische und die homerische Welt*. Stuttgart, 1956

MetrMusBull = Metropolitan Museum of Art, Bulletin

Myres, *Cesnola Coll.* = J. L. Myres, *The Metropolitan Museum of Art. Handbook of the Cesnola Collection of Antiquities from Cyprus*. New York, 1914

Neugebauer, *Bronzestatuetten* = K. A. Neugebauer, *Antike Bronzestatuetten*. Berlin, 1921

Neugebauer, *Bronzen* = K. A. Neugebauer, *Staatliche Museen zu Berlin. Katalog der statuarischen Bronzen im Antiquarium. I: Die minoischen und archaisch griechischen Bronzen*. Berlin, Leipzig, 1931

ÖJh = Jahreshefte des Österreichischen Archäologischen Instituts in Wien

Ohly, *Goldbleche* = D. Ohly, *Griechische Goldbleche des 8. Jahrhunderts v.Chr*. Berlin, 1953

OlBer = Bericht über die Ausgrabungen in Olympia. Berlin, 1938 ff.

Olympia = Olympia. Die Ergebnisse der von dem Deutschen Reich veranstalteten Ausgrabung. Berlin, 1890 ff.
IV: A. Furtwängler, *Die Bronzen und die übrigen kleineren Funde von Olympia*. (1890)

Payne, *Perachora* = H. Payne, *Perachora. The Sanctuaries of Hera Akraia and Limenia*. Excavations of the British School of Archaeology at Athens 1930–3. Oxford, 1940, 1962

Payne, *Protokor. Vasenmalerei* = H. G. G. Payne, *Protokorinthische Vasenmalerei*. Berlin, 1933

Perrot-Chipiez, *Histoire* = G. Perrot-C. Chipiez, *Histoire de l'Art dans l'Antiquité*. Paris, 1882 ff.

Pfuhl, *MuZ* = E. Pfuhl, *Malerei und Zeichnung der Griechen*. Munich, 1923

Reichel, *Goldrelief* = W. Reichel, *Griechisches Goldrelief*. Berlin, 1942

Richter, *Handbook* = G. M. A. Richter, *The Metropolitan Museum of Art, Handbook of the Greek Collection*. Cambridge, Mass., 1953

RM = Mitteilungen des Deutschen Archäologischen Instituts. Römische Abteilung.

Schefold, *Sagenbilder* = K. Schefold, *Frühgriechische Sagenbilder*. Munich, 1964

Schweitzer, *Herakles* = B. Schweitzer, *Herakles, Aufsätze zur griechischen Religions- und Sagengeschichte*. Tübingen, 1922

SwedCyprExped = The Swedish Cyprus Expedition. Finds and Results of the Excavations in Cyprus 1927–31. Stockholm, 1934 ff.

Thera = Thera. Untersuchungen, Vermessungen und Ausgrabungen in den Jahren 1895–1902. Berlin, 1899 ff.

Tiryns = Tiryns. Die Ergebnisse der Ausgrabungen des (Deutschen Archäologischen) Instituts (in Athen). Athens, 1912 ff.

Waldstein, *Heraeum* = C. Waldstein, *The Argive Heraeum*. Boston, New York, 1902, 1905

Willemsen, *Dreifußkessel* = F. Willemsen, *Dreifußkessel von Olympia. Alte und neue Funde*. Berlin, 1957

Young, *Graves* = R. S. Young, *Late Geometric Graves and a Seventh Century Well in the Agora*. Athens, 1939 (= Hesperia Supplement 2)

Notes

Introduction (pages 8–20)

1 H. T. Bossert, *Altkreta*³ (1937). F. Matz, *Kreta Mykene Troja* (1956). S. Marinatos-M. Hirmer, *Kreta u. d. mykenische Hellas* (1959). F. Matz, *Kreta u. frühes Griechenland* (1962).

2 Praschniker, *Wiener Jahrbuch für Kunstgeschichte*, 2, 1923, 14 ff.
Furumark, *Mycenaean Pottery*, 504, 511, 512, 513, 520, 529, 531, 551, 554, 567, 571 f., 580, 581, 661.

3 See below p. 22 ff.

4 H. B. Hawes, *Gournia* (1908), 23, 26 (cf. plan facing p. 22, house He) 46 Pl. 10,8 (amphora of the 14th C.) T. D. Atkinson, *Excavations at Phylakopi* (1904), 19, 27, 55 ff., 270 Fig. 49.

5 This dating is given by the recent finds of 1963 (*BCH* 88, 1964, 775 ff.). F. Matz, *Kreta und frühes Griechenland*, 218, dates the destruction in the early 14th C.

6 Cf. the splendid ivory relief of a warrior with octagonal shield, Mycenaean helmet, spear and apron with codpiece, from a store of the Artemision at Delos (Gallet de Santerre-Tréheu, *BCH* 71/2, 1947/8, 156 ff. Pl. 25). The anthropological type is East Ionian Archaic sculpture. Here: Pl. 180, see below p. 148.

7 A. J. B. Wace, *Chamber tombs at Mycenae* (1932), 30, 176 ff. Pls. 18, 19,5.

8 See below p. 164 ff.

9 See below p. 201 ff.

10 See below p. 186 ff.

11 Marinatos, *AA* 1937, 222 ff. Fig. 4.

12 See below p. 164 ff.

13 See below p. 125 f.

14 See below p. 195 ff.

15 O. Menghin, *Weltgeschichte der Steinzeit* (1931), 209, Pl. 23.

16 M. Hoernes, *Urgeschichte der bildenden Kunst in Europa*³ (1925), 576. Menghin, *Weltgeschichte der Steinzeit*, 526.

17 A. Evans, *The Palace of Minos* I (1921), 35 ff. Figs. 6–8; II (1928), 4 ff. Figs. 3–4. Bossert, *Altkreta*, 34 Pl. 188 No. 323.

18 Xanthoudides, *Deltion* 4, 1918, 136 ff.

19 S. Xanthoudides, *The Vaulted Tombs of Mesará* (1924), 37 ff. Pls. 26–27.

20 Bossert, *Altkreta*, 34 f. Pls. 195–197 Nos. 340–344. Marinatos-Hirmer, *Kreta* Figs. 20–24 Pls. V–XIII. A. Zois, *Der Kamares-Stil* (1968).

21 Nilsson, *Opuscula Atheniensia* I (1953), 1 ff. Schachermeyr, *Saeculum* 5, 1954, 268 ff. *Idem*, *Die ältesten Kulturen Griechenlands* (1955).

22 C. W. Blegen, *Korakou* (1921), 8 ff. Pl. 1. *Idem*, *Zygouries* (1928), 101 ff. Pls. 11–13. H. Goldman, *Excavations at Eutresis* (1931), 115 ff. Pl. 8. Schachermeyr, *Die ältesten Kulturen Griechenlands*, 192 Fig. 61.

23 Goldman, *Excavations at Eutresis*, 144 ff. Pls. 13–16. C. Zervos, *L'art des Cyclades* (1957), Figs. 120–121.

24 S. Lloyd, *Early Anatolia* (1956), 67 ff. Fig. 57.

25 C. F. A. Schaeffer, *Stratigraphie comparée et chronologie de l'Asie Occidentale* (1948), Figs. 243–244 (Iran, Tepe Giyan) 249 (Iran, Tepe Jamshidi) 97 (Syria) 171–2 (Cilicia, Tarsus) Pl. 52, 4 (Cyprus).

26 A. Conze, *Zur Geschichte der Anfänge griechischer Kunst*, Sitz.-Ber. Akad. Vienna, phil-hist. Kl., 1870, 505 ff. The most comprehensive description of Geometric pottery, by J. N. Coldstream (*Greek Geometric Pottery*, London 1968), appeared while this book was being typeset, and therefore no account could be taken of it here.

27 Desborough, *Protogeom. Pottery*, 294.

28 Kahane, *AJA* 44, 1940, 464 ff.

29 Albright in *Studies presented to H. Goldman* (1956), 144 ff.

30 Wace, *BSA* 48, 1953, 15, Note 22. *Idem*. in *Studies presented to H. Goldman*, 134.

31 A. Furumark, *The Chronology of Mycenaean Pottery* (1941), 110 ff., 115.

32 *Kerameikos* I, 1 ff., 162 ff.

33 Wide, *AM* 35, 1910, 17 ff.

34 H. Goldman, *Excavations at Gözlü Kule, Tarsus*. II (1956), 205 ff., Pls. 336–337.

35 P. J. Riis, *Hama II 3: Les cimetières à cremation* (1948), 46 ff., 201 ff. Figs. 33, 42–43, 50–52, 55, 63.

36 On the end of the Mycenaean world and the dark centuries, see V. R. Desborough, *The Last Mycenaeans and their Successors* (1964).

37 Desborough, *Protogeom. Pottery*, 294 f.

38 Schweitzer, *AM* 43, 1918, 8 ff. Kahane, *AJA* 44, 1940, 480 ff. T. J. Dunbabin, *The Western Greeks* (1948), 435 ff. Vallet-Villard, *BCH* 76, 1952, 289 ff.

39 Vallet-Villard, *BCH* 76, 1952, 331 Fig. 7.

40 Bosticco, *La Parola del Passato* 12, 1957, 218 Nos. 102, 225.

41 Buchner, *RM* 60/1, 1953/4, 37 ff. Pls. 14–17.

42 Kübler in *Studies presented to D. M. Robinson* II (1953), 25 ff. Pls. 7–8. *Kerameikos* V 1, 201 ff., 237 f. Pl. 162. Kunze, *Gnomon* 30, 1958, 333. Herrmann, *JdI* 81, 1966, 131 f. Fig. 46.

43 Albright in *Studies presented to H. Goldman*, 149 f.

44 Gjerstad, *Opuscula Archaeologica* IV (1946), 4 ff. Pl. 1.

45 *Kerameikos* V 1, 236 ff.

46 *Kerameikos* I, IV, V 1.

47 Thompson, *Hesperia* 17, 1948, 185 f. Pl. 66,1.

48 Beazley, *AJA* 49, 1945, 156 ff.

49 J. D. Beazley in Caskey-Beazley, *Attic Vase Paintings in the Museum of Fine Arts Boston* II (1954), 53 No. 95.

50 Cf. Kahane, *AJA* 44, 1940, 464 ff.

Chapter I: Attic Geometric Pottery: Beginnings and Ninth Century (pages 22-31)

1 Schweitzer, *Gnomon* 9, 1933, 184 f.; 10, 1934, 341.
2 Riis, *ActaArch* 10, 1939, 1 ff. McFadden, *AJA* 58, 1954, 131 ff. Pl. 27. See below p. 164 ff.
3 On the survival of Minoan-Mycenaean elements in later Greek art: Hafner in *Festschr. des Röm.-Germ. Zentralmuseums Mainz* III (1953), 83 ff. Pls. 5-7.
4 Weickert, *AA* 1942, 512 ff. Richter, *BSA* 46, 1951, 143 ff. Pls. 14-17. J. V. Noble, *The Techniques of Painted Attic Pottery* (1965).
5 A. Furumark, *The Chronology of Mycenaean Pottery* (1941), 21 ff.
6 On Protogeometric pottery, see V. R. d'A. Desborough, *Protogeometric Pottery* (1952).
7 *Kerameikos* V 1, 58 ff.
8 Desborough, *Protogeom. Pottery*, 125 f., 291.
9 Cf. the Early Geometric grave find published by Young (*Hesperia* 18, 1949, 275 ff. Pls. 67-68).
10 Cf. the examples from an Early Geometric grave in the Agora at Athens (Welles, *AJA* 51, 1947, 271, Pl. 64).
11 See below p. 37 ff., 178 ff., and Note 128 in Ch. VII.
12 Schweitzer, *AM* 43, 1918, 52 Pl. 1.
13 Burr, *Hesperia* 2, 1933, 553, No. 6, Fig. 11, 6.
14 Praschniker, *Wiener Jahrbuch für Kunstgeschichte* 2, 1923, 20.
15 Schweitzer, *AM* 43, 1918, 9. (On the figure, cf. Furumark, *Myc. Pottery*, 363 Fig. 62 [50] — also Blegen, *Prosymna* II, 187 Fig. 719 and *Kerameikos* IV, Pl. 23 (Inv. No. 2102). On the interpretation of the Geometric ornamentation, see N. Himmelmann-Wildschütz, *Über einige gegenständliche Bedeutungsmöglichkeiten des frühgriechischen Ornaments* (1968 = Abh. Ak. Mainz, Geistes- u. sozialwiss. Klass. 1968,7) 282 ff.
16 The examples are taken from: *AM* 43, 1918 Pl. 1. *JHS* 51, 1931 Pl. 6. *Kerameikos* IV, Pl. 21. *Hesperia* 18, 1949, 290 f. Figs. 3-4; 292 Fig. 6; 294 Fig. 8 Pl. 68 Nos. 1, 2, 4; Pl. 69 No. 11. *Hesperia* 21, 1952, Pls. 74-77. *Kerameikos* V 1, Pls. 15, 16, 17, 46, 150.
17 On analysis of Geometric, cf. also Matz, *Geschichte*, 41 ff.
18 *CVA* München, *Mus. Ant. Kleinkunst* 3, Pls. 103-104.
19 *Kerameikos* V 1, Pl. 15 Nos. 9, 109.
20 *Kerameikos* I, Pl. 50; V 1, Pl. 15 No. 13.
21 *Kerameikos* I, Pl. 34. Young, *Hesperia* 18, 1949, 294 Fig. 8.
22 Desborough, *Protogeom. Pottery*, Pl. 13.
23 Furumark, *Myc. Pottery*, 416 ff. Fig. 72.
24 *Kerameikos* V 1, Pl. 16.
25 Blegen, *Hesperia* 21, 1952, 287 f., 293 Pl. 77b. *Kerameikos* V 1, 205 Pl. 163.
26 Young, *Hesperia* 18, 1949, 294 f., No. 16 Fig. 10 Pl. 67. *Kerameikos* V 1, Pl. 84.
27 *Kerameikos* V 1, Pl. 146.
28 Schweitzer, *Bonner Jahrbb.* 161, 1961, 244 ff. Pl. 50.

Chapter II: Attic Geometric Pottery of the Eighth Century (pages 32-57)

1 Cf. Young, *Hesperia* 18, 1949, 294 ff. Nos. 16, 18-20 Pl. 69. Blegen, *Hesperia* 21, 1952, 291 f. Nos. 18-19 Pl. 75a.
2 *Kerameikos* V 1, 103, 115.

3 Kontoleon, *Ephem* 1945-7, 1 ff.
4 C. Zervos, *L'art des Cyclades* (1957), Figs. 199-201, 203-204, 212-220, 223-228.
5 *Thera* II, 134 ff., 157 f., Figs. 312-316, 318-327, 330-332, 334-335, 343-344, 346, 350, 361, 363. Pfuhl, *AM* 28, 1903, 96 ff. Supplements 2,1-3; 3,1-2; 4,1; 5,2; 7,2; 8,3; 9,1-4; 14,4-6.
6 *Kerameikos* V 1, Pls. 62-65.
7 *Kerameikos* V 1, Pls. 35, 59, 86, 97, 119.
8 *Kerameikos* V 1, 56 f.
9 Perrot-Chipiez, *Historie* II, 742 ff. Figs. 407, 409, 415. B. B. Piotrovskij, *Il Regno di Van Urartu* (1966), Pl. 37. Herrmann, *JdI* 81, 1966, 101 f. Fig. 24.
10 Kunze, *Bronzereliefs*, 153 ff. See below p. 196 f.
11 Ohly, *Goldbleche*, 73 ff. Pls. 1, 3, 15. See below p. 192 f.
12 Desborough, *Protogeom. Pottery*, 24, 42 Pl. 5 No. 560 (18); 6 No. 911 (28).
13 Hahland in *Corolla L. Curtius* (1937), 121 ff. Pls. 40-43. Kraiker in *Festschr. Schweitzer*, 41 ff. Pls. 2-3.
14 See above p. 32.
15 P. E. Arias-M. Hirmer, *Tausend Jahre griech. Vasenkunst* (1960), 37 ff. Pls. 40-46. A. Minto, *Il Vaso François* (1960). Schefold, *Sagenbilder*, Pls. 46-52.
16 Cf. with this vase Matz, *Geschichte*, 43 ff.
17 *Kerameikos* V 1, Pl. 48.
18 *Kerameikos* V 1, Pl. 112 (Inv. 617).
19 Kunze in *Festschr. Schweitzer*, 48 ff. Pls. 4-10. Ders. *Ephem* 1953/4 I, 162 ff. Pls. 1-6.
20 *CVA* Paris, Louvre 11, III H b, Pls. 1-16.
21 *CVA* Paris, Louvre 11, III H b, Pls. 1; 2,5; 9,8; 11-15.
22 A. D. Trendall, *Handbook to the Nicholson Museum²* (1948), 245 f. Fig. 48 (Inv. No. 46,41).
23 Kunze in *Festschr. Schweitzer*, 53 ff. Pls. 5-8. Idem, *Ephem* 1953/4 I, 163 ff. Pls. 1; 5,1,3; 6.
24 B. Graef-E. Langlotz, *Die antiken Vasen von der Akropolis zu Athen* I (1925), 25 No. 251, 256 Pl. 8.
25 C. Watzinger, *Griech. Vasen in Tübingen* (1924) 11 Nr. B 6 a (Inv. No. 1465-1466). Cook, *BSA* 35, 1934/5, 168 Note 3. Kunze in *Festschr. Schweitzer*, 50 Note 11. R. Tölle, *Frühgriech. Reigentänze* (1964), 100 No. 403.
26 *CVA* Paris, Louvre 11, III H b, Pls. 2-6.
27 Cf. Davison's collection, *Workshops*, 134 ff. (B. The Kunze Painter).
28 *CVA* Paris, Louvre 11, III H b, Pls. 13-14 (A 541, A 547).
29 *CVA* Paris, Louvre 11, III H b, Pls. 11-14 (A 552, A 541, A 547).
30 *CVA* Paris, Louvre 11, III H b, Pls. 9,1.
31 *CVA* Paris, Louvre 11, III H b, Pls. 11.
32 *CVA* Paris, Louvre 11, III H b, Pl. 4; cf. also the fragment A 519, ibid., Pl. 5,7.
33 *CVA* Paris, Louvre 11, III H b, Pls. 2,2; 3,1.
34 Kunze in *Festschr. Schweitzer*, 49 ff. pl. 4. Schefold, *Sagenbilder*, Pl. 3 b.
35 Kunze in *Festschr. Schweitzer*, 54, 55 Pl. 9.
36 Webster, *BSA* 50, 1955, 49 f.
37 On the chronology of the Late Geometric period, see *Kerameikos* V 1, 71 ff., 141 ff., 159 (with Note 121), 183; cf. also Homann-Wedeking, *Gnomon* 30, 1938, 335 ff.
38 *Kerameikos* V 1, Pl. 114.
39 *Kerameikos* V 1, Pl. 79 (Inv. 1356), 124 (Inv. 1235), 136 (Inv. 1357, 1359), 137 (Inv. 1361), 138 (Inv. 1236).

40 *Kerameikos* V 1, 247 Pl. 40. On the Analatos hydria and its master, see Cook, BSA 35, 1934/5, 172 ff.

41 *Kerameikos* V 1, 158.

42 Late Geometric amphorae with neck handles (and similar vessels) c. 750-710 B.C.:

I

1 Brussels, Musées Royaux d'Art et d'Histoire (Inv. No. A 1506): *CVA* Bruxelles, Mus. R. d'Art et d'Histoire 2. III H b Pl. 1,1 (belly-handled amphora).

2 Athens, Kerameikos (Inv. No. 362), from Grave 58: *Kerameikos* V 1, Pl. 36. Here: Pl. 43.

3 Karlsruhe, Badisches Landesmuseum (Inv. No. B 2674), from Athens: *CVA* Karlsruhe, Bad. Landesmus. 1 Pl. 3,1. Here: Pl. 44.

4 Boston, Museum of Fine Arts (Inv. No. 98.894), from Attica (?): A. Fairbanks, *Catalogue of Greek and Etruscan Vases* I (1928), 77 No. 261 Pl. 20.

5 Würzburg, Martin von Wagner-Museum: E. Langlotz, *Griech. Vasen* (1932), 6 No. 52 Pl. 3.

6 Erlangen, Archäologisches Institut der Universität (Inv. No. I 458): W. Grünhagen, *Antike Originalarbeiten der Kunstsammlung des Instituts* (1948), 32 Pl. 10.

7 Amsterdam, Allard Pierson Museum (Inv. No. 3491): *CVA* La Haye, Mus. Scheurleer 1, III H b Pl. 1,1.

II

8 Copenhagen, National Museum (Inv. No. 7029): *CVA* Copenhague, Mus. Nat. 2 Pl. 73,3.

9 Athens, Agora Museum (Inv. No. P 4990): Young, *Graves*, 55 ff. Figs. 37-38.

10 Athens, Kerameikos (Inv. No. 1371), from burnt layer above Grave 51: *Kerameikos* V 1, Pl. 39.

11 Athens Kerameikos: *Kerameikos* V 1, Pl. 40 (isolated find).

12 Cleveland, Cleveland Museum of Art (Inv. No. 1927, 27.6): Cook, *BSA* 42, 1947, 144 ff. Pl. 21.

13 Athens, National Museum (Inv. No. 894): Cook, *BSA* 42, 1947, 146 ff. Pl. 22 b.

14 Hannover, Kestner-Museum (Inv. No. 1953, 148): A. Hentzen, *Erwerbungen des Kestner-Museums Hannover 1952-1955* (1956), 6 Fig. 12.

III

15 Athens, Stathatos Collection, from Koropi (Attica): Cook, *BSA* 46, 1951, 45 ff. Fig. p. 45. Here: Pl. 47.

16 Athens, National Museum (Inv. No. 17470): *CVA* Athènes, Mus. Nat. 2, III H b, Pl. 13 (hydria).

17 Private collection: K. A. Neugebauer, *Antiken in deutschem Privatbesitz* (1938), 35 No. 139 Pl. 58 (hydria).

18 Copenhagen, National Museum: N. Breitenstein, *Graeske Vaser* (1957), 9 Pl. 6.

19 Toronto, Royal Ontario Museum (Inv. No. C 951), from Phaleron: D. M. Robinson-C. G. Harcum-J. H. Iliffe, *A Catalogue of the Greek Vases in the R. Ontario Museum* (1930), 274 f. No. 630 Pl. 101.

20 Athens, Kerameikos (Inv. No. 1356): *Kerameikos* V 1, Pl. 79 (jug).

21 Athens, Kerameikos (Inv. No. 1370), from burnt layer above Grave 51: *Kerameikos* V 1, Pl. 40. Here: Pl. 48.

22 Athens, National Museum (Inv. No. 810), from the Piraeus Street: Pernice, *AM* 17, 1892, 205 ff. Figs. 1-9 Pl. 10. Hampe, *Grabfund*, 50 ff. Figs. 33-38. Here: Pls. 63-64 (krater).

23 Athens, National Museum, from the Piraeus Street (same excavation as No. 22): Pernice, *AM* 17, 1892, 225 ff., Figs. 10-14. Hampe, *Grabfund*, 55 Figs. 39 (fragments of a cauldron).

IV

24 New York, Metropolitan Museum (Inv. No. 10.210.7): Richter, *Handbook*, Pl. 15 c.

25 Athen, Benaki-Museum: Cook, *BSA* 42, 1947, 150 Pl. 19. Here: Pl. 46.

26 Munich, Antikensammlungen (formerly private collection of H. von Schoen): R. Lullies, *Eine Sammlung griechischer Kleinkunst* (1955), 17 No. 29 Pls. 8-9.

27 New York, Metropolitan Museum (Inv. No. 10.210.8): E. Buschor, *Griech. Vasen* (1940), Fig. 20. Richter, *Handbook*, Pl. 15 d. Here: Pls. 49-50.

28 New York, Metropolitan Museum (Inv. No. 21.88.18): Buschor, *Griech. Vasen*, Fig. 19. Richter, *Handbook*, Pl. 16 b. Here: Pl. 51.

29 London, British Museum (Inv. No. 1936, 10-17.1): Robertson, *British Museum Quarterly* 11, 1936, 56 f. Pls. 18-19. J. D. Beazley, *The Development of Attic Black-Figure* (1951), Pl. 1,1. Davison, *Workshops*, Fig. 55. Here: Pl. 45.

30 Oxford, Ashmolean Museum (Inv. No. 1935, 18): Beazley, *Development of Attic Black-Figure*, 4-5 Pl. 1,2. Hampe, *Gleichnisse*, 33 Pl. 13 b.

43 Cf. also Note 42 No. 7.

44 Cf. also Note 42 No. 5; *Kerameikos* V 1, Pl. 38 (from Grave 52. Inv. 1298 from Grave 64).

45 Note 42 Nos. 2, 4, 5.

46 Note 42 Nos. 8-30.

47 Note 42 Nos. 2, 4-6.

48 Note 42 Nos. 16, 17.

49 Note 42 Nos. 19-21.

50 Cf. also Note 42 No. 24.

51 Cf. also Note 42 Nos. 4, 5.

52 Note 42 No. 7.

53 Note 42 Nos. 1, 6, 12, 13.

54 Cf. also Note 42 Nos. 8-12, 16-18, 24, 26.

55 Cf. also Note 42 No. 30.

56 Cf. also Note 42 No. 1.

57 Cf. also Note 42 Nos. 9, 10, 12.

58 Cf. also Note 42 No. 26.

59 Cf. also Note 42 No. 13.

60 Note 42 No. 8.

61 Note 42 Nos. 16, 17.

62 Note 42 Nos. 13, 14.

63 Cf. also Note 42 No. 30.

64 Cf. also Note 42 No. 24.

65 Cf. e.g., a jug from Athens in Munich (Antikensammlungen, Inv. No. 8448): *CVA* Munich, Mus. Ant. Kleinkunst, 3, Pls. 115,4; 116,3-4.

66 Late Geometric oinochoai:

1 Berlin, Staatl. Museen, Department of Antiquities (Inv.

No. 3374): Schweitzer, *AM* 43, 1918, 144 Fig. 32. Willemsen, *AM* 69/70, 1954/5, 30 Supplement 4. Here: Pl. 56.
2 Paris, Louvre (formerly Athens, Lambros Collection): Schweitzer, *AM* 43, 1918, 138 ff. Pl. 3. Himmelmann-Wildschütz, *Marburger Winckelmann-Programm* 1961, 1 ff. Pls. 2–3. Here: Pl. 58.
3 Boston, Museum of Fine Arts (Inv. Nos. 25,42): A. Fairbanks, *Catalogue of Greek and Etruscan Vases* I (1928), 81 No. 269 b Pl. 23. Here: Pl. 61.
4 Copenhagen, National Museum (Inv. No. 1628), from Athens, *CVA* Copenhague, Mus. Nat. 2 Pl. 73,4. Here: Pl. 59.
5 Athens, Agora-Museum (Inv. No. P 4885): Young, *Graves*, 68 ff. Figs. 43–44. Schefold, *Sagenbilder,* Pl. 7 a. Here: Fig. 15.
6 Munich, Antikensammlungen (Inv. No. 8696): Hampe, *Gleichnisse,* 27 Pls. 7–11. Schefold, *Sagenbilder,* Pl. 8. Here: Pls. 60, 62
7 Boston, Museum of Fine Arts (Inv. Nos. 25, 43): Fairbanks, *Catalogue of Greek and Etruscan Vases* I, 81 No. 269 c Pl. 23. Here: Pl. 57.
67 Late Geometric deep bowls. Lists in Schweitzer, *AM* 43, 1918, 143 Note 1. Kunze, *Bronzereliefs,* 76 Note 6. T.B.L. Webster, *Notes from the Manchester Museum* No. 39 (1937), 10. Cook, *BSA,* 42, 1952, 152 Note 2.

a) Bird friezes

1 Athens, Kerameikos (Inv. No. 788), from Grave 91: *Kerameikos* V 1, Pl. 129.
2 Munich, Antikensammlungen (Inv. No. 6220), from Athens, *CVA Munich,* 3 Pl. 124,1–2.
3 Manchester, Manchester Museum: Webster, *Notes from the Manchester Museum* No. 39 (1937), 11 ff. Pl. 1.
4 Edinburgh (Inv. No. L 364): Webster, *Notes from the Manchester Museum* No. 39 (1937), 12 Pl. 2 b.

b) Animal friezes

5 Munich, Antikensammlungen (Inv. No. 6229, 8506): *CVA* Munich, 3 Pl. 125,1–4.
6 Athens, Kerameikos (Inv. No. 1329), from Grave 51: *Kerameikos* V 1, Pl. 130. Here: Pl. 67.
7 Athens, National Museum, from Sparta: Philadelpheus, *Deltion* 6, 1920/1, *Parartema,* 136 Nos. 7–8 Fig. 9.
8 Würzburg, Martin von Wagner-Museum: Langlotz, *Griech. Vasen,* 7 No. 58 Pls. 4–5.
9 Edinburgh (Inv. No. L 363): Webster, *Notes from the Manchester Museum* 6 No. 39 (1937), 12 Pl. 2 a.

c) Figured scenes

10 Athens, National Museum (Inv. No. 874): *CVA* Athènes, Mus. Nat. 2, III H d, Pls. 10–11. Here: Pls. 66,68.
11 Athens, National Museum (Inv. No. 13 038), from Thera: Pfuhl, *AM* 28, 1903, 180 ff. Pl. 3. Here: Fig. 16.
12 Athens, National Museum (Inv. No. 784): Brueckner-Pernice, *AM* 18, 1893, 113 ff. Fig. 10. Kraiker in *Festschr. Schweitzer,* 45 Pl. 3. Here: Pl. 65.
13 Athens, National Museum (Inv. No. 14475), from Anavyssos: Kunze, *Bronzereliefs* Pl. 53 e. Here: Pl. 70.

14 Munich, Antikensammlungen (Inv. No. 6029/1313), from Athens: *CVA* Munich, 3 Pls. 124,3–4.
68 Myres, *Cesnola Coll.,* 78 ff. with figure.
69 Cf. the examples from the Kerameikos necropolis in Athens: *Kerameikos* I, Pl. 62 (Inv. 536); IV Pl. 25 (Inv. 2034). Desborough, *Protogeom. Pottery* Pl. 14.
70 *Kerameikos* V 1 Pl. 76 (Inv. 1327). *AM* 43, 1918 Pls. 5,2; 6,2.
71 Note 67 Nos. 10–14. See below p. 52.
72 Note 67 No. 14.
73 Cf. also Note 42 Nos. 24, 26.
74 Cf. also Note 42 Nos. 9, 10, 12, 18.
75 Cf. also Note 42 No. 17.
76 Note 42 No. 24.
77 Note 67 No. 14.
78 Note 42 No. 26.
79 Cf. also Note 42 Nos. 9, 10, 12, 16, 17, 22.
80 Note 42 No. 22.
81 Note 42 Nos. 16–23.
82 Note 42 No. 20.
83 Note 42 Nos. 9, 10.
84 Cf. also Note 42 Nos. 12, 19, 20.
85 Cf. also Note 42 Nos. 19, 30.
86 Cf. also Note 42 Nos. 19, 26.
87 Cf. also Note 42 No. 16.
88 Cf. also Note 42 Nos. 18–20, 22, 23.
89 Note 42 No. 23.
90 Berlin, formerly Antiquarium (Inv. No. F 56): *CVA* Berlin I Pls. 43–44.
91 See above pp. 18–19.
92 Cf. T. J. Dunbabin, *The Greeks and their Eastern Neighbours* (1957), 35 f.
93 Note 67 Nos. 1–4.
94 Cf. also Note 67 No. 5.
95 Note 67 No. 7.
96 Cf. also Note 67 No. 9.
97 Note 67 No. 9.
98 Cf. also Note 67 Nos. 8, 9.
99 Cf. also Note 67 No. 9.
100 *CVA* Athènes, Mus. Nat. 2, Text of Pl. III H d 10. See under Note 13 in Ch. VIII.
101 Note 67 No. 14.
102 Malten, *JdI* 29, 1914, 179 ff.
103 Schweitzer, *Herakles,* 50 ff., 90 ff.
104 M. P. Nilsson, *The Minoan-Mycenaean Religion*[2] (1950), Figs. 77, 154, 196.
105 Cf. Schweitzer, *Herakles,* 34 with note 1. M. Collignon-L. Couve, *Catalogue des vases peints du Musée Nat. d'Athènes* (1902) No. 774 Pl. 3; cf. also the krater from Kourion in New York (see below, p. 69). Here: Pl. 82.
106 Schweitzer, *Herakles,* 17 ff. with Fig. 17; 97 f. Fig. 26. Hampe, *Sagenbilder,* 48 Pl. 34.
107 Perrot-Chipiez, *Histoire III,* 787 ff. Fig. 552.
108 B. Schweitzer, *Basisrelief d. ältesten Kultbildes d. Hera zu Olympia* (1944; appendix to Winckelmann address at Archaeological Seminar, Leipzig). See below p. 197 ff. and Note 105 in Ch. VIII. In this connection, the wooden stool of the Geometric period from the Sanctuary of Hera on Samos, reconstructed by D. Ohly, is important (*AM* 68, 1953, 89 ff. Fig. 3, Supplements 22–25). This may have formed the base of the wooden statue of Hera. The

goddess would have sat or stood on the stool, flanked by the animal-shaped side rests — only here we have horses instead of lions.

109 Kunze, *Bronzereliefs* Nos. 2,5. Pls. 3, 5, 7–8.

110 *CVA Copenhague*, Mus. Nat. 2 Pl. 74; Hahland in *Corolla L. Curtius* (1937), 121 Pls. 42–43. Ohly, *Goldbleche*, 79. Webster, *BSA* 50, 1955, 40.

111 Ohly, *Goldbleche*, 79 ff. See below. p. 197 ff.

112 Ohly, *Goldbleche*, 76 ff.

113 F. Poulsen, *Der Orient u. d. frühgriech. Kunst* (1912), 25 f. Fig. 15. Gjerstad, *Opuscula Archaeologica* IV (1946), Pls. 7, 10.

114 Kunze, *Bronzereliefs*, Supplement 1.

115 P. Jacobsthal, *Die melischen Reliefs* (1931), 19 ff. Nos. 7–9, 85 Pls. 5–6, 46.

116 Studniczka, *AM* 18, 1893, 225 ff. Pl. 10. J. Kirchner, *Imagines Inscriptionum Atticarum*² (1948), 9 No. 1 Pl. 1 L. H. Jeffery, *The Local Scripts of Archaic Greece* (1961), 15 f., 21, 29 f., 68 f. Pl. 1.

117 Hampe, *Gleichnisse*, 30. Webster, *BSA* 50, 1955, 39 ff. Schefold, *Sagenbilder*, 7 ff.

118 Note 66 No. 6.

119 Schweitzer, *Herakles*, 17 ff. Hampe, *Sagenbilder*, 45 ff. Pl. 34. Schefold, *Sagenbilder*, 21 Pls. 6 b, 7 a.

120 See below, p. 149 ff.

121 Hampe, *Sagenbilder*, 26 Pl. 22,2. *Idem, Gleichnisse*, 30, Pl. 18 b. Schefold, *Sagenbilder*, 22 f. Pl. 5 c.

122 F. Brommer, *Herakles* (1953), 25, 87 Pl. 18. Poulsen, *Meddelelser fra Ny Carlsberg Glyptotek* 11, 1954, 33 ff. Figs. 4–6. Schefold, *Sagenbilder*, Pl. 5 b.

123 *Kerameikos* V 1, 151 f., Pl. 77.

124 Cf. now K. Fittschen, *Untersuchungen zum Beginn der Sagendarstellungen bei den Griechen* (1969).

Chapter III: Local Geometric Styles outside Attica (pages 58–72)

1 Pfuhl, *MuZ* I, 77 ff. § 70 ff. Matz, *Geschichte*, 67 f. Large complexes of Corinthian Geometric pottery have been found in Corinth (Weinberg, *AJA* 45, 1941, 30 ff. *Corinth* VII 1. *Corinth* XIII 13 ff.), Delphi (*FdDelphes* V, 133 ff. *BCH* 74, 1950, 322 Pl. 39. *BCH* 75, 1951, 140 Fig. 35) and in Aegina (W. Kraiker, *Aigina. Die Vasen des 10. bis 7. Jhs. v.Chr.*, 1951, 35 ff. Pls. 8–10).

2 On Late Geometric Corinthian pottery, see K. Friis Johansen, *Les Vases Sicyoniennes* (1923), 4 ff. Pls. 1–3. Payne, *Protokor. Vasenmalerei*, 9 f. Pls. 1–4. *Idem, Necrocorinthia* (1931), 1 ff. Fig. 1 Pl. 1,1.

3 Was this style of decoration copied from the Argolid (see below p. 61 f.)? Cf. also the so-called 'tinsel' style of Attic Geometric pottery (above, p. 46).

4 Friis Johansen, *Vases Sicyoniennes*, 5 Pl. 1,3. Payne, *Protokor. Vasenmalerei*, Pl. 2.

5 D. M. Robinson, C. G. Harcum, J. H. Iliffe, *A Catalogue of Greek Vases in the Royal Ontario Museum Toronto* (1930), 27 No. 113 Pl. 8. Payne, *Protokor. Vasenmalerei*, 9 f. Pl. 3.

6 Shear, *AJA* 34, 1930, 412 f. Fig. 5. Karo, *AA* 1931, 240 ff. Fig. 18. With the picture zone on the krater, cf. the Geometric clay *pinax* published by Hampe (in *Charites. Fest-*

schr. E. Langlotz, 1957, 105 ff. Pl. 14), and the similarly decorated Early and Ripe Geometric Attic amphorae (see above p. 32 and Pl. 19).

7 A. Levi, *Le terrecotte figurate del Museo Naz. di Napoli* (1926), 170 No. 766 Fig. 130. Hampe, *Sagenbilder*, Pl. 35, 1. Schefold, *Sagenbilder*, Pl. 32 b. Cf. also a part of the gold jewellery from Corinth in Berlin (Furtwängler, *AZ* 42, 1884, 99 ff. Pl. 8,2 = Kl. Schriften I, 1912, 458 ff. Pl. 15,2).

8 Wide, *JdI* 14, 1899, 84 ff. Fig. 43 ff. *Tiryns* I, 161 ff. Pfuhl. *MuZ* I, 76 f. § 69. Matz, *Geschichte*, 67 f. Large complexes of Argive Geometric pottery have been found in the Argive Heraion (Waldstein, *Heraeum* II, 104 ff. Figs. 42–43, Pls. 56–58), on Aegina (Kraiker, *Aigina. Die Vasen*, 30 ff. Nos. 66–89 Pls. 4–6), in Asine (Frödin-Persson, *Asine* 312 ff. Figs. 216–224) and in Argos (Roes, *BCH* 77, 1953, 90 ff. Figs. 1–7 Pls. 24–29. Courbin, *BCH* 77, 1953, 258 ff. Figs. 50–59). Now summarized in P. Courbin *La céramique géométrique de l'Argolide* (1966).

9 *Tiryns* I, 132 (Grave 31), 138 Fig. 7 Pl. 19,5. Courbin, *Céramique*, 553 Pl. 149.

10 Frödin-Persson, *Asine*, Figs. 222,4; 224,2. Courbin, *BCH* 77, 1953, 260 Figs. 52, 263 Fig. 59. *Idem, Céramique*, Pls. 1–6.

11 Frödin-Persson, *Asine*, Figs. 222,1–3,7. *Tiryns* I, 137 Pls. 17,1–4,6–9. Courbin, *Céramique*, 189 Pl. 6.

12 *Tiryns* I, 138 No. 15 Pl. 20,4.

13 *Tiryns* I, 147 f. Fig. 13. See below pp. 64, 68.

14 Courbin, *Céramique*, 203 ff. Pl. 28 ff.

15 Waldstein, *Heraeum* II, 116 Nos. 9–11 Pl. 58. Kraiker, *Aigina. Die Vasen*, 30 Nos. 66–68 Pl. 5. B. Graef, E. Langlotz, *Die antiken Vasen von der Akropolis zu Athen* I (1925), 27 ff. No. 276 ff. Pls. 8–9.

16 *Tiryns* I, 150 No. 14 Pls. 15, 10.

17 Desborough, *BSA* 49, 1954, 262 Nos. 2–3 Pl. 45.

18 The best example of this is a flat pyxis from Asine (Frödin-Persson, *Asine*, 320 ff. Abb. 219,8; 220,1).

19 Cf. the fragments of a krater from Tiryns (*Tiryns* I, 143 No. 5 Pl. 20,1) and a pyxis from Aegina (Kraiker, *Aigina. Die Vasen*, 34 No. 113 Pl. 6).

20 Cf. the krater from Argos: Vanderpool, *AJA* 58, 1954, 234 Pl. 45,7. Courbin, *Céramique*, Pl. 43.

21 Desborough, *BSA* 49, 1954, 260 ff. Pls. 44–45.

22 *Tiryns* I, 143 No. 12 Pl. 19,2,4.

23 Courbin, *Céramique*, 391 ff.

24 Waldstein, *Heraeum* II, 115 No. 22 Pl. 57. Roes, *BCH* 77, 1953, 103 Pl. 26 (bottom left). Courbin, *Céramique*, 413 f. Pl. 139 (C. 4175).

25 Wide, *JdI* 14, 1899, 85 No. 2 Fig. 44.

26 Waldstein, *Heraeum* II, 113 No. 10 Pl. 57.

27 Waldstein, *Heraeum* II, 113 No. 12 Pl. 57. Roes, *BCH* 77, 1953, 92 Fig. 1.

28 Waldstein, *Heraeum* II, 113 No. 11 Pl. 57.

29 H. Schliemann, *Tiryns* (1886), 109 f. Pl. 18. Waldstein, *Heraeum* II, 110 ff. Nos. 20–22 Pl. 56; Nos. 1–5 Pl. 57. *Tiryns* I, 143 f. Nos. 6–8 Pls. 13; 15,1–3; 20,3; 146 f. Figs. 11–12. Kraiker, *Aigina. Die Vasen*, 30 No. 69 Pl. 4. A. Roes, *BCH* 77, 1953, 100 Pls. 24, 29. Courbin, *BCH* 79, 1955, 314 Fig. 12. *Idem, Céramique*, 403 ff. Pl. 133 ff.

30 Waldstein, *Heraeum* II, 111 No. 22 Pl. 56. *Tiryns* I, 143 f. Nos. 7–8 Pl. 15. Roes, *BCH* 77, 1953, 97 Pl. 24. Courbin, *Céramique*, 440 ff. Pl. 142 (C. 599).

31 Courbin, *Céramique*, 397 ff.

32 Buschor – v. Massow, *AM* 52, 1927, 3, 37 Pl. 1.

33 Waldstein, *Heraeum* II, 116 No. 7 Pl. 58.

34 Waldstein, *Heraeum* II, 112 f. No. 9 Pl. 57. Hampe, *Sagenbilder*, Pl. 34.

35 R. Tölle, *Frühgriech. Reigentänze* (1964), 41 ff. Courbin, *Céramique*, 490 f.

36 Waldstein, *Heraeum* II, 114 Nos. 17–18 Pl. 57. Courbin, *Céramique*, Pl. 147.

37 Schliemann, *Tiryns*, 130 ff. Pls. 16 b, 17 a. C. Schuchardt, *Schliemann's Ausgrabungen in Troja, Tiryns, Mykenä, Orchomenos, Ithaka* (1890), 158 Fig. 130. Pfuhl, *MuZ* III, Fig 23 a. Waldstein, *Heraeum* II, 114 Nos. 15–16, 19 (this fragment shows Attic influence) Pl. 57. Roes, *BCH* 77, 1953, 96 Pls. 24, 29. Courbin, *Céramique*, Pl. 145 ff.

38 Berlin, Staatl. Museen (Inv. No. 31 093): G. Becatti *Oreficerie antiche* (1955), 162 No. 140 Pl. 27.

39 Waldstein, *Heraeum* II, 113 f. Nos. 7, 17, 19 Pl. 57. Courbin, *Céramique*, Pl. 143 ff.

40 Waldstein, *Heraeum* II, 114 No. 119 Pl. 57. Courbin *Céramique*, Pl. 147.

41 Pfuhl, *MuZ* I, 83 f. § 76. Lane, *BSA* 34, 1933/4, 101 ff. Figs. 1–4 Pls. 20–21.

42 J. P. Droop in Dawkins, *Artemis Orthia*, 54 ff. Figs. 30–39. Lane, *BSA* 34, 1933/4, 101 ff. Pls. 20–21.

43 Tsountas, *Ephem* 1892, 14 f. Pls. 4,1–2. Wide, *JdI* 14, 1899, 83 f. Figs. 41–42. v. Massow, *AM* 52, 1927, 46 ff. Figs. 30–39 Pls. 1–12.

44 Desborough, *Protogeom. Pottery*, 287, 290, 293, 295.

45 v. Massow, *AM* 52, 1927, 51 Pls. 6, 11.

46 Lane, *BSA* 34, 1933/4, 102 ff. Figs. 1–2; cf. also Droop in Dawkins, *Artemis Orthia*, 56 ff. Fig. 31.

47 Lane, *BSA* 34, 1933/4, 103 ff. Fig. 2 M; cf. above p. 49 f. and Fig. 16.

48 Lane, *BSA* 34, 1933/4, 102 f. Fig. 2 C = Pl. 20 e; cf. *Kerameikos* V 1, Pl. 111.

49 Droop in Dawkins, *Artemis Orthia*, 59 Fig. 32.

50 See above p. 61 with Note 13, and below p. 68.

51 Lane, *BSA* 34, 1933/4, 105 ff. Fig. 3; cf. also von Massow, *AM* 52, 1927, 50 ff. Fig. 29.

52 v. Massow, *AM* 52, 1927, 51 Pl. 9.

53 Droop in Dawkins, *Artemis Orthia*, 59 Fig. 35; cf. here Pls. 17–18.

54 v. Massow, *AM* 52, 1927, 51 Pl. 10.

55 Tsountas, *Ephem* 1892, 14 f. Pl. 4. v. Massow, *AM* 52, 1927, 52 f. Pls. 4–5. Droop in Dawkins, *Artemis Orthia*, 63 Fig. 37.

56 Tölle, *Frühgriech. Reigentänze*, 48 ff.

57 v. Massow, *AM* 52, 1927, 52 Pls. 4–5.

58 Poulsen-Dugas, *BCH* 35, 1911, 350 ff. C. Dugas, *La céramique des Cyclades* (1925), 107 ff. Payne, *JHS* 46, 1926, 203 ff. Buschor, *AM* 54, 1929, 142 ff. C. Dugas, C. Rhomaios, *Délos* XV, *Les vases préhelléniques et géométriques* (1934). Karousos, *JdI* 52, 1937, 189 ff. Kontoleon, *Ephem* 1945–7, 1 ff. Brock, *BSA* 44, 1949, 33 ff. 45 ff. 74 ff.

59 Paros: Buschor, *AM* 54, 1929, 142 ff. Brock, *BSA* 44, 1949, 74 ff. Naxos: Buschor, op. cit., 152 ff. Karousos, *JdI* 52, 1937, 189 ff. Brock, op. cit., 76 ff.

60 Cf. the vases from Tenos in the Vatican (C. Albizzati, *Vasi antichi dipinti del Vaticano*, 1 f. Nos. 1–5 Pl. 1) and from Rheneia (*Délos* XV, 13 ff., Group Aa).

61 Dugas, *Céramique des Cyclades*, Pl. 3. *Délos* XV, 39 ff. (Group Ad).

62 *Délos* XV, 23 f. Nos. 44–55 (Group Aa) Pl. 11 ff.

63 Pfuhl, *AM* 28, 1903, 36 No. 1; 179 No. 4; 285, 287 Supplement 24,3.

64 From Thera: E. Pottier, *Vases antiques du Louvre* I (1897) II No. A 266 Pl. 10. Pfuhl, *AM* 28, 1903, 179 Nos. 2–3, 5–8. *Thera* II, 35 Fig. 107. From Melos: *CVA* Munich, Mus. Ant. Kleinkunst 3 Pls. 141,1–2. *CVA* Sèvres, Mus. Nat. Pls. 12,4–5. From Naxos: Kontoleon, *Ephem* 1945–7, 1 ff. Figs. 1–3. From Rheneia: *Délos* XV, 90 f. No. 1 Pl. 42,1. From Crete: Brock, Fortetsa 32 No. 269 Pl. 19. From Nauplia: *BCH* 79, 1955, 236 Fig. 17.

65 From Thera: Pfuhl, *AM* 28, 1903, 179 Nr. 9 Supplement 24,5. From Melos: J. P. I. Brants, *Beschrijving van de Klassieke Verzameling in het Rijksmuseum van Oudheden te Leiden* II (1930), 9 No. 57 Pl. 9. From Rheneia: *Délos* XV, 86 No. 1 Pl. 42.

66 Brants, *Beschrijving van de Klassieke Verzameling in het Rijksmuseum van Oudheden te Leiden* II, 8 f. No. 56 Pl. 8. *CVA* Sèvres, Mus. Nat. Pls. 12,1–3.

67 *SwedCyprExped* II, 81 No. 1 Pls. 19, 140.

68 Wide, *JdI* 14, 1899, 33 f. Fig. 11.

69 *Tiryns* I, 147 f. Fig. 13. See also above pp. 63, 67.

70 *Délos* XV, 33 ff. Pls. 18–19, 53.

71 *Délos* XV, 85 ff. Pls. 43–44, 54, 56.

72 Kontoleon, *Ephem* 1945–7, 11 f. Fig. 4.

73 Myres, *Cesnola Coll.*, 286 f. No. 1702 with Fig. p. 288.

74 J. Sieveking, R. Hackl, *Die Kgl. Vasensammlung zu München* (1912), 37 f. No. 406 Pl. 14.

75 Graef, *AM* 21, 1896, 448 f.

76 Walter, *AA* 1940, 283 Fig. 85.

77 *Délos* XV, 87 No. 6 Pls. 43, 56. Tölle, *Frühgriech. Reigentänze*, 52 No. 131.

78 Wide, *JdI* 14, 1899, 28 ff. Figs. 1–10. *Thera* II, 127 ff. Pfuhl, *AM* 28, 1903, 96 ff. *Idem, MuZ* I, 84 f. § 77 f. Matz, *Geschichte*, 69 f.

79 Wide, *JdI* 14, 1899, 35 ff. Figs. 13–31. Hall, *Vrokastro, passim*. Pfuhl, *MuZ* I, 86 f. § 80 ff. Payne, *BSA* 29, 1927/8, 224 ff. Pls. 5–9, 12. Levi, *ASAtene* 10–12, 1927–9, 551 ff. Hartley, *BSA* 31, 1930/1, 56 ff. Pls. 14–16. Matz, *Geschichte*, 69. Hutchinson-Boardman, *BSA* 49, 1954, 215 ff. Pls. 20–30. Brock, *Fortetsa, passim*.

80 Payne, *BSA* 29, 1927/8, 250 No. 82 Pl. 7. Brock, *Fortetsa*, 46 No. 441 Pl. 35.

81 Brock, *Fortetsa*, 38 No. 366 Pl. 24.

82 Hutchinson-Boardman, *BSA* 49, 1954, 222, 224 No. 20 Pl. 21.

83 Hall, *Vrokastro*, 171 f. Fig. 106. Hutchinson-Boardman, *BSA* 49, 1954, 222, 224 No. 19 Pl. 25. Brock, *Fortetsa*, 63 No. 671 Pl. 44.

84 Cf. also Brock, *Fortetsa*, 32 No. 269 Pl. 19.

85 Levi, *ASAtene* 10–12, 1927–9, 590 ff. Figs. 639–640.

86 Brock, *Fortetsa*, 36 No. 339 Pl. 28.

87 Hall, *Vrokastro*, 117 No. 5 Pl. 28. Hutchinson-Boardman, *BSA* 49, 1954, 224 No. 22 Pl. 21. Brock, *Fortetsa*, 49 No. 476 Pl. 35; 62 Nos. 652, 663 Pl. 43; 63 Nos. 673, 680–681 Pl. 43; 80 No. 880 Pl. 55.

88 Pyxis: Hall, *Vrokastro*, 109 f. Pl. 26. Bowl: Hutchinson-Boardman, *BSA* 49, 1954, 222, 225 No. 55 Pl. 25. Jug: ibid., 225 No. 29 Pl. 21.

89 Wide, *JdI* 14, 1899, 38 f. No. 8 Fig. 20. Payne, *BSA* 29, 1927/8, 235 No. 19 Pls. 7,3. Hutchinson-Boardman, *BSA* 49, 1954, 224 Nos. 11, 15 Pl. 22. Brock, *Fortetsa*, 74 No. 824 Pls. 51; 78 No. 867 Pl. 53.

Chapter IV: East Greek Geometric Pottery
(pages 73-118)

1 *Clara Rhodos* III–VIII (1929–36).
2 K. Friis Johansen, *Exochi. Ein frührhodisches Gräberfeld* (1958).
3 Technau, *AM* 54, 1929, 6 ff. Eilmann, *AM* 58, 1933, 47 ff. Now: H. Walter, *Frühe samische Gefäße* (1968).
4 *Cl. Rhodos* VI/VII, 150 Fig. 178 (Grave 50).
5 H. Gallet de Santerre, *Délos primitive et archaique* (1958), 210 ff.
6 Desborough, *Protogeom. Pottery*, 232 f.
7 *Lindos* I, 233 ff. Nos. 821–843 Pls. 33–34.
8 *Cl. Rhodos* VI/VII, 119 f. Fig. 133; 122 Fig. 134; 204 No. 1 Figs. 244–245.
9 *Kerameikos* IV, Pl. 9 (Inv. 918, 1089). Desborough, *Protogeom. Pottery*, Pls. 4–5.
10 *Cl. Rhodos* VIII, 161 ff. Figs. 149–153.
11 Cf. the jug, *Kerameikos* V 1, 229, Pl. 71 (Inv. 281, from Grave 30).
12 *Corinth* VII, 1,10 Nos. 22–24 Pls. 2–3. In connection with No. 24, Weinberg refers to a jug from Tiryns (*Tiryns* I, Pl. 14,6) and to a number of jugs of the same shape in Nauplia.
13 See above p. 29.
14 *Cl. Rhodos* VIII, 163 f. Fig. 150. P. Jacobsthal, *Greek Pins* (1956), 3 Fig. 7.
15 Cf. the examples with rim handles from the Kerameikos (*Kerameikos* IV, 34, 41 Pl. 8, Inv. 911, 2013), in Mainz (*CVA* Mainz, Universität Pls. 1,1–2; 3,1–2) and from Andros (Desborough, *Protogeom. Pottery*, Pl. 16).
16 E. g. Desborough, *Protogeom. Pottery*, Pl. 10 No. 464. The Early Geometric cup, ibid., Pl. 10 No. 525, still has the continuous curve of the outline, but is the only one of its kind from Attic Protogeometric.
17 *Délos* XV, 55 No. 21 Pl. 27. In the Samos Heraion, predominantly undecorated one- or two-handled cups, with steep outward-curving walls, have been found in a Late Geometric stratum; these are undoubtedly cult vessels, unchanged in form since the sub-Mycenaean period. (Walter, *AM* 72, 1957, 40 Fig. 2, Supplement 51,1, 3–4).
18 *Cl. Rhodos* III, 146 f. Grave 141 Fig. 142. With the flask, cf. *Kerameikos* IV, Pl. 25 (Inv. 2034) and Desborough, *Protogeom. Pottery*, Pl. 14. Grave 14 in the necropolis of Saragia on Cos contained, apart from a somewhat older idol, five bird-vases, including a standing vase with three birds swimming next to each other, and four amphoriskoi with shoulder handles, which are attached next to each other on a clay base (Morricone, *Bollettino d'Arte* 35, 1950, 322 Fig. 93). Cf. also the hydria from the *Kerameikos* V 1, Pl. 50 (Inv. 784).
19 *Cl. Rhodos* VI/VII, 130 ff. Figs. 148–152. The flask is part of the tradition of flasks stretching from Protogeometric through the beginning and into the second half of the eighth century. The flared tall feet of the small bowls occur already, on one occasion, in the Protogeometric period

(Grave 10 in the necropolis of Saragia on Cos: Morricone, *Bollettino d'Arte* 35, 1950, 322 Fig. 90), implying that they were a revival, after the small bowls of the ninth and early eighth centuries which rested only on base rings. They correspond with the steadily lengthening tall feet of the Rhodian kraters and kantharoi towards the end of the Geometric period. Cf. Friis Johansen, *Exochi*, Figs. 8–9, 37–39.
20 Fiis Johansen, *Exochi*, 69 f. No. Z 4 Figs. 142–143; 158 Fig. 223.
21 *Cl. Rhodos* VI/VII, 362 Nos. 14–15 Figs. 103–104.
22 *Tiryns* I, Pl. 16. Desborough, *Protogeom. Pottery*, Pls. 27–28.
23 *Tiryns* I, 155 No. 1 Pl. 16,6. Frödin-Persson, *Asine*, 428 Fig. 227.
24 See above p. 10.
25 K. F. Kinch, *Vroulia* (1914), 171 Fig. 54. Friis Johansen, *Exochi*, 144 f. Fig. 218.
26 *Cl. Rhodos* VI/VII, 128 ff. Figs. 144–145.
27 See above p. 74 f.
28 *Tiryns* I, Pl. 14,6. Corinth VII 1, 6 No. 7 Pl. 1.
29 *Cl. Rhodos* VI/VII, 123 ff. Fig. 135.
30 *Kerameikos* V 1, 253 Pl. 153 (Inv. 337).
31 *Cl. Rhodos* III, 100 ff. Figs. 93–95.
32 *CVA* Bruxelles, Mus. R. d'Art et d'Historie 2, III Hb Pl. 1,1.
33 *Cl. Rhodos* III, 146 Fig. 142.
34 *Cl. Rhodos* IV, 350 Figs. 393–394.
35 *Cl. Rhodos* VI/VII 124 Figs. 135–136.
36 *Cl. Rhodos* VIII, 161 ff. Fig. 149.
37 *Cl. Rhodos* VI/VII, 123 f. Fig. 35.
38 Friis Johansen, *Exochi*, 61 ff. Nr. X 3 Fig. 128.
39 *Cl. Rhodos* VI/VII, 203 Fig. 243 (from the same workshop as the article mentioned in Note 38).
40 Myres, *Cesnola Coll.*, 76 ff. Figs. 608, 647, 649, 654, 707, 712, 714. *SwedCyprExped* II, Pls. 97, 107, 109, 111.
41 With vases mentioned in Notes 37–39, cf., e.g., the oinochoai from Exochi (Friis Johansen, *Exochi*, 29 No. D 2 Fig. 62) and from Camirus (Furtwängler, *JdI* I, 1886, 137, Inv. No. 2949).
42 Friis Johansen, *Exochi*, 155 ff., where there is also a list of the vases of this stylistic type.
43 Two small bowls and one jug of pure or almost pure Proto-geometric type were found among the 11 vases in a Late Geometric Grave (No. 80) on the acropolis of Camirus (*Cl. Rhodos* VI/VII, 191 f. Fig. 227; 192 Inv. No. 14 089 Fig. 231). On Cos, the two periods are found alongside each other—e.g. in Grave 64 in Zone II in Saragia, Late Geometric jugs and small skyphoi with Protogeometric decorations were found, and also jugs of Cypriot shape with Protogeometric circle decoration, small very finely worked bowls, varnished red inside and black outside, with a frieze of concentric circles (turn of the eighth century to the seventh).
44 *SwedCyprExped* II, 81 Pl. 140,1 (from Amathus). Megaw, *JHS* 76, 1956, Archaeol. Reports 1955, 43 Pl. 2 a (from Salamis).
45 Friis Johansen, *Exochi* 28 f. No. D 1 Fig. 61; 46 No. M 1 Fig. 103; 65 f. No. Y 1 Fig. 133. *CVA* Oxford, Ashmolean Museum 2, II d 1 Pl. 1.
46 Cf., e.g., the Attic krater of the period around the turn of

the ninth to eighth century, from Grave 22 in the Kerameikos necropolis (*Kerameikos* V 1, Pl. 20. Here: Pl. 15), and the certainly Attic high pyxis from Tiryns (*Tiryns* I, 138 No. 16 Pl. 19,5).

47 *Tiryns* I, 164 Fig. 23. Friis Johansen, *Exochi*, 102, 108 ff. Fig. 203.

48 Furtwängler, *JdI* 1, 1886, 135 f., Inv. No. 2941. *Cl. Rhodos* VI/VII, 193 Fig. 233 – both also from Camirus.

49 Only at the end of Attic Geometric is there any evidence of this petrification of the meander – e.g. the foot bowl in the *Kerameikos* V 1, Pl. 125 (Inv. 310) and the fragments of a small foot cauldron, ibid., Pl. 135.

50 *Kerameikos* V 1, Pls. 20–21 (Inv. 290). Friis Johansen, *Fra Nationalmuseets Arbejdsmark* 1950, 70 Fig. 7. *Idem, Exochi*, 107 f. Fig. 207.

51 Cf. Payne, *Protokor. Vasenmalerei* Pl. 4,1. Robertson, *BSA* 43, 1948, 33 ff. Nos. 131, 136, 138 Pls. 8–9.

52 Friis Johansen, *Exochi*, 49 ff. Nos. V 1–2 Figs. 111–114; 66 No. Y 2 Fig. 134; 66 f. No. Z 2 Figs. 138–139.

53 This handle motif is found in Athens from the beginning of the eighth century on (*Kerameikos* V 1, Pl. 152, Inv. 379).

54 With the cross-hatched triangles of Attic broad jugs, cf. *Kerameikos* V 1, Pl. 83 (Inv. 1141, 864); with the dotted plants stalks cf. ibid., Pl. 96 (Inv. 342) 97 (Inv. 327, 328).

55 Two unpublished, splendid jugs from Cos (Inv. No. C 527) belong to the same family, around the middle of the century, with decoration consisting of meanders and lozenges, separated by stripes with simple zigzags.

56 *Cl. Rhodos* VI/VII, Fig. 241. Friis Johansen, *Exochi*, 52 ff. No. V 5 Fig. 117. Cf. also *Kerameikos* V 1, Pl. 91 (Inv. 829, 294).

57 *Cl. Rhodos* III, 96 (Grave 56) Fig. 91. Eilmann, *AM* 58, 1933, 51 f. Fig. 1. A third kantharos comes from Delos and was found on Rheneia (*Délos* XV, 67 No. 87 Pl. 32). Cf. also *Kerameikos* V 1, Pl. 97 (Inv. 326–327).

58 Friis Johansen, *Exochi*, 52 No. V 3–4 Figs. 115–116; cf. also the krater, ibid., 65 f. Fig. 133 and here, Note 56.

59 Friis Johansen, *Exochi*, 52 No. V 6 Fig. 118. Corinthian antecedents: Payne, *Protokor. Vasenmalerei*, Pl. 1,4. *BSA* 43, 1948, Pl. I,I (from Ithaca). Attic antecedents: *Kerameikos* V 1, Pl. 99 (Inv. 1251,344).

60 Friis Johansen, *Exochi*, 66 No. Z 1 Fig. 137; cf. the pyxis bottoms *Kerameikos* V 1, Pls. 62, 64.

61 Cf. the ornaments and horses rendered with punched dots on as yet unpublished Peloponnesian (?) bronzes from Olympia (Inv. Nos. B 4661, B 807, B 5031).

62 This phenomenon no longer has anything to do with the Early Geometric cross-hatching of meanders in Athens.

63 Jugs: Furtwängler, *JdI* 1, 1886, 134 f. Inv. No. 2940 (Berlin). *Cl. Rhodos* IV, 342 (Grave 200) No. 1, Figs. 379–380. Friis Johansen, *Exochi*, 91 ff. Fig. 197 a–b (London, British Museum).

64 See above, p. 46 f.

65 In the very late Grave A in the necropolis of Exochi, the grave urn was an amphora 71 cm. tall with neck handles (Friis Johansen, *Exochi*, 12 ff. No. A 1 Figs. 5–7). Here the mainland (Boeotian?) type is adopted, with echoes of the beginning of Early Attic style. On the shoulder there is a painted wriggling snake. The vase was produced at the end of the last quarter of the eighth century.

66 One is almost reminded of the splendid 'woven' belts of lozenge bands on High Geometric Attic jugs with broad necks. The considerably simpler structure of the lozenge fillings in Rhodian patterns is loosely connected with local tradition. A similar type of decoration is found on small Rhodian jugs (Friis Johansen, *Exochi*, 29 ff. No. D 3, 6–7, 9, 13 Figs. 63, 67–70, 73–74; 69 No. Z 3 Figs. 140–141. *Cl. Rhodos* VI/VII, 192 Fig. 230).

67 *Cl. Rhodos* VI/VII, 194 ff. (Grave 82) Figs. 236–238. A similar cup, with a palm-tree motif occurs amongst the Cos finds.

68 Cf. the Late Geometric Argive krater from Melos in Berlin (*Tiryns* I, 147 f. Fig. 13). See above pp. 61 f., 65, 68.

69 The meander, both cross-hatched and linear: Friis Johansen, *Exochi*, 53 ff. No. X 1–2 Figs. 129, 132.

70 *Cl. Rhodos* VI/VII, 102 Fig. 113.

71 *Cl. Rhodos* VI/VII, 200 Fig. 239.

72 Kantharos: *Cl. Rhodos* VI/VII, 34 (Grave 7) Figs. 33, 36. Small jug: Friis Johansen, *Exochi*, 36 No. D 9 Figs. 73–74; 69 No. Z 3 Figs. 140–141. Kantharoi: ibid, 15 No. A 6 Figs. 12; 23 No. B 3 Fig. 40.

73 From Ialysos: *Cl. Rhodos* III, 85 (Grave 51) Fig. 76 (jug); 103 (Grave 59) Fig. 96 (skyphos); 107 (Grave 63) Fig. 100 (jug). From Camirus: ibid., VI/VII, 35 (Grave 8) Fig. 38 (double-handled jug); 73 (Grave 22) Figs. 82–83 (jug); 189 f. (Grave 80) Fig. 224. Dugas, *BCH* 36, 1912, 500 No. 24 Fig. 6 (kantharos).

74 *Cl. Rhodos* VI/VII, 79 (Grave 25) Fig. 87; 189 ff. (Grave 80) Fig. 225.

75 Young, *AJA* 61, 1957, 329 ff. Frontispiece and Pl. 96; cf. also below p. 106 Note 178 and Note 60 in Ch. VIII.

76 Perrot-Chipiez, *Histoire* III, 670 f. Fig. 479. L. P. di Cesnola, *Cyprus* (1877), 68. Cesnola, *Cypern* (German version by H. Stern, 1879), Pl. 5,2.

77 *Cl. Rhodos* VIII, 203 (Grave 84) Fig. 243 (with lid). Friis Johansen, *Exochi*, 61 f. No. X 3 Fig. 128. The ivory imitation was already recognized by Friis Johansen.

78 F. Thureau-Dangin, *Arslan Tash* (1931), 131 No. 94 Pl. 44. J. W. Crowfoot, *Early Ivories from Samaria* (1938), 35 ff. Fig. 5 Pls. 18–20. L. Woolley, *Carchemish III* (1952), 167 P. 71. Cf. also Descamps, *Ivoires, passim*. Friis Johansen (*Exochi*, 111 f.) remarked on these ivory tablets, and rejected the previously accepted theory that the Rhodian palm-tree motif was connected with Mycenaean palm trees. This is undoubtedly correct as far as the immediate prototypes followed by Rhodian painters are concerned. But the Syrian tablets were not produced completely independently of Mycenaean ivory carving. Cf. in this context ivories from Argos (*BCH* 28, 1904, 384 ff. Figs. 21–22) and the numerous palm trees in Mycenaean vase painting, which occur primarily on East Aegean vases. Cf. the naturalistic palm tree on Crete from the Late Minoan I period (*BCH* 80, 1956, 353 f. Fig. 29) and the later stylization of this motif (Furumark, *Myc. Pottery*, 278 ff. Motifs 15: Palm II Fig. 39 No. 5 from Mycenae; 8 from Enkomi; 9, 12 from Ialysos; 14 from Camirus; 19 from Enkomi), with the plate from Kition on Cyprus (*BCH* 84, 1960, 522 Figs. 15–16). This is only one of the cases where a Mycenaean motif has, as it were, hibernated, emerging centuries later to enrich Greek art.

79 Dugas, *BCH* 36, 1912, 502 f. Fig. 10. Friis Johansen, *Exochi*, 98, Fig. 201 (from a later photo).

80 See below p. 194 f.

81 See above Note 56.

82 Kantharos sherd from Grave 51 in necropolis of Marmaro near Ialysos (*Cl. Rhodos* VIII, 172 Fig. 161, below 3): a bird motif enclosed on the right by a triglyph with dot pattern, surmounted by a continuous band with false spirals.

83 *Lindos* I, 244 Nos. 845–846 Pl. 36.

84 *Cl Rhodos* IV, 342 ff. Figs. 379, 381–382.

85 Camirus: *Cl. Rhodos* VI/VII, 46 Fig. 56. Siana: K. F. Kinch, *Vroulia* (1914), 4 Fig. 8 (Private collection, Copenhagen); ibid., 4 (fragments of a similar skyphos from Vroulia).

86 Siana: *CVA* Oxford, Ashmolean Museum 2, II d Pls. 1,3. *Lindos* I, 248 Fig. 30. Ialysos: *Cl. Rhodos* VIII, 173 Fig. 161 (Middle 5 and top left). *Lindos* I, 250 No. 871 Pl. 37.

87 The Rhodian bird-skyphoi cannot be completely catalogued here. I will give therefore only a few examples. Ialysos: *Cl. Rhodos* III, 97 (Grave 57) Fig. 92, 105 f. (Grave 62) Fig. 99 = *CVA* Rodi, Mus. Archeol. 2, II D e Pl. 6,1. Samos: Eilmann, *AM* 58, 1933, 69 Fig. 18 a Supplement 43,3. Thera: *Thera* II, 30 Fig. 80; 180 Fig. 371. Pfuhl, *AM* 28, 1903, 166 Nos. 3–4. Al Mina: Robertson, *JHS* 60, 1940, 18 f. Fig. 8 g–h. The 'Nestor cup' from Ischia. Trendall, *JHS* 76, 1956, Archaeol. Reports 1955, 61 Fig. 14 top right. Buchner-Russo, *Rendiconti Acc. Lincei*, Ser. VIII 10, 1955, 215 ff. Pls. 1–4. Delos: at least ten bird-skyphoi were able to be reconstructed from the sherds of the graves moved to Rheneia (*Délos* XV, 98 ff. Nos. 6–9, 10–15, Pls. 16–17).

88 Pfuhl, *MuZ* III Pl. 9 Fig. 47. *Délos* XV, 100 ff. Nos. 17–35 Pls. 47–48.

89 London: W. Schiering, *Werkstätten orientalisierender Keramik auf Rhodos* (1957), 15 f. 23 Pl. 2,1. Friis Johansen, *Exochi*, 119 Fig. 209 R. M. Cook, *Greek Painted Pottery* (1960), 31, 227 Pl. 7a. See below Note 105. Munich: Dugas, *BCH* 36, 1912, 506 f. No. 35 Fig. 12. J. Sieveking-R. Hackl, *Die Kgl. Vasensammlung in München* I (1912), 44 No. 455 Fig. 57. The shape of these jugs, of which so far four are known, was an important influence in the early orientalizing phase of Rhodian pottery (Schiering, op.cit., 15 ff.).

90 Athen, École Française (aus Myrina): Dugas, *BCH* 36, 1912, 507 f. No. 36 Pls. 9–10. Aus Exochi: Friis Johansen, *Exochi*, 46 No. N 1 Figs. 107–108. London, British Museum (from Camirus); ibid., 104 f. Figs. 204–205.

91 Kinch, *Vroulia*, 26 ff. Fig. 13. Friis Johansen, *Exochi*, 133 f. Fig. 214.

92 Cf. above p. 88 ff. from Camirus, Grave 82: *Cl. Rhodos* VI/VII, 193 Figs. 233–234; Grave 200: ibid. IV, 345 Fig. 381. It is worth speculating whether the appearance of bird friezes and bird metopes in the early eighth century on the mainland, particularly in Attic pottery, was connected with the idea of the dead in the form of birds. There is a good deal of evidence to suggest that it was; e.g. the fact that the earliest examples come from grave vases, and that there is a clear connection between small Attic bowls with bird metopes, and Cycladic-Rhodian bird-kantharoi. The following, however, suggest caution in simply equating Rhodian-East Greek ideas with those of the mainland: that the pictures of birds seem to have a status equivalent to bucks and does; that, on the mainland, bird friezes quickly become decorative and often virtually

degenerate; and finally that on Late Geometric grave vases the only death images are the plastic snakes on shoulders, handles and mouths, of neck-handled amphorae and hydriai.

93 Kinch, *Vroulia*, 26 ff. Fig. 13. Friis Johansen, *Exochi*, 133 f. Fig. 214.

94 Bird-askoi, post-Mycenaean: Cos, Inv. No. C 699. Geometric: Cos without inv. no.; *Cl. Rhodos* III, 147 No. 5 Fig. 142. Late Geometric: *CVA* Karlsruhe, Bad. Landesmus. 2 Pl. 46,4 (from Rhodes). Cos without Inv. No. Late Geometric plastic bird-vases: Cos inv. no. C 569. C 585. C 1039 and without Inv. No. 'Tafelaufsätze': Cos Inv. No. 634 (three times) and without Inv. No. (twice). Kinch, *Vroulia*, 56 No. I, 1 Pl. 34 (from Rhodes). M. I. Maximova, *Les vases plastiques* (1927) I, 87 Pl. 11 No. 45. Morricone, *Bollettino d'Arte* 35, 1950, 322 Figs. 92–93. Kinch, op.cit., also mentions four other bird-vases from Vroulia and Lindos; Maximova, op. cit., some in the Louvre, in the British Museum in London, in the Hermitage in Leningrad and in Berlin, all of which come from Rhodes.

95 Maximova, *Vases plastiques* I, 83 ff. Pl. 10 Nos. 38–39. Levi, *ASAtene* 10–12, 1927–29, 199 f. Fig. 231; 278 Fig. 351; 353 Fig. 461; 385 Fig. 496 also the birds p. 174 Fig. 194 (from the necropolis of Arkades).

96 Cf. *Délos* XV, Pl. 32 No. 87.

97 Buschor, *AM* 54, 1929, 154 f. Figs. 6–7.

98 Protogeometric: *Kerameikos* I, 92 Pl. 63 (Inv. 535). Maximova, *Vases plastiques* I, 85 Pl. 11 No. 43. With bird foot and decoration, around the middle of the eighth century; Athens Nat. Mus. Inv. No. 15 439. Birds from Grave 50 in the Kerameikos necropolis, from the same period: *Kerameikos* V 1, 245 Pl. 144 (Inv. 1308–1309. Bird-askos with flat bottom and pair of bird-askoi on two bird feet, from Grave 49, still from the third quarter of the eighth century: ibid., 243 Pl. 145 (Inv. 1350–1351).

99 *Kerameikos* V 1, 245 Pl. 144 (Inv. 1311).

100 *Iliad* 16, 855 ff.; 22, 361 ff.; 23, 100 f.; *Odyssey* II, 605 f.; 24, 5 ff.

101 The spirit Ba: E. Buschor, *Die Musen d. Jenseits* (1944), Fig. 1. Jug in the British Museum from Rhodes: Dugas, *BCH* 36, 1912, 502 No. 32 Fig. 9. Buschor, op. cit., 22 Fig. 7. Schiering, *Werkstätten orientalisierender Keramik auf Rhodos*, Pls. 1,2; 2,2. See above, p. 90 Note 89.

102 On a red-figured krater of the Hephaistos painter in the British Museum in London (Roscher, *Mytholog. Lexikon* II 1, 1103 Fig. 3. A. B. Cook, *Zeus* III, 1940, 73 Pl. 12. Buschor, *Musen d. Jenseits* 27, 50 Fig. 37. J. D. Beazley, *Attic Red-Figured Vase-Painters*[2] II, 1963, 1114 f. No. 15) above Procris, who is mortally wounded by a spear, there hovers a man-bird, which is usually taken to be the departing soul of Procris. But this would be an anachronism from several centuries earlier. It is much more likely that the bird creature, which is looking back down at Procris, is showing her the way as she dies; the man-bird is a messenger of death *(Ker)*.

103 Lekythos in Jena: Harrison, *JHS* 20, 1900, 101 Fig. 1. L. Deubner, *Attische Feste* (1932), 95 Pl. 8,2. On the death-bird: G. Weicker, *Der Seelenvogel in der alten Literatur u. Kunst* (1902). Hackl, *Archiv f. Religionswiss.* 12, 1909, 204 ff. (with criticism of the inadequate differentiation made

by Weicker). J. Wiesner, *Grab und Jenseits* (1938), 215 f. Buschor, *Musen des Jenseits*, 11 ff. M. P. Nilsson, *Gesch. d. griech. Religion* I² (1955), 197 f.

104 See above p. 75 f.; cf. also the vessels in Furtwängler, *JdI* 1, 1886, 136 f., Inv. No. 2964, 2980, 2990, 2992. *Cl. Rhodos* VI/VII, 360 No. XII 1 Figs. 92; 362 No. XII 14–16 Figs. 103–105.

105 The horse on a sherd from Grave Z in the necropolis of Exochis (Friis Johansen, *Exochi*, 70 Fig. 147) is certainly not Attic, and probably not Rhodian either. A sherd from Lindos with the fragmented picture of a man (*Lindos* I, 254 No. 905 Pl. 39) is, on the other hand, certainly Laconian. The amphora from Grave A from Exochi (Friis Johansen, op. cit., 12 ff. Figs. 5–6), with the form of a mourning man, with arms raised in salute, on the neck, is already sub-Geometric, as is, also, a sherd with the upper body of a man from Rhodes (*Cl. Rhodos* VI/VII, 363 No. XII 17 Fig. 106), the bird-man on a flat jug and the centaur on a pithos in the British Museum in London (Dugas, *BCH* 36, 1912, 502 f. Nos. 32–33 Figs. 9–10. Schiering, *Werkstätten orientalisierender Keramik auf Rhodos*, Pls. 1,1; 2,2). See above p. 87 f., 90 and Notes 79, 89.

106 Dotting occurs fairly frequently on Late Geometric bronze sheets (see below, p. 203 f.). In Rhodian art, however, it occurs commonly on gold jewellery (*Cl. Rhodos* III, 89 Fig. 82. Reichel, *Goldrelief*, Pl. 15 No. 56. Friis Johansen, *Exochi*, 76 No. Z 44–48 Figs. 174–180; 176 f. Fig. 229. See below p. 192 f), but no precise parallel with the lozenge-crosses has as yet been established.

It is worth speculating whether it might have been possible for a craft tradition from the gold workshops through the centuries, from Mycenaean to Late Geometric, to have lasted in East Greece: from, for instance, the lozenge-shaped gold knobs, each with two little balls on top, from Grave V in the circle of shaft graves in Mycenae (Karo, *Schachtgräber*, 127 Nos. 668, 670–672, 674 Pl. 66. Bossert, *Altkreta*, Pl. 95 No. 185) to the lozenge-crosses in Rhodian pottery. Also, a six-leaf, medallion-shaped leaf-star, on a jug from Exochi, Grave D (Friis Johansen, op. cit., 37. Fig. 68)—with dotted ground, as in the Rhodian gold sheets—has striking points in common with the small round gold plates from Shaft Grave III at Mycenae (Karo, op. cit., 47 No. 20 Pl. 28. Bossert, op. cit., Pl. 97 k). Cf. here Hafner in *Festschr. d. Rom.-Germ. Zentralmuseum Mainz* III, 83 ff. Pl. 5,2 and remarks here about the palm-tree motif, above p. 87 f. Note 78.

107 Friis Johansen, *Exochi*, 21 ff. No. B 2 Figs. 37–39.

108 Friis Johansen, *Exochi*, 12 ff. No. A 1 Figs. 5–7; 21 No. B 1 Figs. 34–36. On the back of a krater from Grave 200 in the Camirus necropolis (*Cl. Rhodos* IV, 343 f. Fig. 387) there is, however, already a long-drawn spiral band, similar to one on a type of bronze tripod-cauldron in Olympia (Willemsen, *Dreifußkessel*, Pls. 50–52). See below p. 180 ff.

109 See above p. 52 ff.

110 See above p. 87 ff.

111 Technau, *AM* 54, 1929, 6 ff. Eilmann, *AM* 58, 1933, 47 ff. Matz, *Geschichte* 71. Walter, *AM* 72, 1957, 35 ff. R. M. Cook, *Greek Painted Pottery* (1960), 31 ff. Now: H. Walter, *Frühe samische Gefäße* (1968).

112 J. Boehlau, *Aus ionischen und italischen Nekropolen* (1898).

113 T. Wiegand, *Erster vorl. Bericht über die Ausgrabungen in Samos* (1911, aus Abh. Berl. Ak.). Schede, *AM* 37, 1912, 199 ff. Ders., *AM* 44, 1919, 1 ff. Ders., *Zweiter vorl. Bericht über die Ausgrabungen in Samos* (1929, aus Abh. Berl. Ak.).

114 Eilmann, *AM* 58, 1933, 47 ff.

115 Eilmann, *AM* 58, 1933, 51 f. Figs. 1–2 Supplement 18,1,6,10.

116 Cf. the open-work foot and the kantharos from Delos (*Délos* XV, 31 No. 16 Pl. 31; 65 No. 87 Pl. 32) and the Attic kantharos from the Kerameikos (*Kerameikos* V 1, 226 Pl. 86, Inv. 373).

117 A selection: *IM* 9/10, 1959/60, 52 f. Pls. 51, 1–3; 52, 1–2.

118 From these come sherds *IM* 9/10, 1959/60, 52 f. Pl. 51,4; 52, 3–4. Other Protogeometric sherds come from various finds: *IM* 7, 1957, 121 f. Pls. 36, 1–2, 4 top (from two kraters). *IM* 9/10, 1959/60, 54 Pl. 53,5 (fragment of a Late Geometric krater).

119 *IM* 9/10, 1959/60, 54 Pl. 53,1–2.

120 Eleusis: *Kerameikos* I, 160 Pl. 48 (Inv. 1081, 1085). Desborough, *Protogeometric Pottery*, 67 Pl. 9. Corinth: *Corinth* VII, 1,5 f. No. 6 Pl. 1. Asine: Desborough, op. cit., 207 Pl. 27 (Grave P. G. 25). The Miletan jug is the only example of the Protogeometric type in the early period.

121 Cf. the belly-handled amphora from the burnt layer of the 'Geometric house': *IM* 9/10, 1959/60, 38 f. Fig. 1 (lip profile of the eighth century); in this context, *Cl. Rhodos* VI/VII, 129 f. Figs. 144–145; 204 Figs. 244–245.

122 *IM* 7, 1957, 124 Pl. 37,2 bottom right; 39,2,3, bottom right 4. *IM* 9/10, 1959/60, 94 No. 7 d–e Pl. 79,2 bottom: cf. also ibid., 52, Note 1.

123 Inv. No. 57 031. Cf. the fragment of an Attic krater from the Kerameikos (*Kerameikos* V 1, Pl. 18, Inv. 1149).

124 *IM* 7, 1957, 122 Pl. 37,1a,c; cf. *Kerameikos* V 1, Pl. 89 (Inv. 879, 892) Pl. 99.

125 *IM* 7, 1957, 124 Pl. 39,1 bottom left. *IM* 9/10, 1959/60, 57 Pl. 57,4.

126 *IM* 7, 1957, 124 Pl. 39,1; 122 Fig. 8 top left and right.

127 *IM* 7, 1957, 122 Fig. 8 top right Pls. 37,1 d; 37,2 bottom left. *IM* 9/10, 1959/60, 57 Pl. 57,4.

128 Inv. No. 57 *NK* (not published). A tiny sherd of a bird-skyphos from another find: *IM* 7, 1957, 124 Pl. 39,3, centre.

129 *IM* 9/10, 1959/60, 57 f. Pl. 58,2. Corinth: *Corinth* VII 1, 27, No. 75 Pl. 12. Athens: *Kerameikos* V 1, 231 Pl. 91 (Inv. 330). Cyclades: *Délos* XV, 55 ff. Nos. 25–26, 28, 31 Pl. 27. Rhodes: *Cl. Rhodos* VI/VII, 201 Fig. 241 (preliminary stage).

130 See above p. 46.

131 *IM* 9/10, 1959/60, 57 Pl. 57,2; cf. *Délos* XV, 61 No. 63; 63 Nos. 74–76 Pls. 30–31.

132 *IM* 9/10, 1959/60, 59 Pl. 62,2; 94 Pl. 79,2 top; cf. *Cl. Rhodos* VI/VII, 47 Fig. 50; ibid., III, 60 Fig. 50.

133 See above p. 77. Cf. particularly *IM* 9/10, 1959/60, 94, Pl. 79,2, bottom.

134 *IM* 9/10, 1959/60, 93 Pl. 85,3 (Cretan influence).

135 *Lindos* I, 459 No. 1860 Pl. 80 (rider?). The costume decoration, consisting of zigzags, stars, framed triangles and a bird, suggests it dates from the third quarter of the eighth century, or a little later.

136 E. Akurgal, *Bayrakli. Erster vorl. Bericht über die Ausgrabungen in Alt-Smyrna* (1950 = Periodical of the Faculty of Philosophy, Ankara, 8).

137 I am most grateful to E. Akurgal, J. M. Cook and J. K. Brock.

138 For example, the neck-handled amphora from Fortetsa (Brock, *Fortetsa*, 21, No. 179 Pl. 9; 23 No. 205 Pl. 14), the stirrup jugs (ibid., 25 No. 218; 26 No. 219 Pl. 15) and the pithos with belly handles (ibid., 26 No. 221 Pl. 16; Desborough, *Protogeom. Pottery*, Pl. 31).

139 Brock, *Fortetsa*, 213 ff.

140 *Kerameikos* V 1, 211 Pl. 17 (Inv. 935).

141 *IM* 9/10, 1959/60, 53 Pl. 51,4; cf. Desborough, *Protogeom. Pottery*, Pl. 12 (fragments from the Kerameikos and krater in Munich).

142 Heurtley-Skeat, *BSA* 31, 1930/1, 32 f. No. 149 Pl. 11.

143 Upright meander: Heurtley-Skeat, *BSA* 31, 1930/1, 22 ff. Nos. 56, 70 Fig. 19 Pls. 4–5; 30 No. 132 Pl. 8; 31 No. 135 Fig. 20,6 Pl. 9. Spoke-rim: ibid., 31, No. 136, Pl. 9; 32 f. Nos. 145–146; 148–149 Pl. 11 (kraters). The spoked wheel begins in the second half of the ninth century in Athens; cf. the krater mentioned in Note 140 and the belly-handled amphora *Kerameikos* V 1, Pl. 46 (Inv. 2146).

144 Heurtley-Skeat, *BSA* 31, 1930/1, 32 Nos. 145–146 Pl. 11; 33 No. 150 Fig. 13. The same shape occurs in No. 149 Pl. 11.

145 Eilmann, *AM* 58, 1933, 82 Supplement 23,11. Cf. A. Salzmann, *Necropole de Camiros* (1875), Pl. 45. Now: Eckstein, *Wiss. Zeitschr. d. Univ. Rostock* 16, 1967, 437 ff. Pls. 15–17, 1. See below p. 111 and Note 193.

146 For the type of krater from Myrina, in the Louvre: Dugas, *BCH* 36, 1912, 507 f. Pls. 9–10.

147 Cf. the single ornamental stripe on a krateriskos in Samos: Eilmann, *AM* 58, 1933, 87 f. Fig. 34, Supplement 27,4.

148 Old Rhodian motif, see above p. 75. On the zone with frieze bands, cf. a Cypriot-style jug from Ialysos (*CVA* Rodi, Mus. Archaeol. 2, II De Pl. 5,1).

149 Cf. e.g. the globular aryballoi from Rhodes (*Cl. Rhodos* VI/VII, 36 ff. Fig. 39) and in Lund (*Lindos* I, 303 Fig. 41. Friis Johansen, *Exochi*, 160 Fig. 123) and from Thera (*Thera* II, 179 Fig. 370 a–b). The style is Cypriot-Anatolian; cf., e.g. Myres, *Cesnola Coll.* 80 f. No. 644. Friis Johansen, op. cit., 161 Fig. 224. The motif was originally connected with small jug shapes; its adaptation to Geometric, and its development, took place in Greece.

150 The spiral net was indigenous in the Cyclades and in Crete from the Early Bronze Age onwards, cf., most recently, Bosser, *JdI* 75, 1960, 1 ff.

151 Ankara, Archaeolog. Museum: large hydriai with beak-like mouths, four-handled amphorae.

152 Lamb, *BSA* 35, 1934/5, 157 ff. Pls. 34–36.

153 The same decoration is found on a sherd from the Miletus finds, still in traditional Protogeometric style (*IM* 9/10, 1959/60, 55 Pl. 55,1), which can certainly be dated in the second half of the ninth century.

154 On the amphora handle, *IM* 9/10, 1959/60, Pl. 34,31 cf. *Kerameikos* V 1, Pl. 151 (Inv. 2140, 890), on the fragment of a small bowl, *IM* 9/10, 1959/60, Pl. 34,20 cf. *Kerameikos* V 1, Pl. 94 (Inv. 240,269).

155 Lamb, *BSA* 35, 1934/5, 157 f. The white glaze, both outside and inside, on small bowls, cups, dishes etc, on which painting was then executed, is clearly a preliminary stage of so-called Naukratic pottery (Lamb), which is today recognized as Chiot. This technique recurs not only on

156 Samos, but also in Phocaea (alternating clay-ground and white-ground areas).

156 The best example is the neck of a large jug with a round mouth and rotella handles, from Samos (Walter-Vierneisel, *AM* 74, 1959, 22. Walter, ibid., 60 f. Fig. 1 Supplements 54, 102–103). One can still make out the helmeted head of warriors at the beginning of the shoulder. They are fighting in pairs. To judge by the style of this frieze, the jug belongs to the period around the middle of the seventh century. But the neck, as opposed to the handle, is decorated with five Geometric bands, separated from each other by groups of four lines. On the neck of this jug, therefore, we have a model collection of East Ionian Late Geometric ornaments—still modish decoration—half a century after the end of Late Geometric in the east, and in a completely different artistic climate, extremely accurately executed. But the Geometric idiom had become more a fashionable trend than a period style by the decades after the middle of the eighth century, in the east.

157 Cf. Lamb, *BSA* 35, 1934/5 Pl. 35 Nos 31, 34, 36.

158 Lamb, *BSA* 35, 1934/5 Pl. 35 No. 34 (horse head) 28–30, 33.

159 See Friis Johansen, *Exochi*, 29 ff. No. D 4–10 Figs. 64–70, 73–76 (3rd quarter of the eighth century); 66 ff. No. Z 2, Y 2 Figs. 134, 138–139 (middle of the eighth century).

160 E.g., Pfuhl, *MuZ* III, Pls. 3, 13. Davison, *Workshops*, Figs. 7, 79, 85–86, 108, 127.

161 *Kerameikos* V 1, Pl. 17 (Inv. 935) 18 (Inv. 1149).

162 Richter, *MetrMusBull* 29, 1934, 169 ff. Figs. 1–3. Idem, *Handbook*, Pl. 14 d. See above p. 42.

163 Eilmann, *AM* 58, 1933, 113 Supplement 33,3; cf. the krater in the National Museum, Athens, Inv. No. 806 (Kahane, *AJA* 44, 1940, 477 Pl. 25).

164 Eilmann, *AM* 58, 1933, 113 Supplement 33,4. Cf. also the ornamental frieze on the plate, ibid., Supplement 34,2, where units of upright zigzags, small circle with dot and lozenge are repeated in a pattern a-b-c-b-a. It is not impossible, although hardly capable of proof, that Rhodian and perhaps even Cycladic (cf. the neck decoration of the amphorae, *Délos* XV, 18 f. Nos. 16–19 Pls. 5–6) influences were at work here.

165 Eilmann, *AM* 58, 1933, 110 Supplement 33,1–2. Cf. *Kerameikos* V 1, Pl. 65 (Inv. 795) 64 (Inv. 338, 775, isolated find). Young, *Graves*, 81 f. No. XVII, 14 Fig. 54, with a beautiful eight-leafed star. *CVA* University of Michigan, 1 Pl. 12,4 a–b; also a pyxis in Heidelberg (Inv.No. G 53) and in Dresden (Inv.No. Z.V. 1774).

The transference of pyxis bottoms to the outside and inside of plates also occurs in Attic art (*Kerameikos* V 1, Pl. 104, Inv. 365.1144. Brann, *Hesperia* 30, 1961, 112 No. I 55–56 Pls. 12,23).

166 Antecedents in Athens: *Kerameikos* V 1, Pl. 62 (Inv. 265.834.332–333).

167 *Kerameikos* V 1, Pl. 66 (Inv. 835); cf. also the pyxis lid from the Agora: Brann, *Hesperia* 29, 1960, 412 f. Grave N 21 : 6 No. 3 Pl. 91.

168 Attic bowls with star metopes: *Kerameikos* V 1, Pl. 96 (Inv. 394–395). A small bowl with names on the upper rim (ibid. Pl. 96, Inv. 897) is an early stage which is missing on Samos. Samos: Eilmann, *AM* 58, 1933, Supplement 21.2.4. Attic bird-bowl: *Kerameikos* IV, Pl. 96 (Inv. 342).

Now: H. Walter, *Frühe samische Gefäße* (1968), 100 No. 155 Pl. 30.

169 Attic examples: *Kerameikos* V 1, Pl. 97 (Inv. 325–327). *CVA* Fogg Museum, Pl. III 7. Collections Lambros-Dattari (1912) Pl. 5,16. The last-mentioned bowl corresponds precisely with the Samian fragment with the drop-like dots between pairs of border lines on the lip, the three-striped triglyphs, the cross-hatched triangles in the apices of the hatched leaves, the swastikas above the bodies of the birds, the dot-rosettes on dotted stalks in front of them.

170 Attic: *Kerameikos* V 1, Pl. 87 (Inv. 364) 88 (Inv. 1341) 87 (Inv. 817). Young, *Graves*, 48 f. No. XI 5; 112 No. B 11; 171 No. C 103, Figs. 32, 80, 119. Argolid: Frödin-Persson, *Asine*, 313 f. Nos. 2, 6 Fig. 217, 1–2; 333 Nos. 9–10 Fig. 224. Samian: Eilmann, *AM* 58, 1933, 60 f. Fig. 8 a Supplement 20,9; 101 f. Fig. 43 Supplement 30,3.

171 Attic: see above p. 48 and Note 67 in Ch. II, particularly No. 6. For Samian: Eilmann, *AM* 58, 1933, 67 Supplement 22,6.

172 See below p. 113 ff.

173 For the sub-Geometric spherical triangles cf. the Rhodian flat jug (*Cl. Rhodos* IV, 54 Fig. 28. *CVA* Rodi, Mus. Archeol. 1, II D e Pl. 1,1–2. *Cl. Rhodos* X, 195 Figs. 5–6) and the fragment of a similar Rhodian jug found on Thera (Pfuhl, *AM* 28, 1903, 167 No. 10 Supplement 21,4).

174 The related shape types on Cyprus include pyxides, (mostly) two-handled and (less often) one-handled cups and small bowls, and are spread across the whole of the Geometric epoch. Small bowls: *SwedCyprExped* I, Pl. 124,9; II, Pl. 92,5 = IV 2 Supplement 12 No. 11 (White Painted II); IV 2 Supplement 18 No. 7. (White Painted III). Cups: ibid. I Pl. 124, 6–11; II Pls. 90,5–8, 11 (White Painted I); Pl. 92,4,7–8. (White Painted II); I Pl. 131,6 (White Painted II); IV 2 Supplement 18 Nos. 9–10 (White Painted III). Pyxides: ibid. II Pl. 108,2–4,6 = IV 2 Supplement 31,8 (Bichrome IV ware). The last pyxis belongs to the transition to the seventh century (the absolute chronology of Cypriot Geometric pottery, given by E. Gjerstad on the basis of his classification, *SwedCyprExped* IV 2, 421 ff., needs, by now, a new revision). The chains of lotus buds and blossoms go back to the Assyrian style, and can be compared with a Late Assyrian coloured glazed vase of the same type (W. Andrae, *Farbige Keramik aus Assur*, 1923, Pl. 14 b).

175 See above, p. 82 f.

176 Athens, Nat. Mus. Inv.-No. 998: M. Collignon-L. Couve, *Catalogue des vases peints du Musée Nat. d'Athènes* (1902) No. 328.

177 Cf. *Kerameikos* V 1, Pls. 119–120 (Inv. 815, 823), only checkerboard patterns, as also in Pl. 121 (Inv. 1344).

178 See above Note 75. Cf. the crossed meander spirals on the squares on the upper part of the throne and open-work lower part, the lowest strut with opposed meander hooks around one cross-beam, and the curved bands with checkerboard pattern. The Gordion throne is more recent than the Samian pyxis and belongs to the period around the turn of the eighth century to the seventh. But both together are evidence of a craft furniture industry, which spread across the whole southwest Asia Minor and the offshore islands, working with marquetry techniques with different types of wood. This technique existed alongside the older ivory-inlaying craft in the Near East. To judge from its shape, the Samian pyxis may be an imitation of a wooden lathe-turned vase with inlaid Geometric ornaments. Geometrical patterns, on the other hand, spread from East Greek workshops into Phrygian art, not earlier than the arrival of the meander in the east shortly before the middle of the eighth century. Thus this inlaid-wood furniture industry in the Greek Geometric period existed alongside the craft of ivory decoration of Oriental furniture which was already flourishing in the Mycenaean period.

179 See above, p. 90 f.

180 *Thera* II, 30 Fig. 80; 180 Fig. 371 (unreliable copy). Pfuhl, *AM* 28, 1903, 166 Nos. 3–4. From the Cyclades: *Délos* XV, 99 No. 13 Pl. 47.

181 Technau, *AM* 54, 1929 Fig. 3,1; cf. *CVA* Rodi, Mus. Archeol. 2, II D e Pl. 6,1.

182 Technau, *AM* 54, 1929, 9 Fig. 2,1; cf. Lamb, *BSA* 35, 1934/5, 157 with Note 1.

183 Eilmann, *AM* 58, 1933, 71 Fig. 21.

184 Skyphos from Ialysos: *Cl. Rhodos* III, 103 Fig. 96. *CVA* Rodi, Mus. Archeol. 2, II D e Pl. 5,3.

185 E.g. on late kraters: Friis Johansen, *Exochi*, 46 No. N 1 Fig.108; 105 Fig. 205.

186 Cf. also the atticizing large krater from Camirus in the British Museum in London (*Tiryns* I, 164 Fig. 23. Friis Johansen, *Exochi*, 102 f. Fig. 203).

187 Cf., e.g. the skyphos sherds (Eilmann, *AM* 58, 1933 Supplement 43,2 and its completion 69 Fig. 18c) and the sub-Geometric krater (ibid., Fig. 26 c Supplement 34,1).

188 On the late cross-hatching of the meander: Friis Johansen, *Exochi*, 110. On Samos: Technau, *AM* 54, 1929 Supplement 2,6. Eilmann, *AM* 58, 1933 Fig. 35.

189 *IM* 7, 1957 Pl. 37,2 bottom.

190 Cf. the amphora neck from the Agora in Athens: Young, *Graves*, 73 f. No. XV 1 Fig. 48.

191 *Thera* II, 140 f. Fig. 331.

192 Cf. the much simpler Theran amphora in the Bibliothèque Nationale in Paris (*CVA* Paris Bibl. Nat. 1, Pl. 2,1–4).

193 Amphora from Camirus (now in Colmar, Unterlindenmuseum, Inv.-No. E P 1106): A. Salzmann, *Nécropole de Camiros* (1875), Pl. 45. Eckstein, *Wiss. Zeitschr. d. Univ. Rostock* 16, 1967, 437 ff. Pls. 15–17,1. See also above p. 100 and Note 145. Krater fragment from Samos: Eilmann, *AM* 58, 1933, 82 Fig. 27a Supplement 23,11. The krater fragment in the store of Izmir (from Bayrakli) is as yet unpublished. Kalathos from Crete: Brock, *Fortetsa*, 45 No. 418 Pl. 33.

194 Technau, *AM* 54, 1929 Supplement 2,8–9. Decoration with scratched lines: ibid. Supplement 4,2–4. Eilmann, *AM* 58, 1933 Supplement 24,1; 25,14. More rim sherds in the same technique are amongst the later finds on Samos (now: Walter, *Frühe samische Gefäße* Pl. 21 Nos. 119–124). Similar sherds of skyphoi and small bowls are found in Miletus, where the three broad concentric circles are replaced by bands with dot fillings (*IM* 7, 1957, Pl. 39,2).

195 Technau, *AM* 54, 1929, 15 Supplement 7,6. Eilmann, *AM* 58, 1933 Supplement 36,10; 38,8; 40,13.

196 Cf. Note 186.

197 Technau, *AM* 54, 1929, 17 Supplement 8,1–3. Eilmann, *AM* 58, 1933 Supplement 23,13; 30,4,6–7. One handle (now: Walter, *Frühe samische Gefäße*, Pl. 16 No. 95) has the

same pattern as the fragment *AM* 58, 1933, Supplement 43,7. Sherds of a krater: *AM* 58, 1933, Supplement 43,6. Further examples from East Ionia: belly-handled amphora from Old Smyrna (Bayrakli) in the Culture Park Museum at Izmir (unpublished) with ringlets as eyes of the 'woven' bands, and ringlets hanging down from bands of strokes on the shoulder, between isolated ringlets. Miletus, Inv. No. 57 N 92: ringlets above each other separating dotted circle bands; Inv. No. K 57(7): with the same function, but with ringlets joined by tangents (cf. also *IM* 7, 1957, Pl. 39,3, bottom; 39,4 middle and bottom.

198 Technau, *AM* 54, 1929, 15 Fig. 5. Eilmann, *AM* 58, 1933, 115 f. Figs. 60–61 Supplement 35,3.

199 Examples: Myres, *Cesnola Coll.* 81 Nos. 647, 649, 654; 88 Nos. 707, 710, 712, 714.

200 White Painted III: *SwedCyprExped* II, Pl. 94 Nos. 10, 12. White Painted IV: ibid., Pl. 97 Nos. 6–7, 9.

201 Bichrome III: *SwedCyprExped* II, Pl. 104 Nos. 3, 5. Bichrome IV: ibid., Pl. 107 Nos. 1, 4–7; 108 No. 9; 109 Nos 2–3; 110 No. 3. Bichrome V: ibid., Pl. 111 Nos. 1, 3–4, 6–8.

202 Black on red II (= IV): *SwedCyprExped* II, Pl. 114 Nos. 2–3, 13–15; 115 Nos. 2–3, 10–12; 116 Nos. 1–7. Black on red III (V): ibid., Pl. 117 No. 5. Bichrome red I (= IV): ibid., Pl. 119 Nos. 3,5.

203 Technau, *AM* 54, 1929 Supplement 5–6 (fragments from 15 examples) Eilmann, *AM* 58, 1933, 61 ff. Fig. 9 c, 10.

204 Cf. *Corinth* VII, 1, 35 f. No. 105 Pl. 15; 39 No. 122 Pl. 17. Payne, *Perachora* I, Pl. 12,2; *BCH* 85, 1961, 343 ff. Fig. 30 (from Delphi). Even so typical an ornament as the shovel-shaped zigzag bands, floating around the central circle on the bottom of bowls, is already found in Corinth (*BCH* 85, 1961, 346 Fig. 31 d).

205 Skyphoi: *Kerameikos* V 1, Pl. 132 (Inv. 1355, 651) 133 (inv. 1360). Foot cup, with oblique zigzag lines running out from a round lower rim: ibid., Pl. 133 (Inv. 1363).

206 Finds from Rheneia: *Délos* XV, 30 No. 8 Pl. 16; 61 No. 61 Pl. 31; 63 Nos. 74–76 Pls. 30–31. 'Parian' amphorae: *Thera* II, 199 Fig. 398 b; 201 Figs. 401 a–b. Pfuhl, *AM* 28, 1903, 186 No. 10 Supplement 29,4. Floating oblique zigzag lines around a wheel ornament: ibid., 187 No. 17 Supplement 30,4.

207 See above, p. 45 ff.

208 Eilmann, *AM* 58, 1933, 128 Supplement 39,1.

209 Kontoleon, *Ephem* 1945–47, 11 ff. Fig. 4; Cf. Buschor, *AM* 54, 1929, 142 ff. and the krater fragment found in Naxos, ibid., 154 f. Fig. 6, and *Délos* XV, 87 No. 8 Pl. 44 a–b.

210 Athens Nat. Mus.: M. Collignon-L. Couve, *Catalogue des vases peints du Musée Nationale d'Athènes* (1902) No. 219. Wide, *JdI* 14, 1899, 33 f. Fig. 11. Musée de Sèvres: *CVA* Sèvres, Mus. Nat., II E Pl. 12, 1–3. Boeotian imitation of a Cycladic krater in Munich: J. Sieveking-R. Hackl, *Die Kgl. Vasensammlung zu München* I (1912), 37 f. No. 406 Pl. 14.

211 Technau, *AM* 54, 1929, 17 Supplement 8,1–3. Eilmann, *AM* 58, 1933, 81 f. Supplement 25,1; 96 ff. Supplement 28,5–7 Pl. 1,1; 97 ff. Supplement 28,8; 29,1 and the reconstruction, Figs. 40–41.

212 See above, p. 48 ff.

213 On the krater from Kourion, besides horse metopes, there are also grazing horses in the frieze. May the Cyclades have preceded Athens in developing the realistic horse?

214 Eilmann, *AM* 58, 1933, 101 f. Supplement 30,7.

215 Eilmann, *AM* 58, 1933, 139 Supplement 41,8.

216 E. g. on an Attic Geometric jug in Munich and the fragment of a neck amphora in Oxford: Hampe, *Gleichnisse*, Pl. 13; jug in the National Museum at Athens: *CVA* Athènes, Mus. Nat. 2, III H d Pl. 14,1,3.

217 E. v. Mercklin, *Führer durch das Hamburgische Museum f. Kunst u. Gewerbe* II (1930), 18 No. 30 Pl. 4. Hampe, *Sagenbilder* 27, 29 No. V, 37 Pl. 21. H. Hoffmann, *Kunst des Altertums in Hamburg* (1961), 17 Pl. 52.

218 This obviously ritual gesture is not unique, but is also found on a Geometric fragment with a picture of a prothesis in Athens (Hinrichs, *Annales Univ. Saraviensis*, Ser. III 4, 1955, 131, 132 Pl. 10a).

219 Eilmann, *AM* 58, 1933, 128 Supplement 39,11.

220 If we accept Technau's suggestion (*AM* 54, 1929, 16 f.) that the unclear marks on the left edge of the first sherd are parts of a ship, then this frieze would have shown a battle around a ship—i.e., an heroic-epic scene as on the large Attic grave amphorae.

221 See above, p. 46 f.

222 See above, p 98 f.

223 *IM* 9/10, 1959/60, 54 f. Pl. 54,1–3. Attic parallels: *Kerameikos* IV, Pl. 14 (Inv. 2150) 15; ibid. V 1, Pl. 70 (Inv. 2134, 928).

224 *Corinth* VII 1, 9 f. Nos. 20, 22 Pl. 2; No. 23 Pl. 3.

225 *IM* 7, 1957, 122 No. 37,1 a, c; cf. the Attic small bowls, *Kerameikos* V 1, Pl. 89 (Inv. 2156, 892, 879).

226 Sherds of Cycladic neck-handled amphorae of group Bb (unpublished), cf. *Délos* XV, 73 f. No. 3 Pl. 34; No. 6 Pl. 35.

227 With much unpublished as well: *IM* 7, 1957, 122 Pl. 37,1 b, d; 37,2 bottom left; 124 Pl. 39,1 top and bottom left; Pl. 39,3 middle and right; *IM* 9/10, 1959/60, 57 Pl. 57,4; 58 Pl. 59, 1–3.

228 *IM* 7, 1957, 124 f. Pl. 39,2,4 (bottom centre).

229 Eilmann, *AM* 58, 1933, 113 Supplement 33,3–4 (plate).

230 Eilmann, *AM* 58, 1933 Supplement 21,2,4. The sherd of a bird-bowl, now: Walter, *Frühe samische Gefäße* (1968), Pl. 30 No. 155; cf. *Kerameikos* V 1, Pl. 97 (Inv. 325, 326, 376) and above p. 110.

231 *Kerameikos* V 1, Pl. 96 (Inv. 342).

232 *Kerameikos* V 1, Pl. 87 (Inv. 817, 364). Eilmann, *AM* 58, 1933, 62 Fig. 8 a; 101 f. Fig. 43.

233 Eilmann, *AM* 58, 1933, 120 Supplement 39,1.

234 Eilmann, *AM* 58, 1933, 96 f. Supplement 28,5–6.

235 Eilmann, *AM* 58, 1933, 96 f. Supplement 28,2,4; cf. the still predominantly Attic Geometric ibex on a sherd from Chios (Lamb, *BSA* 35, 1934/5, 158 No. 31 Pl. 35).

236 Cf. *Cl. Rhodos* X, 195 Figs. 5–6.

237 The fragments of a large krater from around the turn of the century are typical (Eilmann, *AM* 58, 1933, 79 Supplement 24,1, and the reconstruction in Fig. 26 c).

Chapter V: Minoan and Mycenaean Small-scale Sculpture (pages 120-126)

1 C. Zervos, *L'art des Cyclades* (1951), Pls. 234–235 Figs. 316–317.

2 Schachermeyer, *AA* 1962, 149 f. Fig. 16.

3 Cf. also Marinatos, *AA* 1937, 223 Fig. 5 (from Poros near Heraklion). C. Zervos, *L'art de la Crète* (1956), Pl. 343 Fig. 499. D. v. Bothmer, *Ancient Art from New York Private Collections* (1961), 22 No. 97 Pl. 26.

4 Lamb, *Bronzes* Pl. 5 b. Neugebauer, *Bronzestatuetten*, 23 Fig. 8. Marconi, *Dedalo* 6, 1925/6, 618 with figure. Zervos, *L'art de la Crète*, Pl. 315 Fig. 457.

5 Cf. the series of bronze figurines from the grotto at Phaneromeni. Only the first of these is clad in Minoan costume. The rest are completely naked (Marinatos, *AA* 1937, 223 Fig. 4).

6 v. Hoorn, *JdI* 30, 1915, 65 ff. Figs. 1–3, Pl. 1. Cf. the flute player on the sarcophagus from Hagia Triada (Matz, *Kreta*, Pl. 47, centre) and the upper body of an adorer in the Metropolitan Museum in New York (Richter, *Handbook*, 15 Pl. 5 e), with one hand above the other in front of the chest.

7 From Tylissos: Neugebauer, *Bronzestatuetten*, 23 Fig. 9. Lamb, *Bronzes*, Pl. 5 c-d. Marconi, *Dedalo* 6, 1925/6, 621 with figure. Zervos, *L'art de la Crète*, Pl. 316 Fig. 458. From Asia Minor in the British Museum: Lamb, *op. cit.*, Pl. 5 a-b. Paris, Louvre: J. Charbonneaux, *Les bronzes Grecs* (1958), Pl. 5,2. From Hagia Triada: Marconi *op. cit.*, 619 with figure. Bossert, *Altkreta*, Pl. 178 No. 311 a. Zervos, *op. cit.*, Pl. 344 Fig. 500. From the Dictaean Cave: J. Boardman, *The Cretan Collection in Oxford* (1961), 10 Nos. 1–2 Pl. 1.

8 Male and female vessel carriers: *Tiryns* II Pl. 8. A. Evans, *The Palace of Minos* II 2 (1928), 707 Pl. 12 opp. p. 725. Bossert, *Altkreta*, Pl. 25 No. 34; 125 No. 231. Matz, *Kreta*, Pl. 38. Marinatos-Hirmer, *Kreta* Pl. XV. Bull jumper: *Tiryns* II, Pl. 18. Bossert, *op. cit.*, Pls. 28–29 Nos. 38–39; 130 No. 238; 174 No. 305. Marinatos-Hirmer, *op. cit.*, Pl. 97. Boxers, wrestlers and bull–fighters: Bossert, *op. cit.*, Pls. 156–158 Nos. 271–275. Marinatos-Hirmer, *op. cit.*, Pls. 106–107. Man in 'stiffened' pose: Bossert, *op. cit.*, Pl. 154 No. 269. Marinatos-Hirmer, *op. cit.*, Pls. 100–102. Prince with feather crown; Evans, *op. cit.*, Pl. 14 (frontispiece).

9 Lamb, *Bronzes*, Pl. 7. Zervos, *L'art de la Crète*, Pls. 346–347 Figs. 504–505, 508.

10 Formerly Spencer–Churchill Collection, now in the British Museum: Evans, *JHS* 41, 1921, 247 ff. Figs 1–2. Higgins, *JHS* 87, 1967, Archaeol. Reports 1966–67, 49 No. 11 a Fig. 11.

11 This superb motif (F. Chapouthier, *Deux épées d'apparat... de Mallia*, 1938, = Etudes Cretoises 5. Zervos, *L'art de la Crète*, Pl. 300 Figs. 427–428. Marinatos-Hirmer, *Kreta*, Pl. 69), which fills the circle like an ornament, is borrowed from Egyptian art.

12 See above, p. 121 and Note 7.

13 H. B. Hawes, *Gournia* (1908), 48 No. 21 Pl. 11. Lamb, *Bronzes*, Pl. 9 a. Neugebauer, *Bronzestatuetten*, Fig. 10.

14 Lamb, *Bronzes*, Pl. 9 b. Neugebauer, *AA* 1922, 60 Fig. 1. *Idem, Bronzen*, 2 f. No. 2 Pl. 2.

15 Zervos, *L'art de la Crète*, Pl. 344 Fig. 501.

16 v. Schneider, *AA* 1892, 48 Fig. 63. Lamb, *Bronzes*, Pl. 9 d. Bossert, *Altkreta*, Pl. 186 No. 321 a. Matz, *Kreta*, Pl. 63 left.

17 Richter, *Handbook*, Pl. 5 d.

18 Boardman, *Cretan Collection in Oxford*, 11 Nos. 8–9 Pl. 2.

19 I have preferred not to risk quoting an apparently some-

what older statuette from the same phase, now in a private collection (K. Schefold, *Meisterwerke griechischer Kunst*, 1960, 117 Fig. 17). It is not known where this figure was found. It is 32 cm. high, larger than any other of the kind, and is unusual in various ways.

20 Tsountas, *Ephem* 1902, 1 ff. Pls. 1–2. Matz, *Kreta*, Pl. 107. Marinatos-Hirmer, *Kreta*, Pls. XLI–XLII.

21 Marinatos, *AA* 1937, 225 f. Figs. 3 a, c; 4.

22 Boardman, *Cretan Collection in Oxford*, 10 f. Nos. 3–7 Pls. 1–2.

23 A. Furtwängler, *50. Winckelmannsprogramm Berlin 1890*, 134 ff. *Idem, Meisterwerke d. griech. Plastik* (1893), 78 ff. G. Lippold, *Die griech. Plastik* (= Hdb. d. Archäologie III 1, 1950), 129 f. Pls. 36–37.

24 H. Bulle, *Der schöne Mensch im Altertum* (1912), Pl. 39. Lippold, *Griech. Plastik*, Pl. 37,1.

25 Ivory statuettes: Matz, *Geschichte*, Pl. 28. See below p. 136 ff. Here: Pls. 146–148. Att. Kuros: R. Lullies – M. Hirmer, *Griech. Plastik* (1956), Pls. 11–13. Hera in Olympia: *ibid.*, Pl. 10. Nike from Delos: Lippold, *Griech. Plastik*, 63 Pl. 7,4. Head from Thasos: Sitte, *ÖJh* 11, 1908, Pls. 1–2.

26 Stais, *AM* 40, 1915, 45 ff. Pls. 7–8. Marinatos, *Deltion* 10, 1926, 78 ff. Figs. 1, 4 a–b. Karo, *Schachtgräber*, 106 ff. Figs. 35–39; 174 ff. Figs. 83–85 Pl. 122. G. Rodenwaldt, *Der Fries des Megarons von Mykenai* (1921), 51 Fig. 27. Marinatos-Hirmer, *Kreta*, Pl. 174.

27 Karo, *Schachtgräber*, 119 f. Pls. 129–131. Rodenwaldt, *Fries d. Megarons von Mykenai*, 26 Fig. 15.

28 Karo, *Schachtgräber*, 49 Nos. 33, 35; 73 f. Nos. 240–241 Pl. 24; 177 Figs. 86–87. Bossert, *Altkreta*, Pl. 235 d-f.

29 *BCH* 78, 1954, 124 f. Fig. 25 (from Patras). Catling, *Opuscula Atheniensia* II, 1955, 21 ff. Figs. 1–6 (from Enkomi).

30 *Tiryns* II, 110 Fig. 47; 116 Fig. 49; Pl. 1,6; 11,4–5. Rodenwaldt, *Fries des Megarons von Mykenai*, 38 Fig. 20, colour plate at end. Lamb, *BSA* 25, 1921/2 1922/3 Pl. 27.

31 Schachermeyr, *AA* 1962, 253 f. Fig. 46.

32 A. Furtwängler–G. Loeschcke, *Mykenische Vasen* (1886), Pl. 42. Bossert, *Altkreta*, Pls. 72–73 Nos. 133–135. Cf. also Pernice, *RM* 59, 1944, 185 ff. Figs. 1–2. Schachermeyr, *AA* 1962, 297 f. Fig. 59.

33 See above p. 122 and Note 16.

34 Bossert, *Altkreta*, Pl. 49 No. 82.

35 Bossert, *Altkreta*, Pl. 123 No. 227. F. Matz, *Kreta u. frühes Griechenland* (1962), 113 colour plate.

36 Zervos, *L'art de la Crète*, Pl. 420 Fig. 676.

37 See above p. 122 and Note 20.

38 Tiryns: H. Schliemann, *Mykenae* (1878), 15 f. Fig. 12. Helbig, *ÖJh* 12, 1909, 32 Fig. 25. Tsountas, *Ephem* 1891, Pl. 2,1. Mycenae: Tsountas, *op. cit.*, Pl. 2,4–4 a. Helbig, *op. cit.*, 32 Fig. 24. Grotto of Patsos, now in Oxford: Helbig *op. cit.*, 32 Fig. 23. Boardman, *Cretan Collection in Oxford*, 78 No. 371 Pl. 25. Thessalia: Evans, *JHS* 21, 1901, 126 Fig. 16. Helbig *op. cit.*, 32 Fig. 26. Boardman, *op. cit.*, 76 f. No. AE 410 Pl. 25.

39 *Kunst und Kultur der Hethiter*. Catalogue (1961) No. 134. Akurgal–Hirmer, *Hethiter*, Pl. 44 (from Tokat; now in Ankara, Archaeolog. Museum).

40 Bossert, *Altanatolien*, Pls. 99–102 Nos. 474–480. M. Riemschneider, *Die Welt der Hethiter* (1954), Pl. 41. Akurgal-Hirmer, *Hethiter*, Pls. 64–65.

41 O. Weber, *Kunst d. Hethiter* (n.d.) Pl. 7. Bossert, *Altana-*

tolien, Pl. 140 No. 583. Akurgal-Hirmer, *Hethiter*, Pl. 51.

42 *Kunst u. Kultur d. Hethiter.* Catalogue (1961) No. 145.

43 Phoenician coast: Helbig, *ÖJh* 12, 1909, 29 Fig. 22. Ras Shamra: Schaeffer, *Syria* 10, 1929, 288 Pl. 53. Beirut: Virolleaud, *Syria* 5, 1924, 119 Pl. 31,1. Ras Shamra had strong trading links with the Mycenaean Aegean civilization.

44 See above Note 38.

45 V. Müller, *Frühe Plastik in Griechenland u. Vorderasien* (1929), Pl. 40 Nos. 393–395. Lists of Hittite Syrian warrior types: Müller, op. cit., 112. Gallet de Santerre-Treheux, *BCH* 71/72, 1947/8, 222 ff. Pl. 39.

Chapter VI: Small-scale Sculpture of the Geometric Period (pages 127–163)

1 V. Müller, *Frühe Plastik in Griechenland u. Vorderasien* (1929), 9 ff. Pls. 1–4.

2 One more statuette in Berlin (Neugebauer, *Bronzen*, 20 f. No. 29 Pl. 5) belongs to this group, in addition to those illustrated. On the problem of area styles and workshops for Geometric bronze sculpture, see Herrmann (*HdI* 79, 1964, 17 ff. Figs. 1–62), who comes to quite different conclusions.

3 Of the later bronzes from Olympia, a similar petasos, rather better preserved, occurs on the rider in Berlin (Neugebauer, *Bronzen*, 18 f. No. 27 Pl. 5) and a charioteer (*Olympia IV*, 40 No. 250 Pl. 15).

4 Pictures on gold rings and seal-impressions: M. P. Nilsson, *The Minoan-Mycenaean Religion²* (1950), 256 f. Fig. 123; 278 f. Fig. 139; 283 Fig. 142; 352 f. Fig. 162. *Idem, Geschichte d. griech. Religion I²* (1955), Pls. 13,3–4; 18,1,3. On epiphany: Schweitzer, *Antike* 2, 1926, 301 ff. *Idem, Gnomon* 4, 1928, 179. F. Matz, *Göttererscheinung u. Kultbild im minoischen Kreta* (1958), 27 f.

5 Nilsson, *Minoan-Mycenaean Religion²*, 100 ff. Figs. 24–26. *Idem, Geschichte d. griech. Religion I²*, Pls. 14,4–5. C. Zervos, *L'art de la Crète* (1956), Pls. 484–488 Figs. 803–807.

6 Kunze, *OlBer IV*, Pls. 38–39, 42–46. *Idem, Antike und Abendland* 2, 1946, 95 ff. Figs. 1–13. *Idem, Meisterwerke*, 10 f. Pls. 14–17. *Idem, OlBer VII*, 138 ff.

7 Kunze, *OlBer IV*, 106 f. Pls. 32,4–5.

8 Blegen, *AJA* 43, 1939, 430 ff. Fig. 17. Willemsen, *Dreifußkessel*, 61 Pl. 43. Herrmann, *JdI* 79, 1964, 45 Figs. 28–29.

9 *Olympia IV*, 44 f. Nos. 280–283, 286 a–b. Herrmann, *AM* 77, 1962, 27 Supplement 3.

10 Willemsen, *Dreifußkessel*, 61 Pl. 40 (Br 7157).

11 Hampe-Jantzen, *OlBer I*, 65 ff. Fig. 29. Kunze, *OlBer IV*, 113 Pl. 36,3. Willemsen, *AM* 69/70, 1954/5, 24, 27 Supplement 12. *Idem, Dreifußkessel*, 150 Pl. 43. Herrmann, *JdI* 79, 1964, 55 Figs. 47–48. Reconstruction of the ring handle: Kunze, *Meisterwerke* 9. Willemsen, *Dreifußkessel*, 148 f. Fig. 18. Fragments of legs of similar horse-leaders: *FdDelphes V*, 31 No. 18 Fig. 109. Kunze, *OlBer IV*, 115 f. Figs. 93–94.

12 See above p. 54 f. and below p. 197 ff.

13 Bossert, *Altanatolien*, Pl. 88 Nos. 437–438. Seyrig, *Syria* 30, 1953, 49 f. Pl. 12,4–5. M. Riemschneider, *Die Welt der Hethiter* (1954), Pl. 26.

14 O. Weber, *Kunst d. Hethiter*, Pls. 10–11. R. Naumann, *Die Hethiter* (1948), 10, 22 f. Figs. 5–6, 16. Bossert, *Altsyrien*, Pls. 181–182 Nos. 588, 591. Riemschneider, *Welt d. Hethiter*, Pl. 27.

15 Female: Gjødesen, *Meddelelser fra Ny Carlsberg Glyptotek* 8, 1951, 12 ff. Figs. 10–11 (in American private collection). Seyrig, *Syria* 30, 1953 Fig. I Pl. 11,4 (Kafer Choula) Pl. 10,1 (Paris, Cab. d. Médailles) 10,2 (from Jezzine, Musée de Beyrouth) 10,3 (from Jezzine). Akurgal-Hirmer, *Hethiter*, Pl. 43 (now in Istanbul). Male: Bossert, *Altsyrien*, Pl. 182 No. 589. Gjødesen, op. cit., 23 Fig. 12. Seyrig, op. cit., 37 Fig. 3 (south of Bekaa).

16 Gjødesen, *Meddelelser fra Ny Carlsberg Glyptotek* 8, 1951, 21 ff. Figs. 4–7.

17 This non-plastic type of head is well illustrated by the statuette from Bekaa (Seyrig, *Syria* 30, 1953, 37 Fig. 3).

18 Statuettes in the Louvre and in the Musée d'art et d'histoire in Geneva: Gjødesen, *Meddelelser fra Ny Carlsberg Glyptotek* 8, 1951, 24 Figs. 8–9. Seyrig, *Syria* 30, 1953 Pl. 9,1–2. From Jezzine: Seyrig, op. cit., Pl. 11,1–2. Upper part of a statuette from Aalma ech Chaab: Weber, *Kunst d. Hethiter*, Pl. 30. Seyrig, op. cit., Pl. 11,3.

19 Benton, *BSA* 35, 1934/5, 62 f. No. 15 Fig. 12 Pl. 16. E. Homann-Wedeking, *Die Anfänge d. griech. Großplastik* (1950), 21 Fig. 4. Himmelmann, *Bemerkungen*, Figs. 28–30.

20 Amandry, *BCH* 68/69, 1944/5, 38 f. No. 3 Pl. 1,1. Homann-Wedeking, *Anfänge d. griech. Großplastik*, 21 Fig. 5. Himmelmann, *Bemerkungen*, Figs. 31–33. Hermann, *JdI* 79, 1964, 47 f. Figs. 33–35.

21 From Athens: A. de Ridder, *Catalogue des bronzes trouvés sur l'acropole d'Athènes* (1896), 240 f. No. 692 Fig. 210. Lamb, *Bronzes*, Pl. 15 a. Willemsen, *AM* 69/70, 1954/5, 26 Supplement 15. J. Dörig-O. Gigon, *Der Kampf der Götter u. Titanen* (1961), Pl. 20. C. Zervos, *L'art en Grèce³*, Figs. 67–70. From Delphi: Casson, *JHS* 42, 1922, 213 Fig. 7 b. Both statuettes are in the National Museum in Athens (Inv.Nos. 6616, 7415).

22 A. de Ridder, *Les bronzes antiques du Louvre* I (1913), 18 No. 82 Pl. 10. Kunze. *OlBer IV*, 113 Pl. 36,2.

23 Corinth: Herrmann, *JdI* 79, 1964, 52 Figs. 42–43. Delphi: *FdDelphes V*, 32 No. 21 Pl. 1,10. From Olympia in Athens: *Olympia IV*, 39 No. 244 Pl. 16. Willemsen, *AM* 69/70, 1954/5, 24 ff. Supplement 13 New York (probably from Olympia): Richter, *MetrMusBull* 32, 1937, 37 f. Figs. 1–3. *Idem, Handbook*, 22 Pl. 13 a. Himmelmann, *Bemerkungen*, Figs. 18–19.

24 Kunze, *OlBer VII*, 145 ff. Pls. 60–61. Herrmann, *JdI* 79, 1964, 46 Figs. 31–32.

25 Cf. for example the charioteer from Olympia (Kunze, *OlBer IV*, 110 ff. Fig. 91 Pl. 35).

26 *FdDelphes V*, 33 No. 26 Fig. 112 Pl. 2,5. de Ridder, *Bronzes du Louvre* I, 18 No. 81 Pl. 10.

27 *Olympia IV*, 39 No. 245 Pl. 16 (later removed to the National Museum in Athens, Inv.No. 6094: Kunze, *OlBer IV*, 114 Fig. 92). From Amorgos in Berlin: Neugebauer, *Bronzen*, 7 No. 12 Pl. 3.

28 Munich J. Sieveking, *Die Bronzen d. Sammlung Loeb* (1913), 4 f. Kunze, *OlBer VII*, 147 Figs. 85–86. Delphi: *FdDelphes V*, 33 No. 30 Fig. 114. Kunze, op. cit., 147 Figs. 87–89.

29 Cf. Wide, *JdI* 14, 1899, 34 Fig. 12. *Tiryns* I, 146 f. Fig. 12.

Charbonneaux, *Préhistoire* 1, 1932, 229 Fig. 16. *BCH* 77, 1953, 260 Fig. 48. *BCH* 78, 1954, 180 Pl. 6 b. See also Courbin, *Céramique*, 421.

30 Kunze, *OlBer* VII, 148 f.

31 *CVA Paris*, Louvre 11, III H b, Pls. 9,8,17.

32 Pernice, *AM* 17, 1892, 205 ff. Figs. 3, 5, 10–14 Pl. 10. (These new photographs of the fragments were kindly made for the author by E. M. Czakó, to whom he is very grateful.) See also above p. 50 f.

33 Pernice, *AM* 17, 1892, 225 ff. Fig. 10. Hampe, *Grabfund*, 55 Fig. 39.

34 Hymettos-Amphora, Berlin F 56: *CVA* Berlin, Antiquarium 1, Pls. 43–44. Amphora from Eleusis, Athens Nat. Mus. 220: G. E. Mylonas, *Ho protoattikos amphoreus tes Eleusinos* (1957). P. E. Arias-M. Hirmer, *Tausend Jahre griech. Vasenkunst* (1960), 26 f. Pls. 12–13. Schefold, *Sagenbilder* Pl. 16.

35 Perrot, *BCH* 19, 1895, 273 ff. Figs. 1–12 Pl. 9. Kunze, *AM* 55, 1930, 147 ff. Fig. 1 Pls. 5–8 Supplement 40–41. Himmelmann, *Bemerkungen*, 20 Figs. 24–27.

36 G. Loud, *The Megiddo Ivories* (1939). Barnett, *Nimrud Ivories*, 49 f., 63 ff., 111 ff.

37 Barnett, *JHS* 68, 1948, 4 f. *Idem, Nimrud Ivories* 128. B. Freyer-Schauenburg, *Elfenbeine aus d. samischen Heraion* (1966), 51 ff. Pl. 12.

38 Barnett, *JHS* 68, 1948, 1 ff. Figs. 1–22 Pls. 1–12. Perachora: Stubbings in Payne, *Perachora* II, 403 ff. Pls. 171–190. Ephesus: C. Smith-D. G. Hogarth in D. G. Hogarth, *Excavations at Ephesus* (1908), 155 ff. Pls. 21–24. Argos: Waldstein, *Heraeum* II, 351 ff. Pls. 139–140. Samos: B. Freyer-Schauenburg, *Elfenbeine aus d. samischen Heraion* (1966). Sparta: Dawkins, *Artemis Orthia*, 203 ff. Pls. 91–178. Now: E. L. I. Marangou, *Lakonische Elfenbein- und Beinschnitzereien* (1969).

39 Kunze, *AM* 55, 1930, 149 No. 4; 153 f. Pl. 8.

40 Barnett, *Nimrud Ivories*, 205 ff. No. p. 181, p. 183, p. 188, p. 192–8, p. 200–6, p. 208–10 Pls. 70–74. A similar, although not identical, polos decoration occurs on ivory fibula plates (Dawkins, *Artemis Orthia*, 205 Pl. 91,1–2; 206 Pl. 92,1–2) and carved bone (ibid., 218 Pl. 117,1–6; Pl. 118,1,3–4; 219 Pl. 119,1–4).

41 Loud, *Megiddo Ivories*, 18 No. 175 Pl. 39. Descamps, *Ivoires*, 82 No. 297 Pl. 26.

42 Barnett, *Nimrud Ivories*, 207 ff. No. p. 206–8, p. 210–11, p. 214, p. 217, p. 219–20 Pl. 73–75 and several fragments on Pl. 76. Descamps, *Ivoires*, 149 f. Nos. 1008, 1015, Pl. 109; Nos. 1013–1014 Pl. 117.

43 See above p. 131.

44 Hogarth, *Excavations at Ephesus*, 179 No. 8 Pl. 30,9; 31,11. Janus-like goddesses from the Nimrud ivories: Barnett, *Nimrud Ivories*, 207 f. No. p. 206–7, p. 210, p. 221 Pls. 73–74, 76.

45 E. Kunze (*AM* 55, 1930, 153 f.) sees the small statuette as a minor work of the Dipylon master, made from surplus ivory from the larger statuette. But there is a considerable difference in the structures of the small goddess and the four larger statuettes by the master. And the former is much more Oriental, in a style somewhat earlier and very unlike the style of the main master. I therefore consider it impossible that all of these five pieces were made by the same hand.

46 Barnett, *Nimrud Ivories*, 207 No. p. 208 Pl. 73.

47 Barnett, *Nimrud Ivories*, 207 No. p. 207, p. 209, p. 211 Pls. 73–75.

48 Descamps, *Ivoires*, 121 No. 806 Pl. 75.

49 See above p. 129 f.

50 Krater A 517, A 522, A 541, A 547 and 552 in the Louvre: *CVA Paris*, Louvre 11, III H b Pl. 1; 2,5; 4,13, 14, 11–12; Hinrichs, *Annales Univ. Saraviensis* Ser. III 4, 1955, Pl. 9. Krater in Sidney: A. D. Trendall, *Handbook to the Nicholson Museum²* (1948), 245 ff. Figs. 48–49. J. Chittenden – C. Seltmann, *Greek Art. An Exhibition . . .* (1947), 25 No. 38 Pl. 8 see above p. 41 ff.

51 Krater in Athens: Hinrichs, *Annales Univ. Saraviensis*, Ser. III 4, 1955 Pl. 2. Krater in New York: Matz, *Geschichte*, 62 Pl. 10. Richter, *Handbook*, Pl. 14 a–b.

52 See above p. 130. Cf. also the side view in Willemsen, *AM* 69/70, 1954/5 Supplement 12.

53 Walter, *AM* 74, 1959, 43 ff. Supplement 87–93. Ohly, ibid., 48 ff. sketch 7–8. Greifenhagen, *Jahrb. d. Berliner Museen* 7, 1965, 147 ff. Figs. 26–31. Freyer-Schauenburg, *Elfenbeine aus d. samischen Heraion*, 19 ff. Pl. 2.

54 de Ridder, *Bronzes du Louvre* I, 21 f. No. 104 Fig. 12. Neugebauer, *Bronzestatuetten*, 32 f. Pl.-Fig. 14. J. Charbonneaux, *Les Bronzes Grecques* (1958), 36 Pl. 10,2. Herrmann, *JdI* 79, 1964, 64 f. Fig. 57. (Olympia is not firmly established as the source.)

55 Sherd from the Argive Heraion: Waldstein, *Heraeum* II, 112 f. Pl. 57,9. Schweitzer, *Herakles* 17 (Vignette). Hampe, *Sagenbilder*, 48 (c) Pl. 34 (Athens). Underside of a bronze horse from Phigalia in the British Museum: Hampe, op. cit., 48 (b) Pl. 34. Krater in New York: Richter, *AJA* 19, 1915, 385 ff. Pls. 17–23. Hinrichs, *Annales Univ. Saraviensis* Ser. III 4, 1955 Pl. 3. Hampe, op. cit., 47 Fig. 21. Fragment of a krater in the Louvre (with opponent): Hampe, op. cit., 48 (d) Fig. 22. *CVA* Paris, Louvre 11, III H b Pl. 5,7. Late Geometric jug from the Agora, Athens: Hampe, op. cit., 87 f. Fig. 31. Young, *Graves*, 68 ff. No. XIII 1 Figs. 43–44. Plate fibulae from Thorikos: Hampe, op. cit., 90 No. 10 Pl. 9. Plate fibulae from Crete: Hampe, op. cit., 92 No. 28 Pl. 14. See also above pp. 44, 56 and below p. 209 f.

56 *Olympia* IV, 87 ff. No. 616 Pl. 27. Papaspyridi-Karouzou, *Ephem* 1952, 138 Fig. 2. Willemsen, *Dreifußkessel*, 145 ff. Pl. 85. Herrmann, *JdI* 79, 1964, 60 ff. Figs. 55–56.

57 *Olympia* IV, 89 f. No. 617 Pl. 27. Neugebauer, *Bronzen*, 17 f. No. 25 Pl. 5. See also Herrmann, *JdI* 79, 1964, 65 f. Fig. 60.

58 de Ridder, *Bronzes de l'Acropole*, 20 f. No. 50 Fig. 1. Hampe, *AM* 61/62, 1935/6, 285 f. Pl. 97. Cook, *JHS* 72, 1952, 93. Early versions of similar heads occur on bronzes which are probably Corinthian from Dodona in Athens (Benton, *BSA* 35, 1934/5, 85 Pl. 21,1–3) and from Delphi in the Louvre (de Ridder, *Bronzes du Louvre* I, 18 f. No. 83 Pl. 10).

59 Papaspyridi-Karouzou, *Ephem* 1952, 137 ff. Figs. 3–6, 8 Pls. 1–3.

60 See above pp. 51, 134.

61 Papaspyridi-Karouzou, *Ephem* 1952, 144 ff.; cf. also Friedländer in Roscher, *Mytholog. Lexikon* V, 236 ff. Herter, *RE* V A 1 (1934), 197 ff.

62 Kunze, *OlBer* VII, 151 ff. Pls. 62–67. Herrmann, *JdI* 79,

1964, 59 f. Figs. 53–54. E. Kunze has already established the source as an Attic workshop.

63 Kunze, *OlBer* VII, 154.

64 *OlBer* VII, Pl. 63 right and 67 bottom left. The tip of the nose is slightly damaged (Pl. 67, top left), but this is barely noticeable in profile.

65 de Ridder, *Bronzes de l'Acropole*, 247 f. No. 702 Fig. 219. Kunze, *AM* 55, 1930, 156 ff. Supplement 44–45. Matz, *Geschichte*, 82 Pl. 30.

66 Tsountas, *Ephem* 1892, 13 f. Pl. 4,4. Kunze, *AM* 55, 1930, 155 ff. Supplement 42,2. Matz, *Geschichte*, Pl. 31. Dörig-Gigon, *Kampf der Götter u. Titanen*, Pl. 21.

67 de Ridder, *Bronzes de l'Acropole*, 247 No. 701 Fig. 218.

68 de Ridder, *Bronzes de l'Acropole*, 245 f. No. 698–699 Figs. 215–216. Matz, *Geschichte*, 157 Pl. 63. Papaspyridi-Karouzou, *Ephem* 1952, 142 ff. Pl. 4. Herrmann, *JdI* 79, 1964, 66 ff. Fig. 61.

69 *FdDelphes* V, 31 No. 19 Pl. 2,4. *BSA* 35, 1934/5 Pl. 20,3 (third quarter of the 8th century). *FdDelphes* V, 33 No. 26 Fig. 112 Pl. 2,5; cf. also the later piece, ibid., 33 No. 28 Pl. 2,5 a.

70 *FdDelphes* V, 32 No. 22 Pl. 2,6 (height: 17 cm.). A shield in the left hand is less likely. Cf. the ring-handle figures from the Argive Heraion (here: Pl. 125) and from Olympia (here: Pl. 126): Kunze, *Meisterwerke*, 9. Willemsen, *Dreifußkessel*, 149 Fig. 18 Pl. 43.

71 *FdDelphes* V, 32 No. 23 Pl. 1,8. Side view: *BSA* 35, 1934/5 Pl. 20,2 (height; 18.5 cm., or, with the missing lower parts of the legs, about 21.5 cm.).

72 From Delphi: de Ridder, *Bronzes du Louvre* I, 18 f. No. 83 Pl. 10 (height of fragment: 8.7 cm.; of complete figure: about 18 cm.). From Dodona: C. Carapanos, *Dodone et ses ruines* (1878), 32 No. 16; 185 Pl. 13,4. V. Stais, *Marbres et bronzes du Musée National* (1907), 304 No. 34. Casson, *JHS* 42, 1922, 211 f. Fig. 4 b. Benton, *BSA* 35, 1934/5, 98, Notes 1, 4 Pl. 21 (Height with missing feet: 14.9 cm.).

73 Reichel-Wilhelm, *ÖJh* 4, 1901, 37 ff. Figs. 26–29, 31.

74 Benton, *BSA* 35, 1934/5, 98 ('excellent works').

75 *FdDelphes* V, 30 f. No. 17 Pl. 1,7. Lamb, *Bronzes*, 41 Pl. 15 d. Zervos, *L'art en Grèce*³, Fig. 72. Matz, *Geschichte*, 159 f. Herrmann, *JdI* 79, 1964, 68 f. Fig. 62 (height 22 cm., with feet c. 23 cm.). – *FdDelphes* V, 30 No. 15 Pl. 1,2. Zervos, op. cit., Fig. 73. Herrmann, op. cit., 68 Note 184 (height 18 cm., with calves c. 20.5 cm.).

76 Kunze, *OlBer* VII, 59 ff, 68 f. Figs. 31–36.

77 The Mantiklos Apollo from Boeotia, now in the Museum of Fine Arts in Boston (Froehner, *Monumenta Piot* 2, 1895, 137 ff. Pl. 15. Matz, *Geschichte*, 157 ff. Pl. 66. R. Lullies-M. Hirmer, *Griech. Plastik*, 1956, 35 f. Pl. 3), has the same type of central axis, running down from the face, through the unnaturally long neck and the torso to the crotch and the sexual organs; except that here there is a furrow running down the length of the body to the crotch. This accentuated axis gives the figure a stiff grandeur, an 'archaizing' touch reminiscent of the grandeur of Geometric form. This is a Boeotian piece with Attic and Corinthian features.

78 Matz, *Geschichte*, 160.

79 de Ridder, *BCH* 22, 1898, 497 ff. Figs. 11, 13, 15. *FdDelphes* V, 31 to No. 17. *Antike Denkmäler* II, Pl. 24,7, 12.

80 Early Attic: Mylonas, *Ho protoattikos amphoreus tes*

Eleusinos, Pls. 5–7. A.; cf. above Note 34. *CVA* Berlin, Antiquarium 1, Pls. 20–21. Bronzemithra: Poulsen, *AM* 31, 1906, 373 ff. Pl. 23. Lamb, *Bronzes*, 60 ff. Fig. 3. Levi, *AS Atene* 13/14, 1930/1, 135 ff. Fig. 35. P. Demargne, *La Crète dédalique* (1947), 231 Fig. 36.

81 Kunze, *OlBer* IV, 109 f. Fig. 90 Pl. 34 (found on the second southern wall).

82 Cf. similar figures from the grotto near Phaneromeni on Crete (Marinatos *AA* 1937, 222 ff. Fig. 3 a, c), although these can scarcely be connected with the chariot anathema in Olympia.

83 Kunze, *OlBer* IV, 110 ff. Fig. 91 Pl. 35. Himmelmann, *Bemerkungen*, 9 Pls. 39–41 (height 13.6 cm.). Second chariot (Athens, National Museum): *Olympia* IV, 40 No. 249 Pl. 15. Lamb, *Bronzes*, 42 Pl. 16 a. Neugebauer, *Bronzestatuetten*, 31 f. Pl.-Fig. 15 (height 10.3 cm.). Charioteer: *Olympia* IV, 40 No. 251 Pl. 16. Neugebauer, *Bronzen*, 15 f. No. 15 Pl. 4 (height 7.3 cm.). Helmet decoration *Olympia* IV, 40 No. 251 a with figure.

84 Cf. two small chariot-boxes, one with a floor and a yoke for the horses at the end of the shaft, the other with only a standing-board, on which the tenons from the feet of the charioteer can still be seen (Kunze, *OlBer* IV, 108 Pl. 33,3). Another chariot in Berlin (Neugebauer, *Bronzen*, 14 No. 17 Pl. 4) still has both wheels, but appears never to have contained a charioteer.

85 This was correctly reshaped in Athens: Lamb, *Bronzes*, Pl. 16 a; cf. Note 83.

86 Kunze, *OlBer* IV, 111.

87 See above p. 130.

88 See above p. 46.

89 *Olympia* IV, 40 No. 250 Pl. 15; 51 No. 258 Pl. 16 (this piece, now in Berlin: Neugebauer, *Bronzen*, 18 f. No. 27, Pl. 5).

90 *Olympia* IV, 39 f. No. 248 Pl. 15. Neugebauer, *Bronzen*, 11 f. No. 14 Fig. 4 Pl. 4. The probably somewhat later chariot: Kunze, *OlBer* VII, 141 ff. Figs. 83–84 Pl. 58.

91 A close parallel occurs in a bronze statuette of a naked woman(?) from Ithaca (Benton, *BSA* 35, 1934/5, 62 f. No. 15 Fig. 12 Pl. 16. Here: Pls. 128–129), but this must be coincidence, since the naked woman comes from a much earlier period.

92 Przeworski, *Syria* 17, 1936, 35 Pl. 9. H. Demircioglu, *Der Gott auf dem Stier* (1939), 74, 147 No. B 78. Bossert, *Altanatolien*, 60 Pl. 144 No. 610 (Late Hittite or Early Iron Age).

93 Gallet de Santerre-Tréheux, *BCH* 71/72, 1947/8, 156 ff. Pl. 25. In terracottas from Samos, this head type often occurs (Ohly, *AM* 66, 1941, 11 Pls. 3–5 Nos. 873, 727, 151, 181, 901 et al. Homann-Wedeking, *Anfänge d. griech. Großplastik*, 22 f. Figs. 6–7).

94 Bossert, *Altanatolien*, Pl. 103 No. 481; 140 No. 583.

95 W. M. Flinders Petrie, *Naukratis* I 1884/85 (1886). Gardner, *JHS* 8, 1887, 119 f. Pl. 79. Idem, *Naukratis* II (1888).

96 Cook, *BSA* 34, 1933/4, 15 No. 31 Pl. 5. *CVA* Altenburg, Lindenau Mus. 1, Pls. 10–12.

97 J. M. Hemelrijk, *De Caeretaanse Hydriae* (1956). Busirisvase: ibid., 114 No. 24. Pfuhl, *MuZ.* III, Fig. 152.

98 The 'Pontic vases' (P. Ducati, *Pontische Vasen*, 1932) were all produced in Etruria, but the painter was of East Greek origin.

99 Walter-Vierneisel, *AM* 74, 1959, 29 f. Supplement 67. E. Buschor, *Altsamische Standbilder* V (1961), 80 f. Figs. 331–332.

100 Buschor, *Altsamische Standbilder* I (1934), 9 Figs. 5, 7–8; IV, 69 f. Figs. 285–292.

101 A chariot containing two bearded men from the 13th century from Ras Shamra-Ugarit, has been tentatively reconstructed (Schaeffer, *Syria* 17, 1936, 138 f. Pl. 18,1. H. Frankfort, *The Art and Architecture of the Ancient Orient*, 1954, 162 Pl. 153 A). Unfortunately no measurements have been given. This chariot certainly belongs to the Oriental predecessors of the Greek votive chariot.

102 Neugebauer, *Bronzestatuetten*, 30 Pl.-Fig. 16. Casson, *JHS* 42, 1922, 209 ff. Fig. 2. Hampe, *Sagenbilder*, 32 No. 3 a Pl. 30. Alexander, *Metr MusBull NS.* 3, 1944/5, 239 Fig. p. 242. Richter, *Handbook*, 22 Pl. 13,2. Matz, *Geschichte*, 83 Pl. 27 a. Himmelmann, *Bemerkungen*, 12 with Note 18 Figs. 37–38. Schefold, *Sagenbilder*, Pl. 4 a.

103 Neck picture: K. Friis Johansen, *Les Vases Sicyoniennes* (1923), 146 f. Fig. 110. Belly frieze: *CVA Copenhague*, Nat. 2 Pl. 73, 2.

104 Apollodor II 5,4; cf. C. Robert, *Die griech. Heldensage* II 2 (1921), 500 f.

105 *Olympia* IV, 39 Nos. 243–243 a Pl. 16. Zervos, *L'art en Grece³*, Fig. 60.

106 *Ancient Art in American Private Collections. A Loan Exhibition at the Fogg Art Museum* (1954), 30 No. 192 Pl. 57.

107 Karo, *AA* 1930, 148. Payne, *JHS* 50, 1930, 250 Fig. 7 a. Hampe, *Sagenbilder*, 33 No. 3 b Pl. 30 Fig. 3 b. Matz, *Geschichte*, 83 Pl. 32 b. Himmelmann, *Bemerkungen*, 7 f. Figs. 44–45. Now: U. L. Gehrig, *Die geometrischen Bronzen aus dem Heraion von Samos* (1964), 3 No. 3; 16, 25 ff.

108 See below Note 111.

109 *Olympia* IV, 36 f. No. 220 Fig. 14. Matz, *Geschichte*, 83 Pl. 32 a. Himmelmann, *Bemerkungen*, 12 Fig. 42.

110 *Olympia* IV, 36 Nos. 217, 219 Pl. 14. Lamb, *Bronzes*, 40 Pl. 14 a–b. Hampe, *Sagenbilder*, 43 Pl. 30 (probably Boeotian).

111 Stevens, *Bollettino dell'Associazione degli Studi Mediterranei* 4, 1934, 27 Pl. 8,2–5. G. Hanfmann, *Altetruskische Plastik* (1936), 116 Note 161 (who believes that the origin was more likely to have been Greek). *Kerameikos* V 1, 180 Note 176, cf. also ibid., p. 287.

112 This motif also occurs in the animal scenes, except that it is a billy-goat here, with a kid in its mouth (K. Schefold, *Meisterwerke d. griech. Kunst*, 1960, 10, 131 No. 61 Fig. p. 129).

113 *Olympia* IV, 93 No. 641 Pl. 30. Willemsen, *Dreifußkessel*, 63, 88, 93, 97 ff., 109 f., 163, 172 Pl. 54. Herrmann, *JdI* 81, 1966, 132 ff. Fig. 47. On the Geometric lion image, see H. Gabelmann, *Studien zum frühgriech. Löwenbild* (1965), 9 ff., although he does not actually mention this earliest example.

114 See below p. 180 ff.

115 Willemsen, *Dreifußkessel* Pl. 55 (Athens, Nat. Mus. 7482, from Olympia. Br 6019 and B 810). Small horses on ring handles with open-work and ribbed ornamentation: Willemsen, op. cit., Pl. 58 (B 2175), 65 (Br 8063), 66 (B 2406), 67 (without no.). Benton, *BSA* 35, 1934/5, 59 f. No. 6 b; 61 f. No. 9 b Pl. 15 b–c; 83 ff. Pl. 18,4–5. None of these animals

on ring handles approach the early lion and horse images. It is not until the horses of the second quarter of the century that a new image emerges.

116 See below p. 185.

117 U. Schweitzer, *Löwe und Sphinx im alten Ägypten* (1948), 16 f. Pl. 3,1–2; 38 Pl. 8,3. Cf. the ivory lions from Samaria: J. W. Crowfoot, *Early Ivories from Samaria* (1938), 24 Pl. 9,1. The lion type remains unchanged from the Predynastic period up to the late Egyptian period.

118 W. S. Smith, *The Art and Architecture of Ancient Egypt* (1958), 212 Pl. 150 A.

119 H. Fechheimer, *Die Plastik der Ägypter* (1914), Pl. 9. G. Steindorff, *Die Kunst der Ägypter* (1928), 42 Pl. 135. W. Wolf, *Die Welt der Ägypter* (1954), 102 f. Pl. 96.

120 W. Speiser, *Vorderasiatische Kunst* (1952), 100 f. Pl. 79. V. Müller, in H. T. Bossert, *Geschichte d. Kunstgewerbes* IV (1930), 146 f. Fig. 2. Bossert, *Altsyrien*, Pl. 138 No. 440–441. The two lions on the lid of the sarcophagus are similarly modelled, with their bodies and hind legs, as though leaping, shown in relief from above, but their heads and forelegs, as though recumbent, are modelled three dimensionally.

121 C. L. Woolley, *Carchemish* II (1921), Pl. B 25–26. Excavations in Sendshirli IV (1911), 363 ff. Figs. 261–262, 265 Pl. 64. H. Schäfer-W. Andrae, *Die Kunst des Alten Orients* (1925), Pls. 562–563. Bossert, *Altanatolien*, Pl. 204 No. 830; 232–233 Nos. 901–904. E. Akurgal, *Späthethitische Bildkunst* (1949), Pls. 7–10, 27–30, 35, 38–39. Akurgal-Hirmer, *Hethiter*, Pls. 109, 125–127.

122 Pottier, *Syria* 1, 1920, 265 Fig. 3. Bossert, *Altanatolien*, Pl. 216 No. 857. Akurgal, *Späthethit. Bildkunst*, Pl. 9 b. Akurgal-Hirmer, *Hethiter*, Pl. 116.

123 *Olympia* III, 26 ff. Figs. 24–29 Pls. 5,3–5. Matz, *Geschichte*, 196 f., 382 f. Pl. 246. Cf. for this basin type Ducat, *BCH* 88, 1964, 577 ff. Figs. 1–18.

124 Crome in *Mnemosynon T. Wiegand* (1938), 50 ff. Pl. 11–16. Matz, *Geschichte*, 205 f. Pls. 132–133. G. Rodenwaldt, *Kunst der Antike⁴*, Pl. 178. Gabelmann, *Studien z. frühgriech. Löwenbild*, 113 No. 32 Pl. 4,3.

125 B. Schröder, notes to Brunn-Bruckmann, *Denkmäler griech. r. röm. Skulptur*, Pls. 641–645, Figs. 12–13. Rodenwaldt, *Kunst der Antike⁴* Pl. 195. E. Akurgal, *Die Kunst Anatoliens von Homer bis Alexander* (1961), Figs. 242–244. Gabelmann, *Studien z. frühgriech. Löwenbild*, 119 f. Nos. 113–115 Pl. 22.

126 Soldered-on figures begin in the thick-walled utensil group (Willemsen, *Dreifußkessel*, Pls. 30, 41 Br 5471; Pl. 31 B 2040; Pl. 40 Br. 7872) and continue in the thin-walled group (ibid., Pl. 53 B 1269, Br 2991; Pl. 55 Athen Nat. Mus. 7482 from Olympia; Pl. 58 B 2175; Pl. 54 Br 11340). They begin shortly before 800 B.C. and continue to be used throughout the first quarter of the 8th century.

127 Kunze, *OlBer* VII, 150 f. Figs. 92–93 Pl. 59.

128 Kunze, *OlBer* VII, 150.

129 Both photographs (*OlBer* VII, 150 Figs. 92, 93) are charming detailed pictures. Fig. 92 was produced by tipping the handle forward slightly, Fig. 93, by tipping it somewhat less backwards. They are valuable because they reveal the inner life of the group. Pl. 59 shows the front view, as intended by the bronze caster.

130 This direct transition from clay to bronze was obviously

131 *Olympia* IV, 41 f. No. 263 Pl. 16. One of the complete examples with seven women is in the National Museum in Athens (Inv. No. 6236), the other in Berlin (Neugebauer, *Bronzen*, 19 f. No. 28 Pl. 5. *Idem, Bronzestatuetten*, 31 Fig. 13). There is also a recently discovered piece: Kunze, *OlBer* VIII, 215 ff. Pl. 107,3.

made in Olympia, i.e. the central Peloponnese (cf. Lamb, *Bronzes* 42; Kunze, *OlBer* VII, 151).

132 H. Lattermann-F. Hiller v. Gärtringen, *Abh. d. Ak. Berlin* 1911, 41 Pl. 13,3. F. Brommer, *Satyroi* (1937), 49, 61 Figs. 1–2. Upright, dancing billy-goats also occur on much later lead figurines in the Sanctuary of Artemis Orthia in Sparta (Dawkins, *Artemis Orthia*, Pl. 184, 19; 189, 23–25).

133 Perhaps another male statuette with arms held in front of the chest, from Olympia, also belongs here *(Olympia* IV, 38 No. 236 Pl. 15).

134 Dawkins, *BSA* 10, 1903/4, 217–219 Fig. 6. A. Mosso, *The Palaces of Crete and their Builders* (1907), 282 Fig. 136. Nilsson, *The Minoan-Mycenaean Religion*[2], 109 f. Fig. 30. Bossert, *Altkreta*, Pl. 167 No. 293.

135 Nilsson, *Gesch. d. griech. Religion* I[2], 161 ff., 486 ff.

136 Lousoi: Kunze, *OlBer* IV, 107 Fig. 89. Tegea: Dugas, *BCH* 45, 1921, 354 No. 49 Fig. 17. Olympia: Kunze, op. cit., 107 f. Pl. 33,1.

137 *Olympia* IV, 45 Nos. 286–286 a, 290–290 a, 291 Pl. 17.

138 Kunze, *OlBer* IV, 107.

139 Jantzen, *AA* 138, 579 f. Fig. 23.

140 E. D. van Buren, *Clay Figurines of Babylonia and Assyria* (1930), 26 No. 139 Pl. 7 Fig. 36; 29 No. 154 Pl. 8 Fig. 42 (3rd millennium). Bossert, *Altsyrien*, Pl. 179 No. 584. E. Strommenger-M. Hirmer, *Fünf Jahrtausende Mesopotamien* (1962), 80 f. Pl. 129 left (Gudea Period) and right (before 2040 B.C.); 89 Pl. 168 right (Mari, 2040–1870 B.C.). R. Opificius, *Das altbabylonische Terrakottarelief* (1961), 167 No. 162 Pl. C. Ziegler, *Die Terrakotten von Warka* (1962), 45 No. 274 Pl. 7 Fig. 123 a–b. Frankfort, *Art and Architecture of the Ancient Orient*, 50 Pl. 50 B. Similar Oriental neck jewellery occurs on a female bronze statuette from the 8th century, from the Dictaean Cave on Crete, now in Oxford (J. Boardman, *The Cretan Collection in Oxford*, 1961, 12 No. 32 Pl. 5).

141 Lamb, *BSA* 28, 1926/7, 82 f. Pl. 8,1. Buschor-v. Massow, *AM* 52, 1927 Pls. 4,4–5 (here: Fig. 27). Hampe, *Sagenbilder*, 25 Pl. 23 top; 23 Pl. 29 bottom. Kunze, *OlBer* IV, 106 f. Pl. 32,3.

142 Ohly, *AM* 65, 1940, 57 ff. Pls. 35–43, although he describes and illustrates only a small proportion of the Cypriot terracottas from the Heraion of Samos. Cf. S. Schmidt, *Kyprische Bildwerke aus dem Heraion von Samos* (1968).

143 Ohly, *AM* 65, 1940, 58.

144 Myres, *Cesnola Coll.* 335 f. No. 2013 with figure.

145 *SwedCyprExped* I, 361 ff., 364 No. 6 Pl. 68,6 Plan 14.

146 *SwedCyprExped* I, 223 (Grave 415,1) Pl. 49,4; 234 (Grave 419,1) Pl. 49,5.

147 M. P. Nilsson, *Griech. Feste von religiöser Bedeutung* (1906), 342 ff.

148 Dawkins, *Artemis Orthia*, 150 f. Pl. 33,10.

149 Reichel-Wilhelm, *ÖJh* 4, 1901, 27 ff. Fig. 29 (more likely to be a horse than a hind) probably also Fig. 27.

150 Payne, *Perachora* I, 228 No. 165 Pl. 100.

151 *Pausanias* VIII 31,1. Other cult sites of Artemis Soteira mentioned by Pausanias: Megara (I, 40,2–3; 44,4), Troizen (II, 31,1), Boiai (III, 22,12–13), Pellene (VII, 27,3) and Phigalia (VIII, 39,5). In Megara Hyblaea on Sicily, one of the terracottas shows an Artemis on a horse, from the second half of the 6th century, certainly an Artemis Soteira (Orsi, *Monumenti Antichi*, 1, 1889, 933 No. 118 Pl. 8,2).

152 The image of the goddess clad in ceremonial costume and sitting on a horse revived in the hellenistic Orient and continued up to the late imperial period. This type is linked with the Archaic Artemis Soteira, of which no examples occur from the Classical 5th and 4th centuries (van Buren, *Clay figurines of Babylonia and Assyria*, 63 Nos. 335–338 Pl. 17 Figs. 81–83). I owe my knowledge of two more terracottas with similar motifs, from Salamis on Cyprus and Antalya in Pamphylia, to H. Hommel (*Theologia Viatorum* 9, 1963, 105 ff. Figs. 21–23).

153 de Ridder, *Bronzes du Louvre* I, 19 No. 84 Pl. 10.

154 New York: Alexander, *MetrMusBull* 27, 1932, 213 f. with figure. Ibid., *NS.* 3, 1944/5, 239 f. with figure. Richter, *Handbook*, 23 Pl. 13 i. Kallithea: Callipolitis-Feytmans, *BCH* 87, 1963, 414 ff. Figs. 8–9. Athens: Young, *Graves*, 64 f. No. XII 23 Fig. 41.

155 See above pp. 54, 158 f.

156 Droop in Dawkins, *Artemis Orthia*, 197 Pl. 77. Himmelmann, *Bemerkungen*, Figs. 54–56.

157 D. K. Hill, *Catalogue of Classical Bronze Sculpture in the Walters Art Gallery* (1949), 77 No. 167 Pl. 36. E. Buschor, *Plastik der Griechen*[2] (1958), 11 with figure. Himmelmann, *Bemerkungen*, 11 Fig. 51.

158 Also already considered by E. Buschor, *Satyrtänze und frühes Drama* (1943), 9.

159 Jantzen, *AA* 1953, 56 ff. Figs. 1–5, 9–11. Cf. also Makridis, *Ephem* 1937 II, 517 Nos. 7–10, Pl. 2. D. M. Robinson, *Olynthus* X (1941), 521 f. Nos. 2624–2625 Pl. 167.

160 Robinson, *Olynthus* X, 521 No. 2624 Pl. 167. Jantzen, *AA* 1953, 59 No. 3.

161 Ilias 6, 130 ff. Nilsson, *Gesch. d. griech. Religion* I[2], 564 f.

162 Jantzen, *AA* 1953, 66 f. Figs. 6–8; cf. also the Geometric sherd with the fat-bellied dancers from Miletus (*IM* 9/10, 1959/60, Pl. 60, here: Fig. 66).

163 Levi, *ASAtene* 10–12, 1927–9, 542 f. Fig. 609.

164 *Ancient Art in American Private Collections. A Loan Exhibition at the Fogg Art Museum* (1954), 30 No. 195 Pl. 57 (probably Peloponnesian).

165 Bulle, *AM* 55, 1930, 181 ff. Supplement 60. Himmelmann, *Bemerkungen*. 11 Fig. 46.

166 Richter, *AJA* 48, 1944, 1 ff. Figs. 1–4. Alexander, *MetrMusBull. NS.* 3, 1944/5, 239 Fig. p. 243.

167 See above p. 160.

Chapter VII: Bronze Tripods and other Utensils (pages 164-185)

1 A rod-tripod with its cauldron, with a bottom bent inwards, was found in a grave near the Pnyx in Athens (Brueckner, *AM* 18, 1893, 414 f. Pl. 14). A rod-tripod and small cauldron which probably belongs to it was found in Grave XI in the necropolis of Fortetsa near Knossos (Brock, *Fortetsa*, 21 f. No. 185, 188 Pl. 13). It is fairly certain that a rod-

tripod and a cauldron from a treasure find from Tiryns, now in Athens, belong together (Karo, *AM* 55, 1930, 131 ff. Fig. 4 Supplements 33, 34,2).

2 See below p. 168 ff.

3 The rod-tripod from Enkomi in the British Museum (Hall, *Vrokastro*, 133 ff. Pl. 34,3) is obviously an item from a 'foundry site' found by Murray (A. S. Murray *et al.*, *Excavations in Cyprus*, 1900, 17).

4 For the exceptions (find from near a foundry, and part of a treasure find), see Notes 1 und 3.

5 Cf. Benton's statistics, even though they are no longer complete *BSA* 35, 1934/5, 118.

6 The exceptions are low and very early tripod-cauldrons, which were the original form, but had quite different functions. See below p. 168 f.

7 Riis, *ActaArch* 10, 1939, 5 f.

8 Myres, *Cesnola Coll.*, 478 ff. No. 4704 with figure. Richter, *Metropolitan Museum of Art. Greek, Etruscan and Roman Bronzes* (1915), 345 ff. No. 1180 with 2 figures. Lamb, *Bronzes*, 33 No. 1 Pl. 10 b. Riis, *ActaArch* 10, 1939, 5 No. 1. Richter, *Handbook*, 17 Pl. 10 a.

9 E. Gjerstad, *Studies on Prehistoric Cyprus* (1926), 238 (Stand 1). Riis, *ActaArch* 10, 1939, 6 No. 5.

10 Gjerstad, *Studies on Prehistoric Cyprus*, 238 (Stand 2). Riis, *ActaArch* 10, 1939, 6 No. 6. McFadden, *AJA* 58, 1954, 142 No. 40 Pl. 27 Fig. 38.

11 Gjerstad, *Studies on Prehistoric Cyprus*, 238 (Stand 3). Riis, *ActaArch* 10, 1939, 6 No. 7. McFadden, *AJA* 58, 1954, 141 f. No. 39 Pl. 27 Fig. 37.

12 Hall, *Vrokastro*, 133 f. Pl. 34,3. Lamb, *Bronzes*, 34 No. 6. Riis, *ActaArch* 10, 1939, 6 No. 8.

13 Lamb, *Bronzes*, 34 No. 7 Pl. 11 b. Karo, *AM* 55, 1930, 131 ff. Fig. 4 Supp. 33. Riis, *ActaArch* 10, 1939, 5 No. 3.

14 Fitzgerald, *Palestine Exploration Fund. Quarterly Statement* 66, 1934, 133 Pl. 7,3. Riis, *ActaArch* 10, 1939, 5 No. 2.

15 The same decoration on the carrying-ring occurs on two cauldron-trolleys from Enkomi, now in Berlin and London (Furtwängler, *Sitz.-Ber. Bayer. Ak.* 1899 = Kl. Schriften II, 1913, 298 ff. Watzinger in *Hdb. d. Archäologie* I, 1939, 806 Pl. 191,1. Bossert, *Altsyrien*, 29 Pl. 88 Nos. 300–301).

16 *Buch d. Könige* I, 7,20. Ras Shamra: Bossert, *Altsyrien*, 52 Pl. 231 No. 786. G. E. Wright, *Biblische Archäologie* (1957/8) 139 Fig. 95. Kypros: Myres, *Cesnola Coll.*, 480 No. 4705. Bossert, *op. cit.*, 19 Pl. 84 No. 283. Enkomi: Murray *et al.*, *Excavations in Cyprus*, 17 Fig. 30.

17 Wright, *Bibl. Archäologie*, 153 Fig. 102.

18 Hall, *Vrokastro*, 132 ff. Fig. 80 Pl. 34,1. Riis, *ActaArch* 10, 1939, 6 No. 9.

19 Hall, *Vrokastro*, 132 f. Pl. 34,2. Lamb, *Bronzes*, 33 No. 4. Riis, *ActaArch* 10, 1939, 6 No. 11.

20 Brock, *Fortetsa*, 18, 22 No. 188 Pl. 13.

21 Brueckner, *AM* 18, 1893, 414 f. Pl. 14.

22 See above Note 17.

23 Hogarth, *BSA* 6, 1899/1900, 83 (Grave 3) Fig. 25; cf. *Kerameikos* V 1, Pls. 31–32 (Inv. 276).

24 A further development of the same motif occurs on gold covering from Eleusis, now in Athens (Philios, *Ephem* 1885, 174 f. Pl. 9,1–2. Reichel, *Goldrelief*, Pl. 4. Ohly, *Goldbleche*, 22 ff. Nos A 7–A 8 Fig. 16 pl. 3. Here: pl. 229). See below p. 190.

25 Brock, *Fortetsa*, 213 ff.

26 A frieze of double spirals (not in open-work) occurs on the carrying-ring of the rod-tripod from Kourion (4). See above p. 164 f. and Note 11.

27 Brueckner, *AM* 18, 1893, 414 f.

28 *Kerameikos* V 1, Pl. 68 (Inv. 416).

29 See above p. 164 f. and Note 11.

30 *Kerameikos* V 1, Pl. 68 (Inv. 931).

31 McDonald, *Hesperia* 30, 1961, 302 f. No. 4 Pls. 63 a, 64 b.

32 Skias, *Ephem* 1898, 102 Pl. 4,3. Schweitzer, *AM* 43, 1918, Pl. 1,5. *CVA* Munich Mus. Ant. Kleinkunst 3 Pl. 125,7. *Kerameikos* V 1, Pl. 68 (Inv. 249) 69 (Inv. 418). McDonald, *Hesperia* 30, 1961, 302 to No. 4 Pl. 64 c.

33 From Mycenae in Athens: Benton, *BSA* 35, 1934/5, 76 with Note 5 Fig. 1 a. Willemsen, *Dreifußkessel*, 10 f, 50 f, 167 f. Pl. 1. In Berlin: H. A. Cahn, *Münzen u. Medaillen AG. Auktion XXII, Kunstwerke der Antike* (1961), 30 No. 52 Pl. 15. Legs from Tiryns: Karo, *AM* 55, 1930, 137 f. Fig. 7 (the leg, Fig. 7 b, belonged to a second tripod).

34 Cahn, *Münzen u. Medaillen AG. Auktion XXII, Kunstwerke der Antike* (1961), 30.

35 Benton, *BSA* 35, 1934/5, 77 Fig. 1 b. *Kerameikos* I, 95 Pl. 63 (Inv. 554) 64 (Inv. 555).

36 (Inv. No. B 1240). Kunze, *OlBer* I, 20 Fig. 11. Idem, *OlBer* II, 106 Pl. 44. Idem, *Meisterwerke*, 5 No. 1 Fig. 1. Willemsen, *Dreifußkessel*, 1 ff. Pls. 1–2.

37 *Kerameikos* I, 95 ff.

38 See above p. 164 f. and Note 11.

39 Benton, *BSA* 35, 1934/5, 74 ff.

40 See Note 36. Cross-sections of leg and ring: Willemsen, *Dreifußkessel*, Fig. 2, 6.

41 Benton, *BSA* 35, 1934/5, 58 Fig. 14 a–b. The legs and handles have a simple cable pattern.

42 Willemsen, *Dreifußkessel*, 3, 166 ff. Pls. 94–95. Kahane, *AJA* 44, 1940, 464 ff. Pls. 17–28.

43 Benton, *AJA* 63, 1959, 94 f. Amandry, *Gnomon* 32, 1960, 459 ff.

44 Amandry, *Gnomon* 32, 1960, 461.

45 Brock, *Fortetsa*, 18 ff.

46 See above p. 167.

47 Willemsen, *Dreifußkessel*, 25 Pl. 25 (B 745, cf. No. 630).

48 Willemsen, *Dreifußkessel*, 76 f. Pl. 44 (B 47); cf. the fragment from Delos (ibid., Pl. 44) and the leg fragment from Palaikastro (Benton, *BSA* 35, 1934/5, 88 Fig. 10 c. Idem, *BSA* 40, 1939/40, 52 Pl. 22,6 A). Kunze, *Meisterwerke*, 5 f. puts the leg B 47 in the first half of the 8th century, and Ohly, *Goldbleche*, 91 f. c. 800 B.C.

49 See above p. 168.

50 Willemsen, *Dreifußkessel*, 29 Fig. 6 Pl. 7 (Br 218).

51 See above p. 167.

52 Benton, *BSA* 35, 1934/5, 114. Willemsen, *Dreifußkessel*, 171 ff.

53 Zigzag: Willemsen, *Dreifußkessel*, Pl. 68 (Br 6247), 69 (B 2404, without no.), 70 (Br 8909), 71 (Br 7715, B 2565). 'Flower' pattern with double 'zigzag stem': ibid., Pl. 68 (Br 2060), 69 (B 2404, without no., B 1280), 70 (B 2511), 73 (Br 11960 + 12543 + 1604). Two-track leg: ibid., Pl. 72 (Br 12126). Two-track handle: ibid., Pls. 78–79 (Br 9694. Athens, Nat. Mus. 7483, from Olympia). One-track handle from Delos: ibid., Pl. 81 (B 1199).

54 Willemsen, *Dreifußkessel*, Pl. 75 (B 2129, Br 4829) 81 (Nauplia, Mus.).

55 For the exceptions cf. Willemsen, *Dreifußkessel*, Pl. 72 (Br 12126). Little ball: ibid., Pl. 75 (Br 4027). Oblique lines: ibid., Pl. 72 (B 2650 without no.). Geometrization of S-lines: ibid., Pl. 76 (Br 7622, Br 11661).

56 Willemsen, *Dreifußkessel*, Pl. 71 (Br 7715). Cross-bars with opposed semicircles: ibid., Pl. 72 (B 2650), 74 (Br 3929). 'Displaced' semicircles in edge friezes: ibid., Pl. 74 (Br 3929).

57 Willemsen, *Dreifußkessel*, Pl. 70 (Br 1742), 74 (without no.), 77 (Br 14258, Br 7628); cf. the fragment of a round handle from Dodona (C. Carapanos, *Dodone et ses ruines*, 1878, 93 Pl. 49,21).

58 Willemsen, *Dreifußkessel*, Pl. 72.

59 Willemsen, *Dreifußkessel*, Pl. 76 (B 2227).

60 Willemsen, *Dreifußkessel*, Pl. 76 (Br 9613).

61 Bather, *JHS* 13, 1892/3, 234 f. Fig. 2 (the drawing ought to be verified once again with the original).

62 Willemsen, *Dreifußkessel*, Pl. 74 (Br 12492), 83 (B 1580). The phases: 1) Pl. 76 (Br 11661, B 2227, Br 4047, Br 4940); 2) Pl. 77 (B 1575, Br 7628, without no.) 3) Pl. 77 (B 2433, Br 1364, Br 6925, B 14258, Br 7008). Of the last four fragments, only B 1364 and Br 6925 can belong to the same tripod.

63 Willemsen, *Dreifußkessel*, Pls. 74, 83.

64 See above Note 62.

65 See above Note 62.

66 For an early example, cf. a belly-handled amphora from the Kerameikos (*Kerameikos* V 1, Pl. 46), and an Attic jug from the third quarter of the 8th century (Wide, *JdI* 14, 1899, 208 No. 31 Fig. 76), and a Parian sherd (Rubensohn, *AM* 42, 1917, 84 Fig. 95).

67 See above Note 62.

68 Bather, *JHS* 13, 1892/3, 235 Fig. 3.

69 Felder: Willemsen, *Dreifußkessel*, Pl. 69 (B 2404, without no.), 70 (Br 1742, B 2511), 71 (7715), 72 (B 2650), 73 (Br 11960, Br 13700).

70 Triple-track: Willemsen, *Dreifußkessel*, Pl. 70, and others. Five-track: ibid., Pl. 68 (Br 6247), 69 (B 1280), 70 (B 2511), 73 (Br 13700). Seven-track: ibid., Pl. 69 (B 2404), 70 (Br 8909), 71 (B 2565), 72 (B 2650). Nine-track: ibid., Pl. 74 (Br 3929).

71 Six-track, only tangential circles: Willemsen, *Dreifußkessel*, Pl. 73 (Br 778/9, Br 4003). A similar limitation to circle tangents occurs only on a clay imitation of a tripod leg from the Samian Heraion (Karo, *AA* 1933, 252 f. Fig. 12).

72 Three-track: Willemsen, *Dreifußkessel*, Pl. 78 (Br 9694) 80 B 2041). Five-track: ibid., Pl. 79 (Athen Nat Mus 7483, from Olympia) 82 (B 2187). Two-track: ibid., Pl. 81 (Nauplia, Museum. Four-track: ibid., Pl. 81 (Delos B 1199).

73 E.g.: *Kerameikos* V 1, Pl. 45 (Inv. 825, three-track); Wide, *JdI* 14, 1899, 198 No. 16 Fig. 63; *CVA* Copenhague, Mus. Nat. 2 Pl. 69,7 (five-track).

74 E.g.: Wide: *JdI* 14, 1899, 193 No. 8 Fig. 55. *CVA* Athènes, Mus. Nat. 1, III H d Pl. 7,4 (seven-track). *Kerameikos* V 1, Pls. 47-48 (Inv. 1256). Between these two examples falls the large grave amphora, Athens, National Museum, 804 (here: Pl. 30), which has abandoned strict symmetry and uses a more sensitive rhythm, like the large jugs (e.g. Wide, op. cit., 205 No. 26 Fig. 71. *CVA* Athènes, Mus. Nat. 1, III H d Pl. 7,1) with their huge necks.

75 See above p. 70 f.

76 *Thera* II, 58 Fig. 199; 136 Fig. 316. *CVA* (Copenhague, Mus. Nat. 2 Pl. 65,1).

77 Battlement meander: Wide, *JdI* 14, 1899, 29 No. 2 Fig. 2. 4,2. Also: Wide, op. cit., (on the shoulder). *CVA* Copenhague, Mus. Nat. 2 Pl. 65,1 (on the neck). *Thera* II, 140 Fig. 331 (at the bottom of the neck) Pfuhl, op. cit., Supplement 2,1 (on the shoulder).

78 See above p. 70 f.

79 *Thera* II, 135 No. 2 Fig. 313. Pfuhl, *AM* 28, 1903, 100 No. 20 Supplement 5,2. J. P. I. Brants, *Beschrijving van de Klassieke Verzameling in het Rijksmuseum ... te Leiden* II (1930), 6 Pls. 5, 9-9a.

80 *Thera* II, 44 No. 10 Fig. 143; 134 No. 1 Fig. 312; 136 No. 7 Fig. 315; 138 No. 17 Fig. 322; 139 No. 19 Fig. 324; 140 f. No. 25 Fig. 331. Pfuhl, *AM* 28, 1903, 99 No. 13 Supplement 2,3; 102 f. No. 32 Supplement 4,2. Taking away one strip produces a four-track composition, with the meander pushed down towards the bottom (*Thera* II, 135 No. 3 Fig. 314; 136 Nos. 8-9 Fig. 316, 318. Pfuhl, op. cit., 100 No. 18 Supplement 3,2).

81 *Thera* II, 144 No. 39 Fig. 343. *CVA* Paris, Bibl. Nat. 1, Pl. 2,1-4.

82 *CVA* Paris, Bibl. Nat. 1, Pl. 1,7-9.

83 Pfuhl, *AM* 28, 1903, 98 No. 12 Supplement 2,3; 99 f. No. 17 Supplement 3,1. Battlement meander: *Thera* II, 140 No. 25 Fig. 331. *CVA* Copenhague, Mus. Nat. 2 Pl. 65,1.

84 *FdDelphes* V, 60 f. Fig. 182-184; cf. also Amandry, *Gnomon* 32, 1960, 463; Amandry points out that not one tripod-cauldron has been found in the Greek colonies of Sicily and Magna Graecia, which imported goods from Corinth from very early times. This is best explained by the lack of major festival sites in Magna Graecia.

85 *Délos* XVIII, 65 ff. Figs. 94-99 Pl. 28 Nos. 203, 205-207; Pl. 29 Nos. 210, 214-215.

86 This question has already been put by S. Benton (*AJA* 63, 1959, 95).

87 See above p. 140 and Notes 58 f. in Ch. VI.

88 Olympia: Willemsen, *Dreifußkessel*, Pls. 61-64 (Br 5177, B 2407 + Br 12152, B 1730, B 1253, B 277, B 1255), also ring handles with ribs, Pls. 65-67. Argive Heraion: Waldstein, *Heraeum* II, 294 f. Nos. 2219, 2222. Delphi: *FdDelphes* V, 62 Nos. 208-209 Figs. 191-192. Ithaca: Benton, *BSA* 35, 1934/5, 62 No. 10 Pl. 10 e.

89 (Inv. No. B 1730). Kunze, *Meisterwerke*, 6 f. Figs. 4-5. Ohly, *Goldbleche*, 77, 117 f. Pl. 28,2. Willemsen, *Dreifußkessel*, 100 ff. Pls. 62-63. Schefold, *Sagenbilder*, Pl. 4 b.

90 Payne, *Protokor. Vasenmalerei*, Pls. 2-3; 5,5; 6,2-8.

91 See above p. 142 and Note 65 in Ch. VI.

92 See above p. 54.

93 Ohly, *Goldbleche*, 116 ff. (early 8th century). Willemsen, *Dreifußkessel*, 109 f. (early rich style), 172 (connection with the strictness of the early phase—early first half of the 8th century).

94 Athen, Nat.-Mus., Inv.-No. 17384: *CVA* Athènes, Mus. Nat. 2, III H d Pl. 14,2 text p. 11 with Figs. 2-3. A second foot fragment from the same krater stand, also with a duel group, is in Toronto (Cambitoglou, *AJA* 64, 1960, 366 f. Pl. 109 Fig. 1). Here, the two arm stumps can be explained: the arms of each figure are crossed, each man seizing the other's helmet crest.

95 *Kerameikos* V 1, 177 with Note 171 Pl. 69 (Inv. 407). F. Brommer, *Herakles* (1953), Pl. 4 a. Schefold, *Sagenbilder*, Pl. 5 a.

96 *Kerameikos* V 1, Pl. 40 (left); cf. the amphora P 4990 from the Agora in Athens (Young, *Graves*, 55 ff. No. XII 1 Figs. 37–38. Davison, *Workshops*, 43 ff. Fig. 36) and the amphora in the Folkwang-Museum in Essen (Tölle, *AA* 1963, 210 ff. Figs. 1–5. Himmelmann-Wildschütz. *AA* 1964, 611 ff. Figs. 1–2). The bases come from the same workshop, but are not by the master.

97 D. M. Robinson-C. G. Harcum-J. H. Iliffe, *A Catalogue of the Greek Vases in the Royal Ontario Museum Toronto* (1930), 274 f. No. 630 Pl. 101; cf. the lower frieze on the fragment from the second krater from Piraeus Street in Athens (Hampe, *Grabfund*, 55 Fig. 39).

98 *Kerameikos* V 1, Pl. 79 (top right); cf. also the amphora in Essen (see Note 96).

99 The mourning men on the amphora in Essen (see Note 96) have the soles of their feet flat on the ground, without the springy gait of the figures in the pictures by the workshop's master. On the other hand, one of the warriors here, with a round shield and a spear, is getting up into a chariot. His left foot is trailing behind, still outside the chariot-box. At the same time he is turning round, so as to be able to calm the leading horse of the following team with his left hand. This audacious motif reflects the master's spirit, but his apprentice has not quite brought it off. A neck amphora in Berlin (Davison, *Workshops*, Fig. 48 a–b) should be attributed to the same workshop. It shows a frieze of marching hoplites, with back feet with heels always raised. This vase must be earlier, like the neck amphora in Cleveland (Cook, *BSA* 42, 1947, 146 ff. Pl. 21).

The same picture arrangement as on the bronze relief occurs on a Boeotian Geometric sherd from a krater in the museum in Sarajevo (Bulanda, *Wiss. Mitt. aus Bosnien u. d. Herzegowina* 12, 1912, 272 No. 61 Fig. 30): two women(?) with scoops round a tripod-cauldron? Or two boxers fighting around a tripod? The style of this vessel, made early in the last quarter of the 8th century, must be derived from the Piraeus Street krater and its master.

100 See Note 96.

101 See above pp. 51, 134 f.

102 See Note 97.

103 Not a wrestling group as suggested by Hampe (*Grabfund*, 55), since the partner is a woman or a girl, and somebody is clearly being led away. Nor are the women on the first krater (see above p. 134 and Note 32 in Ch. VI) 'naked athletes' (Hampe, ibid.), but are dancing a round-dance with measured steps.

104 See above p. 134 f.

105 See Note 89.

106 See Note 95.

107 Willemsen, *Dreifußkessel*, 82 ff., 94 ff.

108 Willemsen, *Dreifußkessel*, Figs. 11–12 Pls. 44–52. Waldstein, *Heraeum* II, 295 No. 2221 Pl. 124. *FdDelphes* V, 67 Nos. 241–243 Figs. 215–217. Benton, *BSA* 35, 1934/5, 62 No. 11 Pl. 17 a–b. Amandry, *BCH* 62, 1938, 309 f. Fig. 3.

109 Willemsen, *Dreifußkessel*, 70 Fig. 12; 71 Note 1 Pl. 49 (B 2585).

110 Payne, *Perachora* I, 55 Pl. 14,6. About 'geometric deposit' cf. ibid., 53 ff. Pl. 139.

111 *Kerameikos* V 1, 269 Pl. 24 (Inv. 789); cf. also the kantharos in Reading (*CVA Univ. of Reading* III H Pl. 8,9).

112 Amphora from Eleusis: Wide, *JdI* 14, 1899, 199 f. No. 20 Fig. 67. G. E. Mylonas, *Eleusis and the Eleusinian Mysteries* (1961), Fig. 86 left. Amphora in Athens, Nat. Mus., Inv. 217: Wide, op. cit., 200 No. 21 Fig. 68. Cf. also Marwitz, *JdI* 74, 1959, 52 ff.

113 Krater in New York: Richter, *Handbook*, 25 Pl. 14 d.

114 See Note 112.

115 Pfuhl, *AM* 28, 1903, 180 f. No. 19 Pl. 3. Also Samian plates: Eilmann, *AM* 58, 1933, 113 Supplement 33,3 (probably around the middle of the 8th century).

116 J. P. I. Brants, *Beschrijving van de Klassieke Verzameling in het Rijksmuseum . . . te Leiden* II (1930), 8 No. 52 Pl. 7. Young, *Graves*, 180 No. C 134 Fig. 130. *CVA* Paris, Louvre 11, III H b Pl. 5,7. Davison, *Workshops*, Figs. 6, 11.

117 Cf. *Kerameikos* V 1, Pls. 62–64; only on the pyxis bottom from Grave 86 (Inv. 836) is the rosette enclosed by a cog-wreath (ibid., Pl. 63).

118 Six-leaf rosettes: *Kerameikos* V 1, Pl. 65 (Inv. 795). Young, *Graves*, 30 f. No. VI 3 Fig. 18.

119 See Note 118.

120 Willemsen, *Dreifußkessel*, Pl. 22 (B 1248), 25 (No. 630. B 745).

121 Kunze, *OlBer* II, 15 Fig. 10; 72 ff. Fig. 48. Hafner in *Festschr. Röm.-German. Zentralmuseum Mainz* III (1953), 83 ff. Pl. 5,1–2.

122 A Samian plate (Eilmann, *AM* 58, 1933, 110 ff. Supplement 332) demonstrates what a plate based on an Attic model, with similar decoration, around the middle of the century, may have looked like (Eilmann, *AM* 58, 1933, 110 ff. Supplement 332).

123 Willemsen, *Dreifußkessel*, Pl. 46 (Br 12823 + B 1665), 48 (B 1665).

124 Dugas, *BCH* 45, 1921, 385 No. 154 Fig. 45. Technau, *JdI* 52, 1937, 89 f. Fig. 9.

125 *Kerameikos* V 1, 223 Pl. 20 (Inv. 290). The other finds (ibid., 223 f. Pls. 32, 41, 58, 73, 75, 86, 91, 156) last up to the second quarter of the 8th century.

126 Wide, *JdI* 14, 1899, 34 f. No. 2 Fig. 12. *Tiryns* I, 146 f. Fig. 122; 143 No. 7 Pl. 15,1. Frödin-Persson, *Asine*, 318 No. 6 Fig. 218,5. Courbin, *BCH* 77, 1953, 260 Fig. 48.

127 *Kerameikos* V 1, Pls. 111, 141 (Inv. 2159) cf. p. 279.

128 See above p. 37 ff. During the 9th century the neck-handled amphorae in the Geometric necropolis of the Kerameikos (see *Kerameikos* V 1) are, on average, 70 cm. high. During the first half of the 8th century, they reach 84, 91 and 117 cm. (Wide, *JdI* 14, 1899, 193 No. 7 Fig. 54; 192 No. 5 Fig. 52; 193 f. No. 10 Fig. 57). From the second quarter of the century on, however, the largest vessels are the belly-handled amphorae, as tall as 155 cm. and 175 cm.—gigantic memorials (Athens, Nat. Mus. Inv.No. 804, 803; here, Pls. 30, 35).

129 Willemsen, *Dreifußkessel*, Pl. 4 (B 2443), H.: 73.2 cm.; Pl. 11 (Br 5025), H.: 58.5 cm. (B 2456), H.: 66.7 cm.; Pl. 12 (B 2335), H.: 75.5 cm.; Pl. 15 (B 1243), H.: 67.5 cm.; Pl. 16 (B 1245), H.: 63 cm.; Pl. 19 (B 1250), H.: 77.5 cm. (here: Pl. 217).

130 Willemsen, *Dreifußkessel*, Pl. 45 (Br 13261), H.: 96 cm.; Pl. 45, 51 (B 50), H.: 1.00 m.; also probably ring handle

Br 11340 with a recumbent lion (ibid., Pl. 54, here: Pl. 188), with a diameter of 26 cm., and Athens, Nat. Mus. Inv.No. 7482 from Olympia (ibid., Pl. 55) with horse, diameter 24.6 cm., and finally, Olympia Br 6019 + B 375 + 2073 (ibid., Pl. 55) with a diameter of 28 cm.

131 *BCH* 83, 1959, 652 f. Fig. 9.

132 See above p. 38 ff.

133 Benton, *BSA* 35, 1934/5, 59 ff. Nos. 6–7, 9–10 Pl. 10 e, 17.

134 Benton, *BSA* 35, 1934/5, 60 f. Nos. 7–8 Fig. 11, 16 b–c Pls. 11 b, 12 a, c.

135 Cf. Willemsen, *Dreifußkessel*, Pl. 56 (B 1270, B 2222); for the horse: ibid., Pl. 58 (B 2175).

136 Benton, *BSA* 35, 1934/5, 58 f. No. 3 Figs. 9, 15 Pls. 11, 14–15; cf. ring handle, Willemsen, *Dreifußkessel*, Pl. 67 (without no.).

137 Benton, *BSA* 35, 1934/5, 61 f. No. 9 Fig. 17 Pl. 11 c, 12 d, 13 b, d; cf. ring handle Willemsen, *Dreifußkessel*, Pl. 54 (Br 2858).

138 Cf. Willemsen, *Dreifußkessel*, 66 f. Fig. 10 (the item from Delphi: *FdDelphes* V, 65 No. 230 Fig. 206) Pl. 44 (Delos, without no.) 51 (without no.) 45,51 (B 50). Amandry, *BCH* 62, 1938, 310 Fig. 3. *FdDelphes* V, 67 No. 241 Fig. 215; cf. the late tripods: Willemsen op. cit., Pl. 61 (Br. 5177, B 2407 + Br 12152) 63 (B 1730, B 277, B 1253) 64 (B 1255).

139 Delos: *Délos* XVIII, 67 Figs. 91–93. Willemsen, *Dreifußkessel* op. cit., Pl. 44 (B 47). Delphi: Amandry, *BCH* 62, 1938, 309 No. 8 Fig. 3 right.

140 Amandry, *BCH* 62, 1938, 309 f. No. 8 Fig. 3 left. Willemsen, *Dreifußkessel*, Pl. 47 (Br 3627, B 2424) 50 (B 278, Br 4414).

141 Willemsen, *Dreifußkessel*, Pl. 50 (Br 4064).

142 Willemsen, *Dreifußkessel*, Pl. 45, 51 (B 13261); cf. the tripod-cauldron No. 9 from Ithaca (see above Note 137), also taller, and with supports like those on item Br 13261 from Olympia, although it comes from the spiral-ornamentation workshop and must have been produced at about the same time as the one in Olympia.

143 See above p. 173.

144 Cf. also Willemsen, *Dreifußkessel*, Pl. 47 (B 2331), where two spiral chains with zigzag tangents run next to each other on the front between the zigzag edges. This motif also occurs on open-work ring handles (ibid., Pl. 54: Br 11340, here pl. 188, modelled on the oldest lion sculptures around the turn of the first to the second quarter of the century, see above p. 152 ff.: ibid., Pl. 55: Athens, Nat. Mus. 7482, from Olympia. Br 6019, B 810).

145 Cf. Willemsen, *Dreifußkessel*, Figs. 4–5.

146 Willemsen, *Dreifußkessel*, Pl. 15 (B 2450), 18 (B 1252), 23 (Br 5897), 24 (Br 13539 + Br 6847, B 1251), 26 (Br 1640, B 49), 27 (B 2412, B 5976).

147 See above p. 166 f. and Note 20.

148 Willemsen, *Dreifußkessel*, Pls. 19–20 (B 1250).

149 On a fragment of the leg of a tripod-cauldron from Olympia (Willemsen, *Dreifußkessel*, Pl. 25, B 2586) there is a spiral chain with individual pairs of spirals joined, so that in the remaining pairs, the spirals abut directly onto each other. In this case, the connection with the Cretan tripod is obvious.

150 *FdDelphes* V, 65 f. No. 233 Fig. 208; cf. a fragment of a handle in Olympia (Willemsen, *Dreifußkessel*, Pl. 23, Br 8339).

151 Willemsen, *Dreifußkessel*, Pls. 26, 33 (B 2085).

152 See above p. 164 f. and Note 10.

153 See above p. 166 f. and Note 21.

154 *FdDelphes* V, 64 No. 227 Fig. 203; Willemsen, *Dreifußkessel*, Pl. 7. Two snakes wriggling round the straight support of the ring handle (?) seem also to have been present on an item from Olympia (Willemsen, op. cit., Pl. 36, Br 8242).

155 Willemsen, *Dreifußkessel*, Pl. 18 (B 1252) 23 (Br 5897) 24 (B 1251) 26 (Br 1640, B 49) 27 (B 2412, Br 5967) 37 (B 2332).

156 See above p. 164 ff. and Notes 12, 14.

157 Willemsen, *Dreifußkessel*, Pls. 65–67.

158 *FdDelphes* V, 65 No. 229 Fig. 205. Benton, *BSA* 35, 1934/5, 58 f. Fig. 15 Pl. 14 d. Willemsen, *Dreifußkessel*, Pl. 14 (B 1241) 20 (B 746, B 1250); cf. here also the Cretan rod-tripod from Vrokastro (see above p. 176 f., Note 18 and Fig. 100). Ring handle (Willemsen, op. cit., Pl. 30, Br 5471:) on the pulling handle are the 'flowers', and underneath them, the horizontal double spirals.

159 *FdDelphes* V, 65 No. 231 Fig. 207 (cf. also 64 f. No. 228 Fig. 204). *Délos* XVIII, 67 No. B 236–7632, B 1321 Fig. 90 Pl. 28 Figs. 200–201. Willemsen, *Dreifußkessel*, Pl. 25 (B 745, No. 630) 22–23 (B 1248, Br 8339).

160 See above p. 179 f.

161 Willemsen, *Dreifußkessel*, Pl. 45 (Br 13261).

162 Semicircles: Willemsen, *Dreifußkessel*, Pl. 27 (B 1247). Spiral chains: ibid., Pl. 47 (Br 3627, B 2331) 50 (Br 4414). Amandry, *BCH* 62, 1938, 309 No. 8 Fig. 3.

163 See above p. 168 and Note 33.

164 Mycenaean precedents from Chamber Grave I 5 in Asine: Frödin-Persson, *Asine*, 394 Fig. 257.

165 See above p. 168 and Note 33.

166 Willemsen, *Dreifußkessel*, 166 ff.

167 Willemsen, *Dreifußkessel*, 166 ff. There is no room here for stylistic overlaps, and the principle that every Greek piece was an original product has been dropped. Cf. ring handles and legs where each item has new features. One can of course devise a rather abstract scheme of development, although it cannot really be compared with Attic Geometric vases of the 9th century without strain. But the logic of this is far too tenuous to establish even a relative chronology for the tripod-cauldrons from Olympia.

168 See above p. 164 ff.

169 See above p. 168.

170 See above p. 167.

171 Skias, *Ephem* 1898, 107 f. Fig. 28. *CVA* Athènes, Mus. Nat. 1, III H b Pl. 6, 13–14.

172 See above p. 176 and Note 110.

173 See above p. 168 and Note 33.

174 Willemsen, *Dreifußkessel*, 11 f.

175 Willemsen, *Dreifußkessel*, Pl. 3.

176 Older type cauldron suppports: Willemsen, *Dreifußkessel*, Pl. 4 (without no.) 5 (Br 12838) 11 (without no.) 12 (without no. B 2335) 13 (Br 11555, B 2422) 14 (B 1241) 15 (B 1243, B 2450) 16 (B 2414, B 1245) 18 (B 1252) 26 (No. 551) later form: ibid., Pl. 19 (B 1259) 21 (Br 2107) 23 (Br 5897) 24 (B 13539 + Br 6847, B 1251). Ithaca: Benton, *BSA* 35, 1934/5, 59 ff. Nos. 3, 7–9 Figs. 15, 16 b–c, 17.

177 Benton, *BSA* 35, 1934/5, 57 f. No. 1 a–b (perhaps from two similar tripods) No. 1 c 2 Fig. 8 Pl. 10 a–d.

178 Willemsen, *Dreifußkessel*, Pl. 1–2 (B 1240), h.: 0.49–0.52 m.; Pl. 4 (B 2443), h.: 0.675 m. (without no.), h.: 0.615 m. pl. 5 (Br 12838, Br 513, B 2453), h.: 0.612 m.; Pl. 11 (Br 5025), h.: 0.585 m. (B 2456), h.: 0.667 m. Pl. 12 (without no.) Pl. 13 (B 1249, Br 11555, B 2422) Pl. 17, 20 (B 1256), h.: 0.84 m. This does not necessarily mean that the three earliest and lowest tripod-cauldrons in Ithaca are older than the taller ones in Olympia. They represent an early phase, but they could be utensils deliberately made less expensively, but produced and dedicated at roughly the same time.

179 Benton, *BSA* 35, 1934/5, 59 ff. Nos. 6–8 Fig. 11 Pl. 11 b, 12 a–c, 13 c, 15 b; cf. the reconstructions: ibid., Figs. 16 a–c, 19.

180 Cf. Willemsen, *Dreifußkessel*, Pl. 1 (B 1240), B 2443, without no.), 5 (B 2453), 11 (Br 5025, B 2456), 17, 20 (B 1256).

181 Cf. the fragment of a handle Br 913 a (Willemsen, *Dreifußkessel*, Pl. 44).

182 See Note 179.

183 Willemsen, *Dreifußkessel*, Pl. 14.

184 See Note 179.

185 Benton, *BSA* 35, 1934/5, 58 f. Figs. 15, 19 Pls. 13 a, 14 d–e, 15 a.

186 Willemsen, *Dreifußkessel*, Pls. 14, 20. The ring handle of the tripod-cauldron from Ithaca has its closest, almost certainly contemporary, counterpart in Delphi (*FdDelphes* V, 62 No. 203 Fig. 190.

187 Benton, *BSA* 35, 1934/5, 61 f. Fig. 17 Pl. 11 c, 12 d, 13 b, d, 14 c, 15 c, 17 e. On the upper part of the legs, cf. fragment Br 5897 from Olympia (Willemsen, *Dreifußkessel*, Pl. 23), and on the ring handles, Br 2991 from the same place (ibid., Pl. 53).

188 See above p. 166 f.

189 See above p. 166 f. and Note 18.

190 Cf. the reconstruction drawing of the rod-tripod from Vrokastro in Hall, *Vrokastro*, 133, Fig. 80 (here: Fig. 100).

191 See above p. 169 f.

192 Forerunners of the motif in Olympia: Willemsen, *Dreifuß-kessel*, Pl. 4 (B 2443) 5 (Br 12838, Br 513, B 2453). The motif itself in Olympia: ibid., Pl. 12 (without no.), 13 (Br 11555, B 2422), 14 (B 1241) 23 (Br 5897).

193 *FdDelphes* V, 61 No. 198 Figs. 187–187 a (the description given is not quite correct: the leg has only three rounded ridges, and it is only the division of the centre one which produces four at the top).

194 *FdDelphes* V, 65 No. 229 Fig. 205 (this fragment, and the one referred to in Note 193, were found near the Daochos votive offering); cf. with this fragment also fragment B 746 from Olympia (Willemsen, *Dreifußkessel*, Pl. 20).

195 See above p. 167.

196 In the first place which comes to mind, Pelopion, no tripod-cauldrons have been found which would certainly be older than fragment Br 8339 of a ring handle (Willemsen, *Dreifußkessel*, Pl. 23). This was made around 800 B.C.

197 Willemsen, *Dreifußkessel*, Pls. 3–17.

198 See above p. 181 ff.

199 See above p. 180 f.

200 See above p. 176 ff.

201 See above p. 173 ff.

202 See above p. 170 ff.

Chapter VIII: Geometric Gold Bands (pages 186–200)

1 Kunze, *Bronzereliefs*, 265 f. (app. I). W. Reichel, *Griechisches Goldrelief* (1942), and Kunze, *Gnomon* 21, 1949, 1 ff. D. Ohly, *Griechische Goldbleche d. 8. Jhs. v. Chr.* (1953), and Cook, *Gnomon* 26, 1954, 107 ff.

2 Furtwängler, *AZ* 42, 1884, 99 ff. Pls. 8–10 = *Kl. Schriften* I (1912), 458 ff. Pls. 15–17.

3 Ohly, *Goldbleche*, 10, 21 f. No. A 6 Pl. 2,3. *Kerameikos* V 1, Pl. 158.

4 *Kerameikos* V 1, 243 ff.

5 Brueckner, *AM* 51, 1926, 138 f. Supplement 7,3. Ohly, *Goldbleche*, 9, 19 No. A 2 Pls. 1,2–3; *Kerameikos* V 1, Pl. 158.

6 *Kerameikos* V 1, 259 f.

7 Ohly, *Goldbleche*, 9, 15 ff. No. A 1 Pl. 1,1.

8 Athens, Nat. Mus., Inv. No. 706: Wide, *JdI* 14, 1899, 206 No. 28 Fig. 73. Ohly, *Goldbleche*, Pl. 26.

9 Furtwängler, *AZ* 42, 1884, 102 Pl. 9,2 = *Kl. Schriften* I (1912), 460 Pl. 16,2. Ohly, *Goldbleche*, 11, 30 f. No. A 11 Pls. 4,2; 8,1.

10 Ohly, *Goldbleche*, 11 Pl. 18. *CVA* Copenhague, Mus. Nat. 2 Pls. 72,4; 73,5; 74,1–6.

11 Furtwängler, *AZ* 42, 1884, 101 ff. Pl. 9,1 = *Kl. Schriften* I, 459 ff. Pl. 16,1. Ohly, *Goldbleche*, 11, 41 f. No. A 20 Fig. 9 Pl. 10,1; 12,4.

12 Cook, *BSA* 46, 1951, 46 ff. Pl. 10. Ohly, *Goldbleche*, 40 f. with fig. P. Amandry, *Collection H. Stathatos. Les bijoux antiques* (1953), 7 Pl. 5,1.

13 A similar problem is posed by another Late Geometric bowl in Athens (see above 52 ff. and Note 67 no. 10 in Ch. II). Here there are two choruses of men and women, with chorus leaders. If one picks up the bowl, five figures can be seen on the top part of the inside: a lyre player, a woman with outstretched arms, and a trio of women with their arms by their sides. On each part of the outside of the bowl there are four tripod-cauldrons—prizes for the winning choruses. S. Papaspyridi-Karouzou ingeniously suggested that the bowl shows the events from the second day of the *Thargelia* (*CVA* Athènes, Mus. Nat. 2, text to III H d Pls. 10–11 p. 9; cf. L. Deubner, *Attische Feste*, 1932, 198. Suidas writes: 'Pythion, the Sanctuary of Apollo, where the winning cyclical choruses dedicated the tripods they had won as prizes in the *Thargelia*'. This would mean that the figures would be Apollo, Leto and the three Horae. This would be very convincing were it not for the fact that the choruses at the *Thargelia* consisted of men and boys (Deubner, op. cit., 198 Note 2). The 'mixed' choruses on the bowl suggest, rather, the *Geranos*, the chorus of Attic boys and girls, celebrated by Theseus with Ariadne after the rescue of the Attic boys and girls from the Minotaur, the Cretan monster (finally: K. Friis Johansen, *Thesée et la danse à Délos*, 1945 = Arkeol. Kunsthist. Meddelelser 3,1). In this case the figures would be Theseus, Ariadne and the Horae. But the matter cannot be conclusively settled, since Geometric artists did not use fixed iconographical types to illustrate myths, nor did they 'freeze' particular rites permanently.

14 Cook, *BSA* 46, 1951 45 f. with figure. See above p. 46 f. and Note 42 no. 15 in Ch. II.

15 Ohly, *Goldbleche*, 12, 44 No. A 22 Pl. 10,3.

16 Ohly, *Goldbleche*, 12 Pl. 24.

17 *CVA* Karlsruhe, Bad. Landesmus. 1 Pl. 3,4.

18 *Kerameikos* V 1, 244 Pl. 116 (Inv. 1305).

19 Wide, *JdI* 14, 1899, 208 No. 32 Fig. 77.

20 *CVA* Bruxelles, Mus. R. d'Art et d'Histoire 2, III H b Pl. 1,2 a.

21 See Note 16.

22 See Note 1.

23 Hampe, *Gleichnisse*, 31 Pl. 12.

24 Ohly, *Goldbleche*, 10, 22 ff. Nos. A 7–A 8 Figs. 7–8, 16 Pl. 3.

25 Ohly, *Goldbleche*, 60 ff. Pls. 15–16. The box was probably 32–33 cm. wide, about 24 cm. deep and, with its feet, 17–18 cm. high.

26 F. Poulsen, *Die Dipylongräber und die Dipylonvasen* (1905), 130. Reichel, *Goldrelief*, 15 ff. (opposed to Oriental importation: Kunze, *Gnomon* 21, 1949, 4 ff.). I myself (*AM* 43, 1918, 88) described the origin of the matrices somewhat unclearly as 'from the East'; what I meant, as the context makes clear, was 'from the eastern islands of the Aegean'.

27 See above p. 180 f.

28 H. Goldman, *Excavations at Eutresis* (1931), 82 Pl. 3,2. Bossert, *JdI* 75, 1960, 9 Fig. 9 No. 17.

29 R. C. Bosanquet–R. M. Dawkins, *The Unpublished Objects from the Palaikastro Excavations 1902–1906* I (1923), 14 Pl. 11 a. Matz, *Kreta*, 37 f. Pl. 19 bottom.

30 R. B. Seager, *Excavations on the Island of Pseira* (1910), 26 f. Pl. 7. Bossert, *Altkreta*, 35 Pl. 200 No. 351. J. D. S. Pendlebury, *The Archaeology of Crete* (1939), 203 f. Fig. 36,5 Pl. 33,3.

31 H. B. Hawes, *Gournia* (1908), 44 Pl. 9,10. G. Maraghiannis G. Karo, *Antiquités Crétoises* II (undated) 10 Pl. 28.

32 Bosanquet, *Unpublished Objects from the Palaikastro Excavations* I, 51 f. No. 6 Fig. 39 a. Pendlebury, *Archaeology of Crete* 207 Fig. 37,8.

33 F. Chapouthier–R. Joly, *Fouilles exécutées a Mallia* II (1936 = *Études Crétoises* IV) 29 Pl. 11. Pendlebury, *Archaeology of Crete*, 112 f. Fig. 18,38.

34 Virolleaud, *Syria* 3, 1922, 284 No. 2 Figs. 4–5 No. 11. P. Montet, *Byblos et l'Égypte* (1928), 191 f. No. 748 Pl. 111. Bossert, *Altsyrien*, 52 Pl. 230 No. 753.

35 Marinatos-Hirmer, *Kreta*, 109 Pl. 147. The spirals on a gold cup from the fifth shaft grave in the grave circle are more delicate and yet more dynamic (Karo, *Schachtgräber*, 122 No. 629 Pl. 125. Marinatos-Hirmer, op. cit., 119 Pl. 194), with individual areas being set in motion by an oblique diagonal. The 15th-14th-century ceiling decoration in the grave chamber in the domed grave at Orchomenos is more splendid, with spiral bands in the form of concave 'canales' (Marinatos-Hirmer, op. cit., 114 Pl. 161).

36 C. A. Edgar in T. D. Atkinson, *Excavations at Phylakopi in Melos* (1904), 151 Fig. 133.

37 Karo, *Schachtgräber*, 122 No. 625 Pl. 55. Marinatos-Hirmer, *Kreta*, 115 Pl. 168.

38 C. W. Blegen, *Korakou* (1921), 45 Fig. 61,2 (Late Helladic II b). Furumark, *Myc. Pottery*, 272 Fig. 36,31.

39 A. S. Murray u. a., *Excavations in Cyprus* (1900), 7 Fig. 10. H. B. Walters, *Catalogue of the Greek and Etruscan Vases in the British Museum* I 2 (1912), 76 f. No. C 387. Furumark, *Myc. Pottery*, 272 f. Fig. 36,32; cf. also ibid., 272 f. Fig. 36,33 (Tell el-Amarna) 36,34 (Athens, Acropolis) 36,35; the series continues up to the period Late Mycenaean III B.

40 Renaudin, *BCH* 47, 1923, 211 ff. Fig. 22. Furumark, *Myc. Pottery*, 355 Fig. 60,38.

41 *Tiryns* II, Pls. 8, 12. Marinatos-Hirmer, *Kreta*, Pl. XL. A somewhat earlier baroque version of the double spiral chain occurs on a splendid gold bowl from Dendra (A. W. Persson, *New Tombs at Dendra near Midea*, 1942, 74 f.). No. 19 Fig. 88 Pl. 4). All the usual features have here been adapted to a dynamic painterly style, but the two opposed spiral chains and the curve under the rolled-up spirals can be clearly seen: cf. the same motif on an Oriental ivory. (G. Loud, *The Megiddo Ivories*, 1939, 14 Nos. 41–42 Pl. 10).

42 See above p. 170 f.

43 *Tiryns* II, Pl. 8. Matz, *Kreta*, Pl. 105.

44 Karo, *Schachtgräber*, 43 No. 1 Pl. 12; 72 No. 230 Pl. 41; 73 No. 235 Pl. 36.

45 Karo, *Schachtgräber*, 124 f. No. 640 Pl. 56.

46 Hogarth-Welch, *JHS* 21, 1901, 88 No. 4 Fig. 16. The whirl rosette also occurs frequently on finds from the shaft graves at Mycenae (Karo, *Schachtgräber*, 125 No. 649–650 Pl. 56).

47 Edgar in Atkinson, *Excavations at Phylakopi*, 137 Pl. 27, 1 A–B (Late Minoan I).

48 Evans, *JHS* 13, 1892/3, 196 f. Fig. 1 a–b.

49 Pfuhl, *AM* 28, 1903, 120 No. 174 Supplement 14,2–3.

50 See above p. 170 f.

51 Evans, JHS 13, 1892/3, 210 Fig. 14. F. H. Marshall, *Catalogue of the Jewellery . . . in the . . . British Museum* (1911), 52 No. 692, 700 Pls. 6–7. Interchange of smooth and grooved bulges is common on ring handles of tripod-cauldrons (e.g., Willemsen, *Dreifußkessel*, Pl. 33, B 2085).

52 See above p. 189 and Note 23.

53 Smith *et al.*, *Excavations in Cyprus*, 45 Fig. 71 (Grave 45 No. 931).

54 Lemnos: Mustilli, *ASAtene* 15/16, 1932/3, 46 f. Fig. 57; 68 f. Fig. 98; 100 Fig. 154; 250 ff. G. Becatti, *Oreficerie antiche* (1955), 162 f. Nos. 141–147 Pl. 28. Skyros: Papadimitriou, *AA* 1936, 228 ff. Fig. 4.

55 *Cl. Rhodos* III, 73 Nos. 1–2 Figs. 63–64. Ibid., VI/VII. 212 ff. Figs. 252–258. Becatti, *Oreficerie antiche*, 167 ff. Nos. 189–199 Pls. 32–34.

56 Grave finds from the Geometric period: two diadems from Grave 82 in the Camirus necropolis (*Cl. Rhodos* VI/VII, 200 No. 7 Fig. 239), mouth bandages from Grave 101 in the same necropolis (ibid., IV 348 No. 7 Fig. 388; the drawings are wrong), a diadem from Grave 53 in the necropolis of Ialysos (ibid., III, 89 No. 2 Fig. 82; Late to sub-Geometric), two round discs from Grave 56 in the same necropolis (ibid., 96 No. 9 Fig. 90) and round discs and gold bands from the Exochi necropolis (Friis Johansen, *Exochi*, 74 ff. Figs. 174–191).

Other Rhodian gold sheets (without grave contents): mouth bandages from Camirus in the British Museum (Marshall, *Catalogue of Jewellery in the British Museum*, 95 No. 1163 Pl. 12), mouth bandages in the Louvre (Reichel, *Goldrelief*, 58 No. 55 d–e), two round discs in Berlin, Staatl. Museen (Furtwängler, *AZ* 42, 1884, 104 f. Pls. 9,6.8 = *Kl. Schriften* I, 462 Pls. 16,6,8) and a round disc from Ialysos in the British Museum, London (Marshall, op. cit., 94 No. 1159 Pl. 13).

The gold band in London (Marshall, op. cit., 94 No. 1158

Pl. 13) was acquired in 1861 without any indication of its source. Jacobsthal (*JdI* 44, 1929, 214 Fig. 19) wrongly gives its origin as Camirus. This view is also adopted by Reichel (op. cit., 58 No. 53). The source given applies to the gold diadem No. 1157 in London, which is described in Marshall (op. cit., 94) immediately above No. 1158, but which is considerably later. The mistake does not in fact matter very much since 1158 must come from Rhodes or at least the Rhodian area.

57 Friis Johansen, *Exochi*, 21 f. Fig. 34, 36 a.

58 Furtwängler, *AZ* 42, 1884, 102 Pl. 9,2 = *Kl. Schriften* I, 460 Pl. 16,2. Ohly, *Goldbleche*, Pl. 4,2. The meander variant has been correctly analysed by Ohly (op. cit., 84 Fig. 43 a–b).

59 In a sketch of Ohly's (*Goldbleche*, Fig. 43 a) the central linear meander is displaced by half an axis. This is mathematically possible, and perhaps neater, but is not in line with the gold sheets found, where the cross-bars are at the same height.

60 It is more likely that something of the same spirit reached Phrygian art; cf. e.g., the wooden throne from Gordion (Young, *AJA* 61, 1957, 329 f. pull-out plate facing p. 319; here: Fig. 50. See above p. 85 f.), the rock relief at Ivriz from the second of the 8th century (E. Akurgal, *Phrygische Kunst*, 1955, 45 ff. Pl. C), the Midas grave at Yazikhaya (Bossert, *Altanatolien*, 82 Pl. 267 No. 1028, E. Akurgal, *Die Kunst Anatoliens*, 1961, 110 Fig. 67) and the architectural item from Akalan (Bossert, op cit., 82 Pl. 277 no. 1049).

61 *Cl. Rhodos* VI/VII, 200 f. No. 7 Fig. 239 b.

62 See above p. 83 f.

63 The handle zone of a Rhodian krater with stirrup handles, from Camirus (*Cl. Rhodos* VI/VII, 102 No. 1 Fig. 113) also has a similar variant of the meander, although looser and later than the simpler examples.

64 *CVA* La Haye, Musée Scheurleer 1, III G Taf. 1,1. *Allard Pierson Museum, Allg. Gids* (1937) No. 1223. The cup is an imitation of an Attic cup in Boeotia, recognizable as such by the delicate slip over the reddish clay.

65 Krater from Camirus: *Cl. Rhodos* IV, 346 No. 1 Figs. 385–386. Jug from Camirus: ibid., VI/VII, 73, No. 1 Figs. 82–83. Jug from Cos: Morricone, Bollettino d'Arte 35, 1950, 321 Fig. 95. See above pp. 86 f., 192 f.

66 Ohly, *Goldbleche*, 11, 37 f. No. A 19 Pls. 9,6; 12,1–3.

67 See above p. 192 and Note 61.

68 See above pp. 84 f., 187 ff. and Note 65.

69 See above p. 187 f. and Note 65.

70 Philios, *Ephem* 1885, 179 f. Pl. 9,3–4. Reichel, *Goldrelief*, 35 f. 57 No. 33 Pl. 9. Ohly, *Goldbleche*, 10 (to no. A 7) 13, 71 Pl. 17,4. Becatti, *Oreficerie antiche*, 160 f. Nos. 126–130 Pl. 27.

71 Five-leaf rosettes are very rare, but they occur on the jug from Cos mentioned above on pp. 86 f., 192 f. and Note 65.

72 Kantharos in Copenhagen (bought from a dealer who gave its source as 'probably Rhodian', which fits the style): *CVA* Copenhague, Mus. Nat. 2 Pl. 65,10. K. Friis Johansen, *Exochi*, 115 Fig. 208. Clay imitation of an ivory pyxis: Cl. Rhodos VI/VII, 203 No. 1 Fig. 243. K. Friis, Johansen, op. cit., 153 Fig. 219; cf. a second pyxis from Exochi, ibid., 61 ff. Fig. 128. See also above p. 77. The only other contemporary 'woven' band is on a large neck-handled amphora

from Bayrakli (Old Smyrna) now in the Mueum in the Park of Culture at Izmir. In the 7th century it occurs on a tall jug of the Protocorinthian type from Cerveteri O. Montelius, *La civilisation primitive en Italie*, Pl. 344,9).

73 See above p. 86 f. and Note 65.

74 See above p. 192 and Note 61.

75 Friis Johansen, *Exochi*, 76 No. Z 47 Fig. 180.

76 A. Furtwängler–G. Loeschcke, *Mykenische Vasen* (1886), 65 No. 377 Pl. 36. Furumark, *Myc. Pottery*, 410 Fig. 71 motif 73 ad.

77 See above p. 18 and Fig. 63.

78 On band A 2 (Ohly, *Goldbleche*, 9,19 No. A 2 Pls. 1,2–3; 6,2) the fifth animal from the left is difficult to interpret: it is a young stag falling to the ground and is the only figure moving from right to left. Its body has dropped, with the front legs bent. Its hindquarters are supported by one leg, with the other still stretched out horizontally. The tail hangs down between the legs. This 'falling animal' motif has an exact counterpart in a fleeing doe in a hunting scene on a four-sided ivory rod from Megiddo (G. Loud, *The Megiddo Ivories*, 1939, 16 No. 125 Pl. 22. Descamps, *Ivoires*, 82 f. No. 305 a Pl. 35).

79 Kosay, *BSA* 37, 1936/7, 163 f. Pl. 19 b, 22 b. Bittel, *AA* 1939, 112 Fig. 12. Bossert, *Altanatolien*, 35 f. Pl. 62 Nos. 299–300. M. Riemschneider, *Die Welt der Hethiter* (1954), 84 f., 106 f. Pl. 33. Akurgal–Hirmer, *Hethiter*, 109 Pls. 1–2. I. The Boston Museum of Fine Arts recently acquired a small bronze stag from Talish in northwest Persia (*Bulletin of the Museum of Fine Arts* 58, 1960, 97 with figs.), which is dated, in the publication, as between 1000 and 800 B.C. It is not as fine as the stag from Alaca Hüyük (Bossert, op. cit., No. 299), but cannot surely be separated by one and a half millennia from it.

80 A. Parrot, *Mari* (1953), Fig. 90.

81 P. J. Riis, *Hama* II 3: *Les cimetières à cremation* (1948), 97 Fig. 130 B No. 102 Pl. 12 A–B.

82 J. W. Crowfoot, *Early Ivories from Samaria* (1938), 5 f, 26 Pl. 10,8–8 a.

83 F. Thureau–Dangin, *Arslan Tash* (1931), 118 f. Nos. 61–62 Pl. 36. Descamps, *Ivoires*, 135 Nos. 879–880 Pl. 89.

84 M. Dunand bei Thureau-Dangin, *Arslan Tash*, 119.

85 C. W. Blegen, *Zygouries* (1928), 193 f. Fig. 182.

86 Karo, *Schachtgräber*, 94 No. 388 Pls. 115–116. Marinatos-Hirmer, *Kreta*, 117 Pl. 177. K. Tuchelt, *Tiergefäße in Kopf- und Protomengestalt* (1962), 28 with Note 88.

87 Tuchelt, *Tiergefäße*, 27 f. Pls. 4–5.

88 Ohly, *AM* 65, 1940, 67 ff. pl. 52. *Kerameikos* IV, 20 Pl. 26 (Inv. 641).

89 *FdDelphes* V, 15 No. 8 Fig. 61. Müller, *Prähistor. Zschr.* 19, 1928, 311 ff. Figs. 4–5 Pls. 34–35. Protogeometric and Protogeometric B: Tsountas, *Ephem* 1892, 14 Pl. 3,1. Buschor–v. Massow, *AM* 52, 1927, 38 Supplement 6 (Amyklaion). Ohly, *AM* 65, 1940, 77 f. Pl. 52 No. 982 (Samos).

90 The continuance of barrel-shaped animal vessels up to the Late Geometric period is illustrated in the East Greek area, e.g. in Rhodes, by a horse or mule with two vessels on its back (unpublished), a ram with a spout (*Cl. Rhodos* VI/VII, 49 ff. No. 12 Figs. 54–55. *Lindos* I, 471 f. No. 1919 Pl. 85) and in Samos by the fragments of a bull (Ohly, *AM* 65, 1940, 77 f. Pl. 53 No. 424).

91 *Olympia* IV, 36 No. 205–207 a Pl. 13.

92 As on the kantharos in the Vlasto collection in Athens (Cook, *BSA* 35, 1934/5, 182 f. Fig. 8. Hampe, *Gleichnisse*, 32 ff. Pl. 14 b).

93 Munich: Sieveking, *AA* 1913, 434 No. 1 with figure. Boston: Segall, *Bulletin of the Museum of Fine Arts* 41, 1943, 75 Fig. 8. Hampe, *Sagenbilder*, Pl. 30. *Idem, Gleichnisse*, 34 Pl. 17 a. See above p. 152.

94 E. Kunze, *Kretische Bronzereliefs*, (1931).

95 The shields: Kunze, *Bronzereliefs*, 14 No. 11; 28 No. 56; 40 ff. Pls. 28, 43. Offerings: Levi, *Liverpool Annals* 12, 1925, 3 ff. Pls. 1, 4–6; now in more detail: *idem, AS Atene* 10–12, 1927–9, 312 ff. Figs. 411–419 Pls. 21–24.

96 Kunze, *Bronzereliefs*, 28 f. Nos. 58–59, 61 Pls. 42, 45.

97 Kunze, *Bronzereliefs*, 27 No. 54; 29 Nos. 60, 62 Pls. 42, 44.

98 See above p. 195 f. and Note 83.

99 Kunze, *Bronzereliefs*, 18 No. 26 Pls. 33, 36.

100 Levi, *AS Atene* 10–12, 1927–9, 353 f. Fig. 462 Pl. 24.

101 Cf. with the omphalos shield (see Note 99), for instance, a vase from Camirus (A. Salzmann, *Nécropole de Camiros*, 1875, Pl. 37) and a superb jug in the Louvre (*CVA*, Paris, Louvre 1, II Dc Pl. 6 with colour Pl. 7. Perrot-Chipiez, *Histoire* IX, 417 Pl. 19).
The stag in a hunting frieze on an only partly preserved Cypriot silver bowl (Gjerstad, *Opuscula Archaeologica* IV 1946, 1 ff. Pl. 3), dated by Gjerstad in the period Proto-Cypriot III after 600 B.C. (?), has little to do with the Rhodian-Cretan area.

102 Ohly, *Goldbleche*, 10, 22 ff. No. A 7; 10, 29 f. No. A 9; 10, 30 No. A 10; 11, 30 f. No. A 11; 13, 48 ff. No. E 3 Pls. 3–5. 8, 13. The fight groups occur in pairs and, in one instance, in fours.

103 See above p. 153 and Note 121 in Ch. VI.

104 Kunze, *Bronzereliefs*, Pl. 53 e. See above p. 54 f. and Note 67 No. 13 in Ch. II.

105 Dörpfeld, *AM* 31, 1906, 210 with Supplement. *Idem, Alt-Olympia* (1935), 203 Fig. 54. B. Schweitzer, *Basisrelief d. ältesten Kultbildes d. Hera zu Olympia* (1944 = supplement to the Winckelmann lecture at the Leipzig archaeological seminar). See above p. 55 and Note 108 in Ch. II. Counterparts of the foot on the lion's paw: Levi, *AS Atene* 10–12, 1927–9, 101 ff. Fig. 76. Cf. the hero between lion and griffin on an ivory relief from the Sanctuary of Artemis Orthia in Sparta (Dawkins, *Artemis Orthia*, 213, Pl. 105).

106 *Pausanias* V, 6–10.

107 Dawkins, *Artemis Orthia*, 233 No. 1 Pl. 149,6; 152,2.

108 H. Schäfer-W. Andrae, *Die Kunst d. Alten Orients* (1925), Pl. 462. H. Frankfort, *The Art and Architecture of the Ancient Orient* (1954), 31, 36 Pl. 32. Engraving technique: A. Springer-A. Michaelis-P. Wolters, *Die Kunst d. Altertums*[12] (1923), 54 Fig. 132.

109 See above p. 54 f. and Note 104.

110 See above p. 128 and Note 4 in Ch. VI.

111 See above p. 151 and Note 107 in Ch. VI.

112 Ohly, *Goldbleche*, 79. See above p. 55 f.

113 Strabo XIV, 5,8.

114 Herodot III, 91; Strabo XIV, 4,3.

115 W. Ruge, *RE* XVI 1 (1933), 243 ff, 250 ff. On the Greek settlements: A. Erzen, *Kilikien bis zum Ende der Perser-herrschaft* (1940), 38 ff.

116 H. T. Bossert-U. B. Alkim-H. Cambel-N. Ongunsu-I.
Suzen, *Die Ausgrabungen auf dem Karatepe. Erster Vor-bericht* (1950), 62. Alt, *Forschungen u. Fortschritte* 24, 1948, 121 ff. *Idem, Die Welt des Orients* 1, 1947–52, 281.

117 It is relevant here to point out that the orthostatic reliefs on the gates at Karatepe (Bossert *et al., Ausgrabungen auf dem Karatepe*, 56 ff. Pls. 11–20. Akurgal-Hirmer, *Hethiter*, 103 f. Pls. 141–150) characteristically go beyond the usual images found in Oriental orthostatic friezes. In addition to cult themes and hunting scenes there are warlike images and fights involving obviously non-Semitic warriors, and a sailing boat of the Phoenician type, where an attempt at boarding has just been successfully repelled, while two enemies or corpses float in the sea in the middle of a shoal of fish. The scene must be on the sea between Cilicia and Cyprus. It has striking parallels in Attic pottery, before the middle of the 8th century, and in the Late Geometric period (cf. the fragment in Königsberg: Kirk, *BSA* 44, 1949, 97 f. No. 4 Fig. 2; cf. also here: Pls. 38, 60, 62).

118 Non-Semitic warriors and helmets with crests: Bossert *et al., Ausgrabungen auf dem Karatepe*, Pl. 13,64; 16,82–83.

119 The wave motif on the gold sheet from Eleusis (here: Pl. 229), with helmeted heads on the crests, recurs in similar form on, e.g., an urn for ashes in the form of a deinos from Arkades on Crete (Levi, *AS Atene* 10–12, 1927–9, 134 f. Fig. 122. Ohly, *Goldbleche*, 27 Fig. 15).

120 Friis Johansen, *Exochi*, 77 ff. No. Z 52–53 Figs. 189–190, in drawing Figs. 188, 191. Both the gold bands, each made up of two fragments, were formed on the same matrix. The drawing (Friis Johansen, op. cit., Fig. 191; here: Fig. 109) does not give an entirely accurate picture of the condition of the two gold reliefs.

Chapter IX: Bronze Fibulae with Engraved Pictures (pages 201–216)

1 The best description to date: C. Blinkenberg, *Fibules Grecques et Orientales* (1926).

2 So-called violin-bow fibula. Simplest version: Blinkenberg, *Fibules*, 46 Fig. 9 (type I 1); variants: ibid., 47 ff. Figs. 10–23 (type I 2–9).

3 This type is particularly well represented in the sub-Geometric graves in the Kerameikos necropolis (*Kerameikos* I, Pl. 27. Müller-Karpe, *JdI* 77, 1962, 60 ff. Fig. 1,3–6; 2,2, 4, 12, 15; 3, 8, 11; 6,4). On the history and typology of Late Mycenaean Protogeometric fibulae: V. R. d'A. Desborough, *The Last Mycenaeans and their Successors* (1964), 54 ff.

4 Blinkenberg, *Fibules*, 60 ff. Figs. 30–36 (type II 1–4). Wide, *AM* 35, 1910, 29 No. 2 Fig. 15. Brock, *Fortetsa*, 14 No. 104 Pl. 7 (the homogeneous Grave VI, to which the fibula belongs, contains only vases in the middle Protogeometric style). The type does not occur any longer in the Proto-geometric graves in the Kerameikos (Müller-Karpe, *JdI* 77, 1962, 62, 65).

5 Blinkenberg, *Fibules*, 65 f. (type II 7–9). Müller-Karpe, *JdI* 77, 1962, Fig. 3,9; 4,8; 5,8, 10, 13, 17, 19, 21.

6 Brock, *Fortetsa*, 93 Nos. 1002–1012 (vases); 97 Nos. 1098, 1106, 1111 Pls. 75, 167 (fibulae).

7 Brock, *Fortetsa*, 97 No. 1098.

8 Brock, *Fortetsa*, 97 Nos. 1106, 1111.

9 Hall, *Vrokastro*, Pls. 19–20.

10 Iliffe, *JHS* 51, 1931, 167 No. 15 Fig. 4.

11 Hampe, *Sagenbilder*, 102 f. No. 88 Pl. 7. Higgins, *British Museum Quarterly* 23, 1960/1, 105 f. Pl. 46. Another small gold fibula in Berlin (Inv.No. 7902. Furtwängler, *AZ* 42, 1884, 105 Pl. 9,3 = Kl. Schriften I, 462 Pl. 16,3. Hampe, op. cit., 19 Fig. 3) has an eight-ray star made up of pairs of lines on the plate; this often recurs on Boeotian fibulae, with double or single lines, in the form of a cross or as a six- and eight-ray star (Hampe, op. cit., 94 f. No. 40; 104 f. No. 103 Pl. 8; 92 f. No. 29 Pl. 15; 92 f. No. 18 Pl. 16; 94 f. No. 33 Pl. 17; 96 f. No. 55 Fig. 2). The gold fibula in Berlin, therefore, certainly comes from a Boeotian workshop.

12 See below p. 211.

13 See above p. 195 ff.

14 See below p. 211 and Notes 50–52.

15 See below p. 211 ff.

16 R. Hampe, *Frühe griechische Sagenbilder in Böotien* (1936). Most important references to date: Kunze, *Göttingische Gelehrte Anzeigen* 199, 1937, 280 ff. Young, *Graves*, 105. Matz, *Geschichte*, 90 ff. Benton, *JHS* 70, 1950, 20 f. Ohly, *Goldbleche*, 62 ff. *Kerameikos* V 1, 193 ff. Caskay, *Hesperia* 25, 1956, 171 f. P. Jacobsthal, *Greek Pins* (1956), 8 f., 42 f., 71. R. A. Higgins, *Greek and Roman Jewellery* (1961), 100. Müller-Karpe, *JdI* 77, 1962, 65.

17 Also on a fibula from Tegea (Dugas, *BCH* 25, 1921, 383 No. 149 Fig. 19, 43. Blinkenberg, *Fibules*, 136 Fig. 168).

18 Jacobsthal, *Greek Pins*, 7 ff. Figs. 16–22.

19 S-shaped curves from the bow to the button-like end of the plate mostly occur on fibulae from Thessaly, e.g. on the ones found in the Sanctuary of Zeus Thaulios in Pherai (Blinkenberg, *Fibules*, 117 ff. Figs. 137–141, 143, 145–146, 148–149, 151–152, 155–156, 160, 167, 170–171, 176, 180, 182, 186–187). This type of fibula also occurs in the Late Geometric period near Thessalonike, in Elateia (Phokis) and on the Peloponnese, but not in Boeotia.

20 Elateia (Phokis): Blinkenberg, *Fibules*, 131 No. 1 a Fig. 161. Jacobsthal, *Greek Pins*, 8 f. Fig. 24 b. Olympia: *Olympia* IV, 54 No. 365 Pl. 22. Jacobsthal, op. cit., 8 f. Fig. 24 a. Delphi: *FdDelphes* V, 113 No. 598 Fig. 406, 406 a–b. Tegea: see Note 17.

21 Olympia: *Olympia* IV, 54 f. Nos. 366–366 a Pl. 22. Jacobsthal, *Greek Pins*, 8 f. Fig. 23 a. Ohly, *Goldbleche*, 62 f. Figs. 30–31. Rhodos: Blinkenberg, *Fibules*, 137 f. Nos. 7–8 Fig. 174. Ohly, op. cit., 63 f. Figs. 33–34. Jacobsthal, op. cit., 8 f. Fig. 23 b. Pherai: Blinkenberg, op. cit., 139 f. No. 8 b Fig. 177. Jacobsthal, op. cit., 8 f. Fig. 23 c.

22 Jacobsthal, *Greek Pins*, 9 (after *Olympia* IV, 54: ox).

23 See above p. 195 ff.

24 Payne, *Perachora* I, 169.

25 Hampe, *Sagenbilder*, 108 f. No. 140 Pl. 6; cf. Kunze, *Göttingische Gelehrte Anzeigen* 199, 1937, 281.

26 The tongue of the plate is set in a slot in the ball and soldered; but the sizes of the two parts do not fit, and the pin would have been crooked when the fibula was closed.

27 Now in the Nat. Mus. in Athens (Inv.-No. 8003): Hampe, *Sagenbilder*, 90 f. No. 12 Pl. 12.

28 Davison, *Workshops*, 41 ('The Lion Painter') Figs. 30–31.

29 See below p. 208 and Note 35.

30 Berlin: Boehlau, *JdI* 3, 1888, 362 Fig. d. Perrot-Chipiez, *Histoire* VII, 252 f. Fig. 118. Hampe, *Sagenbilder*, 94 f. No. 40 Pl. 8. Munich Reisinger, *JdI* 31, 1916, 296 ff. Fig. 3. Hampe, op. cit., 104 f. No. 103 Pl. 8. Athens (Nat. Mus. Inv.No. 8202, from Thebes): Hampe, op. cit., 92 f. No. 16 Pl. 9. Philadelphia: Bates, *AJA* 15, 1911, 1 f. Figs. 2,4. Schweitzer, *Herakles*, 163, 167 Figs. 32–33. Hampe, op. cit., 108 f. No. 135 Pl. 8. On the Lion Master: Hampe, op. cit., 14 ff.

31 Davison, *Workshops*, 36 Figs. 25, 28, 36, 50. See above p. 47.

32 On the high helmet, cf. the Attic bronze warriors from the Acropolis in Athens (here: Pls. 159–161), the late Attic warrior (here: Pls. 164–165) and the bronze statuettes from Olympia (Kunze, *OlBer* IV, Pls. 38–39, 43–46). See above p. 142 f.

33 Fibulae connected with the Lion Master: Hampe, *Sagenbilder*, 90 f. No. 14 Pl. 12 (Athens), 92 f. No. 18 Pl. 16 (Athens, Inv.No. 8204); 94 f. No. 32 Pl. 10 (Athens, Inv. No. 12662); 98 f. No. 64 Pl. 10 (Boston, Museum of Fine Arts); 102 f. No. 91 Pl. 10 (London, Inv.No 1201).

34 Hampe, *Sagenbilder*, 16 f.

35 Berlin (formerly Antiquarium, Inv.No. 8460): Furtwängler, *AA* 1894, 116 No. 4 Fig. 3. Hampe, *Sagenbilder*, 98 f. No. 58 Pl. 11. See above p. 206. On the 'bell-shaped' mouths of the horse and lion, cf. Hampe, op. cit., Pl. 8 No. 40, 103; 9 No. 16; 10 No. 91, 64, 32; 12 No. 14; 16 No. 18.

36 See above pp. 54 ff., 187.

37 D. G. Hogarth, *Excavations at Ephesus* (1908), 110 Pl. 3, 10; 8,4. The picture on a splendid Rhodian bowl from the Vlastos group (*Délos* X, 41 No. 72 Pls. 14,59. Matz, *Geschichte*, 270 f. Pl. 178. A verified drawing is now available in W. Schiering, *Werkstätten orientalisierender Keramik auf Rhodes*, 1957, 54 f. Fig. 1) basically still shows the same 'fairy-tale' world: two lions are rearing up with a helpless ibex between their hind paws. One of the forepaws of each lion is touching the other's; the other two forepaws are reaching up to seize two fleeing dogs. The heads of the lions are inclined sharply back. This is probably the last picture from around the middle of the century to show erect lions.

38 See above p. 173 f.

39 London: H. B. Walters, *Catalogue of the Bronzes ... in the .. British Museum* (1899), 9 No. 121. Hampe, *Sagenbilder*, 102 f. No. 93 Pl. 11, Athens, Nat. Mus., from Thebes (Inv. No. 8199): Wolters, *Ephem* 1892, 232 f. Pl. 11,1. Blinkenburg, *Fibules*, 174 No. 3 Fig. 206. Hampe, op. cit., 90 f. No. 13 Pl. 11.

40 Journey-work: Perrot-Chipiez, *Histoire* VII, 253 f. Figs. 126–129.

41 See above p. 56, and Note 121 in Chapter II; and above p. 59 and Note 5 in Ch. III.

42 Fibulae of the Swan Master (Hampe, *Sagenbilder*, 17 f): Athens (Nat. Mus., Inv. 8203, from Thebes): Wolters, *Ephem* 1892, 233. Hampe, op. cit., 92 f. No. 17 Pl. 13. London (Brit. Mus., from Thebes): Walters, *Catalogue of the Bronzes in the British Museum* 9 No. 119 Fig. 4. Blinkenberg, *Fibules*, 178 No. 8 b Fig. 208. Hampe, op. cit., 102 f. No. 89 Pl. 13. Athens (Inv. No. 11765, from the grotto of Zeus on mount Ida, Crete): Blinkenberg, op. cit., 163 ff. Figs. 195–197 (unreliable drawings). Hampe, op. cit.,

92 f. No. 28 Pl. 14. Schefold, *Sagenbilder*, Pl. 6 b. Berlin (Inv. No. 8145,5, from Thebes): Hampe, op. cit., 96 f. No. 55 Fig. 2.

43 The ship pictures develop on bronze fibulae in several phases, as on large Attic grave kraters, with large warships acquiring more and more a life of their own:

1 Keel, bow and poop, on the same level, form a flat bow, with the ship driven either by a sail or by oarsmen and apparently floating on a glassy-smooth sea (cf. krater A 517 in the Louvre, here: Pl. 37. See above p. 41 f. and Note 21 in Ch. II; similarly krater A 527 ibid., *CVA* Paris, Louvre 11, III Hd Pls. 2,2; 3,9).

2 Keel and bottom are straight. Lower deck has cross-ribs and shrouds, apparently open, since in some instances huge men can be seen down to their knees inside. Other men are stepping down. A warship with an arrow-straight keel has twelve oarsmen shown above the lower deck; there are two enormous warriors with Dipylon shields and two spears, one by the aphlaston, the other by the bow ornament (as on krater A 527 in the Louvre, here: Pl. 38. See above p. 41 and Note 26 in Ch. II; cf. also krater A 522 ibid., here: Pl. 39. See above p. 41 and Note 26 in Ch. II). The fibula by the Ship Master from Thebes, now in Athens (see above p. 208 f. and Note 39) shows a straight keel and ribs. The fibula by the same master in London (see above p. 208 f. and Note 39) shows the ribs and shrouds of the lower deck, in this case, covered, and a slightly raised poop. Both ships have an exaggeratedly large bird, not a warrior, on the aphlaston and the bow.

3 The sea scene by the young Swan Master on the fibula from the grotto of Zeus on Mount Ida, now in Athens, (see above Note 42) shows, for the first time, a keel running straight back from the bow, a steering-oar of which the last third cannot be seen, a curved cabin and aphlaston designed to break the force of the waves, steady the long foredeck, and keep the ship on an even keel. The two archers on this fibula have a long history, including the great ship with steering-oars on krater A 522 in the Louvre (here: Pl. 39) with huge warriors on the bow and poop, and the ships by the Ship Master, with their enormous birds on the bow ornaments and aphlasta (see above p. 208 and Note 39). The archers on our fibula must be later than the figures on the Analatos hydria (here: Pls. 52–55), and the somewhat later hydria in Berlin (*CVA*, Berlin, Antiquarium 1 Pl. 40). This fibula cannot have been produced much before 700 B.C. This would also be about the time when the fibula (here: Fig. 115) by a master who certainly is from the Swan Master's school (see above p. 205 and Note 25) was made. On one side of this fibula is a ship of the same type as on the fibula from Crete, now in Athens. The same ships also occur on large half-moon fibulae (see below p. 212 f. and Note 56 f.)—ships hung with round shields, and with big warriors on their upper decks. A horse is being transported as well as the warriors with round shields. These big half-moon fibulae mostly belong to the first quarter of the 7th century. For ship pictures of the Geometric period, see: J. S. Morrison–R. T. Williams, *Greek Oared Ships* (1968), 12 ff.

44 Nat. Mus, Inv. No. 12341: Hampe, *Sagenbilder*, 92 f. No. 29 Pl. 15.

45 Hampe, *Sagenbilder*, 36.

46 *CVA* Berlin, Antiquarium 1, Pls. 7,2; 8,1.

47 *CVA* Berlin, Antiquarium 1, Pls. 43–44.

48 W. Kraiker, *Aigina. Die Vasen d. 10. bis 7. Jhs. v. Chr.* (1951), 42 No. 191 Pls. 12–13. An aryballos in the first black-figure style, showing a rider, now in Berlin, slightly later (Payne, *Protokor. Vasenmalerei*, Pl. 10,6). Cf. also the aryballos with a fight scene, helmets with waving crests, round shields and archaizing Dipylon shields, produced before the end of the first quarter of the 7th century (Lorimer, *BSA* 42, 1947, 93 f. Fig. 7. Payne, *Perachora II*, 15 ff. No. 27 Pl. 2,57).

49 The sitting position of the rider presented difficulties to the fibula master: the outline of the horse's body here is continuous, so that the warrior has to appear to be completely behind it, which cannot have been intended. One of the legs of the rider ought really to be shown in front of the horse's body, passing through a gap in the outline of the horse. His other leg ought to disappear behind the horse. Similar difficulties occur on the four riders on the Protocorinthian kotyle from Aegina (see above Note 48): on the first and third horses, the bodies of the horse and the youth merge, as in Geometric-Protoattic. On the second horse, the saddle is drawn behind the mane in such a way that the rider seems to be suspended behind the horse. In the fourth rider, buttocks, thigh, calf and foot are joined in a single incised line and the youth is sitting facing backwards in front of the neck of the horse. The kotyle from Aegina is more developed than the fibula from Thebes, but both still belong to the first quarter of the 7th century. In both of them, the problems of drawing a rider are still being worked out. Two more aryballoi in the Protocorinthian style (see above Note 48), from the end of this quarter of the century—one with a fight scene, the other with a rider—demonstrate the greater sophistication of artists at this time.

50 *Kerameikos V* 1, 235 f. Pls. 159–161.

51 Inv. No. M 47. *Kerameikos V* 1, Pl. 159 (whole chain), 160 bottom left (the two smaller of the four bow fibulae).

52 Inv. No. M 48. *Kerameikos V* 1, Pl. 160 bottom right, 161 top left (large plate fibula), 160 top (the two bow fibulae). The two small plate fibulae were severely damaged and are not illustrated.

53 See above 202 and Note 10.

54 *Kerameikos V* 1, 194.

55 Boehlau, *JdI* 3, 1888, 362 f. Fig. e (unreliable) Reisinger, *JdI* 31, 1916, 303 f. Fig. 8 (accurate drawing).

56 Berlin, formerly Antiquarium (Inv. No. 8458): Furtwängler, *AA* 1894, 116 No. 2 Fig. 2. Hampe, *Sagenbilder*, 98 f. No. 61.

57 Berlin, formerly Antiquarium (Inv. No. 8396): Furtwängler, *AA* 1894, 115 f. No. 1. Hampe, Sagenbilder, 98 f. No. 60 Fig. 1 (p. 12). Lorimer, *BSA* 42, 1947, 117 Fig. 11 a.

58 See above p. 211 and Note 55.

59 See above p. 170 ff.

60 Sun-like stars with eight, six or four leaves with single or double rows of teeth round the edge occur on large Attic grave kraters around 750 B.C. Unlike the bow fibulae, however, they are not a central motif, but appear outside death and burial scenes, next to the kraters' large handles.

(Louvre A 522: *CVA* Paris, Louvre 11, III H b Pl. 4,3. Davison, *Workshops*, Fig. 15 a–b. Louvre CA 3382: *CVA* op. cit., Pl. 9,1. Athens, Inv. No. 806: Davison, op. cit., Fig. 18. Athens, Inv. No. 990: Davison, op. cit., Fig. 25; here: Pl. 40. Sidney, Nicholson Museum: Davison, op. cit., Fig. 21).

61 H. B. Walters, *Catalogue of the Bronzes … in the … British Museum* (1899), 372 ff. Nos. 3204–3205 Figs. 85–88. Schweitzer, *Herakles*, Fig. 30–31. Hampe, *Sagenbilder*, 104 f. No. 100 Pl. 1; 104 f. No. 101 Pls. 2–3. Schefold, *Sagenbilder*, Pl. 6 a (No. 3205).

62 G. Loud, *The Megiddo Ivories* (1939), 14 Nos. 55–56; 17 No. 148, 151 Pls. 13, 28–29. Descamps, *Ivoires*, 58 No. 33 Pl. 7 (Tell ed Duweir); 97 Nos. 476–478 Pl. 54; Nos. 480–482 Pl. 53; No. 483 Pl. 57 (Megiddo); 122 No. 808 Pl. 75 (Tell Atchana).

63 A still earlier Geometric jug in Copenhagen may also show Herakles with one dead Stymphalian bird, and the rest of the birds fleeing (see above p. 56 and Note 122 in Ch. II).

64 Preliminary report: Daux, *BCH* 86, 1962, 854 ff. Fig. 16 Pl. 29. Vanderpool, *AJA* 67, 1963, 282 f. Pl. 66 Figs. 18–19. Final publication: Ervin, *Deltion* 18, 1963 Meletai 37 ff. Pls. 17–30. The pithos was used as a burial vessel: remains of human bones were found in it (cf. Ervin, op. cit., 38).

65 Berlin, formerly Antiquarium (Inv. No. 31013 a–b): Reisinger, *JdI* 31, 1916, 288 ff. Pls. 17–18. Hampe, *Sagenbilder*, 98 f. No. 62 a–b Pls. 4–5.

66 In the drawings in Reisinger (see Note 65), the inner ring around the central rosette is thicker, but this does not occur on the fibulae themselves. It is clear, however, that the inner ring in the enclosed circular pattern had a special significance.

67 H. R. Hall, *La Sculpture Babylonienne et Assyrienne au British Museum* (1920), 51 Pl. 56. C. Bezold–C. Frank, *Ninive u. Babylon*[4] (1926), 160 Fig. 135. H. Frankfort, *The Art and Architecture of the Ancient Orient* (1954), 103 Fig. 40. Barnett, *Nimrud Ivories*, 186 No. H 1 a Pl. 13; 189 No. K 2 Pl. 15.

Chapter X: The Architecture of the Geometric Period (pages 218-228)

1 Drerup (*AA* 1964, 180 ff. Figs. 1–14) has now given a general view.

2 *Tiryns* III, 209 ff.

3 Frödin-Persson, *Asine*, 39 f.

4 Burr, *Hesperia* 2, 1933, 542 ff.

5 Burr, *Hesperia* 2, 1933, 552 ff. Figs. 10–11.

6 *Vitruvius* II 1,5.

7 Burr, *Hesperia* 2, 1933, 604 f. No. 277 Figs. 72–73. U. Hausmann, *Griech. Weihreliefs* (1960), 16 ff. Fig. 6.

8 Buschor, *AM* 55, 1930, 16 f. Fig. 6 Supplement 4. Drerup, *Marburger Winckelmann-Programm* 1962, 1 ff. Fig. 1 Pl. 1.

9 Payne, *Perachora* I, 27 ff. Pls. 116, 139. The measurements quoted are taken from the plans. The measurements given by Payne, op. cit., 29 (about 8 x 5–6 cm.) are incorrect.

10 Payne, *Perachora* I, 30.

11 Marinatos–Hirmer, *Kreta*, 45, 103 Pls. 138–139.

12 On the motif, cf. Schweitzer, *AM* 55, 1930, 106 ff.

13 G. Neumann, *Gesten und Gebärden in der griech. Kunst* (1965), 84 f.

14 Payne, *Perachora* I, 34 ff. Pls. 8–9, 117–120.

15 A. v. Gerkan, *JdI* 63/64, 1948/9, 5 f. = *idem, Von antiker Architektur und Topographie* (1959), 384 f.

16 Müller, *AM* 48, 1923, 52 ff. Pls. 6–7. The correct reconstruction is given in Oikonomos, *Ephem*, 1931, 1 ff. Figs. 1–15.

17 Robertson, *BSA* 43, 1948, 101 f. Pl. 45.

18 Dawkins, *Artemis Orthia*, 9 ff. Fig 7 Pl. 1.

19 Marinatos, *BCH* 60, 1936, 214 ff. Pls. 26–27, 31.

20 Mylonas-Kourouniotis, *AJA* 37, 1933, 273 ff. Figs. 4, 6 Pl. 34. *Deltion* 14, 1931/2, *Parartema*, 2 Fig. 3. *Idem, Eleusis* (1934), 9 Fig. 2. Travlos, *Ephem* 1950/1, 1 f. Fig. 2. G. E. Mylonas, *Eleusis and the Eleusinian Mysteries* (1961), 35 ff. Figs. 11, 13.

21 Mylonas-Kourouniotis, *AJA* 37, 1933, 274 Fig. 4 Pl. 34 (the wall K). Mylonas, *Eleusis*, 57 f. Figs. 11, 13.

22 M. P. Nilsson, *The Minoan-Mycenaean Religion*[2] (1950) 77 ff. Fig. 13 (Knossos) 23 (Hagia Triada) 31–32 (Asine).

23 The same applies to the somewhat older horseshoe-shaped temple model from Perachora. The covering of the porch by the pitched roof is only a conjecture of reconstruction, and is not conclusively established by the fragments.

24 E.g. temple A in Prinias on Crete: Pernier, *ASAtene* 1, 1914, 30 ff., 75 ff. C. Weickert, *Typen der archaischen Architektur in Griechenland und Kleinasien* (1929), 57 ff. Matz, *Geschichte*, 371 f. Fig. 22.

25 M. P. Nilsson in *Festschrift f. O. Rydbeck* (1937), 43 ff. = *idem, Opuscula Selecta* II (1952), 704 ff. M. Launey, *Le sanctuaire et le culte d'Heraclès a Thasos* (1944), 172 ff.

26 See Dawkins, *Artemis Orthia*, 10.

27 See above p. 220 f.

28 v. Gerkan, *JdI* 63/64, 1948/9, 4 ff. = *idem, Von antiker Architektur und Topographie*, 384 ff.

29 See above p. 221 and Note 20. Travlos, *Ephem* 1950/1, 1 ff. Figs 1–8.

30 See above p. 221 f. and Note 21. If Travlos's conjectural *anaktoron* really was the adyton to the 'Solonian' *telesterion*, four *anaktora* must have been built on top of each other on the same site: the Late Mycenaean *anaktoron*, the Early Geometric oval building, the Solonian and, lastly, the Pisistratid *anaktoron*. The last two had identical ground plans.

31 See above 218 and Note 4.

32 See above 219 and Note 8.

33 *Hom. Hymnus an Demeter*, 96, 184. M. P. Nilsson, *Geschichte d. griech. Religion* I[2], (1955), 474 f.

34 *Tiryns* I, 2 ff. Figs. 1–5; ibid., III, 209 ff. Pls. 1, 5.

35 Hood-Boardman, *JHS* 75, 1955, Archaeolog. Reports, 21. Now: J. Boardmann, *Excavations in Chios 1952–1955* (1967), 31 ff. Fig. 16 Pl. 7 a–c.

36 Soteriades, *Ephem* 1900, 171 ff. Plate Supplement 1. Rhomaios, *Deltion* 1, 1915, 225 ff. Fig. 2. Weickert, *Typen der archaischen Architektur*, 7 ff. Drerup, *Marburger Winckelmann-Programm* 1963, 1 ff. Figs. 1–5 Pls. 1–2,1.

37 v. Gerkan, *JdI* 63/64, 1948/9, 6 = *idem, Von antiker Architektur und Topographie*, 385.

38 Rhomaios, *Deltion* 1, 1915, 270 ff. Figs. 39–41.

39 Buschor, *AM* 55, 1930, 13 ff. Pls. 2–3. Buschor-Schleif, *AM* 58, 1933, 150 ff. Figs. 13–14.

40 W. Dörpfeld, *Alt-Olympia* (1935) I, 145 ff. Figs. 35–36.

41 Cf. the cave-like 'hut urn' containing a goddess idol, found in the rubbish in the spring chamber of the *caravanserai* in Knossos (A. Evans, *The Palace of Minos* II 1, 1928, 128 f. Fig. 63).

42 Schleif, *AM* 58, 1933, 150, 152.

43 R. Eilmann, who analysed Samian pottery with such care, warned against being too hasty in selecting an early date: 'the sites where a very few Geometrically decorated sherds were found may indicate a date earlier than Altar II ... but some of them suggest that considerable caution is necessary' (*AM* 58, 1933, 95).

44 Hencken, *AJA* 54, 1950, 295 ff., 308.

45 Eilmann, *AM* 58, 1933, 118 ff. Supplement 36, 13–17; 37,2.

46 Perrot–Chipiez, *Histoire* III, 868 Fig. 636. *SwedCyprExped* IV 2, 140 Fig. 23,3. Hencken, *AJA* 54, 1950, 295 Fig. 2.

47 In the Archaeological Museum in Rhodes.

48 Walter, *AM* 72, 1957, 51.

49 v. Gerkan, *JdI* 61/62, 1946/7, 17 ff. = *idem, Von antiker Architektur und Topographie*, 376 ff.

50 v. Gerkan, *JdI* 61/62, 1946/7, 27 = *idem, Von antiker Architektur und Topographie*, 381.

51 As finds testify, Samos, Cyprus and Rhodes are the islands which established early trading links with the Orient and Egypt. Buildings like the funeral temple of Mentuhoteps II in Thebes, constructed at the end of the Old Kingdom, may well have inspired the idea of the peristyle. On the beginnings of the peristyle in Greek temples, cf. also Drerup in *Festschrift für F. Matz* (1962), 32 ff.

List of Plates

List of Text Illustrations

The following figures were drawn by Winfried Konnertz: 1, 2, 3, 13, 14, 15, 20, 21, 22, 23, 24, 25, 26, 27, 32, 33, 34, 36, 37, 38, 39, 40, 44, 46, 47, 48, 49, 51, 53, 54, 55, 56, 57, 58, 59, 60, 64, 65, 66, 67, 69, 70, 71, 72, 73, 75, 76, 84, 85, 89, 90, 93, 94, 95, 99, 104.

Index